D1382591

THE COLLECTED WRITINGS OF JON THOMPSON

EDITED BY JEREMY AKERMAN AND EILEEN DALY

RIDINGHOUSE

CONTENTS

FOREWORD
JEREMY AKERMAN AND EILEEN DALY

Jon Thompson's rules for writing are simple: be jargon free, be an advocate for art and to provide a context that is not just parochial; his voice is distinctive because he writes from the viewpoint of an artist. Over the years writing has been a way for Thompson to carve out space for himself in order to test, defend, attack and define different areas of artistic interest. At times he plays the detective, looking back at how artworks and their practices have developed, at other times he writes with a lyrical voice. Underlying all the writing in this volume is a depth of first-hand knowledge backed up by formidable amounts of study. Thompson is credited with being one of the most influential British teachers of his time, so it is no surprise that through all his writing there is much to learn. The essays collected here provide an overview of his range, and form a substantial legacy.

In the 1960s, after studying art in London at St Martins School of Art and at the Royal Academy Schools and spending some time at the British School in Rome, Thompson was taken up by the Rowan Gallery as an emerging Pop artist. His flirtations with Pop came to a quick end as he began to perceive the limitations of the movement. An academic career also called, and soon he was embroiled in thinking about how best to run an art college. His approach

was to provide an 'umbrella' under which his colleagues and students could flourish, an approach that reached a commonly recognised series of successes when he held the position of Head of Fine Art at Goldsmiths College, London. Goldsmiths was later to be enshrined as the birthplace of the Young British Artists. Thompson then moved on to teach at the Jan van Eyck Akademie, Maastricht and at Middlesex University.

Along the way, Thompson has also been responsible for curating exhibitions such as *Falls the Shadow* and *Gravity and Grace*, both staged at the Hayward Gallery, London. These exhibitions are renowned for their impact on ways in which young artists in the UK came to think about and make art. Thompson has remained constant in his own work and recently his attention has been entirely devoted to painting, realising a series of brilliantly spirited solo shows through the Anthony Reynolds Gallery, London.

Many people will be familiar with his voice, either as a tutor, a contentious critic or as a curator. Others may have read essays by him, but few may be aware of the extent of his writing, which has proved to be an invaluable contribution to recent art history and the role of art writing. When we began to track down his essays, we estimated there would be 50 or so, but the number proved to be nearer to 80 pieces. His perspective, insight and clear style has led to numerous commissions; he writes for artists of fame and no fame, for exhibitions, lectures, catalogues and museums. Most of all, this book is for those interested in art. Thompson articulates art's ability to continually lever us free from a routine world.

We would like to thank the following individuals and organisations for their very generous support of this project, Richard Deacon, Mark Wallinger, Ria Pacquée, Joëlle Tuerlinckx, Christoph Fink, Jon Bird and Middlesex University, The Henry Moore Foundation, Maria Crossan and Arts Council England, Anthony Reynolds, Charles Asprey and *Picpus*. We would also like to thank the publisher Ridinghouse, especially Karsten Schubert, Doro Globus and Louisa Green, as well as designer Marit Münzberg. Additional thanks to Colin Painter, Matty Pye and Sacha Craddock.

Special thanks goes to Andrew Webb and Jon Thompson, as without their help this book would not have been possible.

WHY I TRUST IMAGES MORE THAN WORDS: JON THOMPSON TALKS ABOUT WRITING WITH JEREMY AKERMAN AND EILEEN DALY

Eileen Daly: *What was the initial motivation for you to start writing?*

Jon Thompson: It was in the late 1970s, early 1980s. The John Murphy interview (pp.26–39) was one of the very first things I had published. The critical writing started because there were whole areas of art that weren't being written about at all, and I felt that if nobody was going to write about them then we [artists] should do it. I've never been that comfortable with writing, but I just thought at the time that a space had opened up, which needed to be explored.

ED: *Talking about creating a space for artists to operate in – how does one find such a space? What might you advise younger artists about opening up such a space for themselves?*

How younger artists operate really amounts to them prising a little gap in which one can act in and think independently. I think that's the only kind of space that today's art world affords you. You just have to think a little bit off the beaten track and you have to act on it very quickly, otherwise the space is

closed before you've done anything. We are suffocated by newness now and that seems to be so obvious, but newness is mostly trivial.

Jeremy Akerman: *Were you sympathetic to other artists' requests for you to write about them because you were making a similar kind of art?*

There was an element of that in it. I started off as a painter and found after a while that as a member of the British Pop art movement I was running out of steam, because there's only a limited number of trips to the Golden Mile in Blackpool that you can make as a form of inspiration for work. So I thought, 'I've got to stop, rethink and start again.' The writing became part of that process of rethinking. I didn't deliberately start off to be a writer. I was rethinking my own practice at the time and I was searching around, reading a lot of theory, reading a lot of art history, reading a lot of philosophy, and beginning to map the ground for a different kind of practice for myself.

ED: *What books were you reading during this period?*

I first read Foucault at that time. *The Order of Things* (1966) was a tremendously important discovery for me, especially the introductory passage on Velásquez. Barthes, I was obsessed with Barthes; I still am to a certain degree. I think Barthes was one of the great poetic thinkers of the modern movement – I can't think of anyone else who is as good as that.

ED: *When you were in this regrouping phase, was the writing an experimental space for you?*

I've always felt that writing – to some extent – is an experimental space; it's a way of challenging my own orthodoxies if you like. I don't know if you've noticed, but there's an iconoclastic side to my writing which might sound as if it's outward-looking but it isn't, it's also iconoclastically directed at myself. I always find that what I think is often at odds with what I see. I look at a work and think, 'I ought to be thinking this', but actually the work isn't telling me to think that, it's telling me to think something else. So I end up in this kind of struggle while I'm writing, and that's why I don't write easily – I'm always trying to reconcile what I'm seeing with what I'm thinking.

JA: *Could you elaborate on this struggle between seeing and thinking?*

Thinking is analysing, so I am always aware of the difference between what your intuition tells you to do and what your analysis tells you to do. Is my intuition telling me what I should rely on, or is my analysis telling me what I should rely on? The point about this struggle is that it's never clear.

ED: *There often comes a point in your writing where there seems to be a kind of break and you go to another place where you begin asking other questions about art or philosophy. A kind of wrestling within your writing comes through. I don't know if you feel that or not?*

That description is something that I recognise; I often find when I'm writing I start off with quite basic questions or insights about what I'm supposed to be writing about and I find the more I think about them the more I'm almost led away from them, and then I have to make a deliberate effort to get back. That's partly to do with the fact I've read a hell of a lot and have not always been able to reconcile what I've read with, as it were, the life of art. I've always been very, very suspicious about the notion that art is a language. It starts with Foucault, Barthes, and all of the French tradition, Derrida and so on, around the notion that art is a version of language and although I follow that diligently as a theoretical argument, I've never been convinced by it. I always have the feeling that I've got to get back to the thing itself, to the visual experience, and so that war that goes on inside me often materialises in the writing. I am deeply suspicious of words and the way that they shift. In Barthes there is the idea of the shifting signifier. I think language is about shifting signifiers, but I don't think art is really about shifting signifiers.

JA: *How influential are these crisis moments where your understanding of something seems to be at odds with the world?*

Well, I originally started off as a sculpture student because my grandfather brought me up during the war and he had been an ecclesiastical woodcarver, and through him I was brought into contact with all the skills of representational woodcarving. So when I went to art school I thought that I knew what art was about, that is skill, craftsmanship and veracity in terms of the appearance of things, but at art school there was a brutal moment of awakening to discover

all the contemporary artists of the period were not doing the things I thought art was about at all.

ED: *Brutal in a horrible way or in a good way?*

In a bearable way. It wasn't that horrible, it just threw all sorts of spanners in the works, but that was the first big rupture in my life. The Pop thing carried me along for a bit, but at the end of all that I began to say to myself, 'What is this? What does it have of lasting value?' And almost I kind of flipped back to that notion that art has to have something deeper and stronger. It put me in a terrible dilemma; it was like turning summersaults. So I started to paint landscapes again; I bought a cottage in Derbyshire and started to paint from the motif. I thought that I had to go back to school again, as it were, and put myself back through the whole process and see where I landed. I started looking at philosophy and reading Kant and trying to wrestle with the *Critique of Pure Reason* (1781).

JA: *When you were in Derbyshire, were you outside painting in the fields – reading Kant by night and painting by day?*

Yes, that's more or less what I was doing. I started with Kant because of Cézanne. Cézanne carried a copy of *Critique of Pure Reason* around with him in his pocket, and it was in his studio when he died, heavily thumbed – he must have read it over and over and over again. Nobody knows what he made of it. I suspect he was probably completely baffled by it, which is why he read it so much. You can see how Cézanne would have been totally fascinated by it. So that connection between Cézanne, painting landscapes and Kant was my starting point.

ED: *Would you be able to describe the evolution of your work as a writer?*

I made certain rules for myself when writing about art – I don't always manage to stick to them – but I did make certain rules and I still think they're the right rules. If you're going to write about art you must put yourself in the sway of the work itself. That must be the starting point and must, in the end, be the thing that you're seeking to elucidate in one way or another. So much writing about art, in my view, is really writing about writing about art. When I'm writing at my best I manage to stay focused on the work and manage not to wander off too much, as I have a tendency to wander off into philosophy and into other areas.

ED: *What are the other rules?*

I think the other major rule is to try and avoid using jargon and to try to be clear by writing in commonly understandable English. In so much writing about art the vocabulary is taken wholesale from theory and it produces a kind of obscurantism, which is unbearable. I think you need to put yourself in the service of the work and then in the service of the reader. If you can somehow make those two things meet, then I think you've done a reasonable job. It might not be great writing or great criticism, but you've done a reasonable job, a workman-like approach.

ED: *Do you think you're always writing primarily from the perspective of an artist?*

That's inescapable for me. I've read an awful lot of philosophy and a lot of post-critical theory as well, but I've never thought of myself being entirely comfortable with the technical side of either of those two things, I'm not a technical philosopher and I'm not a technical theorist either. It's mostly because I'm a trickster figure in a funny kind of way. I like getting hold of things and playing games with them. I don't feel that I'm responsible to them: I'm not responsible to critical theory or philosophy.

JA: *Being an artist places you outside of that...*

Yes. I'm not responsible to those disciplines, but I am responsible to art. That's my practice.

ED: *I think that's a good description, the 'trickster', because in your writing those elements are evident: the guise of the theorist is there, the guise of the critic is there, but actually the text often doesn't come down on either side of those two things, it's something else.*

The third rule is that ultimately you're a kind of advocate as a writer. And by that I mean that you shouldn't find a case for something you can't be an advocate for. I've never tried to do that, although on occasions it can cause some difficulties. An example being the Tuymans article (pp.212–222), it caused such a massive stir and it's the only time I've really let loose on somebody, on an artist. I just felt it was very necessary for somebody to talk about the effect of Luc Tuymans on

young artists practising in Belgium at that time. They saw it as the royal route to success, that all they had to do was a vaguely Tuymanesque dab or two on the canvas and life would become sweet and they would make quite a lot of money.

JA: *You clearly state what you think the rules are for writing, could you expand on this a little?*

They are my basic rules, and I think there is another one you could add to that which is the context for the work. I think a lot of criticism doesn't do that. I think writing should provide a context that is not just parochial which you can measure the achievements of an artist against.

JA: *So it's been a huge arc really from writing notes to yourself to writing about other people from the position of someone who was thinking about art, making art understandable, and as an advocate for other artists. Was there a point when all that eclipsed your own practice completely?*

No, I think what eclipsed my own practice was teaching. Teaching never eclipsed it totally, thank god, but it did go a long way towards doing so. I don't have regrets about that, but I think that teaching takes up a lot of different types of energy, which are the same kinds of energy you need to practice. So I found myself taking shorter and shorter cuts within my work in order to conserve energy. I don't think writing was a substitute for my art; instead, writing was a supplement to my practice.

ED: *Do you ever write about your own work?*

I find that absolutely impossible. I recently wrote about the pianist Glenn Gould in relation to my work, but it wasn't published. When you write about yourself it can sound pompous because the focus is never clear. When you're writing about someone else's work the focus is always clear because it's outside of you. When you write about your own work it's both inside and outside of you and it's very difficult to manage. I don't know of anybody really who's done it successfully.

ED: *Jon, let's go back to your rule about being an advocate for artists. One of the things that came through in the essays was that you seem to be concerned with the question of what it means to be an artist, and I wondered if that was one of the*

things you were trying to communicate through your writing? For example, in the Ria Pacquée interview you talk about how an artist may be expressing the failure of an artwork (pp.333–41), or in the Richard Deacon piece you talk about how an artist has to grapple with the artwork and how it is wrestled into being (pp.180–202). Are those the kind of things you were trying to communicate?

At the start of every artwork, it doesn't matter how small or large, there is a propositional moment where you're saying, 'I'm going to do this because I think it will result in a work of art.' That propositional moment is entirely a shot in the dark no matter how experienced you are as a practitioner; it's never merely repetitive, even with somebody like Frank Stella doing a 'Black Painting'. The propositional moment is always there. That's the big risk that all artists grapple with all of the time, it's what makes their life both satisfying and hellish, because when it blows out it really blows out. The state of risk is what art is built upon. I don't know if I'm answering the question here, but it's a starting point. I'm always trying to write from the standpoint that art starts from a proposition and that that proposition is dangerous. Most people don't understand that. Most people who look at art don't understand that at all. They always see the accomplishment, and unless they're very clever they don't actually go back to the moment of risk. I've recently been looking at some of Carlo Crivelli's early Renaissance paintings; in *The Annunciation* (1486) he paints the blowing tree... I keep looking at these over and over again and I think they're such dangerous paintings – everything is brought to the point of focus where it could fall apart in an instant. If you can get some of that sense of the excitement of origin into the writing, I think you can maybe begin to say something.

JA: *How close do you think you are to being a kind of detective in trying to find that point of origin?*

I can't think of any other way to do that, although works of art have a certain appearance the appearance itself has a genesis. You need to begin to get into that genesis a little bit, to find out why they appear the way they do. This means you have to get into the thinking process that produced the artworks at the point of them first becoming an image. It's a futile task, but I think you can try to get into it a bit.

JA: *How aware are you of positioning things art historically?*

I'm very aware of it; it's inescapable. It's that issue of advocacy again. Advocacy is not just about speaking on behalf of something, it's speaking about something in a particular context. As that context is formed historically you have to think about the historical configuration that allows the work to appear at a particular moment. Now that might not be the main focus of the writing, because I'm not an art historian, but I always have to think about the context. In the article on Kounellis (pp.64–75), for example, I refer to the connection between Kounellis and Baudelaire, I don't think anybody had ever written about it or spotted it before. Yet Kounellis is highly well-read in the area of poetry and knew his Baudelaire upside down, back to front and inside out. That's a historical link, and that piece is setting him in the whole context of the history of Symbolism. Those kinds of insights are artist's insights; an art historian would perhaps never be naive enough to actually say it, because they'd think you have to introduce this and that and set out all that groundwork. I often talked to Ian Jeffries when we were at Goldsmiths – a proper art historian – and I seem to remember that even he acknowledged that the curse of the art historian is that they have to map out the territory and might never come to focus on the real point of the practice.

JA: *There's a creative power to your writing, for example, where you've put Kounellis and Baudelaire in the same frame and have created something new. I wonder how much of that is born from an artistic view or from a teaching view?*

It's partly teaching; it's partly artistic. The great thing about being an artist is that you don't actually owe any allegiance to academic discipline. You're not a member of that fraternity so they can't really whip you and punish you if you cut a few corners. I do think you have a responsibility to try to be diligent when you write, but it's not that kind of scholarly diligence, it's a diligence about ideas.

JA: *And yet to take some of these technical points on, you've had to fully understand many scholarly styles, thus covering a huge amount of ground in order to write something seemingly quite light. Is that a style that's yours, a particular kind of writing?*

I don't know if I have a particular style or not. I seem to be able to write in different ways and that has something to do with the task. The piece I did on Orla Barry (pp.444–52) is a different way of writing altogether. But that was

the licence she gave me; she said 'Just write the way you want to write. I'm not interested in a scholarly text, just write however you want to write.' It was an opportunity to get at the meaning of the work from a different direction.

ED: *Talking about your different styles of writing, what about the writing you do for lectures, where the text is set out on A3-paper like stream of consciousness notes* (pp.252–97).

Well, I used to slavishly write out lectures and then read out the notes, but everybody usually fell asleep. And what I realised very quickly was that they went to sleep quite rightly because it was boring. Some people can do that and it's not boring, I've heard some lectures by Frank Kermode which were electrifying, they were so beautifully written, so beautifully articulated and spoken. I couldn't do that. My lectures only came to life when there was an element of risk involved, and that meant picking my way through the material afresh. One way of doing that was to make these complex maps so that I could take different routes at different times.

ED: *So you could veer off on to another road if you wanted to, or stick to the path...*

Exactly, I never wrote down what I was going to say and that was my way round the problem of sending people to sleep.

ED: *This question also relates to your writing style. It was something you said in the Richard Deacon essay (pp.180–202) when you were linking the poetic aspect to the more technical aspects of his practice. You talked about the poetic side being refined and sensual, and the technical side being more rigorous. As I was reading this I saw some parallels within your own writing: the more lyrical poetic pieces were often opposed by more rigorous pieces – are these two sides to your writing?*

There are two sides to my writing; there are probably more than two. But those are the two main sides and I think that it has something to do with the feeling of responsibility. When I become more technical I feel a sense of responsibility to be clear to the reader about what the grounds are upon which I'm making the argument. I think that piece on the sublime, *The Sublime Moment: The Rise of the Critical Watchman* (pp.320–31), is quite a technical essay. It's probably the closest I've come to writing a technical philosophical essay, but then it seemed

to me to be absolutely necessary to do that, otherwise how would you make the case for the modern sublime unless you really unpicked the historical sublime to some extent? I had to go through Edmund Burke and the philosophers that defined the sublime in the first place before I could come to the modern sublime. You can't assume that the reader has already done that work. You have a sense of responsibility, to be clear and to try not to bamboozle people.

JA: *Who is your reader?*

A lot of the time I think of the reader as the ordinary man in the street, oddly enough. I'd like to think that most of the things I've written, with a certain amount of application, are understandable by most reasonably intelligent people.

JA: *We've touched on it in different ways but the connection between the verbal and the visual, could you try to say how that's changed for you over time?*

It has changed over time and still is changing to some extent. I am quite a dyed-in-the-wool Wittgenstinian in the sense that I really do believe that the senses are connected to particular art forms. So the visual sense is connected to visual art, and in some ways that's an indissoluble compact; words are connected to the aural sense and that's an indissoluble compact. Wittgenstein said in *Philosophical Investigations* (1953) that there are translations; he had a special word for these connections, not licence, it's something like that, but what it means is, is it possible to claim to be able to translate between the senses in anything but the most general form? The more and more I think about it, it is impossible. The only thing that rationalises the connections is description, but description is a very doubtful vehicle. I can describe things one way and you can describe them another way, and these descriptions may appear to have very little in common, except that they are attached to the same object. More and more I come to the position where I think art shouldn't have too much traffic with words.

ED: *Is there one thing that differentiates your writing?*

Yes, the one thing I've always tried to avoid is getting too far away from the work; appearing to stand at too great a distance from the work. I do think that's important.

ED: *Looking back over your writing, is there anything that surprises you?*

I'm amazed at just how much I've written; that does surprise me.

Sandwich, Kent, June 2008 and November 2010.

This interview with John Murphy was my first attempt to put something into the public domain that brought out the complexity of the subject. Interviews with artists tend to be either bland and superficial or they suffer from inconsistencies generated by the interviewing procedure itself. In this case we decided not to rely on a straightforward sound recording but to augment it with extensive note-taking and follow up discussions in order to arrive at an agreed text. The final result then, is an edited version drawn from quite an extensive range of source material. It was a technique that I used a number of times afterwards but not with the same degree of success. There was something about Murphy's work at that time, which lent itself to this kind of discursive approach.

JOHN MURPHY:
INTERVIEW WITH JON THOMPSON

Jon Thompson: I saw your work for the first time at the ICA. The pieces had a collective title – Nature Morte – Collected Works *(1976) – and consisted of collaged images of birds' eggs with writing underneath. The overall atmosphere was that of a museum of rare and fragile things, each item fondly displayed and documented.*

John Murphy: That particular exhibition was unusual in this respect. The rooms themselves contributed to the feel of the show, but there was also something in the work itself which required that kind of installation. The work deals with the idea of the culturalisation of nature: an extreme example of which might be found in an institution like the Natural History Museum where nature is taken out of its 'natural' context and presented as a cultural artefact. That's one of the ideas embedded in the work. I wanted also to draw a parallel between this set of culturalisation and the culturalisation of art. The images of the birds' eggs allowed me to do this; to make the connection between art and nature and between nature and culture.

You do though, work thematically, don't you? The works are often grouped under a generic title. The egg pieces are one example of this but there are others... An

Art of Exchange *(1976), for instance. You would agree then that there are important connective characteristics within each series; connective characteristics which are just as important as those which are made within each work.*

JM: Yes, certainly, all of my work is conceived like that – it all interrelates in some way. There are no strictly individual pieces. The connections that I make in each work, the signs, symbols, analogies, are properties of the groups of works just as much as they are properties of each piece. I might go further and say that these connections also reach out to embrace the work of other artists as well – there is a sense, for instance, in which I 'take over' the *Grande Odalisque* of Ingres (1814) or *Les Demoiselles* of Picasso (1907) when I use them as pictorial elements within my work. They become a part of the cipher.

You so often use terms like signs, symbols and ciphers when you speak of you work; almost as though they were ideograms, things to be read.

JM: Yes, what I'm basically trying to do is to force the spectator to think, not, though, to think about something specific but rather to engage in the process of thought itself. I came across quite a useful definition of thought in Destutt de Tracy, one, anyway, that I would subscribe to. He makes the point that to make a judgement of any kind is an act of thought, 'in fact, to pass a judgement, true or false, is an act of thought. This act consists in feeling that there is a connection, a relation. To think as you see is always to feel there is nothing other than to feel.' De Tracy's idea that judgement, thinking and feeling, are all aspects of the act of seeing, is one that appeals to me and no doubt you can see how I get from this to the notion of a work being what you call 'readable'.

Could you attempt a one-sentence definition of the way your work is intended to function?

JM: Yes, I think so: the work is intended to provoke thought and the signifying elements in the works allow me to structure the pieces to this end.

You see your role, the artist's role, as being prescriptive then? You use your work to prescribe certain ways of thinking or certain ways of feeling; or certain thoughts and certain feelings?

JM: Certainly not my thoughts and feelings. The works are meant to have many possible readings, some of which are intentionally paradoxical – their meaning is never really fixed – they never express one point of view and certainly not my point of view. I never use the work to say that 'such and such is the case' or 'this is what you should think'. The works are prescriptive then only insofar as they provoke certain patterns of thought, certain ways of arriving at meaning.

Do you mean by this something rather analogous to Duchamp's notion of images reverberating? I think he described it as similar to a stone thrown into a pond – the ripples always move in a related way to the cause even though one might not be able to predict where they are eventually going to strike dry land.

JM: Yes, I've often used the image of the spiral when discussing my work. Each piece or group of pieces creates a spiral of meaning, one meaning suggesting another meaning, which in its turn suggests another and so on and so on. The spiral is always different because of what the viewer brings to the work.

Again, this raises this very interesting notion of reading a work – you use the term deciphering I think, which is an even more technical term than reading.

JM: This is because the word deciphering describes precisely what I think we do when we confront a work of art. Works of art are ciphers. Ciphers of a very particular kind amongst many other very particular kinds; faces, landscapes, words, houses – there's an endless list. I think that we relate to things in general via a process of deciphering, that's how we make sense of what's in front of us. Making art works for me is very much a process of building ciphers.

This brings me to an important point. I find your work very cold, very preconceived and pretty well without affect. It is almost as though it is completely mapped out in your head before you start and that you make no imaginative interventions in the making process. Is this a fair description?

JM: On the whole, yes. The ideas often take an enormous length of time to germinate – a year or two years is not unusual.

This is before you start making a work?

JM: Yes, the idea can be around for a long time or at least, certain elements can be around for a long time until I discover a key element which will allow me to construct the work. Generally speaking, I know exactly the form of the work before I start making it; although occasionally I will attempt to make a piece and find that I have to alter it radically in mid-stream – changing the whole form of the work.

Why would this be, do you think? Is it because in the process of making you find that your cipher is just not going to work?

JM: Yes, usually it becomes apparent that the *form* of the cipher is not going to work.

It's a formal problem that emerges, then?

JM: Yes, the making process is purely a matter of realising the appropriate form for the content of the work and sometimes it just simply doesn't work out according to plan. I then have to rethink it from scratch.

It's interesting that you make a distinction between form and content in quite such a straightforward way, I would have suspected from just looking at your work that you would have had difficulty in being so clear-cut about it.

JM: Well I think of form and content as being two sides of the same coin; that they are quite distinct aspects of the work which become inseparable only when the work is correct.

When we spoke together before about your work, I remember that you said that there was a way in which it could be said that your works made themselves. Anyway, what I distinctly remember is that you said that you wanted to interfere in the forming process as little as possible.

JM: The work has a kind of inherent logic to it which develops as the work progresses. A good example of this would be the series of works entitled 'An Art of Exchange'. It consists of German bank notes from the inflationary period of the 1920s. I set out, in those pieces, to deal with the notion of exchange, using as a special case the buying and selling of works of art.

I wanted to make the obvious point about valuation as connoted by money changing hands but I also wanted to point to the exchange which takes place in terms of ideas. The person who buys a work of art, in connecting with it, in desiring it, in possessing it, is desiring, connecting with, possessing the ideas in the work also, in fact, a number of interesting connections between art and money emerged as I thought the piece through. For instance, the notion of floating value; certain artists are resurrected as a part of the system of currency in a particular period because they serve the ideology of that period. With this in mind, the first task I set myself was to find banknotes employing images from 'high art'.

So the idea of banknotes came in a way before the banknotes themselves. You predicted their existence out of prolonged thinking about the connection which obtains between art and money?

JM: Yes, as I said, I started looking for banknotes that employed images from painting and during this process I discovered a whole series of German notes of the inflationary period which led to the rise of National Socialism and the Third Reich. In this way the connection I had sought in the abstract proved to be a potent reality. The notes had portraits by well-known German artists including Holbein and Dürer. Now do you see what I mean by a work making itself? I didn't know when I started thinking about the work that these notes existed and I had certainly no idea that they encapsulated so completely the conceptual material I was dealing with. There was a remarkable bonus too in that some of the notes had overprinted values because Germany at the time was in hyper-inflation and they couldn't change the face value of notes to keep pace with this and so they simply overprinted them. This gave to my pieces an extra tightness that I could never have predicted.

When you speak of the work making itself then, you are defining yourself as a decipherer of the signs that come to you and the connections that they make.

JM: Hopefully, I draw ideas together in order to make connections that have not been made before or at least to make connections in a way that is new. I always use images and words that already exist so that there is a sense in which I don't invent anything, but I try to ensure that there is always an element of shock or surprise in the work. The main formal device is that of

placing elements in relationship to one another so that new analogies, new connections, are made. The aim is to be as clear as possible and the coldness you refer to is quite deliberate. I have always wanted to make the work as impersonal as possible. My opinions, my feelings, would only make the work anecdotal, would connect it absolutely to me and I would really like the work to exist independently of me. Flaubert was one of the first to break with the idea of the artist as a kind of inspired mystic, possessed by irrational forces. He said, 'one should write coldly, it's not the heart one writes with but the head. One should not use one's work as the chamber pot of one's moods.'

Flaubert is saying there that if the artist loads his own feelings, fancies, passions, on the reader, viewer or whoever, then that would be an unwarranted imposition.

JM: I think that's what he is saying and this is certainly the way I feel about it. Work should be as objective as possible. If work is heavily subjective then the viewer has great difficulty in making sense of what's there, whereas with work which is deliberate and objectively constructed the spectator is allowed to recreate the work in line with the intelligent contrivance of the artist.

You really are advancing a structuralist position aren't you? You are separating out content from form or at least you are splitting content into that which is absorbable into the structure of the work, objective content; and that which is attached to you as a sensing, feeling individual, subjective content. The former the spectator should be able to follow and read in the form of the work, and the latter you aim at excluding altogether.

JM: Can you put that more clearly?

I'll try. It seems to me firstly, that you're saying that it's quite legitimate for a work to produce in the viewer the same structuring thought processes that the artist goes through...

JM: Yes, certainly...

...but it's not at all legitimate if it provokes thoughts and feelings about the artist's subjective involvement with the content of the work. This would be tantamount to presenting the viewer with Flaubert's chamber pot to play with.

JM: In principle I would agree with this but you are perhaps stating it more strongly than I should like – clearly my work has both subjective and objective qualities. All that I would say is that I aim to play the subjective aspects down so that the work makes sense.

You wish, then, to control the parameters of the viewer's response without specifying it.

JM: Yes, that's quite a good way of putting it. I like to set out the boundaries whilst allowing the viewer to make whatever readings he likes within them. This way the work can have many different meanings, in fact, can contain completely opposite meanings although these I would have to have accounted for in the structuring of the work – they would have to be purposeful opposites. I have always liked Mallarmé's description of the work of art being like a crystal, something that is very clear and hard and very sharp but which has many facets to it.

Perhaps we might shift tack now just a little. We've discussed the cold, calculating side to your work but there seems to be an important antithesis to that, in that the works often contain clear erotic references.

JM: Perhaps I should make it clear right away that I don't actually think of the works as being erotic. A lot of them, however, discuss the correspondence between intellectual pleasure and sensual pleasure. The starting point that I employ often is the notion of desire. I would example this with the series called 'Objects of Desire' and another piece called *Desire not Geometry* (1929). These are intended to focus on erotic pleasure as an elusive thing and to make a parallel between this and the fleeting sensations of pleasure that we derive from good art. The link that I make between these two ungraspable entities is the metaphysic or essence of desire, infinite separation. As soon as the object of desire is achieved then the desire vanishes and I tried to touch on this in a piece called *Everything the Heart Desires can be Reduced to the Figure of Water*, it dissolves, it escapes through our fingers. I used, therefore, the image of the fountain. You can't, in the mind's eye, freeze a fountain or stop it, it is a completely fugitive image and yet in another sense it is always the same. This is a very good visual metaphor for desire and also a telling analogy for the work of art and our inability to fix that too.

Are you making the fountain analogous to the complexity of the work of art? Is it the complexity that renders it so fugitive?

JM: I don't really know, I don't think it's simply the complexity of works of art that make them so difficult to fix. I suppose works of art, like everything else, are subject to continual change.

The odd thing about painting is this struggling to make a complex of simultaneous relations that we think of as having all the trappings of permanence even though they can never be experienced as such and in a curious, almost sinister way, become mirrors in which we see reflected our own impermanence, our own changing natures, if you like. That's really what you've been talking about, isn't it? That's the analogy with water that you've been making.

JM: Yes.

...and your piece Everything the Heart Desires can be Reduced to the Figure of Water, *I read that as a rather interesting essay on the fleeting nature of permanence in that it places side by side in the same image, a stone statue and a fountain. The one in our scale of values a very permanent thing and the other a constantly moving and changing, fleeting thing.*

JM: When I was thinking of the piece, I was equating sculpture with the idea of gradual decay and I used the human image to tie this idea of decay to us humans. Water doesn't decay, it just changes. That's the point I was trying to make.

The statue and the fountain also embody two very different notions of time. Poetically speaking, the rock refers to timelessness whereas water refers to the fugitive nature of time.

JM: Yes. I was reading something the other day about fountain symbolism and I realised then that it added another dimension of meaning to this particular work. It's perhaps interesting that this was something of a surprise since other pieces have specifically dealt with the notion of time, I made one piece, for instance, that was called *The Philosophy of Time* – its full title being *After Giulio Romano, After Jean Dominic Ingres – The Philosophy of Time*. It deals with the notion of time and copying. It's a drawing of two people copulating and it was

constructed by making a copy of a drawing by Ingres which he in turn had copied from Giulio Romano. Stated very crudely, the idea was to shift an image bodily through time or at least to continue a journey which it had already begun, but this rather simple device allowed me to deal with notions of repetition, of similarity and difference, which are in any case implied elements in the subject matter of the drawing. You know, no act is ever the same, no copy is ever identical to the thing copied. The image of copulation is a particularly poignant way of dealing with the notion of sameness and difference in that it is one of the most powerful reminders of all of the body's ultimate defeat by time. I came across a quotation in the introduction to the exhibition *The Batchelor Machines* which is very related to this – 'sexual figuration and the configuration of time, far from being incompatible, the two perspectives are facets of a single all-embracing perspective, that of geneology which embodies sex and death in time.'

Can we shift ground a little now? Earlier you said that you didn't want your work to have a single meaning and often you structured them to have paradoxical meanings. Would you like to discuss a particular work that demonstrates this?

JM: I made a piece which was entitled *The Veil Hides and Doesn't Hide, it Discloses by Covering and Conceals by Revealing* and it consisted of a postcard of a painting of a woman who at first sight appears to be naked but in fact isn't naked at all. She is wearing a necklace and a hat and she is holding a veil in front of her. Above the image I placed the text – 'The veil hides and doesn't hide, it discloses by covering and conceals by revealing.' Underneath the image I used the quotation from De Sade's *120 Days of Sodom* – 'conceal your cunts, ladies'. I chose this quotation because it is an extremely modest sentiment but expressed in the most immodest terms. You can see from this that the whole piece is structured through many layers of paradox, mostly of a very extreme kind.

I think it was Bergson who pointed out that strong oppositions or contradictions produced a 'dangerous hiatus'.

JM: I think the notion of danger in paradox is very true but I would consider that to be a very positive thing, the kind of dizzying neutrality which occurs between opposites or paradoxical readings in a piece is highly subversive in that it gives nothing for the reader to hook on to so that they are thrown back on to themselves to make judgements, devise points of view, or make decisions about meaning.

You're sure that when you present the viewer with these irreconcilable elements you are in fact leaving them with something to decide. I'm thinking of that passage in the Tractatus *of Wittgenstein (1929) referring to tautology and contradiction. He says that they are both extreme examples of the truth condition, 'Tautologies and contradictions lack sense,' I think he says, and later, 'for the former admit all possible situations and the latter, none.' I would read this to mean that there is no way that one can intervene in an opposition.*

JM: I don't know whether I'm really talking about contradiction in the very strict sense that Wittgenstein is – the oppositions and paradoxes in my work are less clear-cut than that. Very often I make the label or text beneath the image distort the function of the image so that it moves off in a different, perhaps unexpected, direction. This device produces a kind of friction between the image and the text but would not constitute an absolute contradiction. I'm aiming at reciprocity rather than contradiction. I'm aiming to create meaning in the space that exists between the words and the image, without at the same time specifying meaning. Similarly, the subject comes to rest somewhere outside the mere facts of a piece. I think works of art are rather like the objects of our desiring. They are the material forms of things which are not actually present. The decor, if you like, of things absent.

Decor puts a rather theatrical slant on things.

JM: Well I do think of my work as tableau as a frozen reality which brings us right back to that earlier question about 'reading' – figuratively speaking the work is very frontal, two-dimensional, to make apparent the system of the work, to allow the viewer to construct meaning, to force on the viewer the act of reading.

The construction of meaning is the subject matter of your work, then?

JM: Yes, that's a very good way of putting it.

I should like to return now to the subject of eroticism. You said earlier on that you didn't intend your works to be erotic and you were very emphatic about it. Yet the more we talk about your work, the more the spotlight seems to fall on that area of human experience. Your latest painting, called Delta *(1978–79), again focuses on sexuality, albeit in a highly schematic and formalised way.*

JM: Yes, in fact it is made of a whole lot of paleolithic symbols for the female genitals. The painting is organised in five columns, each headed by a capital letter which together spell the word 'Delta': the first four columns are female genital symbols and the final column comprises symbols of a more general kind, representing the feminine. It's a very simple piece of work, the symbols already existed and the form is taken directly from a diagram – I simply added the entitling word, *Delta*.

The whole piece smacks to me of a very carefully contrived process of distancing.

JM: Yes, I wanted the whole presentation to be very impersonal.

Isn't this, though, a feature of erotic art, that it is distant and depersonalised by structural devices? De Sade uses the term 'contrivance' to describe the process by which he transforms common-or-garden sexual acts into elements of erotic fantasy.

JM: Of course, you're right – eroticism by definition needs to be lifted out of the 'natural' sphere of things and this is most often achieved by a very severe act of structuring which takes it beyond the realms of the passionate encounter, tying sensuality to thought in a very special way. The process of transforming the natural into the erotic is a paradigm of the way we turn nature into art. Eroticism, like art, is a product of culture. I came across a very interesting piece in an essay on De Sade by Foucault, where he says, 'the scene in Sade is profligacy subjected to the order of representation and (there exists) within the scenes the meticulous balance between the conjugation of bodies and the concatenation of reasons.'

There are some very important ideas embedded in that quotation. What he's doing is stating the importance of the act of imagination to the erotic or at least the importance of 'deliberate imagining' which is what I think he means by representation.

JM: He's doing more than that: he's tying reason and passion together in a canon form. On the one hand, he's saying that the erotic is reason subordinated to the ends of passion and on the other, that it is passion subordinated to the ends of reason. I find this model very exciting because it unites seemingly opposing elements, sensual pleasure and intellectual pleasure.

It's a very Catholic idea.

JM: It's the notion of sin – yes.

And of religious ecstasy. One only needs to think of the poetry of St John of the Cross.

JM: Yes, that's passion developed out of reason all right.

To come back to the mainstream of our discussion – I think I would argue that your works are erotic in the Foucault sense. A good example is the piece called Pyromenon *which I view as rather a key work. It connects the cold, calculating, forming process with quite hot subject matter.*

JM: Yes, it consists of a colour reproduction of a half-naked woman, leaning on an antique chair with fine paintings in the background. Under the picture is a text, an anonymous alchemical text – 'art in imitation of nature opens a body by means of fire but uses a much stronger fire than the fire that is produced by the fire of confined flame.' Above the photograph is the word 'Pryomenon' which means 'product of fire'. The text is making a direct equation between erotic pleasure and intellectual pleasure.

The term 'opening a body in alchemy', refers to the alchemical vessel in which transformations and transmutations take place and it's always been loaded with sexual meaning.

JM: Also, the words 'the fire of confined flames' are a metaphor for the sex act.

The other interesting thing about Pyromenon *is that the picture is not an ordinary piece of pornography, she's posing in a rather classy interior; was this important in selecting the photograph?*

JM: Yes, I wanted the pose to be culturally situated, more especially I wanted it to make the link with 'high' art. Of course, the way that pornographic photographs are constructed is very similar to the way works of art are constructed, at least it's similar to the way I make my work – they are contrived in a very cold and dispassionate manner.

Even then the pornographic photographer is seeking to produce a hot response from the spectator whereas presumably you are not. Likewise, he is seeking a neurotic rather than a passionate response – he is definitely not wanting the viewer to fall in love with the model.

JM: No, it's a device in the Sadean sense.

It seems to me that your work takes this distancing a stage further. He's trying to create a neurotic mechanistic sexual response but you are re-contexting the implied sexual act, reculturalising it so that it is extremely distanced.

JM: Yes, with the intention of giving the viewer pleasure through uncovering the structuring devices. It's a form of seduction if you like. You see, I really believe that art is not invented but that it's discovered. This is as true for the person looking at it as it is for the person making it. Making a work of art is one historical process amongst others. It's a series of acts in but also on history. My involvement is with the act itself rather than with its capacity to carry messages.

Aspects: A Quarterly Journal of Contemporary Art, no.9, Newcastle, Winter 1979–1980.

SIGNS OF LANGUAGE

The Lord whose oracle is at Delphi neither speaks nor conceals;
he gives signs.
– Heraclitus

Many artists of importance to the modern period have made 'procedure' or 'system' the central issue of their work. And yet to argue that any work of art is reducible to a mere procedure or system would be foolhardy. Even more artists have used a combination of the two as part of their working strategy. It would seem that there is an attraction in the distinct and recognisable quality of 'authenticity' that these disciplines bring. In so far as it sets the tone of the work as unquestionably modern, we might call this authenticity 'modernist', and we would not be far off the mark. Actually, it is more precisely located than such a term would imply. The very special notion of authenticity which a strong version of 'method' brings to the modernist work of art is connected, in general, with the sense of verity which artists since the middle of the nineteenth century have appropriated from modern science. In order to produce a sense of truth which has the appearance of being objective and 'concrete', artists in common with scientists have attempted the creation of non-metaphorical forms of language. This has led to work which shares some of the characteristics of scientific research; often 'propositional', it works to a programme, but one which is never seen as exhaustive in its scope; it deploys an 'objective' method which is retraceable or retrievable at any stage and one

which is in touch with 'underlying order, a system of deep and simple systematic connections', which, 'if only they could be perceived to their fullest extent, would serve to explain all things.'[1]

In the context of British art Mary Kelly's *Post-Partum Document* is an example of precisely this attitude. The *Document*, started in 1974 and completed in 1979, assumed a research method which took its theoretical parameters from Marx, Freud and Lacan. The relationship between mother and child, after the point of physical separation at birth, was given a material and aesthetic parallel in the developing form of the *Document* itself. By adopting a critical method to treat the most intimate of social exchanges Kelly placed her experience in the objective realm of social anthropology as opposed to personal anecdote.

Crucial to this kind of art is the forcing of the distinction between 'seeing' and 'reading'. To 'see' is to apprehend the thing itself; to 'read', on the other hand, is to reach beyond its physical attributes – it establishes a relationship with that 'underlying order'. From Giorgione to Picasso and beyond, all art has required of the viewer both levels of assimilation, reading as well as seeing. However, for artists up to the middle of the nineteenth century, the idea of reading was closely attached to representation and therefore focused on the interpretation of iconography. With Impressionism all this changed. An alliance was forged between scientific method and artistic vision which signalled a new concept of visual language. Thenceforth the modern artist would speak no more of 'pictorial language'. He or she might speak of 'picture' in certain prescribed circumstances, or indeed of 'language', but never in the same breath.

The crucial modernist separation had been made – which not only changed the perception of artists in relation to their task, but also changed the role of the viewer. It was no longer possible to play the passive spectator; the comfortable cocoon of illusionism had been dismantled. From then on, every image was virgin territory – a new world with its own language, a code to be cracked. And every new language was to require of the respondent a purposeful act of imaginative construction. It is almost the definitive characteristic of the modern work of art that it seeks to place the viewer alongside the artist in this critical position – in or astride the gap between 'seeing' and 'reading', knowingly constructing the art object and at the same time reconstructing the self as a responding, participating subject. With the emphasis placed on the generation of language or languages in opposition to the traditional trappings of mimesis,

the modern artist is continuously in a critical relationship to his or her means of expression; the condition of modern art is shown to be reflexive.

Many individual artists have made this reflexive process the central theme of their work. For them, to bring art so firmly within the domain of language is to make it clearly part of culture and distinct from nature. Nevertheless, the objects of art enter the natural world. They can therefore employ something of its behavioural rhetoric – the language of gesture, for instance – and can parallel some of its processes of operation – lying, stacking, leaning, and so on. Beyond this, art remains essentially relational and abstract.

The taut – the straightening and stretching, sometimes arcing – lines in the sculpture of Anthony Caro, are redolent with bodily presence, which is their point of contact with the natural world. Yet they are more than frozen gestures clinging stubbornly to reality. Through Caro's attention to the demands of sculptural language, one is brought to that point – both historical and experiential – where the need for language is first understood.

The same process is at work in the less formal sculptures of Richard Long. For Long, the setting is nature; the action is the imposition of a line or circle, made or walked. The effect is to confront nature with the 'indifference' of geometry, represented by the 'cruel' act of drawing. The harshness of his assault on the natural world is always well disguised; cloaked in ironic attentiveness. He rehearses the rituals of barely cultured man but he does so from the high ground of sophisticated contemporary culture. Lines, circles, marks of hands are the evidence of human presence, and their ordering is the first sign of human culture – primal language.

In the language of film the camera's eye, its gaze, is perhaps the nearest equivalent to the kind of drawing which Long undertakes in his walking pieces. The camera also traces a passage through reality, caressing everything in its visual field. The lens is intentionally focused and records the path of its intention. In so doing it establishes the interface between the medium of film and its subject. Paul Bush's film *The Cow's Drama* (1984) is exemplary in this respect. It is all about looking; the camera's indifferent eye watches farmer and cow, cow and calf locked together in the recurring drama of their daily round. Bush's involvement is undoubtedly subjective; his method of observation is objective. The result is the creation of an ironic distance which is interposed not simply between the filmmaker and his subject but between the audience and the film as an object of the audience's attention. In the end, language supersedes narrative.

This form of drawing, then, is the direct trace connecting action and thought. At the simplest level drawing is the making of a mark, but it can function as schema, emblem and inscription, and this is clearly shown in Long's later 'word drawings'. In *Three Moors: Three Circles* (1982) for instance, the contradictory schema of the piece is set, on the one hand by the placing of the title two-thirds of the way down the page, which suggests an elevation – the basic landscape division between earth and sky – and, on the other by the concentric circles, which are seen as plan. We are therefore presented with a problem of reading, and are offered no easy solution. Instead, we are left to slip sideways into the emblematic – seeing the page as a set of simple signs: sun; sky; horizon; earth. Thus we return the word to its prime function of naming, placing and describing – we see the page as inscription. His actions, walking the circles and walking the line, are constructions in language, part of the topology of mind.

In the wall drawings and relief constructions of Michael Craig-Martin and the sculptures of Tony Cragg we can see a similar breaking down of emblem to reveal more intricate levels of reading. In Craig-Martin's work this is in part a product of scale. Drawings are expanded to a size at which the conventions that give the image its coherence start to function in an almost maverick fashion. Straight lines bend and twist; familiar objects distort and dislocate; the drawing is transformed into a network of nodal points, out of which sense has to be continually fought for and remade. In the reliefs this is carried a stage further. Through the intervention of the third dimension the schematic character of the line breaks down. *Sharp Practice* – first of all an emblem, replete with powerful associations – is coolly and deliberately 'atomised' by the planal structure: language is robbed of its purpose and made the object of style. In this respect the works have a disarmingly seductive appearance. But there is also a hidden and more disturbing side to them – the emblem itself is made out to be little more than an accident of language; one of those occasional illusions of 'sense' which language throws up.

This Borgesian double bind is an important element in Cragg's work also. He starts with a common-or-garden image, which he remakes using a collection of found bits and pieces, coded according to shape, scale, character and material. All the elements are given equal weight. Cragg allows no formal or structural hierarchies in his work. Nor is there any attempt at crafting. When more than simple placing is needed he resorts to do-it-yourself engineering. His philosophy of making might be said to be that of least possible interference. In

fact Cragg is holding the balance between two quite distinct orders of language; the grammatical and the lexical – the former concerned with making sense and the latter simply with the listing of parts. Once the emblem is set aside, the sculpture is a kit of parts for us to make of what we will. We are faced with Borges's 'labyrinth'; we become searchers after accidental truths.[2]

However, Cragg's sculptures are not an arbitrary scattering; more a painterly, 'restless accumulation' of objects across a constructed grid. These are qualities which the modern sculptor shares with more formally concerned performance artists. For example; Anthony Howell who in his early work with the Theatre of Mistakes (founded in 1974) always worked with a strong sense of 'plan'. Plan provided a fixed order against which he could pitch time-based kinetic action – the movements of his performers. With the pace set by counting, an accumulation of errors led to chance events occurring out of overlapping cycles of action; thus generating a concatenation of chance with order. In the more recent solo pieces the ordering devices are less apparent; more hidden by the sequence of 'things to be done'. But the feeling of a submerged order at odds with human intentions; actions and desires remains. And it is this that compels our attention since it offers a possible level at which things might actually make sense. As always the ghost in the machine is – paradoxically – the human presence.

Howell allows himself no solace in abstractions: he must be seen to act in the real world. At first sight this appears to be the point at which, although working with similar conceptual concerns, he would seem to part company with a constructivist artist like Kenneth Martin. In Martin's work the numerical system which dictates the overall form of the work is sacrosanct. It is converted into a consistent visual language by using multiples of a fixed linear unit. Martin, however, retains the essential aesthetic freedom of choosing when and how to activate his system. Both objective choice and intuitive judgement are contained within an abstract network of formal relationships, and language is realised as concrete order.

Artists like Susan Hiller and Joel Fisher view language from a very different perspective. While Martin sees language as an all-embracing 'deep and simple system of connections', Hiller and Fisher return us to the view of language implied in the work of Long, Cragg and Craig-Martin – an unknowable domain which is continually throwing up the illusions of sense and order, an effective 'veil' which we can never quite see beyond. Susan Hiller's recent work focuses our attention on precisely this veil. She 'projects' the most primitive

forms of utterance, signs and sounds, which are like the written and oral fragments of a language for which we no longer have the rules. She invites us, through the projection of our own knowledge of grammar and syntax, to search for the traces of a coherent structure which will provide us with the opportunity of making sense. But her invitation is an invitation to transgress, to invade the site of language beyond the 'veil'. The ironic analogy which Hiller invites is that of being transported beyond death to the world of spirit; we are to pass over temporarily to the other side, there to discover a different notion of sense, a new *raison d'être*. At the same time we are left no alternative but to see that this is an illusion.

For Joel Fisher the act of paper making provides a similar kind of metaphysical conundrum. Each new sheet of paper becomes 'a barrier, a gate: an image of each and, simultaneously, a space in which a new universe (or an image of an old one) can find a base.'[3] Once again it is the metaphor of the 'veil' that springs to mind and seems to demand a state of rapt attention if it is to yield up an image that can be mapped onto the paper surface. The pretence is objectivity, but in reality the image is called forth by Fisher's imagination – it is his projection, identified and articulated by drawing and returned to the surface of language. He emphasises this turning away from the abstract by reinterpreting the drawn image as a fully rounded sculptural object. Cast in bronze, carved in wood or stone, it enters the natural world. It is a transitional object between two very different domains of language.

The British Art Show 1979 – 84, exhibition catalogue, Southbank Centre, London, 1984, pp.94 – 97

1 Extract from a definition of science in C.G. Hempel, *Recent Problems of Induction – in Mind and Cosmos*, University of Pittsburgh Press, 1966.
2 Jorge Luis Borges, 'The Library of Babel', *Labyrinths*, Penguin, Harmondsworth, 1970.
3 Joel Fisher, 'Sitting on the Gate' in *Joel Fisher*, exhibition catalogue, Kunstmuseum Luzern, 1984.

BEFORE AND BEYOND THE SHADOW

Those who have crossed
With direct eyes, to death's other kingdom
Remember us – if at all – not as lost
Violent souls, but only
As the hollow men... [1]
– T.S. Eliot

To *'cross with direct eyes'* – what a curious metaphor. The idea of passage between one state or world, and another, is clear enough, but the term 'direct eyes' is surprising, at once arresting and opaque. It is almost as if Eliot is trying to separate the 'eyes' seeing' from the 'mind's thinking', from the 'body's feeling': as though he is trying to turn sight itself into an autonomous thing. Those familiar with *The Hollow Men* (1925) will recall that this feeling is reinforced time and time again in the remainder of the poem.

Eliot was a disciple of the metaphysician F.R. Bradley, and like Bradley he was a 'monist'. He believed, in other words, that reality was a 'non-relational entity': one, indivisible whole thing. He also believed, however, that it could never be perceived that way. Seeing, for Eliot, meant interpreting, and interpretation involved thought and feeling: forms of response which were bound to separate and divide – to work relationally. Reality for Eliot, then, was one, but thought and feeling made it appear otherwise; as a complexity of relations between distinct properties and things. For him, seeing was always clouded, never direct.

There is, then, a certain philosophical archness in Eliot's metaphor; a hidden proposition. Namely, that if the function of seeing could be made autonomous, if it could be separated from the 'mind's thinking' and the 'body's

feeling', then the eyes would see the world as it really is: as a unity. 'Direct eyes', in Eliot's terms, would therefore be 'truthful eyes'. But they would also be eyes which had achieved their independence out of the death of mind and body. They would have passed over from the physical into the metaphysical domain.

> Eyes I dare not meet in dreams
> In death's dream Kingdom
> These do not appear:
> There, the eyes are
> Sunlight on a broken column
> There...[2]

There the eyes are at one with all that is, with all that is not 'I'.

In *The Hollow Men*, Eliot, like Rimbaud in his *Lettre du Voyant* (1871), is reflecting ironically upon the business of writing poetry and upon the problem of creativity in general. For him, art is a relational matter. It is the product of feeling and thought. But its purpose is to reflect that other, indivisible reality. In this way, the objects of art manifest a sublime paradox. They must appear complete, as full-blown 'new' things, with the force of a single, irrefutable idea: they must have a quality of miracle about them. And yet they are made through a painstaking accretion of work on their constituent parts. All of the artist's labour, then, is directed towards achieving an appearance of unity, which, in its turn must seem effortless, if the work of art is to have an effective, independent life. And at the point of completion, when the 'shadow' finally falls between the idea – all that has been thought and felt – and the reality – a new thing declaring its independent right simply to be – the artist experiences a profound feeling of ennui.

> But his one avocation was self-seeing.
> Whatever left him he loved back again,
> he whom the open wind could not contain;
> rapt, closed the round of reciprocity,
> annulled himself, and could no longer be.[3]

Consider. The writer, faced by the empty page. The painter, faced by the sheer white expanse of an untouched canvas. Both confronting the fearful moment of origination, of bringing something new into being. And

always, before the line is written, before the mark is made, falls the shadow of the hand. Then the pen is lifted, the brush withdrawn. After the first caress, in the chilling moment of separation, also falls the shadow. Signalling an end, an absence, a kind of death. We have, in witnessing this single creative act, plunged with writer and artist down the vertical shaft which links Eros to Thanatos, love to death.

'Between the desire and the spasm', wrote Eliot, 'between the potency and the existence, falls the shadow.' The echo of an endlessly repeated erotic disappointment is unmistakable. We are in the presence of an unfulfilled longing, a desire incapable of satisfaction; a shadow, the dark centre of which cannot be penetrated. The work is complete. The hand which has laboured to engender it has been withdrawn. The artist subjects this new thing to the closest scrutiny. It is at once both familiar and unfamiliar. The shadowy presence of something unseeable within the seen; of something unknowable within the known, is at the same time compelling and unnerving. It is as if a voice whispers: 'What is this strange other thing I have made; whence came this strange life which is no life – which is the antithesis of my life. From whence comes this mysterious force I see moving within it?'

Consider now the ritual actions and working mien of the artist. The hand moves. The pen writes. Mark is added to mark. The concentration, the watchfulness is absolute. It is as if the reality of time and place – the world to which you and I as observers, are fast bound – has been dissolved through a forceful desire to forget. We must wonder at this passionate pursuit which can grip and rule the human heart so, pushing all but the object of its attention into deep shadow.

Observe how the actor in this play moves. Economically, elegantly, both there and not there, conscious and unconscious. It is as if a substitution of worlds has occurred, as if everyday reality has been first punctured, and then parted and held at bay by a dense and unyielding solitude in the space of the work. And strangely, within this space, it seems that the artist discovers a kind of freedom: a certainty of values, of judgement, of action. In this solitary place, focus is sustained, judgement spawns decision and leads quite naturally to firm and correctly weighted intervention.

Rainer Maria Rilke, in his *Letters to a Young Poet* (1929), describes the space of the poem as a 'place of self-purification', and the young Arthur Rimbaud, in the *Lettre du Voyant* (1885), describes it as a place of refuge 'from

the false significance of the Ego'. The space of the work intervenes between the 'singer' and the 'song', he argues, between the idea as intended by the poet and the idea as it emerges in the poem, allowing the 'I' to be perceived as if it were 'someone else'.

> For I is someone else... To me this is
> obvious: I witness the unfolding of my
> own thoughts: I watch it, I listen to it:
> I make a stroke of the bow: the symphony
> begins to stir in the depths, or springs
> unbidden on to the stage.[4]

So it is that the artist making the work observes him or herself both as subject and object, but from within the gathering unity of a single spatial experience.

The artist moves, acts and reacts in what seems to be an infinite present; removed from historical time. The dialogue is spatial rather than temporal. Yet the traditions of poetry, of painting, of art are within reach – immediately accessible. For here, in the place where art is made, time does stand still. We are observing a world which is essentially Arcadian: a world where cause and effect are influenced by no moral or ethical imperatives. And while it may appear that the artist is 'willing' the work into being, nothing could be further from the truth. Here, desire and the consequences of desire rule all. Here, the poet becomes lost to the desire for poetry and the painter lost to the desire for painting.

The involvement of the artist is both centred and penetrating. In the words of Roland Barthes, the work of art 'develops like a seed, not like a line; it manifests an essence and holds the threat of a secret.' Herein lies its power to fascinate and to dazzle. Each new poem, new painting is like any other poem or painting, but during the process of making it is animated in a singular way. There is something within it – some fleeting expressive quality, at first barely perceived – which is in every sense unique. On one level its demeanour is open, inviting; on another, like the Giaconda's smile, it is delightfully secretive, even devious, and its attraction is similarly erotic. For the artist who sees this face forming in the shadows, a captivating ambiguity seems to colour the whole of the work, energising it in its every part. It is so compelling and yet so elusive that he or she is consumed by the desire to fix this singular expression; to possess this face, alone, in its specificity.

To exist in this state of erotic fixation demands excess: a profound form of self-forgetting, an out-flowing and a fusion. Engagement must be sought knowingly, eagerly. The surrender to desire must be complete. The embrace between this lover and this beloved is that melting embrace which hurries towards oneness, excluding all without. The closeness of it obliterates all but the ache – a space in the memory – a trace of the last searching caress.

At the same time the artist knows that responses in themselves bring no enduring knowledge, no lasting satisfaction. To seek out, to choose, and to draw to oneself, is to submit the object of desire to an intense critical trial. It is to test desire itself to destruction, so that a separation might be achieved. After the act, contentment is always curtailed.

> He calls to it. It twitches, jumps and stands.
> What stands? The other, all this is not he,
> materialises. And it turns to him
> a face that's more, assembled instantly.
>
> Magician, O hold out, hold out, hold out!
> Create on equilibrium. Keep still
> the scales that here will bear you and your house,
> there, the accreted otherness. Until.
>
> Decision comes. The fusion has been found.
> He knows, conjuring has outweighed denial.
> And yet his features, like a covered dial
> make the time midnight. Even he is bound. [5]

Loose in the domain of Eros, we would do well to remember the often cruel ambivalence of this satyr God, whose gaze hides fear in longing, hatred in love, death in life: whose manner mixes indifference with passion. For Eros is essentially a dualistic deity. It is within his nature to blow hot and cold: to fascinate and to inhibit by turns. The one who looks upon his face with eager desire must also risk existential despair. And the one who chooses to follow this 'God who blinds with youthful fire', must also bear in mind the funeral garlands that he hides behind his back. To the artist he offers priapic force: the power to create. But there is a price to be paid. The artist must be prepared to look beyond this 'other sun', the shining face of Eros, into the

metaphysical abyss from whence all new things spring. He or she must be prepared to engage in a dalliance with the void: must seek out and risk nothingness; must face the possibility of self-annihilation. Eliot, in *The Hollow Men*, describes this dangerous terminus in typically ambiguous, 'erotic' terms. He asks those 'who have crossed with direct eyes to death's other Kingdom', to remember with sympathy those who are left behind, 'the hollow men'. The eyes of those who have looked upon death must be persuaded to 'reappear as the perpetual star, the multifoliate rose', if there is to be even the smallest hope of salvation.

It remains only for us to consider the macabre possibility that our subject, the artist, is moved by a desire for oblivion; is enamoured of death. Maurice Blanchot, in his *L'Espace Littéraire* (1955), likens the artist's task – the search for the singularity of the object – to a willed act of self-destruction, to suicide. They share the same delicate, endlessly arching trajectory, he argues, which 'at the decisive moment is cut', making the culminating act of parting and departing 'as unreal as a dream'. Both acts, because they spring from an inalienable individual right, 'detached from power and duty', are assertions of an absolute competence, of an indisputable omnipotence. Both, in a moment, in a spasm of decisive action, trade self for other; life for death; 'my life' for 'my death'. And they require a similar kind of madness. But as Blanchot points out, this 'is a madness we cannot be spared without we exclude ourselves from the human condition.'

> for otherwise
> my beauty is
> made of last
> moments –
> lucidity, beauty
> face – of
> what would be
> me, without myself
>
> and it is my
> shadow not knowing
> of myself, who
> dresses in mourning.[6]

To look with 'direct eyes', towards 'the twilight Kingdom', as Eliot says, is to seek to fill the hollowness within: the place where falls, endlessly, the shadow of death.

For Eliot the major questions of purpose, order and value, remained to perplex and trouble the individual consciousness. His enigmatic dedication 'Mistah Kurtz – he dead' on the title page of *The Hollow Men*, is significant. Kurtz was the anti-hero of Joseph Conrad's novel *Heart of Darkness* (1902). He was a hunter adventurer who had penetrated the very centre of the congo rain forests, and finally come to rest there, close to death. He was a wild and troubled spirit who lived his life by continuously transgressing. In Conrad's words, 'He had kicked himself loose from the earth, he had kicked the very earth to pieces.' But Kurtz was a kind of artist, he had 'the gift of expression', Conrad tells us, he could 'unleash a pure stream of light' from out of 'the heart of an impenetrable darkness.' Kurtz lived his life as a 'Shadow' (Conrad's capital), a shadow of death in life and he had a powerful effect on all those who came close to him, transforming their lives. At the moment of his death he utters only two words 'the horror, the horror'. Not in fear, but in recognition of the truth.

Falls the Shadow: Recent British and European Art, exhibition catalogue, Arts Council of Great Britain, London, 1986, pp.26–33.

1 T.S. Elliot, *The Hollow Men*, [School of Art Press, Oxford, 1964].
2 *Ibid.*
3 Rainer Maria Rilke, *Narcissus*, 1914.
4 Arthur Rimbaud, 'à Paul Demeny, Douai, Charleville, 15 mai 1871', *Lettres du Voyant (13 et 15 mai 1871)*, 1885.
5 Rainer Maria Rilke, *The Magician.*
6 Stéphane Mallarmé, *A Tomb for Anatole*, translated and with an introduction by Paul Auster, North Point Press, San Francisco, 1983.

OF SAMENESS AND DIFFERENCE

Lock oneself up with the whole family of the paradigm.
Paradeiknymi: to show place, opposite, whence to compare,
to show, to exhibit, to assign, to distribute, to attribute...
– Jacques Derrida, *Cartouches* (1978)

It would be surprising if on entering this exhibition we were not immediately struck by the marked (if on closer inspection, rather superficial) similarities between the works on view. Five artists are shown together; five artists who work, for the most part quite separately – certainly they are not in day-to-day contact with each other – and all refuse any form of direct representation; all employ a reduced geometric format, use colour as colour and work serially. This impression of 'sameness', in the instant that it leaps to mind, seems to offer us a haven; a comfortable retreat; a means of closing ourselves off from the disquietude of 'difference'. But is this offer as ingenuous as it appears to be, or is it just another example of the game of curatorial bluff, in which our attention is drawn to one thing only to find ourselves assailed by its opposite. And if it is that we are being invited to contemplate 'sameness' in order that we should be made the prey of 'difference', what would be the point of such a strategy. The question is an intriguing one and one that opens up important areas of speculation.

Certainly 'sameness', or its apparition, is closely allied to the question of typology. When we designate a grouping through common characteristics; when we attribute likeness or argue familiarity we are engaging in typology. When we invoke a commonality of context; argue or

identify according to precedent; when we, in the construction of a description, give prime consideration to genre, we are deploying typologies. Our recognition of 'sameness', then, on the surface anyway, is little more than an 'assigning to type'. But at a deeper level, in as far as it relies upon a quasi-scientific or an authoritative account of things, it signifies our desire for and attachment to some version of an unchanging order: to evaluations which persist willy-nilly in the teeth of change. In this respect, the apparition of 'sameness' might be 'said to be antithetical to the most vital preoccupation of all forms of critical practice: that of erecting an effective comparative paradigm, in order, as Derrida puts it, 'to assign, to distribute, to attribute', through the imminent revelations of 'difference'.

But when we speak of 'sameness' and 'difference' we must be careful, also, not to be lured on to the double-edged sword of 'either/or' by asserting a simplistic preference for one quality over the other: we must refuse the invitation to take sides. The temptation to assign enduring, negative and positive characteristics, or passive and active principles, is strong. It would be all too easy to equate 'sameness' with inertia, and 'difference' with forward motion and change. But to do so would be to substitute a static, one might say a frozen relationship, for an active one within which 'relatedness' itself is continuously, renegotiated. In short, we must see 'sameness' and 'difference' for what they really are; two halves of a single dialectical entity; two thoroughly interdependent hemispheres, between which the argument is unceasing and the struggle for dominance is without end.

This ongoing process – this unending renegotiation of the very condition of relatedness – situated within the dialectical sphere prescribed by 'sameness' and 'difference', is worth closer attention.

On the level of our immediate experience, the fact that each of these qualities works to define the other, its opposite, is obvious. We need only refer back to our own habits of 'looking' to know that this is the case. No sooner have we registered a visible similarity – a family resemblance if you like – between things, than our attention switches, changes direction in order to pursue those characteristics which set them apart one from another. Human perception, it seems, manifests a perverse desire to disassemble resemblances and to find common features or properties in the seemingly unrelated. But is this desire as perverse as, at first sight, it appears to be. Or does it represent, in the moment of apprehension, some more fundamental property of human perception and human consciousness.

It would be easy to dismiss this curious oscillation in the process of 'looking', by describing it in purely functional terms: for instance, as an auto-erotic mechanism, inherent to perception itself, the purpose of which is to set and reset the limits to our perceptual play. To do so, however, would be to misrepresent, both in form and function, the relationship which must pertain between our immediate perceptions and our prior experience and prior knowledge. 'Foreground' experience of whatever kind is always set against – is even to a large extent defined or made visible by – a wide contextual vista: our knowledge of, and attitude towards the world and human affairs in general. This is true no matter how sharply defined is the subject of our gaze; no matter how thoroughly it is hedged about by specialist discourse. In short, the human condition – our common humanity – dictates that we are not, can never be mere receivers of perceptual information. There is no such thing as 'pure vision', and no 'purely visual' experience. There is no perception which is not situated (either consciously or unconsciously) ideologically. This oscillation, then, between the recognition of similarities and the recognition of differences, within our habit of looking, must have its equivalent in our processes of thought. It might even represent a movement 'to and fro' between quite distinct attitudes of mind.

In order to take this question a stage further, we must look again at some of the structural factors in play when we recognise sameness as a prime quality of 'relatedness'; we must try to unravel some of the complexities involved in the seemingly simple assertion that 'this object is similar to that', or that 'these objects are similar'.

As we have already remarked, the recognition of 'sameness' is closely allied to the workings of typology. It is one way of 'designation' or 'assigning to type'. In the instant that we descry a certain similarity between things, we are placing them according to a deep structure of correspondences. Thus, when we make the seemingly simple claim – 'these objects are similar' – in effect we are saying that given the multi-layered background of our prior knowledge and experience, the objects in question, taken together, represent – re-present – certain familiar coordinates. The term represent (re-present) here is crucial, since it serves to situate the designation of 'sameness' firmly in the reflective domain of ideology, where factors aesthetic, historical, ethical and moral are permanently in play.

Such a clear-cut definition leaves us face to face with an important and highly provocative question: if 'sameness' represents the reflective,

ideological dimension in the act of reading, what then of 'difference'. Can we legitimately make the claim that 'difference' stands outside or reaches beyond, is in excess of, the ideological. In other words, is the apprehension of 'difference' that aspect of the act of reading which treats of pure relationality; which addresses relationship itself, stripped – no matter how fleetingly – of all representational baggage.

Certainly it would seem reasonable to argue that the descrying of 'difference' represents some kind of rupture in the otherwise seamless 'background noise' of accumulated ideological material. To assert dissimilarity is a way of setting things apart either from each other or from the generality. When we say – 'this object is different to that' – we are (at the very least) postponing, perhaps we are even denying, ideological linking. We are turning our backs – or so it would seem – on that way of classifying and evaluating things. But what is the purpose of this postponement or denial. Is it intended to clear the ground for some other, quite different form of evaluation; a form which, for the sake of argument, we might call – 'the evaluation of things in themselves'. And if this is so, how might we construct a plausible version of 'things in themselves', one that does not pitch us headlong into the path of one metaphysical fallacy or another: some variant, for instance, of the notion of essential or 'utterly intrinsic qualities'.

This problem is not as intractable as it appears at first sight. We need only shift the direction of our gaze slightly by substituting the term 'relationship' for 'thing' and the whole picture is transformed.

The very idea of 'relationship' depends upon difference and the space that 'difference' opens up between things: in this respect it is antithetical to the notion of 'things in themselves'. Nevertheless, the space of 'difference' is undeniably concrete. It is the place to which the artist goes to 'do work'; to practise discrimination in the pursuit of relationship. By the same token, it is the place where the viewer – the respondent – must go in order to perform the act of 'reconstruction' necessary if he or she is to draw close to the life of art. We can quite properly, then, speak of 'relationships in themselves'. For they exist in artist and respondent alike, as constructions within the domain of concrete experience. They are attributes of our patterns of thought; firsthand experiences over which we exercise absolute control; imminent presences built out of intimate knowledge. We possess them and are possessed by them utterly. Thus the descrying of 'difference' is, in a very real sense, that aspect of our mental process which clears the ground; which holds at

bay the ideological inrush just long enough to permit of the consideration of 'relationships in themselves'. It functions – quite literally – 'to make room for thought'.

The site of Derrida's Paradeiknymi, then, is a place of trial; a place wherein historical and aesthetic imperatives, where moral and ethical laws are put to the question by new insights, new ideas and new constructions generated in the space which is created and sanctioned through 'difference'. However, it is important that we continue to see this space as situated within, rather than outside of, or beyond the confines of ideology. For it is characteristic of 'relationships in themselves', that they must become connected – that is they must be ideologically mapped – if they are to make sense or accrue meaning. What 'difference' does is to ensure that this connectedness, once established; is particular; appropriate; even unexpected.

o o o

Perhaps now is the moment to retrace our steps, and to make our entrance to the exhibition a second time.

Certainly, at the level of curatorial choice, the initial impression of 'sameness' is borne out. At a glance we perceive a deliberate narrowing of the range of possibilities; a sharpening of focus around a limited range of visual characteristics. The individual artists, too, use 'sameness' as a part of their working method. All of them work serially, so as to establish and sustain fixed and unchanging elements. Nor, it seems, are they concerned with novelty; on the contrary, they embrace, willingly, previously established formal attitudes and ways of doing things. But can we go further, can we assume, for example, that both curator and artists are seeking to represent similar ideological conjunctions. Are we in the presence of a homogenous set of beliefs and values; a unity of known sources. Is there a very particular version of tradition at work here.

The question is fairly easy to answer as long as we stay within the confines of 'sameness'; as long as we stay within the domain of ideology. For instance, we can make the argument on the basis of historical antecedence, starting from the roots of modernism, passing, via the Russian Vanguard, De Stijl, the Bauhaus, French Formalism, Minimalism and so on to the present day: it is one, perfectly legitimate way of contexting the works on view. Alternatively we might play the game of family resemblances. By picking over

the aesthetic terrain which stretches between Malevitch and Marden, Lohse and Rothko, we can build up a dossier which weighs the works according to rules, laws, influences and derivations. But these methods, while they would yield up some information, while they might even serve to describe a tradition, would provide little in terms of insight or firsthand experience. We would merely be massaging that part of the ideological field that happens to be already within our reach.

But if we turn our attention to the 'differences' between these artists – the differences between the works on view – then the ideological terrain begins to shift. It is no longer so certain, so concrete. Great fissures open up; seemingly unbridgeable chasms. And the invitation that 'difference' makes, is that we should follow the artists into these secret places, there to engage with the life of art: that process of constructive discrimination upon which all forms of ideological representation depends.

A Disquieting Suggestion, exhibition catalogue, John Hansard Gallery, Southampton, 1988.

This essay was commissioned jointly by Marjorie Althorpe-Guyton then at *Artscribe* and Judy Adam then from the Anthony D'Offay Gallery, who wanted to make sure that the show was covered in Britain. Kounellis was only the second important artist from the west to be invited by the AUSR to make a large-scale exhibition at the Tretyakov State Gallery in Moscow. It came at the very height of a political and economic crisis in Russia. The value of the ruble had collapsed, the Moscow shops were empty of goods and corruption was rife. Even basic things like nails and screws were hard to come by. I spent four days in Moscow fighting with petty officialdom and trying to lend a hand where I could. Despite the difficulties – or maybe in part because of them – the exhibition was a triumph. It showed Kounellis at his most considered and most inventive, and provided me with a unique opportunity to look more closely at the work of an artist who I had long admired.

DEADLY PRESCRIPTION:
JANNIS KOUNELLIS IN MOSCOW

There have been few stranger symptoms of the crumbling of the East / West divide than the large Kounellis exhibition in Moscow. Especially as it is housed in the public gallery built for the national collection of 'official', post-revolutionary art: acres of peasants ploughing, athletes running and jumping, naked boys swimming in the Moskva and endless depictions of the heroic socialist peoples in victorious battle.

Kounellis is not, of course, the first important western artist to be shown in Moscow: Bacon, Rauschenberg, Tinguely, Gilbert & George and Rosenquist were there before him. But as far as the average Russian citizen is concerned, he is far and away the most difficult to understand. His precursors were largely figurative and pictorial artists, intelligible in the Russian context. But his are difficult works and they yield up their secrets grudgingly to the unschooled eye.

Having said this, there is something uncannily far-sighted, even compelling about showing Kounellis in Moscow at this time. Against the background of this great city, teetering on the edge of economic collapse and social decay – freed temporarily from the demands of the market and the stylish mood of indifference which infects the western European / transatlantic

art world – his work looks tougher, more exposed and for some strange reason, much more connected to the world outside.

A good starting point for understanding this work is provided by the series of untitled 'bed' works made in 1969, and in particular one of the earliest of these works: the single, wire-sprung bed with gas-bottle and lighted blowtorch. The intense atmosphere of erotic isolation surrounding this work immediately puts one in mind of Duchamp's melancholic statement in the notes to the *Large Glass* (1961): 'The bachelor grinds his chocolate himself.' The 'bed' has the same caste of icy decorum about it and is equally assertive. Where Duchamp lays stress on the auto-eroticism implicit in bachelorhood, Kounellis is just as insistent on the poetic energies which can arise out of sexual isolation. Significantly, the steel-framed bed – equivalent of the 'nickled chassis' supporting the chocolate grinder – is conspicuously 'undressed'. There is a strong whiff of exposure about it; an electric quality of physical unease. It could be an instrument of torture, a device for burning and branding the flesh. In fact it is entirely ambiguous in a way familiar from later Kounellis works: an aperture, it is open as well as closed; it is a frame as well as a doorway; a platform and a grille; a site for offering up the eroticised body as a sacred unity and also for its systematic dismemberment and destruction.

Furthermore, this 'chassis', this 'undercarriage', this diabolic 'engine' is forcefully and unambiguously gendered by the roaring and consuming flame of the unguarded blowtorch. As with Duchamp, the masculine sexual reference is unavoidable. Kounellis, it would seem, has made a bed for a man who either chooses, or is condemned to live alone and thus experience the gathering momentum and violent force implicit in male sexual desire. As the philosopher and historian of science Gaston Bachelard pointed out in his important essay on the metaphors of 'sexualised fire' in alchemy: 'Masculine fire, the object of meditation for the lonely man, is considered to be the most powerful fire. In particular it is the fire which opens bodies.' And he goes on to quote from an anonymous, eighteenth-century alchemical text: 'Art in imitation of nature, opens a body by means of fire, but uses a much stronger fire than the fire of confined flames.'

The writer is referring to the secretive and arcane practices of alchemy. Nevertheless, as Bachelard is at pains to point out, it remains a poetic statement before it is a scientific or even an alchemical one. The notion that the artist disposes of some kind of engendering infusion – a thermal introjection which has the effect of energising and animating inert matter – is not new. It has

persisted as a hidden subtext within modernist practice from the time of the Vitalists at the end of the nineteenth century. As a metaphor it continues to colour both our talking and our thinking about art even now, and not always in politically unacceptable ways. The idea that works of art are not passive things; that they involve an active, nowadays we might say an interactive principle; that they are invested with the power to change the way we think about and relate to the world, remains the most generally accepted article of faith in the modernist credo.

But there is another important limb to this metaphor of fire, which Kounellis's 'bed' brings to the fore. Unless it is of celestial or infernal origin, fire is a finite element. From the moment of ignition until the occasion of its extinction, its progress is predetermined. Thus the metaphor of fire inevitably brings into play the spectre of death. It homes in on the question of duration, on our human perception of 'limit'. Kounellis's gas container and the flame that feeds off it together form a stark predictive geometry that points up the mutability of flesh and the finality of death: the perennial theme of the *Vanitas*.

This 'deadly' prescription tensions the work in a way which is typically ambiguous. The calorific images – images of light and heat – are almost fatalistic about the bonding between sexuality and death, but there is a disarmingly straightforward, seemingly optimistic side to them too. They could easily be about nothing more than making visible and instilling warmth into things, they might be uncomplicated representations of the life force; but this is never Kounellis's way. The metaphorical circle must always be closed, trapping the reading subject within its boundaries, with no instructions about which way to face. If these images are about living, consuming life, we would do well to remember that they are also about being consumed by it. The scope of their radiational powers is closely confined by the cold which encircles at the limits of the flames' reach. After the fire nothing remains but the cold, spent ashes, recalling D'Annunzio's assertion that: 'In human life and love, death and fire are united in the same instant.' But in this work the torch spills its heat into a vacancy. If it is intended to function as negative entropy holding at bay the inrush of human despair, the gesture is charged with a corresponding futility.

Even if this piece had occurred in isolation it would have marked an important stage in the development of Kounellis's work. But set among the group of works belonging to that same year – many of which used the bed-frame as an 'assisted readymade' – it can be seen as a foundational work that carries much of the *Prima Materia* for all his subsequent work. These works picked up on the

many diverse thematic strands from the 'trolley' sculptures of the previous year and the series of installation works using sack-cloth, cotton-duck and raw wool made from 1967–78 and knitted them together into a coherent poetic fabric: absence and the displaced body; sexuality and death; the *Vanitas*.

Thomas McEvilley in the 1986 Chicago catalogue also argues for the central importance of this group of works, but he does so from within a very narrow compass of interpretation, which is unremittingly optimistic. From his point of view these works gave sharp focus to Kounellis's continuing preoccupation with the concept of the 'human measure': 'The bed was the measure of the human, but it was subjected to the fire of change. It is the measure itself that is being burnt into change, forced by fire into transformation.' The point is well made but surprisingly anodyne. The idea of 'human measure' is too confined by the emphasis he places on the transformational side of the fire metaphor. There is an unavoidable noisome and messy side to being human which McEvilley's pallid utopianism quite vanquishes from the scene. He is content to emphasise the idealistic and heroic aspects of these works and to play down their sinister, threatening, even cruel demeanour. And yet their ambivalence is crucial to the way in which we relate to them.

In one 'bed' work of 1970 there is a real figure – a woman, lying down, wrapped in a blanket so that only one foot protrudes, to which is attached a lighted blowtorch. McEvilley's description of this piece serves admirably to highlight the selective and rather ingenuous character of his reading: 'The wrapped woman suggests the hiddenness or unknownness of the new measure of humanity – a new measure of which she is the faceless or unknown mother.'

But in truth this is a murderous piece. It is almost impossible to look upon it without experiencing the coldness of death; without sensing – albeit as a remote intimation – something of the breathless anticipation of the necrophiliac. Neither is this a stone cold, nor even an old corpse, Kounellis is introducing us to, but an intensely present and sexual one. It brings with it an invitation to transgress. Its body heat is held all within and yet it burns with that self-same fire the alchemist strives mightily to intensify by means of self-denial and abstinence.

If these works are truly about the 'human measure' – and there is no reason to oppose McEvilley's basic premise – then it must be seen as an all-embracing measure. Certainly it must reach well beyond the blind hope of renewal and rebirth McEvilley gives to it. To 'have the measure' of someone is to give credence to the idea of negative as well as positive power: it is to hold the gift of life or death over them.

To work seriously to define and redefine 'human measure' is to be in thrall of a dialectic which is precariously poised over the gap between the mythic and the real. In this place contradictions abound. As Lévi-Strauss has so effectively demonstrated, when dealing with mythology connected with the duration of human life, the relationship between positive and negative codes and the forces they represent is always unstable: 'The fugue is always accompanied by a counter-fugue.' What appears to be rejuvenating, life-enhancing, life-giving in one instant, can be destructive in the next. As McEvilley must well know, by invoking the benevolent image of the fecund mother he, and by implication Kounellis too, is risking the unbidden advent of its opposite: the Hesiodic Earth Goddess. The justifiably vengeful, destructive and ultimately castrating power of the feminine. For men to appropriate fecundity for their own ends, also means that they must confront the possibility of being disempowered. It is this element of risk which lies at the heart of Kounellis's way of working. To enter again and again unknown places with the work only partly realised: to practice this ritual Orphic submersion in order to seek out Persephone's grant of poetic insight is to risk also the fate of the Titans, creative paralysis and obliteration.

But we must take care not to mythologise too much. We are not dealing here with the gathering momentum of narrative, but with a poetic distillation. Like most poets, Kounellis is gifted with a visionary apparatus which begins with an intuitive attachment to an object in the world and then proceeds to greatly magnify its significance by turning it into an image to be used. The process is one of mental ingestion – the desired object is taken within to be worked on by the imagination – and its product, in as far as it emerges whole, lubricated by all of its potential meaning, might well be described as a form of imaginal excreta. It has an appropriate air of untouchability about it and is impelled by a certain amount of primal energy. It is also, recognisably, the issue of an involuntary activity, one that proceeds automatically from the initial instant of engagement to the final grant of uniqueness. As Rainer Maria Rilke wrote in *Letters to a Young Poet*, the 'poetic soul' has no option but to 'respond to the demon he finds most attractive and rush to obey the call of a wickedly charming image.'

But this ability to imbue objects with a quality of absolute singularity – an ability that Kounellis has to a marked degree – is only one side of the poetic equation. As well as enjoying the simplest and most direct images, Kounellis also courts and cherishes formal and linguistic elaboration; those occasions when suddenly the blueprint for the poetic seems infinitely extendable into

action, or capable of carrying a huge diversity of material which at other times would have appeared incongruous, incoherent, irreconcilable. This is the active side of his poetics. The images have to be forced into relationship with each other and in a way that increases their individual and collective power. And the scale of the operation can vary enormously, from a simple combination of two or three objects, to the manipulation of a multiplicity of things, materials, spaces, architectural details and features on a monumental scale. The Kounellis exhibition at the Musée Contemporain de Bordeaux in 1985 is perhaps the most striking example of an installation which combined prodigious control over the imported architectural elements with exactly this quality of super-abundance and excess of poetic affect. In the great vaulted spaces of a building which was still more wine warehouse than museum, Kounellis succeeded in organising his resources on a truly massive scale; at the same time achieving an intricately woven yet intensely dramatic exchange between his own carefully weighted interventions and the richly patinated and detailed fabric of the building as it stood.

Here, of course, we are speaking about Kounellis's language at the macro-level; at the level at which it impacts upon the eye or imposes itself as a physical presence. But there is another, more complex and less exposed level which is never so easy to unpick.

So often the works seem to present themselves to us in a disarmingly open and simple way; as a carefully contrived contradiction, for instance, in a play of a sameness and difference in the Gallery Bernia black and white 'wall' installation of 1985; as an outright denial of function a boarded-up window, a blocked-up doorway, a stone-filled confessional box; as the separation of cause from effect – the smoke without the candle, the lamp without the light; as things stacked, shelved or stored in the great Chicago work of 1986; or by the presentation of a substance – wax, coffee, paper, coal and so on – as a geographical and economic indicator as in the 'various sacks' installations in Berne, 1969. But above and beyond what appears at first sight to be a naive act of presentation, there lies the whole panoramic sweep of the Kounellis vocabulary and the history of its usage. Because of this the individual works can never be seen in isolation. They are always participants in an etiolated lexical game involving objects, materials and pre-factured elements of various kinds, signs, sets, categories and number: all of those things, in short which he has used over the years to energise and motivate the many different layers of meaning within the work. And it is this encyclopaedic, kaleidoscopic aspect

of his language – the overarching complexity of it – that makes the reading of Kounellis so demanding. The same objects appear over and over again, at different times and in different locations, carrying with them their own accumulating genealogy; and each time they appear they are called upon to fulfil two quite distinct functions. They must fully engage with the dramaturgy of the new work and they must also carry through into that work the traces of a larger history – the history of Kounellis's work over all.

This rather baroque side to Kounellis's usage is well exampled in the Moscow exhibition. Here he has made a new set of works, mostly using secondhand furniture: clothes, cupboards, chests of drawers and wardrobes with distressed and peeling veneers and the remnants of their inner workings exposed. As usual Kounellis has taken total command of the installation of the work and has gone to considerable lengths to integrate the new pieces with a selection of earlier works; some left intact and exhibited as discreet entities, others incorporated or conspicuously reworked. The immediate response to these works is to feel that somewhere, sometime, Kounellis has led you down this path before and gradually the realisation dawns that you are being made the victim of a precisely contrived textual insertion.

The insinuated reference is to the coolly voyeuristic installation Kounellis made in the Hotel Lunetta (little moon) in Rome, 1976 – adjacent rooms, identically furnished with fully made-up double beds, carefully positioned pairs of upright wooden chairs and matching, between-the-wars style mirrored wardrobes. A single, shaded light bulb illuminated each room and the doors were kept permanently open. The wall of one room was split horizontally at eye level to allow the insertion of a table-tennis ball – a little moon – in a position which corresponded with the median line of the double bed. The work functioned according to a severe, almost canonic, structural parallax; and this was further emphasised by the way in which the mirrors all the time played back the viewer's changing relationship to the objects in the room. The purpose of this process of 'doubling' seemed to be that of making the 'self' conscious of the 'self' in the act of looking, and it is this aspect of the Hotel Lunetta installation to which Kounellis returns in the new Moscow works.

Facing each other across the main room of the Tretyakov Gallery, Kounellis has contrived two large-scale assembled works, which use pieces of old furniture presented in harness with different pre-constructed elements. One incorporates double steel plates with attached steel-bound sacks of coal and, the other, steel plates cut through by vertical slots, faintly illuminated from behind

and covered with square wire mesh. This last work also includes within it a complete work from 1976: the slit steel container filled to the brim with virgin white, cotton fibre. Both assemblages use articles of furniture with outward facing mirrors. In one the mirror is deeply recessed and tends to catch the viewer unawares; while in the other – as in the Hotel Lunetta work – the mirror is part of the wardrobe door and so is immediately apparent.

The effect of opposing these two assembled works in this way is to activate and greatly enliven the space in between. Once again the viewer is made intensely aware of the act of viewing, only this time in an almost clandestine way. The disquieting occasions of self-recognition seem always to occur obliquely, out of the corner of the eye – the feeling is almost that of being under surveillance. Neither is the Moscow installation possessed of the classical calm or the stern symmetries so prominent in the Rome work. Rather than reinforcing a sense of orderliness, the mirrors here are used disruptively, even destructively. They interfere with and all the time fragment the viewer's experience.

Kounellis has deliberately increased this drift into fragmentation by the way in which he has hung the rest of the room. Otherwise quite separate works commune and consort with each other, some out of clever positioning of reflective and semi-reflective surfaces and others simply by placement. In several instances, works have been forced into very uneasy relationship to each other, being neither exactly together nor apart. The geometrical steel flower with blowtorch of 1967, for example, is sandwiched between the assemblage with coal sacks, and another new work, a line of black overcoats hung from a metal rail by meat-hooks. It is hard to be certain where one work ends and another begins: whether, indeed, you are looking at one work or three. This uncertainty about boundaries seems to affect the whole show. Is it a container for the arrangement of discreet things, or is it to be read as one grand installation?

This tendency for Kounellis's works – individual pieces as well as assemblages and installations – to retreat from any sustained state of wholeness, to fall into fragments, has always been present, since the untitled 'sign' works of the early 1960s. Objects must always remain open to transformation by poetic relocation. Nothing must be allowed simply to be what it is, or to fall back into a comfortable or habitual relation to the rest of reality. Things must be forcefully used, if necessary wrenched from their context, cruelly displaced, shorn of all residual elegance. This 'savagery' is directed at the viewer too; so often they are left bereft of their fondest expectations. The feeling is that the work is driven, perhaps even diabolically so. Certainly this is true of the Tretyakov installation.

Jean-Paul Sartre, in his seminal essay on Baudelaire's *Les Fleurs du Mal* (1857), seeking to establish a general phenomenology for a poetics of evil, eventually alights upon Baudelaire's own description of the 'poetic object' as being chiefly recognisable in a persistent quality of 'fixed unsatisfaction', a quality which, according to Baudelaire: 'both causes anguish and reflects it.' Sartre goes on to interpret the poet's term to mean that the poetic object appears never to be entirely at ease with the meanings ascribed to it by its present situation. In other words, it must always be reaching towards the future, striving for a resolution in 'new meaning' and in the process transforming itself.

Thus, according to Sartre, the notion of 'fixed unsatisfaction' provides a basis for a new, essentially modern version of poetic transcendence; one that is freed from all metaphysical imperatives. But it has serious implications for the nature of the poetic text too. If the 'poetic object' is always constrained to move uncertainly along a trajectory of meaning reaching from the past into the future, it must follow that it can never be completely contained by, or wholly absorbed into the text. It must retain the power to break free, to assert its independence, even to migrate into another temporarily more appropriate text. The 'poetic object', then, in certain important respects, stands in opposition to hierarchy, to the monolithic and to the unified. In fact it might justifiably be said to be charged with a cruelty directed at the structural integrity of the text itself. Once again, this potential for poetic slippage, for the migration of the 'poetic object' and the consequent generation of new imagery bearing new meanings has been fully exploited by Kounellis in the Moscow installation.

By far the starkest of the recent works – a number of second-hand wardrobes, crudely cut through by band-saw, part propped against and part hanging from the wall on meat-hooks – is made to function not only as a shrilly insistent introjection, but also as a reservoir of migratory referential and physical material. It is as though Kounellis has charged this particular work with the task of entering into, and realigning, the readings of several other works in such a way as to infect the reading of the exhibition overall. To begin with, the piece itself is strongly reminiscent of the Barcelona works of 1989, in which Kounellis used carcasses of meat hung from steel poles against his favoured steel plates, interspersed with forked, twin gas-jets reaching upwards and outwards like the horns of a fighting bull. The wardrobes are roughly shaped to resemble the fore and hind quarters of butchered cattle and the ungainly way in which they stagger and lean – one thoroughly useless leg propping them up – is like carcasses in a slaughter house, cut open and in the

process of being bled. At the same time, two of these vertical sections have parted company from the rest and have relocated themselves in the work opposite – itself a sort of immigrant – a reconstructed section of the Barcelona exhibit, only this time without the meat. Where once the heavy, dead flesh had rubbed and the blood seeped out, the steel plates now are deeply scarred – partly eaten through by rust – and the steel poles now carry nothing but grotesque wooden replicas of the meat and coils of rope of the kind used to drag the remains of the bull from the ring when the matador's work is done.

These are the very trappings, the impedimenta of ritualised death, pushed beyond pathos into bathos. And all around are scattered the funny, sad traces of a mourning that carries with it no offer of consolation. There, at the far end of the gallery, the funereal black overcoats hang from their own butchers' hooks, migrants several times over – Naples 1975, Eindhoven 1985, London 1990 – and now, in this context, they bring vividly to mind the Rimini installation of 1983, owned by the Tate Gallery. Pinioned carrion, fallen to earth and hung up as a warning sign. Look in the other direction and there is a single wardrobe, its door swinging forlornly open and pushed up against it a heavily layered surface made of steel, lead and sack-cloth: deeply pierced through – wounded even – and afterwards filled to the brim with molten lead. An empty carcass, its emptiness sealed within.

Under the seemingly malign influence of these recent works, everything is tinged with melancholy, awash with darkness. Even the miscellany of antique garden urns, which, when it was installed in Naples took on such a humorous, humanistic aspect, at the Tretyakov looks to be an altogether more sober work. Here its fatalistic tone is undeniable. Now it is about the passing away of something. And the ubiquitous double bed frame – shown here in one of the 1969 versions with loosely stretched, worn and spoiled coffee sacks – has openly assumed its rightful portion of ambivalence. Its warmth is never so comforting, nor its casualness so disarming. Suddenly there is a severity and a chill about. Yes, it is about the 'human measure', but at the most fundamental level. Life and death – shelter, human warmth, sexuality – it is about a bare existence at the margin; an existence which trembles at the very brink of non-existence.

And against this insidiously creeping reductivity, this all too present threat of imminent extinction, there is nothing but the ever-probing tongue of language, the affirmative power of the utterance, the solitary, distant voice of the poet. In one of the earliest photographic portraits, Kounellis is pictured

standing against a steel plate with the hissing flame of a blowtorch apparently issuing from his open mouth. The implications are plain. On the one hand it is arguing a necessary coincidence between the act of poetic utterance and that of making visible the audible. More than this, it turns neatly on its head the rhetoric of address, in that the image utters to the viewer, rather than vice versa. It resituates the poet – the artist – as reflected subject. It was the German Romantic poet, Schlegel, who first argued that the poet was always the living subject of the poem that reflected him. 'Every poet is Narcissus', he is reported to have cried out. But, as Maurice Blanchot has so accurately pointed out, there is another way to understand Schlegel's assertion. Where the poet writes himself he does not always recognise himself. Often he is dismissed, excluded from what he has written by the strangeness of his own image. And there again, in the background continues the insistent buzz of decayed language, the endlessly repetitive, duo-syllabic utterance of the distant and invisible E-cho. The poet's voice, then, his fondly imagined utterance must be hurled into the teeth of this non-language; and between the tongue that impels and the point of impact, there is nothing but a translucent wall of silence, a limpid pool which blurs the image to a point at which self-recognition is no longer possible. In the mesmeric beauty of the image, the poet is condemned always to bear witness to the death of his own image.

Kounellis's chief endeavour, then, is to search out the boundary; to mark-out and record the limits of poetic utterance. This is not a comfortable or a particularly optimistic pursuit, more a dark and saturnine one and it is disturbing for the viewer too. Time and time again, in pursuit of this terrible edge, Kounellis brings the viewer to rest at a place which is neither origin nor terminus, but is situated midway between the two, precisely at the point where the impulsion of one is cancelled out by the pull of the other. And here, as this critical point of annulment – this visionary no place, as Ossip Mandlestam called it – the viewer is also brought face to face with the inevitability of death.

The great Spanish philosopher, Migual da Unamuno, in a typically ironic, imaginary conversation with his favourite fictional hero, Don Quixote, asks the old knight to describe the moment of death, and Don Quixote replies: 'Of this no man can speak. But all men shall know where to find it. It is forever in the same place: half way between the no longer and the not yet.'

Artscribe, no.88, London, September 1991, pp.60–66.

In the spring of 1992, on a trip to Antwerp, I had the good fortune to come across a most stimulating and informative exhibition of and about the work of Marcel Duchamp put together by Ronny and Jesse van der Velde. A clever combination of original works, authorised replicas and photographic material; it opened up a lot of new avenues of thought for me – especially about the readymade *Fountain* (1917), the urinal. When I returned to England I enthused about it to Marjorie Althorpe-Guyton and she asked me to write down my insights for *Artscribe*. It proved an ill-fated commission. The day after I handed over the manuscript, *Artscribe* was closed down by the owners. A month later I received an invitation from Demetrio Paparoni to contribute to a *Tema Celeste* special issue on Duchamp, so the article was not wasted. Indeed, it was later taken up by Arturo Schwarz who included it in his anthology of new Duchamp essays, *Duchamp Doppo Duchamp*.

IN THE GROVES OF PHILADELPHIA:
A FEMALE HANGING

Fresh Widow (1920) points to the separation by death from a subject of affection, and in Duchamp's case this would seem to imply the death, or temporary submersion, of the male aspect of the self. The taboo this work represents thus goes beyond that which operates against incest to reach into the more troubling depths of necrophilia.

When Marcel Duchamp arranged for the clandestine submission of the work *Fountain* (1917) – the now notorious gentlemen's urinal, signed 'R. Mutt 1917' – to the first exhibition of the newly formed 'American Society of Independent Artists', he set in motion a controversy which is still alive today. More than any other of Duchamp's works, it seems that it is *Fountain* that has retained the capacity to intrigue, to confound, even to shock. And despite an extensive and erudite literature – an endless stream of learned articles and books – despite all of this, the artist's intentions remain obscure and the question of Duchamp's authorship a matter for continued speculation. Even though he admitted responsibility for *Fountain* fairly soon after its rejection from the exhibition of the 'Independents', this did little to dispose of the questions raised but left unanswered by his previous explanations, not least the mysterious 'woman artist friend from Philadelphia', Duchamp's earliest and most enigmatic attribution.

As a founder-member of the 'American Society of Independent Artists', intimately involved in drawing up the rules governing their first, major 'open' exhibition and elected head of the hanging committee too, Duchamp was no doubt admirably well placed, first of all to engineer the scandal which attended the submission and rejection of *Fountain*, and thereafter to exploit the discomfiture of all concerned to the absolute maximum. In this respect it would appear to have been a classic surrealist stratagem. With the intention, presumably, of illiciting a knee-jerk reaction from the rest of the committee – a response that was out in the open before reflection could temper it and one that could not easily be revoked without further increasing the embarrassment quotient – Duchamp, with characteristic precision, succeeded in locating a point of bourgeois susceptibility around which there cohered a treacherous accretion of barely conscious social taboos. His chosen weapon – the men's urinal – this curiously fashioned, functional object, abstracted from an exclusively male domain and subject – in normal circumstances – to an exclusively male address; this gaping creature of the gentlemen's room, so alluringly female in its form, carried with it an array of provocative associations and references likely to ensnare even the most liberal members of the so-called enlightened middle class. In as far as it focused attention on personal hygiene – the private rituals, gender division, transgressive curiosities and desires which situate themselves around human acts of excretion – it was of a character perfectly fitted to insinuate itself into the psychological fabric of middle class propriety, and to demolish it from within. Duchamp's circle were confronted, then, with a precisely coded invitation to enter into a speculative relationship with an object, the identity of which was not in doubt, and yet the proffered engagement was aggressively ambivalent. Is it really a vessel in which to urinate, or is it a drinking fountain, a watering hole, a place from which to take refreshment? Is it mouth or vagina, or is it, as Duchamp himself would perhaps have it, the 'infra-thin' impression of their opposites; that which snugly fits within, male into female, positive into negative, like the cast adhering to the mould?

Is it not possible then that this urinal is as much a mould – something which determines form – as it is a thing cast? And if this is so, what of its blank interior space, what image might we inscribe upon that: a dematerialised pouch of genitalia, perhaps, or a mount of Venus turned in upon itself, geometrical perforations indicating front and back passages – a sort of gynaecologist's eye

view but from the inside looking out? And why has Duchamp chosen to rotate the object thus and present it to us laid upon its back?

Much later on in his life, when asked precisely this question in an interview with Pierre Cabanne, Duchamp proffered the explanation that this kind of inversion and rotation around a double axis of symmetry, effectively transported the object – in this case the urinal – out of the third dimension and into the fourth. In the 'notes to the glass', just such a 'passage' of transformation – I use the word 'passage' in the strictly Duchampian sense – is referred to as a 'demi-tour', in other words as a journey which, according to the prefix used, has been halved, shortened or curtailed. A slight stretching of the meaning would perhaps permit the use of the word to which Duchamp gave such prominence in the subtitle to the *Large Glass* (1961): the word 'delay'. This 'switch', as Duchamp called it, into the fourth dimension, by its very nature is never completed, always it is shortened, truncated, its climax always and forever 'delayed'.

But there is also a hidden and deeply erotic aspect to this notion of a geometric 'passage'. About the time that Duchamp was conceiving the work *Fountain*, he was greatly intrigued, even influenced by the ideas of the French mathematician Esprit Pascal Jouffret. Jouffret argued – prophetically as it later transpired – that a simultaneous rotation of the kind advanced by Duchamp in his interview with Cabanne – a three-dimensional object 'switched', taken on a 'demi-tour' through the fourth dimension – would necessarily involve a 'flip-flop', the effect of which would be to return the object mirror-reversed and inside-out. Furthermore, the mathematician exampled this phenomena by reference to one of Duchamp's favourite playthings: a pair of gloves. The left-hand glove, Jouffret observed, rotated about an axis drawn along its length and simultaneously turned inside-out, is made coincident in every respect to the right-hand glove. Thus, as Duchamp was quick to appreciate – the difference between the left and right might just as easily be categorised as temporal, as physical. Rather than its being attributable to a difference in material form, it could be more interestingly explained, perhaps, as 'a more-or-less minuscule difference in time'. Given this conceptual framework, the difference between inside and outside, too, would no longer enjoy a dependable status – unless it was as an unbounded region of erotic interaction, in which two absolutely contiguous surfaces continuously massage each other.

There are echoes here of the poet Paul Valéry's obsession with the 'finger-stall', and of his fictional hero Mons. Teste's fixation upon the 'sea-cucumber' – a creature which Valéry describes as having 'no obvious fixed

dimensions'. It can appear as a floating flat disc in one instant and as a tube with a closed end the next. In this form too, it can travel at great speed by drawing water into its interior and then forcefully expelling it by means of muscular contraction. It reverses instantaneously simply by turning itself inside-out. This capacity to conflate 'inside' and 'outside' experiences, or at least to exchange one for the other seemingly at will, brings us close to the sort of intimate exchange suggested by Duchamp's several definitions of the concept that he labelled the 'infra-thin': the difference between the mould and the cast; that which distinguishes two casts taken from the same mould; the sound of velvet trouser legs brushing against one another in the act of walking; the warmth that remains behind when a seat is vacated, and so on. All of these examples speak initially of a close coincidence of some kind, and then of an exchange of properties, even a transmission. But this transmission, this exchange, at the point at which it is 'stopped', ostensibly so that it might become visible, paradoxically – by dint of the very fact that it has been arrested, curtailed, 'delayed' – is rendered invisible. It is, for instance, of the very essence of our experience of the *Large Glass*, that none of the processes to which it refers can be seen. We are given the apparatus that impels the exchange but nothing of the fluid substance in motion. We are provided with a diagram of its trajectory, but have no means of testing its efficiency. The imaging of 'delay' which the *Large Glass* provides, then, is not that of a coitus interruptus but of an ejaculation endlessly postponed. The bridal cloud is permanently congealed, the tubes, the condensers, the love-filters are unused, barren. The possibility of the 'demi-tour' – a fruitful exchange between the two halves (top and bottom) and the two sides of the 'Glass' – is revealed as little more than a cruel parody of the 'demiurge': the creative force all dried up.

Craig Adcock, in his fascinating essay, 'Duchamp's Eroticism – A Mathematical Analysis' (1990), develops the argument further by suggesting that it was this idea of the 'demi-tour' – the switch through the fourth dimension – which, in the manner of H.G. Wells's hero, Mr Plattner, provided Duchamp with the rationale for his adoption of the female alter ego, Rrose Sélavy. In short, that it was this key concept which grounded the puzzling and provocative gender-inversion which surfaced in Duchamp's work some three years after the submission of the 'urinal', in the attribution of the 'assisted readymade' – *Fresh Widow*: 'R[r]ose Sélavy, New York, 1920'.

The implications of Adcock's proposition are worthy of more extended analysis in two important respects. Firstly, it would seem to suggest that Duchamp intended to shift the distinction between 'male' and 'female' out of

the static, biophysical domain and into the temporal, and secondly, that he wanted the gender difference itself to be considered as nothing more significant than a particular example in the category of the 'infra-thin'. The argument is best understood by reference to the mechanisms of conceptual translation exampled by Jouffret's inversion of the 'left-hand glove', whereby concavities are made into convexities; outside becomes inside; conspicuous promontories – things which stick out – are transformed into ingressive passageways; and in the course of which, at a very particular stage in the process – just like Mons. Teste's 'sea-cucumber', drifting in its relaxed, disc-like flattened form – the 'sphincteral' contradiction between 'opening as entrance' and 'opening as exit' is completely neutralised. If we are able to take Adcock's suggestion seriously, then Duchamp is positing an instant of absolute inter-penetration of inside and outside, such as that which obtains between mould and cast, before separation is attempted. Locked in such a close embrace it appears, from the outside at least, as if neither party is dominant, but inside – in the 'infra-thin' interval between the two – there rages a continuous, essentially sub-visible struggle to establish specificity of gender. Arguably, it is this seemingly closed state, this impenetrable condition of coexistence which constitutes the 'delay' to which Duchamp refers in the subtitle to the *Large Glass*. In other words, the 'delay', as well as being a sucking resistance to withdrawal, a denial of separation and therefore of the possibility of an excited 'transmission', as we have already remarked, is also a 'delay' in the mutual recognition and reinforcement of specific gender difference.

Significantly, after the initial controversy which attended the submission of *Fountain* and Duchamp's resignation from the Society of Independent American Artists, as the scandal was beginning to die down, Duchamp – by deploying friends as more or less unwitting intermediaries – began, cautiously, to insinuate into the minds of the so-called radical, middle-class, New York cultural set and the press too, the idea that the 'urinal' had been submitted on legitimate aesthetic grounds; that far from being 'obscene' or 'dirty' as the accusation ran, it in fact represented the beautiful in everyday things. And he took his provocation even further: firstly by accepting publicly Katherine Dreier's somewhat giddy assertion that the 'chaste simplicity' of the 'urinal' was 'like a lovely Buddha', and then by the artist himself suggesting that its elegant curvilinear exterior shape was quintessentially 'feminine'. Suddenly, the notion was abroad that *Fountain* – this functional object, mass-produced for the exclusive use of men, intimately

connected with their private functions and therefore deemed to be deeply offensive to women – in fact partook of the archetypal form of the Christian 'Madonna'. Here, then, we no longer have an object suitable for vilification, but one that verged upon the venerable. It reflected the most mysterious and enigmatic of Judeo-Christian desires, the dualistic desire for 'two bodies' – the corruptible and the incorruptible – in the sublime concatenation of fecund mother and Virgin Queen.

In retrospect there seems little doubt but that Duchamp deliberately unleashed this deeply subversive second reading of *Fountain* with the deliberate intention of thoroughly confusing those members of the Society who had been instrumental in ensuring that the work be rejected from the exhibition. It should be remembered that *Fountain* had been temporarily mislaid – deliberately lost, it has been suggested, for the period of the opening of the exhibition – and that it was Duchamp accompanied by his close friend, Walter Arensberg, who went in search of it, eventually discovering it packed out of sight behind the exhibition screens. Together, they transported it to the studio of the photographer Alfred Stieglitz, where Duchamp had arranged for it to be photographed for inclusion in the next issue of his magazine, *Blind Man*. Stieglitz later gave testimony to the close attention paid by Duchamp himself to the taking of this particular photograph. He recalled that they discussed the project at great length, paying close attention to the positioning of the camera and the placing of the image of the urinal within the frame. Duchamp's declared intention was to enhance the 'voluptuous' feminine characteristics of the object. As the art historian William Camfield puts it in his excellent essay on the subject, Duchamp was intent upon producing 'an image which exuded sexuality'.

Duchamp published the resulting photograph as planned in *Blind Man*, No.2, in the late spring of 1917. More interestingly though, he gave a second version of the photograph – taken from the same negative, but this time cropped so that the forward reaching lip of the urinal is just within the bottom edge of the frame – as a present to Walter Arensberg, sometime during the following year. The timing of this gift is sufficiently close to the dating of his 'rectified' reproduction of the Mona Lisa, *L.H.O.O.Q.* (1919), to justify speculation about the close connection between the two. Certainly it would seem to show that the artist continued to experiment with the Stieglitz photograph after it had appeared as the leading page in *Blind Man*, and with the apparent intention of bringing the image even closer to that of a seated, Madonna-like woman, with

long hair or head covered by a shawl. In this respect, *L.H.O.O.Q.* offers some striking similarities with the earlier work. Visually speaking, there is a clear dual resemblance to its sweeping curvilinear form; firstly, out of the way in which the face and neck down to the top of the breasts, where they are cut by the braided edge of the dress, are framed by the downward sweep of the woman's hair; and then again by the way in which her arms and hands are linked in front and the feeling of enclosure that this linkage generates.

But the most important common thread joining these two works is to be found in the phonetic punning of the title in the later work: *L.H.O.O.Q.* – '*Elle a chaud au cul*' – 'She has a hot bottom'. This title, replete with its subversive erotic meanings, together with the drawn addition of masculine facial hair, serves to complete a complex, cyclical process of double-inversion, from female into male and back into female once again. In linguistic terms the title turns the whole arrangement into the very model of the 'demi-tour'. Starting from the original image of the enigmatic courtesan, face animated by a post-coital smile, Duchamp first switches the reading to that of a somewhat fastidious, perhaps even a slightly effeminate man about town – waxed moustache erect and beard like a young girl's pudenda – and then, by means of the title, he returns it to a full-blooded representation of female sexuality: 'She has a hot bottom'; she is a woman who itches to have sex. The phrase presents us with two alternative readings: as a description of type – she has a tendency towards promiscuity, she is the sort of woman who is characterised as having 'a hot bottom' – or as a description of a present condition – she desires sexual satisfaction, her present state is that of having 'a hot bottom'. Either way, the implied trajectory of transformation moves from first to last, out of the past into the future: from the expression of an appetite recently satisfied, through a state of nominal neutrality and towards the expression of a sexual desire in urgent need of satisfaction. Thus desire is passed in time and space, through itself in order to renew itself, in the endless alterity that exists between satiety and hunger.

But what of the gender transformation worked by the drawing on of the beard and the moustache. Here, surely, we are given the very opposite case to that represented by *Fountain*. There Duchamp was overlaying the feminine upon the masculine, whereas in the case of *L.H.O.O.Q.*, it would seem that the opposite is true: the male identity is superimposed upon the female. However, this apparent difference soon dissolves when the argument is taken to a deeper level.

Both works, it should be remembered, were what Duchamp himself described as 'rectified' readymades. They were altered by an action of the hand; in both cases by means of inscription. As we have already remarked, in the case of *Fountain* this took the form of a false signature – 'R. Mutt, 1917' – which inscription, as the artist later acknowledged, was a complex amalgam of references and multilingual puns. The urinal itself was selected by Duchamp from the New York showrooms of the Philadelphia based firm of 'J.L. Mott, Iron-founders and Sanitary Engineers'. Even before he altered it, then – with the intention as he told Cabanne of making the subterfuge less obvious – the name resonated with alternative meanings linked with his native French tongue: 'mot', the answer to a riddle; 'bon mot', a witticism, a double entendre, a practical joke; 'motte', a clod of turf, in Parisian slang a woman's pubic bush. Changing the 'O' for 'U' produced further layers of meaning. Apart from the well documented reference to the short, fat character 'Mutt' in the popular strip cartoon *Mutt and Jeff*, it suggests additional truncated, trans-lingual puns: 'Mutt(er)', or the more affectionate 'Mutt(i)', mother in German; or in English 'mutt(er)', to speak inaudibly; and in Italian, the several declensions of the verb 'mut(are)', to change. The inscription was also intended to act as a bridge to other works, most notable of which was the last of Duchamp's 'painted' works commissioned and already planned for the Katherine Dreier library and bearing the deliberately nonsensical title, *Tu m'* – to which it was possible to respond by attaching 'any (French) verb as long as it begins with a vowel' – a purposeful inversion of the inscribed surname 'Mutt'. Mystery still surrounds the addition of the fictitious 'Mutt's' Christian name, 'Richard'. Viewed in retrospect, it was certainly a part of Duchamp's original intention; he admitted as much in an interview with Otto Hahn: 'I added Richard, French slang for moneybags. That's not a bad name for a *pissotière*. Get it? The opposite of poverty ("Armut" is German for poverty). But not even that much, just "R. Mutt".'

Nevertheless, the first press reports referred to the unknown artist as 'J.C. Mutt' – a confusion, no doubt, with the manufacturer's name of 'J.L. Mott' – and thereafter as plain 'Mr Mutt'. And Duchamp himself, when approached during the heat of the controversy, unhesitatingly attributed the work to an 'unknown woman artist friend of mine from Philadelphia', only to change his mind later, referring to it in the editorial of *Blind Man* as the work of 'Mr Richard Mutt of Philadelphia'.

It would seem that there is ample evidence, then, to support the view that Duchamp – despite its having originated in the gentlemen's room – saw

the urinal as essentially feminine in character, even as the very essence of womanhood. And this impression is reinforced by reference to the anonymous photograph of his studio at 33 West 67TH Street, in which the urinal is clearly visible hanging from the ceiling. This photograph, cryptically annotated in Duchamp's hand with the title phrase, *Le Pendu Femelle* (the female hanging), taken in concert with the earlier notes included in the *Box of 1914*, where Duchamp writes, 'one only has for female the public urinal – and one lives by it', bears ample witness to his persistent, almost obsessive conflation of the idea of the feminine with the male urinal. Furthermore, given the evidence overall, it would seem reasonable to suppose that his original attribution was a fully worked out part of the game plan. In other words, that his reference to the 'woman from Philadelphia' was intended as a tautological description of the urinal itself: that the work that Duchamp called *Fountain* was none other than the 'woman from Philadelphia' in person.

At this time the artist was still working to define and refine his concept of the 'readymade', of which, eventually, there were three quite distinct main categories: the 'readymade' pure and simple – a pre-factured object of some kind (the *Bottle Rack*, 1914) would be one example) brought within the arena of art by an act of placement; the 'assisted readymade' – a pre-factured object (the bird cage in *Why not Sneeze* (1921), for example) transformed into a work of art by the addition of new and unexpected elements; and the 'rectified readymade' – a pre-factured object, recontexted by an act of inscription. This last category, which includes both *Fountain* and *L.H.O.O.Q.*, would seem to imply some form of correction, or a restoration of the object to a previously more total, less deviant condition. In both of the works in question the act of inscription serves to overlay a male identity upon the female one. But this is no gesture towards a crudely sexual or bestial coupling. In as far as it is intended to restore or to 'rectify', to return the object to its original identity in some way, it is a motion towards the neutral, towards, if you like, the primal state of the mythic androgyne. The process is reminiscent of that which Freud points to in *Beyond the Pleasure Principle* (1920), when he speaks of a property, observable as a general tendency in organic life,

> impelling it towards the reinstatement of an earlier condition... that of the inorganic. The sexual act, the combining of male with female, remains the place where Eros measures up to Thanatos; but the

victories of life are never more than respites in the journey towards death. Life's provisional equilibrium always, unfailingly ends by disintegrating into the definitive equilibrium of death.

At the very centre of Duchamp's notion of 'rectification', then, is a movement towards a state of absolute stasis – a kind of death – in which difference is permitted no observable visual dimensionality; in which difference, in other words – if it is allowed a place at all – is confined to the conceptual (non-retinal) domain of the 'infra-thin'. For Duchamp, as we have already remarked, the coexistence of mould and cast represents a state of absolute, mutual pathicity and the type of circularity – in material form – that we associate with the great metaphysical systems: the eternal return to a pre-existent state of unity. Here though, in Duchamp's case, this unity is highly eroticised. The uncomposing of the original, androgynous condition of oneness – its potential for splitting into male and female parts – has as its necessary sequel in the pathology of a species divided according to gender: an unrelenting and ultimately unassuageable attraction between the sexes. In this respect, the condition of androgynous unity between mould and cast can also stand for a version of absolute creativity: a self-completing coincidence of masculine and feminine principles in which duality is held in check (delayed) just long enough to allow for something approaching autonomous incarnation. It holds out the tantalising possibility of a thing that can make and re-make itself ad infinitum.

Fountain, the urinal, the 'woman from Philadelphia' – author as well as the thing authored – in as far as it might, quite legitimately, be said to have made itself, presents us then with a very special case within the overall category of the 'readymade'. Perhaps it even sheds important new light on Duchamp's thinking with regard to 'readymades' in general. It is one thing to pay lip-service to the pre-facture and pre-existence of a chosen object by designating it 'readymade' and emphasising selection and placement over any aesthetic qualities it may possess. It is quite another matter to suggest that this same object might, in some strange way, have made or 'authorised' itself. Such a notion would, however, serve to explain why Duchamp repeatedly and so vehemently denied the play of his own taste in relation to the appearance of the 'readymades'. A miraculous autonomy of the kind suggested would argue some sort of radical disjunction between the world of art and the world of everyday things, a disjunction which would demand of an object passing from one into the other,

that it remake itself. In other words, wrested from the visual conditioning placed upon it by its mundane function, it would be forced to take responsibility for its own appearance. To example this by reference to a similar kind of self-generating translation, we might usefully turn to a later work by the artist, *Door, 11 rue Larrey* (1927): two doorways set side by side at right-angles to one another – one leads to the bedroom and the other to the bathroom – sharing a single door hinged between the two, capable of closing off one or the other of the rooms but never both at the same time. According to Man Ray, Duchamp was fond of asking visitors to the tiny apartment whether the door was 'always the same door'; 'a rhetorical question which seemed to cause him some considerable amusement.' If one stays within the realm of common sense, of course the answer to such a question can only be both 'yes' and 'no'. But in the realm of Duchampian language games and spatio-temporal 'switches', it becomes a more complicated matter. Certainly, with each successive swing of the door it changes, nominally speaking, from being the 'bedroom door' into being the 'bathroom door', but it also undergoes an implied dimensional change too, not dissimilar in kind to Jouffret's example of the glove: the inside becomes the outside, and the 'left-handed' door becomes a 'right-handed' one, or vice versa. But this is no simple one-for-one swapping of identity. In fact, within the space of one swing of the door, its identity changes twice. There is a neutral mid-point at which the door is neither one thing nor the other: it is neither bedroom nor bathroom door, neither right-handed nor left-handed, its surface neither inside nor outside. At this moment, stripped of both identities – with its functional identity delayed – it is simply what it is: a door. More significantly it is a door which denies retinal confirmation. In this position, it must be approached from its leading edge so as not to privilege one possible reading over another, and suddenly the door is tucked away out of sight, submerged within itself, rendered invisible. It is collapsed into another telling example of the 'infra-thin', the invisible line which dissects a right-angle; the conceptual and schematic representation of a regression to infinity. And out of this fleeting moment of invisibility, the door reemerges dressed in its other guise. Once again, as with *Fountain* and *L.H.O.O.Q.*, we find Duchamp passing the object through its own hybrid, androgynous self, to return it to us as its seeming opposite.

But this point of neutrality, as well as a location for transformation, is also a locus of reconciliation. Francis Naumann, in his essay *Marcel Duchamp – a Reconciliation of Opposites*(1987), makes a direct and convincing connection between *Door, 11 rue Larrey* and the theme of the book on chess which Duchamp

co-authored with the German master, Halberstadt: *L'Opposition et les Cases Conjuguées sont Réconciliées – Opposition and Sister Squares are Reconciled* (1932). Naumann points out that the main purpose of what otherwise is a highly arcane and, as far as the game of chess is concerned, a relatively useless book, is to show that in the 'endgame', 'oppositional' and 'sister' squares, far from being the functional antithesis of each other, can be seen as having a common identity and a common purpose. Similarly, that *Door, 11 rue Larrey* is intended to disprove the French adage: *Il faut qu'une porte soit ouverte ou fermée* – a door must be either open or closed. Duchamp's door, when in its median position, is cunningly disconnected from both of the available apertures in equal degrees. In this respect it might be said to be neither open nor closed: the either/or is simply not applicable. In this instant the door is oddly free-standing, independent, responsible for its own identity. Neither is it like a discarded door. In no sense is it bereft of its function or denied an appropriate context. As Jean-François Lyotard has indicated in his remarkable book *TRANS/formation*, it is the 'hinge' that, for Duchamp, determines the sum total of relationships. All the 'analagisms' of the passage from three to four dimensions, with that from the second to the third: a rectangle turning like a hinge engenders a cylinder; imagine the hinge-plane of a volume (three-dimensional) engendering by rotation a four-dimensional figure. The two transversals of glass that separate the Bachelor region and the Brides region are also generators of this sort. 'Make a hinged picture.' (M.D.) The door, hinged between bathroom and bedroom, would seem to represent precisely this case, as indeed does the 'reconciliation' of 'sister' squares, demonstrated by Duchamp's poster for the French Chess Congress of 1927 and one of his last etchings, *King and Queen*, of 1968. Here the chessboard has been broken up and turned into three-dimensional segments, three hinged squares at a time, one black and two whites, or vice versa. Thus the oppositional square is placed in an equal, but at the same time highly ambiguous relationship with the diagonally related 'sister' squares of the opposing colour by a process of double hinging. In the course of this dimensional translation, the field of combat – which in the case of the 'endgame' is given over to one purpose and one purpose only: that of manoeuvring the opposing King into a 'mating position', usually after a Pawn (the Page-boy, the young male servant reminiscent of the Malic Moulds resplendent in their liveries) has been converted into a Queen – is rendered inoperable and no longer amenable to reconstruction. The tumbling cascade

of half-cubes, like the 'stripping', diagramatised in the iconography of the *Large Glass*, represents a frozen and ultimately unrealisable enterprise. The King's direct progress along his own file is denied. His potency is thus blunted by an alliance of feminine forces. We might almost say that the King has suffered castration at the hands of a doubled representation of dissimulating handmaidens: the Queen's household. In this scheme of things, the attacking oppositional square is not available to him; instead he must make common cause with the Queen's interests. He cannot avoid what Jacques Derrida has called the inversion that comes with negation.

What is at stake here – it might even be the central thread that connects all of Duchamp's work – is an elaborate theory of opposition, chiefly exampled by a strangely ambivalent reconstruction of the male / female relationship. Looked at through one end of the telescope, Duchamp's attitude here might appear to be an utterly reactionary one. The male is cast in the active role and the female in the passive. The man – the Post-Freudian man that is replete with his overweening sexual drives – is seen as a kind of Honest-John figure; the woman, as a deceiver and a seducer. The masculine principle is represented as a transparency – in the *Large Glass* for example – while the feminine principle is represented by an opacity. However, as we have already demonstrated, Duchamp is possessed of a much more complex turn of mind than would permit of such an inelegant and one-sided formulation. The view from the other end of the Duchampian telescope provides for a very different topography of gender and sexual difference. To begin with, things are much closer together: far more difficult to separate and to hold apart. Qualities are never intrinsic either. They can easily up and migrate to and fro across the gender divide. The principle of opposition then, in a Duchampian sense, is only realisable in a fluid, ongoing engagement. Difference is a form of transaction: it is of the very essence of the 'infra-thin' that difference exists not in things, but in the space between them. The idea of observable, fixed, masculine and feminine characteristics is thus the product of a curtailment of exchange out of which there arises an illusion of difference. Jacques Derrida, in the footnotes to his *Spurs / Éperons* (1979), makes the following telling observation with regard to oppositional formulations of sexual difference in general. At the moment that the sexual difference is determined as an opposition, the image of each term is inverted into the other. Thus the machinery of contradiction is a proposition whose two Xs are at once subject and predicate and whose copula is a mirror. Under this rubric, the game of

gender difference is perhaps best understood as a kind of filial square-dance in which brother and sister images exchange with each other qualities drawn from a predetermined catalogue of family resemblances. The difference discernible between members of this filial foursome is determined from within the over-arching edifice of a larger, common identity. Seen in this light, the oscillation that we have observed elsewhere, between male and female parts in works such as *Fountain* and *L.H.O.O.Q.*, and in the proposition of an intimate coupling and exchange in the *Large Glass*, might be accurately compared with a situation in which an image of a 'sister' faces the mirror and receives back the familiar image of a 'brother', which in turn causes its opposite and so on, thus inaugurating a recurrent pattern of mutual confirmation in which the recognition of difference is endlessly delayed.

Viewed in this light too, *Fountain* – the gentlemen's urinal turned female hanging; the mysterious 'woman from Philadelphia'; a self-made woman, author as well as thing authored – assumes a preeminent position in the progress of Duchamp's work overall.

The clue to this preeminence is to be found in Duchamp's choice of Philadelphia as domicile for his fictitious artist. Literally translated, Philadelphia means 'city of brotherly love', after the teachings of the Greek philosopher Ptolemy Philadelphus. Philadelphia, Pennsylvania took its name from the 'Philadelphians', a highly secretive, non-conformist religious sect, not unlike the Quakers, which flourished in England at the time of the Pilgrim Fathers; and no doubt it found its echo in Duchamp because of the late-eighteenth-century French neo-classical brotherhood of an almost Masonic kind which bore the same name. The name Philadelphia, then, represents an esoteric site, which allows under the cloak of secrecy for certain transformations to be set in train. Most importantly it allows for the kind of 'reflexive' quadrille between paired brothers and sisters, touched upon by Derrida, with its undercurrents of transsexuality, narcissism and incest, to be danced to its icy conclusion in an eroticism without fulfilment; in an altogether de-sexualised amour. The consummation of this amour occurs, paradoxically, with the narcissistic splitting of male and female identities within the same persona, allowing each to become the subject of the other's gaze. That such a relationship is necessarily governed by filial resemblances – it is dependent, in other words, on recognising the self in the other – needs no further elaboration. That it is governed, in the psychological sense, by filial taboos of a similar order to those that intended to inhibit sexual activity

between brother and sister is perhaps worth more extended consideration, especially in the light of Duchamp's later invention of a female alter ego in the person of 'R[r]ose Sélavy'.

The title of the first work signed by 'R[r]ose Sélavy', *Fresh Widow*, would seem to be highly significant in this respect. In one of the interviews that Duchamp gave to Cabanne, he speaks of the idea of 'being freshly widowed' as representing a crucial change of state, but ventures no more than this. How then are we to construe this change, unless it be in terms of a splitting, a breaking apart of something which hitherto had appeared as an indissoluble unity. To be 'freshly widowed' is to be separated by death from a subject of affection, and in Duchamp's case this would seem to imply the death, or temporary submersion, of the male aspect of the self. For this reason the windows of *Fresh Widow* are dressed in black leather to prevent their offering back any confirmative reflection. The taboo this work represents thus goes beyond that which operates against incest to reach into the more troubling depths of necrophilia.

'Special Duchamp Edition', *Tema Celeste*, Siracusa, February 1992, pp.41–49.

In 1992 the South Bank exhibitions committee asked me about putting on an Arte Povera exhibition at the Hayward Gallery. At the meeting I argued strongly that it should include the American 'neo-minimal' artists too, since it was the only time in the postwar period when there had been a genuine transatlantic sharing of interests and exchange of ideas. Two days later they invited me to curate a combined exhibition. I borrowed the leading title of the resulting show, *Gravity and Grace – The Changing Condition of Sculpture* from Simone Weil; an eventuality which I can only blame on the artist and critic Yehuda Safran, whose essay 'The Condition of Gravity is Grace' (1975), had triggered a long-standing, if somewhat sporadic engagement with Weil's writing. This catalogue essay, especially its title, caused some controversy. There were some who argued that Arte Povera arose out of and was chiefly connected with painting rather than sculpture. This criticism didn't trouble me too much, since I had already concluded that sculpture as a craft tradition was in crisis; that sculpture as a practice was passing through a period of radical transition, perhaps even one of decline.

NEW TIMES, NEW THOUGHTS, NEW SCULPTURE

There is a very amusing apocryphal story which has it that when asked
to define sculpture, the French Symbolist poet Charles Baudelaire replied
by saying that 'it was something that you fell over when you stepped back
to look at a painting.' Whether the story is true or not matters little: the
sentiment is precise enough. Painting took precedence over sculpture – was
considered to be a superior fine art practice from the late Mannerist period
of the Renaissance until the end of the Second World War. The reasons are
obvious enough. Painting was capable of carrying all the transcendental
qualities that sculpture was not. It was painting that had the monopoly of
the supra-physical world of angels and gods. It was painting that could speak
most easily of the enchantments of Arcadia: its honeyed-light; its rolling
vistas and mysterious recesses. Only painting could contain the sublime
exaggerations of the picturesque landscape, or the crusted detail and
material transformations of Realism. Only painting could yield up the
luminous evocations of Impressionism. Even in the immediate postwar
period it was painting that offered the freedom necessary for the gestural
excesses of Abstract Expressionism. By comparison, sculpture seemed
confined by its materiality, earthbound, resistant to flights of fancy, always

stubbornly what it was; a shaped piece of wood or stone, a lump of plaster or wax or clay, a moulded piece of bronze. Yet, more recently, sculpture has increasingly occupied the centre stage.

My purpose here is to trace this change of focus and to seek explanations for it from within the practice of sculpture itself as well as from the complex critical and theoretical discourse which has grown up around it. Nor do I want to make of it a simple polarity of interests. Sculpture too has been transformed in the same period, losing the centrality of its different generic practices (modelling, carving and constructing) and taking under its mantle a wide diversity of hybrid forms and strategies of making. In the first instance this was powered by the mixture of 'high' art with popular forms of communication that came together in American Pop art. Afterwards, Minimalism and Conceptual art took sculptural practice into an area of theory which connected with the speculative thinking of other more scholarly disciplines: philosophy, linguistics, phenomenology, psychology and social and political theory.

My chief intention is to shed light upon the transition which took place in the 1960s, when Minimalism gave way to the post-Minimalist tendency in America and Europe. Previously, American influence had tended to dominate the development of the visual arts in Britain, France, Germany and Italy, as well as further afield. With the rise of Arte Povera in Italy and the activities of Joseph Beuys and those around him in Germany, the transatlantic exchange was suddenly transformed into one between equals. Even so, the political climate of the time meant that relations between American and European art in the 1960s and early 1970s was marked by very considerable tension, as can clearly be shown in the critical writings of the time. By the middle of the decade resentment had begun to surface in Europe and a corresponding defensiveness arose in America, as exampled in the early writings of the American critic, Rosalind Krauss.

In her seminal essay on postwar American sculpture, 'The Double Negative: a New Syntax for Sculpture',[1] Krauss argues that there is a clear difference of approach between the emergent generation of New York artists working with sculptural ideas – later called the post-Minimalists – and their counterparts working in Europe. And she gives authority to this notion of difference by quoting from Donald Judd's essay in the *Arts Yearbook* of 1965, and by reference to the joint interview that Judd and Frank Stella had with the art historian Bruce Glasser, 'New Nihilism or New Art',[2] which appeared

in *Art News* in 1966. These quotations are well worth repeating since they shed light upon the attitude of the artists of Judd's generation towards European art in the first half of the 1960s, an attitude which was to change dramatically in the course of the next decade. Donald Judd writes about the new sculptural order: 'It is not rationalistic and underlying, but is simply order: like that of continuity, one thing after another;' later, in tandem with Stella, when questioned by Glasser about this 'one thing after another' way of making works of art, he argues it as standing in sharp opposition to what he calls 'European Formalism', an approach which Stella says is primarily concerned with balance: You do something in one corner and you balance it with something in the other.' In Donald Judd's more philosophical manner of speaking:

> It is that they [the Europeans] are linked with a philosophy –
> rationalism, rationalist philosophy... All that art is based on systems
> built beforehand, *a priori* systems; they express a certain type of
> thinking and logic that is pretty much discredited now as a way of
> finding out what the world is like.

This statement is revealing, not simply because, as Krauss points out, it shows Minimalism to be an attempt to make a form of art which, to all intents and purposes, was analogous with 'inert matter – things untouched by thought or unmediated by personality' – but also because it contained within it a programmatic, one might even say a political, intention too – that of continuing the search for uniquely American ways of thinking about things; establishing clear criteria of difference between themselves and their European counterparts. It also demonstrates, with startling clarity, just how inward-looking the New York art world had become by the early 1960s.

Even the most cursory examination of that particular period of art activity in western Europe will serve to show that Stella and Judd could not have been wider of the mark. Indeed, far from being a time of formalist retrenchment as they would seem to suggest, the early 1960s in Europe was a period during which the ground was cleared and the foundations laid for an extraordinary resurgence in the visual arts. Two quite remarkable facts will suffice to demonstrate this beyond peradventure. In 1966, at the time of the Judd / Stella interview in *Art News*, Joseph Beuys was already well established as a teacher at the Academy in Düsseldorf and engaged with his 'revolutionary',

'free' seminars linking art, politics and economics.[3] In his own work too, Beuys was passing through his most radical and iconoclastic phase, halfway through a long series of performance works of which *The Infiltration-homogen for Grand Piano: the greatest contemporary artist is the Thalidomide Child* was dated 1966, exactly coincident with the interview under discussion. Similarly, the work of the Italian artist Michelangelo Pistoletto bridged some of the most important tendencies current at the time,[4] most especially between American and European Pop and the early formative stage of Arte Povera.[5] Pistoletto had made his first 'mirror piece', synthesising past, present and future in the form of an image at the surface, in 1962. In 1966, the year in question, he made his most ambitious 'mirror' installation to date in the Italian pavilion at the Venice Biennale. More significantly, he had already completed his innovatory series of constructed objects, the *Oggetti in Meno (The Minus Objects)*.

It is of no relevance to our purpose here to decide whether the attitudes underlying the Judd / Stella interview were the product of ignorance, prejudice or a combination of both. What is important is to reach an understanding of just how much the ethos governing attitudes in the New York art world had changed by the 1960s. The openhanded and optimistic internationalism which had characterised the immediate postwar period, during which New York had become a safe haven and creative forcing ground for a whole generation of artists, one or two of whom were indigenous Americans but most of whom were political refugees from western Europe, had given way by the end of the 1950s to a more American-centred view of things. For the first generation of New York artists – the generation of Pollock, Rothko and de Kooning – the issue had been one of personal freedom. They were not interested in identifying themselves with narrow nationalistic interests or prescriptive ideologies. As far as they were concerned, freedom could never be the gift of a type of state or a particular shade of political philosophy. As Robert Motherwell wrote in his essay of 1944, 'The Modern Painter's World',[6] modern artists 'value personal liberty because they do not find positive liberties in the concrete character of the modern state', and he continues, 'Modern art is closely related to the modern individual's freedom... for this reason the history of modern art tends at certain moments to become the history of modern freedom.' The painter William Baziotes, writing at about the same time, strikes an even more uncompromising note: 'When the demagogues of art call on you to make the social art, the intelligible art, the good art – spit upon them and go back to your dreams.'[7]

By the end of the 1950s this untrammelled idealism, which allowed the first postwar generation of New York artists to stand aside from any form of overt political commitment, was quite dispersed. By this time, America was locked into a bitter ideological struggle with the Soviet Union, seeking to win and to hold the hearts and minds of the peoples of what was then euphemistically referred to as the free world. And as the shadow of the Cold War widened and deepened, as the dissemination of propaganda intensified, American avant-garde art was increasingly drawn into the fray. The model of individual freedom, so beloved of Motherwell and his contemporaries, effectively placed the creative necessity of the individual artists and by implication of all individuals, above the power of the state to command it. Here was a society which not only tolerated individual dissent, but also saw it as intrinsic to its social strength and cultural purpose.

Not surprisingly, there was a negative side to this belated and somewhat cynical process of official endorsement. It showed itself, first of all, as a gathering sense of disillusionment amongst the older generation of New York artists, who felt that they were being used, manipulated – their work re-interpreted, even misrepresented – and for nakedly political ends. The belief which had sustained them, namely that the practice of art could best exist in an apolitical Arcadia, a utopic space in which there occurred a pure combination of originating gesture, material process and sublime insight – a product of what Harold Rosenberg has called the 'authenticity of the real act'[8] – looked less and less tenable and, as a consequence, unsustainable as a *modus operandi*. As Max Kozloff put it, by the late 1950s 'false consciousness' had become 'a not so secret enemy within the artist's organism.'[9]

By contrast, the effect of this process of cultural politicisation on the younger generation of American artists was altogether more constructive. They were much more prepared to recognise and respond to the invasive power of political realities. For them, the activity of making works of art took its *raison d'être* unavoidably from within the public domain, and was therefore subject to the same social, political and economic factors as all other forms of human endeavour. The issue was no longer one of how to sustain a private and more or less autonomous world in which to perform uniquely insightful creative acts, but of how to position oneself as an artist in relation to the pressing political realities governing society at large.

This progress away from a creative site which was interior to the individual artist concerned, towards one which cast the social world as both cause and proper location for creative work, started, in the case of sculpture,

with the 'totemic' works of David Smith. Smith was the first to empty out the internal volume and material density of the sculpted object conceived in the round, in favour of a form of construction which allowed, even celebrated, formal discontinuity. The fullest comprehension of the work required the reconciliation of opposing energies and forcefully different imaginal configurations. The effect of this change, in short, was to make the viewer an active participant in the construction of the work through a self-conscious act of reading. For the first time, the viewer was made present within the space of the work, not as a passive receiver of the traditional sculptural verities (a sense of wholeness emanating from within the form; material coherence being the play of symmetry and asymmetry; the gradually transforming and always surprising profile), but as a respondent, aware of the self, positioning in relation to the work, and the constructive play of his or her own thoughts. Smith had opened the door on a world in which the viewer was incorporated physically and implicated psychologically in the life of the work.

Nevertheless, as Rosalind Krauss argues in her essay 'Tanktotem; welded images', even though Smith had cleared the way for a new attitude to sculpture, he himself remained at root a classical 'modernist'.[10] His adherence to 'totemic' form – with all its hermeneutic referencing of the human figure – meant that the offer that he made, of an equalising play between the sculptural object and the viewer, was never to be fully consumated. Always, at a certain point of engagement, it was curtailed in favour of a powerful, even overpowering sense of 'otherness'. The physical space was transformed into a mythical one – an arena for subjective identification – in which the sculpture was translated into a surrogate human or superhuman presence.

However, Smith had once more raised the question – touched upon first of all in the analytical phase of cubist painting – of the relationship that obtained between the work of art as image and the work of art as material transaction and material form. He allowed himself to entertain the possibility, in other words, that the one aspect could exist independently of the other, or at least, that a separation might be effected between the two, which would allow much greater scope for formal invention and imaginative play. And while his predilection for the 'primitive' power of the solitary vertical, figural image was such as to prevent him from fully exploring this more 'open' territory for himself, his work served as a crucial speculative pointer for those who came later, amongst whom the most notable and influential was the British sculptor Anthony Caro.

Caro was quick to recognise that the separation David Smith had essayed, between the image and its material form, had cleared the way for a radical and far reaching reappraisal of the language of sculpture. On the one hand it offered the possibility of a more concrete – that is to say less referential – notationally abstract and syntactically precise, material form; and on the other, a less concrete, more ethereal image-quality, closer to the sublimity of painting. The issue was one of how to manage, or hold in play at one and the same time, two quite different intersecting modes of existence: the 'real' and the 'pictorial'; the extended spatial world of sculpture, with the flattened, illusionistic space of painting. Caro solved this by imposing a strong feeling of frontality that worked counter to the sculpture's disposition in real time and space. This duality demanded that the viewer's apprehension of the work shifted between its identity and its 'presence': it involved nothing less than a complete change of state of the kind referred to in Rosalind Krauss's description of the Caro work (now in the collection of the Tate Gallery), *Early One Morning* (1962): 'The axis along which one relates to the work as physical object is turned 90 degrees to the axis which establishes its meaning as image. The change from horizontal to vertical is expressed as a change of condition or being.'[11] Furthermore, this change of state within the object demanded a corresponding transformation in the mental disposition of the viewer: a knowing appreciation of two distinct and radically different principles of formal unity.

On one level, Caro's work of the 1960s answers the programmatic analysis of an aesthetic style compatible with the condition of modernity, sketched out by the American critic Clement Greenberg in his essay of 1949, 'Our Period Style'.[12] While recognising that the modern period 'presents a picture of discord, atomisation, disintegration and unprincipled eclecticism', Greenberg makes a plea for an art which is 'characterised by directness and consistency in the fitting of means to ends'; what he chooses to call 'rationalisation in the industrial sense', and an art which is free from 'illegitimate content – no religion or mysticism or political certainties'. It would seem that works such as *Early One Morning*, *Red Splash* (1965) and *Shore* (1968) are exemplary in both respects. But on another level, Caro's flight into 'pictorialism' represented a considered act of aesthetic entrenchment: an insistence upon 'art for art's sake'. It is by now a curious fact of postwar art history, that Caro and his immediate followers – Philip King and Tim Scott amongst others – having fully opened up the space of sculpture to the human presence by ridding it of its own very particular brand of illusionism, then strove to impose upon it the

spatial artifice of its sister art, painting. Having at last allowed the sculptural object to enter into the world of real things – to stand four-square as object amongst other objects, stripped of the magical, ritual and referential trappings which had been its burden since prehistoric times – the artists themselves, fearful of an absolute convergence between art and the real, of a kind that might render the art object indistinguishable from any other class of object, sought refuge and solace in the illusionistic language of pictorial space.

The answer to this riddle is to be found, in part at least, in the critical debate which came to surround the practice of sculpture as the 1960s progressed. The central question was one of boundaries. Does art define itself through the gradual evolution of its own peculiar rules of practice, or is it, necessarily, permeated by and therefore subject to factors derived from the social world.

The argument is best approached through the writings of Clement Greenberg, with particular reference to his notion of 'purity'; through the historical perspective provided by the British critic Adrian Stokes's discourse on 'handling'; through the New York-based critic Michael Fried's critique of Minimalism – his negative use of the term 'theatricality'; and by contrast, through the influential writings of the Italian philosopher and critic Umberto Eco – his important concept of the 'open' work.

THE FEAR OF DECORATION

In his book *Modernist Painting* (1965), Greenberg argues that for any 'formal social activity' to survive, it must be capable of generating firm and stable grounds and irrefutable criteria, sufficient to sustain an ongoing and aggressive process of self-criticism; and the purpose of this self-criticism is one of purification:

> The task of self-criticism became to eliminate from the effects of each art any and every effect that might conceivably be borrowed from or by the medium of any other art. Thereby each art would be rendered 'pure' and in its 'purity' find the guarantee of its standards of quality as well as its independence.

And elsewhere:

Having been denied by the Enlightenment all the tasks they could take seriously, they [the Arts] looked as though they were going to be assimilated to entertainment pure and simple, and entertainment itself looked as though it was going to be assimilated like religion, to therapy. The arts could save themselves from this levelling down only by demonstrating that the kind of experience they provided was valuable in its own right and not to be obtained from any other kind of activity. [13]

Purity for Greenberg, then, is closely bound-up with the question of value, and not, as the critic Stephen Melville has pointed out, merely with the question of whether works of art have value, but with the much more rounded question of whether art itself can retain its value in the face of a culture which threatens, always, to engulf and eventually submerge it. [14] In this context, the repeated marking out and patrolling of the boundaries which define a particular generic, aesthetic practice are as important to its continued existence as the reiteration of its central founding principles. What appears at first sight, then, to be a thoroughly defensive posture on Greenberg's part, is not entirely devoid of purpose. Even though it works with a fear of loss which is to a large extent illusory – it fails to recognise the importance of assimilation to the dynamic of cultural history – it is nevertheless an argument made on behalf of the well-being of art, and voices an anxiety which, in historical terms, seems to have been endemic to its several practices from the outset – the fear of 'decoration'.

THE DECLINE OF HANDICRAFT

The British critic Adrian Stokes, writing in *Stones of Rimini* (first published in 1935), makes what was then a fairly unexceptional claim, namely that the visual arts are rooted in handicrafts. [15]

At this point in his text, Stokes was engaged in making clear the distinction between two different forming processes, 'carving' and 'modelling'. Furthermore, he was attempting to show that the former was in certain important respects superior to the latter, in as far as it offered a more complete and challenging aesthetic experience. The sense of this assertion depends upon the qualitative judgement that he makes between what he calls 'plastic shape' on the one hand and 'carving shape' on the other.

Plastic shape, Stokes argues, is by its very nature abstract, whereas carving shape is always perceived 'as belonging to a particular substance', 'one recognises "fine carving" when one feels that not the figure, but the stone through the medium of the figure, has come to life.' By comparison, modelling allows for no such separation: the image is through and through the artist's conception. Clay has 'no "rights" of its own': it offers no resistance to the process of conceptualisation. For this reason, modelling, like handwriting, is essentially calligraphic. And he carries this argument further in a brief discussion of painting, finally concluding that only paintings 'in which the pigment is directed by some architectural conception of planes, is preferably classed with carving.'

Despite the fact that the subject of Stokes's address is quattrocento sculpture and architecture, and the relief carvings of Agostino di Duccio in particular, it is important to recognise that his critical insights and sensibility are quintessentially 'modern'; indeed we might even use the term 'modernist'. As a painter, Stokes had chosen Cézanne as his major influence. In his criticism too, he used Cézanne as a touchstone: he was the artist who, more than any other, had succeeded in carrying the achievements of Renaissance painters through into the modern movement. In Stokes's own words, taken from an essay on Cézanne written in 1947, it was Cézanne who managed 'to coalesce this revolutionary art [post-Impressionism] with the more important lessons that may be learnt from the masters.'[16] Nonetheless Stokes's commentary remains essentially a post-Cubist commentary, bringing together his own insights from the earlier *Stones of Rimini* and an analysis of pictorial construction which properly belongs to cubist painting. Elsewhere in the same essay, in trying to articulate the 'strangeness and shock' we experience in front of a late Cézanne landscape, Stokes writes:

> The painting will not be regarded as a conceptual painting' – in other words it is neither 'modelled' nor drawn in a conventional sense – 'neither is it concerned with mimesis, or with imitating the play of light, such as one finds in Monet.

Instead, Cézanne:

> needed to treat every part of every plane as minutely divided and differentiated and yet merging and coagulating like the advancing

and receding planes of a sphere... he wanted the volumes to take their place without belying the homogeneity of the picture surface, without hindrance to a mosaic of distance.

I have spent some little time detailing some of Stokes's more important critical constructs, because in many respects they provide a description of 'the modern' in painting and sculpture which is altogether more profound – because it is less reductive – than that provided by Clement Greenberg. Like Greenberg, Stokes starts from an antipathy towards the 'decorative', but where Greenberg found a solution in the closely related notions of 'formal purity' and 'emphatic flatness', Stokes searches for an antidote in the more immediate and intimate realm of material practice. Since the visual arts are for him 'rooted in handicrafts', they are at their most revealing when studied from the point of view of 'handling'. And it is through a close analysis of this topic that he is able to make some extremely telling modal distinctions; distinctions which, in their turn, serve to illuminate some of the more puzzling aspects of the development of modernism.

The underlying question for Stokes revolves around the role and functioning of drawing – an activity which he divides into two main categories: calligraphy and geometry. Calligraphy is seen as an attribute of plasticity, and while the plastic, in its abstract sense, is a part of both the carving and the modelling processes, in Stokes's scheme of things, it is most closely connected with the latter. Geometry, on the other hand, is seen as a property – maybe even a prerequisite – of carving: it is the architectonic aspect of carving shape. Calligraphy involves a contradiction which is without resolution. Like handwriting it is at one and the same time highly conventionalised, and thus demands a considerable degree of conceptualisation (for Stokes, this, by definition, always occurs before the act) and yet it must be evidenced through an immediate expressive involvement with the material. By comparison, 'geometry', because it permits a clear separation between construction and the surface treatment of forms, is free of this kind of contradiction. The two aspects of carved shape, the locating of edges, the fixing of boundaries – its geometry in other words and the working of the surface in relation to these limits, are brought together and reconciled, in painting by achieving an equal play of light across the picture plane, and in sculpture, when the substance carved becomes 'animated by the equal diffusion of light'. He examples this by reference to the separation he observes between the obsessive re-stating of drawn forms and the

'tegament' and treatment of surface texture in the paintings of Cézanne, and by reference to the distortions which occur in the sculptures of Agostino di Duccio, out of the need to flatten the forms against the light.

Stokes's modal distinctions offer some important lessons in relationship to the development of modernism. On the level of material practice, for instance, they go a long way towards explaining the conspicuous decline of modelling as a primary sculpture discipline. If the artist's task is seen as essentially a 'dialectical' one; that is, as the day-by-day working-out of certain contradictions which are inherent to the practice itself – between surface and spatial construction; between volume and flatness; between abstract schema and material evolution; between conception or preconception and realisation – then clay is at once too submissive a substance and too 'earthbound' to hold all of these several contradictions in play at one and the same time. This problematic is perhaps most vividly demonstrated in the serial bronze sculptures of Henri Matisse: in the five portrait heads of 'Jeanette', modelled between 1910 and 1913, and more especially in the series of 'Nu de Dos' ('The Back'), executed at widely spaced intervals between 1904 and 1929.[17] Both series of works bear testimony to a gradual translation of sculptural form which moves away from that which is characteristic of modelling – in Rosalind Krauss's words, 'the gouging and pinching, the minor editions and subtractions of material, the traces of thumb and hand as they worked the clay'[18] – and arrives at forms that are more typical of carving. The hand is less and less in evidence, and the fine, manual modulation of surface gives way to the slicing, cutting and incising of curved and flattened planes. The forms themselves are made more geometrically simple and therefore more concrete, belying the yielding friability of the stuff out of which they are made. In this respect, it is informative to compare the last of the 'Nu de Dos' series of 1929 with the stone sculptures of Constantin Brancusi, made between 1910 and 1916, in which the formalisation, although more extreme, is of a similar order. In the Brancusi sculptures no such conflict is apparent. Form and material act together; indeed, the one appears to be absolutely integral to the other.

But more importantly, Stokes's criticism provides a historical rationale for sculpture after Cubism to veer progressively towards the use of open structure and constructed form. There are major exceptions to this general tendency, of course (Alberto Giacometti and Henry Moore might both be cited, but even they are not entirely free of the apparent need to deconstruct the solid,

modelled form); nevertheless, overall the general drift is clear. It could well be described as a movement away from 'handling' in its most literal sense, towards methodologies which are at once more technical and more mechanical. There is, then, a curious paradox at the very heart of Stokes's writings on sculpture. Despite his insistence on the founding role of handicraft in the visual arts, the separation of geometry from the surface working of forms which he observes and admires so much in the late paintings of Cézanne would appear to be nothing less than the acknowledgement of the start of a gradual process of manual disassociation which reaches its apotheosis with Minimalism.

Both Stokes and Greenberg feared that the pursuit of decorative effects would disempower art in some way and it would no longer be capable of carrying the level of serious content observable in the work of the old masters. For Stokes, the resolution of this problem lay in the intimate engagement of hand and eye towards the piece-by-piece construction of the image, or reconstruction of the motif. Greenberg, on the other hand, adopted a more essentialist approach, arguing that each generic practice should be pared down to its most fundamental and unique characteristics.

Greenberg's argument is fleshed-out historically and given greater weight and precision in a series of essays by the art historian and critic Michael Fried, published collectively under the title *Absorption and Theatricality: Painting and Beholder in the Age of Diderot* (1980).[19] And one of Fried's main objectives here is to sound a cautionary note to the artists and critics of his own time.

THEATRE: THE ENEMY OF ART

By the mid 1960s, the critical focus in New York had shifted away from the generation of artists so strongly supported by Clement Greenberg, and towards a group of mostly younger artists, the Minimalists – Tony Smith, Robert Morris, Donald Judd, Sol LeWitt and Carl Andre.[20] These artists had continued with the task, begun by David Smith in the 'Cubi' sculptures made in the early 1960s, of evacuating extraneous content from the language of sculpture, but in their case this included the 'gestural' and pictorial' effects characteristic of the work of Caro and his followers. Their attack was directed, then, at the residual traces of 'handling' in the work: their project was nothing less than the elimination of all evidence of aesthetic process from the sculpture itself. In Fried's view, the anonymity that this more distanced

way of working brought to the sculptural object laid these artists open to the charge of 'theatricality'. They had surrendered some of sculpture's essential qualities, bringing it into close proximity with decor. I quote from his important essay 'Art and Objecthood':

> The concepts of quality and value – and to the extent that these are central to art, the concept of art itself – are meaningful, or wholly meaningful, only within the individual arts. What lies between the arts is theatre.[21]

Once again we are faced with a conceptual framework which links purity with value; but this time with the significant corollary that the enemy of both is theatre – a term which Fried allows from time to time to slip into the more general and contentious category of entertainment.

Now it is no simple matter to arrive at a clear idea of precisely what Fried means by 'theatre'. Clearly he sees it as a hybrid form, and one which uses key aspects of the other arts – dance, literature, music and the visual arts for the purpose of its own adornment, whilst at the same time preserving its own dramatic and oral traditions intact. In other words, theatre has the ability to elide or even to colonise the other arts without in any way putting itself at risk. But this is altogether too general an account of Fried's position to be of much use to us here. It is important to bear in mind that his critical attack, in the first instance, was directed at the Minimalist sculptors Morris and Judd, accusing them of surrendering 'presentness and instantaneousness' in favour of a sculptural experience which unfolded in time. This he connected with the overbearing scale of the works and the rhetoric of repetition they employed, thereby 'theatricalising' the space and rendering the work's relation to the viewer unclear. Fried casts this change in the nature of sculpture's address to the viewer in moral terms: Minimalist sculpture had given over its essential self and could no longer function as an exemplar of ineluctable values; it had 'lost' itself and in doing so could no longer lay claim to being a model of rightness and so continue to speak on behalf of the good of art.

To grasp fully Fried's position, we must understand more completely the distinction that he seems to make between what, for the sake of argument, we will call 'normal time', meaning the unreflected-upon passage of time in which we exist and experience everyday events – the illusory version of which is the proper condition of theatre – and 'present time', experienced as a

compression rather than a continuum. This latter, for Fried, is the condition to which 'real' sculpture aspires, and the nature of the experience which 'real' sculpture seeks to invoke:

> It is this continuous and entire presentness, amounting, as it were, to the perpetual creation of itself, that one experiences as a kind of instantaneousness; as though if only one were infinitely more acute, a single infinitely brief instant would be long enough to see everything, to experience the work in all its depth and fullness, to be forever convinced by it.[22]

It is on this basis, because they compress the experience of the work into a transcendental moment, that Fried places the works of Caro and Smith above those of Morris and Judd in the rankings of sculptural excellence.

Fried, like his teacher and philosophical mentor Clement Greenberg, developed his critical position along distinctly Kantian lines. It follows, then, that to understand his resistance to the inclusion of art in general and of sculpture in particular, within a wholly contingent reality – the world of our everyday experience or what Kant calls the 'phenomenal' world – such resistance must be viewed in the light of the general distinction Kant makes between the 'phenomenal' and the 'noumenal'.[23]

The phenomenal world, Kant argues, is nothing more nor less than the world 'as it appears to us', and is constituted out of the forms that our intuition takes and the categories we devise for the understanding of it. The noumenal world, on the other hand, is the world and its objects as they exist 'independently of our mind's grasp', and the structuring of our intuitions in knowledge. Consequent upon this splitting of the world is a corresponding division of the self. As selves, like all other things in the world, we are both phenomenal and noumenal, so that the self participates in both worlds. The phenomenal world, including the phenomenal side of the self, is subject to the iron rule of physical causality, leaving the possibility of human freedom as an open question only in the noumenal realm. It is this openness which permits the bringing together of notions of aesthetic freedom and morality such as we have remarked upon in Fried's commentary on Minimalism. For Kant, art, like morality, demands freedom of action as a basis for moral responsibility. The aesthetic, then, is part and parcel of the several complexions of freedom, characteristic of

noumenal selves. Given this particular critical background, Fried's construction of 'presentness' and 'instantaneousness', in as far as it represents some kind of rupture in the temporal continuum of the everyday, phenomenal world, suddenly takes on the appearance of a slippage which allows us a glimpse through the endless curtain of the phenomenal into the more open noumenal realm beyond. Thus, to experience a work of art 'in all its depth and fullness' means nothing less than to experience the possibility of a 'real' freedom of action outside the restrictive bonds and seamless web of the causality that defines 'normal' existence.

As T.J. Clark has pointed out, there is something fundamentally regressive in Fried's espousal of Kant's dualism, which shows itself in a concern to preserve 'a certain myth of the aesthetic consciousness, one where a transcendental ego is given something appropriate to contemplate in a situation essentially detached from the pressures and deformities of history.'[24] In this respect, Clark argues, in as far as Fried situates the aesthetic experience in a place which is either removed from or elevated above contingent reality, his account of it is indelibly marked by bourgeois notions of consciousness and freedom: 'The interest [in art] is considerable because the class in question [the bourgeoisie] has few other areas (since the decline of the sacred) in which its account of consciousness and freedom can be at all compellingly phrased.'[25]

On a less political note, it would be reasonable to argue that the locus of Fried's version of aesthetic contemplation – this inwardly inflected, more or less private revelation of the noumenal – is at odds with the broad drift of modernist culture as it unfolded in the postwar period. Perhaps it was deliberately so. Certainly it is tainted by a desire to escape from, or to resist, those aspects of modernity which embrace dislocation, disjunction, doubt and uncertainty as their meat and drink. Ultimately, as Fried concedes, the question is how works of art gather to themselves their audience, how they come to build their constituency of interest. This would suggest that the work of art cannot stand altogether apart from the temper and character of the culture of which it is a part. As Stephen Melville says, there can be no true account of modern painting which does not take full cognisance of 'its violations and excesses – performance work in particular'.[26] By the same token, there can be no account of modern sculpture that does not recognise the collapse of its generic disciplines – carving, modelling and construction – and the movement away from the 'prioritising of perception';[27] sculpture's

romance with the machine aesthetic, technology and the media; the challenge to its very life posed first of all by the 'readymade', and afterwards by the 'happening' and the preformed cultural artefact.

In this respect, Fried's historical view emerges as a highly selective one. It takes no account, for instance, of the tradition of the 'counter-culture' inaugurated by Dada and Surrealism. It chooses to ignore the influence of important postwar movements, groups and tendencies, in America and Europe, which had already opened up the visual arts to forms of practice intended to subvert the 'objective' of the singular masterpiece and the kind of monumentality of which Fried speaks. Often these new formulations were time-based, ephemeral, hybridised or transient. Reading Fried today, one might be forgiven for concluding, for instance, that movements such as Pop art, New Realism, the Zero Group, Fluxus and Destructive and Auto-Destructive art, had never actually occurred. Indeed, with the benefit of hindsight, Fried's highly prescriptive writings look more and more like a futile attempt to stem a flood of change which, in reality, had already engulfed him. By 1967, when 'Art and Objecthood' appeared in bookshops and newsstands on both sides of the Atlantic, the 'pure-bred' aesthetic horse had long since fled the cultural stable. Even on his own doorstep, the formalist aesthetic he espoused had been overtaken by a new and much more inclusive attitude to the sculptural object and the range of possible experiences it might offer to artist and viewer alike. Pop artists Jim Dine and Claes Oldenburg had shown the way. Their pioneering work in the area of 'environments', and in Oldenburg's case, 'performance', film and video, had cleared the ground for artists such as Robert Morris, Dan Flavin, Richard Serra and Bruce Nauman to initiate an in-depth exploration of 'placement' as a form of mediation between the factured object and architectural space; for Allan Kaprow's and Vito Acconci's 'happenings' and 'event structures'; for Jasper Johns's and Andy Warhol's simulated objects. By 1967, the definition of the sculptural object had already been expanded to include photographs and film, video and performance work, propositions and declarations, informal scatterings, imaginary sites and specified geographical locations, maps, books and audio-discs.

Both Greenberg and Fried start from the proposition that the modern experience of the world is characterised by uncertainty, disorder and chaotic change, and that faced with this confusion, the purpose of art is to manifest orderliness. In his later writings, especially in his public correspondence with T.J. Clark carried on through the pages of the magazine

Critical Inquiry, Fried repeatedly denies that this separation amounts to the arid formalism of which he often stands accused. Nevertheless, the undertow of reaction is unmistakable. If the purpose of art is to stand aloof from the conditions which prevail in the world at large, it must also, to a degree at least, deny social, political and historical context. If it is to put its capacity to endure before all else, it is hard for it to escape the accusation of disconnectedness. Furthermore, a close reading of his replies to Clark shows that despite all Fried's protestations, the distinction that he draws between serious art and trivial art privileges the past over the present; disengagement from rather than involvement with the temper of the time. Here is his riposte to T.J. Clark's accusation that the codes of modernist, abstract painting 'lack the constraints of social connectedness':[28]

> Does he [Clark] simply dismiss the insistence by Greenberg and others on the need to distinguish between the large mass of ostensibly difficult and advanced but in fact routine and meretricious work – the product, according to those critics, of an ingratiating and empty avant-gardism – and the far smaller and less obviously extreme body of work that really matters, that can survive comparison with what at that juncture they take to be the significant art of the past?[29]

Thus we can see clearly that underlying Fried's critical assault on the Minimalists is an idea of continuity with the past, at least on the level of values. As well as introducing 'theatricality' into sculpture, Minimalism is an art built upon negation; an extreme point in the relentless progress of vanguardism's rhetoric of nihilism. It cuts across what Fried construes as the deepest impulse of mainstream modernism (in sculpture this means Smith and Caro) not to 'break with the pre-modernist past but rather to attempt to equal its highest achievements, under new and difficult conditions', with the deck stacked, as he puts it 'against the likelihood of success'. Given this scenario the artist is cast in the archetypal role of tragic hero, driven to fight a more or less doomed rear-guard action against the forces of scepticism and disbelief. It is interesting to compare this bleak view of the condition of art in the second half of the 1960s with that of the influential Italian philosopher and critic Umberto Eco.

Eco too, sees the modern world as 'unstable, crisis-ridden, senseless and disorderly', but as a social philosopher and cultural critic, he is concerned to place the emphasis on positive human qualities: on awareness, involvement and the recognition of the redemptive power of change. For this reason his conclusions about the condition of modern culture are entirely opposite to those of Greenberg and Fried. Where they are largely pessimistic and defensive, Eco is unfailingly optimistic and progressive. It comes as something of a shock, therefore, to discover that his revolutionary work, *Opera aperta (The Open Work)*, in which he attempts the first interdisciplinary, critical and theoretical analysis of modern culture and its impact upon aesthetic practice, was first published in Italy in 1962, thus pre-dating Fried's 'Art and Objecthood' by some five years.

Opera aperta starts by accepting 'complexity' as a precondition of any 'contemporary' cultural endeavour. According to Eco, information – in its broadest sense – is the lifeblood of the modern society: it powers the engine of change; combats 'conformism, unidirectionism and mass thinking', it prevents 'the passive acquisition of standards', it serves to question 'right form' in ethics, politics and matters of taste. Art is a part of the same machinery of transgression. By constantly frustrating its own rules and conventions; by courting diversity; by dwelling in ambiguity; by refusing to exercise closure; by continually frustrating normative expectations, it serves to expand and accelerate the flow of information in favour of new codes and new patterns of behaviour. 'How often', Eco asks, 'have new creative modes changed the meaning of form, people's aesthetic expectations, and the very way in which humans perceive reality?' and he continues:

> Here is a culture [the culture of fine art] that, confronting the universe of perceivable forms and interpretive operations, allows for the complementarity of different studies and different solutions; here is a culture that upholds the value of discontinuity against that of a more conventional continuity; here is a culture that allows for different methods of research not because they might come up with identical results but because they contradict and complement each other in a dialectic opposition that will generate new perspectives and a greater quantity of information.[30]

To grasp fully Eco's theory of 'openness' it is necessary to reach some understanding of the linkage that he makes between 'formal innovation', 'ambiguity' and 'information'. We shall start with 'ambiguity' since it is this which, for Eco, distinguishes the 'modern' work of art from all that went before.

Traditional or classical works of art, Eco argues, are in an essential sense unambiguous. They worked always with a preferred reading, and while they were open to misreading or misunderstanding, there was generally only one correct way in which they were meant to be read or understood. By contrast, the work of modern art, he argues, 'is deliberately and systematically ambiguous'; a great variety of potential readings coexist within it, and none can truly be said to be dominant. Ambiguity is generated out of formal innovation and increases proportionately with the breaking of established conventions. As David Robey puts it in his excellent introduction to the 1989 revised edition: for Eco,

> conventional forms of expression convey conventional meanings, are part of a conventional view of the world... the less conventional forms of expression are, the more scope they allow for interpretation and the more ambiguous they can be said to be; since ordinary rules of expression no longer apply, the scope for interpretation becomes enormous.

Traditional works of art confirm existing attitudes, stabilise cultural prejudices, institutionalise existing patterns of knowledge, and ground existing opinions. The modern work of art, the 'open' work of art, on the other hand, puts all of these things in question by means of ambiguity. This represents a radical change in the relationship between art and the public at large; between the work of art and the viewer. More than this, it places art at the very centre of what Eco calls the 'modern questioning culture'. In its new-found openness, Eco argues, art has become invested with the power to 'go well beyond questions of taste and aesthetic structures, to inscribe itself into a much larger context'; in his view it might even come to 'represent man's path to salvation, towards the reconquest of his lost autonomy at the level of both perception and intelligence.'[31]

We must now turn our attention to the link that Eco makes between formal innovation, ambiguity and his theory of information. Already, by the time Eco was engaged in writing *Opera aperta*, he was beginning to lay the

ground for his later work in linguistics and semiotics.[32] At this early stage this took the form of a fascination with the then fashionable subject of 'information theory', most particularly the mathematics-based theories of Max Planck and the linguistic theories of Roman Jakobson. This interest came to focus around the formula, traceable to Jakobson, that 'the information of a message is in inverse proportion to its probability or predictability' – the more unpredictable a source of information is, the more information it generates.[33] It is important to recognise here that Eco makes an absolute distinction between 'meaning' and 'information'. For him, meaning is something more or less fixed, and where it exists in a strong sense, tends to work against the efficacious functioning of information. By contrast, information is characterised as an expanding field: 'it is an additive quantity, it is something added to what one already knows as if it were an original acquisition.'[34]

Information, then, is the natural and necessary offspring of the unfamiliar. Furthermore, because it is liberated from, rather than embedded in its source, it is non-confirming – it works against finishedness, completeness or textual closure – and in this respect acts, in the strictest sense, as an opening up.

Even from this very brief description of Eco's interest in 'information theory', it is easy to see how his notion of information ties in with a theory of art based in formal innovations and ambiguity. Formal innovation means the continuous generation of new and unfamiliar patterns, configurations and codes, and these in their turn serve to expand the quantity of available information like ectoplasm around a nucleus. Given this model, the work of art operates at the centre of what Eco calls a 'field of possibilities' and offers up 'a plurality of possible readings', and he examples this by reference to developments in modern physics:

> The notion of 'field' is provided by physics and implies a revised vision of the 'classic' relationship posited between cause and effect as a rigid, one-directional system: now a complex interplay of motive forces is envisaged, a configuration of possible events, a complete dynamism of structure.[35]

And this dynamic 'field' of forces interlocks and reacts with 'a continuously altering and sensible subject' – the viewer – displacing the traditional dualism between subject and object.

As befits a synthesiser and a polymath of Eco's intellectual standing, his theory of openness draws upon a wide range of disciplines, philosophical concepts and theoretical topics current at the time. His notion of a 'reactive subject', dependent upon external stimulus as a confirmation of existence, is clearly drawn from the 'existentialism' of Jean-Paul Sartre. We can recognise (as Eco does himself) a profound debt to the phenomenologists Edmund Husserl and Maurice Merleau-Ponty, in his insistence upon 'open reading' and his theory of 'incompleteness': his refusal, in other words, to accept 'closure'. The link that he makes between 'information theory' and perception was essayed first of all by Roman Jakobson and afterwards, more cogently, by Jean Piaget and his circle, and his forays into psychoanalytical theory owe much to the early writings of Lacan. Nevertheless, *Opera aperta*, at the time of its publication, represented a significant step forward in the developing discourse of art criticism and cultural theory. Certainly it sprang from a close engagement with the most advanced manifestations in art, music and literature available for critical scrutiny at that time. More than this, as a political activist (political in its broadest sense) he was also concerned with the promulgation of his critical ideas at the level of practice.

As a founder member – with Nani Balestrini, Edoardo Sanguineto, Antonio Porta and others – of the *Gruppo 63*,[36] he set about trying to establish grounds for a renewal of the spirit of Italian vanguardism. The declared purpose of the group was 'to blow up the invisible structures of the "tiny clique" which governed cultural affairs' and to reveal 'culture as political act'. As Eco himself puts it in his essay of 1970, 'The Death of the *Gruppo 63*':

> We had to call into question the grand system by means of a critique of the superstructural dimension... Hence we decided to set up a debate about language. We became convinced that to renew forms of communication and destroy established methods would be an effective and far-reaching platform for criticising – that is overturning – everything that those cultural forms expressed.[37]

Despite the revolutionary rhetoric, which has a more than familiar stridency to it, the avant-gardism of the *Gruppo 63* is curious in two very important respects. Firstly, it was an avant-gardism of the already established, rather than of the dis-established. Eco, Sanguineto and the rest of the group were already successful poets, writers and academics, and they started from the

proposition that the precondition for subversion in a highly complex modern culture was that you were already a part of the value-forming machinery of that culture. Subversion could only be achieved from within, not from outside. Secondly, in the aesthetic domain, avant-gardism necessitated an acceptance of the existing organs of cultural promotion and distributions: the theatres and opera houses; literary magazines and music publishing houses; the gallery system and museums; publishers, newspapers and the media. The poet and polemicist Sanguineto expressed this in terms of a revolutionary 'rite of passage', arguing that the purpose was 'to turn the avant-garde into an art of museums', and that the new avant-garde would plunge themselves 'into the labyrinth of formalism and irrationality, into the *"palus putredinis"* of anarchy and alienation with the hope of really escaping from it, perhaps with dirty hands, but certainly with the mud left safely behind us.' The vision of the vanguardist revolution espoused by *Gruppo 63*, then, was of a revolution which took place from within the confines of specialist discourses. Its purpose was to put those discourses into a more or less permanent state of internal transformation. In the case of the visual arts, this posited a new and more interventionist role for the museum: making it the proper site for the most extreme manifestations of the avant-garde impulse.

 With all of Eco's early writings it is difficult to make a clear distinction between original, speculative thought and closely observed cultural commentary. Certainly by the time *Gruppo 63* was formed, some of the changes pointed up by their new avant-gardism had already begun to take place. The growth of the new critical disciplines in the social and political sciences, in the universities of North America, Britain, France, Germany and Italy, had produced a new generation of politically educated young people from the ranks of the affluent middle classes. Thus it was that when the student revolutions of 1968 started, it was the university departments of sociology, social anthropology, political economics and political science which led the way, reversing the classic Marxian narrative of the proletarian uprising. This was a revolution engineered by the bourgeoisie and staffed by the bourgeoisie. Its revolutionary discourse was powered by the new academia. It was a revolution bent on exorcising the newly awakened conscience of a class which had come to see war and social disadvantage as a devastating indictment of its own political philosophy and political institutions. In this respect, the project of *Gruppo 63* had been overwhelmed by events. As Eco himself relates in 'The Death of the *Gruppo 63*', the clarity of a revolutionary scenario based upon the idea of giving a voice to the oppressed – summed up

in Lacan's famous question, 'Who is to speak?' – had been transformed into questioning of a more distanced kind: 'Who is one speaking to?'; 'How is one to do it?'; 'Why?'; 'Should one go on speaking at all?'.

The transformation in the culture of the visual arts, although less obviously dramatic, more or less paralleled developments in the political domain. The middle and late 1960s constituted a period of great turbulence and change. Already by 1965, the museums had begun to open their doors to young, living, avant-garde artists. New kinds of exhibition space had opened up – converted warehouses, old garages and disused factories – operating outside the confines and financial constraints of the art market. First the Minimalist and then the Conceptual artists had set about testing the capacity of the traditional commercial gallery to deal with the 'unsellable' work of art. The sculptural object had been massively increased in size, dissolved altogether, reconstituted as process, as event, as direct intervention in landscape. Installation and site specific work had brought the sculptural project into more complex relationship with architecture and landscape, as well as with the existing institutions of promotion and patronage.

On the theoretical front, the critical arguments surrounding the practices of painting and sculpture had been subsumed, incorporated into the wider cultural debate inaugurated by Structuralism and the New Linguistics. The question of value – of art's enduring value in the terms in which it had been couched first by Clement Greenberg and afterwards by Michael Fried (namely that painting and sculpture possessed unqualified, intrinsic merit as distinctive aesthetic practices, precisely because they were 'univocal' and spoke only in the dumb language of their own immutable 'presentness'), seems unsustainable when subjected to the searching general critique of Structuralism. If we take the generic practices of art to be languages of some kind, subject to the same rules of interpretation that govern language in general – the complex interplay of codes, schemata and mechanisms of selection – then it follows that topics such as 'purity', 'instantaneousness' and 'presentness' in the Friedian sense are reduced to something approaching wish fantasy.

But this complex question should not be left here. As the Structuralist Claude Lévi-Strauss argues in his '*Ouverture*' to his classic work *The Raw and the Cooked* (1971),[38] to define the various practices of art as language presents important theoretical difficulties. Works of visual art, Lévi-Strauss argues, are 'grasped in the first place through aesthetic

perception and secondly through intellectual perception, whereas with speech the opposite is the case.' This reversal in the normal perceptual order by which language is understood – giving primacy of the perceptual over the intellectual – would seem to offer some scope for the kind of experience Fried, at least, is arguing for, although not, perhaps, in the transcendent terms in which he argues it. Be that as it may; more germane to the discussion here is the debate that Structuralism inaugurated around the question of 'seriality', which brought Umberto Eco into direct dispute with Claude Lévi-Strauss. A rehearsal of the argument brings us full circle to the 'one thing after another' theory of forming, espoused by Donald Judd and Frank Stella in their interview with Bruce Glasser.

'Structural thought', Eco argues, is an attempt to adduce 'eternal structural principles' out of the complex interaction of the whole diversity of existing language forms, 'the deepest generative structures underlying all grammar, and all negation of grammar, as well as every selective system'. In this respect its ambition is to provide 'deep' explanations for existing states of affairs. 'Serial thought', on the other hand, 'is an activity that involves the production of forms.' He continues:

> Permanent structures may well underlie all modes of communication, but the aim of a serial technique (technique rather than thought – a technique that may imply a vision of the world, without being itself a philosophy) is the construction of new structural realities and not the discovery of eternal structural principles. [39]

The weakness of Structuralism in relationship to aesthetic operations, then, for Eco lies in the fact that it is a theoretical model which pretends to deal not only with forms as they are, but also with formations which have yet to occur. His criticism is that such a model may, in the end, lack sufficiency.

The importance of Eco's observations regarding Structuralism to our understanding of the developments which occurred in the visual arts in the late 1960s and early 1970s cannot be overstated. Indeed, the change of outlook which took place as Minimalism shaded almost imperceptibly into post-Minimalism and Arte Povera could perhaps best be characterised as a change, of the kind Eco is pointing to: a movement away from 'thought' – the deployment of some kind of structured, holistic principle of forming – towards 'technique' – ways of dealing with things which were non-predictive. Such a rationale would

also serve to explain why, in the wake of Abstract Expressionism, the focus of aesthetic practice moved so dramatically in favour of sculpture as the predominant fine art practice. It was sculpture that appeared to give the greatest scope for innovatory 'techniques' – I use the term as Eco intends it, to mean strategies rather than methods. It was sculpture that permitted new kinds of operations and new ways of structuring the relationship between the work of art and the viewer. Where the capacity of painting to invent new strategies of forming seemed to have exhausted itself, sculpture presented the practitioner with a seemingly endless horizon of new possibilities.

The degree to which Eco's writings influenced the work of the post-Minimalists and Arte Povera directly is hard to say. We have no means of knowing which artists had read or were aware of *Opera aperta*, for instance, or his classic riposte to Claude Lévi-Strauss, *La Struttura assente*[40] (*The Rise of Structure*), published in 1968, the year the students occupied the University of Turin. Certainly Eco's writings provide the most vivid, informed and precisely weighted account of a critical moment of transition in terms of the history of modern culture.

The affluence of the postwar period in the countries of the west had allowed the rapid expansion of the education system to encompass a wide cross-section of class interests. Even so, this egalitarianism had only reached so far, exposing at the same time the deep-rooted societal rigidities which sustained urban poverty, social disadvantage and racial prejudice. The Vietnam War had brought to the surface questions pertaining to western imperialism and democratic freedom, which in America led to a prolonged confrontation between the people and the hierarchical structures and institutions of government; and in the countries of western Europe, to a ground swell of anti-American feeling amongst the students and the new intelligentsia. All of these issues were brought into sharp focus by the student uprisings of 1968. But beneath the frenetic surface of events a far more fundamental confrontation was taking place. The issue, in the political sense, was one of power. Where, in the emergent technological society, did power reside? How was it to be deployed and on whose behalf? And in the ethical domain, whose values were to prevail, those of the political and professional 'elites' who dominated the formations and instruments of the state, or those of the broad mass of ordinary people? In short, the events of 1968 represented a new kind of class struggle along 'Gramscian' lines,[41] a struggle between a newly politicised, critical intelligentsia and the established interests of the several 'hegemonies' – to use Gramsci's term – that constituted modern

government: politics, economics, law, education and religion. This was a revolution which despised Soviet-style state socialism as much as it distrusted rampant capitalism. Rather than Karl Marx and Vladimir Ilyich Lenin, it took G.W.F. Hegel and Antonio Gramsci as its theoretical progenitors, placing the revolutionary emphasis on action rather than a thoroughly worked out ideology expressed in words. For this reason it lionised Mao Tse-Tung, Che Guevara and Fidel Castro. It sought an ideal, participatory, socialist democracy, possessed of 'moral direction' and built upon the Gramscian principle of polycentralism – diversifying the instruments of decision-making to encompass people from all walks of life. It also represented an important theoretical change of direction for the culture of the left: shifting the attention from base to superstructure; from the economic foundations of the society to its cultural configurations; from an obsessive concern with structural questions to an interest in 'organic' evolution; and from the modes of production to the means of communication. Most importantly, it envisaged a truly liberal socialism, which could embrace the aesthetic of 'modernity' as a valid cultural project as well as the politics of the factory and the field.

The historical development that preceded this important revolutionary moment coincided almost exactly with the rise to prominence of the neo-Minimalist artists in America: the generation of Eva Hesse, Robert Morris, Bruce Nauman, Richard Serra, Robert Smithson and Keith Sonnier; with the emergence of Arte Povera in Italy: Giovanni Anselmo, Luciano Fabro, Jannis Kounellis, Mario Merz, Giulio Paolini, Giuseppe Penone, Michelangelo Pistoletto and Gilberto Zorio; and with a new generation of artists in northern Europe: amongst them Barry Flanagan and Richard Long in Britain; Marcel Broodthaers and Panamarenko in Belgium; and Joseph Beuys and Reiner Ruthenbeck in Germany. In stark contrast to the Minimalists, these artists saw themselves, in the first instance, as part of a distinctive international tendency, showing together in exhibitions on both sides of the Atlantic. By the middle of the 1960s, however, this initial spirit of unity had begun to break down. In part this was connected with the increasing power of the New York gallery system, which, supported by the immense purchasing capacity of America's museums and private collectors, had come to dominate not just the American art market but the European art market too. As the American critic Dan Cameron has documented, when Robert Rauschenberg carried off the first prize at the Venice Biennale of 1964, 'it was as if someone had challenged Europe's honour directly'; more importantly, it provided the Italian critic Germano Celant, with the

opening he needed to launch Arte Povera as a specifically Italian phenomenon. Significantly, Cameron argues, Celant's text of 1968, in which he uses the term 'Arte Povera' for the first time, is subtitled 'Notes for a Guerrilla War', and while Celant does not refer to America by name, the idea of poverty is intended as a rebuff to the money-led, propagandistic and competitive aspects of the American art market.

But to dwell too much on the internal politics of the art world is to concentrate on the symptom rather than the disease itself. Anti-American feeling had been increasing in the countries of western Europe from 1962 onwards, and when in 1964 the American Congress passed The Gulf of Tonkin Resolutions, committing America to direct military involvement in the Vietnam War, thus ensuring a substantial escalation of the conflict, what had existed as an undercurrent of protest surfaced as a widespread and highly vocal opposition led by students and intellectuals. America's image as the protector of liberal, democratic ideals was suddenly eclipsed by a vision of her as a rampaging imperialistic power, bent upon the military subjection of a small and economically backward Asian country. In this respect the fragmentation which occurred in what, for the sake of argument, we will call the international post-Minimal tendency, was only a reflection of a much deeper malaise: a breaking up of the political and cultural consensus binding together the western democracies. Viewed in this light, Germano Celant's 'declaration of Italian independence' was clearly grounded in a politics of protest which reached far beyond the confines of the art world. Nevertheless, there remains something chimerical about Celant's protestations of independence. In as far as he was seeking to align the aesthetic avant-garde with the political avant-garde occupying the universities of Milan, Turin and Rome, he was also, by implication, aligning it with the anti-war demonstrations that were sweeping the campuses of America's universities: Berkeley, Ann Arbor, Wisconsin and Kent State.

Today it is against art-historical fashion to view post-Minimalism as a tendency, and Arte Povera in particular as representative of a crucial revolutionary moment – even of the last possible revolutionary moment. And yet, if we address the literature that attended these movements, the feeling that emerges most strongly is that of a vanguardism of the kind that was advocated by Eco and the rest in the *Gruppo 63*: a vanguard of 'insiders', bent upon revolutionising the very institutions of which they were already an accepted part. The idea of 'poverty' as described by Celant is clear in this respect. In his 'Arte Povera: Notes for a Guerrilla War' he says this is 'a "poor" inquiry that aims at

achieving an identity between man and action, between man and behaviour'[42] (a formulation which finds a neat equivalent in Rosalind Krauss's description of the work of Eva Hesse and Richard Serra as a sculpture 'of activity and effect'),[43] and this makes no sense except when viewed from within the confines of an already elaborated, specialist discourse. In fact, Celant himself is quite explicit on this point, declaring that this 'poor inquiry' does not seek 'dialogue with the system of society or that of culture.' It would seem then, that 'poverty' is defined in opposition to an 'affluence' which Celant perceives as already characteristic of the formations and procedures of art itself.

On a superficial level it would be easy to construe the change from 'affluence' to 'poverty' in strictly technical and material terms: as the rejection of sophisticated ways of forming things in favour of simple processes and structural directness. But it is perfectly clear that Celant means more than this and the clue to this surplus is to be found in his use of the term 'essential information'. 'Poor' art, Celant argues, 'prefers essential information'; it is an art, in other words, which is stripped of superfluous meanings. It addresses the viewer on its own terms, without the obfuscations and mediations of existing interpretive structures. Thus the 'poor' work of art is a 'transparent' work of art; it hides nothing, it carries nothing within its interior space least of all the psychological trappings or biography of its maker. 'Poverty' is revolutionary, then, because it represents a clear shifting of the locus of authority, away from the artist to an authority of interpretation invested in and by the viewer, through their direct engagement with the work of art.

Thus it is that the process of 'empowerment' which began with David Smith emptying out the solid sculptural form and using formal dislocation as a way of encouraging the act of reading, reaches its conclusion with post-Minimalism and Arte Povera. 'Poverty' had finally turned the viewer into the one who 'acts'.

POSTSCRIPT

The making of this exhibition and catalogue has meant revisiting the most formative years of my own development as an artist and as a thinker about art. Such a journey necessarily involves the indulgence of sentiment as well as hard critical thought. The title of the exhibition, *Gravity and Grace – The Changing Condition of Sculpture, 1965–1975*, is indicative of both. Firstly, on an anecdotal level, I remember sitting in the common room of Goldsmiths College, when in

came Yehuda Safran. He walked straight up and threw a paperback down on the table in front of me, declaring, 'If you want to understand sculpture, read this.' It was Simone Weil's posthumously published writings, *Gravity and Grace*. And I shall be forever grateful for that moment, since reading Simone Weil taught me, as Yehuda Safran intended, that there was more to sculpture than meets the eye – or more importantly, than meets the ground. Secondly, more publicly, I remember visiting the exhibition *The Condition of Sculpture* at the Hayward Gallery in 1975, a show curated by William Tucker. As I walked round, I recall getting more and more angry that so many of my favourite artists were not included. Now, with the benefit of hindsight, I can better appreciate exactly what he was about. I still believe, however, that his position was unnecessarily astringent, and did not properly represent a time of great diversity and change. I hope this exhibition will serve to redress the balance.

Gravity and Grace: The Changing Condition of Sculpture 1965–75, exhibition catalogue, Southbank Centre, London, 1993, pp.11–33.

1 Rosalind E. Krauss, *Passages in Modern Sculpture*, New York, 1977.
2 Lucy R. Lippard (ed.), [*Art News*, no.5, September 1966].
3 See *Joseph Beuys in Düsseldorf*, Punt de Consluencia, Barcelona, 1988.
4 See P. Gilardi, catalogue foreword, *Op Losse Schroeven*, Stedelijk Museum, Amsterdam, 1969.
5 See G. Celant, *Arte Povera*, Milan, 1969.
6 See Barbara Rose (ed.), 'Readings in American Art', *Painting in America since 1900*, New York, 1968.
7 See Max Kozloff, 'American Painting During the Cold War' (1975), in Francis Frascina (ed.), *Pollock and After: The Critical Detail*, New York, 1985.
8 Harold Rosenberg, 'The American action painters', *Art News*, December 1952.
9 Kozloff, 'American Painting During the Cold War', see note 7.
10 Krauss, *Passages in Modern Sculpture*, see note 1.
11 Krauss, *Passages in Modern Sculpture*, see note 1.
12 Clement Greenberg, in *Partisan Review*, 1949. See Clement Greenberg, *The Collected Essays and Criticism*, Vol. 2, *Arrogant Purpose 1945–1949*, Chicago, 1986.
13 Clement Greenberg, *Modernist Painting*, 1965. See Frascina (ed.), *Pollock and After*, see note 7.
14 Stephen W Melville, *Philosophy Beside Itself: On Deconstruction and Modernism*, Minnesota, 1986.
15 Adrian Stokes, *Stones of Rimini*, (1935); Part II: 'Stones and Clay'. See Lawrence Gowing (ed.), *The Critical Writings of Adrian Stokes*, London, 1978.
16 Adrian Stokes, 'Cézanne', 1947, in Gowing (ed.), *The Critical Writings of Adrian Stokes*, see note 15.
17 One complete set of the 'Nu de Dos' is in the permanent collection of the Tate Gallery.
18 Krauss, 'Narrative Time', *Passages in Modern Sculpture*, see note 1.
19 Michael Fried, *Absorption and Theatricality: Painting and Beholder in the Age of Diderot*, California, 1980. The most pertinent essay, 'Art and Objecthood', was first published in

Artforum, vol. V, in 1967.

20 It is usual to list Richard Serra amongst the Minimalists, but the way in which he uses material to evoke a strong sense of 'bodiliness' in the viewer would seem to set him apart from the other artists listed.

21 Michael Fried, 'Art and Objecthood', *Artforum*, vol. V, 1967. See note 19.

22 Fried, 'Art and Objecthood', see note 19.

23 Immanuel Kant, *Critique of Pure Reason*, (2nd edn.), London, 1933.

24 T.J. Clark, 'Arguments about Modernism: A Reply to Michael Fried', in *The Politics of Interpretation*, Chicago, 1983.

25 Clark, 'Arguments about Modernism', see note 24.

26 Melville, *Philosophy Beside Itself*, see note 14.

27 Clark, 'Arguments about Modernism', see note 24.

28 T.J. Clark, 'Clement Greenberg's Theory of Art', *Critical Inquiry*, vol. 4, 1982.

29 Michael Fried, 'How Modernism Works: A Response to T.J. Clark', *Critical Inquiry*, vol. 9, 1982.

30 Umberto Eco, 'Openness, Information, Communication', in David Robey (ed.), *The Open Work*, London, 1989.

31 Eco, 'Openness, Information, Communication', see note 30.

32 Eco's first book on semiotics, *A Theory of Semiotics*, was published in 1976.

33 See Introduction, Robey (ed.) *The Open Work*, see note 30.

34 Eco, 'Openness, Information, Communication', see note 30.

35 Eco, 'Openness, Information, Communication', see note 30.

36 The *Gruppo 63* was founded in 1963 in Palermo, Sicily.

37 Umberto Eco, 'The death of the Gruppo 63', *Quindici*, 1969. Final publication of *Gruppo 63*.

38 Claude Lévi-Strauss, *The Raw and the Cooked*, London, 1971.

39 Umberto Eco, *La Struttura assente*, Milan, 1968.

40 Eco, *La Struttura assente*, see note 39.

41 Antonio Gramsci, *Selection from the Prison Notebooks*, New York, 1971.

42 G. Celant, 'Arte Povera: Notes for a Guerrilla War', 1968.

43 Krauss, 'The Double Negative', see note 1.

FICTION IS MORE TRUTHFUL THAN HISTORY

I am going to tell you a story, but before I start I want to tell you why a story and not a learned paper or a theoretical text. The reason is very simple: I want to speak as a practitioner and as an artist who from time to time turns his hand to criticism and not as a theorist who happens also to make works of art. I want the scope in which to use my imagination. I also want to avoid the danger of turning what I do in the studio into a symptomatic, most especially to myself. For me, making works of art is first and foremost a question for the human heart. And the problem for the artist is always the same problem: how to keep the concerns of the heart ahead of the machinations of reason; how to uncover the deep purposefulness of all of the hearts' doubts and contradictions. For this reason I am much taken with Bernard Shaw's oft-quoted dictum: 'Fiction is more truthful than history, and poetry more thoughtful than philosophy.'

Wishing to avoid the trap of appearing to know more than even a fictional history would permit, I have chosen to tell my story in the form of a dream. A dream in which I am, and am not, myself; or should I say that I am both myself as well as another. I have chosen as my double a real historical figure: the painter and revolutionary, member of the political avant-garde, the

French painter Jacques Louis David. The thoughts expressed then are never entirely my own thoughts, but a reasonable deduction based upon an appraisal of historical circumstances.

My intention is to entangle you into the snare of a double irony. I will speak as if through the mind of another, at the same time deploying all of the benefits of historical hindsight; and I shall do so from a position twice removed – that is, at least twice removed. Sometimes I shall utter the thoughts of myself, as the sleeper who dreams and at other times I will speak as the author struggling manfully to remain consistent with his characters. Throughout I shall be trying to address the present through the past.

It remains for me then just to provide a brief word of explanation as to why in a seminar devoted to the avant-garde, I have chosen David, an eighteenth-century figure, as my subject. I have always thought of David as one of the more curious figures of post-Renaissance art history. John Berger has called him the first of the moderns and it is certainly true that he manifests many of the characteristics and contradictions of later avant-garde artists, even though he was active long before Ducasse coined the term. He was also a committed revolutionary who chose to place his art at the disposal of the political avant-garde. Out of his social and class background, he clearly felt a powerful need to identify with a progressive caucus – to be part of a corporate effort. And yet he was possessed of a highly individualistic turn of mind and was extremely jealous of his hard-won status as an artist. He believed fervently in the ideal of progress, but was mindful too of the burden of tradition. Janus-like he looked backwards as well as forwards. More significantly perhaps, he was the first artist to require of art that it should reflect upon its own condition and in doing so he gave tacit recognition to a characteristically modern distinction: the separation of the cultural from the political order. In this, for good or for ill, he was the first to recognise art's autonomy. Now to my story.

It seems to me that for the last few years I have been possessed by a dream. A dream that has returned to me so frequently that it has achieved the character of a nightmare. It is, in the strictest sense, a horrible spectacle. Certainly the chief protagonist has all the vacant qualities of a chimera, a ghost no less. And more frighteningly, despite the fact that he is wearing some kind of disguise, he is dearly my very own double.

This man is dressed from head to foot in the attire of an eighteenth-century French gentleman, and his entrance into the scene always occurs in precisely the same way: he is bundled unceremoniously by disembodied hands

through a dark aperture out into the light. In this repeating parody of rebirth he is being thrust back into the world, a world still pungent with the acrid smell of recent civil strive.

This thin and pale creature – my other self – after only 12 months in prison now has the unmistakable air of lost authority about him. He hesitates, as if he has forgotten which way to go, or even how to contrive the movements necessary to forward progress. He seems to be consumed by doubt. Should he advance his left foot or his right. Should he turn to the left and head for *St Germain*; or to the right and the *Ile de la Cité*? To any observant bystander, such as myself, his state of confusion is palpable. Indeed, as I look, he appears to be swaying slightly as if he is about to topple over, to and fro, backwards and forwards. And in his critical state of anxiety he has crushed flat the roll of drawings stuck beneath his left arm. He has squeezed the very life out of them: months of thinking, planning and hard, concentrated work.

In part at least the clear discomfiture of this erstwhile revolutionary, my second self, is due to the very simple fact that there is no one there to greet him. No wife and no children; this he had expected. His wife had remained a staunch supporter of the old regime, their estrangement then had been long-standing. The pain is no less acute for all that. But none of his colleagues of the revolutionary council are there either, none of the remaining members of the Jacobin faction, none of his close friends or his students; even more demeaning for a man accustomed to being courted for favours, there is not a single person in sight, no grovelling supplicants or weasel-worded fellow travellers.

In the cold light of this Parisian morning the stones across which only 12 months earlier he had strode with such confidence, are now almost completely deserted. The stage from which he had mouthed his revolutionary rhetoric stands empty. The exalted position from which day by day he had harangued the backsliders and those who had called for moderation, the platform from which he had demanded the blood of the people's enemies is now an empty site, a vantage point without a view. The grand auditorium stares back like so many blank tombstones, anonymous and uninscribed. There is no audience to address, no one to applaud or raise a cheer. His sense of loneliness at this moment is quite overwhelming. True, there are figures moving in the shadowy recesses of distant arcades going about their own affairs, but they show no interest in citizen painter David. Why should they? To them he is nothing more than the last digit in a procession of thousands, just one more example of the recently dispossessed.

He finds himself contemplating just how easily does the colossal inflate into the monstrous, and how quickly the monster, once slain, turns waxlike and cadaverous, failing, fading and eventually shrinking into a small wizened thing barely visible to the naked eye. Shivering he draws his new-found anonymity around himself like, seeking and finding some comfort in the fullness of its obscuring folds. It seems to provide this my famous, or should I say my infamous double, with sufficient confidence to take the first halting steps into an uncertain future. Starting across the *Rue Vaugirard* he turns right intending to make his way to the Louvre by way of the boulevard *St Michel*, the *Ile de la Cité* and the *Rue de Rivoli*. And even as I watch the gaunt figure of this second self in motion, his baring becomes more erect, his stride more certain, his eyes less down cast, his gaze more direct. This measured walk – measured in the sense that it serves to set a temporal limit to the brief respite that he can enjoy before he must confront the vacancy which has become his place of work: his studio – allows him also a first opportunity to scrutinise and make mental notes of details of the post-revolutionary world.

The first impression is one of disunity, of dislocation, of a failing perspective. It seems that all is foreground and backdrop with nothing very substantial in between. In the *Rue Vaugirard* desolate groups of people pose like figures in a *tableau-vivant*. There is a lot more going on in the *Rue St Michel*, where he is jostled by different groups of pamphleteers, pressing upon him texts, each pretending to contain the key to the new order.

First he is surrounded by a faction calling themselves *The New Barbarians*, stinking of sentiment in their sackcloth shifts and open-toed sandals. They bemoan the passing of the simple life. They wail aloud for the loss of the regulatory power of the natural. Not only do they suffer from perpetual cold feet, but colds in the head too.

Free of them, he falls into the gang of self-styled Old Revolutionaries – not a familiar face amongst them. Draped from head to foot in the Tricolore, their painted red hands thrust upon him dog-eared bundles of outdated revolutionary tracts. These are a haughty bunch. They wear their stubbornness like a spinal support and their intransigence like a tragedian's frown. 'Stand fast by the Revolution,' they cry out, 'hold faith for the blood of the terror. Liberty, equality, fraternity.' But in truth these are men of straw, men who actually never lived the revolutionary moment. These are the latecomers, people who prefer words to actions. Now that the coast is clear and the heat

is off, they have emerged from under their stones, seeking assimilation to a history which is already over and done with. For a moment David contemplates doing serious violence to these men of clay, but refrains, opting instead for a small experiment in practical politics. He raises a hand as if to strike one of them and the man shrinks from him, crouches down in the posture of a frightened dog.

Suddenly ashamed of himself David brushes the man aside and walks on, only to find himself straightaway engulfed by a procession of grey-haired men disporting themselves in the flowing costumes of Greek senators. These, David thinks to himself, must be the new intellectual bourgeoisie. They are marching behind a banner demanding government by artists and intellectuals, but they seem more bent upon conviviality than on real political action. They are all the time milling around each other, smiling and shaking each other by the hand and just for a moment I lose sight of my other self, lost in the flurry of purple and white robes. My fiction, it seems, has been incorporated into an even greater fiction; the painter has been absorbed into his own painting. And then, just as suddenly, the bodies of these would-be immortals part and I see David again borne along on a bubbling tide of New Athenians: some carrying large leather-bound books ostentatiously inscribed with the names of great philosophers and poets, some bearing small replicas of Greek and Roman statuary, while others play musical instruments so that the rest can sing. Every-so-often, as if at the behest of some hidden power, they all chant in unison, 'Mind before body, mind before body', and break into a trot.

As this comic band proceed down the *Rue St Michel* they are joined – or should I say infiltrated – by a sinister group of grey-faced men in black suits. These are the undertakers of the revolution, now swelling the ranks of the unemployed. David knows their kind well, they are ideological mercenaries who pass always like ships in the night, seeking the safest possible political haven. Not wishing to be recognised, he pulls his hat down over his eyes and pulls his collar up about his ears. These grey-faced men are busy now, plying the New Athenians with questions. They are out hunting for political advancement, but these men are old hands – they recognise political naivety when they meet it. And by the time the procession has reached the *Ile de la Cité*, they have melted away entirely. I watch this carefully contrived disappearing act with some amusement, neither is it lost on my other self.

As the last grey eminence fades into the shadows, his whole demeanour changes; the tension goes out of him and he begins to engage

those around him in animated conversation. For David it is like being caught between the pages of a carnivalesque novel, accompanying these high-stepping thoroughbreds who have even learned how to nod in unison through the streets of Paris. They are mildly lunatic, these learned men, loose for the first time in the domain of practical politics. They want nothing less then to save the world. They are blind, but they are not stupid. They discourse intelligently on all manner of things, each believing fervently that his own specialism will be central to the new order. Just now they like nothing better than to talk about the future and David, weary of being caught up in a serious political argument, stops them on the second bridge and for purely diversionary purposes delivers an impromptu lecture on the virtues of the classical canon in the shaping of modern architecture, citing examples from the panoramic view of Paris, afforded by the broad sweep of the river Seine.

Without even realising it, David has just slipped backwards into an all too familiar role. In his imagination he is once more back in his studio preaching immutable laws of composition to his students and apprentices. For the first time that day he feels completely at ease, but as we have all experienced to our cost the dream is nearly always an untrustworthy site; it permits no certainties, least of all certainties of mood, place or event.

Abruptly the scene changes, warmth turns to cold, light turns to darkness. Leaping ahead, the procession has reached the *Rue de Rivoli* and turning the corner is met head on by a marauding band of rough-cut young men, armed with pitch-forks and wooden stakes, their pockets stuffed with stones. Some of them still sport the Phrygian cap of revolution. Jeering and shouting abuse, they set about the New Athenians who, without more ado, gather their togas around their thighs and scatter to the four winds, leaving David – my second self – to face the mob alone. They advance across the litter of dropped names and scattered remnants of knowledge, left behind by the grey-haired men in full flight. A stone strikes him on the temple, drawing blood. Another hits him in the chest just above the heart. He drops to the ground. The crowd closes in punching and kicking. He loses consciousness.

Just for a second, from some place quite removed, I see myself lying on the ground like a blood-soaked bundle of old rags, a piece of historical detritus, and then the scene changes again. David is standing in the very centre of the great courtyard of the Louvre, in the middle of a huge throng of people. These are people of a kind that he has never seen before.

Their dress is outlandish, disparate, outrageous and eccentric. Some are wearing oriental robes, strange headdresses and marks of birds and animals. Others wear the clothes of working people and seem careless of their appearance. The strangest group of all comprises men dressed as women and women dressed in the sober suiting of city men. They seem to be intent upon a variety of fairly aimless pursuits, acting out private rituals and meaningless games. The air is filled with the smell of exotic perfumes mixed with tobacco; all is languidness and ease.

David has unfurled his bundle of drawings and one by one he tries to engage them in conversation about his great revolutionary work. Each in turn smiles politely and passes on showing little or no interest, indeed it seems to be beyond their comprehension. Feeling a growing sense of desperation, he redoubles his effort moving from group to group, babbling on about the *Spartans* and the *Sabinii*, the great Athenian tradition of stone carving. He is met by vacant gazes, uncomprehending, even puzzled faces. He feels the panic welling up inside him. He must leave; find his studio; his own world; peace of mind. Pushing his way through the crowds, he reaches the stairs leading to his rooms, and even there as he climbs he has to push his way through groups of men and women disputing with each other wildly different and unfamiliar points of view.

By the time he reaches his studio he has the air of a hunted man about him. Now the emptiness, the stillness of his workplace, which he had feared so much on leaving the Luxembourg, seems to be a blessing. Here he can find the space to think, to construct for himself a new beginning. Thus far his odyssey, his walk through the streets of his native city, has almost functioned as an embodiment, a terrifying embodiment of all his most negative thoughts. And now, secure at last in the silent vaulted space of his own studio, he must try to put these thoughts and experiences into some kind of order; try to understand them, weigh them for truth.

I watch him pacing up and down. 'Where to begin', he is asking himself, 'where on earth to begin.' He looks at his easel, gaunt as an empty scaffold waiting for its daily ration of carrion flesh. He scrutinises the piles of canvases stacked against the wall. Should he start by turning them round? One he knows is *The Death of Marat* (1793), still uncollected by the commission. Perhaps this painting more than any other, would provide him with the courage to go on, still he hesitates. Wouldn't this be just one more futile resurrection? He flops down in a chair, closes his eyes, tries to concentrate

his thoughts on the future, what to do next; for the past is insistent. The great cycle of his history paintings, vivid, bright images, flash on and off repeatedly in his mind's eye like the pages of a flick book.

History, yes, that had been his obsession, that is what all of his very best paintings had been about: how to represent history; to mirror history's representations to itself. And he saw now that that too is what the revolution had been all about. This was the point of absolute coincidence between his works and his politics. Sixteen years during which he had sought to reestablish the canon of history painting and six of those years were revolutionary years. Six years during which the ownership of history had been at issue. Six years in the course of which the people had laboured mightily to rest the historical process from the hands of a decadent and extravagant aristocracy.

And then a brief moment of new times, *Thermidor*, during which it was possible to sustain the illusion at least that the same rain that was falling upon those who governed also fell upon those who were subject to the acts of government: the petty bourgeoisie, the peasantry and the urban poor. Three years treading the same pavements and walking beneath the same sun. Yes, history had been the issue.

If equality meant anything at all, it was this, that history would no longer be shaped elsewhere: in the divine person and rotting corpse of the Monarchy, in the palace of Versailles and its ante-chambers stuffed with so-called learned councillors, in the Land Courts, in the ancient offices of privilege. Addressing the Committee of Public Safety, he had himself stated that it is part of his revolutionary credo. 'Henceforth history will be made in the streets and public places wherever two or three are gathered together, in the houses and the cafes, in the parks and watering places, it will find its authority in the instruments of a democratic state.'

But hadn't these been so many empty words. A dark shadow passes over him. As a close observer of this my other self, I experience the pain of it in my own head: his thoughts at this moment are my thoughts. Was he not guilty, along with all the others, of practising to deceive. Were not their actions, in part at least, powered by an ancient envy, the envy of the bourgeois for the airs and graces of the Aristocracy, its easy assumptions of the rights of privilege and of government.

But there was something deeper too, this he knew full-well: the desire to break out of the prison of behavioural rules, to free himself from the responsibilities and etiquette of his class. Yes, he had wanted so desperately to

escape the trap of bourgeois orderliness and acquiescence, to exorcise in himself an inherited fear of change, to demonstrate to himself beyond the shadow of any doubt that change, far from being something to be feared, was something to be sought after, something to be embraced with passion.

This restlessness, this unease, had been at the root of his friendship with the ascetic Robespierre. Whatever their differences, this they held in common. They shared the transgressive tendencies of their class. Indeed it was Robespierre who had taught him the language of revolution, convinced him that the future was there to be determined by actions taken in the present. It was Robespierre who had persuaded him that political crisis was also cultural crisis, that they were two sides of the same coin, that an art that was harnessed to the engine of political progress was ipso facto a progressive art. It was Robespierre, in other words, who had shown him how to put together the idea of an artistic revolution with that of a political revolution. It was Robespierre who had helped him to formulate his concept of a new artistic epoch, a new golden age.

As I watch, just for a moment his face is animated by an ever so faint smile. He is remembering his one time friend pacing up and down before an orderly desk in an office on the first floor of the *Hotel de Ville*. He is remembering the vigour of his argument and the unwavering certainty of his belief. 'For those of us who have been called upon to form the vanguard of historical change, the end must in necessity justify the means... We are on the threshold of a new epoch... We must advance with confidence without so much as a backward glance... Our responsibility is to the future.'

It was this last injunction, spoken with such conviction, that had provided David with the courage to sign more than 300 warrants for the arrest of the people's enemies. Men, women and children; all, except for a handful, now dead. In earlier times, many of them had been his patrons. They had entertained him in their homes. He had hunted with them on their country estates. They had included prominent courtiers, public figures like Madame du Barry and Philippe Egalité whose portraits he had painted. These were the faces – faces he had come to know better than his own – that now peopled his nightmares.

During his time in the Luxembourg prison, the long cold nights when he had so desperately tried not to sleep so that the nightmares would not come, he had spent his time rehearsing his revolutionary vocabulary, examining it word by word, searching for clues that would explain the

gathering feeling of dissatisfaction, that would keep at bay the frightening spectre of an irreversible error. But the doubt had persisted. All those deaths. And for what? For a plethora of words, a fabrication of language. Or had it been more than that? History, progress, future. The words seemed to fit together so snugly when he had been organising the committee for revolutionary events, but in the Luxembourg prison they had started to fall apart.

And now, progressing through the streets of post-revolutionary Paris, seeing for the first time what the revolution had led to, these were notions that seemed to be worlds apart.

History, he finds himself asking, whose history? Who is making the inscription and on whose behalf? History in memorial to whom? In the Luxembourg he had asked himself these questions a thousand times over without reaching any real conclusion. Now suddenly it all seemed startlingly clear. History was almost always a carefully disguised fiction, an interpretation dressed up as some kind of immutable truth.

And progress, what of *Progress*? What precisely does it mean to read history in terms of progress, to make of it an axiomatic trajectory for determining the shape of things to come? Isn't this the most dangerous and misleading fiction of them all? He more than anyone else should have seen through this deception. He had spent his life, after all, preaching the pre-eminent qualities and values of classical art. He had used the superiority of form in Imperial Roman Statuary as a rod with which to beat the backs of the Academiciens, as a scourge to lay bare the flesh of the rococo artists: Boucher, Robert, Fragonard and their followers. Out of his own mouth he had himself time and time again given the lie to the notion of progress. And yet he had succumbed to the silken web of revolutionary rhetoric. He had fallen victim to a chimerical wish-fantasy which carried history beyond the scope even of fiction: turned it into a mythology; made of it an aerial thing, almost a cosmogony. He had begun to believe ardently in a metaphysic of the future.

And what about the concept of *future* itself? Isn't this another similar kind of displacement? To say that we act in the present on behalf of the future. Is not this to run the risk of committing a cardinal epistemological error? Even if it does not exactly assume a steady state, it certainly assumes some kind of deep continuity. Had he not himself experienced a sense of cultural and historical rupture firsthand at the storming of the Bastille, as the walls came down? Had he not felt something go from the world, something

familiar, a sense of certainty, and something unfamiliar take its place? Something had snapped inside him too, perhaps it was the thread that he had always felt drawing him inexorably into the future.

He remembers this now as a critical moment of panic, quickly suppressed. Just for a moment he had caught a glimpse of himself as one of the last representatives of the old order and not as he had always cast himself in the *Vanguard of the New*. He knew now the truthfulness of that brief moment of revelation.

This one event, the storming of the Bastille, had turned all of them – Marat, Danton, Robespierre and the rest – into historical figures; made of them players on their own revolutionary stage, seeking to control an audience whose desires and appetites they no longer understood; waiting to be picked off one by one when their performance failed to satisfy. Had it not turned them all into impresarios, puppet masters, entertainers?

He had seen this same certain knowledge written upon the face of Robespierre; the faintest shadow of fear the day that he ordered the killing to stop. Two weeks later, accused of betraying the revolution he was arrested and executed. Blood with blood with blood. *Émigré, Aristocrat*, fallen *Revolutionary Idol*. It made no difference to the mob that daily attended the execution on the *Place de la Republique*. It was all the same colour, part of the same currency.

Wasn't this a clear example of the lie which exists at the heart of the vanguardist illusion, the notion that it is possible to stay ahead of the collective historical consciousness, that there is always free air out there to be breathed? Surely in the end even the most radical action must fall victim to the normalising fiction which is history. This, surely is the fate that the vanguard, any vanguard, brings upon itself. From the moment that it becomes conscious of its own historic role, the illusion can only fail. Advancement is turned quickly into regression. Leaders become servants, organisation is elided into instruments of surveillance and control. Each radical impulse is absorbed by the same repressive structure that it has sought to limit or overthrow.

He had watched Danton become the writer of his own history, the perpetuator of his own fiction. Had David himself not accompanied him on his emblematic walks in the Tuileries gardens, nodding and smiling at the people, the living embodiment of equality and accessibility? A trick, a mere representation. And was not he, David, guilty of precisely the same kind of slight

of hand? Just now, in the courtyard downstairs, had he not presented himself to the Romantics as a representation, as a historical cipher, an authentic sign, a signifier of an important revolutionary moment or attitude, as a vision of authority? Try as he might, he had been unable to stop himself. It was his habit. He had wanted with all his heart to convey to them his immense feeling of cultural loss, but the representation had drowned out the feeling. It had absorbed his grief like a sponge. Even his expression of a sense of high aesthetic purpose was lost on them. They could perceive him only as a picture of a revolutionary thinker; it seems that they could not see beyond the thought itself. To them he was inescapably one of yesterday's men, a relic of past times, a dinosaur.

Wearily he leans forward in his chair and begins to unroll the drawing that he has carried with him from prison. The first tentative steps in a great new project, intended, when it was first conceived, for the purpose of reestablishing him in the ranks of the revolutionary elite. Now there was no elite, not even a revolution. Times had moved on. The project must be redirected. He studies the drawings closely, eventually getting down on his hands and knees to examine their details more closely. Now he is completely absorbed in his task. He stands up, hand cupping his chin in deep thought. He nods to himself, a look of contentment spreads over his face, as if he has finally reached an important conclusion. Knowing him as well as I know myself, almost I can think his thoughts for him. Yes, he is saying to himself, the subject can remain, but the style that is a different matter. Perhaps it should be less imperialistic in feel, less Roman, more Greek. That would fit the expansion of the subject too. As a revolutionary work, one strong message was enough. Now it must work on many different levels, point to many different solutions. Still there must be at least two main themes: a political one and a cultural one. Perhaps more. The *Sabinii* were, after all, a Spartan Greek extraction, their subjection then might be construed as a form of cultural genocide just as easily as it can be construed as political subjection. The new picture then will speak to the condition of art as well as to the condition of France. Indeed, it will address the central question of tradition as a concrete and lively political reality, perhaps as a more reliable monitor of value than history. Not that version of tradition which is advanced by hack critics and reactionary journalists.

Nor even the version of tradition which is adumbrated by academic procedures and specialisms, but that sense of deep connectedness which we all feel with the culture in which we live and work. This in the end is what

determines the artist's judgement, powers his or her ideals, even the desire or the need to transgress.

Of a sudden, as I watch, and as the dream fades, my other self, citizen painter David appears to achieve at last some sense of contentment.

"*And Justice For All...*, Ole Bouman (ed.), Jan van Eyck Akademie Editions, Maastricht, 1994, pp.125–35.

Given this text's purpose as a catalogue foreword, the preamble seems rather too long and the section about Mark Wallinger's work too short. However, it still interests me for another reason. When I wrote it, I had just moved to Belgium and was teaching at the Workplatz in Maastricht. Before I left England the talk had all been about globalisation – how on the coattails of global commerce contemporary art had become an international language – and my experience in Maastricht had tended to contradict this notion. Crossing the border to work, the cultural differences between Holland and Belgium were endlessly apparent. Furthermore, I was teaching a cohort of postgraduate students that came from several different countries and in their working habits and ways of thinking I observed these distinctions first-hand. For me, this highlighted the profound Englishness that lies at the very heart of Wallinger's work. He is an artist whose work can be seen as a celebration of difference not simply because of his choice of subject matter but for deeper reasons. Not least the mildly self-deprecating ironic eye that he casts over his own thoroughly English preoccupation with politics and sport, using one as a metaphor for the other.

DOING BATTLE WITH DECOMPOSITION: THE WORK OF MARK WALLINGER, 1985–1995

To put things to right! Do you not know how refreshing it is, even to put one's room to rights, when it has got dusty and decomposed? If no other happiness is to be had, the mere war with decomposition is a kind of happiness. But the war with the Lord of Decomposition, the old Dragon himself – St George's war – are none of you proud enough to hope for any part in that battle.

– John Ruskin – Fors Clavigera, *Letters to the working men of England*

Living in self-imposed exile on the mainland of Europe, I have come to realise more and more that internationalism, that much vaunted shibboleth of the high modernist, is, at very best, only skin deep. Just a geopolitical stones-throw away across the other side of the English Channel, and you find yourself a stranger in an art world shaped by distinctly different attitudes and values. Of a sudden you are surrounded by artists who seem to talk about art in a fairly unfamiliar way. Furthermore, the take that you have on the art world you have left behind – the pool in which you once swam, almost oblivious of its culturally specific peculiarities – makes it seem like a very distant place indeed. It comes as quite a shock to discover that there is, after all, something called Englishness, just as there is Belgianess or Dutchness, although, like English artists speaking from the security of their own patch, most Belgian and Dutch artists fiercely deny it. But it is an odd, not to say a somewhat disturbing experience, to discover that simply by shifting location a short distance by train and boat away, you have translated yourself into an emblematic embodiment of nationhood, stamped with all of that nation's negative characteristics as well as its more positive ones. Phrases like 'but you're so English' become an almost permanent adjunct to your Christian

name. Neither is this process of labelling merely the recognition of Britain's moatedness, a byproduct of the island mentality. Similar distinctions are all the time drawn between the Germans and the Dutch, and even more surprisingly perhaps, given that their histories are so closely intertwined and they share the same basic language, between the Dutch and the Flemish-speaking Belgians.

I am not, of course, referring to that jingoistic version of nationality which nowadays is everywhere spewed out by the tabloid press, ultra-conservatives, and the political parties of the far right: *Fons Nationale*, *Vlaames Block* or the British National Party. The cultural difference of which I am speaking arises from a much deeper level and is rarely, if ever, negatively inflected. It is given to us from out of the furthest reaches of the historical culture and it tends more to secure a sense of identity – untainted by social paranoia or the fear of material loss – rather than to threaten dispossession. Its outward show is more in the order of a celebration rather than a prophetic rattling of funeral bones.

More important for our purpose here, these almost subliminal traces of nationhood serve to colour the art of different countries in wonderfully subtle, complex, and in the case of certain artists, a thoroughly definitive way. It is hard to imagine, for example, work like that of Wim Delvoye or Patrick Van Caeckenbergh, with its focus in personalised kitsch, the arcane and the decaying baroque, arising out of any other cultural context but that of Belgium. The matter-of-factness and the Calvinistic spareness of artists like Dan Van Gulden or Niek Kemps seems to be quintessentially Dutch, just as the mocking irreverence and self-parody which marks the work of so many of the new generation of British artists from Damien Hirst to Sarah Lucas, is unmistakeably English: a reflection perhaps, of the long tradition of popular scepticism, but seen through the cynically opportunistic glass of the Thatcher years.

The work of Mark Wallinger, while undeniably part of this sceptical tendency in contemporary British art, is, at the same time, a distinctive, even an exceptional example of it.

Wallinger is a politically committed artist and an intellectual, whose researches into the Englishness of the English have led him to penetrate into the furthest corners of social and cultural history. More than this, he is a passionate man who is possessed of a profound affection for the unconscious eccentricities, even the downright stupidities of his subject, and for the very

simple reason that he is discovering traces of them in himself all the time. He is, then, his own first subject of analysis and for this reason his critical gaze, while it is relentlessly inquisitorial, is never cynical. As an incipient carrier of the very diseases he is looking to cure, he wishes, before all else, to preserve the life of the patient, and when he employs the sharp instruments of satire and irony, he does so for the sole purpose of healing and making well. In this respect he is the true inheritor of that tradition of political satire and moral commentary which reached its apotheosis in eighteenth-century England with the paintings and engravings of William Hogarth and the satirical cartoons of James Gillray and Thomas Rowlandson.

Compared with today, of course, the forces which shaped the politics of eighteenth-century England are relatively easy to understand. The patterns of economic exploitation and social deprivation were formed locally, and the causes of moral decay, certainly as they were depicted by Gillray and Rowlandson, were very largely excesses of the flesh: carousing, wenching and gambling. Wallinger faces a very different and infinitely more complex world, seen through the obfuscating glass of a postcolonial Britain, still, in its bones, mourning the loss of empire and trying desperately to hold on to the last vestiges of global influence that was once grounded in real economic power and unquestioned moral authority. In the urban Britain that he confronts, the dangerous legacy of this imploded imperial past is everywhere in evidence; in its most stark form in the minority Asian and West Indian communities who, in part, populate the poorest districts of the once great Victorian cities of the industrial midlands and the north as well as the crumbling council estates of metropolitan boroughs like Brent, Tower Hamlets, Lambeth and Southwark – where Wallinger lives and works. It is in these places that the insidious poison of racism, driven by unemployment, educational disadvantage and the fear of cultural difference, finds the most fertile social tissue on which to feed. It is in these places too, that the rigidities of the British class system – ideologically reconstructed as 'the politics of choice' by modern conservatism – bares down hardest upon the petty, domestic economies, the day-to-day living conditions of those who form the least advantaged groups in the society, reeking the most terrible social havoc. Here, powerlessness breeds desperation, futility breeds violence and despair.

But this is only the foreground clutter of the political landscape Wallinger is seeking to address. In the middle-distance there extends the ideological wasteland the graveyard of hopes and ideals – left behind by the failure of state socialism in Eastern Europe. The consequences of this historic

moment of cataclysmic collapse democratic, oppositional politics in the countries of western Europe are only now beginning to surface. As those parties which traditionally served to coalesce the voters left of centre, move markedly to the right in an attempt to occupy the political, centre-ground, they leave their previous strongholds in the industrial working class prey to infiltration and take-over by the extreme right. Wallinger, like most thinkers from the critical left, sees this, the rise of neo-fascism in the countries of mainland Europe, as a direct outcome of the stagnating, political centerism which has dominated European politics for most of the postwar period. Furthermore, he sees it as a possible doom-scenario for the future of a British political system struggling to realign the constituencies of economic interest in the wake of Thatcher's monetarist experiment. Viewed from his position, the preconditions necessary for a resurgence of the undemocratic right, in Britain, have already been established through the progressive erosion of the Welfare State and the increased subjection of the great public institutions – the education and legal systems, the social and health services to narrow ideological objectives and the so-called discipline of market economics. A hard and unyielding wedge has been driven between those who have the knowledge and capacity – not to mention the financial means – by which to exploit the system and those who do not. And all the while, an anti-liberal, largely right-of-centre, populist press, chants the authoritarian rhetoric of moral-rearmourment; argues the case for a return to Victorian values; promotes the patriarchal model of the middle-class family as the natural bulwark against social disorder and at the micro level at least, economic and moral turpitude.

Wallinger's Britain, his world and his political universe, then, is a far cry indeed from that of William Hogarth and his contemporaries. If it provides a difficult task for the political or economic commentator, it provides an even more difficult one for the artist who finds in himself a pressing necessity to speak out. As Lyotard has said there are certain themes – the Holocaust, he argues, is one – which seems to be beyond the reach of representation, outside the scope of metaphor. They are too vast, too ephemeral, or too unspeakably horrid to be approached directly or in their entirety. The artist is driven to speak in parables, to wrap himself and his subject in the cloak of irony, to metonymise the larger picture by resorting to humorous asides, personal anecdote, parody and satirical diversionary ploys. Wallinger's main target, the contemporary political landscape – the German feminist philosopher and critic Elizabeth Lenk has described it as 'nothing less than the end of Modern

Times' – is a subject of this magnitude. In its entirety it stretches way beyond our field of vision; it has no discernable centre and no fixed boundaries. It can only be approached piecemeal: made visible and communicated about to other people, by deploying a wide range of depictive and reflexive subterfuges.

Wallinger, himself, has said that it was an important moment of revelation for him when he discovered that works of art, if they were to answer the demands of specific meaning, had to be constructed. Meaning, in other words, had to be made. Up to this point he had been greatly under the influence of the new German painting, artists like Georg Baselitz, Anselm Kiefer and Walter Dahn. Like many young artists in the early eighties, without consciously realising it, he had been a subscriber to the late modernist notion that works of art, in as far as they were a product of the individual creative will, flair and intuition – were intrinsically meaningful. Growing political awareness showed the limitations of this way of thinking. He began to see that his paintings – and he was exclusively concerned with painting at that time – seemed always to reach a similar level of generalisation. That while this philosophy of painting – we might call it neo-expressionism – was capable of generating a powerful metaphoricity, the metaphors themselves were nearly always out of control and prey to dangerous levels of ambivalence. Thus the intention of an artist like Kiefer, in raising the dark mythology of the German imagination, could be mistaken altogether and seen in the same light as Hitler's romance with the Wagnerian legends – the translation of private revelation into public creed – just as Marcus Lupertz's reworking, in pictorial form, of the Dythirams of Friedrich Nietzsche could be mistaken for an invocation of the classical, judeo-christian will to order which had powered Nazism.

Before all else Wallinger wanted to avoid this kind of ambiguity; he wanted his work to be politically clear. He wished to excavate deep into the mythic sub-soil of his own culture, but to do so without risk of misunderstanding. Most particularly he wanted to anaesthetise the spectral voice of chauvinistic nationalism, while at the same time making real critical in-roads into the social and political terrain which feeds it.

Significantly, Wallinger saw clearly that the necessary first stop towards achieving this degree of clarity involved the rejection of the highly emotive, subjective force of expressionism, in favour of the constructed image. For Wallinger, the issue was one of authority at the point of reading. Where expressionist painting pretended a unity of intention and meaning, manifest as psycho-physical affect and authorised through the heroic struggle of each

individual artist to 'express himself', the constructed image offered no such authoritative unity at the point of reading. Rather it presented itself as an obvious compilation of fragmentary visual and verbal texts, drawn from a wide variety of sources, and carrying with it such a strategy of image making, Wallinger took on the responsibility for revealing his sources and showing how he was coding and contextualising them; he had to run the critical risk involved in allowing the conceptual seams to show. The principle that underlies this type of working procedure, then, is fairly easy to sum up: 'what can be seen to have been joined together by the artist, can just as easily be taken apart and examined for its meanings, by the viewer.' Thus through the act of reading, the viewer is critically empowered. While the artist might continue to work with a preferred reading or readings, at the cutting edge of reception, the responsibility for making specific meaning – specific, that is, to that time and that place – is given in trust to each member of the viewing public.

In certain respects, this is a classic avant-garde strategy, in the same spirit as the formal inventions and deconstructive method of analytical cubism, or the use of collage, frottage and autonomistic techniques by the Dada and surrealist artists. Indeed, the constructed image employs many of the same devices: fragmentation, collage, layering, super-imposition and erasure. Wallinger employed all of these disruptive, conceptual techniques in a typically aggressive and uncompromising manner in his first solo London exhibition, *Hearts of Oak*, at the Anthony Reynolds Gallery in the spring of 1986. As the title of this exhibition suggests, the artist was intent upon distilling some notion of Englishness which in the tradition of History Painting, used the past as a diagnostic tool in relationship to the ills of the present. The works incorporated a wide range of historical and contemporary references. Quotations from the paintings of Gainsborough and Stubbs, the political writings of William Morris and the poetry of Blake and Clare; references to gentrified living and the decorative culture of the country house; the oppression of the rural peasantry; the making of the popular hero, exampled by reference to the historic figure of John Barleycorn, were overlaid by, juxtaposed and interwoven with images of the Brussels football riot, references to urban decay and social violence, jingoistic sloganising and the dumb voice of opportunistic, political populism. For the first time, Wallinger departed from the restrictive format of traditional easel painting, choosing instead to work with materials which were already loaded with potential meaning, which spoke of a political wasteland in the language of material dereliction: builders plywood, burnt and blackened

timber, corrugated iron and packing cardboard. Most of these works were collaged directly onto the gallery wall and cloaked in the garb of bitter irony through the use of titles like, *Stately Home* (1985), *National Trust* (1985), *Blood On Our Hands* (1985) and *Where There's Muck* (1985). Significantly, in this, Wallinger's first major London showing, he employed the closely related ironic modes of 'allegory' and 'parabasis' for the first time, by writing himself in as titular participant, subject, commissioning agent and owner of a reworked version of the allegory of St George and the Dragon. In this parody of an eighteenth-century tapestry depicting the '*Stately Home*' of its title, John Arnold Wallinger Esq (or his ancestor), assisted by a man-servant, prepares to do battle with that most British of dinosaurs, class privilege.

Wallinger returns over and over again to the use of these twin ironic modalities in the years that follow, and so it is perhaps important to pause here for a moment in order to consider them in greater detail.

The main problem confronting all serious critical projects tends to revolve around the question of 'truth': the inherent claim that criticism makes to authenticity, despite the fact that each critical act works to produce its own distinctive blind-spot. The subject of its address, in short, is always to a degree obscured by the authoritative mantel of an assumed objectivity, reenforced by the claim that it makes to exist in what Paul de Man has called 'organic time': the implication being that 'what can be said to be true today, has always been true, and will be true hereafter'.

The serious critic, then – we might better use the term 'honest critic', and Wallinger is precisely this – whilst not wishing to deny altogether the version of authority that criticism works with, must at the same time seek out ways of rendering this authority transparent. The critical account, must acknowledge, from within itself its quasi-fictional character, and one of the most effective ways of achieving this is through allegoresis. Allegory, out of the way in which it turns the critical text into narrative, separating it from 'normal' temporal frameworks, has the power to rescue criticism from an inbuilt and hidden lapse of authenticity without diminishing its hold upon its particular version of the truth.

The same is true of 'parabasis', a favourite strategy, of political satirists of the English literary tradition, as exemplified by writers like Jonathan Swift, Samuel Butler and John Ruskin in his later years. Parabasis allows the author to be both inside and outside of the action: to make comment before, during and after the depicted events.

Like the Shakespearean chorus which is situated in an eternal present and yet is seen to be the one who is 'presumed' to know the pattern of events in advance of the unfolding of historical time, parabasis allows the writer or artist to expose him or herself as deeply implicated in the course of events, but to do so in the distanced voice of objective, critical commentary. This overt intrusion of 'time present' in the person of the author, or by the incorporation of selected elements drawn from the author's lived biography, fastens our attention on the kind of mundane preoccupations which colour everyday life – in Wallinger's case we might cite bird-watching, football and horse racing – and provides us with an exemplary critical space in which to position ourselves in relation to the author's world view as well as the subject of depiction.

In the case of the particular work which inaugurated this present discussion, *Stately Home*, the purpose underlying this carefully contrived duality of reading can be summed up in the form of two quite straightforward dialectical functions. Firstly, by addressing what are preeminently social and political questions through the allegory of St George and the Dragon – a device which Ruskin had used before him in his letters to the working men of England, 'Fors Clavigera' – Wallinger encourages us not only to ask questions about the authenticity of a given social order, but a lot about the veracity of his critical reconstruction of that order. Secondly, by using parabasis, he invokes the authority of the one who is 'presumed' to know, at the same time as exposing himself as nothing more than a subject of knowledge. Nothing, then, is ever simply what it seems. In this respect, these two ironic modalities, as they reveal themselves in Wallinger's work, have a strong element of the carnivalesque about them and are closely allied to masquerade.

This quality of masquerade occurs in a very obvious form in the six-part photographic work, *Passport Control* (1988), in which the artist works over images of his own face, coding them as ethnic stereotypes, and achieves its most complex form in the series of painted portraits, *Capital* (1990) made two years later and exhibited at the ICA, London in 1991. In *Capital*, Wallinger again chooses to parody a particular art-historical genre: the full length court portrait, the contemporary version of which is the boardroom portrait. Each figure is positioned centrally in front of a grand architectural detail. But Wallinger's subjects are no princes, princesses or presidents; company directors, chairwomen or chairmen, but down-and-out, homeless men and women, posing not in palatial interiors, but in the street, before the imposing entrances of well-known city banks. If there was no more to the reading of these works than can

be summed up by the causal assertion that capital, at the other end of the economic spectrum produces poverty, then we might be forgiven for concluding that the artist is making his political point with a bluntness not far removed from crassness. But there is a curious and palpable ambiguity about these figures, a feeling that they are acting out their role for us, the audience, at the behest of an invisible control. Like actors in a play, Wallinger's socially disadvantaged ragamuffins strut the stage of capital, exchanging intimate and knowing glances with the viewer, asking, on behalf of an extra-pictorial, authorial voice, that we consciously embrace artifice – that we knowingly suspend our disbelief.

This element of masquerade is integral to Wallinger's critical intention. By using friends – fellow artists, critics and writers – as models for the figures in these portraits, and at the same time making this subterfuge apparent, not only does he secure the work against the charge of voyeurism, but also successfully extends the reading of it into the realm of reflexive, ironic commentary. Accordingly, we are all implicated in the charade of *Capital*. Either actually or metaphorically, we are all financial opportunists as well as the more or less innocent victims of capitalism's dehumanising mechanisms. We might all, quite justifiably, be posed as economic and spiritual vagrants before the great bronze doors of the Chase Manhattan Bank, or stride its marble halls as surrogate executives and money-men. Wallinger offers us no escape from the cruel oppositionary forces which together shape our lives in the theatre of capital. We are reminded of the words of the nineteenth-century moral philosopher, utopian thinker and social reformer, the Mancunian, Henry Bradshaw, who, in an open letter addressed to 'The Men of Threadneedle Street', wrote: 'Usury is the same evil as war; the taking of interest makes of us all its carrion flesh.'

I have chosen to use this rather barbed quotation from Bradshaw, not simply because it seems to capture the underlying spirit which informs *Capital* but it also serves to connect Wallinger with a distinctly British tradition of Left-wing thinking, one which, historically speaking, was rooted in the Christian nonconformist origins of the British Labour movement. This was a political radicalism which arose from below. It was the very opposite of the lofty, patrician socialism of Oxbridge scholars and Hampstead Marxists. It spoke the language of ordinary working men and women and dressed its most solemn thoughts in popular metaphor.

Wallinger, himself, has said repeatedly that he intends his work to be readable not just by the art *cognoscenti* – that he wishes it to resonate well beyond the narrow confines of the art world. This ambition is most clearly

revealed in the choice and metaphorical thrust of his subject matter. One of the most lucid examples of this was the exhibition, *The Full English*, made for the Anthony Reynolds Gallery in 1994. Here, two discreet works, a wall-sized photographic piece and an object-sculpture – each deploying its own specific metaphorical array – were bought together to produce an even more complex set of possible meanings through the strategy of installation.

The Full English, it should be said, showed Wallinger flirting dangerously with the sardonic. The huge photographic work in which Wallinger appears in the midst of an animated crowd of football supporters holding aloft a Union Jack, appears at first sight to be claiming the artist for that flag-waving, jingoistic nationalism and mindless tribalism which finds its most familiar outlet in football violence. But with the deftness of conceptual touch which is so much a feature of Wallinger's later work, he succeeds in turning this potentially regressive reading on its head.

Once more we find him resorting to the use of 'parabasis'. While the crowd is advancing towards the camera – one man, arms raised, seems almost to be rushing forward to occupy the gallery space – the artist and his helper are conspicuously static. They are in the scene, but not quite part of the action. Occupying the middle-ground of the photograph, holding their banner high overhead, they have more the air of people attending a political rally in Trafalgar Square than excited football supporters on their way to a needle fixture. More pointedly, they are displaying a Union Jack which has been deliberately and very neatly 'defaced'. The artist's name MARK WALLINGER – is lettered in white block capitals across the red horizontal band of the cross of St George. The critical issue to be addressed, then, is clearly that of identity, and this reading is underscored by the title, the format of which we are all familiar with from our school days: *Mark Wallinger, 31 Hayes Court, Camberwell New Road, London, England, Great Britain, Europe, The World, The Solar System, The Galaxy, The Universe* (1994).

Thus the politics of identity is signalled as a question that must be dealt with on the macro as well as the micro level.

Identity, then, and this, Wallinger is suggesting is true for each and everyone of us, while it is socially constructed, is formed in relationship to factors which reach beyond the boundaries of any particular social or interest group – beyond even the influence which accrues from being born or long-time domiciled in a particular place – town, region or country although all of these factors play their part in the process of its construction.

We have what might be called a constitutive identity shaped by immediate circumstances, and for most of the time we can feel reasonably comfortable and at home with this; but it is only half of the equation. There are other, more distant and ultimately more powerful forces at work which can threaten to fragment or erode this illusion of centredness completely. These are the forces which drive us to look for security elsewhere, in collective identities shaped by chimeric wish-fantasies and simplistic political slogans. At one end of the scale the tribalism of the football supporter, at the other the rabid nationalism of the far right. Like the schoolboy inscribing his solipsistic litany in the front of a new notebook – thereby fixing himself at the centre of all that is, known or knowable – while the geography teacher drones on about coffee yields in the countries of the Southern Hemisphere, we all feel the need to be able to say, with some degree of certainty, who and where we are. The danger is that we mistake the need for certainty as a guarantee of certainty itself, that we begin to see identity as given to us by god, biology, history or nationality, All sorts of barbarisms ride on the back of such an error: gender-prejudice, blind nationalism, racism, homophobia, the list is extensive.

By bringing this work together with *Behind You* (1993), the object sculpture which occupied the gallery space in *The Full English*, Wallinger carried this reading a significant step further by advancing a special case.

Here two male figures perform an intimate homosexual act, dressed in the traditional comic costume of the Pantomime Horse. The ambiguous nature of this masquerade – the alterity of reading it proposes between the homosexual as a subject of popular prejudice, ribald comment and gratuitous verbal abuse and the Pantomime Horse as object of good-natured, even affectionate banter – is another example of Wallinger's determination to confront the viewer with difficult interpretive tasks.

Clearly, the issue is again that of identity – in this case, sexual identity – and it is further complicated by an element of contractual roleplaying, The very English expression 'horsing around' springs to mind. Men playing boisterously together, with a tacit agreement between the parties about how far to go, or else the play tips over into real violence. In this respect, the Pantomime Horse willingly submits itself to humorous play, and part of its abiding charm is that it does so with an air of pathetic resignation. Like the figure of Pierrot in the *Commedia dell' Arte*, it seeks and finds security by being complicit with the forces of its own victimisation.

As the eighteenth-century Irish satirist, Jonathan Swift, discovered when in a short pamphlet called *A Modernist Proposal*, he advocated consumption by the aristocracy of *fattened* year-old babies – 'stewed, roasted, baked or boiled' – as a way of ameliorating the 'over-production of children by the lower orders', thus wreaking the wrath of the Irish Catholic establishment; an irony of the kind of enmity invoked by *Behind You*, risks catastrophic misunderstanding. It assumes that we are all able to see beyond the smile to the pain that lies beneath and, beyond the pain, the fear; that we can all discover within ourselves a similar fear and detect the hollowness in our own laughter. It is a tribute to Wallinger's critical grasp on his subject matter – his own control of context and deft use of nuance – that *The Full English* succeeded in avoiding this kind of misunderstanding.

We have already touched upon the fact that both of these works focus on what for Wallinger is a key theoretical concept: the shaping of identity through social construction. It occurs in a fairly straightforward form in early works like, *The Bottom Line* (1986) and *Natural Selection* (1988) but surfaces in a very sophisticated and less overtly political form in the seven-part work, *School* (1989). This work is crucial in another respect, in that it links the political and social dimension of his work with the post-Duchampian discussion of the object which is so much a characteristic of a great deal of contemporary art in Europe and America. The work comprises seven schooroom blackboards, each with a perspective drawing in white chalk of a typical school site: 'the Classroom', 'the Assembly Hall', 'the Woodwork Room', 'the Gymnasium', 'the Changing Room', 'the Climbing Frame' and 'the Playground'. The first six of these have their construction lines intact, and where these lines converge at the vanishing point Wallinger has placed a lighted-bulb. By contrast, the seventh board, 'the Playground', is a construction plan – two tennis courts side by side, laid transversely over a five-a-side football pitch – and the lighted-bulb is placed centrally to coincide with the point at which the game would kick off.

School was made at the same time as *Capital*, and Wallinger has said that while the latter was intended as a very public statement addressing itself to collective consciousness and collective memory, *School* functioned in relationship to individual memory, and thus provided what was an altogether 'more private' experience. Leaving aside the fact that Wallinger made the drawings from photographs taken in the school where he spent the most formative period of his own education, the notion that 'schooling' can be linked

easily to an idea of 'privacy' is, at first sight, a curious one. As institutions, schools are perhaps the most public of places, and since we are all compelled by law to enjoy or endure them, they are the most obvious and most naked public instruments for the shaping of identity and the formation of society.

Of course, both *Capital* and *School* are about power: how power bares down upon the lives of people, and most fundamentally, about how it represents itself. While *Capital* reveals it as a grandiose, institutional illusion, *School* reaches beyond the theatrical facade, beyond the opaque rocky faces of those institutions which seem, from the outside to constitute the very seat of power – banks, law courts, schools and the rest – in order to point to its structural character. As the French philosopher and theorist, Michel Foucault, has so cogently argued, in complex modern societies – within the battery of institutions which together formulate their governance – power no longer resides in the hands of individuals. There are no kings, princes or satraps replete with divine rights and absolute authority; rather, power is diffused structurally throughout the whole system. In *School* then, by the use of single viewpoint perspective, Wallinger raises a most appropriate metaphor through which to discuss power at the level of its representation. Perspective pretends a 'truthful' coincidence between its own constructions and the visible world. Superficially, it seems to put everything in order. Just as the institution of 'schooling' claims to be able to capture the fundamentals of human knowledge for the common social good, so perspective seeks to claim everything in the physical world for a unified system of representational control. The metaphor is indeed a telling one, most especially because perspective constructs its representation of the visible world back-to-front: from the vanishing point, the place at which nothing can exist or make itself visible, forwards into a fictive space, which, while it is possessed of internal structural integrity, is only paradigmatically related to the way in which we really apprehend the world. In this sense, perspective involves a special kind of a lie, a lie which Wallinger renders transparent by placing the lighted bulb, the source of illumination (metaphorically speaking we can cast this as knowledge which transcends institutional patterns of learning) at the point at which, according to perspective's own logic, everything disappears.

The American playwright, Edward Albee, has said that consciousness of the ironic, at its most basic level, is nothing more nor less than 'being aware that we are reading between the lines'. As pupils in Wallinger's classroom we are made critically aware of being able to do nothing else, and this is where the claim to privacy comes in. We can only fill in its blank, black expanses – large

and small – from the landscape of our own memory, and we must do so in dalliance with the scary poetic trope of eternal absence. The purpose of *School* is to encourage a truancy of mind, from the childlike daydream to cosmic dispersal, Mallarmé's *Igitur* and the authorial voice of the narrator in Samuel Beckett's, *What*: 'Where now? Who now? When now? Unquestioning I, say I.'

In a recent conversation with Wallinger, he admitted to having become more and more engaged with the question of absence. He cited as examples two installation works, one devoted to the comedian, the late Tommy Cooper, made for the London gallery, City Racing in 1993, which bore the clever palindromic title, *Regard a Mere Mad Rager* (1995), and the other, *Untitled* (1994), made at Richard Salmon Ltd in the artist and filmmaker Derek Jarman's studio, shortly after his death from AIDS.

In both installations, Wallinger was concerned with the tricky problem of how to construct an absent subject – a subject who is mourned – without mawkishness or sentimentality. They had to capture something of the spirit of Tommy Cooper or Derek Jarman – as it persists in the memory – and at the same time provide space for a more open-ended contemplation of the meaning of loss. Not surprisingly, given this seriousness of intent, these works show the artist at his most formal, most conceptually punctilious, and least aggressive. In *Regard a Mere Mad Rager*, he uses the mirror-symmetry of visual, oral and written palindrome – a videotape of Cooper played backwards – to create an 'unfigured space' filled only with the scrambled sound of Cooper's voice. In *Untitled* (1994), Wallinger inserted a locked or silenced, grand piano into the preemptive ceremonial geometry of Jarman's workplace, filled with the recorded sound of the piano being tuned in discordant thirds, punctuated by birdsong coming from an open window. Both pieces see absence in terms of a 'passage' in time and space, experienced as a 'sectioned' or arrested transmission. The sectioning occurred in the Tommy Cooper installation at the surface of the mirror which replaced the window to the outside world, and in the Jarman work at the point of entrance and exit, the threshold of Jarman's studio.

I suggested earlier that the work *School* had an important Duchampian aspect to it, and we can now usefully fill this out by reference to Wallinger's temporal construction of absence in the two later works.

The notion of transmission – the sectioning of time and space is characteristic of Duchamp's use of 'causal' irony; an irony which Duchamp described as a re-working of Cartesian principles of logic to create a believable world, one which was parallel to, but self-evidently distinct from the real world.

He examples this by reference to the fantastic novels of Raymond Roussel. This brand of causal irony occurs in it most complex form in *The Large Glass – The Bride Stripped Bare by Her Bachelors, Even* (1961) – wherein all modes of spatial-temporal representation, (two, three and four dimensions) are made to coexist as a coherent structural narrative on the surface of a transparent sheet of glass. This idea attains its most elegant formulation in the Duchampian concept of the 'infra-thin'. The 'infra-thin' implies a transfer of energy which has no discernable agent of transmission, or which is, in the very strictest sense, an agent which is 'less than thin'. Conceptually then, the 'infra-thin' is as much about absence as it is about presence, and its nearest equivalent in language is the forward and backward anagramatisation of the palindrome. It bridges time and space (to use a rather curious example from Duchamp himself), in the way that the sound of two trouser legs brushing together in the act of walking bridges time and space. The connection between this, the Duchampian notion of transmission and the palindromic construction of *Regard a Mere Mad Rager*, is fairly obvious, and if we begin to think of threshold as a plane of transmission between absence and presence, then *Untitled* (1994), fits neatly into place too; *School*, however, remains a more complicated case.

In its own way, it is also about loss. It too, seeks to evoke a version of absence, but in the form of a disembodied viewing subject. If we choose to engage directly with its migrating vanishing-points and shifting eye-levels, then we are made captives of its deadly, diagrammatic net. Time present is collapsed into time past, and we can only secure ourselves against this imminent danger of slippage through the most immediate object of our fixation – the lighted-bulb – which remains stubbornly attached to real time. We are held then, on the very threshold of memory, at the point at which memory is continually reconstructing itself. We are made to experience our own memorial 'transmissions', as if through a semi-permeable membrane. Only when Wallinger turns us loose to roam the lucid, two-dimensional, planal space of the 'playground', where the timeless geometry of pitch and rule points away from the past of memory towards actions that might be taken in the future, are we offered some small respite. Again we find Wallinger reaching for the metaphor of sport – this time in order to release us from *School's* crippling double-bind. This is the nearest he will allow himself to go towards a metaphor for political freedom.

The artist turns again to this conceptual conundrum of transmission, and in openly Duchampian terms, in the work *Fountain*, an installation made for the Anthony Reynolds Gallery in 1992. In this work,

a water-hose made its serpentine journey through the gallery space, from a tap in the basement to the first floor, eventually passing neatly through the plate-glass window, where it emerged as an adjustable nozzle releasing a gently arching, continuous stream of water onto the pavement, from where it made its way to the gutter and back into the public drainage system. As the title suggests, it is intended that we should read this piece with Duchamp's 'urinal' – also called *Fountain* – very much in mind.

Typically, the comparison which Wallinger's *Fountain* invites, is more dialectical than it is tautological. Indeed, his work figures almost as a conceptual mirror image of the Duchamp work. Where the 'urinal' is disconnected, non-functioning, Wallinger's *Fountain* is very much connected and active. Where the 'urinal' is gendered as feminine – horizontal, gynaecological and vulvic – Wallinger's *Fountain* is conspicuously masculine: vertical, ejaculatory and phallic. Where the Duchamp piece is about erotic stalemate and voyeuristic paralysis, Wallinger's piece seems to involve a vision of superfluity and Rabelaisian excess.

In this regard, much that was written about the work when it was first shown, made the connection with Duchampian erotics in a far too simplistic way. Certainly there are connections to be made, parallels to be drawn with the economy of liquids – water and gasoline – in works like *The Large Glass* and *Étant Donnés*, but they must be made with a measure of circumspection. Eroticism in Duchamp is invariably obsessional, locked in and private, while the eroticism of Wallinger's *Fountain* seems almost casual; certainly it is very public. Furthermore, the allegoresis practised by Duchamp is always one of arrest, while Wallinger offers us an allegory of completion, albeit a completion which, from a political standpoint, has a disturbing sting in its tail.

The key to unravelling the particular 'causal irony' of 'transmission', which lies at the heart of Wallinger's *Fountain*, the notion of repetitive circularity. The water passes from the private to the semi-public domain, from the semi-public to the public and back to the private domain via the network of public facilities and institutions which underpin what we might call 'hygienic' social life. The work proposes an endlessly repeating alterity of oppression and release, to be seen as a societal allegory. Its version of eroticism, then, would seem to be closer in spirit to the post-Freudian, politicised Eros of Herbert Marcuse, than to be deeply personalised, frustrated erotic play of Marcel Duchamp, More pointedly by circumscribing a space in which the idealistic

and materialistic aspects of contemporary culture collide head-on, it directs our attention to the politics and validation at work in the vertical – we might say phallic – culture, and shows its seemingly carefree masquerade of abundance, to be very largely reiterative and self-reflecting.

As we have seen, Wallinger tends to work with conceptual models which, stripped of their surface elaborations, are often disarmingly simple. We might cite the figure-ground separation in the construction of 'parabasis' in works like *Capital* and installations like *The Full English*, the reversible linearity of the palindrome in *School* and *Regard a Mere Mad Rager*, or implied ouroborus in *Fountain*. And if, for a moment, we raise the dense representational cloak that hides the conceptual ground of Wallinger's 'horse racing' works, we find another very similar structuring device at work; the bifurcating linearity of the genealogical map.

The first series of these works bares the punning title, *Race, Class, Sex* (1992) and was shown at the Saatchi Gallery in 1993. Comprising four life-sized 'portraits' of thoroughbred stallions, representing a single breeding line reaching back to *Eclipse*, painted by George Stubbs in the eighteenth century, they display marked difference of colour, size and conformation. They are self-evidently groomed, polished, highly specialised racing machines, more man-made than natural, and this feeling of artificiality is heightened by the slightly exaggerated character of Wallinger's *trompe l'oeil* technique. Isolated against a stark white ground, they have a strongly emblematic, even a mythic quality.

Here Wallinger layers a number of different genealogies of representation, one on top of another. The two most obvious references are to art history and horse racing: the recasting of a historical painting genre in terms of the rhetoric of the stud book. But this rather straightforward duality points to another reading which is altogether more interesting: they can be read in terms of a discourse on representation itself. Between these more or less overt matrixes of interpretation there occurs a complete network of more speculative, metaphorical references which for the most part subsist in the socio-political domain and cohere around the topic that we have already addressed in relation to other works: Wallinger's insistence on the social construction of identity, race, class, and gender.

We are left then to face one outstanding question, and it concerns the nature and limits of representation. At first sight, the theoretical drift of *Race, Class, Sex* would seem to be a totalising one: something like the Baudrillardian hall of mirrors. It would seem to be suggesting that there is,

quite literally, nothing else but representation, at least at the point of reception. It casts the horse as subject and constructed object, as depiction and work of art; and the work of art as exemplary of craft and genre, and of representational 'style'. Finally, and tautologically it 'pictures' representation as some kind of steady state, a plane of coincidence between mind and world. All would seem to be subsumed within the reiterative maw of mimesis. But Wallinger is far too critically astute to fall into this kind of nihilism without a fight. By a neat piece of visual legerdemain he succeeds in turning mimesis against itself. The device is a simple one: he presents us with only half a picture. The subject – that of origin, ownership and control seen in terms of political allegory – is split and re-framed. The horses' reins pass out of the picture to an invisible hand – to an unspecified, controlling subject who can only exist in real time – thus creating a critical ambiguity between the horse as horse and the horse as painting. By this means, both are brought under the over-arching political metaphor of property.

This reading can be further reinforced by reference to the later 'horse racing' work, initiated in 1994 and still ongoing. A 12-strong syndicate – the artist included – bought a two-year-old filly and Wallinger named her *A Real Work of Art* (1994). In reference to this conspicuous act of nomination, Wallinger wrote: 'Here, beyond representation, was the lost object which I could restore in all its fullness and potential by denoting it as a work of art.' The tone is ironical, the statement itself, paradoxical, but the intention is more or less clear, to rescue reality, even if for only the most fleeting of moments, from the snappy jaws of representation.

As I have already suggested, Wallinger is still, at heart wedded to vanguardism, but such a claim needs careful qualification. Although he re-works and reuses a number of the strategies familiar from the historical avant-garde, he differs radically from these earlier tendencies in his attitude to subject matter or, to be more precise, in the way in which he characterises the relationship which obtains between the human subject – our subjectivity – and the social world. As the American critic, Meyer Schapiro pointed out in his seminal essay of 1936, 'The Social Basis of Art', (despite its antagonistic posturing) the modernist avant-garde evolved in harness with the emerging industrial and post-industrial middle class. It exploited the new space and taste for leisurely living; addressed itself to the refined consumer of luxury goods and celebrated a notion of individual freedom under the banner of social and political progress. At the deepest cultural level, it worked with a

version of the ideal human subject made in the bourgeois image of personal freedom, independence of mind and material advancement. More pertinently for our purposes here, it inaugurated a reactive contract between itself and the new 'moneyed' class, a contract which persists to the present day. Indeed, it remains a precondition for the successful marketing of the aesthetic avant-garde, even for those artists who, like Wallinger, see themselves in a critical relationship to this constellation of cultural, economic and class interests.

In this respect, Wallinger is caught on the horns of a dilemma. As a well-informed, practical intellectual, he is possessed of the critical tools necessary to render the mechanisms of oppression visible. He knows very clearly what he is angry about. But he also knows that the contemporary world, where political power is difficult to situate, he too is subject to its inherent arbitrariness and contradictions. His solution to this double-bind is to use the provocative tactics of vanguardism, linked with the will-o-the-wisp, incursive gamesmanship of the bricoleur, as a form of resistance. And, when he chooses to make a frontal attack, he does so in order to show the way in which the play of structural power disfigures and distorts the surface of social life.

Mark Wallinger: Ikon Gallery, Birmingham, 25 February – 1 April 1995, Serpentine Gallery, London, 10 May – 11 June 1995, exhibition catalogue, Ikon Gallery, Birmingham, 1995, pp.7 – 22.

This essay was a response to an invitation to contribute to the catalogue of *Revolution: Art of the Sixties Warhol to Beuys*, the opening exhibition at the new Museum of Contemporary Art in Tokyo. The brief was to give a political overview of the forces that shaped European and American art in the 1960s – a daunting task that came at comparatively short notice. I remember that I really had to struggle to sort through the wealth of critical material relating to what was perhaps the most complex political and cultural moment post the Second World War. In the end, I FedExed it to Japan feeling that the piece had all the signs of having been rushed; that I rambled too much and it was only barely adequate. Reading it again now I am surprised at how close it comes to a comprehensive account and how well it reads despite certain overly abbreviated arguments and some obvious omissions.

REALISM, POP AND POVERTY

For many years, and for many people, the words 'revolution' and 'modernism' were made almost interchangeable terms. In such times the modernist project was seen as a process of continuous revolution, action and re-action: ongoing and without end. A revolution, in other words, not simply of material circumstances, but also of the human consciousness; a revolution in the aesthetic domain, almost in the classic Maoist mould. Now, it would seem that we all know better. Viewed from this, our position in the centre of the relativistic, cynically eclectic and apparently 'value-free' swamp of postmodernity, we feel free to deny our 'heroic' past, describing it instead as a series of collapsed utopias, futile ethical projects and failed revolutionary moments. With our feet planted firmly in the here and now – even while the bulldozers are still busy irradicating the last traces of the Berlin Wall, that troublesome symbol of global ideological division – we feel at liberty at last to contemplate a new world order, built in the shadow and image of the 'market-culture' inimitable of late, high capitalism.

But we would have to be very simple minded indeed to view this, the transition from 'modern times' to the free-floating condition of postmodernity, in this blindly optimistic and – dare I say it – mindlessly benign light. The notion that the market, if left to its own devices, can and will

deliver everything, from individual material well-being to the 'just society', and will do so ultimately on a global scale, is surely a chimeric wish-fantasy of even greater magnitude than any of the utopian, socialist dreams that powered high modernism in the 1960s and the 1970s. More significantly, it is entirely without the tendency to reflexivity and critical self-consciousness which modernity, viewed as a value rather than simply as a changing and contingent historical moment, demanded of its adherents.

If there were no other reason, then, for looking at the art of the 1960s under the general heading of 'revolution', excepting for the fact that it provides us with a dramatic ideological counterpoint to the art of today, and one that is in urgent need of critical analysis, this alone would be sufficient reason. But add to this the important consideration that the decade of the 1960s saw most of the inherent contradictions and tensions of modern life brought into sharp political focus in almost every field of human endeavour and sphere of thought, from the 'hard' sciences to the visual arts, then the historical and critical importance of mounting such an exhibition is guaranteed.

As all of this would tend to suggest, it seems to me impossible to deal adequately with the art of the 1960s – in all its complexity – without bearing in mind a checklist of socio-political and economic topics that are stitched into the very fabric of life in the postwar period: the legacy of colonialism and the trauma of de-colonialisation; the gathering momentum of world poverty; the politics of the Cold War and the psychology of the nuclear deterrent; the shifting patterns of global industrialisation; the expansion of educational opportunity and the rise of popular culture; immigration and racial oppression; the imperialistic adventurism of the Super Powers in South East Asia, the Caribbean and Latin America. Taken all together – but inflected somewhat differently when filtered through the historical consciousness of separate nation-states – this often highly explosive cocktail of issues forms the vital back-drop against which we must view the vanguardist art of western Europe, North America and Japan, if we are to reach beyond the conventional view afforded by 'official' postwar art history.

That America, through the machinations of the State Department – in the 1950s – decided, quite deliberately, to use art as a weapon in the propaganda war with the Soviet Union, is by now a well documented fact. Viewed in retrospect, the reasoning behind this decision seems to us today to have been simplistic, even naive. Seen as the antithesis of the Russian 'Socialist Realist' artist, victim of the aesthetic dictates of the Soviet State, the American

artist – the Abstract Expressionist painter – by contrast was cast in the exemplary role of 'free individual' acting independently under the rule of law. While the 'Socialist Realist' personified the oppression of the individual and the regimentation of social life, the Abstract Expressionist celebrated 'newness', exercised personal creativity, believed in human progress and made work which bore testament to a better life and a better future. It is also by now a matter of historical record that this crude propagandistic construction was directed not at the people of the Soviet Union and her Eastern European satellites, nor even at politically unstable governments in the countries of the developing world – around the Pacific rim, in the Middle East or Central America – but at America's own allies in Europe, in particular it was directed at Britain, France, Germany and Italy.

According to the collective wisdom of John Foster Dulles, the US State Department and the CIA, the issue was one of how to secure the solidarity of America's main European allies, which, in the paranoid atmosphere of Cold War politics was not something that could simply be taken for granted. From the other side of the Atlantic, the European democracies seemed to be under attack from within by largely Left-of-centre protest groups, mobilised by peace campaigners and student unions and supported by left-wing politicians and liberal intellectuals. In Britain, the anti-nuclear movement, CND, had acquired a substantial following in the wake of the Suez Crisis and the Soviet invasion of Hungary. They were able to organise demonstrations on a national scale. While the more prestigious Committee of One Hundred, which boasted amongst its number some of the foremost artists and intellectuals of the day, was mounting large and heavily publicised demonstrations using non-violent civil disobedience, in the very heart of London. It was not long before other European capitals saw a succession of similar protests, often accompanied by more violent confrontations between Left-wing students, peace campaigners and the police.

In truth, both Italy and France had shown signs of deep-seated political, even constitutional crisis, from the end of the Second World War. In both countries, a procession of elected leaders and governments had shown themselves incapable of establishing a stable political atmosphere or substantial periods of effective governance. France, a key member of NATO because of her military strength, was of particular concern to the Americans at this time. She was experiencing the failing political light of the Fourth Republic; a constitutional weakness greatly exacerbated by internal power

struggles brought on by the shedding of her African colonies, and more particularly by the Algerian problem. Even the return to public life – in 1958 – of the powerful and stoic figure of Charles de Gaulle, with a mandate to extricate France from the Algerian War, introduce constitutional reforms and usher in the Fifth Republic, provided little comfort for Foster Dulles and the American State Department. De Gaulle was an old style French nationalist who wanted to use French power and French influence on the international stage, chiefly for the benefit of France. Furthermore, he was openly critical of what he saw as American interference in European affairs.

Given this background of apparent instability amongst America's allies, it is perhaps not so surprising that the US felt the need to build upon, and reinforce her cultural ties with Europe, especially at the level of the cultured, middle-class intelligentsia. What is surprising, however, is the naked insensitivity with which she set about it, and nowhere was this more apparent than in the field of the visual arts. Indeed, the ideology of political freedom claimed for doctrinal Abstract Expressionism, in reality was no more than a piece of political slight-of-hand. Not only did it deny the personal histories of many of the artists involved, but it also denied the history of the movement itself which had been promoted and sustained mainly by critics of the Left. Nevertheless, as part of a propaganda package, this piece of political trickery seems to have worked. Certainly it contributed greatly to what can only be described as a process of 'Americanisation', occurring in European art in the middle and late 1950s and the first half of the 1960s.

To give this assertion some historical perspective. By the early 1950s, Jackson Pollock, Willem de Kooning and Arshile Gorky had already figured in exhibitions in the American pavilion at the Venice Biennale. Given the calibre of the artists concerned this, in itself, is perhaps not surprising. The mid-1950s, however, showed a dramatic change of gear with respect to the promotion overseas of the 'new' American painting. Within a span of five years, three large-scale touring exhibitions – promoted by state agencies, supported by Rockefeller money and organised through The Museum of Modern Art in New York – had been dispatched to Europe and selected countries in Latin America and the Far East: *Modern Art in the USA*, which toured eight countries in Europe during 1956; Alfred H. Barr Jr's, *The New American Painting*, an exhibition devoted exclusively to Abstract Expressionist painting was on world tour for two years starting in 1958; and in 1960 the *Vanguard America* exhibition opened in the new American Embassy in London en route to Paris and Berlin.

However, it would be misleading to suggest that the process of Americanisation that happened in European art in the 1950s and early 1960s was entirely the result of US efforts in her propaganda war with the Soviet Union. Indeed, it is arguable that the promotion of American art would have made very little difference but for the fact that these exhibitions coincided with profound changes already underway in the social and cultural fabric of Europe in general and of Britain in particular in the period following the Second World War. It is therefore worth examining something of the political background against which the first of these touring exhibitions, *Modern Art in the USA* was seen in the countries of western Europe.

The 1950s were a sombre decade as far as European politics were concerned. The euphoric mood and political optimism of the postwar period had begun to falter. With the exception of the German economy which was showing steady and sustained improvement, the recovery of the other main European economies had not been sustained; and at the same time a more broadly educated, younger population were demanding a different, less acquiescent lifestyle within a more open society: greater political influence; more personal freedom and increased spending power within the several national economies. In reality, of course, this was one of the most telling outward signs of the much deeper social and cultural changes underpinning the emergence of what sociologists later called 'Youth Culture': a specific socioeconomic category within the broader sweep of postwar 'Popular Culture'. Youth Culture, by its very nature, was dissatisfied, rebellious and in the pursuit of change: a new generation seeking to wipe away some of the shibboleths of existing 'high' culture including entrenched, middle-class establishment attitudes; the rigidities of the class system; nineteenth-century moral values; the control ethos and the demand for social and political compliance. More than anything else they rejected the lifestyle of their parents. This was a generation of young people who wanted to grow up fast and live recklessly, and they found their own particular brand of hero personified in the wayward, filmic image and ill-starred life of the film star James Dean. For them, he more than any other, seemed to sum up the ambivalent, even nihilistic psychology of young lives lived out under the shadow of the Bomb. And his death, when it came so unexpectedly in 1955, seemed as much a consequence of the Cold War as the Korean conflict, the McCarthy hearings and the Suez Canal crisis.

These 'teenagers' – and the word was first coined at about this time – the life experience of the first two or three generations which together shaped

the first manifestations of Youth Culture, spanned a decade which started with the Korean War and finished with the U2 Spy Plane fiasco. And in between they witnessed the Soviet invasion of Hungary, the beginnings of the Vietnam conflict, and the communist takeover of Cuba. All of these separate events served only to demonstrate to them – this more sceptical and more politically demanding generation – just how fragile a thing peace can be. Youth Culture was thus made at one with the culture of protest.

Within the specialist discourse of the visual arts, the early 1950s in Europe had been dominated by a return to 'realist' painting, even it might be described as 'social realist' painting. In the three years immediately preceeding the London showing of *Modern Art in the USA*, for example, the Tate Gallery alone included in its programme a group exhibition of the new French 'realist' painters grouped around André Mineaux, and solo exhibitions by the Belgian painter of rural life, Constantine Permecke; the Italian socialist realist painter, Renato Guttuso; and the British painters of agricultural and industrial life, Joseph Herman and L.S. Lowry. Add to this the significant fact that the most successful private gallery in London at that time, the Beaux Arts Gallery, showed only realist painters of the generation of Jack Smith, Derrick Greaves and Edward Middleditch, and the more expressionistically inclined younger painters who had been taught by David Bomberg, the most notable of whom were Frank Auerbach and Leon Kossoff, and in the case of Britain at least, a very curious picture emerges. It was not that news of the so-called 'new' American painting had not reached her shores, on the contrary, its influence was already reasonably well established in two very active regional centres: in Leeds, through the institution of the Gregory Fellowships and with the active support of the critic Herbert Read, and most notably in St Ives, Cornwall, where a number of British abstract painters including Patrick Heron, Peter Lanyon and Bryan Winter, lived and worked. Significantly, prior to the American exhibition of 1956, this generation of British abstract artists, although they had London galleries that regularly showed their work – the Waddington Gallery and Gimpel Fils, for example – enjoyed very little 'official' support. It was only after the American 'occupation' of the Tate Gallery that their work began to be collected by major public institutions.

In retrospect, it seems clear that by 1956 the stage was already set for some kind of fragmentation to occur at the very centre of the European culture of high art. For the most part, the creative atmosphere in the main cultural centres, where it was not stagnant and inward-looking, was reactionary or

critically oppressive. Paris was living through the twilight years of the School of Paris. A new generation of artists, amongst them such important figures as Pierre Soulages, Hans Hartung and Yves Klein, were struggling to escape the critical burden placed upon them by comparison with the acknowledged masters of their own tradition; Picasso, Braque and Matisse. While in Germany – an occupied country up until the summer of 1955 – artists were still trying to work through the complex and bitter historical and cultural legacy of the Second World War. And here a significant split had already begun to show itself, between artists like Wols, Ernst Wilhem Nay and Willi Baumeister, who were pursuing a transnational identity for postwar German art, based upon what they saw as the 'internationalism' characteristic of the School of Paris, and others like Gerhard Altenbourg and Joseph Beuys who were more concerned to understand and accept as crucially important, the almost mythic force of Germany's cultural heritage, and – more specifically in the case of Joseph Beuys – to redefine its political meaning in the context of contemporary social life.

Here, Beuys was inaugurating a debate in the German situation around the question of the trajectory and political purpose of art, which was already much more advanced in Italy.

Unlike their German counterparts, a number of the most influential Italian artists, especially those committed to the Left, had found refuge during the Second World War in the anti-fascist resistance movement, where they had carried on an intense political debate about the future of Italian art. Even as early as 1942, the Corrente group, which included such diverse figures as Emilio Vedova, Renato Birolli, Bruno Cassinari and Renato Guttuso, had published a manifesto calling for an art which fed upon popular images and took account of 'life as it is lived' by embracing 'realism as an explicit manner'. While there is little doubt but that this manifesto, in as far as it set an explicitly revolutionary agenda for postwar Italian art, was of great historical importance, it also served to cover over deep ideological divisions. There remained fundamental differences in creative philosophy and conceptual method between the main parties, disagreements which emerged again with great force in the 1950s, and which paved the way for the crucial moment of Arte Povera in the decade that followed.

The key theoretical argument revolved around the definition of the term 'realism'. For those on the pro-Soviet Left – the communist group led by Renato Guttuso – referred to as the 'Picassoists' because they had declared Picasso's *Guernica* (1937) to be the exemplary modern revolutionary painting,

'realism' was defined along unequivocal socialist realist lines: not a mimetic but an expressive realism, intended to extract high sentiment by addressing the everyday lives of ordinary men and women. In their broad objectives this group correspond very closely to the new generation of social realist painters active in France and Britain at the time, to which I have already referred. And indeed, Renato Guttuso had some direct influence upon the British group through his friendship with the Marxist critic, John Berger. But there were other versions of realism in play too, ranging from the ideologically softer and more poetic Arte Sociale proposed by the magazine *La Fabbrica*, to the radical extremism of the Milan-based, self-proclaimed 'objective realists', co-signaturists of the Manifesto del Realismo with Emilio Vedova and Ennio Morlotti. Theirs was an altogether more interesting and at the same time more problematic version of the realist project. The 'real', the manifesto argued, had very little to do with 'the natural', with truth to appearances, or with the expression of common sentiment. The 'real' was beyond visible phenomena as such; rather it subsisted in a state of empathy wherein the artist achieves a consciousness at one with 'reality' as it is experienced by others. Vedova and his friends were claiming the 'real' as nothing more or less than the common human measure.

On one level, the Manifesto del Realismo – afterwards known as Oltre Guernica because of the polemic it was seeking to initiate with the more traditional socialist realists grouped around Guttuso, seems at first sight to be precariously abstract in the way in which it trades in states of mind and states of being. Almost it seemed to be arguing for a form of mystical distraction resulting in the physical dissolution of the tangible, material 'real'. But it is important to bear in mind that this was a debate that was taking place between comrade artists of the Left, many of whom were card-carrying members of the then highly respected Italian Communist Party. In this respect it was a positional manifesto which took for granted a shared political agenda and a consensus view of the main revolutionary objectives: to transform, to improve and to advance society along humanist and egalitarian socialist lines. Nevertheless, their differences were real enough, involving, as they did, opposing views of the artists' relationship to tradition; different constructions of history and historical necessity; and ultimately, irreconcilable pictures of what a future society might or should be like. Where the socialist realist painters saw themselves as part of a tradition of painting reaching back to Gustave Courbet and the brothers Le Nain, incorporating along the way all of the politically constructive elements from post-Impressionism to the Neue

Sachlichkeit, enshrined in a nationalist, communist party politics, and working a distinctive identity within a global ideology; Vedova and Morlotti were seeking to assert a renewed vanguardist position for the visual artist of the Left, making them part of an international community of creative intellectuals with a distinctly anti-Stalinist drift. And here it would seem there is a striking similarity with the debate that had split the American culturally engaged, intellectual Left a decade earlier.

This too was an argument between two quite distinct ideological positions within theoretical socialism, but in this case it was openly characterised as an opposition between an authoritarian, Soviet-style, Stalinism which aimed at the democratic control of the State apparatus – including the institutions of cultural production – and the more theoretically correct version of Marxism as argued for by Trotsky. This split is registered in a precise form in the history of America's leading cultural journal of the Left, *Partisan Review*.

Like so many of the politically inclined magazines which had grown up during the time of the John Reed Clubs and the American Artists Congress, *Partisan Review* started life as an instrument of a Leftish caucus which, while it was never entirely happy with the totalitarian direction taken by State Socialism in the Soviet Union, was certainly communistic in its general outlook. Editorially it tended to represent the brand of collectivism which saw the future of art as being redirected along specifically proletarian, class lines. By the late 1930s it had become entirely apparent to many thinking Americans that this somewhat nostalgic vision of a unified proletarian state in which ordinary working men and women controlled the means of production for the general good was difficult to square with the reality of a thoroughly modern industrial society as it was beginning to emerge in America in the wake of the Great Depression. Furthermore, it was already all too clear to many Left intellectuals, that the formation of the Popular Front, coupled with the way in which State Socialism was developing in the Soviet Union after Stalin's purge of the intelligentsia and the Moscow Trials, that communism pointed the way towards cultural conformity, administered through the apparatus of political oppression. It is by no means surprising then, that the intellectual Left in America should turn towards the more theoretically radical Marxism espoused by Trotsky, most especially because Trotsky denied the necessity of building a mass base as a prerequisite for the effective construction of culture; claimed the rules of art to be sovereign and sacrosanct; and argued forcefully that art could only usefully be applied to political revolution if it remained true to

itself. In the case of *Partisan Review*, this important shift of thinking was given a precise edge when, in 1936, it closed publication under one broad-Left editorial board to recommence publication a year later under a new board dominated by Trotskyist sympathisers, including the painter and polemicist, G.L.K. Morris, the celebrated novelist, Mary McCarthy and the professional Left-wing 'magazine-man', Dwight McKintosh. Little more than a year later, *Partisan Review* published Clement Greenberg's seminal essay, 'Avant-Garde and Kitsch' in which he sets out his classic opposition of cultural forces: the distanced, even disengaged yet progressive bourgeois apparatus of the avant-garde as against the ersatz, industrial commodity-culture he calls Kitsch – a tool of political reaction.

Although Trotsky is never mentioned by name, it is clear that the underlying theoretical drift of Greenberg's essay comes from his political writings, in particular, *Literature and Revolution*, published in 1923. In this respect 'Avant-Garde and Kitsch' is a very curious historical document. It attempts – maybe it even succeeded for a time – to reconcile Marxist ideology with that specifically modernist notion of individual freedom embedded in the notion of artistic experimentation, by making a necessity out of 'progress', invoking 'newness' as a value, and by raising the spectre of economic and social paralysis and a culture and a society in decline. More importantly from an art-historical point of view, it began the process of establishing a new, high modernist system of specialisations within the practices of art themselves built around 'conception', 'form' and 'formula', which was later worked out in its fullest form in the art movements and tendencies of the 1960s and 1970s. Subject matter was deemed to be extraneous to the essential nature of art and was therefore abandoned in favour of an examination of the peculiar methodologies, conceptual processes and material forms and formations of the discipline of art itself, and this, in its turn gave rise to a new set of specialisations independent of the traditional categories based upon craft.

To a certain extent, then, it is fair to say that the battle that was being fought between the artists of the Left in Europe – most particularly in Italy – during the 1950s, had already been worked through in the American context more than a decade earlier. Indeed the argument between the 'Picassoists' and the signatories of Oltre Guernica produced a very similar outcome. It served to introduce a specialised discourse which both preserved the autonomy of art and at the same time linked it to progressive ideas of freedom in the wider political sense.

But important differences remain between the American and the European context, differences which must not be overlooked. As the American art historian and critic, Thomas Crow, has pointed out in his important essay, 'Modernism and Mass Culture in the Visual Arts', the formative force throughout the whole history of modernism in the visual arts, is 'inseparably an effort to come to terms with cultural production as a whole under developed capitalism'. This is the most powerful factor shaping the commerce of cultural production itself – the operations and vicissitudes of what we call the art market – but more specifically the strategies of 'complicity' and 'resistance' used by artists to deploy or to restrict the all-pervasive character of market energies. It is also fairly easy to see that such energies work differently in different socioeconomic contexts – in America as opposed Europe, for example – and for this reason we are bound to approach the developing 'international' discourse of art with the notion of distinctive causal conditions very much in mind, if we are to avoid producing a seriously distorted picture. Crow, of course, is accusing Greenberg of a kind of bias, and one that renders his whole argument in 'Avant-Garde and Kitsch' open to serious question. Greenberg's attitude to industrial society is sceptical from the outset, and he is particularly unsympathetic towards industrial, popular and mass-produced cultural artefacts, seeing them as by definition, inferior to and subversive of the values of high culture and real art. Crow's point, then, is an important one if we are to reach a balanced view of the art of the late 1950s and the early 1960s when Pop art staged its confrontation with the ultra-formalist tendency Minimalism. Where Pop embraced the world of mass-produced imagery as a superfluity of visual material waiting to be used; Minimalism chose to reify the disassociative aspects of industrial process as a way of achieving purity of form. Where Pop took an open, even optimistic approach to the whole field of cultural production; Minimalism sought to establish a distance between the abstract ideals achievable through form and finish and the values of the industrial ethos in which the artist lived and worked. Significantly, neither of these movements or tendencies took on the distinctive form that they did in America when they were taken up in the European context, and the reasons for this are worth some attention since they hinge upon the different conditions and constructions of bourgeois capitalism in the two continents prevailing at the time.

Greenberg, as we have already remarked, tied the notion of vanguardism absolutely to the evolution of bourgeois needs, preoccupations and aspirations. There is nothing exceptional about this formulation. Glossed

somewhat differently in each case, this connection was also made by such important critical thinkers as Greenberg's fellow American Meyer Schapiro as well as the Europeans, Georg Lukács and Walter Benjamin. But we must be careful not to assume too simple a category on the basis of this kind of consensus. Indeed we must recognise that while the American and European industrial bourgeoisies may have had parallel economic interests, they were constructed entirely differently. While the bourgeoisie in Europe is a historically-grounded, more or less settled socioeconomic group with established traditions, cultural preoccupations, powers and identity as a political class; the American bourgeoisie is first and foremost a product of the immigrant experience, characterised by a high measure of insecurity, uncertain political perspectives and a wide variety of different cultural and economic interests. When we speak of New York, then – the New York that produced the great postwar flowering of American art we call the first and second generation New York School – when we refer to it as a 'cultural melting pot', we are describing a very specific, perhaps in global historical terms, an entirely unique set of class, social and economic circumstances. We are speaking about a society and a culture which, to all intents and purposes, had no indigenous or native peoples, no long-term identity or tradition. In this context, it must be said, that the politics of social and cultural integration at work in the US is a far cry indeed from that which acts so powerfully in the ex-colonialising countries of western Europe, where immigrant communities are usually the consequence of colonial exploitation and generally speaking form one of the toughest strands of the industrial and servicing underclass. The nearest approach to this, in the American context – and while it is connected with the history of colonialism but subjected to a distinctly different set of social and economic processes – would be the plight of the African American and the history of integrational politics in the Southern United States.

But to return to the two bourgeoisies. It is a comparatively straightforward matter to claim, as Meyer Schapiro does, that with the growth of industrialisation a certain kind of displacement occurs within the lived perspective of the leisured middle class, and that this displacement was manifest not only in the pattern of daily life, but also – and most importantly – by changes in the consumption of commodity goods of all kinds, including the demand for, and the buying and selling of luxury goods, including works of art. But as a historical statement, this tells us very little about the state of the middle classes in Europe and America by the middle of the 1950s. Of course,

by this time in Europe the historic process of displacement referred to by Schapiro had transformed itself into what Crow has dubbed a process of 'self-liquidation': the complete dissolution of middle-class political culture in favour of a new version of the autonomous individual constructed outside of the official institutions of the society. And amongst the disaffected children of this once coherent and powerful class, the search was on for more extreme political postures and conspicuously alternative lifestyles. The 1950s, then, were the fertile soil out of which middle-class revolutionary groups like the Bader Meinhoff and the Brigate Rosse were to spring a little more than a decade later.

In the context of cultural politics in general and the visual arts in particular, the 1950s was the decade of the Situationist International set up by Guy Debord, Gil Wolmans, Raoul Vaneigen and others. The Situationists, in developing their theory of '*détournement*', the reduction of all cultural messages and cultural artefacts, 'high' and 'low' – a press photograph of Marlene Dietrich and a philosophical text by Jean-Jacques Rousseau, for example – to the same level of ephemera, prefigured many of the attitudes of the Pop artists in a surprising way. *Détournement*, Debord and Wolman claimed, in a now classic Situationist text of the time, was designed to clash, head-on, with 'all social and legal conventions'; it was to function as a 'powerful weapon in the service of the real class-struggle'. The conspicuous cheapness of their products, they declared, was the 'heavy artillery' directed at the 'Chinese walls of understanding'; the first step towards a new kind of 'artistic education' and the establishing of 'literary communism'.

In the United States, the picture was rather different. The internal dynamics of middle-class revolution were perhaps more immediate and more urgent. The great myth of the classless, prosperous, industrial society in which all citizens of whatever ethnic or religious background would find equality under the law – the American dream of equal economic and educational opportunity – was beginning to be perceived by a new generation of young, educated, white, middle-class Americans – the offspring of comfortable middle-America was without political substance. Racial segregation was still being pursued by white politicians in the Southern United States, and the growing mass of America's urban poor were still without even the minimum of basic health care or social security. While abroad, the State Department and the Pentagon were pursuing a series of semi-colonial excursions in the countries of the Far East, ostensibly with the sole purpose of holding global communism at bay. The focus of the revolutionary impulse amongst young Americans then,

was at once less generalised – less ideologically abstract – and at the same time, defined more by pressing concrete issues within the domestic politics of the country: poverty; racial segregation; the growth of a new brand of jingoistic militarism; and the rigidity and secretiveness of America's political institutions, especially when national security was deemed to be at stake. Like their European counterparts, these young people were also of a very different mental set to that of their parents. They were highly impressionable and open to the idea of change. Perhaps we might say that it is in the very nature of the immigrant mentality – even beyond the second to the third and fourth generations – to seek to establish and hold on to economic security before all else, and that this showed itself in middle-class America, on the one hand in the entrepreneurial energy of her commercial life, and on the other in a marked degree of socio-political myopia which did not encourage them to look much beyond the ends of their neatly manicured, suburban lawns and the chrome-trimmed Oldsmobiles Estate standing in the driveway. While their children were being educated in the new spread of subjects within the political and social sciences and living the semi-communal life of the sprawling university campuses of the mid-western states, they themselves were busy amassing the whole panoply of domestic appliances and meeting with their social peers and business colleagues for brunches and summer barbecues. In this respect it is not without a certain significance that the student rebellions of the 1960s in the US did not start in the 'old' universities of the New England States, or those in large urban conurbations, but in the wide-open spaces, plazas, parks and tree-lined avenues of state universities like Wisconsin, Ann Arbor and Kent State. While in Europe the students marched with the express purpose of disrupting the centres of the cities – in London, Paris, Düsseldorf, Berlin, Milan and Rome – while they staged their 'occupations' in long-established city universities and colleges like the London School of Economics and Catolica in Milan; in America – because they were campus-based – the confrontations, as far as the general public was concerned, seemed at once more remote and more self-contained. Indeed, it is arguably the case, that this sense of remoteness was only finally broken down when, in May 1970, amateur 'guardsmen' panicked and opened fire on students demonstrating against the Vietnam 'draft' at the University of Ohio, Kent State, killing and wounding some of the demonstrators.

A great deal has been written about the rise and decline of the Left in American political life, and it is far too complex a subject to deal with in full here. Suffice it to say that from its origins in the political writings of the

New England anarchists – people like Randolf Bourne and Henry Thoreau – it was tainted with a romantic idealism which, in the end, seemed to lead the Left to fall into all manner of escapist strategies, rather than to a durable ideology or persistent political engagement and political action. We might cite the American 'Beat Generation' and the Hippies as extreme examples, and with some justification, the more pernicious retreat of Left-wing intellectuals out of the domain of real politics into academia. However, just for the briefest of moments in the late 1960s the opposite seemed to be the case. It looked as if a new kind of politics had been born, bent upon direct political action to transform American society into a more just, less oppressively violent, more open and more generally humane one.

In Europe the Left was much more deeply embedded in the historical culture and much more completely a part of the political system out of the tradition of Christian Socialism and the Trades Union movement. Here, ideology was not simply the property of an intellectual elite, but was a genuine part of the foundations and fabric of industrial, working-class culture. Most particularly this was true in Britain, France and Italy. Certainly, political thinking was not perceived as the prerogative of the middle-class intelligentsia, and as a consequence, had the appearance, at least, of being more practical and more durable. At crucial moments in their confrontation with the apparatus of state power, for example, the students in France and Italy were given solid support from workers in the factories and service industries.

By the beginning of the 1960s American art had become almost completely depoliticised. The painters of the first generation New York School, partly out of political disillusionment, had already withdrawn into the protective cocoon of their own, very considerable, success; and the second generation of New York artists had sought to distance themselves from things political from the outset. Jasper Johns, for example, had adopted the cool detachment demanded by the Duchampian inheritance, and although Robert Rauschenberg used political images, he did so almost in the manner of a Situationist, giving them no more than an equal status with all of the imaginal detritus of modern urban living. American Pop too, came across more as a celebration than a critique of the media society out of which it sprang. Even though artists such as Roy Lichtenstein, Claes Oldenburg, Tom Wesselmann and James Rosenquist employed a degree of tongue-in-cheek irony in order to point up the problematic nature of certain of the values inherent in their source material, the irony was so submerged beneath the

glossy pictorialism of comic and magazine culture, or hidden behind the brash grandiloquence of devices drawn from the advertising industry, that it was almost entirely lost to the majority of viewers. In fact, if we are to discover a truly critical Pop, it is necessary to look to Europe: to the studied commentary on modern urban life afforded by the oeuvre of the British artist, Richard Hamilton, and to the photography-based coolly analytical early works of the German artist, Gerhard Richter. Seen purely in the context of Pop, Hamilton emerges as a very special case. In fact the question must be asked as to whether Pop is a big enough category through which to discuss an artist with Hamilton's breadth of interests and capacity for precise conceptual elaboration. Certainly he was the first to use the term 'Pop' in a pictorial collage of 1956 called, *Just what is it that makes today's homes so different, so appealing?* But he also used the term 'Pop Art' in his writings of the mid- to late 1950s, not as an art-historical category, this came later, but as a catch-all term referring to the artefacts of popular culture. Pop art comprised things that were designed for a mass audience, he argued, they were 'transient', 'expendable' and 'mass-produced' at 'low-cost', and, most significantly, they were aimed at a 'young audience'. They should be 'witty, sexy, gimmicky, glamorous and big business', with an irresistible air of sincerity about them. In a commentary upon this inventory of definitive characteristics, Hamilton points to the fact that artists from Rubens to Duchamp conform with some or all of these categories, excepting, perhaps, for the notion of 'expendability'; and here Hamilton adds that it was left to the American Pop artist, Andy Warhol, to make the first truly expendable work of art, which intention was quickly frustrated by museum officials who 'found not the slightest difficulty in preserving Warhol's work'.

Not surprisingly, Hamilton's work of the mid-1950s has been linked with the theories of the Situationists. Indeed, his collage, referred to above, *Just what is it that makes today's homes so different, so appealing?*, was made in the same year as the first manifesto of the Situationist International and would seem to provide a clear example of the Situationist strategy of *détournement*. But it is unlikely that he had even heard, of Debord, never mind read any of his writings. The coincidence is best explained by Hamilton's capacity for close and detailed observation of the culture in which he lives. It was this which led him to fasten upon the growing importance of popular culture before any other artist of his generation; to advance the issue of contemporary style long before the American Pop artists entered the debate; and to recognise the

influence of the media and communications technology in transforming the visual culture before it was made a subject of study in the social sciences. For him, as he put it himself, the issue was no longer one of finding 'forms for Art', but of seeing art as an 'examination of values', and values, by definition, were situated in the society and in the culture. Where his view coincided with that of the Situationists was in his rejection of any given hierarchy of cultural value.

Despite his involvement with the manifestations of popular culture in all its many aspects, in the context of the British art scene Hamilton was a somewhat remote and 'mandarin' like figure, gifted with a sense of scholarship and an exacting analytical intelligence. In a comment upon his painting, *Hommage à Chrysler Corp* (1957), the artist describes his intentions at that time as: 'a quest for specific aspects of our time and the contributions that new visual tools make to the way that we see the world'; an engagement with 'life at the banal level, without in any way relinquishing a commitment to fine art'. In terms of his ideas, he influenced most of the younger generation of British Pop artists – David Hockney, Peter Philips, Derek Boshiers and the rest – but he did so from a distance. Hamilton's demand for procedural exactitude, and his coolly measured painting style, reminiscent of the painters of the Euston Road School, lacked the qualities of immediacy and imaginal potency that characterised American Pop art. And it was this type of directness which came to dominate British Pop in all of its various stylistic guises in the early 1960s.

Most importantly, although it was never his stated intention, it is Hamilton's work, taken altogether – the paintings, prints and objects, his writing and his thinking – that provides the most effective critical antidote to Greenberg's pessimistic outlook on the plight of modern art, contained in his essay 'Avant-Garde and Kitsch'. Where Greenberg expressed the fear that 'art might lose itself' in the welter of trivial visual material thrown up by the industrial commodity, media culture – a view that was taken up by his one-time student, the art critic Michael Fried – Hamilton saw in the profligacy of popular culture a way of giving the subject matter of art back to the relatively uninformed majority of people, at least in terms of the objects of its address. Furthermore, he also saw clearly that it was impossible to hold the line against the fierce invasiveness of a technologically-based media culture, and that to take up a defensive posture of the kind advocated by Greenberg and Fried was futile and likely to lead only to a stultifying formalism in which art would become more and more detached from real life.

It is quite feasible, then, to construct an argument that casts the work of Hamilton, or indeed sees Pop art in general, as the extension of one important limb of the debate around the definition of realism which took place between artists and critics in Europe and America in the aftermath of the Second World War. On the surface, at least, Pop art seems to answer the Corrente group's call for an art of 'popular imagery' close to the lives of ordinary people. By the same token, it is not entirely unreasonable to see the introspective formalism advocated by Greenberg, which we might say reached its apotheosis with Minimalism, as a flight away from direct, political responsibility in broad social terms, towards an exclusive involvement with the more or less autonomous world of aesthetic specialisation. In this respect, Pop art would seem to point to one kind of terminus and Minimalism to another. However, this kind of polarisation takes insufficient account of the very real complexities of historical and cultural processes. For instance, close examination reveals clearly identifiable elements of each within the other. 'Pops' artists such as Oldenburg, Warhol and Jim Dine employ Minimalist strategies in certain of their works, and some of the Minimalists – Donald Judd, John McKracken and Robert Morris might be cited – demonstrate some of the wit and the gloss that we associate with Pop. Simplistic polarisations too, just like insistently linear, historical descriptions, tend to obscure the important fact that at any one time, there are always many different strands in play; different theories and types of practice occurring simultaneously. It is therefore important to bear in mind that as well as Minimalism and Pop art, the early 1960s also saw the beginnings of post-Minimalism in America and Arte Povera in Italy, where Michelangelo Pistoletto was working on his important series of conceptual objects under the collective title, 'Oggetti in Meno' – the 'Minus Objects' – crucial to the formulation of an 'aesthetics of poverty'. In Germany too, Joseph Beuys was already lecturing, teaching and performing at the Düsseldorf Academy, from which position he was to influence two generations of German painters and sculptors including such important figures as Blinky Palermo, Sigmar Polke and Georg Baselitz. Themes and strategies of working which were to emerge as major concerns in the 1970s and 1980s also first surfaced at this time: the poetics, philosophy and politics of language in the work of the important Belgian artist, Marcel Broodthaers; the German artist, Hanne Darboven; and in the more 'technical' early works of the British collective, Art & Language; and new ways of dealing with space by engaging with natural and architectural space directly, as

exampled by the British artists Richard Long and Hamish Fulton, the young German artist Blinky Palermo, and most particularly in *Decor* and the museological works of Broodthaers; opening the way for what became a dominant form of presentation in the 1980s, installation art.

But the 1960s were preeminently the decade in which the much vaunted internationalism dreamt of by successive avant-garde movements from the turn of the century, finally became a reality – or so it seemed anyway – with European artists showing in America – even in New York – and American artists showing in the metropolitan cities of Europe. For the first time a real dialogue at the level of ideas seemed possible, and this exchange occurred most importantly between the group of Italian artists that the critic, Germano Celant, christened Arte Povera – Giovanni Anselmo, Luciano Fabro, Jannis Kounellis, Mario Merz, Giulio Paolini and Giuseppe Penone – and the loosely-knit transitional group of American artists, Minimalists and post-Minimalists – Carl Andre, Eva Hesse, Bruce Nauman, Dennis Oppenheim, Robert Ryman, Richard Serra, Robert Smithson and Lawrence Weiner. This was the time of the International Artists Register, started by the American critic, Barbara Rice. Operating out of London and Amsterdam, the Register was set up with the express intention of building a truly international discourse embracing the ever-broadening spectrum of fine art practices, by linking art practitioners and institutions to those of communications and the media. Like the Italian polymath and critic, Umberto Eco, who published his seminal text *Opera Aperta (The Open Work)* in 1962, Rice was concerned to maintain the space for artistic practices as a 'free, speculative and experimental' one. Art, she argued, is founded upon the free-flow of information and represents 'a very particular kind of knowledge about the world', such as is capable of bringing to the surface 'the nature of the contemporary political crisis'. Her objectives, then, were political in nature in that they were directed as much at what art might become, what it might accomplish in a transformed and transforming world, as at its contemporary manifestations. In this, she coincides exactly with the hope expressed by Eco in *Opera Aperta*, that the 'language and peculiar procedures of art', because they are capable of carrying a specifically 'political charge', would realise their 'potential to change the world'.

As we have already remarked, while critical thinkers like Rice and Eco were arguing for and speculating about revolution at the cultural level, imagining a soft revolution, if you like, that worked to transform society at the

level of its cultural processes; the international, student protest movement was already gathering momentum. Indeed, by the mid-1960s the students had already begun to take to the streets, stage sit-ins, and occupy university buildings in many of the major universities of Europe and America. At the same time global, revolutionary socialism had succeeded in establishing a new pantheon of political heroes forged in the fire of exemplary political action – Mao, Ho Chi Minh, Fidel Castro and Che Guevara. To the new generation of student leaders who despised armchair polemicists and were determined to act in order to achieve social and political change, it was figures such as these charismatic activists, who functioned as models. In America this was the generation of white, middle-class college students, many of whom took 'The Long March South' to stand shoulder to shoulder with their black brothers and sisters in civil rights demonstrations in Mississippi and Alabama. It was the same generation that burnt their draft papers on the White House lawn, and chose self-imposed exile or even prison rather than accept complicity in America's imperialistic war in Vietnam. In the guise of an almost hysterical anti-Americanism, Vietnam was a focus for protest in Europe too, but only as one issue alongside equally pressing domestic issues: education; unemployment and the rigidities of the class structure.

Given this as background, the submerged political dimension of much of the visual art of the period seems somewhat subdued even to the point of irrelevance. But this would be to mistake the very real importance of those truly revolutionary voices that chose to make their utterances *sotto voce*, from within the poetic domain of particular art practices, rather than to shout their message from the rooftops. In the long run it is these voices that work the most important transformations in the life of art, reflecting as they often do, profound shifts in the politics of culture. This has certainly been true of the two movements that came to dominate the last half of the 1960s and the first half of the 1970s: Arte Povera and post-Minimalism. Between them, they succeeded in working a fundamental change in our understanding of the relationship between artist and work, work and audience. Where Pop had sought to disarm the viewer through the power of the image, and Minimalism to distance the spectator in order to theatricalise the object, Arte Povera and post-Minimal art made the respondent cognisant of its procedures and processes and complicit in the constructions it made at the level of language. In this respect it is no exaggeration to suggest that these two closely related tendencies represent a democratisation of the place of art, in a

socio-political sense, conceptually and as an actuality, opening up the work of art to active interpretation by the viewing subject. This is an art which keeps nothing up its sleeve, which offers itself in trust to its audience, which makes meaning a matter of negotiation. In this lies its claim to be revolutionary.

Revolution: Art of the Sixties from Warhol to Beuys, exhibition catalogue, Museum of Modern Art, Tokyo, 1995, pp.62–71.

When I was asked to write something about Richard Deacon's work for his Phaidon monograph, I had to think carefully before saying yes. I had long been an admirer of his sculpture, but I was not immediately convinced that I was the best person to write about it. As far as I was concerned, he was very much the sculptors' sculptor. He had a strong feeling for the tradition, but also a keen sense of what was required if sculpture was to achieve real contemporary significance. At the time I felt that I belonged in the opposite camp, that both as a thinker and a practitioner I was mainly of the post-Duchampian, anti-formal persuasion. It was my memory of Deacon's early works, when he was at St Martins School of Art, which gave me a way in. It was reflecting on Deacon's radically inventive, *Stuff Box Object* (1971–72) that led me to seize upon the 'performative' aspect of his working process which still – it seems to me – lies at the core of his sculptural practice. A word about the title, I still think of Deacon as the most thoughtful sculptor of his generation. There is a well-grounded philosophical centre to everything he does, which has proved a stalwart defence against the merely spectacular or the superficial.

THINKING RICHARD DEACON, THINKING
SCULPTOR, THINKING SCULPTURE

According to Homeric legend, it was Hermes, the messenger of the gods, who invented writing. The story has it that he first of all confided his invention to Zeus, adding that he intended to make a gift of it to humankind. Zeus, apparently, was not enthusiastic and begged him not to do so, fearing that it would result in the loss of human memory.

For us today, this odd little story with its roots in the pretextual world, can be seen as an expression of an exemplary fear: that through the all-pervasive power of coded inscription something important has been lost; a sense of connectedness or wholeness perhaps; the deep knowledge of social life which subsists in the community of bodies. The issue then, is not simply about the human capacity to recall hard information, but more about writing's tendency to dismember and disperse the human subject. If we can be forgiven the impudence of attributing human thought to the mind of a god, Zeus, who we might take as being all-knowing, was surely never so naive as to have suggested that through the invention of writing, human beings would cease to be able to remember anything at all – the date of the battle of Hastings, family birthdays, or where they had parked the car – but that the regulated space of written language might render some of the shared aspects of human knowledge, immemorial.

This notion of a primal linguistic space – a domain of language which exists prior to the sign – in which the potential for human communication is neither distanced nor over-determined by the constraining rules of syntax, has continued to haunt modern linguistics. Roland Barthes, for example, in a key short article of 1975, 'The Rustle of Language',[1] writes about the possibility of such a space in almost euphoric terms, describing it as an 'expanded' even 'limitless' space, constituted out of the 'music of meaning'. In this 'utopic space', language he argues, 'would be enlarged to the point of forming a vast auditory fabric in which the semantic apparatus would be made unreal' and the 'phonic, metric signifier would be deployed in all sumptuosity, without ever becoming detached from it.' Here, meaning would persist without being 'brutally dismissed' or 'dogmatically foreclosed' by the functional imperatives of the sign. Indeed to use Barthes's own words, 'it would be liberated from all the aggressiveness of which the sign, formed in the sad and fierce history of men, is the Pandora's Box.'

This dream of returning to a social space formed out of live communicative transactions finds an interesting echo in an early text by Richard Deacon, *Silence, Exile, Cunning*,[2] a retrospective reflection on a series of drawings made during his stay in America in 1978–79. Deacon has described this particular year as a 'turning point'[3] in his development as an artist, and the drawings in question, collectively titled *It's Orpheus When There's Singing*, as providing something akin to 'a grammar': as standing in anticipation of the work that was to follow.

In America Deacon had read and re-read Rainer Maria Rilke's *Sonnets to Orpheus* (1992) and in the process found himself greatly attracted to the poet's lyric conceptualisation of 'being' – grounded in musicality, vocalisation and the mobility and independence of the body in dance. This seemed to offer an antidote to the 'formal stiffness' (Deacon's own words) of his earlier sculpture, and at the same time provide for a different way of thinking about the autonomy of the sculptural object.

Significantly, in *Silence, Exile, Cunning*, Deacon situates his practice for the first time firmly within the shared social realm determined by language and he does so by metaphorising the making of work by reference to the making of speech. 'Since speech is constitutive of ourselves as human', he writes,

> to speak is both to cause the world to be and to be oneself. At the same time, speech is not a thing, but rather it is a product of community, built bit by bit in discourse. Speech is not nature like

stone or rock: it is manufactured. To make is also to bring into being, to cause there to be something.[4]

Even though in this short text, as elsewhere, there are real difficulties in the way in which Deacon deploys the language metaphor – drawing for example, even when it is developed into a systematic method, is no more capable of furnishing a grammar than speech – this short extract touches upon three central issues which are important to understanding his work thereafter.

Firstly, by making speech and, by implication, facture – the making of things – a fundamental attribute of human being; and by bringing the making of works of art within this general framework, Deacon is being careful to claim no more for the objects of art than for any other category of man-made thing. There is a strongly egalitarian undertow to much of his thinking as an artist, and under this rubric, if under no other, he is insisting that works of art enjoy the same status in broadly human terms as newspapers, washing machines, motorcars and buildings. They are all part and parcel of the one reflexive relationship – that of manufacture – linking the human subject to the world at large. Making the world present to us and ourselves present to the world. It could be that Deacon is guilty of a degree of overstatement here, since the world is present to us in a brute sense even if we do not speak about it or act upon it. But in terms of providing a construction of the work of art which has an unequivocal social dimension – which sees it as arising out of the complex, communicative fabric given to human societies – the point is well made. And this brings us to the second important issue.

Deacon makes it abundantly clear that he sees speech as the vital connective tissue of community. There is nothing exceptional about such a notion, nor is it unreasonable to argue that the making of things functions in a similar way. However, when he then describes spoken discourse as something 'built bit by bit' and goes on to claim that speech is 'manufactured', a curious and highly significant reversal occurs in the thrust of his metaphor.

Out of its very nature, spoken discourse is never unitary. Neither is it constructed piecemeal, sentence by sentence, in the manner of written language. It is a much more fluid and open-ended affair involving a whole range of different modes of physical communication. St Augustine, in a quotation much loved by Ludwig Wittgenstein and used by him as the opening paragraph of *Philosophical Investigations*,[5] puts it very neatly when he states that 'meaningful speech' is 'shown by body movements, as if it were the

natural language of all peoples: the expression of the face, the play of the eyes, the movement of other parts of the body, and the tone of the voice which expresses our state of mind in seeking, having, rejecting and avoiding things.' Before all else, speech is a product of our bodylines, and the inherent human tendency to conviviality. Addressing a colloquium on 'Style',[6] Barthes, in a typically witty aside, described speech as a 'congregation of communicators' beyond the constraints of grammar and the reach of conventional linguistics: the congregational aspects of which 'remained to be described'. Just exactly how speech manages to convey clear and unambiguous meaning, then, is no simple matter. Texts are self-evidently additive, unitised assemblages of a linear kind, subject to the syntactical closure which meaningful sentences demand, and with a locus in the abstract space of the printed or written page. Speech, by contrast, is more in the order of an 'incarnation' expanding and moving within the social space. Certainly it is not 'built' in any sense; neither is it 'manufactured'. In spoken discourse meaning resides as much in its disjunctions, its truncations and its dislocations – in a gesture of the hand, the involuntary twitch of a muscle or a barely perceptible flicker of the eye – as it does in those oral fragments which, in terms of grammar, happen to be glued together properly: the bits which make immediately transcribably, continuous sense. In this respect, speaking tends to reveal what writing purposefully seeks to hide: the complex and genuinely mysterious, ontological terrain out of which all meaning emerges – the place of language itself.

Viewed in this light we might be forgiven for concluding that writing is perhaps a more appropriate referent through which to discuss matters like 'building', 'manufacture' and the 'making' of works of art. We might even be excused the suspicion that Deacon is guilty of making spoken discourse over again in the image of his own working practices. But this would be to mistake the serious purpose underlying his statement.

Later writings show Deacon to be very preoccupied with the problem of meaning. Most especially he argues against the two extremes of 'literal' and 'epistolary' meaning: meaning which subsists in a reification of the material facts of the work, as it arises, for instance, in Minimalist sculpture; and the meaning which depends on some kind of secondary text, validated through the person of the artist acting as a ghost author. What is also clear from Deacon's writings is that he wishes meaning to arise from within the bounds of social discourse, and for this he needs a theory of making which is closely tied to the workings of language. The critic and art historian Lynne Cooke,

in her essay *Object Studies*[7] – a catalogue introduction to a series of works by Deacon grouped under the title 'Art for Other People' – quotes him, quoting Charles Harrison's book, *Empathy and Irony* (1987):

> Sculpture mediates and models a notion of what the world is like, a belief which owes much of its embodiment in language as its objecthood and its material identity.

Harrison is quite correct of course, but the simple fact of sculpture's 'embodiment' in language might not be considered sufficient guarantee of 'intentional' meaning.

Given that language is the very ground of social being, just how does a work of art – a sculpture in this case – in its specificity achieve common recognition as a 'model' of what the world is like? Is it, must it be, out of the artist's 'intention' to model the social world and to accept the burden of responsibility for embodying its meanings, or might it come about in some other way?

By temperament Deacon would most likely choose the path of intention and responsibility, but like many other artists of his generation who trouble themselves with this question, he can also see the pitfalls that lie in wait along the way. If we are to take on board the general thrust of his metaphor we must conclude that he is particularly afraid of the kind of closure which the intention 'to mean' demands: the punctum; the terminus; the full stop. Above all he wishes to reserve a space for innovation, and here we can see clearly why he chooses to link the making of sculpture with speaking rather than with writing. In spoken discourse meaning is always open to negotiation, and negotiation, in its turn, serves to situate innovation – the making of new meanings – firmly within the social domain. For Deacon, the space in which meanings are made is a communal space, and the artist's relations to it is an ethical one. It is the very opposite of that free-wheeling space – playground of the ego – in which the artist rehearses and celebrates what Charles Altieri has described as 'the metaphysics of an assumed marginality'.[8]

And this brings us to the third key issue raised by this fragment of Deacon's 'Orpheus' text: the problem of 'being'.

Some ten years later, in an interview with the Yugoslavian critic Marjetica Potrc published in *M'ARS* magazine,[9] Deacon seems to take a very negative position in relation to the idea of 'being'. After a brief discussion on

meaning in which he argues that the Minimalists, far from solving the problems of meaning, had only postponed it, he goes on to discuss the experience of the work of art and the relationship of experience to meaning. He praises the Minimalists for having got rid of the 'essentialist' notions associated with high abstraction, and states that for him the question of meaning is not about identifying the essence of the work with a metaphysical experience like 'being' and that he tends to view such experiences as 'contextual rather than absolute'. There appears to have been a very significant shift in his thinking, then, from the time that he made the Orpheus drawings and wrote the commentary *Silence, Exile, Cunning*.

Closer examination, however, shows that this shift is not as great as it first appears. Under the sway of Rilkian poetics Deacon was unavoidably caught up with the question of 'being', and not just human 'being' or the 'being' of things in the world. The very first stanza of Sonnets to Orpheus sets the metaphysical tone of Rilke's whole enterprise:

> A tree ascending. O pure transcension!
> O Orpheus sings! O tall tree in the ear!
> All noise suspended, yet in that suspension what
> a new beginning, beckoning, change, appear![10]

Transcendence, transubstantiation, suspension, the apparition of change; this is the stuff and vocabulary of a metaphysical experience of 'being': the idea that there is something above, beyond or passage of time can be slowed down or even stopped and the exact moment of change '"being" in the process of becoming' as Plato called it – directly apprehended in the form of a ghostly intimation of a different order of existence. Such notions are the meat of Rilke's poetic vision, and it is hard to imagine a close involvement with the Sonnets of the kind which Deacon describes, which at the same time rejects all of this. Nevertheless, it is possible to detect a certain wariness on Deacon's part as early as the Orpheus commentary.

It shows itself in a confusion or a reluctance to confront certain very difficult questions with regard to the constellation of meaning and representation with autonomy. Writing about the Orpheus drawings in his notebooks[11] he says, for example, 'the drawings are intentionally extremely representational' but that he has 'difficulty in deciding of what they are representations.' And the passage continues: 'This concerns their reference.

I have difficulty in corroborating their reference with something. Except I have considered *Sonnets to Orpheus* to be their subject.'

The question which is struggling to surface here is unmistakably that of the work of art's autonomy. How does the intention to represent something square with the desire for autonomy in the work of art? How does the work of art come to represent something other than itself and at the same time remain nothing but itself? And, more pointedly, precisely what order of experience does autonomy represent?

Deacon's preferred solution is to interject the works themselves – in this case the finished drawings – into the space between his intention to represent something and the specificity of the subject – *Sonnets to Orpheus* – in the belief a representation might, will, has occurred, which in no way depends upon the particularities of the thing represented. It is rather like saying that you can paint a portrait of someone without referring at all to their physical appearance; and so you can, but only by recourse to things invisible. The painting would have to refer to the 'spirit', 'Psyche' or 'being' of that person, where 'being' is manifest through qualities other than their physical characteristics. Picasso's retort when Gertrude Stein complained that her portrait looked nothing like her, comes to mind: 'No, but one day you will look like it.' From Picasso's point of view he had been concerned to represent the 'essential' Gertrude Stein rather than Gertrude Stein as she appeared in front of him. He therefore regarded his portrait to be more 'true' than one based on appearances.

But Deacon is clearly very reluctant to resort to this kind of explanation. As he readily admits, for him it is one thread in a knot of theoretical questions which he finds very difficult to untie. He wishes to retain a more or less strong version of the autonomy of the sculptural object without having to ground this autonomy in a metaphysical alterity like 'being' and 'otherness'. He wants his work to be implicitly meaningful rather than 'textual': and he wants to hold on to the possibility of intentional representation without the sculptures themselves being shaped in any obvious way by what they represent.

In practice Deacon bridges this theoretical lacuna by recourse to two key working principles: the belief that work itself – his engagement with the processes and means of manufacture – is its own guarantee of meaning; and that both representation and autonomy are realised in, are determined by and in relationship to context. The model he uses to achieve this theoretical

bridging is a theory of language, and here something of a contradiction emerges. Deacon's approach to language seems to bear some of the hallmarks of a phenomenological way of thinking, and in phenomenology the question of language is closely tied to the question of 'being'.

Viewed in the light of Deacon's early student background, the most intellectually formative period of which was in the sculpture department at St Martins School of Art between 1969 and 1972, this trace of phenomenological thinking is in no way surprising. At St Martins, Deacon worked in what was known as the 'A' course; a course which had been set up to provide an alternative way of thinking about sculpture to the prevailing ethos of the department: the perception-based, formal approach of Anthony Caro and the younger 'New Generation' sculptors. The 'A' course employed 'behaviourist' teaching methods, and encouraged the students to adopt a critical, even a sceptical attitude towards traditional notions of sculpture-making. The result was a wide variety of process-based sculptural work, ranging from performances to object-making which used materials as part of an 'event-structure' to arrive at a completed form. Integral to the teaching of this course was an approach to thinking which went beyond the normal boundaries of art historical and critical material into selective areas of general philosophy, linguistics and psychoanalytical theory. Certain writers and texts were from time to time deemed de rigueur, amongst them James Griffin's *Logical Atomism* (1964), Edmund Husserl's *Phenomenology of Internal Time Consciousness*; and Maurice Merleau-Ponty's *Phenomenology of Perception*, as well as books by more fashionable writers like Marshall McLuhan, Edward de Bono and R.D. Lang.[12] The approach taken to this material was by no means systematic, rather it served to institute a climate of discourse with its own very distinctive vocabulary.

In this milieu Deacon was engaged mainly with performance work, albeit performance which had a strongly material-based aspect to it. This was the time of *Stuff Box Object* (1971), a work which developed through several different stages; starting its life as part of a communal student project, progressing through a performance phase – during which Deacon took up a foetal position, working inside the box – and ending up as a process-based sculptural object. As the critic Michael Newman has pointed out, *Stuff Box Object* initiates many of the issues and themes which surface in a different way in Deacon's later work, in particular, 'it looked forward to the way in which the sculpture was to become both a literal object and a metaphorical substitute for the person',[13] an aspect of Deacon's work we will need to return to later.

At this time too, Deacon was reading widely in the field of general linguistics and in his last year at St Martins wrote a paper linking language with perception, or to be more precise 'speaking' with 'looking' by way of description.[14] A notion which is not far removed from the phenomenological term 'self-showing',[15] part of phenomenology's tendency to 'linguifaction'[16]: turning the world into language.

More generally, the period of Deacon's studentship at St Martins and his continued involvement afterwards with the studio-based performance group 'Many Deed' was a time of intense material and procedural experimentation as well as searching examination of himself and the social world, including the nature and purpose of works of art. It was already apparent that he was gifted with great practical intelligence: his hands had little difficulty in accomplishing what his mind thought. At St Martins he was encouraged to challenge this facility and also to think in more radical ways about the possibilities of sculpture as an interventionary practice. Even so, in the midst of all this questioning and experimenting, concerns began to be established which were to surface in a different form in his mature work. Two are worth mentioning here: a fascination with the way in which materials behave when they are subjected to repetitive forming processes; and an obsessive preoccupation with the unfamiliar, or more precisely, with defeating in himself the 'denial' which the unfamiliar often provokes. In this respect, a piece like *Speak/Work Performance*, performed by 'Many Deed' in 1974, out of the way in which it used routine, repetition, disruption and playback, might be considered as something of a model for the formal games and strategies of making which Deacon engages with in his later work. Writing in the Tate Gallery catalogue in 1983 he says of his working method:

> I work with materials in the most straightforward way. I do not make plans. The activity is repetitious... I begin by shaping stuff... I may have something in mind or I may not. There are often radical changes. The unexpected happens. I am never sure whether I finish the thing I am making or whether it finishes with me.

Underlying these staccato, seemingly very direct statements is a conception of sculpture as both practice and object of a highly provocative, even a revolutionary kind, and it has its origin in the event structure aspect of performance work. It opposes the 'occasion of making' against the more

traditional notion of a preemptive creative vision; 'serialised fabrication' against ideated sculptural form; 'repetitive action' against original intuition; and the 'condition of possibility' against the intention to reach a particular kind of sculptural conclusion.

To return briefly to the *Orpheus* text. As we have already observed, there is an important side to Deacon's thinking which seeks to hold the making of works of art within the scope and reach of a definition of 'normal' human activity. And to this end he invokes the generic category of 'things manufactured'.

Manufacture, the making of things, he argues – and here he means all making, machine-made as well as handcrafted items; consumer durables as well as sculptural objects – is to 'cause something', it is to 'bring it into being'. Once again, as a generalisation, the statement is beyond argument, just as long as we pay no special attention to his use of the term 'being'. If we put any weight at all on the word 'being' the import of Deacon's statement changes. No longer is it a straightforward description but a reference to the existential root of phenomenology as represented by the writings of Martin Heidegger.[17] Looked at from this point of view – and Deacon was reading Heidegger at about this time – it is reasonable to assume that he is implying more here than appears at first sight, and at the same time avoiding an important question of definition: just how do works of art differ from other manufactured things; in what sense might they be said to be special?

By making the metaphorical link between speaking and facture; in claiming that speech is man-made – he is careful to point out, remember, that it 'is not nature like stone or rock' – Deacon would seem to be giving tacit recognition to two and possibly three, quite distinct, notional categories of 'being': being in language; being in nature; and more obliquely, being in culture. These categories, of course, are not unrelated, on the contrary, our construction of the natural world as well as the cultural, is made from within language, since language has no boundaries and so permits of no exterior space. In Heidegger's now classic formulation: 'Language does not need to be founded, for it is what founds.'[18] In this important respect, 'beingness', in as far as we are able to know it through language, is indeed, indivisible. All things, whether natural or man-made, are incorporated into the work and 'being' of language. All things partake in what Michel Foucault has called the 'illusionary inwardness' of language – our subjectivity– and the process of reconciliation this demands of us *vis à vis* our experience of the external world.

But this is to speak of language only on the ontological level: it is to speak of Language with a capital 'L'; the foundational terrain which allows 'languages' to become intelligible one to another. And viewed from this site, to 'bring into being' is neither more or less than to 'bring to consciousness'. The question of how things come into consciousness, how they describe themselves to us – in which particular language or by what manner of usage – is the critical one. Indeed, it is not overstating the case to say that it is this aspect of language which provides the essential ground for the hermeneutic work of all changing and lively cultures.

Ludwig Wittgenstein in the posthumously published fragments *Zettel* (1929–40), touches upon this question when he writes: 'Do not forget that a poem, even though it is composed in the language of information, is not used in the language game of giving information.' [19] A poem by Sylvia Plath, then, though it uses the same lexicon and rules of grammar as a government circular explaining how to go about claiming housing benefit, by the way in which it engages with language declares itself to be absolutely other to it. It deploys the panoply of linguistic means differently and for palpably different ends.

As Michel Foucault has argued, although as human beings we are possessed of the strong impression that language is internal to us – an interior faculty of some kind by means of which we negotiate our relationship with the external world – in fact the opposite is the case. Language starts from outside with the world of real things. The word is as much an object as the thing or state of affairs to which it refers, free to detach and relocate itself within new configurations of meaning, and poetic rhetoric depends crucially upon this mobility. The possibility of using many words for the same object; several expressions to describe the same mood or state of mind; new and different ways of speaking about ordinary things such as will lift them into the realm of the extraordinary, is the necessary precondition of the poetic text. Poetry works with, indeed it is a celebration of this arbitrariness in language. While the functional, communicative, administrative text closes down the space between the sign and the signified, seeks to preserve the illusion of a necessary relatedness on behalf of objectivity or clarity, the poetic text opens it up, uses it as a site for the play of individual subjectivity in writer and reader alike. Where the rhetoric of the instrumental text pretends a fixed relation between words and world, poetic rhetoric sees this relation as one which must be forged over and over again in the engine of the individual imagination.

To bring the example closer to home, and in a more complex form, Deacon, who in his notebooks describes himself as a 'fabricator', uses the language – forms, configurations and methods of making and building – we tend to associate with processes of manufacture, technical engineering, furniture construction and industrial pattern-making. His sculptures derive their surface detail from these various processes, which results in a complicated play of what he called 'resonance' and 'equivalence'.[20] They resonate other levels of meaning and refer analogously to other things in the world. At the same time they have a strong sense of identity as autonomous works of art. A work like *Blind, Deaf and Dumb*, for example, one of the two related works made for his Serpentine Gallery exhibition of 1985, looks very much like a piece of industrial ducting; *More Light* (1987–88), has the appearance of an abandoned piece of space technology; and the sardonically titled *Never Mind*, commissioned for the Middelheim sculpture park, Antwerp (Belgium) and installed in 1993, looks like a huge wooden former of the kind that might be used to spin a large metal vessel or panel-beat something like an engine-housing. However, while they might be said to resemble certain familiar things – while they seem to make connection with objects that we know from other contexts – they do not represent them in a straightforward way. Deacon's use of the term 'equivalence', in as far as it seems to suggest a hyphenation of the word 'representation', is important here. His sculptures tend to 're-present' carefully selected aspects of familiar things as a part of their linguistic array rather than serving to specify the sculpture as a singular representation. 'Equivalences', in this respect, are not authorised directly by the artist, but authorise themselves in the mind of the viewer as a transaction in language. Furthermore, these resemblances or 'equivalences' as Deacon calls them are a function of only one kind of language deployed in the making of the sculpture; we might describe it as a technical or instrumental language. And this in turn is overlaid upon another very different kind of language. This second language we might call 'poetic' language since it is centrally concerned with the aesthetic play of material manipulation and material forms. The ruggedness and immediacy which often characterises the working of poetic language in Deacon's sculptures – the feeling that they have been wrestled into existence rather more quickly than their scale or detailing would permit – gives to them their very distinctive charge.

To some degree these languages displace and modify each other. The technical language enters the aesthetic domain as a mark of excess; as a decorative overload. And this surplus of technical detail, in turn, serves to

desublimate the aesthetic and formal aspects of the work, returning to and holding it firmly within the bounds of human labour. We could describe this transaction as a redistribution of language, a transmigration of characteristic usages, and in some respects this is precisely what it is. But it is also important to recognise that this is not a simple homogenising process. The result is never a true amalgam. Redistribution happens across a gap, a fault-line which draws into itself the viewing subject as an active agent in the making of meaning. Most importantly, it is in this linguistic gap that the identity of the object as a work of art – rather than any other kind of manufactured thing – is first negotiated. At the heart of this exchange, the pivot around which this double play of languages is organised, there lies a characteristic argument about the nature of sculptural form. We might describe it as a dialectic between inside and outside as well as between volumetric, spatial structure and what Deacon calls 'lump': the solid, fully rounded, no-nonsense sculptured object.

As we have already remarked, reading Rilke's sonnets and making the *Orpheus* drawings started Deacon thinking in a new way about the autonomy of sculpture. The works exhibited at The Gallery on Acre Lane immediately prior to his trip to America,[21] seemed to be studiedly earthbound, their form ponderous in its construction and static in the way in which it engaged with space. The several untitled works which followed his return from the States had a very different feel to them. They enjoyed a more active relationship with the floor and with the space in which they stood. Indeed, *Untitled* (1980), a large, curvilinear, open structure made of laminated strips of plywood jointed with steel, might be considered a seminal work since it manifests many of the procedural characteristics which Deacon returns to over and over again in the years that follow. It is the first truly open form. It has its own very specific brand of formal integrity. While it sits upon the ground it does not seem to have been built in relationship to it: rather it seems to spring from it. Taken together these qualities make it the genuine precursor of the other great laminated works; pieces like *For Those Who Have Ears* (1983); *Blind, Deaf and Dumb* (1985); *Double Talk* (1987); and *Breed* (1989).

But this early work, *Untitled* (1980), is significant for another and perhaps more important reason: it seems to have inaugurated the dialectic of inside and outside in a new way. The work implies a closure but is also possessed of a strong invitational aspect, reaching out and beckoning the spectator to enter its interior space. The possibility of effecting such an entrance is signalled by a tear-shaped opening – it is almost a schematically

drawn vagina. Negotiation between inside and outside is given a distinctly erotic edge, an edge which allows us to approach the question of 'being' from a different direction.

Eros is unmistakably present when 'being' and 'other' are brought into a particular geometry of relationship. It might be described as both a 'coming together' and a 'holding apart'; a proximity in which a distance is integrally maintained. The deep pathos which Eros commands is made up of this closeness and this duality. Immanuel Levinas describes this alterity with great precision by means of the linked and hyphenated phrases, 'being-in-one's-skin, having-the-other-in-one's-skin'.[22] The comma stands between, binds together and holds apart. The skin, as container, becomes a site for oscillation and substitution.

With Eros in tow, then, 'bringing into being' goes beyond mere cognition; beyond the selfish pleasure we routinely derive from sensible exchange with things in the world – our own 'being' is implicated. Deacon himself remarks upon this kind of dynamic substitution in an interview with the curator Julian Heynen. The spectator, he suggests, is 'in the position of feeling occasionally outside and occasionally inside the sculpture... the feeling of being engulfed by the object you are looking at does change the subject/object relationships... one has the sense of becoming, on occasion, the object of the sculpture as much as the sculpture is object for you'.[23] 'Engulfed' – taken over by, submerged within – seems to suggest more than a simple switching of the relationship between subject and object: it suggests a dissolving of the distinction altogether. Certainly it proposes a state of being with the work that cannot be encompassed by a term like 'looking at'.

Another way in which Deacon describes this alternating relationship between the sculpture and the viewer is as 'private engagement' and he qualifies this by adding 'as if with another person'.[24] Furthermore he attributes this kind of intimate 'engagement' to the larger sculptures rather than the smaller works which comprise the *Art for Other People* (1983–84) series. The experience offered by these works is more 'public' and has something of the quality of a 'conversation' about it. Once again 'engagement' seems to suggest some kind of encapsulation, a losing of the self to the work, a wrapping up of the subject / object duality within an experience of solitude; while 'conversation' proposes a more open and objective relationship taking place as part of the discourse of community. This seeming reversal of our expectations with regard to public and private space raises another fascinating question in the

domain of language. Is the language of 'engagement' occasioned by the large sculptures the same as that inaugurated as 'conversation' by the smaller ones, and if not, in what sense might it be said to be different? And more pointedly: given the alterity of erotic substitution which characterises our 'engagement' with the larger pieces, does connective, communally constitutive language enter into the equation at all, or are we in the presence of an entirely different order of discourse?

Significantly, the notion of autonomy in the Orpheus story finds its most powerful representation in the image of Orpheus's decapitation. His head is torn from his body while he is still speaking, and it continues to speak even after it has been thrown into the river. Indeed, Orpheus's voice remains audible long after his head has floated out of sight. Eurydice, the subject of his adoration and his lamentation, has long since shaded away into the gross darkness of the underworld. To whom then is Orpheus's severed head addressing itself and on whose behalf?

Surely in this brutally separated, continuously vocal head, song, speech, language itself is quite literally disembodied. The voice is driven by its own momentum into the beyond of language, to the outer reaches of reality, to the very edge of the unreal, and there, separated from the community of bodies, it becomes its own delicate affirmation. In this utterly 'other' place, the head speaks sweetly to itself in its own tongue. It has only to convince itself of the truth of its own descriptions: it has only to persuade itself of the validity of those sadnesses and delights which animate its inner world. Thus it is that Orpheus's decapitation represents an extreme form of autonomy within the domain of language: the possibility of an utterance which is 'of' and 'for' itself; a retreat from the language as a routine affirmation of community into the solitary space of one's own 'being'.

The disembodiment which entrance into this solitary place implies is precisely that of an 'engagement' in which the duality of subject and object, the distinction between 'self' and the 'other', is dissolved. From within, this solitude has the appearance of the absolute, but in reality its offer is, in the very strictest sense, that of an 'engagement' which in turn necessitates a 'dis-engagement': we can enter it and leave it at will. It is in this respect the opposite of 'conversation'. Conversations begin and end; they are interrupted or they are concluded. Either way they are sufficient unto themselves; they carry with them no promise of continuity. 'Engagement' by contrast, suggests that there is always something there to be engaged with, something to return

to; a different order of discourse, a different quality of experience. And because engagement is instigated in solitude it can only be shared paradigmatically. We might all have the same experience, but the attribution of 'sameness' can never be tested without recourse to the guarantee afforded by common language and common usage. The encapsulation which 'engagement' works with gives no such guarantee and needs none, so intense is the experience it provides.

Deacon's larger sculptures exercise a very different version of sculptural presence to the smaller works which comprise the *Art for Other People* series. In part, this is out of intention: Deacon intends the small works to function differently; he intends them to occupy the world in a more matter-of-fact way. Lynne Cooke, in her catalogue essay introducing these works, puts it very succinctly when she writes:

> In these small pieces Deacon can be said to be proposing a singular alternative to the homeless state endemic to much modernist sculpture, undermining the social isolation of sculpture as a fine art by seeking out spaces in which the discourse of high art is traditionally absent. [25]

But Deacon's intention to difference is only part of the story. There is something about the way in which he uses scale in conjunction with different strategies of making, which brings the larger sculptures more into the domain of bodily sensation than mental apprehension. Addressing sculptural objects we tend in any case to 'look at' small things and 'look into' larger ones – where 'into' might be taken to mean a peripatetic investigation as well as the movement into or through something. In Deacon's case this 'looking into' is greatly enhanced by the way in which he fabricates his work: the studied use of open form as in the elaborately constructed *What Could Make Me Feel This Way A* (1993); and forms which are self-evidently not solid but are built as a skin, of which the most dramatic example is *Struck Dumb* made in 1988. Even when he chooses to use solid form as with *Distance No Object No 2*, (1989), the mass or 'lump' as Deacon calls it is constructed from the inside out, and its exterior surface – its skin – functions as a graphic record, a mapping of its internal complexities. In one way or another, all of Deacon's larger sculptures describe and articulate an interior space and by doing so invite a particular kind of 'interjection' on the part of the spectator. The viewer is required to make an

imaginary journey into the interior of the work, and once this process of 'interjection' has occurred, once the viewer has taken possession of this interior, then the inrush of contextual material is held at bay and a state of identification is achieved which is more physical than linguistic. As it is with the inward experience of our own body, the viewer is in an important sense 'unvoiced'. Once inside, there is no 'other', there is no one to speak to, no one to hear. Paradoxically, if we are to describe this experience of inwardness, we must first of all withdraw from it, and this act of withdrawal is a withdrawal 'into' the world of constitutive language. For this reason the adequacy of our description must always be in doubt.

We have already touched upon the way in which Deacon's sculpture utilises the interface between two very different languages – the instrumental and the poetic – and shown how the identity of the object as a work of art is first negotiated in the gap which opens up between the two. The play between 'inside' and 'outside', so characteristic of Deacon's work in as far as it asks a fundamental question about the efficacy of language to deal with all aspects of our experiencing works of art, tends to function as another, similar kind of alterity. This time it is inescapably an alternating movement between 'being' and 'other': between the eroticised, undifferentiated site of desire – 'before' desire has been put into words – and the social world as it is shaped by and through the intricate play of different languages. Surface detail, the skin and the metaphorising of the sculpture as body allows for an outwardly inflected reading as well as an inwardly inflected one. The former, by its nature, is highly conventionalised. It is a reading, embedded in context and subject to the normative experiences which context offers. In this sense it serves chiefly to reinforce the notion of sculpture as a public transaction. The latter, the inwardly inflected state of reading, is emptied of customary meanings; it yields up no comfortable assumptions about world, self, or other. Reading occurs in an anachronic space in which the only consistency is an inconstant self and the welter of desires which self represents. But it is important to emphasise that these two types of identification are experienced as an alterity, and not as an opposition. Levinas's formulation 'being-in-one's-skin, having-the-other-in-one's-skin', describes a two-way passage between 'inside' and 'outside'; one that allows for an inner experience of an outwardly apprehended 'other', and conversely, allows us to project the intimate experience of 'being in and by oneself' into some 'other thing' situated in the outside world. This process of exchange is the root and ground of the work of art's autonomy.

While this pressing duality might be described as 'transphysical', it need not necessarily amount to something 'metaphysical'. Certainly it does not depend upon the transcendent notion of 'being' of the kind that we find described in the opening stanzas of Rilke's *Sonnets to Orpheus*. But it does pose a radical question to the exclusive definition of the work of art, which makes it out to be constructed entirely from within bounds set by socially constitutive languages. Indeed, it suggests that there is a relational aspect to our apprehension of things which precedes language both as a system and sign – in other words in the Barthian sense. If we are to take Barthes's idea of the 'music of meaning' seriously, then it can only be seen as something that we all carry with us as part of our baggage as sensible subjects. Meaning must then be 'caused', must arise out of desire, or, more precisely, out of the ontological joining of 'being' with language as it is first manifest in desire. Furthermore, the work of art must find its point of origin in this triangular constellation. It must speak on its behalf more or less directly and by doing so establish its absolute difference to all other 'manufactured' things.

Paradoxically, this idea that there is something in the presence of a work of art which stands in a problematic relation to the routine constructions of everyday language is signalled most clearly in the way in which Deacon uses titles. He chooses phrases which themselves are possessed of a high degree of autonomy – verbal asides, figures of speech, vernacular usages – which are immediately recognisable and have an independent, almost closed identity. Deacon's titles tend to produce a quality of silence around themselves. Almost they turn written language against itself through the deployment of a whole battery of closure devices: a rapid and irreversible slide from word into image (*Nose to Nose*); the use of onomatopoeia (*Struck Dumb, Double Talk*); tautological doubling (*Feast for the Eye*); cryptic nomination (*Breed*); self-referencing (*What Could Make Me Feel This Way, The Back of My Hand*); contradiction between word and image (*Like a Snail*); and personal asides (*O.T., The Interior Is Always More Difficult J.H.*). Not only do these devices allow the titles to stand to one side of the sculptures they name, but they isolate them in language too. Rather than qualifying the works verbally they function more like an appendix, an addendum or a footnote. They are neither essential to the apprehension of the sculpture nor do they serve to complete its meaning. In fact they occupy a different conceptual space altogether. Once again Deacon seems to be refusing to wrap things up, refusing homogenisation. He is quite deliberately bringing things together

and holding them apart at one and the same time. The conjoining of word with object is offered, but it must be negotiated by the viewer as a part of their engagement with the work: and this time the negotiation is between language and its 'other' – the 'before' of language rather than one involving languages of different kinds.

Deacon's sculpture, then, works with two very different versions of autonomy. One, we might call 'the autonomy of the Orphic head' and the other, demonstrated clearly in the way in which he attaches titles, we might describe as an erasure of the background noise of language. The first of these reveals itself through an attitude to forming which denies even the vestiges of the secure anchorage which, in its least disguised form, figured historically as the plinth. In most cases Deacon's sculptures consist of 'rolling' forms which are shown in particular configurations but which always carry with them the suggestion that they might have fallen to the ground differently. This quality is most apparent in a work like *Lock* made in 1990. But it is also present to some degree in the sculptures which are clearly built in relation to the ground-plane, of which *Border* (1991), is a good example, or the more architectural *The Interior Is Always More Difficult G* first exhibited at the Lisson Gallery in 1992. In both cases the turning of the base-edge of the work proposes an independence or even a separation from the ground which is entirely opposite to the causal, gravitational relationship which governs most sculpture. The second form of autonomy is one of nomination: privileging certain carefully selected words or phrases in such a way as to detach them from customary patterns of language and usage, thereby creating a 'meaningful' silence around them which allows them to be floated across the gap between language and object. The initial separation in both of these strategies occurs in relation to context. One gives the sculpture as object something of the character of an event, the surprising nature of which subsists in its sense of something having just occurred in this place and no other. The other – the nominative – casts the sculpture as an emergence, a coming into focus as a bearer of specific meaning, detached from the general flux of meaning given by language.

This insistence upon the play between the sculpture as object and name, and context as an interactive social space, sets Deacon very much apart from the rest of the sculptors of his own generation. Most especially it has provided him with real social and philosophical grounds for intervening in the public space and the large-scale, publicly commissioned works like *Nose*

To Nose, Beginning To End made for the Glasgow Garden Festival in 1988, and *Moor* (1990) commissioned for the Victoria Park bridge, Plymouth, as part of the Four Cities, 'New Work for Different Places' project, take the idea of public sculpture far beyond that of the decorative addition to plaza architecture.

Deacon's public works function as a real and highly provocative intervention in relationship both to architecture and landscape. They are not easy on the eye, neither do they carry the affirmation of the monument. They tend to focus more upon issues arising out of the context itself, to function contrapuntally in relationship to factors like social dereliction and urban decay.

Deacon has been described as the inheritor of the tradition of British sculpture represented historically by Barbara Hepworth and Henry Moore, and his increasing involvement in public commissions has contributed to this attribution. But we can see from what has gone before that this connection is at best superficial and at worst downright misleading. His work stands very much apart from the tradition of high abstraction espoused by Hepworth, and in radical opposition to the 'picturesque', nature-focused abstraction we associate with Moore. If there is a link to be made, it is best negotiated through the influence on British sculpture of the constructivist Naum Gabo. Like Deacon, Gabo was interested in a wide range of different discourses bridging the gap between art and science: philosophy; mathematics; architecture; design; and most especially advances in the social and natural sciences. And these interests helped shape the conceptual ground as well as the material look of his work. Like Deacon also, there is a clear dialectic of contrasting languages at work in Gabo's objects linking the poetic with the technical: a very refined 'sensual' side to the work and a more rigorous 'hard' side. In this respect, a sculpture like *Spheric Theme (Penetrated Variation)* worked on by Gabo over a three-year period in the early 1960s, in its attitude to the making of sculptural form and by the way in which Gabo opens up the centre of the form bears some comparison with a Deacon work like *Body of Thought* (1988), or with *Under My Skin* made in 1990. Gabo's *Red Stone* (1964–65) seems to share some of the sculptural concerns addressed by Deacon in works like *Skirt* (1989), and *Coat* (1990). There are some grounds for connecting him with the constructive lineage of modern sculpture as it is represented by a figure like Gabo – certainly Deacon would identify closely with Gabo's much quoted dictum, 'the images man constructs determine the shape of the universe about us.' Furthermore the early influence of artists like Phillip King and more especially William Tucker, who himself taught

alongside the British constructivist Kenneth Martin at Goldsmiths College prior to his time at St Martins, might he seen as reinforcing this connection. However, we must be careful not to tie his work into it too directly. Constructivism is preeminently a part of the modernist, scientific utopian view.

 Deacon, on the other hand, is quintessentially the postmodern artist. He belongs to no tendency or movement. He shares no stylistic concerns even with the British sculptors of his own generation: Tony Cragg, Anish Kapoor, Bill Woodrow, Richard Wentworth and the rest. It is intrinsic to the condition of postmodernity that artists, freed from the progressive, programmatic aspect of modernism, are at liberty to choose their own style. Nowhere was this freedom of choice more clearly demonstrated than at the re-opening of the Middelheim sculpture park in Antwerp, when Deacon was shown alongside five other European sculptors who, with the exception of the Belgian artist Panamarenko, were of his own generation: the Spanish sculptor Juan Muñoz; the Germans Harald Klingelhöller and Thomas Schütte, and the Danish painter and sculptor Per Kirkeby. At the level of content there were connections to be made. For example, Deacon might be said to share an interest in the interface between technology and the natural sciences with Panamarenko; a concern for language with Klingelhöller and Schütte; an interest in architecture with Kirkeby; an intention to activate social space with Schütte and Muñoz. But these shared interests manifest themselves in radically different sculptural forms. There is no evidence of a collegiate working method or sculptural style. There is no overarching idea about what art or more particularly sculpture should be or looks like. The climate of ideas he inhabits is very much after structuralism and after what has been called 'the linguistic turn' in modern philosophy. If he were to believe in utopia at all, it would most likely be a utopia of the Barthian kind, a utopia of discourse. If he were to permit himself to dream, it would be a Barthian dream in which the fragmentation which characterises contemporary culture would be dissolved into a unifying play of language. More importantly, in the more specialised context of contemporary art, Deacon is very much a post-Minimal artist – using the term literally rather than art historically – throughout his writings he casts his work in a critical relationship to artists like Carl Andre and Donald Judd. In some respects he sees himself working to correct some of the reductive errors of Minimalism, especially with regard to its formal strictures and its endemic 'materialism'.

But Deacon's contribution to contemporary sculpture goes a great deal further than can be summed up by reference to a slender thread of art-historical argument. As we have seen he is first and foremost a thinking artist who is determined to keep a lot of difficult historical, social and theoretical issues in play. He wishes to hold on to the notion of sculpture as an exemplary practice given to him out of its tradition and its history, but he wants at the same time to maintain it as a strong site for innovation. He sees it as part of his responsibility, as an artist to connect his practice to the 'horizontal culture',[26] rather than being content to sit comfortably within the protective fold of a privileged discourse. Before all else he wants to take account of the post-critical debate without losing the sculpture as object to the shifting sands of fashionable discursive practices.

Richard Deacon, Phaidon, London, 1995, pp.38 – 87.

1 Roland Barthes, 'The Rustle of Language', Basil Blackwell, Oxford, 1986, title essay.
2 Richard Deacon, Kunstverein Hannover, 1993. Catalogue appended, Workbiography.
3 *Ibid.*
4 *Ibid.*
5 Ludwig Wittgenstein, *Philosophical Investigations*, Basil Blackwell, Oxford, 1962.
6 Roland Barthes, *Collected Papers*, University of Leiden, 1969.
7 Lynne Cooke, 'Richard Deacon', catalogue essay, Whitechapel Art Gallery, London, 1988.
8 Charles Altieri, 'The Dilemma of Modernity' conference paper, unpublished, University of Michigan, 1993.
9 Marjetica Potrc, 'Interview', *M'ARS*, Ljubljana, vol.II, no.4, 1990.
10 Rainer Maria Rilke, *Selected Works Vol II*, J.B. Leishman (trans.), Hogarth Press, London, 1980.
11 *Richard Deacon*, Kunstverein Hannover, 1993.
12 I was teaching at St Martins at the time and these were examples of the books that were passed amongst the staff as well as the students.
13 *Richard Deacon*, Kunstverein Hannover, 1993.
14 *Ibid.*
15 Georg Wilhelm Friedrich Hegel, *Phenomenology of Spirit*, AV Miller (trans.), Oxford University Press, 1986.
16 Stephen Mellville, *Philosophy Beside Itself*, Manchester University Press, 1986.
17 Confirmed in a conversation with Richard Deacon.
18 Martin Heidegger, *Poetry, Language, Thought*, A Hofstadter (trans.), Harper and Row, London, 1970.
19 Ludwig Wittgenstein, *Zettel*, Basil Blackwell, Oxford, 1967.
20 *Richard Deacon*, Kunstverein Hannover, 1993.
21 *Ibid.*
22 Immanuel Levinas, 'Time and Other', in S. Hand (ed.), *The Levinas Reader*, Basil Blackwood, Oxford, 1989.
23 *Richard Deacon*, Kunstverein Hannover, 1993.
24 *Ibid.*
25 Lynne Cooke, 'Richard Deacon', catalogue essay, Whitechapel Art Gallery, London, 1988.

26 The term 'horizontal' culture used by the Italian political philosopher, Vincenzo
 Sparagna. It means the ground of social life as opposed to the mechanisms of cultural
 validation which he describes as 'vertical'.

I went through a period in the late 1980s and early 1990s when I wanted to write something about my own life. I wanted to make it more oblique than a real autobiography by mixing imaginary excursions with real facts. It was an approach that allowed me to write in short bursts and to avoid the structural problem of an overarching narrative. From the outset, there was to be no beginning and no end, no argument and no summation. To give some focus to the writing I used colours to head up the small sections. I ended up with a fairly large pile of imaginatively extended written fragments, some of them dealing with highly charged emotional material connected with real events in my life. I decided to use a selection in the catalogue of an exhibition of my photographic works at the Museum Dhondt-Dhaenens. Looking back, they too were autobiographical in their drift, combining elements of masochistic fantasy with self-portraiture.

EXTRACTS FROM AN AUTOBIOGRAPHY: SELECTED WITH REFERENCE TO THE COLOUR BLUE

...but then I have no visual memories before the age of five, excepting one – the first – an overwhelming sensation of blue. Not a strong blue, you understand, but the most limpid aquamarine, and out of it – or was it IT – my mother's voice. This certain kind of blue has indicated the feminine for me ever since. Even now...

When I saw the pale blue velvet suit, my very first uniform – the high-cut blazer, the shorter than short trousers and the peaked cap – I felt suddenly quite giddy and had to sit down. Luckily nobody noticed my slight faint and I quickly recovered my composure... It turned out to be a very impractical colour.

...shocked into wakefulness by the sound of something heavy falling... lots of footsteps on the stairs... The next morning grandfather was not at breakfast... There was an atmosphere. Liz looked as though she'd been crying, my mother too, and they were barely speaking to me, only endlessly to each other, *sotto voce*. I decided to go in search of the old man... eventually, pushing open the door of my grandmother's bedroom and advancing into semi-darkness beyond, I came across him, to my surprise fully dressed in his best navy-blue chalk-stripe, hands clasped across his chest, fast asleep on the bed.

...the old man was dead... they were murmuring meaningless prayers in unison, the whole family dressed in mourning. For me, close to and at eye level, the beloved face... 'you, you favour your grandfather': this then was the site of my resemblance, but after the bluish iridescence that comes with death had quite chased the warmth of living flesh away. I felt the chill that was emanating from his body and quickly glanced down at my own very pink hands.

...wearing a dark blue beret... appearance-wise he was neither one thing nor the other. My aunt was convinced that he wore eyeshadow... yet we became very firm friends.

He very soon came to assume the authority of an old master. One day he took me aside with the obvious intention of tearing a strip off me. 'You know young JT, the trouble with you is that you make too much up out of your head; you should pay more attention to what's out there,' his finger was stabbing the air in the direction of the window, 'when I was your age my father made me draw everything in sight.' The old master was gripping the nape of my neck, forcing my gaze towards the light. 'That's real knowledge – what you see out there – the trees and the fields, the flowers and the birds.' But I couldn't see, I really couldn't. Much much shorter than the old master, all that was visible to me was an unbroken expanse of clear blue sky.

It was some time later that he decided – I don't know why – to show me his own paintings... snowscapes, paradoxically, hotter than hell... too much ultramarine. I decided there and then that there was no bigger failure than a failed impressionist.

...later, I changed my mind... it was the wrong blue...

...comforting the wide expanse of the Atlantic Ocean; one day a cold and turbulent grey and the next – when the sun was shining – that deep, Giorgionesque, translucent blue. I set up my sketching easel and lay out my paints... below me the waves were rushing in and breaking like matted feathers over the rocks, and when I looked up, I could see in the distance that picturesque array of uninhabited islands which pepper the sea off the north-west coast of Scotland... I had chosen the site for my secret experiment

in painting from the motif with the greatest possible care... facing, looking out towards, but well out of sight of the Americas... as I made the first tentative marks I remember thinking 'behind me André Derain and in front Edward Hopper'. No wonder the painting turned out to be such a terrible disappointment... neither one thing nor the other.

When I returned to school the old master was no more and in his place there was a 'Tiggerish' young man who implored us all to greater and greater heights of creativity... no more gazing out of the window... losing myself in the blue beyond...

...blond hair and bright blue eyes. Corker was quite literally that... but not so bright upstairs.

...out of the blue I acquired a beaten up old Hillman Imp...

My father phoned me to ask me if I would entertain the son of a friend of his from Paris ... I met him at Victoria, discovered him eventually by the left-luggage, torn blue jeans, shoulder-length brown hair and bare feet – sitting on a concrete slab reading poetry, looking for all the world like a Flandrin faune... But Dominic, I ask you, and even worse Jean-Paul Dominic, for such a pagan soul ...I decided, without consulting him, that in future I would call him Ampelos pseudo Dionysos – the first original imitation... it was hardly surprising that he protested so vigorously... in the end we settled for the simple, unadorned Ampelos.

...the sparks rising and swirling about in the hot air; scurrying this way and that like living things, before disappearing into the inky darkness of the night sky... as by the amber glow of the fire we shared with each other our passion for Novalis. Quoting lines by heart, turn and turn about. Each trying to out-do the other with heady feats of remembrance... till on the home run, Ampelos – self-proclaimed '*der alles Vergängliche*' – Will-o'-the-wisp that he was, beat me hands-down... rounding off triumphantly with the final Chorus from Faust... At that moment his stentorian excess would have upstaged even a Garrick or a Keene; pathos toppling over into bathos: more like the great Goethe was suffering an attack of the 'mean reds' than the 'mood Indigo'.

...escaped for the summer and doing the rounds of the galleries in Paris after two miserable years at the Academy... I came across my first Yves Klein: a circular blue 'Monochrome', a tautological *'Disque bleu'*. Quite a shock for someone who had been force fed on Social Realism.

...strangely enough it stopped me thinking about pictures and started me thinking about things... and light, more and more about light. Not the light that drawing teachers tend to talk about, not the light that falls on objects in an academic still life, but the light that seems to emanate from things, the light that breathes life into them. We can see it very clearly in that greeny-blue tint beneath the chins of Carpaccio's red and green stockinged Venetian boys and in the carmine flush on the faces of Pierro's angels...

Speaking of blue, the bluest blueness, of this I am sure, is the Aegean viewed from the terrace of the Cycladic Museum at the top of Naxos town. From here there is only blue... the whole world splits in two. Things are either blue or they're not blue...

'Is it not true that we Greeks, like our ancient bronzes, see with lapis eyes', Demetri asked me with an air of great seriousness, '...like the sea, do we not make blue the stones and the bodies within them... isn't this what Calisthenes taught us'. I glanced quickly from his face to the faces of his sons and his daughters... such incredible intensity in that family of brown eyes... 'When I stand before the Cretan warrior, and when I look into the emptied out orbit of his eye, I know that it is the horror of blindness that we Greeks fear, more than we fear death.' Demetri always scared me when he started to talk like this, it was as if he was trying to drag me back two thousand years...

...leaving the Academy and heading for Rome after two whole weeks redecorating my mother's kitchen. On a whim she had decided to change everything from red to blue...

...I began to like Poussin... of course I'd seen his paintings before, in the Louvre, acres and acres of them, but I'd never cottoned on. Here in Rome it was different ...here, where in the late afternoon everything shades from gold to a soft vegetational black and the sky changes from cobalt to cerulean, as the shadows lengthen into the flatness of twilight... It was just this kind of Poussinesque

evening, strolling in the cedar groves in the farthest reaches of the Forum, when I discovered the divinity that was Laetitia... and lost her again, almost immediately. But, then, this was the time of great confusion ... looking at ancient stones, remnants of a phallic empire by day while indulging in the same by night...

It was about this time that I painted my portrait of Hackenschmidt: arms akimbo, all muscle, a blue-black monochrome on a racing-yellow ground. It was shown back in London the following spring... nobody liked it very much... Hackenschmidt was destroyed three years later along with all the other paintings that formed my pantheon of Pop heroes... No more weekends in Blackpool, playing the pin-ball machines on the Golden Mile...

...you see I have never really understood the term 'indigo days'. To me, indigo, far from being a carefree, innocent sort of colour, speaks of a state of mind which I can only describe as a blueness very close to black despair. My indigo days then were those seemingly endless years after my return from Italy when absolutely nothing was going right. 'The Dylan years', I call them...

...my monthly pleasure, Demetri jetting in from Athens with the Aegean in his eyes... researching ancient music in the British Museum.

The ward furniture was all covered in blue floral prints – wild Hibiscus – supposed to be cheerful – I think.

It was well after mid-day and still the curtains were tightly drawn. I rang the doorbell and waited... Sushil was blinking in the strong sunlight like some small nocturnal creature caught suddenly in the beam of a torch. He was pale and the purple-blue rings around his eyes made them look wider, bigger, even blacker than usual... I said nothing. At that moment there seemed to be nothing that I could say. But he answered my thought anyway – mechanically – 'I know, it was a terrible waste...' Later I heard that in the days immediately after the funeral Sushil had destroyed all of D's paintings... attacking the stretchers with – of all things – a chainsaw and tearing the canvases with his bare hands... it was his way of objectifying the pain, Mica said... As it turned out, the waste was greater than he could have known. After all those long months patiently attending to D's every need – watching his friend slowly die...

less than a year and Sushil himself was dead. First he had lost his sight and after the pace of the disease had been fast and furious... he was not yet 28 years old.

...the fruitless search for a likeness... 'like the blue-white rays of a star', as Roland Barthes wrote, 'linking the body to be photographed to my gaze'. It is the search for a lineal identity. This is my – indeed everybody's – eternal chastisement, no longer to see, not to be able to conjure up the faces of absent friends, living or dead: abolished by time and distance, by the leaden weight of the earth or by the ether... and here, even the photograph, memorial trace, for the most part tends to function like old age: it disincarnates the face... '...I saw the wan blue eyes of Marcelle, gazing at me through tears of urine...'

I don't know why it is exactly, but every time I start off by painting something blue, I end up painting over it in black... perhaps it is the indeterminacy in the colour blue that I can't stand, like being afraid of deep water...

Burial Ground, exhibition catalogue, Museum Dhondt-Dhaenens, Deurle, 1996, pp.24–32.

Initially, I wrote this essay for an occasional publication edited by the Belgian art critic Luc Lambrechts. He caught me in a bar in Brussels one night suffering from one of my post private view depressions. I was complaining vociferously to a friend about the baleful effect that the rise to prominence of the Belgian painter Luc Tuymans was having on the practice of painting in the art schools of Belgium and Holland, and he asked me if I would like to write something about it for his magazine. I agreed, but also said that I would want to extend the argument to cover the parlous state of young artists in the Belgian situation. At the time Luc Lambrechts was also in the final stages of curating a large exhibition of Belgian art for the then Centre d'Art Santa Mònica in Barcelona and without asking me he released my essay in a cyclostyled-form at the opening, with the whole of the Belgian art world present. Not surprisingly my essay became a controversial topic of discussion overnight, hitting the Belgian press the very next morning. The Belgian art scene in the late 1990s was one where influence – personal and private patronage – counted for everything. Furthermore, there was not much open criticism of the institutions that supported the status quo. It is also not surprising then that in some circles, for a short period of time, I became the most hated man around. Subsequently, the conditions for young artists in Belgium have improved markedly and I like to think that that started in Barcelona.

REVIVALISM AND THE LUC TUYMANS EFFECT, A PERSONAL VIEW

Normally speaking, when someone suggests to me that there is something of a revival underway in the practice of painting, I tend to treat it with a pinch of salt. 'What form could such a revival take', I find myself asking, and 'from which new conceptual order might it have sprung'. I am old enough too, to remember the so-called revival of painting of the late 1970s and early 1980s which, with substantial backing from the West German government, served to launch a new 'school' of German Expressionist painting – Georg Baselitz, Anselm Kiefer, Rainer Fetting and the rest – by way of an exhibition selected by Christos Joachimides, Norman Rosenthal and Nicholas Serota which in its title, so naively trumpeted *A New Spirit of Painting*. To read Joachimides's introduction to that exhibition now, makes one acutely aware of just how misleading these types of claims can be; and perhaps, more pointedly, just how conceptually barren notions of revival usually look when viewed with the benefit of hindsight. In this particular instance – in the case of *A New Spirit of Painting* – what started off with the claim that there was an historically rooted and internationally recognisable 'new spirit' abroad in painting, has in retrospect tended to show only that in the shift into postmodernity, painting, as a generic practice, was no longer capable of holding the centre ground, and

that apart from a rather feeble claim to a unity of purpose based upon a decaying craft tradition, it was in reality, an increasingly fragmented and idiosyncratic form of art practice: no more or less coherent or more pertinent to that particular historical moment than any other.

Now, over the course of the last couple of years, I have been hearing the siren song of a painting revival sounding again; especially here in Belgium and the Netherlands. Nowadays, knocking around the art scene in Antwerp and in Brussels, it seems to me that wherever two or three artists or paid up members of the art *cognoscenti* are gathered together, sooner or later there is talk of the 'new Belgian painting'. And in Holland too, I have noticed that a similar discussion is gathering momentum in the state academies, where it is said that 'more and more students are turning back to painting'. But how much real weight can we give to these rumours of an immanent painterly instauration occurring in the 'Low Countries', beyond, that is, those changes in the pattern of practice which can be explained very simply and directly by examining the prevailing economic circumstances that shape the working lives of artists in this particular part of the world.

In the domain of art practice, as with every other arena of human endeavour, economic forces are in play which have real and concrete outcomes, and not simply in terms of the day-to-day well-being of the individual artists concerned, but most importantly in relationship to what artists actually do; what they feel able to do; what the general economic climate seems to want to permit them or, indeed encourage them to do. It is for this reason that both the patterns and forms of art practice can shift or even transform themselves in times of economic astringency. It is my observation too that in the post-Cold War period, these changes are more and more connected to the demands of the market; that more often than not there is a distinctly conservative drift to them. And here I think it is pertinent to point out that despite the fact that public funding for artists in the Netherlands is altogether more generous than that which obtains in Belgium, the same coercive forces are at work. If in Belgium and the Netherlands, then, there is indeed a revival underway in the practice of painting, we must at least entertain the possibility that, far from it being 'progressive' in its general thrust, it is a regressive and reactionary one. We must ask ourselves whether it has arisen as a genuine response to the changing patterns of signification occurring within the lived culture, or whether it is merely a product of changes in the focus and the buying habits of the local and international fraternity of collectors: the result, in other words, of a movement in the dynamics of the art

market. And here I should like to report a conversation that I had recently with a London gallerist friend of mine, who suggested that the days of what he called the 'warehouse type of collector' were more or less over, killed off by the price of property, and that the new breed of collector wanted works of art to enrich the domestic setting; paintings and objects to adorn the place in which they lived. The question of marketing art objects, then, is also tied to the price of real estate in the metropolitan centres and not just for the dealer renting or buying premises in which to display or store works of art, but for those who wish, eventually, to own them too. At a time when a family-sized apartment in a desirable London inner-city area changes hands for £1.5 million, the notion of purchasing extra space for the purpose of exhibiting museum-size works of art tends to come under very severe question. Perhaps as well, given this kind of economic climate, it is not too cynical to suggest that paintings – as long as they are not too large – become the preferred luxury commodity over three-dimensional works: sculptures or the ubiquitous postmodern object.

Whichever way you choose to look at it though, in an art world so much under the sway of late, of transatlantic capital, as in every other area of commerce, marketability tends to be a powerful determining factor. Certainly, as far as the commercial gallery system is concerned – and here I refer to that curiously osmotic relationship that links the local to the international arena of exchange – marketability is the index of recognition and the key, therefore, to success. Thus, as far as young artists are concerned, it remains the horizon beyond which – realistically or otherwise – their dream can persist of a possible, viable future as a practising artist.

When viewed from the much wider political perspective afforded by consideration of the whole range of modernist art practice in the postwar period, this also represents something of a seed change in the climate of practice itself. For the first time in the postwar period, it would seem that the private sector of the art world has wrested the initiative from the public, and the distinct shift of power reaches beyond the practice of individual artists to influence the way in which public institutions carry out their different roles. It is not uncommon, for example, for dealers to align their interests and activities with the known preferences of key individuals operating from within public institutions – museum directors, curators and the rest – thereby effecting transactions which blur the crucial, implicit distinction between judgements made on strictly museological grounds and those that are made in the pursuit of commercial objectives. Some recent commentators have even

suggested that by now the distinction between private and public has been largely dissolved; that the public art space has become annexed to commercial interests. But no matter how we choose to view or to evaluate the current state of affairs, it would seem to me to be a sad reflection on our own time that the idealism and the ambition necessary to establish and sustain an exemplary arena of practice outside of that provided for by the commercial gallery system – an objective which so fired the imagination of artists throughout the 1960s and the 1970s – has by now, for the most part, quite faded away. Certainly as far as the present generation of young artists is concerned, what previously had proven itself to be an invaluable, imaginative space for experiment and for provocative and interventionary forms of creative activity, by now has been almost entirely closed down. And with nowhere else to go, young artists are being driven – mostly prematurely – into the arms of the dealers, and to view the private gallery as the main institutional focus for their ambitions.

Today's commercial gallery is no simple sales outlet either – not a neutral showroom or a simple shop – but the point at which a whole network of different interests intersect; a place where a diverse collection of individuals with quite distinct roles and spheres of responsibility – the dealer, the collector, the agents of public funding bodies – join forces under the common umbrella of a tacitly mutual and highly complex promotional apparatus. Nor is this commonality of interests entirely free from the subtle forms of corruption that the thoroughly duplicitous values of commerce tend to breed, even in the most elitist and specialised of marketing operations. In this respect, the gallery system mirrors other oppressive and reactionary power structures at work in the society at large. Under the guise of cultural – even political – liberalism, it seeks before all else to preserve the existing order of values and to sustain the illusion of a benign, public-spirited and highly cultured moneyed class, functioning constructively as an integral part of a broader social fabric.

In seeking to understand and give proper weight to any notional revival within the scope of the visual arts then, the gallery system is the first stone that must be turned over if we are to gain a real insight into the particular configuration of interests that lie beneath. And here, for the purpose of clarification, it is important to bear in mind that different art worlds – that is the unique political and economic conditions that shape the practice of artists in different countries – tend to yield up very different formations and patterns, even though the engine that drives them comprises an identical list of component parts.

In the Netherlands, for instance, the interventionist character of successive postwar governments has led to a longstanding and sophisticated regime of state patronage for the arts and this has tended to determine the mentality of the private sector as much as that of the public one. Thus public institutions in Holland have come to play an absolutely dominant role in shaping a common visual culture, over and above, say, any influence that might be wielded from the art market. By contrast, in Belgium the opposite is the case. The very paucity of public patronage coupled with the somewhat casual use of the 'arms-length' principle for distributing such funds as are available from government, has placed the power and influence firmly under the sway of the private sector. Indeed it has produced an art scene which operates almost entirely on the basis of personal patronage, and this is true even where public money is being used.

The motor that powers the Belgian art world, of course, is the purchasing power of an exceptionally large number of private collectors, grouped in relation to quite specific marketing interests – galleries and dealers – with a more itinerant, ideologically ambivalent collection of critics, freelance curators, museum people and public agents of different kinds in orbit around them and sometimes moving in between.

Although on the surface at least, these two systems, the Dutch and the Belgian, seem to be diametrically opposed to each other – seem to argue different philosophies of public responsibility and different ways of constructing the public, cultural domain – strangely enough they seem to have given rise to similar submerged patterns of manipulative behaviour, even – we might think – similar forms of petty corruption. In the Netherlands, because of the unwieldiness of its public and semi-public institutions of patronage, an elaborate secondary network of personal, cross-institutional contacts has grown up, made up of people familiar with the many ways in which influence might be exerted; with ways of speeding up, or even bypassing, the main mechanisms of control altogether. Thus, despite the claim to a cultural climate organised along open, democratic lines, still there are a large number of transactions which take place to one side of the public domain – hidden, as it were, from the public gaze – occurring as between a fairly select group of policy-makers and other interested parties operating ostensibly in the name of some version of the public good. In Belgium, by contrast, because there is little or no attempt by government to build a coherent public cultural sphere – for example, artists are not even recognised in Belgium for taxation purposes – the balance of interests tends

to be very different. As we have already remarked, the dominant mentality is governed by the values at play in the private sector, with the result that the power to make judgements on the public's behalf is given over into the hands of a small group of individuals whose allegiances are never really up for discussion. It would seem then that in both countries, who you know – who is in your circle – who you can get on the end of a telephone, is far more important than what you know, or, perhaps more pertinently, what you do as an artist.

Now I can hear the shuffle of feet as defensive positions are being taken up: I can hear the voices claiming that all art worlds in whichever country or continent function in this way; that all of them evolve patterns of influence and secondary channels of decision-making; that all of them generate a certain level of petty corruption and comparatively harmless forms of graft. And to a certain extent this is true. But it is my contention that of all the art worlds I have been a part of for any length of time – Italy, Spain, the USA, and of course Britain – the 'informal sphere of influence' is more active here than anywhere else and that this arises out of a chronic imbalance in the structural economic circumstances within which artists are forced to work. In the case of Belgium I would go so far as to say that the imbalance between the private and the putative public sector turns everyone, even the artists who ultimately succeed within the system, into victims.

And this brings me to the point where I should like to discuss what I shall call the Luc Tuymans effect. But before I do so, I want to make it clear that it is not my purpose here to pass judgement on Tuymans the artist: that would require an entirely different kind of essay. Rather I want to deal with his influence – or the influence his success has had – on other artists, in particular the younger generation; and with his place as an exemplary figure within the Belgian and Dutch art scenes. However, before I do so I should like to make just one comment on his position as an artist. I do think that like a number of artists who have hitherto graced the history of Modernism, Luc Tuymans is a thoroughly reactionary figure, and like famous reactionaries before him – we might cite De Chirico or Morandi after the early 1920s; Wyndham Lewis after the Vorticist period; or, more recently Balthus and Freud – his influence on the younger artists who choose to follow him is a predictably baleful one. Let me emphasise once again that I am not making a judgement of Tuymans the painter. In my view reactionary painters can be especially good painters, though their influence on others is almost always a negative one. Think of all the generations of young painters who have followed in the footsteps of the painters of the School

of London – Bacon, Freud, Kossoff and the rest – over the last 30 or 40 years: where are any of them now. The answer is a depressing one. Either they are isolated and disillusioned figures, still making their stylistic and mute homages to their chosen heroes and operating under the mistaken belief that history has unjustly passed them by for some reason, or they have long-since given up practising altogether. And this leads me to the interesting question as to why this type of reactionary artist tends to attract followers so easily in the first place.

Of course, at a certain level, they appear to be very attractive models. More often than not, they seem to be very sure of themselves; certain about what they like or what they approve of and swift to criticise or condemn more or less everything else. At the same time, they offer a reasonable, familiar and fairly easily assimilated formula for making work, and this linked as it so often is with the heady and bittersweet rhetoric of revival, gives the model the seeming weight of a moral imperative. When this is linked, as it is in Luc Tuymans's case – more I hasten to add out of the arguments of his apologists than what he has had to say for himself – with very considerable critical and market success, then the pull of such a figure becomes almost irresistible.

Now, during the course of the last 18 months or two years, doing my rounds of exhibitions in the academies of Belgium and the Netherlands, I have discovered a growing number of Luc Tuymans look-alikes; at least two or three in every school. These are figurative painters who like to work small, employ a restricted range of colour and paint in a slightly Hopperish manner to achieve a winsome vagueness of form, almost as if the painting is in its first stage or has not quite been brought to the finish. The chosen subject is quite often a little offbeat; or if it is generic, then it is cropped in a slightly awkward or unusual manner. I could carry on with this list of characteristics but I would only end up with a complete description of a genre of figurative painting which, for someone such as myself, educated in a well-known painting department of a famous London art school during the 1950s, has something depressingly familiar and crushingly academic about it.

The British postwar art schools, especially the London ones, taught a form of painting which combined the Euston Road School's total misunderstanding of Cézanne with a strong tradition of painterly reportage stemming from the painters of the Camden Town School; most particularly the later work of Walter Richard Sickert. This combination tended to produce a rather eccentric form of figurative painting, couched in the depictive language of mark-making derived from Impressionism and using an almost through-the-

keyhole approach to the motif. The style was characterised by the use of a reduced palette; the closing down of tonal difference; the eschewing of local colour, excepting when it had some literal or tautological meaning within the painting – *Girl in a Red Hat*, or *The Blue Caravan* – and a sideways engagement with photography. Sickert, it should be remembered, painted most of his late works from press photographs, thereby launching a new style of figurative painting which took hold in the art schools of the day, but was only more widely appreciated in the 1970s. Linked to this way of painting, at the conceptual level, was an almost Proustian idea about the painting as a memory-trace; as a form of image-making that could slice through time in some way.

The art schools too had evolved a thoroughly worked out method for teaching this type of painting and in this sense it had become an academic project replete with rules that governed both the product and membership of the 'good painting' club. This method started out by requiring the students to master the art of painting in monochrome and – even more interestingly in terms of my argument here – of avoiding line, and painting the shadows of things rather than the things themselves, using a controlled range of optical greys. Afterwards, this regime was relaxed and the student was allowed, in the first instance, to add one other colour, usually an earth colour of some kind like Yellow Ochre or Burnt Sienna. Too much finish was greatly frowned upon, and students were taught to stop the development of the image at a certain stage, to allow for the memorial introjection of the viewer.

It is by now a matter of history that this orthodoxy became something approaching an 'official' modernist style in Britain during the early 1950s. It dominated the radical wing of the Royal Academy of Arts, and was the guarantee of progress to postgraduate level within the art school system. For a good number of years as well it was the key to preferment thereafter. And this orthodoxy continued until the British Pop art movement got underway in the late 1950s and early 1960s.

Of course I am not arguing that what is now referred to as 'the new painting', or at least, that which I have chosen to call 'the Luc Tuymans effect', is identical in every respect with what went for good painting in Britain in the first half of the 1950s. It is more my contention that the underlying philosophy is similar and that at the level of taste there is a middle-class ideological consensus hidden in it that makes it entirely regressive in its general thrust. It is one thing to argue a revival in painting – even of figurative painting – it is quite another to argue a form of painterly representation which is nostalgically polite and

smacks so much of the aesthetics of the drawing-room. And here I should like to record an important difference between the work of Luc Tuymans and that of his young followers. There is at times a partly submerged, rather aggressive edge to some of Tuymans's work; a hardness, if you like, which tends to show itself in both the subject matter and the overall mood of some of his pictures. And this, in my view, is what sometimes gives his pictures their distinctive quality.

Now none of this would be particularly disturbing if it were not for the fact that when you talk face to face with this new generation of painters, so fired up with their revivalist zeal, they pick examples of excellence which are of an entirely different order of ambition to that which seems to be the intention underlying their own work. Always, for example, they speak of Francis Bacon, of Lucian Freud, of the late paintings of Philip Guston and the figurative works of Gerhard Richter: all of them artists who have taken up strong and uncompromising positions in relationship to the fashionable preoccupations of the art world, and in terms of the type of images they wanted to make. There is not one of them who could be accused of pandering to a bourgeoisie sensibility; providing for the taste of the socially advantaged; or for that matter being overly timid or polite. In this respect, this new revivalist generation of painters would seem to be victims of an incipient conservatism running counter to their own most radical desires and it is an interesting task – I would argue – and an extremely important one, to speculate as to why.

And here, by way of arriving at some kind of conclusion, I should like to return briefly to some of the issues and points of arguments that I made earlier on in this essay.

It seems to me that neither the Netherlands nor Belgium offers a context which is really conducive to the sound and proper development of young artists. In the case of the Netherlands, the institutions of the state are too much in evidence and over the years, this has tended to produce a rather smug and comfortable radicalism, without a great deal of critical depth. In the case of Belgium, the values of the marketplace seem to have come to dominate everything, and not just in the commercial gallery sphere of buying and selling, but also in the public institutions. Most disturbing of all is the way in which it also seems to dominate the thinking of the artists, young as well as old. Meeting with artists here – in their studios, at openings or in the bar afterwards – the powerless predicament of artists working in Belgium is always a topic, albeit in a coded form. The discussion always seems to come to focus on questions like, who is doing what with which dealer; who is receiving

public support via the Commission; what new liaisons have been made between critics and dealers or between dealers and curators and who is likely to benefit from them, and so on. Indeed, there is a curious brand of pecuniary parochialism abroad, which seems to take precedence over any discussion of the work itself. Of course, artists in Belgium, especially those who are just beginning to try to make their way in the art world, operate in what can only be described as chronically insecure circumstances. As I have already remarked, they can claim no status as professionals for taxation purposes which means that they cannot claim reasonable expenses against earnings. Furthermore, there are comparatively few openings for teachers in the academies or the universities. They are forced, then, to try to find a way of continuing with their work as artists which at least provides a minimum turn-over to cover professional expenses and some form of living. This usually means achieving a relationship with a commercial gallery, whether it is timely for them or beneficial to them or not.

There remains only this to be said about what I have called 'the Luc Tuymans effect' then. While it is certain that an artist of the quality of Tuymans would have gained the personal recognition that he has received here in Belgium in another country – say Britain or America – it is highly unlikely that he would have become influential amongst younger artists as he has here. No artist, of course, can be blamed for the influence that they have had on others, unless, that is, they also set themselves up as the leader of a tendency or a school as some of the revivalist artists of the School of London – say Leon Kossoff and Frank Auerbach – have tended to do. Neither can Luc Tuymans be blamed for the fact that, because of his success, he has been given an exemplary status by those who have an ambition to succeed in financial terms as creatures of the art market. But even though Tuymans himself might be quite innocent of the spurious claims to a painting revival that have been attached to his name and have become so much the talk of the secondary art scene in this part of the world, there are others who are by no means so free from guilt. There are the dealers who have decided to go along with and even to promote the notion of revival, dare I say it, entirely as a temporary commercial strategy and for short-term financial gain. And then there are the critics who have jumped on the bandwagon in order to appear the prophets of the next generation. A plague on all their houses.

Trapped Reality: Centre d'art Santa Mònica, Barcelona, Centre d'art Santa Mònica, Barcelona, 1997, pp.43–54.

When Jan Debbaut, then director of the Van Abbemuseum, asked me to write about Steve McQueen's film installations for the first major showing of his work on mainland Europe, I jumped at the chance. I had long been an admirer of McQueen's work from his time as a student at Goldsmiths College where he first showed interest in the medium of film. In his last year at art school he made a number of short films, which illustrated his instinctive grasp of cinematic time and its narrative potential. It was about this time too that he began to talk about his ambition to eventually write and direct movies. I have to say that when I got down to it, I didn't find writing about McQueen's films – from *Bear* (1993) to *Just Above My Head* (1996) – at all easy. At the point of reception these early short films are so tightly structured and immediate to the eye, so absolutely visual, that they seem to offer little room for critical extrapolation. For this reason, I fastened upon McQueen's use of cinematic convention and quotation as a way of approaching these films. We never discussed my essay, but I had the feeling that he was not altogether comfortable with it – possibly because of my use of the term 'cliché'. To me 'cliché' is not necessarily a negative category but one that opens upon the possibility of recuperation. And in the case of McQueen's early films it still seems to me important because it connects them to the vernacular: it allows them to be high- and low-brow at one and the same time.

The text was published without me seeing the edited version, and so I have reconfigured the essay here to return it to the original.

'IT'S THE WAY YOU TELL 'EM': NARRATIVE CLICHÉ IN THE FILMS OF STEVE McQUEEN

Basically you can put the camera anywhere. There is no right or wrong angle for something. The idea of putting the camera in an unfamiliar position is simply to do with film language. Sometimes it is spectacular, sometimes it is ugly, sometimes it is uninteresting... but it has to do with looking at things in a different way. Cinema is a narrative form and by putting the camera at a different angle – on the ceiling or under a glass table – we are questioning that narrative as well as the way we are looking at things. It is also a very physical thing. It makes you aware of your own presence and of your own body.

– Steve McQueen [1]

Where the work of Steve McQueen is concerned, it is important to address the topic of cinema before speaking about artists' films; cinema being the narrative form that gives shape and purpose to his filmmaking as language. His films start from the idea of the physicality of the cinematic experience and this carries his work beyond reductive notions like 'reading', beyond the reach and analytical scope of semiotics. This sets him very much to one side of the dominant stream of recent British artist/filmmakers most of whom have espoused the post-Structuralist and 'materialist' tradition. While he does not deny the potential that lies with the 'performative' aspect of artist filmmaking, or that of documentary film and filmic language, McQueen prefers instead to work with film's tendency always to construct meaning through the play of movement and duration. In this respect, his idea of narrative is not the typical moviemakers attachment to storytelling. Rather it is seen by McQueen as implicit to the main structuring operations of cinema – to framing and to cutting – and more importantly, intrinsic to the moving image itself. His films demand – arguably they even cause – a very special quality of attention out of the way in which he uses the 'cinematic eye' to fixate upon movement or its absence; out of the camera's power, in other words, to mesmerise the viewer.

This approach might be seen as a shade old fashioned. Indeed, the primacy that McQueen gives to the close observation of the moving image might almost put him in the camp of the movie fundamentalists but this would be to misrepresent his intentions altogether.

While it is certainly true that McQueen's films seem always to be built around and address themselves reflexively towards, certain quite basic rhetorical devices and familiar cinematic forms, it would be quite wrong to call his work formulaic. In the case of his film *Bear* (1993), for example, it is hard not to see it in terms of the cinematic trope that Gilles Deleuze, in his taxonomy of the 'action image' has labelled 'the duel'. We might cite the trial scenes in Carl Dreyer's silent masterpiece *The Passion of St Joan of Arc* (1928) as a pertinent historical example, and more recently, the gymnasium and fight sequences in John Huston's *Fat City* (1972) or the midnight torture sequence in Volker Schlöndorff's *Young Törless* (1966). At first sight, the formality of McQueen's shooting schema seems to invoke precisely these kinds of models. Despite this it would be wrong to think of him as some kind of closet formalist. He is certainly not interested in playing historiographic games by all the time referencing the cinema's past in his own films. Always it is the immediacy of the cinematic experience that concerns him most and this is what is foregrounded in all of his recent films: the trilogy comprising *Bear, Five Easy Pieces* (1995) and *Stage* (1995) and his most recent film *Just Above My Head* (1996). All are shot in black and white, all of them are silent. Not because McQueen is a purist, a reactionary backwoodsman or nostalgist either, but because he wishes to insist upon the indexical or textural integrity of the moving image and its capacity for shaping and detailing the cinematic narrative. In these films, his every decision seems to caste the act of filmmaking as a form of highly tactile, psycho-physical, visual enquiry.

Such an approach must of necessity pass by any notion of grand narrative; must seek out instead those tiny nuances and glosses that together can constitute an effective micro-narrative. The French theorist, Paul Virilio, citing what he thinks of as a new kind of cinema that he calls the *Cinema of Fragments,* describes a type of film which has hardly any plot but accrues its forward motion and compelling force out of a parade of minutely observed details. It is a model which corresponds very closely to McQueen's film *Bear.* Certainly it has no plot to speak of, just a rather bald cinematic cliché; that well-worn fight sequence of popular cinema. It manifests all the familiar rhetorical devices: the low camera angles that simulate ring-side viewing;

the perspiring proximity of naked male flesh; the halating lights, sometimes hardening and sometimes eating away at the circling profiles of the two protagonists. In popular cinema these devices serve a very direct purpose. They empower the viewer by seeming to place them in the best possible vantage point from which to witness the fictional spectacle of mutual aggression and destruction. But in McQueen's version something else happens. There occurs something close to what Dick Hebdidge has called 'the withering of the signifier' and it happens before our very eyes. The generic cinematic cliché is made slowly to collapse; to fall in upon itself. The principle of voyeuristic visibility remains the same – 'the closer you are the more you see' – but what you see – that which the camera dwells upon – the cliché that McQueen has put up for our close observation is of a sudden made strangely fugitive. As the film progresses the relationship between the two men passes through a whole gamut of different emotional signings, from aggression to something bordering on sexually charged affection. All of it is coded in close up; in the shifting emotional landscape of the human face.

The narrative course of McQueen's *Bear,* then, moves from tense confrontation – the fettered proximity of the macho trial-by-combat – first of all into a kind of emotional no man's land where the viewer is not at all certain about what exactly is being depicted – are the two men taunting each other or are they engaged in affectionate banter – and finally reaches its point of release in the sexually ambiguous, mutual touching of the boys' club changing room. This curious emotional journey is not dissimilar to that which occurs in Ken Russell's *Women in Love* (1969) except that McQueen's film is not part of a larger narrative. It has no overt political purpose; no overarching social or moral argument. Neither is it a fragment but is possessed, like all good narratives, of a beginning, a middle, and an end. Even though, time wise it is very compacted, it manifests itself as a controlled and systematic shifting through different narrative expectations.

By comparison, the second film in McQueen's trilogy, *Five Easy Pieces,* is at once more structurally complex and more critically demanding. From the instant the tightrope walker's rope snaps into position it is immediately apparent that this film is going to progress in an entirely different way from the lingering, evolutionary watching and waiting that we experienced in *Bear.* *Five Easy Pieces* uses abrupt positional cutting and proceeds from narrative section to narrative section with startling precision. First we are craning our necks to look up at the careful steps and the slowly moving, almost amoebic

torso of the tightrope walker and then we are high up, looking down from above at the sexually charged, gyrating movements of the five hula-hoop dancers. One minute we are flying, the next earth-bound. There is a barely disguised violence in this strategy of editing. Where *Bear* depicts violence from the outside – symbolically – *Five Easy Pieces* makes violence part of the filmic language itself; ties it into the moving images' indexical function, making it one with cinematic experience. McQueen underscores this drawing together of primary and secondary codes when, as the film's chief male protagonist, he appears to urinate into the eye of the camera from above. Pisses into the face of the viewer. Surprisingly, there is nothing particularly shocking about this parting gesture, which serves to bring a different retroactive intensity to the viewing of the film as a whole.

Repeated viewing of *Five Easy Pieces* reveals, beyond its baroque excesses – the shifting arabesques which seem to dominate its surface imagery – another one of those ubiquitous Hollywood clichés: 'the fight on the top of the train'. Beyond the sharp intelligence of the cutting; beyond the dizzying shifts of camera position; beyond the array of unfamiliar and often very beautiful images and the quality of attention that McQueen brings to the business of framing them, memory carries the viewer back to the Hollywood Western and John Ford's famous dictum: 'if it's height you're after then the camera must first look up before it looks down.' We know this trope from so many Hollywood spectaculars and art movies alike. Think of Peter O'Toole's boots, pounding the top of the train, his stomping walk punctuated by shots directed vertically downwards as he strides from one carriage to another, in David Lean's *Lawrence of Arabia* (1962). Think of the opening sequence with the camera tracking the baroque ceilings, room to room, in Mad Ludwig's castle before going into slow free-fall in order to scan the formal, classical gardens in Alain Resnais' *Last Year in Marienbad* (1961). Despite its familiarity, however, there is something entirely new about the use of this device in McQueen's *Five Easy Pieces.* The points of visual connection are stretched and drawn out. It is as if McQueen is trying to test the visual fabric of the piece – its unity at the point of reception – to breaking point. The narrative links are barely holding together and when the *denouement* finally arrives – when the pissing scene occurs – although it a highly charged cinematic moment it is also quite brutally dismissive. In as far as it links the abject with the monstrous in order to create a moment of confrontation, it serves as a clear reminder of the power-play which is always present between the moving image and the passivity of the audience.

The mood is very different in the third film in McQueen's trilogy. Where the visual dynamic of *Five Easy Pieces* is vertical, *Stage* operates almost entirely along a horizontal axis giving a feeling of greater containment and an atmosphere that is more inward looking.

Stage is by far the most structurally complex of McQueen's films to date. It is packed with visual/verbal allusions, little language games, some of which, like the crawling and tip-toeing sequences, have the appearance of having being inserted against the flow of the narrative. Certainly they demand a conscious act of recuperation on the part of the viewer if sense is to be made of the film as a whole. There is an air of apprehension about the film which is established from the opening shot: a close-up of a woman's shoe-clad feet descending a staircase with precise but very cautious steps. The main rhetorical play of the film is then introduced. This takes the form of a persistent oscillation between the separate domains of the two main protagonists – a black man and a white woman – who occupy the right and left sides of the screen respectively. Once again there is something familiar about this cinematic device, especially when it resolves itself into a potential confrontation between the two, occurring from both sides of something like a street corner used to divide the screen vertically from top to bottom. Hidden from each other's view, the man and the woman approach the corner seemingly with trepidation; entirely unsure of what lies beyond. Here again we discover McQueen playing with another one of those movie-makers clichés – 'the predictable surprise' – familiar from films of the silent era, from westerns and comedy-action movies. However McQueen gives it serious psychological purpose, as a means of sealing off the two characters from each other. Effectively locking into their heads and their own worlds. So that when, at the point at which they seem to meet, the screen itself divides – architecture is replaced by a real rupture in the filmic narrative surface – the feeling of dislocation is overwhelming.

It is in *Stage* that McQueen's insistence upon the physicality of film and filmic language is most apparent. Shot on 35 millimetre black and white film and often deploying a sharp, raking light that hardens up all of the visible surfaces – the floor and the walls – most importantly, emphasising the texture of skin, hair and eyelashes, all that the camera fixes its gaze upon has a gritty tactility about it; almost it becomes hyper-real. And when the physical immediacy of the image is joined with McQueen's favourite presentation strategy of wall-to-wall projection above human scale in an enclosed space, his intention to heighten awareness of the body is made absolutely palpable.

In a recent *Art Monthly* interview, McQueen, when asked why he insists upon his films being silent, replies that it is precisely the absence of sound which produces the feeling of airlessness in his installations and this is certainly true in the case of *Stage*. As the film progresses the silence becomes almost unbearable. It seems to generate an atmosphere of suspense that comes close to panic. In this respect, it is a terminal point to the trilogy as a whole by intensifying the feeling in the viewer of a psychological progress from outside to inside. The overall mood of the trilogy is of gathering darkness each film delivering its own particular brand of claustrophobic tension.

Since completing the trilogy McQueen has made one new film, *Just Above My Head* (1996). It has an entirely different atmosphere and seems to signal a new approach to method. Closer to structuralist film, but still focused on cinematic narrative, it seems to embody a different set of concerns and deals with a different set of conceptual problems. It also draws closer to the modernist tradition of the artist/filmmaker, most especially the Minimalists, Dennis Oppenheim, Bruce Nauman and Richard Serra but also more contemporary video artists such as Gary Hill. The scenario of *Just Above My Head* is very simple, its methodology, straightforwardly 'performative'. The image tracks McQueen himself walking briskly across a very uneven piece of ground. The camera holds in vision the piece of sky just above, and including, the artist's head which is seen bobbing along at the bottom of the screen. Hence the title of the film. It is only when the viewer realises that the film is one long, tracking shot, that the manner of its production becomes apparent. Having carefully positioned the camera to capture the scene that he wants, McQueen is pushing it along in a wheelbarrow. The unevenness of the ground producing a highly unstable moving image. The silhouetted head seen against the cloudy sky continues in an almost monotonous fashion until – in the end – their occurs an electrifying moment. The spreading branches of a tree suddenly break the frame from the right and spread quickly across the screen filling the space behind like a Pollock drawing. In common with all of McQueen's recent films *Just Above My Head* is installed wall-to-wall and floor-to-ceiling and this is crucial to the reading and legibility of the piece. Along the edge linking image to floor there occurs an inverted partial reflection which transforms both its spatial and its metaphoric reading. The viewer is no longer outside the work but incorporated into it to be absorbed within its unnerving oceanic character.

As we have already remarked, *Just Above My Head* seems to represent a distinct shift in McQueen's filmmaking trajectory; away from the cinematic concerns of the trilogy towards the 'performative' and the minimal. But look more closely at this; his most recent film, and his interest in filmic language and cinematic rhetoric are as strong as ever. *Just Above My Head* also attaches itself to a particular cinematic cliché, 'the empty screen'. In this respect, it raises such important historical figures as Michelangelo Antonioni, Jean-Luc Goddard and, most importantly, the master of this particular device, Robert Bresson; in films like *Man Escaped* (1956) and *Diary of a Country Priest* (1951). When the tree spreads across the screen in McQueen's film, it calls to mind the extraordinary moment in *Diary of a Country Priest* when the priest of the title is crossing the park of the grand chateau and is suddenly seen against the sky with the trees creeping up the screen behind him. In *Just Above My Head,* then, as always with McQueen's films, the language games are never as obvious as they first appear.

Steve McQueen, exhibition catalogue, Portikus, Frankfurt am Main and Stedelijk Van Abbemuseum, Eindhoven, 1997, pp.5–9.

1 Patricia Bickers and Steve Mc Queen, 'Let's Get Physical', *Art Monthly*, no.202 (Dec–Jan), pp.1–5.

THE GHOST IN THE MACHINE MADE VISIBLE

The multiplicity of presentational strategies; the various mechanisms of display and sources of imagery; the careful referencing of key moments in art history and in the history of technology, tells the viewer straight away that there is much in the work of Mat Collishaw that is waiting to be excavated and understood. Often both the manner of installation and the individual images too, operate on several different levels at once. And there is a tendency for each exhibition to utilise this diverse array of historical, technical and linguistic material in such a way as to bring into sharp focus some aspect of the current debate on photographic representation. For this reason, we might quite properly characterise Collishaw's engagement – and this despite his metaphorical use of the furniture of old technologies – as a thoroughly contemporary one, centrally concerned with the contradictory nature of the photograph: the visibility and invisibility of its subject; the at once corporeal and yet spectral nature of the photographic image; its gift of a simultaneously tactile but untouchable presence.

Before addressing the works themselves, then, it is important to set the scene by looking at some of the current debate on photography and the mediated image, especially that arising out of the comparatively new study of 'mediology'.

It seems that nowadays – in thrall of the videosphere – we are all of us adrift in the indexical, visual universe; subject to a bewildering range of image-making and image-disseminating technologies. Worse still, many contemporary thinkers argue, we have all become pretty well accustomed to the impoverishment this represents. There is no common or shared symbolic order any more; only a kaleidoscopic concatenation of images, seemingly freed from any demanding sense of cultural or historical purpose and experienced through the heavily mediated ubiquity of today's semiotic order. As the French philosopher, Regis Debray, has so effectively argued in his seminal essay, 'The Three Ages of Looking' (1994): just as surely as Alberti's deployment of linear perspective in the fifteenth century was a crucial moment of change in the history of vision, with far-reaching consequences for the political construction of the human subject; so the invention of photography in the nineteenth century once again changed the way in which we apprehend and give conceptual shape to reality, has transformed completely our understanding of what it means to be an observing subject, loose in the world. The invention of photography, Debray suggests, spelled the beginning of the end for 'The Age of Art', and at the same time provided the important, initial impetus for 'The Age of the Visual', wherein the illusory tactility afforded by the indexical sign leads us to believe that we can touch, even verify, everything with the eye.

In this visually replete here-and-now it would seem also that the image is all there is; it is the subject of our visual curiosity and the endlessly fascinating but fugitive object of our speculative contemplation. And it has become all of this without, at the same time, providing for any symbolically framed representational certainties. This, then, is the place where 'Doubting Thomas' meets 'Peeping Tom'. Here is the nightmare world of the scopaphiliac; a world in which the Tantalus of human curiosity is all the time challenged by crippling doubt as to the truth of the object of desire. The index, in other words is required to do the work of vision, while the eye is required to do the work of carnal exploration: to penetrate – to pass through and beyond – the peephole in the Duchampian door; to reach for the place where object and image become one.

This illusive and largely illusory offer of a unity between hand and eye; an intimacy that we experience directly perhaps, only in a lover's caress – when touching is believing – and which in its imaginal context is peculiar to our experience of the photograph out of its indexical nature, has a tendency, Roland Barthes suggests, always to point towards – or to cite – the body as an object of desire. Like the lover, Barthes argues, the photograph 'points and says only

"that"... the fact of being "this", of being "thus", of being "so"; "tat" means "that", "there is it", "lo" and says nothing more.' For this reason, he goes on, 'love and photographs index and do not represent their objects'. By means of the photograph the desiring spectator can touch the love-object, and reciprocally, the desired object can reach out and touch the beloved spectator. In the strictest sense out of sight of each other, slithering and sliding in the thinning optical space which is the surface of the photograph, amorous bodies collide.

It is small wonder then, that the age of the photograph has increasingly shown itself to be the age of the body. In advertising, on television, in the cinema and in art; everywhere we look the obsession with the photographic and kinetic imaging of the human body is all too apparent. And in art this is taken a step further by the increasing number of artists who seem to be obsessed with imaging their own bodies. It is as if, in this 'Age of the Visual', the camera has replaced the confessional in the search for truths about the self. And nowhere is this last tendency more apparent than amongst the generation of younger artists to which Mat Collishaw belongs; a generation that has increasingly turned to the use of the camera, camcorder and the computer as their chief means of expression. As first sight this would seem to demonstrate a desire to assert the integrity of the single human subject, even of the self – a unitary perception of the individual existing both inside and outside of community – as a site for the play of a plurality of irreducible forces and a multiplicity of sensations, feelings and desires. It would seem to be a positive response to a negative bias occurring in the culture in general; the chimerical unity of the human subject provided by the media which is demonstrably merely a performative one. In as far as it makes out the body to be little more than a site of action; the property, in other words, of a subject who is incapable of thinking much beyond the needs and well-being of the self as a preeminently physical entity, it is a construction of the human subject that blunts reflexive consciousness; shatters and fragments that sense of spiritual wholeness which subsists in the consciousness becoming conscious itself. Perhaps we would be justified in describing this as a distinctly contemporary sense of lack and loss.

But the study of mediology teaches us that this performative chimera arising within the pulverising machinery of representation which comprises the videosphere, is nothing less than a defining condition of contemporary cultures. Certainly it is a distinguishing feature of the mediating instruments of popular culture; but it is also a thoroughly invasive element at work in the more rarefied, specialist areas of cultural production, such as the

professional field of fine art practice. Indeed, we are all of us only too aware of the surfeit of recent works, especially in film and video, which depend for their effect on performative rhetorics of different kinds. Those works which seem to define the human body as some kind of machine, for example. Here the action tends to be relentlessly repetitive; the *modus operandi* one of physical endurance; and the objective, if there is one, some kind of projected state of absolute exhaustion. And then there are those works which designate the body as a site to be performed upon; to be scrutinised at close quarters; to be examined and mapped for its scars and its blemishes; to be cut, scratched or altered in some way; to be punished, confined or penetrated. The argument advanced in favour of these works seems always to suggest that there is some certain benefit to be obtained from a heightened sense of the physical, something in the proximity of flesh quickened by action that can tell us something essential about the human condition. But in reality they treat the body as an empty site, as a blank awaiting inscription, animated entirely by messages from without; devoid of the need to utter sensible thoughts of its own.

Such processes of abstraction – even of mechanisation – with their attendant utopian illusions of completeness, as Roland Barthes points out in *Camera Lucida* (1980), because they partake of the 'skin' of light which covers all sensible things, can seem as if as images they have the ability to bypass language, even to stand outside of culture and the general run of cultural processes. We might be forgiven for thinking then, that this increased use of the camera, video and other forms of visualising technology by artists, has something important to say to us about art's evolution in language, as well as for our understanding of its place in contemporary culture. If it is true, for example, as the mediologists suggest, that the work of art, in our time, has to a very considerable extent lost its power to resist absorption by the broader visual culture, and that artists have conspired with the 'spectacle' of the media culture at the same time as claiming some special status within it, then it would seem that a change has already occurred in the way artists themselves define practice. To be more precise, it suggests that a change has occurred in the relationship between artists and their subject matter. And here we need only allow our thoughts to dwell on the many different discursive forms of practice essayed by artists from the 1970s through to the 1990s to recognise that something quite fundamental has happened to the very notion of 'subject' itself. Indeed, it would seem that without quite realising it we have lived through 'the death of the subject'. Certainly it has ceased to be the way that

most artists focus meaning in the work of art. This responsibility has long since been passed to the context. Furthermore, since art itself – the whole diverse range of activities which, taken together, comprise contemporary practice – is by now thoroughly permeated by and locked into the endlessly proliferating universe of images thrown up by the ongoing development of image-making and communication technologies; since it is more and more subject to the same dynamics of image-production, dissemination and consumption – of image use, in other words – even if only at once removed, then art's expressive force is also to a degree neutralised within the generality of today's visual culture, with its inherent tendency towards de-symbolisation.

Karl Marx, in *Capital* (1867), was perhaps the first to raise the spectre of a late-capitalist culture as some kind of 'phantasmagoria' – an obfuscating, alienating and gaudy parade, lacking in historical or social rootedness – a theme that was subsequently picked up and given more substance by Walter Benjamin in his important text *The Work of Art in the Age of Mechanical Reproduction* (1936), and afterwards sharpened to an almost apocalyptic edge in Guy Debord's Situationist manifesto, *Society of the Spectacle* (1967). And here – and most importantly – mediology is careful to put some distance between itself and the Situationist critique, which Debray accuses of untested and untestable 'essentialism' and one which 'hovers like an entelechy' above the real specificities which give shape and muscular definition to historical cultures. In this respect the mediologist position is clear: all of the transformations at work in today's visual order are given out of the techno-genesis's of human life and as such have a certain inevitability about them. For this reason their needs must be accepted and worked with, rather than denied or passed over. Certainly we must resist the ever-present temptation to take flight into a nostalgically grounded, ideologically shaded past towards which there is never any real possibility of a return.

From the outset, modernity's progress – even its progress into the dustbin of postmodernity – had a conspicuous forward dynamic about it. It required from the artist a state of mind that was prepared to cancel the past in favour of the present and sought to curtail the present even, in the rush to engage with the future. At Modernism's inception, the Symbolist poet Arthur Rimbaud, in the very last paragraph of his valedictory work completed in 1873, *Une Saison en Enfer*, writes of the compulsion, the necessity that modernity placed upon him to be absolutely of his own time. In a despairing frame of mind and powerless to resist the dynamic of modern life driven by the

gathering momentum of industrialisation, at the age of 19, whether he knew it or not, the young poet was penning his last published words. Shortly before this, Rimbaud's old school friend and confident Paul Delahaye tells us, the poet had spoken to him about a new kind of poetry he was going to write, which would 'set forth a new view of life'. Rimbaud's theory now was that 'literature was to be prosaic and rational, devoid of symbolism... more suited to the modern world.' The magician had decided to forsake his charms. Like Jules Michelet before him, Rimbaud too was going to 'cease from chasing devils and angels, and desist from dreaming', and turn his hand instead to creating a 'literature of action'.

In retrospect it can be seen that Rimbaud's unrealised project for a new kind of writing was both symptomatic and prophetic at one and the same time. The coincidence between the Symbolist movement in art and literature and the early industrial phase of modernity and the emerging economic framework provided by industrial capital, was no mere accident of history, but one of those barely conscious, collective responses that herald periods of profound social and cultural instability and change. Similarly, its coincidence with the rapidly expanding use of photography and the beginnings of the cinema would seem to presage another type of crisis – a crisis in the order of social and cultural representation – in which, as Jacques Derrida has suggested, truth would henceforth be held (quite spuriously) to be visible and available to us in every image fixed by the eye of the camera. As the philosopher, Friedrich Nietzsche wrote in his posthumously published *Ecce Homo* (1888), as well as the old forms of idolatry and the old ideals, modernity brought with it 'new idols, weak because of their youthfulness'. And he goes on:

> A great wind blows among the trees and everywhere fruits fall –
> truths. There is the prodigality of an all too abundant autumn in it:
> one trips over truths; one even treads some to death – there are too
> many of them... But those one gets one's hands on are no longer
> anything questionable, they are decisions. Only I have the standard
> of 'truths' in my hand, only I *can* decide.

Here, then, we find Nietzsche hinting at the new brand of criticality appropriate to the profligate age of the image; pointing to the astringency – in the moral sense – and the chronic loneliness of a human existence lived out under the shadow of a modern, de-spiritualised and highly individuated notion of truth.

It follows from this that for art to continue to survive in a meaningful way in the 'Age of the Visual' it must develop and maintain a critical purchase on it. We have already remarked upon the growth of critical and discursive forms of practice in the art of the postwar period, and the increased emphasis these different forms of practice have placed upon the process of conceptualisation and the locating of the work in relation to certain extended areas of theoretical discourse: social anthropology; psychology; political theory; feminism; identity politics; trans-culturalism, and so on. Because all of these approaches depend for their conceptual viability upon an already existing set of exemplary texts, they tend to pose the 'invisibility' of the word – its innate potential for carrying reasoned and rational pictures of the world – against the banal and somewhat suffocating 'visibility' of the image. And not, either, with the intention of proving the superiority of the word over the image, or of attributing a fundamental state of non-intelligibility to the image; but more in order to reveal its 'constitutive incompleteness'. To reveal, in other words, the very thing that the image always seeks most of all to hide.

This brings us neatly back to mediology's discussion of the photographic image. Regis Debray argues that it is because the photographic image speaks to us always of things which are not present that it raises questions which are unmistakably religious in tone, and so tend towards the 'metaphysical' in its manner of signification. Of course he is careful to point out that he is not here referring to religion or religions per se but to that sense of the human self which arises out of the certain knowledge of our own mortality. Indeed, for Debray the photograph is in very truth 'the word made flesh', with all of the uncertainty that such a process of trans-substantiation would seem to imply, and it is for this reason that he wishes to give the photographic image a special place in his taxonomic history of human visuality. Like Roland Barthes before him, out of his desire to revitalise the audio-visual, kinetic imaginary of the televisual regime, Debray reaches for the essential mystery of the photographic image; its capacity to invoke – on certain occasions – a simulacrum of real presence rather than merely pointing to the presence of reality. This seems to offer him some kind of hope. But even here, as if to echo Barthes's brooding sense of disappointment in *Camera Lucida*, Debray checks himself for indulging in unverifiable optimism: 'photography too is an idol; let us not believe blindly in it; real presence is always elsewhere.' There are distinct shades of the old Nietzschean melancholy in this moment of self-rebuke.

Debray, of course, is only one thinker amongst many who in recent years have turned their attention towards the history of the image; the history of human visuality and the evolution of technologies of vision. In fact it would be no exaggeration to suggest that 'sight' and the imaginary of 'seeing', has become a key issue in contemporary scholarship and in contemporary writing in general; from William Burroughs to Christian Metz; from Stuart Hall to Pier Paolo Pasolini; from Jonathan Cary to Jorge Luis Borges. Where the mediologists' contribution is perhaps of particular interest is that it seems to open up a space for a postmaterialist approach to the image, as well as at the same time providing real intellectual ground upon which to develop a more historically sympathetic and sensitive account of the place of art in contemporary cultures than those thus far afforded by historicist, formalist and strict Marxist constructions of modernity and its avant-gardes.

The mediological notion of 'techno-genesis' – an evolution occurring in the very fabric of human society, changing and transforming the way we think the way we see and, most importantly, the way in which we represent things and ourselves to ourselves and to others – provides us with a new and perhaps more 'truthful' glass through which to see the historical rooting of our contemporary reality more clearly. Most particularly, it helps us to see afresh some of the important changes which have occurred in the practices and theoretical concerns of artists in the postwar period. Viewed from this standpoint, for example, the decline of the generic forms of painting and sculpture – the seeming collapse of their rhetorics of representation – would seem to have a certain inevitability about it; as does the corresponding rise in the use of photography, film, video and other forms of mediated and digitalised imaging. Indeed, it is perhaps only now that this change can be seen clearly for what it is; as part of a much broader linguistic shift away from the deployment of signs as a means of attributing symbolic value, towards the use of signs as 'conveyances' in the brute transmission of information. At this point – with the ubiquity of the image in the information culture – even the mighty engine of representation grinds to a halt. In the new, information-led, performative, virtual regime, things are 'presented' rather than represented. They figure – in other words – as a precise form of analogy, without past or future, as if seen in the instant in a mirror. This experience of reality is what gives weight to Baudrillard's claim that the 'simulacrum' is the formative condition of today's aesthetic.

To return then to the work of Mat Collishaw.

There are certain artists who seem to be able to situate themselves at the very centre of a whole range of quite complex contemporary creative, theoretical and aesthetic concerns, almost without conscious effort. It is as if the cultural terrain is utterly clear to them, and how to move within or across it, something close to instinctual. Look to the progress, range and scope of Collishaw's work and straightaway this is the type of picture that emerges. Though he started out as some kind of painter, spotting the freedom that working directly with the image would give him, he turned very early on to the use of photography. And even at this stage he had already ruled out the use of the framed or mounted print, preferring instead to work with light-boxes and other more experimental means of presenting the image, most of which tended to emphasise the physical nature of the photographic print, almost giving it the status of an '*objet trouvé*' or even a 'readymade'.

Towards the end of his time at Goldsmiths College too – well ahead of the field – he had already begun to use appropriated and reworked images borrowed from medical textbooks and books on criminology. Re-photographing the pictures that he found there, reworking them in the darkroom and afterwards displaying them over crudely made and rather grubby light-boxes, it seemed that he had decided to make his journey into the future by way of a carefully planned detour through the past. The images that he produced at this time; mostly the *mis en scènes* of certain exemplary murders with the corpse – always of women – still in place, had a haunting but highly disturbing beauty about them. Like certain Pre-Raphaelite paintings – think, for example, of the 'Ophelias' of Arthur Hughes or John Everet Millais – the necrophilian blossoming was all too apparent. These were images in which the violence of a violent death had given way to the elegant stasis of an abstract event occurring in a natural setting. The reference, of course, was not just to the Pre-Raphaelites but also to the last major work of Marcel Duchamp, *Étant Donnés (Given)* (1946–66), in which the corpse is depicted as a conduit through which a 'quick' fluid – the illuminating gas – is reduced to the semi-stasis of a permanently burning lamp. Illumination is achieved in the back-lit, murderous images by Collishaw, just as surely, then, as in the voyeuristic and scopaphiliac 'beyond' of Duchamp's last great work.

Already these early works then, revealed certain key preoccupations and shared conceptual characteristics. For instance, all of these works were possessed of an icy quality, something approaching studied indifference towards their depicted subject matter and perhaps not surprisingly, given the source

material, they became the focus of considerable controversy. As well as demonstrating a marked interest in the photograph's inherent tendency to hover between the real – the natural – and the constructed or the artificial, they also shared a strategy of presentation deliberately aimed at keeping the viewer at a distance, emotionally as well as perceptually. Beyond this, there is also clear evidence of a number of quasi-psychological, even obsessional preoccupations: necrophilia certainly; but also androgyny and the beginnings of what was to become in the fullness of time a thoroughly reflexive play upon narcissism. Indeed, over the years that followed, no matter whether Collishaw is working with images of flowers, of animals or of human beings, it is this deeper and more troubling level of content which tends to supervene. Almost it emerges as a theme, shaping and giving a sense of direction to his regular foraging expeditions into the history of painting and the history of photography. And he borrows from a wide range of artists and photographers too, from Nicholas Poussin to the Count Wilhelm von Gloeden, from Jean-Antoine Watteau to Charles Kingsley, from Juliet Margaret Cameron to Joseph Wright of Derby. His chosen points of reference stretch from high classicism to classical kitsch, from romantic melancholia to Victorian sentiment, from pictorial documentary to images of the spectral and supernatural 'other'. Collishaw's insistence upon appropriation, seen in its entirety, then, would seem to amount to much more than a method, rather it is central to his way of thinking. Something close to a prescription for and a definition of, the work of art.

It is worth pausing for a moment to consider Collishaw's use of appropriation in the light of some of the theoretical discussion that has gone before, most particularly where it relates to the process of de-symbolisation at work in contemporary, information-based visual cultures. First of all, it should be said, there is rarely any portentousness or swagger about the manner of Collishaw's appropriations. With one very notable exception which I will return to shortly, his acts of pictorial theft are usually carried out with consummate discretion; at times they can be almost furtive. When, for example, you first see a work like *Antique* (1994) – although the reference is clearly present – you do not instantly connect it with Joseph Wright's *Experiment on a bird with an Air Pump* (1768). Similarly, when you first come across the series of works called 'Infectious Flowers' (1996) their point of origin in a modern, dermatological textbook is not immediately apparent. In this last case disguise is clearly a part of the way in which the piece is intended to work. The true significance of the digitally reworked images of flowers must necessarily be uncovered through the

act of looking. But there is also something else going on; something that is much clearer in the case of a work like *Antique*. Each of these works, in its different way, designates another place, another site of meaning; each points to a more or less exotic realm – almost a parallel universe – in which a different kind of linguistic order might be said to prevail. In the case of *Antique*, the past is advanced as a sort of domain of coherent symbolic signifiers, stable enough to incorporate even the innovatory force of science. In the case of the series, 'Infectious Flowers', our attention is directed towards a nexus of conflict between three quite different symbolic realms of knowledge – aesthetics, horticulture, and medicine – and three correspondingly different formations in language. Furthermore, these different symbolic orders are shown in the very act of consuming each other by being forced to partake of a shared visual spectacle which could be described as a routine version of the beautiful. Almost it is a model for what occurs all the time in the visual excesses of today's videosphere. This type of appropriation is thus not simply one of borrowing images, indeed the image is nothing more than a portmanteau which carries indicators of a whole set of human preoccupations that happen to exist in a particular time and a particular place. And it works as a form of leaked enrichment, a controlled seepage across a carefully constructed and precisely skewed parallelogram of relationships; holding together at the same time as holding apart different times, places and/or spheres of reference.

Collishaw set the scene for this type of appropriation when, shortly after he had completed the early series of works using images drawn from criminological and medical textbooks he was asked to make a new work for an exhibition at the Riverside Studios in London. In the event he chose to make a work which, because of its scale assumed the appearance of a grand gesture, and because of the blatantness of the appropriation involved seemed to function as a *cri de coeur*. The work took the form of a large scale – many times above the size of the original – coloured, photographic reproduction of Watteau's last great picture painted just before the artist's death in 1720, *L'Enseigne de Gersaint* – often referred to simply as 'The Lesson'. The image was tacked somewhat unceremoniously onto the front of what looked like a very large packing frame. Very pointedly, we might think, Collishaw had chosen to borrow the painting which, more than any other, had brought the curtain down on the epoque of the '*Fête Galante*': a 'counterfeit idyll', as the Marxist critic and cultural philosopher Georg Lukács described it, 'set in a fake Arcadia'. It was typical of the painters of the '*Fête Galante*' to depict a

world in which things are never quite what they appear to be, and in *L'Enseigne de Gersaint* the sick and dying Watteau chose, with acid wit and calculated irony, to raise slightly, the veil of pretence and to reveal what lay beneath. This, then, was in very truth Watteau's *'L'Enseigne'* – his lesson – a painting which at first sight seems to be a celebration of the marriage of art and commerce; cultural ease and romantic dalliance; the carnival of manners and the fashionable life: but ends up instead, heavy with the symbolism of displacement and decline, reeking in its every part of death and decay.

At the time, Collishaw's grand gesture seemed somewhat overblown. The size of the work alone provided sufficient excuse to dismiss it on the grounds of hubris. Nevertheless, for the artist himself, it was very much an agenda-setting piece. It provided a checklist of topics of a broadly theoretical kind which he returns to again and again in the years that follow.

For example, it demonstrated a characteristic unusual in artists of Collishaw's generation: a fascination with history; with history in general, but with the history of art in particular. Of course his fascination is very different in kind to that of the historian. It has no systematic outcome, but it also reaches way beyond seeing history simply as a resource; a parade of images linking together different aspects of human life, conceptually packaged and ripe for plunder. It is certainly true, as we have already remarked, that he sees it as one ready-to-hand means by which he can hold at bay something of the contemporary feeling of lack and loss. But it would seem to be something more than that. Significantly, *L'Enseigne de Gersaint* also looks to the past as well as to the present and the future. Although it is quintessentially a work that typifies the early phase of 'The Age of Reason', with all of the corrosive feelings of self-doubt that this implies, it also retains an unmistakable air of magic about it: a magic which, as Max Weber wrote 'is characteristic of times prior to the disenchantment of the world'.

Either knowingly or intuitively then, Collishaw – by means of a very aggressive act of appropriation – was using the painting by Watteau to point to a very particular locus of potential meaning situated in one of the gaps which can be opened up between different, historically dominant forms of signification: in this case, to use Debray's reworking of the 'Peircean' categories, between the mythic and symbolic languages of art and the tychistic, visual tendencies of the photographic, mediated or mechanically reproduced image. By using a photographic and therefore indexical re-presentation of a well-known painting with all of its symbolic trappings still intact; by stretching its visual

fabric through a very extreme use of the mechanistic and largely instrumental processes of digital enlargement and commercial photographic printing – flattening its surface and thinning out its visual density – Collishaw succeeded in fragmenting the web of associative, historical and temporal relations which would normally govern its perception by the viewer, so that instead of it being seen as an orderly and holistic thing, it was experienced almost as a random scattering of visual incident, held in suspension only by the skin of light which is both the subject and fact of the photographic surface.

The appropriation of a complete painted image in the form of a reproduction of one kind or another was first essayed, of course, by Marcel Duchamp in the work called *L.H.O.O.Q.*(1919); a 'rectified' readymade which took as its starting point – as a site of inscription, in other words – a chromo-lithographic reproduction of Leonardo da Vinci's *Mona Lisa* – *La Giaconda* – to which Duchamp added a thin upward-curling moustache and a small 'goatee' beard, drawn on in pencil, with the inscription 'L.H.O.O.Q.' hand-lettered underneath. Certainly, in as far as both were using an 'old master' painting as a readymade, the Duchamp might quite properly be seen as a precursor to the Collishaw piece, but it is important, at the same time, to record certain very crucial differences. Where Duchamp was using the readymade image of the *Mona Lisa* as a site of inscription and as an agglomeration of 'class' susceptibilities and values waiting to be transgressed, Collishaw, by contrast, was using *L'Enseigne de Gersaint* more as a platform from which to address a general, very topical theoretical question concerning the status of the image in the contemporary, visual, semiotic order. He was using appropriation in order to demonstrate how all images, because they are in part drowned out by the background noise of our time, tend to acquire the secondhand appearance of the readymade. Just as the photographic image must have a prior existence before it can make itself present to the eye of the camera, so in the profligacy of today's visual culture, every other type of image seems to have been 'signalled' before it has appeared. Cut off from any unifying symbolic superstructure, the images of our time – with notably few exceptions – far from gaining power are losing it. If they burn for us at all, they burn for us as new things only for the briefest of moments, before being swallowed up by the generalising crisis of representation arising in the age of the computer screen. This problematic relating to representation is one that Collishaw returns to more directly in later, serial works like 'Infectious Flowers', but it starts with this very early piece: his reiteration of Watteau's great master-work, *The Lesson*.

Afterwards, Collishaw's use of appropriation becomes more subtle; more distanced; less direct – on occasions close to subliminal. In some of the large-scale black and white photographic works that follow, especially in those where he is intent upon reworking certain classical themes like 'the drowning of Ophelia' and 'the fixation of Narcissus', it takes more the form of quotation or of some kind of memorial transcription. They allude, in a barely recognisable way, say to a painting by Millais or Poussin, but quickly flip over into more contemporary types of framing, closer to the world of high advertising. Once again, the game seems to be one of rendering transparent the different forms and regimes of signification; of overlaying them one upon the other at the same time as holding them apart so that the complexities occurring in the region of interface can be seen, understood and enjoyed – as some kind of reward, in an almost Pavlovian sense – by the attentive viewer. This insistence upon maintaining a separation between the different regimes and modes of representation, most importantly for the subsequent development of Collishaw's work, also served to reveal the conceptual mechanisms and the metonymic character of the relationships at work between the image and the viewing subject in the case of the photographic image. And this, in its turn, brought him close to the Marxian notion of the 'phantasm', in Collishaw's case, as it is produced out of the interplay between the technical apparatus of photography and the inherent perceptual capacities of the viewer, refigured metaphorically as what Marx called a 'part-to-part' mechanism linking the optical device of the camera to the eye and to the mind.

Not surprisingly, after these early attempts to re-energise, deepen and prolong the life of the photographic image by using it as a means for recouping something of past symbolic regimes, Collishaw turned his attention more and more towards the technical impedimenta of photography and of image-making in general, as a prime site for exploring the exchange of linguistic qualities taking place between the apparatus and the image, shaping and controlling the particular form and language character of the re-presentation through what Theodor Adorno described as the 'visible traces which betray the occultation of (its) production'. In works like *Untitled–Old Camera* and *Hollow Oak*, both made in 1995, in order to make it absolutely clear that where the photograph is concerned the camera is always present, Collishaw makes the optical device itself, the camera, both image and container of the image. Thus it is that the resulting object – the total work – with all of its references to the studio, the laboratory and the darkroom – to

the history of science, to the history of art and to the history of photography – functions as a kind of lens bringing the viewer closer to the momentous event which is the making of the photographic image. In the case of the work, *Untitled–Old Camera*, for example, the ground-glass screen, normally used by the photographer for sighting and framing the image to be recorded when the shutter is released, is used instead as a screen upon which is projected a video image of a landscape containing a continuously tumbling cascade of water. This landscape is similar to those that we find in the background of almost any Renaissance portrait: distant hills framed on one side by trees; a middle-distance without very much foreground; and a waterfall. The model is the same that Marcel Duchamp chose for *Étant Donnés: 1' la chute d'eau, 2' le gaz d'eclairage, (Given)*, and like Duchamp, Collishaw is making this reference in order to focus attention on an argument concerning the status of the image as indexical sign. In the case of Duchamp's *Given*, the appearance of the perceived image is quite clearly an illusion hybridised out of the bits and pieces that Duchamp has used to construct the scene and the stereoscopic circumstances of its viewing. Which he then puts into question by the apparent movement of the water over '*la chute d'eau*' of its subtitle. By contrast, Collishaw's landscape as image, is all movement, even though, for the most part, this quickness is barely perceptible. We are given instead only the tremulous, pixillated reality and immediacy of the televisual image. In both cases though, the image figures as a kind of allegorical apparition, mapping an event in time whilst at the same moment insisting upon a fixed point of erotic engagement. Both offer the image up to be caressed by the gaze at the same time denying any possibility of touching. The mechanisms which determine the photographic illusion, in both cases are conspicuously enclosed within an interior space. This point is made even more forcefully in Collishaw's *Hollow Oak*, mentioned above, in which the empty interior chamber of the camera – the place where the illusion is conjured up – is very pointedly punned by the title as well as by the image it contains: a projected video-recording of a grand and aged oak tree, its trunk split open and hollowed out by time.

Several distinguished commentators have described Duchamp's *Étant Donnés* as a 'dead end'. Certainly its positioning at the end of a dimly lit corridor space – according to the artist's instructions – makes the confrontation between the prospective viewer and the door, in François Lyotard's words 'the epitome of our experience of the *cul-de-sac*'. It invites voyeurism but instead produces a kind of breathlessness by closing down the

surface of vision to what lies beyond. In the case of Collishaw's work, by contrast, it is as if the *cul-de-sac* has been turned inside out. We seem to be viewing it from back to front. The closure that he performs is not in advance of the image as in *Given* but occurs at the photographic surface itself, indeed it might be said to be coincident with it. Where Duchamp was presenting us with a distanced metaphorical relationship between 'light' and 'reason' – one that was capable of subsuming even the most deviant of human impulses – Collishaw offers us a more intractable and at the same time more sentimental – I use the term for its more positive aspect – coincidence between 'light' and 'breath', out of the certain knowledge that the photographic surface is always poised on the edge of self-asphyxiation. This theme – if theme it is – emerged very strongly in an installation of photographs that Collishaw made for a private gallery in Naples in 1993: two adjacent rooms each containing a series of photographs shown under controlled lighting conditions. In the first, images of Renaissance stone-carvings of angels which were visible only under ultra-violet light; in the second, unfixed photographs of transvestites shot in the streets of the city at night made demonstrably dependent for their continued existence as images upon the subdued red glow of darkroom lights. The analeptic role of these different kinds of light playing upon the original wound – the burn which is the photographic image – bringing the subject back into visibility – back to life – served to heighten the confusion between eye and 'I' in the act of viewing, thereby putting at risk the photographs' promised gift of some kind of verisimilitude. Collishaw approached this disturbing area again and more directly in a work made some two years later, bearing the title *Enchanted Wardrobe*. Reminiscent of Duchamp's injunctions to himself in *Notes to the Box of 1914* to 'make a mirrored wardrobe', to 'make a painting of frequency'. The notes refer to that moment in Duchamp's conceptualisation of *The Large Glass* when photography and the role of the camera surfaces as an important metaphor through which to address the question of reflexive exchange. Indeed, at this point in time, Duchamp was planning to have a 'Kodak Lens' incorporated into the surface of the 'Glass' close to where the mirrored 'occulist witnesses' are situated in order to lay stress on the notion of visual oscillation and the layering of time expressed as 'frequency'. Whether there is a direct connection or not, there is a similar insistence upon visual oscillation in Collishaw's *Enchanted Wardrobe*. The piece consists of a walnut wardrobe cabinet the front door-panel of which has been replaced by a large two-way mirror printed on the inside with an edge to edge monochrome

picture of a forest. The interior of the cabinet is lit by fluorescent tubes which make the forest visible as a ghostly presence when the mirror is viewed from the outside. Above the door of the wardrobe Collishaw has placed an electronic sensor set to respond by switching off the lights when the viewer draws close. The effect is a movement passing through a subtly combined image in which the forest scene is dominant to a sharp confrontation with an image of the self. The photographic language of rapid exposure is thus parodied in the use of an electronic trigger.

To return finally, then, to the deeper level of content, driving Collishaw's work. As we have previously remarked, much of the artist's early work showed a distinct preoccupation with death and most particularly seemed to involve a necrophiliac projection of some kind: in the light-boxes which used images of murders, for example, as well as in certain of the black and white photographic pieces based on paintings, like his *Ophelia*. But as Maurice Blanchot has pointed out, 'where death is sighted, Narcissism is almost always present'. In this respect and in the light of Collishaw's subsequent work it is clear that this early tendency to dwell upon death, rather than a thing in itself, was more the beginning of a prolonged meditation on Narcissism as an aspect of the camera's particular form of imaging. As we know, Narcissus is not, as it is often portrayed, a simple obsession with the self. Indeed, the myth shows clearly that Narcissus is fixated upon his reflection without realising that it is his own image. Thus we might quite properly describe Narcissism as a preoccupation with self as 'other', or with 'otherness' figured as some kind of dislocated aspect of reality. In Collishaw's work this 'otherness', more often than not, takes the form of a metaphorical scientism; of objects and images that have something of the look of scientific experiments about them. This is further enhanced by the way in which the still camera or the camrecorder images things by claiming some notion of 'truth' to an external reality of some kind. We can see this combination of factors at work in pieces like *My New Kitten* and *Harlow's Monkey*, both made in 1996. But it must also be said that this scientism is a very studied form of duplicity; it is intentionally practising to deceive by dressing art up in the guise of its absolute, instrumental other, in order to give it presence in a Narcissistic sense, as a reflective, complimentary imaging of itself. And here it is important to note once more the seminal place of the series of works based upon images of flowers that Collishaw made between 1995 and 1996. These were perhaps the sharpest and clearest examples of the imaginal mechanisms that have given shape to

Collishaw's work since the early 1990s: the overlaying of one order of representation upon another – in the case of the flowers, fauna upon flora and medicine upon horticulture; the contrasting of the natural with the artificial at the same time bringing them together to produce an almost populist version of the beautiful; the attraction and repulsion involved in the deceptive or aberrative image, where it also assumes something of the authority of a closely observed truth.

The advantage of using the indexical image in this way – as a vector of contrasting regimes and modes of signification – for the most part lies in its spontaneous or 'readymade' appearance. In this Collishaw remains by instinct and by conceptual orientation, a true Duchampian. At the same time his fascination with photography is very different to that of Duchamp; in as far a Collishaw's camera seems to wish to devour its subject as well as to record it, it would seem to bring him closer to the surrealist, André Breton, who described the camera as 'the shadow mouth which speaks its thoughts effortlessly and seems to place the very depths of language in reach of our every command.'

Mat Collishaw, Artimo Foundation, Breda, 1997.

This lecture was first given in its complete written form at the Royal College of Art and afterwards at the Jan van Eyck Akademie in Maastricht (1998). In the form in which it is shown here it was given as a guest lecture at the Architectural Association Schools a year later.

A LECTURE IN NOTATIONAL FORM

During my teaching career I spent an increasing amount of time writing
and giving lectures. At first, mainly through lack of confidence, I would
type them out in their entirety and then read them from the typed-script.
I quickly discovered that this was a sure-fire way of boring the audience to
death. The crunch moment came when I was giving a lecture at Tate Britain
one evening and looked up and saw that there were two people fast asleep in
the front row. After that I began to experiment with different methods and
finally came to rest on two approaches. The first I called 'flying by the seat
of my pants' – this meant preparing all my material mentally in advance and
speaking without notes. The second was to construct an elaborate diagram
that mapped several different routes through the material and making
directional choices as I went along. This last method was particularly suited
to very complex subjects or interpretive propositions. Both approaches allowed
me to keep my material fresh and to make my delivery more immediate and,
as a consequence, more compelling.

④ The Inscription: |||

Highly enigmatic, seemingly erotic statement.
Possibly homo-erotic if, as Artoro Swartze has
suggested, it is an Alchemical reference.

⑤ The Bicycle: |||

Present as an image in Russian icons of the 12th and
13th centuries, where they are depicted as conveyances
for heavenly beings.

But this image is older than that.

Look up Bicycle in the Dictionary of Science and Technology,
and you will find that the earliest depiction of the
Bicycle is 9th or 10th century.

THE BICYCLE WINDOW at Stoke Pogis. The same church
at which the romantic poet Grey wrote his immortal
"Elergy in a Country Curchyard".

In the Bicycle Window - a fragment of stained glass
only 15 inches across, again shows the Bicycle as only as
a means of transporting angels, this time of the trumeting
variety.

The suggestion has been made that this fragment of
glass is English, and that it represents part of the
stage machinary used in the Cycles of Mystery Plays
- devices for drawing the pneumatic, angelic bodies
across the skies, while they trumpeted loud the good
news.

But this image appears nowhere else either in the
stained glass of that period or in manuscripts. We
mightthink then that such a utilitarian explanation

A LECTURE IN NOTATIONAL FORM

During my teaching career I spent an increasing amount of time writing and giving lectures. At first, mainly through lack of confidence, I would type them out in their entirety and then read them from the typed-script. I quickly discovered that this was a sure-fire way of boring the audience to death. The crunch moment came when I was giving a lecture at Tate Britain one evening and looked up and saw that there were two people fast asleep in the front row. After that I began to experiment with different methods and finally came to rest on two approaches. The first I called 'flying by the seat of my pants' – this meant preparing all my material mentally in advance and speaking without notes. The second was to construct an elaborate diagram that mapped several different routes through the material and making directional choices as I went along. This last method was particularly suited to very complex subjects or interpretive propositions. Both approaches allowed me to keep my material fresh and to make my delivery more immediate and, as a consequence, more compelling.

THE SUBJECT:

"The Spherical Body"----- That perfect sphere, invoked
by Pere UBU at the very
moment that he is cuckolded.
At the moment in UBU COCKU
when he is un-manned:

> " I AM, BY MY GREEN CANDLE, SOMETHING OF A
> SPHERICAL PERFECTION AND I SHALL RISE AGAIN; "

Duchamp Drawing:

> " HAVING THE APRENTICE IN THE SUN "

Check list of parts:

(1) The manuscript paper. **|||**
The ultimate absraction.
Potential for a boundless auditory space.
A place of inscription; representing an
orderly forward progress; achieved by
upward and downward moving cadences of sound.

(2) The Stroke of the pen. **|||**
A single, transgressive upward movement; a sustained
exceleration, or rising pitch.

(3) The Cyclist. **|||**
A solitary figure bent on the task of going
uphill as fast as possible

THE SUBJECT

↓

DICTIONARY DEFINITION OF

"PNEUMATIC"
"PNEUMATOLOGY"

↓

"THE SPHERICAL BODY."
(JARRY'S UBU')

START WITH DUCHAMP'S
DRAWING.

1
SLIDE
DUCHAMP
APPRENTICE DRAWING

→ THE MANUSCRIPT PAPER

↓

THE STROKE OF THE PEN

↓

THE CYCLIST.

↓

④ The Inscription: **❙❙❙**

Highly enigmatic, seemingly erotic statement.
Possibly homo-erotic if, as Artoro Swartze has
suggested, it is an Alchemical reference.

⑤ The Bicycle: **❙❙❙**

Present as an image in Russian icons of the 12th and
13th centuries, where they are depicted as conveyances
for heavenly beings.

But this image is older than that.

Look up Bicycle in the Dictionary of Science and Technology,
and you will find that the earliest depiction of the
Bicycle is 9th or 10th century.

THE BICYCLE WINDOW at Stoke Pogis. The same church
at which the romantic poet Grey wrote his immortal
"Elergy in a Country Curchyard".

In the Bicycle Window - a fragment of stained glass
only 15 inches across, again shows the Bicycle as only 15
a means of transporting angels, this time of the trumeting
variety.

The suggestion has been made that this fragment of
glass is English, and that it represents part of the
stage machinary used in the Cycles of Mystery Plays
- devices for drawing the pneumatic, angelic bodies
across the skies, while they trumpeted loud the good
news.

But this image appears nowhere else either in the
stained glass of that period or in manuscripts. We
mightthink then that such a utilitarian explanation

THE INSCRIPTION.

THE BICYCLE

FOUND IN RUSSIAN & GREEK ICONS
OF THE 12 H CENTURY.

EARLIEST DEPICTION 9H or 10H
CENTURY.

A MEANS OF TRANSPORTING
ANGELS

MACHINARY IN THE MYSTERY
PLAYS.

is, at the very least open to question.

What is not in question, however, is the relationship
which is struck between the Bicycle and the Angel,
A relationship which reiterated in Russion and Greek
Orthodox iconography: long before the two-wheeled
veheicle, as a machine for transporting mortals was
invented.

The Bicycle, it seems, is a Pneumatic symbole of some
kindclosely connected with the translation, elevation
of material into airy bodies; with the pneumatic
morphology of spiritual beings.

It is perhaps not stretching a point too far then to
connect Duchamp's drawing with pneumaticism of Alfred
Jarry, With his text "The Passion of Our Lord Jesus
Christ Considered as an Uphill Bicycle Race".

The drawing is obviously of inormous importance to
Duchamp. He included in the "Green Box" of 1914 and
it reappears in thenotes to the "Large Glass" on both
occasions without any explanation, without any cross-
referencing.

Indeed, it functions almost as a midrash. Its very
incongruity giving a kind of authenticity to all the
rest.

But it is much more than this and I will try to show
why.

The Bicycle, of course, is quintesentiall a "Batchelor
Machine". In Jarry's text the Bicycle becomes the
ultimate Bachelor Machine precisely because it is
conveying the ultimate and the most celibrated Batchelor,

↓

THE UTILITARIAN EXPLANATION MAY
BE OPEN TO QUESTION.

↓

NOT IN QUESTION THE RELATION
BETWEEN ANGEL & BICYCLE

↓

THE BICYCLE "A PNEUMATIC SYMBOL"
AIRY BODIES
THE MORPHOLOGY OF SPIRITUAL BEINGS

↓

DUCHAMP'S D.
THE PASSION OF OUR LORD JESUS CHRIST
CONSIDERED AS AN UPHILL BICYCLE
RACE

↓

IMPORTANT:
GREEN BOX OF 1914
NOTES TO THE LARGE GLASS

↓

MIDRASH

↓

BICYCLE
THE QUINTESSENTIAL BATCHELOR
MACHINE FOR THE MOST CELIBRATED
OF BATCHELORS — CHRIST.

"Our Lord Jesus Christ", who is rendered by the text doubly alone.

He is intended to be racing Barabas, but Barabus is scratched by Pontius Pilot before the off. He is not onlyalone on his Bicycle as all cyclists are, but he is also racing himself.

We find ourselves, then at the heart of a portmanteau metaphor, similar to that of the 'engeine' in the Stupraof Arthur Ribaud. Bicicyling is an activity which is undertaken alone, equals self-propulsion, equals mastibation.

In this respect, this drawing bridges the gap between Jarry's mastibatory fantasy around the Bicycle and Duchamp's own fantasy on the Chocolate Grinder, stated in the notes to the large glass - itseld a Batchelor Machine - in the phrase "The Batchelor Grinds his Chocolate Alone'.

Jarry, remember was deeply fascinated with theology and particularly with gnostiism - one of the hot and fashionable intellectual topics of that day. Indeed Jarry published an underground theological journal called'The Wild Duck' which he described to the Countess RACHILDE Rachilde - ~~ his ~~closest~~ only female friend - as "atheological Decoy".

The implications of this are very clear.

Thinking of the decoy in the duck shoot: Jarry's magazine was intended to attract real theological argement precisely so that it could be shot to pieces.

CHRIST IS RENDERED
DOUBLY ALONE — BARABUS IS SCRATCHED
BEFORE THE OFF — AND HE IS RACING
HIMSELF

PORTMANTEAU METAPHOR.
(ENGEINE OF)
RIMBAUD
"STUPRA"

BYCYCLING = SELF PROPULSION = MASTIBATION 2

JARRY'S BYCICLE
LINKED DUCHAMP AND THE CHOCOLATE GRINDER
TO

CHOCOLATE
GRINDER
SLIDE
DUCHAMP

JARRY AND GNOSTICISM

THE WILD DUCK.
"A THEOLOGICAL DECOY"

But it was not simply that.

Read Jarry's Novella, "The Supermale" and a very different
picture emerges.

Here, what is at stake is not 'self-propulsion' but
'perpetual motion' - not a one-mile upward dash, but a
10,000 mile grind of a Bicycle-race on the flat.

It is the difference - if you like - between straight forward
'hard work' and 'super-human effort'...

And in an explicitly sexual domain, too.

Mercieul - Jarry's anti-hero the Supermale - is persuaded to
test 'perpetual-motion food' by its inventor, the scientist
Elsen.

The effect is to turn Mercieul into a sexual gymnast who can
perform the copulative act repeatedly: seemingly without end,
thus making him the equal of the mythical Indian beloved of
~~Zarraphrastus,~~ THEOPHRASTUS.

Here we find Jarry turning to an explicitly Gnostic reference.
According to the Menean Gnostics, ~~THEO~~phrastus the Wise was
able to shed his limbs and rise up to heaven at will. ‾
 But I want To reckon To this par
 later.
Foolishly, Elsen had given his own daughter over to this
experiment, and she responds by falling in love with Mercieul,
who in his turn , as the cold and calculating Supermale, is
incapable of returning her affection.

And it is this incapacity on the part of the Supermale to
experience human feelings of any kind which leads to the
brutal denouement of Jarry's Novella.

LOOK TO THE "SUPERMALE"

NOT SELF-PROPULSION BUT PERPETUAL-MOTION
NOT A ONE-MILE UP-HILL DASH BUT A 10,000
MILE GRIND ON THE FLAT.

DIFFERENCE BETWEEN HARD-WORK AND A SUPER-
HUMAN EFFORT AND

IN A SPECIFICALLY SEXUAL DOMAIN TOO

Mercieul - Jarry's anti-hero, the Supermale - is persuaded
'to test "perpetual-motion food' by its inventor, the
scientist, Elsen.

enters into a wager with Elsen *inventor of perpetual motion food*

~~The effect is to~~ *claims that he is* turn Mercieul into a sexual gymnast who can
perform the copulative act repeatedly and without apparent
end, thus making him the equal of the mythical "Indian
beloved of Theophrastus".

And here we find Alfred Jarry turning to an explicitly
Gnostic mythology.

According to Menean and carpocration Gnosticism, Theophrastus
the Wise was one of the only mortals who had learned the trick
of sheding his limbs and after having spent all of his bodily
fluids, rising up to heaven. **LIKE AN ANGEL**

But I will return to this form of pneumatic translation, later.

Foolishly, Elsen had given his own daughter to this experiement,
and she responds by falling in love with Mercieul who, as the
cold and calculating supermale, is incapable of returning her
affection.

And it is this, the in-ability of the Supermale to experience
or to value human feelings, which leeds to the brutal denouement
of Jarry's novella.

M. TESTS PERPETUAL MOTION ~~FOOD~~

TURNS INTO SEXUAL
GYMNAST

= TO THE INDIAN BELOVED OF THEOPHRASTUS.

GNOSTIC REFERENCE

MENAEN AND CARPOCRATION GNOSTICS

THEOPHRASTUS THE WISE COULD SHED HIS
LIMBS AND AFTER EXPELLING HIS BODILY
FLUIDS RISE UP TO HEAVEN LIKE AN ANGEL

DAUGHTER FALLS IN LOVE
WITH THE SUPERMALE

BRUTAL DENOUMENT OF JARRY'S
NOVELLA

Elsen - a highly conventional character - responds
to his daughters plight in a typically middle-class
manner; demanding that the two should be married.

But Mercieul refuses, protesting that he feels nothing
for the young woman.

Where-upon Elsen sets about creating a 'love-simulator'.
An electronic and mechanical device intended to produce
feelings of desire in the Supermale.

When the machine is completed, Elsen persuades Mercieul
to try it out and the story climaxes with a typical
Jarryesque inversion.

The machine falls in love with the Supermale, finally
subjecting him to a bizarre sexual crucifixtion.

At the moment of death, Mercieul - the Supermale - wheeps
one solitary tear. Super-hard and entirely durable, it
is made of pure crystal.

Now between these two moments in the relationship between
the scientist, Elsen, and the Supermale. Elsen decides
on a more thorough test of his perpetual motion food, in
the form of an event which takes up the whole middle
section of the book. The 10,000-mile Bicycle-race.

FIVE - MAN

He feeds pellets of perpetual-motion food to an ~~eight-man~~
team of cyclists riding a single machine, a kind of 5-seater
Tandem.

It is to compete with a Steam-locomotive, pulling a carriage
of celebrities over a measured distance of 10,000 miles.

ELSEN MIDDLE CLASS RESPONSE
SUPERMALE AND DAUGHTER MUST
MARRY

↓

MERCIEVL REFUSES

↓

LOVE MAKING MACHINE TO
MAKE SUPERMALE FALL
IN LOVE

↓

ENDS WITH A JARRYESQUE INVERSION
THE MACHINE FALLS IN LOVE
WITH M.
WHO CRIES A SOLITARY TEAR

↓

10 000 MLE

5 SEATER TANDEM.

↓

STEAM LOCOMOTIVE + CELEBRITIER

↓

In the event the race sets off, and for the first half of
the distance the Cyclists and the Locomotive are neck to
neck.

Then an extra-ordinary thing happens

The cyclist riding just ahead of ~~Simon~~ **TED** OXBOROUGH - the narrator of the
story - a ~~Welshman~~ man called ~~Delwy~~ JEWY JACOBS, dies in the saddle.

TED.
~~Simon~~ smells the stench of muscular decomposition comming
up from his boots, and feels the resistance of ~~Delwy's~~ JEWY JACOBS
rigour-mortis slowing the Bicycle down...

And he calls on the others to peddle harder...

With the result that ~~Delwy~~ JEWY JACOB is brought back to life... starts
peddling even harder than his team mates can manage.

Thereby threatening the whole enterprise.

HERE WE HAVE IT THEN, DEATH AND RESSURECTION, THE VERY ESSENCE
OF THE 'ONANISTIC GAME'.

And finally the cycle gets ahead of the Locomotive, but with the
growing sense of another third presence ~~behind them~~ ahead of the train and
catching up with them - who AND threatens to pip both of them to the post.

It is the furious dwarf on solo machine. Oxborrow calls him
the ROAD HOG. But IT is
It is Jarry himself. The BLACK FROCK COAT, THE MOLE-SKIN WAISTCOAT
THE GREEN BOW TIE - THE PINZ-SNEZ Etc possible
In Jarry himself then, we find embodied the triumph of the ~~possible~~
'solitary ' over 'orchestrated onanism'.

ACCEPT THAT H E VAPOURIZES - ENTIRELY DISAPEARS BEFORE THE
FINNISHING LINE

↓

NECK AND NECK
UNTIL.

↓

JEWY JACOBS.
DIES IN THE SADDLE

↓

CALLS ON THE OTHERS
TO PEDDLE HARDER

JEWY JACOBS RESSURECT

A THIRD PRESCENCE
THE ROAD HOG
JARRY HIMSELF

↓

VAPOURIZES BEFORE THE
FINNISHING LINE

↓

As is often the case in Jarry's writings, there is an auto-biographical precedent for his ~~own victory~~ VALOURIZATION AHEAD OF THE FIELD in the 10.000 mile Bicycle-race.

Madame - or the Countess - Rachilde, as Jarry preferred to call her, tells a story in her diary of a trip that she and the writer did together out of Paris to have a picnic.

Jarry had built for himself a small four wheeled cart and prevailled upon Rachilde to tow him behind her riding her bicycle, ultimately with disastrous results.

Arriving at the top of a steep hill Jarry, who had failed to fit breaks to the cart, lost control the cart overtaking the bicycle, the ropes getting entangled in the wheels and precipitating them both in the ditch at the bottom of the hill.

Jarry, contra to intention, Rachilde remarks, arrived ahead of her, if not ahead of himself.

* * *

To return then to Theophrastus and the I dentity of his 'beloved Indian'.

He is referred to a number of times in the writings of Jarry and is therefore of more than passing significance. Who, exactly was 'the Indian beloved of Theophrastus'.

Theophrastus - friend of Aristotle - had been brought to prominence in the French literary world of the 19th century by La Bruyere's translation of his work "CHARACTERES", a sometimes humerous study of Athenian types.

Jarry adopts precisely this model for his own work "The Exploits and Opinions of Dr Faustrol, Pataphysician" Fuatstrol travels around Paris observing Characters in the

AUTO BIOGRAPHICAL PRESIDENT.

↓

THE ADVENTURE WITH RACHILDE

↓

" JARRY ARRIVED AHEAD OF HER IF
NOT AHEAD OF HIMSELF "

✳ ✳ ✳

WHO WAS THE INDIAN BELOVED
OF THEOPHRASTUS

↓

LE BRUYÈRE'S TRANS OF " CHARACTERES " by TH.

INFLUENCED

company of the Ape who can only say HA HA, Bos de Nage.

The influence of Theophrastus on Jarry, then is fairly easy
to pin down. But beyond him there remains the enigmatic
Indian.

And here, to be very direct, I want to suggest that the word
Indian is a Pataphysical disguiseing of the word 'Ionian';
that Jarry's Idian is none other than the pre-socratic
philosopher Emedocles.

Let us look at the evidence.

Firstly. Theophrastus was the one who wrote the most important
commentary on the fragmentary writings of Empedocles,

Secondly. It was Epedocles who devised the first logical theory
of Locomotion the theory of "ANTIPeristasis" or 'counter-
circulation.

I shall return to this in a moment

And thirdly. It was Empedocles who devised the distinctly
pneumatic notion of spiritual beings known as 'Katharmoi' a
translation of the human being into an insubstantial, limbless
entity:

I quote: We cannot bring it near to be approachable by our eyes,
or grasp it with our hands, which is the greatest path
of persuasion leading to mens minds. For its limbs
are not fitted out with human heads, nor do
branches spring from shoulders, nor feet, nor swift
knees, nor hairy chest; but it is only a wholly
superhuman mind, darting with swift thoughts over the
entire world.

THE APE BOSDE KAGE

INFLUENCE OF THEOPHRASTUS ON
FARRY CLEAR.

BUT WHAT OF HIS
BELOVED INDIAN.

EMPEDOCLES. (INDIAN FOR IONIAN)

EVIDENCE

(1) THEOPHRASTUS WROTE COMMENTARY

(2) THEORY OF LOCOMOTION
"ANTIPERISTASIS"

(3) THE SPIRITUAL BEINGS
"KATHARMOI"

INSUBSTANTIAL - LIMBLESS

I will deal with the Epedoclean notion of the Katharnoi fully
later on, when I come to speak of the work Takis Tinguely
and Aves Klein.

For now I want to return to his locomotive theory 'ANTIPERISTASIS'
and I want to do so through a consideration of Duchamp's bicycle
wheel.

Check List of Parts:

The Stool: a highish Stuart̶s̶ ̶k̶i̶t̶c̶h̶e̶n̶ stool, intended to elevate and
　　　　　isolate at the same time: the seated person or in
　　　　　this case the forks carrying the wheel, inverted.

The Forks: upside down front forks of a roadster (it is not a
　　　　　racing bicycle this one) the shaft inserted into
　　　　　the stool at the place at which there is usually a
　　　　　hole for inserting the fingers for the purposes of
　　　　　carrying the stool.

The Bicycle Wheel itself. a front wheel, ungeared or ratcheted,
　　　　　capable, in other words of both forward and bacward
　　　　　rotation

Once again then we find ouselves confronted by an object which
reiterates the notion of the solitary act and here it is heavily
underscored by referrence to a notional 'MONO - CYCLE'.

As Artoro Schwarz has said, "The bicycle wheel is nothing less
than a 'mechanomorphic' expression of the Batchelor or of
Batchelorhood as a condition...

And Lawrence Steefel makes whole series of observations about the
Bicycle-wheel some of them drawn from observations made by Moholy
Nage.

KATHARNOI LATER.

NOW 'ANTI PERISTASIS'

DUCHAMP'S BICYCLE WHEEL

CHECK LIST

STOOL
|
FORKS
|
WHEEL

SOLITARY ACT UNDER-
SCORED BY — "MONO-CYCLE"

AUTORO
SUCHARZ

STEEFEL
NAGY.

OBSERVATIONS BY LAURENCE STEEFEL

Quote from Steefel in full:

"Subject to the indifferent impulse of any idler, the wheel can be accelerated or 'idled' without the customary friction of the road. This free-wheeling device goes no place in a hurry. The wheel is thus the first 'mobile' sculpture of the 20th Century.

There are also important visual effects. If spun slowly, the object becomes blurred at the outer extension of the spokes, but still retains its object-quality. Pushed harder, the spokes blur into what Maholy-Nagy calls a virtual volume, transforming the object-quality into a luminous illusion and dematerialised spatial motion.

In its range of transformations from sculpture to an appearance like painting, "Bicycle Wheel" seems to link the subjective world of dreams and the objective world of things. Because this readymade offers a continuum of transformation from physicality to the generation of sheer motility - spatialised - and can do so against the most heterogenious of environments, it serves as a concrete symbol of internal self-transformation which creates its own ambienc of magic space and enclosure.

In motion, the seperate forms begin to comprehend each other until there is some kind of reconcilliation between them.

Neither Schwarz or Steefel make the obvious connection here to the Empedoclean notion of locomotion 'ANTIPERISTASIS' or 'counter-circulation'.

Empedocles starts from the notion that in the natural world there is no such thing as a void or a vaccuum.

Nature abhors emtiness and must 'make room' if it is to encompass locomotion.

He exampled this by reference to the swhirling of liquids, a childs spinning top and a quartered black and white disk in motion.

STEEFEL
IN FULL

EMPEDOCLES NO SUCH
THING AS A VOID OR VACCUM

LIQUIDS
SPINNING TOP
BLACK AND WHITE
DISC IN MOTION.

④
TWO PAINTING
SLIDE
KLEIN

REPOST TO MILETUS.

THE BICYCLE-WHEEL SECOND BY SECOND
REFUTATION OF MILETUS

IN MOTION A VIRTUAL VOLUME
SOMEWHERE BETWEEN A
DISC AND A SPHERE

KLEIN AND HIS EXHIBITION
'VIDE' or VOID.

THE FIRST PNEUMATIC EXHIBITION

ONE QUARTER PERSUING THE OTHER IN A SMOOTH PROGRESS

THE THEORY WAS MADE AS A REPOST TO MILETIUS' WHO HAD ARGUED THAT FOR SOMETHING TO MOVE THERE HAD TO BE A VACANCY SOMEWHERE READY TO RECIEVE IT

WE MIGHT THINK, THEN, THAT DUCHAMP'S BICYCLE WHEEL, IS THE SECOND BY SECOND REFUTATION OF SUCH A NOTION

AN OBJECT WHICH, WHEN IT IS IN MOTION, TRANSLATES WITH SPEED INTO A FLUID DEMATERIALIZED "VIRTUAL VOLUME", AS STEEFEL CALLS IT, WHICH HOVERS SOMEWHERE BETWEEN A DISC AND A SHPERE.

⑤
LEVITATING GLOBE
SLIDE
KLEIN

THE ARGUEMENT REMINDS US OF A COMMENT THAT 'YVES KLEIN' MADE IN RELATION TO HIS EXHIBITION "VOID" HELD AT THE GALLERY 'IRIS CLERT' IN 1958.

HE CALLED IT, REMEMBER "THE FIRST PNEUMATIC EXHIBITION". ~~GEE~~

"ONE DAY" - KLEIN RECALLED "- "A VISITOR CALLED TO ME 'I WILL COME BACK WHEN THE VOID IS FALL', AND I RESPONDED BY SAYING "WHEN IT IS FULL, YOU WILL NOLONGER BE ABLE TO ENTER."

THE REFERENCE MIGHT BE UNDERSTOOD
AS AN ASSERTION OF THE PRINCIPLE OF
"ANTIPERISTASIS"

THE NOTION THAT THERE IS NO SUCH
THING AS AN "EMPTYNESS"; THAT ALL IS
CHECK BY TOWAL MUTUAL MOTION
IMPLIES ALSO A "CIRCULARITY" OF SOME
KIND... CLOSED

SUGGESTS THAT THINGS WILL EVENTUALLY
ARRIVE BACK TO FILL THE SPACE FROM
WHICH THEY STARTED,

IT IS A VIEW WHICH IS EVEN TODAY
NOT AN ENTIREY DISCREDITED ONE

RUSSELL REFERS TO IT IN THE
INTRODUCTION TO THE "PRINCIPEA
MATHAMATICA" AND IT FINDS SOMETHING
OF AN EQUIVALENCE IN MODERN
COSMOLOGICAL PHYSICS WITH THE
DISCOVERY OF "DARK MATTER".

* * *

TO RETURN, BRIEFLY, TO DUCHAMP'S
"APPRENTICE" DRAWING.

SWARTZ PROVIDES FOR A VERY
STRAIGHT-FORWARD, ALCHEMICAL
EXPLANATION.

THE APPRENTICE IS ONE WHO IS BOUND
TO THE ALCHEMICAL WORK, AND HE
IS STRUGGLING UPWARDS TOWARDS THE
LIMIT - THE DISCOVERY OF THE PHILOSOPHERS
STONE

KLEIN
UNDERSTOOD AS
ANTIPERISTASIS PERHAPS

CIRCULARITY
THINGS ARRIVING BACK
AT THE BEGINNING.

NOT DISCREDITED
TODAY

RUSSELL.

DARK MATTER

+ T +

THE APPRENTICE
AGAIN

THE ALCHEMICAL
EXPLANATION

SLIDE 6

Duhem
Stolo

APPRENTICE ONE WHO
IS BOUND

THE WORD FOR SUN 'SOLEIL'

THE CATHERINE WHEEL

APPRENTICE BOUND TO A TURNING WHEEL

PATRON SAINT OE

UP TO A POINT IT IS HARD NOT TO
AGREE WITH THIS INTERPRETATION.

CERTAINLY AN APPRENTICE IS "ONE
WHO IS 'BOUND': EITHER TO ANOTHER;
TO A WORK; OR TO A THING.

BUT I WOULD LIKE AN ADDITIONAL
PNEUMATIC LAYER TO SCHWARTZ
READING.

TO ME THE WORD FOR 'SUN' - SOLEIL (SAW-ley)
IS CRUCIAL.

NOT ONLY IS IT THE FRENCH WORD FOR
'SUN' BUT IT IS ALSO ANOTHER WORD
FOR "THE CATHERINE-WHEEL". - A FAST
-SPINNING FIREWORK WHICH EVENTUALLY
EXPLODES AS IT BURNS ITSELF OUT.

LIKE ~~DUCHAMP~~'S ST. CATHERINE, DUCHAMP'S
APPRENTICE IS BOUND TO A TURNING
WHEEL.

AND IT IS PERHAPS RELEVENT, SOMEWHERE
ALONG THE LINE, TO REMEMBER THAT
ST CATHERINE —AFTER DEFEATING A
CONVOCATION OF 12 PHILOSOPHERS IN
THEOLOGICAL ARGUEMENT, EVENTUALLY
PUT TO THE TORTURE, BROKE THE WHEEL
THAT WAS INTENDED TO BREAK HER.

INDEED THE WHEEL EXPLODED, KILLING
AND INJURING SOME OF HER
PERSECUTORS...

... TO REMEMBER TOO, THAT SHE IS
THE PATRON SAINT OF STUDENTS,
APPRENTICES, PHILOSOPHERS, THEOLOGIANS
AND APOLOGISTS.

Certainly an apprentice is one who is 'bound' but
he might be bound to another, to a work or to a
thing.

And here the word for 'sun' - 'soliel' - is crucial. (SAWLEY)

Soliel in Frenchas well as meaning sun also is used
to describe the 'Catherine Wheel' - a fast-spinning
firework which eventually explodes as it burns itself
out.

Like St Catherine then, Duchamp's apprentice is bound
to a turning wheel.

And it is perhaps relevent somewhere along the line to
remeber that St Catherine, after defeating a c onvocation
of philosophers in arguement, broke the very wheel that was
intended to break her. Indeed it exploded injuring
her persecutors...

... as she became the patron saint of students, apprentices,
philosophers, theologians and apologists.

The link from Jarry's bicycle to Duchamp's apprentice then
is a complex and powerful one.

Furthermore it testifies to a long-standing thread of *Judeo Christian*
mysticism which reaches back to French Symbolism and
beyond - think of Pousin's involvement with Rosicrucianism ?
and forward to Yves Klein Tinguely and so on.

What is somewhat special about Jarry's rather arcane interest
in Gnosticism is the hard edge of bitter irony which
underpins it.

In his notes relating to the unfinnished novella, Messaline,
for example we find him referring to the Divine KARPOC

|

BYCICLE-WHEEL AT TARRY'S B.

IMPORTANT.

|

TUDEO CHRISTIAN MYSTICISM

IN FRENCH THOUGHT

|

IRONIC ᶠᵒᵛ TARRY

|

THE DIVINO KAPOC

|

An obvious reference to the Gnostic teacher, Carpocrates.

It is interesting to speculate as to what access Jarry had
to the ideas of this particular brand of heretical teaching.

Most probably it was through the writings of the Catacitical
College headed by Clement of Alexandria who was charged
by Rome to put down heretical gnostic sects in the eastern
mediteranean.

Clement texts are thus highly propogandistic, a d may
contain very little that is true.

Nevertheless it is easy to see why they would appeal to Jarry.

The objective of the Carpocratians was to achieve angelic status
and as quickly as possible.

On becomming an angel they would fly imediately up to heaven
as airy bodies.

But they were also caught on the cusp of two contradictary
doctrines.

Firstly they beleived that there was a finite quanity of
divine grace in the world. Therefore the more people there
were the less there was for each person.

And secondly they believed that bodily fluids were spiritually
speaking the heaviest of all substances; primarily
responsible for preventing angelic status. They therefore
had to be expelied at all possible occasions.

According to Clement then this contradiction drove them to the
most sinful and heinous practices....

CARPOCRATES.

WHAT ACCESS DID BARRY HAVE

RECORDS OF CATACLITICAL
COLLEGE AT ALEXANDRIA

CLEMENT AND HIS PROBAGANDA

THE STATUS OF
ANGEL

AIRY BODY BOUND
FOR HEAVEN

FINITE QUANTITY OF GRACE

WEIGHT OF BODILY
FLUIDS.

HEINOUS PRACTICES

RITUAL COPULATION.

COITUS INTERRUPTUS.

PRIMITIVE FORMS OF BIRTH CONTROL.

HERBALY INDUCED ABORTION

AND OMOPHARCY

THE EATING OF FOETAL MATTERIAL
AND OF NEW-BORN CHILDREN.

WOMEN, THEN, PRESENTED THIS PSEUDO-
THEOLOGY WITH A VERY PARTICULAR PROBLEM.
AS THE BEARERS OF CHILDREN THEY
WERE THE AGENTS WHEREBY GRACE
MIGHT BE RELENTLESSLY REDUCED TO THE ASPIRANT
INDIVIDUAL

BUT THEY WERE ALSO ONE MEANS BY
WHICH A MAN MIGHT REACH SALVATION

IT IS EASY TO SEE NOT ONLY HOW
THIS FED JARRY'S MASTIBATORY FANTASY
BUT HOW IT FUELLED HIS MYSOGONY TOO.

AS FAR AS WE KNOW, HE HAD ONLY ONE
CLOSE WOMAN-FRIEND DURING HIS LIFE-TIME
THE AFORSAID 'COUNTESS RACHILDE'.

FURTHERMORE, HE WAS FOND OF STATING
PUBLICLY ON EVERY AVAILABLE OCCASION
THAT WOMEN WERE INCAPABLE OF
COMPLETE SPIRITUAL TRANSLATION

WOMEN. PARTICULAR
PROBLEM

MASTIBATORY FANTASY
AND HIS. MYSOGINY

ONE CLOSE WOMAN
FRIEND

WOMEN INCAPABLE OF SPIRITUAL
TRANSLATION.

IN OTHER WORDS – THAT THEY WERE
INESCAPABLY EARTH BOUND.

* * *

LET US PAUSE FOR A MOMENT NOW
AND CONSIDER WHERE WE HAVE GOT
TO IN DESCRIBING THIS PARTICULAR
BRAND OF PNEUMATIC FANTASY.

WHAT ARE ITS CHARACTERISTICS SO FAR

FIRSTLY WE CAN SAY THAT IT INVITES
OR REQUIRES THE DEFEAT OF GRAVITY

PERE UBU, AS I SAID AT THE
BEGINNING BELIEVES THAT HE WILL
RISE AGAIN.

DUCHAMP'S APPRENTICES' WHOLE EFFORT
IS UPWARDS. AN ASSENCION WHICH LIKE
IGATUR'S WILL END WITH HIS DISPERSAL
IN SPACE.

KLEIN PERSUED THE IDEA OF FLIGHT AND
CLAIMS TO HAVE ACHIEVED IT ON AT
LEAST 3 OCCASIONS. PERHAPS HE TOO
WAS TREADING IN THE FOOTSTEPS OF
EMPEDOCLES WHO THREW HIMSELF INTO
THE GAPING CRATER OF MOUNT ETNA.

(+) →

SECONDLY – WE CAN SAY THAT IT INVOLVES
THE ABSTRACTION OF MEASUREMENT

HE WANTED TO INDUCE FLIGHT OR
LEVITATION IN OTHER THINGS TOO
WITNESS IS PLANS FOR LEVITATING
SPONGES AND EVEN THE WORLD.

THEY WERE GROUNDED
EARTHBOUND

‡ ‡ | *

CHARACTERISTICS OF
PNEUMATIC FANTASY

INVITES OR REQUIRES THE
DEFEAT OF GRAVITY

PERE UBU WILL RISE
THE APPRENTICE IS PEDDLING UPHILL

KLEIN FLEW THREE TIMES
(EMPEDOCLES) ETNA.
AND ALSO MADE OBJECTS LEVITATE

SLIDE 7
KLEIN FLYIN

SLIDE 8
SPONGE
KLEIN

SLIDE
KLEIN

I REQUIRES THE ABSTRACTION OF
MEASUREMENT

JARRY DESCRIBES 10,000 MILES — AN
UNIMAGINABLE DISTANCE — AS A GOOD
ROUND FIGURE

MAZONI'S 10,000 METER LINE — PACKED
IN ITS CONTAINER IS LIKEWISE
UNIMAGINABLE AND MIGHT ALSO BE
DESCRIBED AS A GOOD ROUND FIGURE

AND WHAT OF HIS PLAN TO PUT
A LINE ROUND THE GLOBE AT THE
EQUATOR.

DUCHAMP AIR OF PARIS AIR (50 cc's)
IS LIKEWISE ABSTRACTED BY DUCHAMP
WHEN HE MADE THE REPLICA'S WITH 25 cc
PIPPETS.
ANSELMO WANTS TO SHORTEN THE SKY

AND HAND IN HAND WITH THIS TENDENCY
TO ABSTRACT MEASUREMENT, THE PNEUMATIC
FANTASY SEEMS INTENT UPON CONSTAINMENT,
WITH ALLOWING NOTHING TO ESCAPE

KLEIN MADE A MOST TELLING STATEMENT IN
THIS REGARD.

"THE META-MATIC WORKS ARE INTENDED AS
AN ANTIDOTE TO THE PETTY ABSTRACTIONS OF
THOSE ARTISTS WHO PLAY WITH NONE-FULL
VOIDS.".

10,000 MILES A GOOD ROUND FIGURE

10,000 METERS A GOOD ROUND FIGURE

9
SLIDE
MANZONI.
LINE

THE EQUATION.

DUCHAMP'S PIPE 7.

10
SLIDE
DUCHAMP
SLIDE 11
ANSELMO
SLIDE
ANSELMO

ANSELMO'S SHORTENED

PNEUMATIC FANTASY

AND CONTAINMENT.

12
PAINTING WITH
SLIDE
KLEIN.
BODIES

CONTAINMENT THEN IMPLIES
FULLNESS. —IMPLIES COMPLETION OF
SOME KIND...

AND COMPLETION, EMPOWERMENT.
AND FULSOMENESS.

BARRY'S USE OF THE TERM 'A-GOOD-ROUND
FIGURE' IS MORE THAN A FIGURE OF
SPEECH.

MANZONI'S INTEREST IN HIS OWN BODY
YOU WILL RECALL IS. BRACKETED BY.
2 OF HIS MOST. POWERFULL WORKS.

"FIATO D'ARTISTA"
THE ARTISTS BREATH.

AND "MERDE D'ARTISTA.
THE ARTISTS SHIT.

THE BREATH AS THE UTTERANCE AND
SPIRITUAL ESSENCE OF THE CREATOR
GOD) IS CONTAINED ~~IN A BREATHE~~
~~SPHERICAL~~ BODY.

IT IS A THEME THAT RECURRS AND RECURRS
IN ITALIAN ART FROM THE RENAISSANCE

in CIMA.
in GIOTTO
in THE works of
in ~~Andrew.~~
an in ~~Fabro.~~

IN MANZONI IT IS CONTAINED IN A
SPHERICAL BODY —THE RED BALOON.

AND HERE I WANT TO SAY SOMETHING
MORE ABOUT THE EMPEDOCLEAN NOTION
OF THE KATHARMOI. (PAGE 9)

THEY HAVE NO LIMBS, REMEMBER AND
LIKE SWIFT THOUGHTS CAN RANGE OVER THE WHOLE WORLD

CONTAINMENT
IMPLIES
FULLNESS
IMPLIES.
CUMPETION.
IMPLIES
EMPOWERMENT.

A GOOD ROUND FIGURE THEN MEANS WHAT IT SAYS

FIATO D'ARTISTO

MERDA D'ARTISTA.

BREATH
BREATH AS SPIRITUAL UTTERANCE

SLIDE 9
MANZONI
SLIDE 10
MANZONI
SLIDE 11
MANZONI
SHIT

RENAISANCE TO PRESENT.

THE RED BALLOON AS
SPHERICAL BODY.

KATHARMOI.
PAGE 9

COMPARE THIS WITH KLEINS DESCRIPTION
OF THE ANTHROMETRIC FIGURE

> " I VERY QUICKLY PERCEIVED THAT IT WAS
> THE BLOCK OF THE BODY ITSELF — THAT IS TO
> SAY THE TRUNK AND PART OF THE THIGHS,
> THAT FASCINATED ME. THE HANDS, THE
> ARMS, THE HEAD, THE LEGS WERE OF NO
> IMPORTANCE. ONLY THE BODY IS ALIVE,
> ALL POWERFUL AND NONE-THINKING.
> THE HEAD, THE ARMS, THE HANDS ARE ONLY
> INTELLECTUAL ARTICULATIONS AROUND THE
> BULK OF FLESH THAT IS THE BODY.
> IT IS IN THE ESSENTIAL MASS THAT IS THE
> TRUNK THAT WE FIND THE REAL UNIVERSE
> THE RESURECTION OF THE BODY, IN THE
> RESSURECTION OF THE FLESH.

HERE THEN KLEIN IS DESCRIBING THE PURE
PNEUMATIC BODY ALL SPIRITUAL FORCE, NONE
THINKING BECAUSE IT IS ALL KNOWING
IMPERIOUS OMNIPOTENT EVEN. IN ITS
TENDENCY TOWARDS SPHERICITY.

MANZONI'S RED BALLOON IS INDICATIVE THEN
OF A PARTICULAR MALE FANTASY — EMBEDDED
IN THE NOTION OF CONTAINED FORCE AN
OMNIPOTENCE WHICH IS ALWAYS A GIVEN OF
HIS POSTURE AS AN ARTIST.

THE 'ARTIST SHIT' BY CONTRAST, IS LITTLE MORE
THAN INTELLECTUAL WASTE PRODUCT.

ANTHROMETRIC FIGURE

16
YVE KLEIN
BODY
PAINTING

Lecture delivered at Royal College of Art and Architectural Association School of Architecture, 1998.

One of my greatest regrets is that I never met Piero Manzoni. I have known people who knew him well and I have met members of his family; everything that they have told me leads me to believe that he would have been the most charming, thoroughly fascinating and highly entertaining companion. So when the call came to write about him for the opening exhibition at a refurbished Serpentine Gallery I jumped at the chance. As things turned out the curator of the show Germano Celant, elected to write about Manzoni's work himself, while I was charged with the more speculative and perhaps more difficult task of tracing Manzoni's influence on artists since his premature death in 1963. In particular, they asked me to look at a cross-section of younger artists who might be seen as continuing something of Manzoni's concerns today. I had just seen Joëlle Tuerlinckx's remarkable 'A' Exposition at Opus Operandi in Gent, which focused entirely on the idea of 'white' as presence and absence. It was seeing this exhibition that helped me make what I now think of as an essential connection between Manzoni's invention of the Achrome and the ghosted, 'negative' image in photography.

PIERO MANZONI:
OUT OF TIME AND PLACE

Piero Manzoni was one of certain key figures who were instrumental in redrawing and substantially extending the map of artistic practice during a crucial period of innovation and change in the 1950s and 1960s.[1] His achievements prepared the way for Conceptualism and Arte Povera, anticipated the decline of Modernism itself and the subsequent slide into the relativistic complexities of postmodernity. Through his lifelong preoccupation with the *Achrome*, it was Manzoni who carried the 'anti-retinal' redefinition of the art object, inaugurated by Marcel Duchamp, into a new and, in part, metaphysical dimension.[2] It was Manzoni who invented the dumb work of art, the work of art that refuses to vocalise, precursor to the ubiquitous, cheekily blank postmodern object. It was Manzoni who gave us the category of living sculpture. In the subsequent development of art practice after the Second World War, these were distinct new territories. For Manzoni, they were all part of a central enterprise of mounting an effective critique of institutional modernism which was consecrated in an unholy alliance between artistic production and the demands of an increasingly active and dominant art market.[3]

In considering the life and work of Piero Manzoni, we are also looking at that very special moment in art history when the focus of experiment ceased

to be contained by the more traditional, linear model afforded by the generic disciplines of painting and sculpture. At this time, artistic experimentation was joined to an outward moving force – something akin to a colonising instinct – bent upon transforming and expanding the landscape of artistic practice by raiding and pillaging the culture at large: past and present, high and low. Alongside this rush to found new territories, the mid-1950s also brought a revision of the list of Modernism's heroes. Duchamp was placed centre stage; grouped around him were writers, artists and thinkers like Antonin Artaud, Georges Bataille, Alfred Jarry, Francis Picabia, Man Ray, Oskar Schlemmer and Kurt Schwitters. In this more open and questioning atmosphere, the notion of moving between different arenas of creative action became a compelling topic; cross-disciplinary activity became the hallmark of a thoroughly contemporary attitude towards practice, a characteristic which still dominates the approach to art-making today. This was a critical project that Manzoni shared with other artists of that time, most notably with the Belgian poet and artist Marcel Broodthaers whom Manzoni met in 1961 and whom he signed and certified as an authentic work of art in the same year.[4] Afterwards, Broodthaers described their meeting as a mixing together of grand but foolish humours: 'Our encounter,' he wrote, 'was as if we were two comedians.'[5]

The suggestion has sometimes been made that it was this meeting with Manzoni that finally persuaded Broodthaers to stop writing poetry and to become a visual artist. Whatever the truth of this claim, theirs was a profound meeting of minds. The two men shared an almost classical melancholia of the spirit; a passion for dark comedy; and, although it sprang from two entirely different sources, a fearful cultural pessimism which drove them each to seek refuge in distinctive ironies of truly Socratic proportions. In the case of Manzoni it was as the heavily breathing, defecating and self-punishing, pneumatic 'corpo d'Italia'.[6] In the case of Broodthaers, it was as the culinarily bifurcated 'homme belge',[7] an affectionately detailed critical grotesque through whom the artist was able to open up a discussion of religious, political, social, cultural and linguistic difference as a collocation of framing concepts in the debased spectacle afforded by the emerging culture industry.[8]

Consideration of the relationship between the work of Manzoni and Broodthaers brings us face to face with the question of influence and of progress taken as a theoretical topic.[9] In the context of postmodernity, too, the concept of progress – essential to the evolution of artistic style – no longer holds sway, and even the notion of history has come under severe question, with the result

that today's artists tend to look at the past rather than into it; they tend to see art history more as territory than as teleology, thereby collapsing the past, the present and the future into a single plane. While Modernist artists positioned themselves with respect to traditional forms and according to received beliefs that laid claim to universal truths, for artists today, positioning is always undertaken in relation to the present. Style is never a given, but something that must be chosen. Enclosed within a highly demanding and more or less continuous state of self-consciousness – forced all the time on to the rocks of ironic self-inquisition, the postmodern artist must suffer the repeating spasm of a return to the condition of an ahistorical stasis. Self-irony, with regard to the tenuous predicament of terms like 'author' and 'original', has become an essential outcome of the temporal predicament posed by postmodernity. During the 1950s and 1960s it was suddenly very obvious, at least to certain artists of the time such as Manzoni, that the concept of influence had become almost entirely detached from the linked questions of 'material handling' and the evolution of style, and had instead realigned itself with the more urgent issue of conceptual territory, resulting in a momentous shift in the redefinition of the artist and the art object. Manzoni's *Linee* (*Lines*, 1959–61) are a series of single line drawings on paper, placed in sealed containers, labelled and signed by the artist and identified by their lengths, expressed in metres, by the month and the year. Throughout this series, the artist stages an irresolvable conflict between the material quality of the cylinders, the concreteness of the information on the labels and the fact that the lines themselves can be visualised only in the mind's eye. Such a conflict resulted in opening up the possibility of the artwork not only as literal object but as idea, an ongoing leitmotif in contemporary art. Two works by the young Mexican artist Gabriel Orozco from 1993 specifically come to mind: *Caja vacia de zapatas*, an empty shoebox standing in its own lid and lying on the floor of the gallery, and *Aliento sobre piano*, a photograph of the artist's breath on the cold, shiny lid of a grand piano.

If the scope and conceptual range of art were transformed at this time then so, too, was the public face of artistic practice. Manzoni's embracing of a somewhat peripatetic lifestyle, in which he worked sometimes *in situ* and improvised events on the spot – an unusual way of operating at that time, although it is almost routine for artists today – and his preparedness to realise the work through a performative act of some kind involving the audience directly in the process of making, served to open up a potential area of practice

which proved to be an immensely important legacy for the subsequent development of art. In Manzoni's last published text *Alcune realizzazioni. Alcuni esperimenti. Alcuni progetti* (*Some Realisations. Some Experiments. Some Projects*), he recalls making two exhibitions / performances (he calls them 'events'), one in Copenhagen and the other in Milan, in 1960. During these events, Manzoni 'consecrated art, imposing my fingerprint on some hard-boiled eggs. The audience enjoyed direct contact with these works, swallowing an entire exhibition in seventy minutes.' Both of these events positioned the occurrence of the work of art between action and site. Such examples within Manzoni's *oeuvre* resonate in the work of diverse and influential figures including Broodthaers, Joseph Beuys and Michelangelo Pistoletto. This blurring of boundaries between action and site led, on the one hand, to the further extension of visual art into living sculpture and performance work and, on the other, into the architecturally contextualised or site specific and more institutionally critical area of installation work. This form of practice was engaged first of all by Broodthaers in works like *Entrance to the Museum* and *Decor* created at the ICA in London in 1975, and has been taken up more recently by artists such as Hans Haacke in his 1996 storeroom installation, *Viewing masses: upstairs* at the Museum Boijmans Van Beuningen, Rotterdam.

Despite the overall diversity of Manzoni's practice, he returned repeatedly to the invention he named the *Achrome*. These works are characterised by surfaces without colour which are at once more physical and more of an object than, say, Yves Klein's *Monochrome* paintings. For example, in 1962, Manzoni made a number of *Achrome* which used *rosette* – common Italian breakfast bread rolls, hollow at the centre with crisp outer crusts scored in a rose-like fashion to allow them to be broken easily between the fingers. These particular *Achrome* brought to the surface his fascination with pneumatics as a spiritual exercise (the breaking of bread in the Christian Mass) and with pneumatology, a concern for the nature of spiritual beings. Indeed, Manzoni's works in general, and the *Achrome* in particular, are rooted in a specifically metaphysical vision of corporeality, one that starts by acknowledging a special mutuality between substance and light – between something that endures, in other words, and something that is always changing. The recognition of this mutuality is clearly present in the more concrete or abstract works of artists like Lucio Fontana, Alberto Burri and Francesco Lo Savio. This last group can be contrasted with certain of the American Minimalists – say, Donald Judd, Sol LeWitt and Frank Stella – for whom substance is ready-made and preexists the work: it is bought

from builders' merchants, off the shelf in DIY stores, or found stacked high in scrap-metal yards. Or consider the later work of Richard Serra, who deals so much in the brute presence of things: their size, their mass, their sheer weight. For Manzoni and his contemporaries, substance is the body as it is revealed by light.

The philosopher George Wilhelm Friedrich Hegel described this metaphysical enterprise as 'the search for substance', a search for those matters – 'things' mediated by thought – to which a state of relative permanence can be attributed, providing us with an approximate, or even provisional, fixed point from which to attempt an account of the ongoing nature of change. Hegel was fond of summing up this relationship in the aphoristic statement: 'There is no smile without a substantial being who smiles it.'[10] In the work of Manzoni, notwithstanding the *Merda d'artista* (*Artist's Shit*) and the audience-participatory works, the smile is a closed smile. It is implacably blank and entirely inscrutable. Nevertheless, consciousness of the beyond – a reflected-upon interior of some kind – remains absolutely central to our experience and understanding of his work.

The factuality (what Donald Judd has called 'literalism') that we observe at work in so much postwar American art must be looked upon as something quite distinct from the blankness of Manzoni's *Achrome*, the resistance that they offer to interpretation – a quality Germano Celant calls 'tautology'.[11] Tautology always indicates a reiteration of some kind, and this reiteration, in its turn, tends towards closure. The closure that Manzoni makes around the *Achromes* is a material one, paralleling the sense of closure operated by the works themselves, the way in which they return us over and over again to consideration of their physical characteristics. Manzoni's own definition of the *Achrome* is merely a catalogue of the materials used:

My first *Achromes* date from 1957, and are of canvas impregnated with kaolin and glue. In 1959, the seams of the *Achromes* consisted of machine stitching. In 1960, I made some in cotton wool and expanded polystyrene. I experimented with phosphorescent pigment and with other surfaces soaked in cobalt chloride that would change colour with the passage of time. In 1961, I carried on with still more surfaces in straw and plastic and with a series of paintings, also white, made of balls of cotton wool, and then some that were furry like clouds, made with natural or artificial fibre. I also made a rabbit skin sculpture.[12]

The *Achrome* are material tautologies, deploying a strictly material form of reiteration: the laying of canvas upon canvas, of soft-chalk ground upon soft-chalk ground; they are objects that fold mould-matching surfaces against each other, or generate entirely new and mutant surfaces through the symmetrical ordering of matching elements including bread rolls, cotton wool balls, polystyrene pellets and pebbles. They are made part of a transcendent unity through the reduction of chromatic difference to a nominal zero-point. In this respect, Manzoni's 'achromatisation' of mundane things taken from everyday life and the transformation of them into their metaphysical blanks is not far removed from the tautological transmission that Marcel Duchamp envisaged as the 'infra-slim': the contiguity of mould and cast.[13] Very often the impression given by the *Achrome* is of something cast or, more particularly, cast in plaster. Their whiteness in conjunction with the complexity of their surface detail, tends to produce an optical sensation of blurring, almost a mixing together of positive and negative light – impressions similar to those we experience in relation to a newly emerged, virginal white plaster-cast. It is as if they have the memory of a negative other self stitched into their surfaces; as if they are, at one and the same time, both themselves and a ghostly trace or optical mould of themselves, held in a more or less permanent state of suspension. They face their own negative image across the same gap as Duchamp's infra-slim.

Of a younger generation of artists working today with this shifting relationship between substance and void, two spring immediately to mind: the British sculptor Rachel Whiteread, and the Austrian artist, Pepi Maier. They are both attracted to the ghosting of things, not out of an interest in metaphysical play, but because it provides a useful conceptual site from which to address certain key issues relating to the human *habitus*. In Whiteread's case, her carefully formed and finished negative moulds of domestic objects have the appearance of solid emanations that 'index' their lost objects, almost in a photographic sense. And not just their lost objects, but the pathos of a lost function, too. For this reason, they seem to carry with them a whole host of memory impressions that mime back to us an image of life as entropy, experienced as gradual but irreversible loss. A work like Whiteread's *Ghost* (1990), for example – the complete cast of the interior of a typical room in a Victorian house – is heavy with sentiment, but without a trace of mawkishness. It is as if the emotion attached to loss has been clarified, held in suspension, frozen and preserved in some way.

By contrast, Maier's cast objects start from a humorous impulse very close to that of Manzoni and Broodthaers. First of all, Maier dismantles the object and classifies the bits and pieces by material. He then dismantles or grinds up these materials into similar sized particles. After mixing the particles together and adding a clear casting resin, he shapes them back into a mould of the original object which the material can only partially fill. Our first response, then, is to smile the smile that so often attends a precisely directed bolt of irony, before the chill strikes at the heart and a feeling of bleakness sets in. The world that Maier plays back to us seems studiously prosaic, even deadpan – at the same time a reducing, even a vanishing one, filled with consumer-objects which, through some mysterious brand of material alchemy, appear to be in the process of consuming themselves. In a work like *Fernseher* (1993), he gives the notion of the material tautology an added twist. This part-cast of a television set is made from the sum total of its material self. As with the work of Rachel Whiteread, there is a distinctly photographic side to Pepi Maier's work. Both index or, to use Roland Barthes's phrase, 'play back' the past in some way.[14] As with Peirce's infamous 'bullet-hole', both tend to hide a pronounced performative aspect, which is crucial to the way in which the works signify. This is also, perhaps, where they draw closest to the work of Piero Manzoni.[15]

The curious optical ambiguity present in the *Achrome* of Manzoni come very close, as I have already suggested, to the Hegelian notion of matter: the point of intersection between thought and substance. During the course of the 1980s this same broad territory was occupied by figures such as the Belgian artist Didier Vermieren, to whom I shall return later when I deal with Manzoni's treatment of the plinth, and the Austrian sculptor Franz West. I am thinking here of the series of plaster works cast in relationship to different gestures and postures of the body which West made in the 1970s, and the combination objects – separate things, usually containers of different kinds, bound together with packing tape and treated to coat after coat of household paint.

Manzoni's critical and metaphorical reification of the artist's body, its processes and products, pointed the way towards an understanding of the persona of the artist and the product of the artist's body as a consumable object. The *Merda d'artista* (1961), the artist's shit, dried naturally and canned 'with no added preservatives', was the perfect metaphor for the bodied and disembodied nature of artistic labour: the work of art as fully incorporated raw material, and its violent expulsion as commodity. Manzoni understood the creative act as part of the cycle of consumption: as a constant reprocessing,

packaging, marketing, consuming, reprocessing, packaging, *ad infinitum*. With the *Merda d'artista*, the creative act and its presentation become a means of sanitising the gifts of the body, rendering them abstract by giving them a market value. In the spirit of Bataille's 'excremental economics', Manzoni priced his precious cans of shit according to the shifting daily price of gold, an ironic reference to market values which was picked up more recently by the New York-based artist David Hammons, when he set himself up as a street-trader selling snowballs, priced according to size, to casual passers-by in a work he called *Bliz-aard Ball Sale* (1983).

The notion that the artist should figure in some important way as a nominal human presence – should be inside, rather than standing outside, his or her own work – also precipitated a whole range of new approaches to depicting and referencing the human subject, which began with post-Minimalism and Arte Povera and has continued to gather momentum since. Of works by American artists made in the 1960s I would cite, in particular, the film by the young Richard Serra in which his hand tries over and over again to catch a falling piece of lead; the body-based works of Bruce Nauman, such as *Neon templates of the left-hand side of my body taken at ten inch intervals* made in 1966, and the slightly later *Hand to Mouth* made in 1970. Among Arte Povera works are the whole range of *Oggetti in meno* (*Minus objects*) by Michelangelo Pistoletto (for example, *Mappamondo*, 1966–68), and the early plexiglass and metal pieces by Giovanni Anselmo, made in 1965–66. All of these works employ some form of ghosting, in relationship to the artist's own body, the object itself, or the physical presence of the viewing subject.

It is very clear that, for Manzoni, art often involved an active principle of some kind and that it demanded to be 'performed'. In this respect, the notion of human agency is central not just to his thinking about his own practice but to his thinking about art in general. He saw the artist as one kind of agent – not a remote, disembodied or lofty presence, more an active worker of what he sometimes liked to call magic – and the spectator as another. It is also clear that when Manzoni speaks of the artist as an agent of magic, he means something altogether more immediate and easy to get hold of than, say, the sombre, shamanistic games of the younger Joseph Beuys, or the elegant wizardry of James Lee Byars. When, in 1961, Manzoni signed his first *Scultura vivente* (*Living Sculpture*), metaphorically speaking he had nothing up his sleeve. It was a very straightforward, simple act. In the same year, he created the *Base magica* (*Magic base*), a simple plywood box imbued with the power to

transform into a work of art anything or anybody placed on it; and the *Socle du monde*, a steel plinth with its title inverted, which takes possession of the world as a unitary object, thus turning it into a work of art. These two works were deeply consequential for the subsequent practice of art, just as were Duchamp's placement and authorisation of the urinal in the work he called *Fountain*.[16]

Henceforth, the *socle*, the plinth, would be addressed not merely as a residual, historical impediment of the kind that so preoccupied American and European sculptors in the wake of David Smith, but as a site of agency. Like the Apollo Stones of ancient Greece, it would offer the opportunity to make a hierophantic passage from one world into another. It would signify a magical place of assignation: a place where art separates itself from the rest of reality, thereby providing the viewer with the means of short-circuiting the routine transactions of everyday life. The plinth also offered an advantageous beginning for those who, like Manzoni, were desirous of lofty elevation.

After Manzoni's intervention, the plinth was no longer simply a means of support, a way of delivering the object to the viewer's gaze at the right height. It was no longer merely a lump of stuff, to be hidden away, camouflaged, endlessly redesigned or, whenever possible, done away with altogether. Instead, for certain artists, it became an item of intense interest and they began to play elaborate conceptual games with its identity. Marcel Broodthaers transformed it into a packing-case, a table or a chair, sometimes into a pair of step-ladders or even a valise. Joseph Beuys substituted for it a wooden bench, a printer's settle, a cardboard box, a piano stool. In his early assemblage works, Reinhard Mucha played games with chairs and library ladders; while the defiant Martin Kippenberger returned it to its lowliest status as an unadorned plywood box. For Thomas Schütte and for Langlands & Bell, it served as a prime archaeological site upon which to excavate different types of Piranesian fantasies; for Didier Vermieren it became almost his only subject, to be tested to destruction for its capacity to signify. None of these acts of substitution is simple. Rather, the *Socle du monde* makes much broader points about social and political life. What does the plinth say about the work of art's connection to the social world, to the institutions of art, and to the formation of culture? What does it contribute to the politics of public and private life? As Manzoni so clearly demonstrated, the plinth embodied one of the great critical issues concerning how artists situate themselves in the world. It provided the perfect site upon which to focus a new kind of critical discussion of the role of the artist. It is worth noting that Manzoni had mapped on the top surface of the first of his plinths, *Base magica* (1961),

silhouettes intended to function as a guide to the positioning of his own feet: one foot placed carefully at an angle, just in front of the other. He makes it clear that the pose to be struck by the artist is to be a self-consciously heroic one, similar to that commonly used for the depiction of statesmen and important historic figures. The ironic nature of his proposition is clear. The *Base magica*, closer to the lay preacher's soapbox than the orator's dias, was on the one hand to be seen as a place heavy with quizzical irony, and on the other to serve as a site of exposure – an eminence upon which the artist, first and foremost, would be viewed as a fallible human subject and, most importantly, would be photographed as such.

Nor was Manzoni's perception of the artist as a new kind of subject standing exposed before the unblinking gaze of the camera lost on the generations of practitioners who followed him. Indeed, release from the bondage of technical connoisseurship delivered photography into the more open hands of the artist. Here it could find a place in the context of a much broader set of creative values: it could function more directly in a mediumistic way. And the most important factor to lend real impetus to this process was the growth of interest in performance and pose art. We need only look back to the early living sculpture presentations of Gilbert & George – works like *Metalised Heads*, *The Singing Sculpture* and the 'pose lecture' piece (1961), *In the Underworld* (1969), made with Bruce McLean – and the series of performances given by McLean's own pose band, *Nice Style*, at the beginning of the 1970s, to see how live work led to new ways of thinking about the photograph. What started out as a problem of documentation – how to achieve and preserve a legible trace of a transient event – ended up as a full-blown and very varied means of expression in its own right. Thus a new range of practices was born, reaching from the self-declamatory picture-making of artists like Cindy Sherman, Janine Antoni and Sarah Lucas to more sculptural and perceptual preoccupations. Examples include pieces as diverse as Giulio Paolini's photographic works like *L'arte lo Spazio* (1983), his response to a proposition by Martin Heidegger consisting of four photographs of classical fragments holding apart the pages of a book; the 'pneumatic' objects and photographs of Michel Francois, as well as his recent balloon sculptures;[17] the large-scale installation works of Joëlle Tuerlinckx featured in *Pas d'histoire, Pas d'histoire* at the Witte de Witte in 1994, and the photographic records that she makes of these works which show her, in her own words, visiting her own exhibition 'as if she were a tourist';[18] and Mona Hatoum's own *Socle du monde* (1992–93).

The work of Manzoni occupies a crucial historical moment when the old, binary modernist order of movements and counter-movements was beginning to break down. As we have seen, he felt free to open up new areas of thought and to explore new strategies of making and subverting existing ones. Alongside other developments of the period, his work provided part of the impetus for exploring the space between language and object, central to the progress of Conceptual art. In this respect, his legacy is indeed marked by a continued play around the question of the object – its substantiality or otherwise – and the metaphysical space in which it might be said, with Plato, 'to be thought into being'. Perhaps more relevant to contemporary practice is Manzoni's objectification of the very act of creating – without, at the same time, dispelling its mystery. Manzoni, more than any other artist of his generation, was able to preserve what the French philosopher and critic Maurice Blanchot has described as a: 'presence which escapes comprehension, which is unascertainable, yet brilliant, explosive, and yet which, at the same time, is an event, seems the silent repose of a closed thing – all this we try to bear in mind and define appropriately by saying: the work is eminently what it is made of. It is what makes its matter visible and present.'[19]

Piero Manzoni, exhibition catalogue, Germano Celant (ed.), Serpentine Gallery, London and Charta, Milan, 1998, pp.39–49.

1 I am thinking here of artists like Yves Klein, Emilio Vedova, Marcel Broodthaers, Robert Smithson, Michelangelo Pistoletto, Joseph Beuys, Gordon Matta-Clark, Dan Graham and Lawrence Weiner. All of them opened up new territories of practice, to be remapped by others afterwards.

2 Marcel Duchamp: 'Abandoning my association with Cubism and having exhausted my interest in Kinetic painting (Futurism), I found myself turning towards a form of expression completely divorced from straight realism... no more a tributary of already existing schools... my stay in Munich was the scene of my complete liberation.' *La Vie en Rose*, Anne D'Harnoncourt and Kynaston McShine (eds.), Museum of Modern Art, New York, 1973, p.263.

3 See Nancy Spector's concise and very illuminating essay, 'A Temporary Blindness: Piero Manzoni and America', in *Piero Manzoni*, Musée d'Art moderne de la ville de Paris, 1991.

4 In 1961, Manzoni presented *Sculture viventi* (*Living Sculptures*), signing people and declaring them as living works of art. Each person received a certificate of authenticity, which was colour-coded with a coloured stamp indicating whether the person was a complete work of art, like Broodthaers, or only when performing specific acts such as sleeping, singing or drinking.

5 Fragment of a letter written by Marcel Broodthaers to an unidentified person. Courtesy Maria Gilissen, Brussels.

6 The theme of the 'corpo d'Italia' was later taken up and elaborated as a political critique by Pier Paolo Pasolini in his film *Salò* (1974): 'The exploiters of the second industrial revolution (otherwise known as Consumerism, that is to say, great quantities, superfluous goods, hedonistic functions) produce new goods and therefore produce a new kind of human being (now social relations)... hence my recent commitment to greater legibility – *Salò*.' Pier Paolo Pasolini, *The Lutherian Letters*, Carcanet Press, Manchester, 1983, Stuart Hood (trans.), p.123.

7 Broodthaers made two works using the human femur or thigh-bone: *Femur de femme française* (1965), painted in the red, white and blue of the French tricolore, and *Femur d'homme belge* (1964–65), in the black, yellow and red of the Belgian flag. Moreover, throughout his work, Broodthaers uses the *moules* (mussels) of the Flemish kitchen, alongside the *oeufs* (eggs), raw material of the ubiquitous omelette of the French, Walloon cuisine, as interchangeable metaphoric or metonymic elements. It is interesting note that, as part of his daily round, 'l'homme belge' eats and drinks 'difference'. In this respect, Broodthaers already shared with Manzoni a profound interest in the culture of food and drink. One apocryphal story has it that on a famous evening in Brussels, Manzoni ate three successive evening meals in three different restaurants; and then, at about midnight, asked his companions if there was anywhere they could go to eat cakes! As an otherwise reluctant materialist, Broodthaers came close to sharing something of Manzoni's more mystical preoccupations with the transforming and sublimation of material substances and material things, such as his canned *Merda d'artista* (Artist's Shit).

8 In his sketches for his book *Pauvre Belgique*, Broodthaers stipulates the typeface as Batonnet, the exact translation of which would be the English Grotesque. See Yves Govaert, 'An Asterisk in History', *October*, no.42, 1987, p.187.

9 There is, of course, an important general question to be asked about whether the art-historical notion of influence is at all useful beyond some broader academic discussion of the history and evolution of styles. There is also a more specific question, one that is especially relevant to our purposes here. Can we continue to apply the term 'influence' at all when it comes to discussion about the diverse range of works and the complex web of interrelated ideas which, taken together, form the Duchampian inheritance? The issue is further complicated when the ironic stance clearly starts, as it did for Duchamp himself, with some version of historical disengagement that deliberately seeks to exercise what Roland Barthes has called 'the refusal to inherit'. Arguably, when this particular brand of irony is involved, the questions of style and the transmission of influence hardly arise.

10 See G.W.F. Hegel, *The Phenomenology of Spirit*, Oxford University Press, Oxford, 1977, A.V. Miller (trans.); quotation taken from Frederick Sontag, *Problems of Metaphysics*, Chandler Publishing Co., Scranton, Pennsylvania, 1970, p.109.

11 Germano Celant, 'Piero Manzoni, an Artist of the Present', in *Piero Manzoni*, Musée d'Art moderne de la ville de Paris, 1991, p.16.

12 Piero Manzoni, quoted in 'Some Realisations, Some Experiments, Some Projects' (Milan, 1962), reproduced in *Manzoni: Paintings, reliefs and objects*, Tate Gallery, London, 1974, p.84.

13 Writing in *View*, no.1, March 1945, Marcel Duchamp made what was perhaps the perfect marriage between the pneumatic and the limits of substantiality when he wrote the little poem that introduced the world to the notion of the infra-slim: 'When / The tobacco smoke / Also smells / Of the mouth / Which exhales it / The two odours / Are married by / Infra-Slim.' Afterwards, he gave several different definitions of infra-slim, including 'the space between mould and cast before they are separated'. *The Writings of Marcel Duchamp*, Sanouillet and Peterson (eds.), De Capo Press, New York, 1973, p.194.

14 Roland Barthes, *Camera Lucida*, Hill and Wang, New York, 1982, p.88.

15 Quoted by Justus Buchler in *Philosophical Writings of Peirce*, Dover Books, New York, 1955, p.101. It is worth giving his explanation in full: 'An "index" is a sign which would at once lose its character if there were no interpretant. Such, for instance, is a piece of

mould with a bullet-hole in it as a sign of a shot; for without a shot there would have been no hole; but there is a hole there, whether anybody has the sense to connect it with a shot or not.'

16 Marcel Duchamp purchased a gentlemen's urinal from the Mott Works company of New York in 1917, signed it 'R. Mutt' and submitted it as a work of art to the exhibition of the Society of Independent Artists in New York, whereupon it was rejected by the jury. The historical importance of this work, which he called *Fountain*, now rests upon its use of the notion of designation alongside the issue of placement, and its questioning of the importance of authorship.

17 Show at the Marie-Puck Broodthaers Gallery in Brussels.

18 Made for Opus Operandi art centre in Ghent (1996).

19 Maurice Blanchot, *The Space of Literature*, University of Nebraska Press, 1982, Ann Smock, p.223.

CAMPUS CAMP

I want to preface my paper with one very simple statement, and that is that I am, have been, and remain always a firm supporter of the idea of artist-teachers in art schools. Historically at Goldsmiths College we have maintained the lowest possible number of full-time members of staff and the highest possible number of part-time members of staff, who are all practitioners in theory or in practice in the remainder of their time.

But I do not think that the notion of the artist-teacher is quite as simple and as easy to justify as we have been led to believe; it has problems on many levels. Speaking as a practitioner and an artist who exhibits, I have enormous difficulty sustaining both my practice and my teaching at the optimum level, and I expect that this is true of most people in that position. It is a form of state patronage in many ways. It is probably the largest form of state patronage in the arts, and yet it could be argued that it does as much damage to the artist as it does to the education system. So I am not quite so sanguine about the argument that it is automatically the case that artists teach art better than anybody else. I think it is essential that artists teach art, but there are other ingredients as well.

I want to trade Harry Thubron's quotations with Andrew Brighton's. Harry was the first person who ever indicated to me (and it was in my first

years of teaching at an art school) that there was any problem in art schools. I had drifted through St Martins and the Royal Academy Schools; we had all been jolly friends together and I had never learned to think very much really, and what I had learnt I felt to be highly problematic only four or five years later. I should add that both schools were full of practising artists; it is not as though they were devoid of practitioners. At St Martins alone, I think we had about ten Academicians teaching us how to portrait paint – the relevance was never questioned. It was just taken to be automatic – they were practising artists, they knew, they transferred their skills to me and off I went. And what did I do with those skills? I became a society portrait painter.

It was not true that somehow the Coldstream Report ushered in a phase where for the first time practising artists entered into British art schools – the teachers were all practising artists in one way or another. When I first taught at Lancaster, a printmaker there was selling prints faster certainly than I have ever sold any art in my life. He was a full-time professional printmaker, a practising artist. He had nothing to offer to the students, but that was never questioned. In fact he got them off the presses fast so that he could get his own editions on! The notion that the Coldstream Report was responsible for some kind of rosy glow in the art education world that we all look back on nostalgically ever since is not true.

When I came back from Rome my first job was in Lancaster College of Art, and I met Harry Thubron again. In the bar one night he commented: 'Jon, the enemies of art are in the art schools. And mostly they are running them.' And that was the first time anybody had ever indicated to me that there was any problem. But it has come back to haunt me as a quotation ever since. I think that it has almost always been true, that the enemies of art are in the art schools, and mostly they have been running them, and they will go on running them I suspect.

Something else very interesting that he said was directly about artist-teachers: 'One of the problems with artists teaching is that so many of them see their role as that of casting artificial pearls before genuine swine.' I think, thank God, that it is a lot less true today that the role of the artist-teacher was an occasion for often quite dreadful abuse of the learning situation. And I think, strangely enough, that improvement followed the introduction of foundation courses, where the whole question of how one taught was dealt with as an experimental question in this country, probably for the first time.

That began to breed a different attitude to the whole question of teaching, and set a different kind of standard for the artist-teacher.

Another memorable quotation comes from William Coldstream. It was in the Fitzroy Tavern, three days after Coldstream and the whole of the Coldstream Committee had resigned. He said to me (he was quite well-oiled – I think that was his term – it is a good term for a painter anyway, 'well-oiled'): 'You know, Jon, the problem is that we just do not have enough artists who are also good teachers to run the system.' And that was a man who had just resigned and a whole committee with him, after setting up the system, organising it, selecting the schools that were going to be approved, and so on, over a substantial period of time. And in many ways it was said in the tone of a kind of confession. The system is fine, but we don't have the kind of manpower that would be needed ideally to run it.

That is something we may now need to look back on, because I think in many ways the system of English art education has always been too expanded, too overproductive and so on. In a paper I produced several years ago I pointed out that to justify the roughly 3,500 fine art graduates per year (a) argued that you had absolutely remarkable teaching resources and (b) that you had somewhere to put all these people. There are studio complexes up and down the country where the residue of various art schools – those people we have no place to fit, who have lost touch with their desire to be artists, and so on, sit out their time painting objects which are on the whole incomprehensible. The question of the production of arts graduates, fine artists and fine arts practitioners in this country is not one we can simply ignore. It is a crucial question, which is the way the government would like to see it. It is a question of how effectively you can do your job and what sort of people you have, what sort of resources you have to do it with.

Another quotation in a bar, this time in Milan, sets a slightly different parameter. It was at the opening of the British Art Exhibition in Milan in 1978 or 1979 – I cannot remember which. We were sitting with Mario Mertz and one or two people. I said to Mertz: 'What do you think of British art?' And he said: 'Well, it's very well made.' I queried: 'You don't want to say any more than that?' 'No, that's it. It's very well made.' But it was said in a deeply critical tone of voice. It started me speculating as to precisely what he meant, and with one or two British artists who were representatives in the exhibition we talked about it. What we all thought he meant, and I think it was indeed what he did mean, was that in some way the objects

of British art are largely overdetermined. They are the product, in many cases, of extremely effective teaching that overdetermines them in some way. They are well-made conceptually, well-made physically – all of those things, but they do not feel like art.

We could say that yes, we have 150 years of the most effective, the most famous, the most expansive art education in the western world, but it is often a good thing to pause from time to time and look at the effect of this.

The time is the early 1960s, and the setting a wine bar off the King's Road. The now well-known West Coast American artist, Ed Ruscha, as he used to be called (I think he is now simply called Ruscha) was staying in London, and paying the occasional visit to Chelsea College of Art. I, too, was a visitor at Chelsea at the time. One day we had lunch together. I asked him what he thought of art schools, and his reply was a memorable one. 'They are the same everywhere,' he said. 'Full of teachers, camping it up pretending to be artists, and a lot of artists pretending to be concerned individuals. If it's not rape, then it is seduction.' Black and bleak and even cynical though this remark was – and it is typical of the man, he is a very dry character – I have cherished Ruscha's remark ever since, for two reasons. Firstly, I have always used it as a kind of negative touchstone against which to measure my own behaviour as a teacher. It is quite a salutary thing to ask yourself from time to time whose particular interests you have in mind. Are you genuinely helping them with their creative problems or are you forwarding your own philosophy of art at their expense, or even dominating or seducing them? And secondly, there is something in Ruscha's equation of pretence which has always seemed to me to perfectly encapsulate my dilemma as an artist-teacher.

The dilemma of the artist-teacher seems to me to be the difficulty of, on the one hand, fulfilling my duties as an effective role model, an exemplary figure who can show the way, even provide access to a greatly desired professional coterie and the lifestyle that goes with it, whilst at the same time providing knowledge of critical method, a great deal of hard information relating to theory, history and practice, as well as a wide range of insights covering everything from politics and culture through to more personally psychological, social and spiritual matters.

As an artist-teacher I am thus required to combine the necessary self-centred and self-seeking partiality of the artist with the careful solicitude and studious impartiality of a scholar priest. And if, in the process of achieving this extraordinary feat, I am at the same time to avoid committing rape or

seduction, to use Ruscha's terms, I must achieve this miracle of integration whilst at the same time maintaining a high degree of objectivity, and measured neutrality where matters of belief are concerned, and a continuous awareness of the sensibilities, susceptibilities and vulnerabilities of each and every young artist in my charge.

Any reasonably intelligent, pedagogically concerned, but otherwise uninvolved outsider might be forgiven for dismissing such an educational role and such a task as being downright impossible. And so it would be if it were not for one very exceptional, important factor: the part that desire plays in the game of art and life, and in particular the part that desire plays in this game of chance encounters, intuition, and unsystematic knowledge that we call art education.

In my view it is this, this curious, unmeasurable, but forceful thing called desire which is the single most important factor in any thorough-going educational process, regardless of the subject to be addressed. It is desire which provides the site about which the teaching and learning transaction will find its most effective form. This is particularly true when the subject and object of desire is art. It must be that the shared desire for art is the pivotal point around which the delicate negotiations between artist and teacher, teacher and young artist, young artist and artist, occur. And it is here that partiality and impartiality are rendered indistinguishable, that oppression and deceptive persuasion hold little or no sway.

It was Ortega y Gasset who asked the rhetorical question: 'Who knows where the desire for art comes from?' He goes on: 'We know without a shadow of doubt when it is absent, and when it is there it is plain for all to see. But who knows where this desire comes from?' As Ortega knew full well, his question is without an answer. Nevertheless, it is a question that must be repeatedly asked, since it serves to remind us of art's proper place in that dark void that comes before reason. I need only look to myself to know the force of Ortega's question and to experience again the central mystery to which it points. For instance, I cannot remember a time when I did not draw, paint, shape things and build objects. I cannot remember a time, in other words, when I did not desire to make art, to be with art, to be an artist. This is true in the way I remember my life – looking back, the way in which my life always seems to have been cast. No doubt the social scientist would have great difficulty with such a romantic and unscientific proposition, and would argue for a more objective and more analytical

approach to the question of my creativity. Desire, the social scientist would argue, must have its point of origin within an examinable constellation of social circumstances and social relationships. We need only search diligently into one's past, sift away the evidence and we inevitably reach a point of kindling, a point of generation which gave birth to one's desire for art. A person, a group of people, a place, a peculiarity of circumstances, no matter what. But of one thing we can be certain, it would be firmly set in this concrete world of social and material exchange.

But as an artist and as a teacher, I do not and cannot accept these arguments – the arguments of the social scientist. And this after six years of psychoanalysis during which time this ground was gone over and over *ad nauseam*. As arguments they simply do not square with my own experience. There is nothing in my background, in my family history which can explain this all consuming but utterly irrational passion which guarantees me nothing – not peace of mind, not a living, not a roof over my head – and yet still persists. No, for me Ortega's question, though it allows no room for answer, nevertheless embodies an undeniable truth. No one knows and no one can know from whence the desire for art springs. And his qualifying statement in my experience seems to me to be true also.

As an artist and a teacher I know without a shadow of doubt when the desire for art is present in those young aspirant artists that I teach. And, at the risk of sounding arrogant, I know from their responses that they recognise with unerring certitude that it is present in me at least for some of the time. In other words, they know exactly when I have lost touch with my desire, when (to use Ruscha's term again) 'I am camping it up', either pretending to be an artist or pretending the role of professionally concerned pedagogue – they know, in short, when my heart is in the right place and when it is not.

I would like to take this question of desire even further, and to examine its institutional implications. It is one thing to recognise the centrality of desire in the making of an artist and quite another to recognise and respect its implications for the planning of an educational programme. It is one thing to pay lip service to the notion that the most important and most precious characteristic that young artists need to have is a burning, irrational, some would say irresponsible, desire to do something and to be something, and another to design an educational operation which respects that desire absolutely and unconditionally, even fearlessly. Nevertheless, it seems to me that the consequences of accepting Ortega's model of creativity are clear,

certainly insofar as they seem to point to an unavoidable principle, a principle which I have worked with in 20 years of leading the teaching of fine art at Goldsmiths College. Namely, that in any educational endeavour focused on the practice of art, desire for art and by implication the artist must be placed at the centre. And it is this principle that has most come under attack in recent years for very dubious institutional and political reasons.

I want to say more about this principle of making the artist central to the educational process, because it is often misrepresented and misunderstood. Ultimately, the question is one of authority, and from where authority is derived. As an institutional animal – a paid hand, if you like – I juggle around with several different kinds of authority. That which is vested in me, by dint of my status within the institution, that which is lent to me by my academic reputation within the university, within what the university calls my 'subject', and that which I can invoke by recourse to some superior knowledge of history and tradition of practice. There are others, but it is not necessary to list them here. I would argue, and it is an important qualification to my central educational principle, that all of these versions of authority avail me nothing when the question of the quality of my desire for art is at stake. At this point, there can be no distinction between teacher and student, at least no authoritative one. And at this point it is a measuring of and a testing of mutually held desire for the unattainable. At this point it is a discourse between equals, between, in other words, artists who are together seeking after something in hope and good faith and good trust.

To put the artist at the centre of the art education programme is to place a particular subject and a particular type and quality of discourse at its centre. This discourse is characterised by rigorous doubt which must, in the face of all forms of authority, be directed, pointed, shaped, not just by the student, the young artist, but also by the teacher. Certainly it permits no easy programmatisation of the learning process. And that is a hardship which I am afraid as teachers we all just have to live with.

Essay derived from a lecture delivered at St Annes College, Oxford in 1999.

When the call came to contribute an essay to the catalogue for the South Bank's travelling exhibition, *Sublime: The Darkness and the Light*, it was one of those uncanny serendipitous moments. For one thing, I was in the middle of re-reading Kant's *Critique of Pure Reason* in another vain attempt to come to grips with the subtlety and depth of Kant's thinking. But I had also, just a month before, attended a series of seminars in Maastricht, based on readings from Jean-François Lyotard's, *The Differend*, and some of his ideas were still fresh in my mind. This coincidence seemed to offer a golden opportunity to attempt a different type of essay, one that was more philosophically rigorous. I had a long standing interest in eighteenth- and nineteenth-century English Romantic thought, the writings of people like Sir Uvedale Price, Joseph Addison, Edmund Burke, Edward Days, Samuel Taylor Coleridge and John Ruskin, which provided me with an excellent starting point from which to address certain aspects of Kantian aesthetics. It also offered a link between the later writings of Kant and the more contemporary notion of 'sublimity' that we find in Lyotard.

THE SUBLIME MOMENT:
THE RISE OF THE CRITICAL WATCHMAN

...downwards we hurried fast,
And enter'd with the road which we had miss'd
Into a narrow chasm; the brook and road
Were fellow-travellers in this gloomy Pass,
And with them did we journey several hours
At a slow step. The immeasurable height
Of woods decaying, never to be decay'd,
The stationary blasts of water-falls,
And every where along the hollow rent
Winds thwarting winds, bewilder'd and forlorn,
The torrents shooting from the clear blue sky,
The rocks that mutter'd close upon our ears,
Black drizzling crags that spake by the way-side
As if a voice were in them, the sick sight
And giddy prospect of the raving stream,
The unfetter'd clouds, and region of the Heavens,
Tumult and peace, the darkness and the light
Were all like workings of one mind, the features

Of the same face, blossoms upon one tree,
Characters of the great Apocalypse,
The types and symbols of Eternity,
Of first and last, and midst, and without end.
 – William Wordsworth, *The Prelude*, Book VI, 1805

While traces of 'sublime' experience are to be found in the art and literature of almost every period, the aesthetic category of 'the sublime', as we know it today was essentially an invention of the late eighteenth century. Taking his cue from a first-century fragmentary treatise, *On Elevation or Impressiveness of Style*, by the Athenian rhetorician Longinus,[1] the English classical scholar and poet Joseph Addison was perhaps the earliest Enlightenment thinker to theorise 'the sublime', although his collected essays on the subject, written at the turn of the seventeenth century, were not published in their entirety until 1768,[2] some ten years after Edmund Burke's seminal work, *A Philosophical Enquiry into the Origin of Our Ideas of the Sublime and the Beautiful*.[3] It is Burke, then, who is credited with the first thorough-going account of 'sublime' experience from a philosophical standpoint, and it is his treatise that has had a profound and lasting affect on British art and literature. The passage from William Wordsworth's great *The Prelude*, quoted above, is exemplary in this respect. Rich with 'sublime' devices drawn from the writings of Edmund Burke and very consciously applied, it deploys the whole kaleidoscopic array of conflicting forces: the prescient and the timeless; the dynamic and the formless; the frighteningly proximate and the distant; the still and the giddy. And the most important characteristic of all, the restless oscillation between wonderment and dread, between calm and terror; a dynamic process, the perceptually moderated form of which, according to Burke, constitutes the very essence of 'sublime' apprehension:

> ...if pain is not carried to violence, and the terror is not conversant
> around the present destruction of the person, as the emotions
> clear the parts of a troublesome encumbrance, they are capable
> of producing delight; not pleasure, but a sort of delightful horror;
> a sort of tranquility tinged with terror.[4]

Burke's view brings together the idea of imminent threat and the certain knowledge of security; a feeling of physical danger, fully grasped and understood, yet apprehended from a position of safety. We experience 'the

towering force of things', Burke writes, and our own powers of resistance as '...of trifling moment in comparison with their might', so that '...their aspect is all the more attractive for its fearfulness'. It was a theme which was later taken up by the most important continental thinker of the eighteenth century, the German philosopher, Immanuel Kant. Kant wrote his first essay on the subject, *Observations on the Feeling of the Beautiful and the Sublime*, in 1764,[5] and he was to touch upon the philosophical function and definition of 'the sublime' thereafter in all of the major *Critiques*, paying special attention to it in the *Critique of Judgement*.[6] It is Kant who has provided by far the most comprehensive account of 'the sublime', an account which has provided the bedrock of virtually all subsequent theorising on the subject.

Both Burke and Kant start with the task of differentiating between two distinct but closely related categories of experience, our recognition of 'beauty' and our apprehension of 'sublimity'. Burke argues that 'beauty' stays within the compass of human comprehension and in this respect confers a sense of well-being on the subject, while both 'the grand' and 'the sublime' seem to reach for, or suggest, a state or condition beyond the scope of immediate comprehension. And the distinction that he draws between 'the grand' and 'the sublime' hinges upon the notion of fear. While both lead eventually to feelings of pleasure, even of well-being, they do so indirectly: 'grandeur' by way of a sense of awe, and 'sublime pleasure' only after an initial feeling of terror. In his first essay on the subject, Kant, by contrast, attaches the distinction to quite a simple theory of morals. Feelings of both 'beauty' and 'sublimity' are generally speaking aligned to the idea of 'the good'. But still these is an important difference, and the separation Kant makes between the two is at once more complex and more difficult to pin down than that of Burke. For Kant, the experience of 'beauty' is an experience of the 'measurable', while 'sublimity' is an experience of magnitude without limit. Indeed, 'the sublime' can be a part of every kind of overwhelming feeling, from 'quiet wonderment' and 'pastoral contentment' to extreme states of 'fearful excitation' and 'delightful horror'.

For Kant, measurement is also closely allied to the notion of form. As he writes in Book Two of the *Critique of Judgement*:

> The beautiful in nature is a question of the form of the object, and this consists in limitation, whereas the sublime is to be found in an object even devoid of form, so far as it immediately involves, or else

by its presence provokes, a representation of limitlessness, yet with a super-added thought of its totality.[7]

Here, 'beauty', by way of 'measurement', is clearly tied to an idea of 'limit' – of boundedness – as opposed to 'limitlessness', which is seen as a characteristic of 'the sublime'. But Kant goes much further with his definition. 'Limitlessness', he seems to be suggesting, is also 'formlessness' and requires a 'super-added thought of totality' for it to constitute sublime experience. 'We must not only experience a sense of a boundlessness – something without limit and beyond comprehensible form – but we must also at the same time have intimations of its totality. The notion of a formlessness given over to a sense of totality, even a super-added one, would seem to suggest a mental transaction which is against reason. But this is precisely the opposite of what Kant intends. While 'beauty' is recognised through imagination and understanding, recognition of 'the sublime' requires completion by reason. Even though the first impression of a 'sublimity' is of something formless and without limit, the experience must be brought within some notional order – a form and a limit of some kind. Taken on one level, then, his formulation would appear to be contradictory, baffling even, but taken on another – on the aesthetic level – it might be construed as essential to the very idea of sublime experience as it occurs in works of art.

To apply the idea of limitlessness linked to formlessness would at first sight appear to suggest that no work of art could be construed as sublime, nor any simple and direct thing of nature. On the whole, works of art, like things in the natural world, are determined by limits and given through form. They are also purposeful: directed towards an intentional end. Thus, according to Kant, they are not amenable to what he calls 'pure aesthetic' judgement, but imply a teleology. But let us consider for a moment the common case of the (re-)presentation of the experience of landscape; either by means of words – as description – or in the form of a painting. In early nineteenth-century literature and in the history of late eighteenth- and early nineteenth-century painting, there are numerous examples of writers and artists who are clearly attempting to provide a semblance of 'sublime experience': given in the first instance by nature and 'presented', as Kant would say, through the mediating processes of literature and art. In the British context, writers from Samuel Taylor Coleridge to John Ruskin and painters as diverse as Joseph Wright of Derby, John Martin, J.M.W. Turner, and James McNeill Whistler all worked

with typically 'sublime' subjects: mountainous landscapes with remote and misted peaks; tortuous, torrent-filled ravines; still and hazy scenes, dissolved in intense sunlight or swimming in an aqueous mist; travellers struggling to traverse mountains, to negotiate wild and wind-swept passes; sailors embroiled in life-threatening storms at sea. And all of this couched in typically exaggerated terms: mountains that are more ungraspable than the real thing; torrents that are more threatening; sunlight that is more golden, more corrosive; mists that are more mysteriously opaque. The intention of these artists would seem to have been to depict an experience which was for them already imbued with sublimity: to provide the viewer with the same overwhelming feelings they themselves had already experienced with indelible intensity before the motif. Think for a moment of Turner confronting the Chamonix Glacier for the first time and the feeling of awe mixed with trepidation that the sight would have inspired in him. And then think of the great tumbling, chaotic, yet totally unified picture that flowed from it. Think of the powerfully isolated, even disturbing condition of detachment which must have given rise to Whistler's *Nocturnes*. In both cases, it is easy to see the problem of 'presentation' that the experience brought to the painter working in the studio – far removed from the inspirational immediacy of the motif – seeking to convey what was clearly an entirely unique experience of great visual complexity and involving feelings that were trans-visual, oceanic, even limitless in their scope and intensity.

Kant withdrew his seeming stricture against the work of art ever achieving the status of 'the sublime' in a famous footnote to the *Critique of Pure Reason*,[8] by giving recognition to the sublimity of the experience that afterwards becomes the subject matter of the work of art: Turner confronting the Chamonix, say; or Whistler in his rowing boat – dumbstruck by the effects of light – floating in the mist on the Thames tide. The sublimity of the subject was acknowledged even if the works of art themselves were still seen as being unavoidably purposeful. But this partial withdrawal reveals just how little Kant understood the creative process itself, as it is reflected in the conceptual concerns of the artist.

And here we must part company with the philosophical particularity of Kant's argument for a moment and instead consider the question from the point of view of the artist. We must try to reach some understanding of the practical dialectic which lies at the heart of the making process itself: the age-old relational problem, the endlessly absorbing search for reconciliation between the fragment and the whole. If we place this issue at the forefront of

the argument, we might quite reasonably claim that visual artists – painters, sculptors *et al.* – are inevitably caught up with this most profound of metaphysical questions: how to achieve a sense of wholeness out of experiences – either of the world or of the work itself – which are received piecemeal. In the case of the figurative artists, out of what might we call 'atomistic' visual data (the perceptual struggles of Paul Cézanne are a clear example of this problem); and in the case of the non-figurative artist, by way of the structure (Piet Mondrian would be an exemplary figure in this respect); or by attempting the question of a transcendental experience of unity directly, as with artists like Mark Rothko and Jackson Pollock.

The issue is one of how we pay attention to things in the world. Is the act of paying attention itself inherently relational, or is the process by which we pay attention to things entirely atomistic? Is there, in other words, a necessary process of translation involved, something akin to linguistic mediation? Most thinkers from the eighteenth century onwards have made 'attention' a two-stage process. In the case of Kant's theorising of 'the sublime', these stages are described as 'apprehension' and 'comprehension'. 'Apprehension' is seeing and recognising things, while 'comprehension' is the 'sensible' – given in space and time – intuitive process of understanding 'apprehensions' all at once as part and parcel of a unifying order. [9] For this reason, 'apprehension', as far as Kant is concerned, is common to our experience of both 'the beautiful' and 'the sublime', while 'comprehension' is peculiar to our experience of 'beauty'. 'Sublime' experience is beyond 'comprehension'. As all experience of the 'infinite', it is only ever apprehensible partially, as a collection of details divorced from any ordinary intuition of a 'whole'. This conclusion left Kant with a problem in relation to the overwhelming nature of 'sublime experience', where there was clearly some unifying force at work, but one that was ungrounded – beyond what he called the 'super-sensible'. Hence, his notion of a 'super-added totality'. And, very significantly for our purposes here, 'super-added totality', as magnitude, could be judged by the dictates of 'the eye alone'. It had to be sensed before it could be submitted to reason.

This contradictory assertion of a double function for the eye in the act of paying attention when faced with sublime experience would seem, as I have already suggested, to draw close to the way in which artists – painters and sculptors in particular – experience and work through the 'relational problem' in the throes of practice. In both cases there is the suggestion of an endlessly fascinating oscillation between fragmentary detail and a notional

totality: one which is reasoned over, but remains, at the same time, absolutely unreasonable. The outcome of Kant's theorising of 'the aesthetic sublime' might quite properly be summed up, then, as the creation of an autonomous eye which, in its turn, permitted the creation of an aesthetically autonomous work of art. Indeed, it would not be unreasonable to suggest that it is the 'Kantian sublime' that underpins the modernist notion of the autonomous work of art, where the claim is made that the piecemeal apprehension of the work must add up to an experience of 'wholeness' which is more than the sum of its parts.

It is small wonder, then, that modernist criticism and theory, from Renato Poggioli to Clement Greenberg and Michael Fried, even if they do not take the writings of Kant as their starting point, rely on them as an essential part of the intellectual terrain upon which the aesthetic formulations of Modernism stand. Indeed, the weight of argument arising out of consideration of the Kantian 'sublime', stamped as it is with the notion of a pre-linguistic experience and the primacy of the visual, seems to give powerful support to the 'formalist' side of the critical debate. On the other side of the argument, of course, there lies the whole weight of post-Saussurian, language-based criticism – modern linguistics, psychoanalytical and other interpretive methods, as well as the development of critical semiotics – a vast array of contemporary theorising occurring after what has been described as 'the linguistic turn' in modern philosophy and determining to a very large extent the postmodern critical climate. In this context, the eighteenth-century invention of 'the aesthetic sublime' would no longer have any credence if it were not for the fact that its vocabulary has tended to migrate into widely different contemporary critical fields, where if has found new definition.

Even so, the contemporary version of 'the sublime' is fundamentally different to Kant's. It does not depend on a mathematical antilogy for dealing with nature, but functions more as a kind of absolute. Thus theorists of different persuasions, from Maurice Blanchot to Julia Kristeva, from Michel Foucault to Giorgio Agamben, seem intent upon defining 'the sublime' against a notion of implacable absence – the uncapturable, the unknowable, the unthinkable and, most important of all, the unspeakable – the vacant 'beyond' of language, unrelieved by any form of transcendence. It is a characteristic of language that it compels us to stand apart from the world and, like spectators at some great public event, look at everything with distance. So it is that the more the net of language spreads, the denser its weave, the greater our feelings of disconnectedness – a disconnectedness which, paradoxically, allows us to

indulge freely in the pleasures that language has to offer through the infinite variety of its formations. As Walter Benjamin argued, language allows us even to contemplate our own destruction as an aesthetic pleasure of the first order.[10]

This theme is taken up in it most interesting fashion by the most important contemporary theoriser of 'the sublime', the French philosopher Jean-François Lyotard. Lyotard is something of a Kantian and continually returns to the *Critiques* of Kant in order to establish reliable philosophical ground. As with Kant, there is also a moral edge to his reading of 'the sublime', albeit a somewhat ambivalent one. Just as Kant conflates the moral with the aesthetic 'sublime' under the general heading of 'the good', Lyotard brings them together in the chiasma of what he calls an 'Apollonian dream', in which mind and body are made one and the old Burkian distinction between beauty and sublimity is eliminated.[11] For Lyotard, aesthetic experience, including the experience of works of art, is in the strictest sense physical; it involves the body as a spatio-temporal presence in the world. The visibility of things is only possible because we ourselves are visible. 'The world is of the same flesh as my body', he states, and he goes on in the same passage to talk about 'the fleshiness of the human gaze'. The reference is to the writings of Maurice Merleau-Ponty:

> So what is there is not things identical to themselves which, afterwards, offer themselves to the seer, and it is not a seer, empty at first, who, afterwards, opens himself to them, but something that we could scarcely get closer to except by feeling it with our gaze, things we could not dream of seeing 'naked' because the gaze itself envelops them, clothes them with its flesh.[12]

And Lyotard uses this deeply 'sublime' metaphorical connection between world and body as the model relationship between artist and world, between viewer and the work of art: a highly eroticised relationship between the object of sight and the subject who sees. He imagines Cézanne, for example, standing before *Mont Sainte-Victoire* and says that under this kind of intense engagement it is not only the array of 'small impressions' that shift or relocate themselves but the whole unity of space and time. This 'shift', Lyotard describes as an 'event'. And by 'event' he means an absolute 'singularity'; something without equivalence. 'Events' occur in a context of some kind but their force is not determined by it.[13] Cézanne's engagement with his subject, *Mont Sainte-Victoire*, took place over a considerable period of time. It was an established, fixed point of reference for

the painter. But this was not what determined his apprehension of it as an 'event'. 'Events' are not shaped by referentiality, they are not in any sense mimetic – not determined by the 'real' – but take the form of a transfer of energy. They occur in what Lyotard describes as a 'tensor': a transport out of the social into the libidinal economy. '...event (is experienced) ...above all as a tensor or intense passage, and this tensor requires not the three-dimensional, Euclidian space of the theatrical volume and the organised social body, but the n-dimensional, neutral and unpredictable space of the libidinal film engendered by the tensor-event itself in its amnesiac singularity.'[14]

The tensor, then, produces a 'singularity' through a process of forgetting. Cézanne could approach Mont Sainte-Victoire again and again because of a kind of amnesia; an amnesia which demanded that on each occasion he should undertake the task of making passage into a 'singularity' once again. Significantly, I would suggest, Lyotard sees this as a shift between a three-dimensional, theatrical space in which utterance is always directional, and a flatter, more circumlocutary, filmic space with a strong sense of surface. This distinction has a markedly political dimension. As Lyotard himself has said, it implies a movement out of the notional 'we' that governs most things in social life and establishes the 'event' as outside any formulation of the normal. 'Normal' implies a real perspective, a real place and a real history. The forgetfulness required by the event, on the other hand, for good or for ill, must sublate all three. The filmic space licenses the extremes of libidinal play through presenting it as an 'image event' coincident with a seemingly transparent, optical surface. Thus entirely disparate occurrences – a Cézanne painting of *Mont Sainte-Victoire*, Auschwitz, a Michelangelo Sonnet, the murder of JFK, the Kosovar exodus – are brought together by the concept of the 'event', to occupy a darkened, interior, imagined space bounded by the immemorial and the unspeakable. In its sublimity, its glory or its horror, 'the event', Lyotard writes, 'produces itself, of itself'.

At first sight, it would appear that with Lyotard's concept of the 'event', we have travelled a long way from 'the sublime' of Addison, Burke and Kant and the firm belief in an exterior, undeniably real world, quite definitely outside the human subject and waiting to be apprehended (and, thereafter, comprehended). But in the aesthetic domain at least, the distance travelled is not as great as it first appears. In his book *Discourse and Figure* (1971), Lyotard is concerned to insist upon the 'fact' of an outside world. Indeed, he is clearly averse to any notion that might seem to reduce external experience to the

subjective play of mind. But his prime concern is with thought and, as he argues in an essay on the painter Daniel Buren, to think is to suspend the predicate of reality: 'To think is to have ideas and ideas go beyond what is given.'[15] The artist, then, in search of the 'event', must force a suspension of both subjective and objective seeing, since both, in their different ways, are built upon presuppositions. Rather, the 'event' must deliver the artist over to the most profound state of spectatorship in which everything is unexpected because nothing is remembered.

Perhaps it should come as no surprise that again this concept is prefigured in the writings of Kant. It comes in *Political Writings*, where Kant is musing over the role of the spectator in the events of the French Revolution.[16] According to contemporary engravings, huge crowds gathered in Paris to watch the burning down of the Bastille, and Kant remarks on their seeming passivity and their expressions of 'rapt attention'. Their reaction, he argues, because of its very 'disinterestedness', is essentially an aesthetic one. The magnitude of the event, the powerful play between attraction and repulsion, between pleasure and pain, it seems had placed these ordinary spectators in thrall of 'sublimity' just as surely as Turner's first view of the Chamonix Glacier. Here, then, we are brought face to face with a defining moment in the translation of the eighteenth century into the modern 'sublime'. Kant's observations concerning the spectators at the burning of the Bastille point to the emergence of what at that time was a new, specifically 'modern' type of event, the 'urban spectacle', which, in its turn, produced a new kind of 'spectator', one who did not wish to look beyond the effectiveness of the scene as it presented itself to the eye, but simply to take 'consolation and pleasure' from it. Lyotard, in his turn, has built upon this notion of the 'indifferent' essentially modern viewing subject, to produce a more self-conscious postmodern version of the spectator, epitomised by the figure and role of the 'postmodern artist'; one who is born into the semiotic universe and can read all the signs. He calls this new viewing subject the 'critical watchman'. The 'critical watchman' is compelled to live through contemporary nihilism without the possibility of an appeal to an 'ultimate tribunal'.[17] Furthermore, there can be no remission of sentence in what Lyotard describes as 'time beyond history'. In this respect, today's artists' engagement with the dynamics of 'sublimity' is inescapably wedded to the present rather than to 'presence' and in this they are radically different – share an entirely different perspective – to Turner or Whistler, Cézanne or Mondrian, even to Pollock or Rothko. In a world in which immediacy is everything, in which

cathartic distance has been done away with, we can no longer look at what presents itself but must wait endlessly upon events. The mere passing of time comes to define every kind of human experience. Held by such an entelechy – time without history – the artist can do little more than bear witness to the phantasmagorical parade of mediated images. Lyotard's postmodern 'sublime', then, is constituted through the pleasurable possibility of thought that can think itself beyond the end of history, and the painful knowledge that human 'imagination or sensibility may not be equal to such a concept'.

Sublime: the Darkness and the Light: Works from the Arts Council Collection, exhibition catalogue, Hayward Gallery Publishing, London, 1999, pp.21–29.

1 Longinus' authorship of the treatise is disputed. Nowadays it is commonly classified as 'Anon'.

2 First published as a series of essays for the *Spectator* under the collective title *Essays on Pleasure and Imagination*.

3 *A Philosophical Enquiry into the Origin of Our Ideas of the Sublime and the Beautiful*, Routledge and Kegan Paul, London, 1958.

4 *Ibid.*, p.136.

5 *Observations on the Feeling of the Beautiful and the Sublime*, trans. Goldthwaite, UC at Berkeley Press, 1960. It is clear that Kant had had sight of both Addison's essays and Burke's book, the *Introduction* of which was translated into German as early as 1761.

6 *Critique of Judgement*, Meredith (trans.), Oxford University Press, 1973.

7 *Ibid.*, p.90.

8 *Critique of Pure Reason*, Kemp-Smith (trans.), Macmillan, London, 1973. Footnote to A99, p.131.

9 *Critique of Judgement*, p.99.

10 Walter Benjamin, 'The Work of Art in the Age of Mechanical Reproduction' in *Illuminations*, Zohn (trans.), Routledge, London, 1970, p.236.

11 Jean-François Lyotard, *Discourse, Figure*, Klincksieck, Paris, 1971. Lyotard argues that 'good' form is Apollonian while 'bad' form is Dionysiac; indifferent to any overall unity, even a 'sublime' one.

12 Maurice Merleau-Ponty, *Le Visible et l'Invisible*, Gallimard, Paris, 1964, pp.180–81. Lyotard comments extensively on Merleau-Ponty in Discourse, Figure.

13 Lyotard's concept of 'event' starts with the idea of a new kind of grammatical construction; the linking of a verb to a noun signifying something done to a subject, as in, 'I music you'. The rules of language cannot account for this new construction. It speaks of tension and conflict.

14 Jean-François Lyotard, *Les dispositifs pulsionnels*, Union générale d'éditions, Paris, 1973. Lyotard's idea of the 'tensor' is drawn from the fields of engineering and anatomy. In engineering, it signifies a metal element in tension; in anatomy, it is a muscle that serves to cantilever a limb.

15 Jean-François Lyotard. *Les Couleurs, Sculptures; Les Formes, Peintures*, Centre Georges Pompidou, Paris, 1981, pp.23–38.

16 Immanuel Kant, *Political Writings*, Reis (trans.), California University Press, 1970, pp.41–53.

17 Jean-François Lyotard. *Le Differend*, Minuit, Paris, 1984, p.196.

AN INTERVIEW WITH RIA PACQUÉE

Jon Thompson: *Ria, I want to start by asking you about the idea of travelling. It seems to me that this has become a more and more important aspect of your work. Even with the cemetery photographs, the systematic planning of an itinerary of some kind, which allows you to search for the right images, has become almost as important as the making of the images themselves.*

Ria Pacquée: I think that this is true. The planning, the travelling, the method of search... these have become a very important part of my activity; as important as the resulting photographs. It is, though, always a matter of intention. Whether I am envisaging a trip to a cemetery in Rome or in London, or more recently with my visits to remote villages in West Palestine, it always starts with the basic intention to take photographs. To be precise, the object of my travelling – the chosen location – is determined in advance as a site for photography. In Palestine, for example, I would decide on a village somewhere in the mountains, pack my camera and simply set off. Of course arriving with a camera in the place itself, as far as the people that lived there were concerned... I was nearly always seen as a suspect person: either as a suspicious westerner or more problematically as a Jewish person. It was very important, then to try to talk,

or at least to communicate with the people in order to dispel their unease ... with myself but also with the presence of the camera. And this often produced a paradoxical state of mind for me. At this particular moment, in that particular place – at the point of introduction – the real situation seemed suddenly much more important than my purpose in going there in the first place, was more important than the business of taking photographs.

For you, then, the intention to photograph precedes everything else...

RP: Yes. The idea of the photograph occurs in advance.

...so that the arrival on site – the cemetery, the Palestinian village, wherever – has a real sense of occasion about it. It is a site where an imagined reality – an image which already exists in the back of your mind – is tested against reality itself.

RP: That's right... in general anyway... in the event though it is often less clear-cut... much more complicated than that. In my trips to the cemetery, for example, I was looking for certain kinds of images: the stone book lying open to the weather from which the traces of writing had disappeared; the faces of carved figures where the features had been virtually removed by the erosion of the stone; other kinds of absences, the places where words, crucifixes, floral decorations etc., had once been. I knew in advance that this returning of the carved image to stone, was part of the iconography of the cemetery... of nearly all cemeteries... and so when I set off with my camera I was searching for images that I was pretty sure I was going to find. Whether I was going to find them in a form that would be appealing and useful to me was much less certain, of course.

This notion of 'absence' is one that has been there in your work from the start; in the 'Madame' works, for instance, and with the 'It' figure; and afterwards with the 'City Rambling' pieces. But it seems to me that this has progressed recently, starting with the cemetery photographs, into much more abstract territories.

RP: If I understand what you mean by 'more abstract' correctly... yes... they refer to the absence of language, which I guess we can only conceive of as an abstract space of some kind, and also to the absence of human expression... but again, paradoxically, both of these 'absences' tend to highlight their opposite, the idea of presence.

But did you make your Palestinian journeys also in search of 'absence'.

RP: No, not really, there I think I was in search of presence... human situations, anyway. I still can't properly explain it. But definitely not for absence... certainly not... The people there are especially interesting to me.

But you couldn't communicate with them directly... you couldn't speak to them in their own language and they couldn't speak to you in yours... So there is a sort of parallel with say the books in the cemetery... there is a kind of absence there.

RP: Yes, this I liked. I had to communicate with them through my eyes and by means of body language and gestures, but not through spoken language, nor with words.

I haven't seen the photographs you brought back...

RP: They were terrible. I have been there twice now. The first time for three weeks, when I spent most of my time in the desert. And the second time, four weeks visiting sites and villages in Palestine and Jordan... When I came back from the first trip and I looked at the photographs, I have to say, I was horrified. There were five or six packets of photographs, all of them rather undistinguished images of sand and stones. There was nothing I could use. This has never happened to me before. Usually when I take a photograph I know immediately, as I look through the camera even – long before I see it printed – whether it is going to be useful to me or not. At first I was very disturbed by these results, but then I began to realise that it represented a change of consciousness of some kind... for some reason, being in the desert, had made me see things in a different way... I had begun to see something in everything... things are so clear there... and if I finally came across something familiar, like a bottle, it was like seeing it for the first time... and I found myself photographing that too.

And on your second trip.

RP: It was a little more successful from this point of view. I ended up with about half a dozen images that I can use as part of extended sets.

So the photographs that you took in Palestine were in a way the opposite of the ones that you took in the graveyards. With the latter you set out to find certain images that you knew already existed, and these you succeeded in finding in abundance. In the case of your travels in Palestine you were unclear from the outset about what precisely you were looking for and ended up with virtually nothing.

RP: It was worse than that. I even ended up with the kind of photographs that I never normally take: tourist type photographs. You know, blue skies and picturesque views. Of course I did get quite interested in the vernacular architecture... the dome houses... I got quite a lot of pictures of them.

You say that you are intending to go back there. Does this mean that you are beginning to get some idea of a subject?

RP: No, not at all... and I don't know at this moment, whether this next time I will even go back there with the idea of taking photographs. The reason I went in the first place was hardly logical... more on the basis of an irrational connection. I had been making photographs in the Jewish cemetery in London. That's where I found the best of the stones with the absent words. They were really very old graves and over the years the stone had become sand, but with the shape of the letters of the alphabet still visible. Altogether I took about 70 photographs there... all of them sandy-yellow in colour. Playing around with them afterwards, putting them next to each other, I discovered something like a desert landscape. It was as if I had been busy taking pictures of the desert... it was this that started me thinking that I had to go to the real desert... initially to take photographs... but when I got there I found that I was not able to do it... the really strange thing is that when I came back to Antwerp... walking in the docks and some of the hinge parts of the city; roaming the larger building sites – the station, for instance, and the St Jans Plein where there are great voids and mountains of sand and soil – I have found that I can take photographs that say more about the experience of desert than all of the pictures that I made in Palestine. These photographs, together with some of the ones I took in the Jewish cemetery in London, seem capable of carrying much more of the desert story than the conspicuously empty photographs that I took on my travels in the Middle East.

So no subject, and no regrets either.

RP: Certainly no regrets. When I go back to the Middle East I know now that it will be more about discovering things about the place, about the people there, and about myself... I want to soak myself in the atmosphere of the place.

If one takes the long trajectory... starting with the performance pieces, the 'Madame' and the 'It' figure works, which also had a strong performance element in them even though they ended up as photographs... then move to the 'City Rambling' pieces in which you don't appear, but where there is an occasional human presence – a child in a red coat, for example.

RP: You never really see the child as a human presence though. Just as a colour...

That's right, the child is used as a colour-coded object, nothing more. That's precisely the point that I wanted to make. In all of the photographic works after the 'It' figure where you play the central role as image, you will permit of no rival human presence to yourself implicitly present as the eye of the photographer... and this crisis in terms of the human presence seems to reach its apotheosis with the blanked-out or veiled faces of the cemetery photographs. It is as if your refusal to absent yourself in favour of another sensing subject, is suddenly made concrete. Now I wonder if your flight into the desert might have something to do with this as well. What are you trying to do with your travels, rediscover 'otherness' as human presence or rediscover yourself in some way?

RP: I don't know, to be honest.

It could be that it's not an important question.

RP: No. There is obviously some very important reason why I am so attracted to these places. Maybe it has something to do with placing myself in a situation – in a very strange situation... I have to add.

Certainly the search for images you have undertaken thus far has always been in fairly familiar circumstances. In fact, as you said just now, you have usually known that the images you were after, preexisted your search. Where your trips to Palestine are concerned the opposite is the case. In this sense they are a real visual adventure.

RP: That's right. Everything was new to me... I was almost drunk with it all –
and this might sound like a cliché – but in the desert itself, emptiness and
fullness seem to exist both at the same time... do you know what I mean? At
first sight it seemed that there was nothing, but oddly enough, it was precisely
because of this nothingness that I ended up taking so many photographs...
I began to imagine that I could see a lot of things... like I was walking in
history. There was more there than I could ever describe; more than I could
ever photograph. I know now that I am never going to be able to take fantastic
photographs there, but I also know that this is not the point... it's inside myself,
you see... the desert changes something in me.

It works some kind of transformation in you...

RP: Yes, and this I am never going to be able to photograph. I can do it obliquely,
but not there, not while I'm in Palestine... but maybe with the images I make
here, back home in Belgium...

Your trips tend to be mediumistic then... in a certain way...

RP: Yes.

*...somehow they change your consciousness, so that you can look at your immediate
situation in a slightly different way.*

RP: What is also very strange, before, when I was four months in Rome...
then coming back from Rome... I got interested in cemeteries and churches
which also started me thinking again about religion in a certain way...
I began to feel quite awful. It left me with an emptiness of some kind, a void...
I seemed to be slipping backwards almost. Now, after Palestine, I feel more
inclined to work with up to date things. And I seem to have got my interest
in the city back again. The religion thing seems further away... I can take
more distance from it.

*It's interesting that this should have happened... even so, it does seem that with
a lot of your work there has always been – to use a hackneyed expression – some
kind of spiritual undertow to the work which is never really declared... it comes
closest to being declared, in a dark sort of way, with some of the veiled heads in*

the cemetery photographs where the emptying out of the human presence seems to point to the emergence of a presence that is more metaphysical than physical… the emergence of some almost superhuman being… It also seems to me that whatever it is about your journeys in the desert… whatever it is that they do to you, it can't simply be described in terms of a physical, or even a straightforward perceptual experience. Something happens to your mind, and to your sense of being and that something, in its turn, transforms the way you see.

RP: It transforms the way I see things… but it has also taken me back in time in a certain way. I think, quite an important way too… I seem to be able to be more direct again. I've started to take photographs in the way I used to take them… but yes, it has also changed my sense of being in the world… it's not just a matter of seeing.

So it's possible that your travels in the desert have brought you full circle. In the cemetery photographs you had arrived at a representation of something approaching a metaphysical presence, but in a rather literal sense. And perhaps now, after your trips to Palestine, you have found a more direct way of addressing…

RP: I haven't found a way yet. The exhibition I am doing at Campo-Santo is still very much in between. It's part of a period of transition. There is also this work called *In Search of God*…

In Search of God…

RP: Yes, *In Search of God*… But I think after my travels, things have really changed. I can feel a completely new angle coming into the work. I'm not yet sure what form it's going to take… to be honest. It will take some time.

Say something about this title, In Search of God *… it's ironic, surely.*

RP: It's ironic, yes, but also in some strange way it is also a reality. In the last years for me, especially being in Rome and going to the churches and photographing in the cemeteries, the work actually began to take on the nature of some kind of spiritual quest… a search for a god… a god that I didn't find of course. The defining characteristic of this set of images I have called *In Search of God*… the common element is that each of them has a little

red or orange mark in them, like the stigmata... and one of these images is from a painting of a woman who is also crying. But all of them have this little red sign in them... and I think it is because in these last years I made only grey photographs... without realising it, you understand. But when I sat down and went through my photographs of the last five or four years, they were all completely grey... and I began to think, 'I don't want to have this grey thing, I want to find a little bit of colour'... and the search for this little trace of colour became synonymous for me with *In Search of God*. But don't mistake what I am saying. During all this process, I think I was in a real way in search of God... it might sound a little bit crazy, but I think that such an idea can only ever be attached to moments... there is something revelatory about the moment... that's why this series especially, can only exist in so many fragments.

But you seem also to be attaching the idea of God to the presence of blood which in a way is the ultimate manifestation of the human.

RP: Yes, and the sequence ends also with the red jacket hanging on a pole... it's as if the human presence has recently passed from it... has just departed... taken flight. But for me, the real irony lies in the fact that the search for God was already completed a thousand years ago and yet the search, in one form or another, seems to be inescapably a part of the human condition. It's not even a matter of belief.

You mean we seem all to be condemned to search for something...

RP: Yes... that... but also there is this question of our individuality; whatever it is that we mean by 'I'. There is a point where this goes away from us, and we become creatures without races. This is what happened for me with the cemetery photographs. This was the greyness, in a way... and the sense of loss... But losing yourself in the desert is something very different. There you don't have a grip on things, least of all your own ego, your 'I'. This goes much further...

There is, it seems to me, a sense of unity, some notion of wholeness, at the centre of all of your work. Perhaps it is what the 'Madame' figure, in the earlier work, is searching for... or expecting all of those social institutions that she visits to deliver. This changes its character, begins to take on a distinctly metaphysical tone with the

solitary labours of the 'It' figure. At this point the suggestion creeps in that this unity,
or sense of wholeness, is in the strictest sense, unattainable... it cannot even be
revealed by the camera.

RP: Yes, and perhaps this is why I always end up making sequences of pictures,
or stories as I call them... it seems that it can exist as an evanescent presence
between images – in the spaces between the images but not in individual ones...
Certainly for me, meaning, whatever that is, accumulates in the spaces in
between, and this brings me back to this notion of 'the moment'... you know, the
photographic moment itself. I guess this is why I am so wedded to photography,
to the camera... because it is just about capable of grabbing the moment itself...
I say just about, because usually, when I finally have the photograph in my hand,
it doesn't quite capture the moment, it has to be brought out of itself in some
way. So the futility of photography is quite obvious. It starts with an instant in
which I think that I have apprehended a momentary unity of some kind, but
then it seems that it has to pass through disunity, a process of deconstruction,
in order to achieve a sense of unity once again.

A Small Box of Air Trapped and Drawn, exhibition catalogue, MuHKA Museum of Contemporary Art, Antwerp, 1999, pp.3–10.

PAINTING AND THE CREATIVE IMAGINATION

Ladies and gentlemen – friends – tonight I am going to talk about painting. Although I shall be touching upon historical matters in passing, I will not be talking about painting as a history. I prefer to leave real history to the art historians. Instead, I want to talk about painting as a response to what I think of as a very basic human need – that of putting something new into the world; I want to talk about painting as a basic form of human expression.

By now, if many of our theoreticians were to be believed, we should all of us have mothballed our paintbrushes and bought digital cameras. According to them, to paraphrase *Monty Python*, painting is already a dead practice, deceased, an 'ex'-practice, and yet it seems that the cadaver refuses to yield up its spirit. Despite all of their funereal words, painting continues to enthral us, and tonight I want to ask 'why', and hopefully make some progress towards providing an answer.

I will look first of all at the paintings of Le Douanier Rousseau, a visionary painter who seemed to emerge on to the Paris art scene in the late 1880s, with his style – or his two styles – fully formed, and who showed no tangible evidence of what might be called 'stylistic evolution' over the 25 years that he practised as a painter. Then I want to examine the comparison

Rousseau himself suggests between his own paintings and the early and transitional works of Pablo Picasso. Thereafter, I want to look in some detail at the two models for painting arising out of Rousseau's comparison: a form of painting which is ahistorical and dominated by the single-minded pursuit and realisation of the image, as opposed to a form of painting which derives its authority from the invention and application of rules of procedure. I want to compare and contrast the drive to make paintings in which the singularity and absolute mono-vocality of the image takes precedent, and that which sets the linguistic means above everything else.

Finally I want to argue – controversially, I suspect – that the fragmentation of the field of painting that followed the virtual collapse of the craft tradition during the nineteenth century – the termination of the great historical sweep of representational rhetoric that began before the Renaissance – far from being *aberrative* in some way, marks a return to forms of expression which are genuinely closer to the way in which the human imagination forms itself. I want to argue that the decline of the perceptually-driven image and the rise of what today we call the 'conceptual image' – an image that no longer looks to the outside world for its sense of authenticity but to the functions of the mind – is more truly representative of the human condition and all its different inflections. I want to argue that an image that shuns the search for similitude and is conjured up instead out of the play of memory; the often wayward desires of the human heart; the delights and shocks of imagination and the complex and many-layered processes of linguafaction, denotation and description is, in the deepest sense, more psychologically true to our lived experience; more suited to a modern imaginary in which the individual consciousness is endlessly in play.

I will begin then with the famous anecdote in which Rousseau seems to be accusing Picasso of being old-fashioned. Many of you will be familiar with it. But I make no apologies for that. To my way of thinking, it is such a good story that never tires, either in the telling or in the hearing.

The scene is Picasso's studio in the *Bateau Lavoir* in Paris. The year is 1908 and the occasion, a celebration of the life and work of the self-styled customs official and so-called naive or 'primitive' painter Henri 'le Douanier' Rousseau, arranged by no lesser figure than Picasso himself. Taking pride of place above the head table, draped with banners – including the *Tricolore* – and garlanded with flowers, was a portrait by Rousseau painted some 11 years earlier in 1897. The story goes that Picasso had discovered this full-length

Portrait of a Woman (c.1895), sometimes referred to as '*Mlle M*', in the secondhand shop of Pere Soulier opposite the *Cirque Medrano* and had bought it for a few francs. He later described his discovery and its effect on him as a crucial moment of revelation. These are Picasso's own words:

> Rousseau is not an accident... He represents the perfection of a certain order of thought. The first of the Douanier's works that I had the opportunity of acquiring took hold of me with the force of obsession. I was going along the *Rue des Martyrs*. A bric-a-brac dealer had piled up some canvases outside his shop. A portrait head protruded from the pile, the face of a woman wearing a stony look with French penetration and decisiveness and clarity. The canvas was immense. I asked the price. 'Five francs' the man said. 'You can paint on the back.' It is one of the most truthful of all French psychological portraits.

This little event, remember, occurred in 1908. The Picasso who bought the portrait from Pere Soulier then was no longer the precociously talented but rather sentimental young painter of the 'Blue' and 'Rose' periods; not the same Picasso who had painted the orphaned street urchins with big, black eyes and the pale, sad, long-limbed nudes bathed in blue light. Not the same Picasso either, who had painted the naked Columbines and waif-like Harlequins, the roseate acrobats, jugglers and circus folk, but the Picasso who, more than two years earlier, had started to look to African carving for his inspiration. He had already painted the stony-faced portrait of his friend, the writer Gertrude Stein, for example, as well as his great revolutionary picture, *Les Demoiselles D'Avignon* (1907), a seminal work that took Picasso two years to complete to his satisfaction, and which I will return to in a few moments.

When Picasso handed over his five francs for the purchase of the Rousseau portrait then, he had already embarked upon his own quest to revitalise and revolutionise the language of painting. And, according to his own testimony, he recognised qualities in Rousseau's painting that not only made connection with his own obsessional character, but which also corresponded with his interest in a more direct psychology of representation. Today we can only guess at what Picasso meant by this from his own letters to friends and the writings of others who knew him well. For example, according to Douglas Cooper, when in 1906 Picasso embarked upon *Les Demoiselles* his declared

intention was to rediscover 'the assertive fury of the primitive; to put impulse and passion before rule', in the belief that this would allow him to express himself, 'without the impediment of conventions and without inhibition'. Perhaps it was the struggle to achieve this type of urgency and directness that sustained his engagement with the painting for so long. But underlying Picasso's stated intention and in his recognition of the Rousseau portrait, I would like to suggest, there is also a fear of a certain kind of lack, namely that despite all his knowledge and all his background and training in painting, he will fail to achieve the simplicity, certainty and unwavering psychological power of the Rousseau. There is a rather telling comment to this effect in the collected short criticisms of Guillaume Apollinaire, and it has the ring of truth about it. 'Why, after the completion of *Les Demoiselles*,' Apollinaire asks, 'did Picasso choose to abandon the search for that savage simplicity that he so admired in the paintings of le Douanier Rousseau', and he answers his own question, 'because, despite the years of struggle, he remained unconvinced by the painting.'

The story of the grand dinner in honour of le Douanier Rousseau at the *Bateau Lavoir* is by now a part of modern art legend. The list of those present reads like a 'Who's-Who' of the Parisian high cultural set of the first decade of the twentieth century. As well as a speech by Picasso and violin playing by Rousseau himself, there were five contributions of all different kinds – recitals, performances and eulogies – by Guillaume Apollinaire, Georges Braque, Maurice Cremnitz, Maurice de Vlaminck, Max Jacob, Marie 'Coco' Laurencin, Andre Salmon, Gertrude Stein and Maurice Raynal. According to eyewitness accounts, gaiety quickly progressed into delirium and drunkenness, and drunkenness into brawling and fighting. And throughout it all, the guest of honour, the 62-year-old le Douanier, perched high above the rest of the assembled company on a packing case – when he was not dozing off because of the huge amount of wine he had consumed – smiled paternalistically down on the often outrageous antics of his young friends; waving his hand from time to time in acknowledgment of their repeated cries of, '*Viva, viva Rousseau*.' The food, which had been commissioned by Fernand Olivier from the nearby, Café de Felix Potin, arrived very late, and it was the early hours of the morning before the final course had been served and the room could be silenced to allow Rousseau to speak.

Good anecdotes require good punch lines, if they are not to disappear quickly from the collective memory. And on this occasion, le Douanier Rousseau was to supply a punch line of such nerve-jangling effrontery, that it was sufficient on its own to write the whole event into the history of modern art.

Rising to his feet – somewhat unsteadily, according to the diary of Leo Stein – Rousseau, always the gentleman – in public at least – first of all enquired after the physical well-being of 'Coco' Laurencin who had been engaged in fisticuffs with Apollinaire earlier in the evening, and by this time was lying bruised and battered on Picasso's studio couch. He then turned his attention to thanking all of those present, signalling out anyone who had made particular contributions either to the catering arrangements or to the schedule of entertainment. Finally, and momentously as it turned out, Rousseau raised his glass to toast Picasso, chief author of the evening's celebration. As silence fell, Rousseau – according to Leo Stein – adopting a rather pompous manner and speaking in a loud voice that captured the attention of all present, made his now-famous assertion, 'We are the two greatest painters of our time. You in the Egyptian style and I in the Modern.'

After a brief and rather shocked silence – so the story goes – it was Picasso himself who led the applause.

Since it was made, of course, Rousseau's statement has been worked over for its meaning, a thousand times. It has been variously explained. As a product of le Douanier's naivete. As a confused reference to Picasso's barely submerged 'classicism'. As a shorthand statement about differences of subject matter. And while all three of these explanations have a degree of truth about them, none of them is entirely convincing. Yes, in certain respects Rousseau appeared as a naive. But his naivete was a naivete of a very particular kind. Best described as a 'studied' naivete, designed to preserve his very personal vision from contamination by the stylistic preoccupations of his avant-garde friends. We must therefore ask whether, in all truth, it was naivete at all. After all it was le Douanier Rousseau who had sworn, publicly, to rid French painting of what he called the 'brown soup' of the academies. The same witty and provocative intelligence that when confronted by an exhibition of paintings by Cézanne, declared that he would like nothing better than to take them all away and finish them. Neither statement is that of a naive personality or an unsophisticated intelligence. It is also true that the paintings made by Picasso between 1903 and 1906 prior to the artist's new-found interest in African sculpture and the painting of *Les Demoiselles*, retained a strong flavour of classicism. But it was a version of classicism that seemed to owe more to Greek and Roman sculpture than to anything Egyptian. In fact the more one thinks about Rousseau's attribution of Egyptian style to the work of Picasso, the more provocative it becomes.

Not so Rousseau's own preeminent claim on the condition of modernity. If, as the German philosopher, Walter Benjamin, has suggested, the emergence of Flaneurism – street rambling – is the archetypal indicator of modern city life in the early years of the twentieth century, then le Douanier's existence might be seen as exceptionally modern. He was the Flaneur – the street rambler – par excellence.

According to his own accounts in prose and verse form, when he was not painting, Rousseau haunted the streets of Paris by day and by night. Most of all he preferred the twilight hours and the soft luminosity of summer evenings. This was, for him, the time of day when fantasy commingled quite naturally with reality to produce what he described as the 'enigmatic half-life of the city'. Starting in the early evening, he would walk great distances from his studio in the *Rue Perrel* to visit remote parts of the Parisian suburbs – places like *Bellevue*, *Vincennes*, *Saint-Cloud* and *Alfortville* – only turning on his heels to retrace his steps as dawn broke. And during these nocturnal perambulations, Rousseau would conjure up, in his mind's eye, the tropical forests inhabited by all manner of exotic creatures that we are familiar with from his paintings. For le Douanier, the narrowing streets of districts like *St Germain* at night were charged with a terrible, an almost dangerous beauty. Swift-footed huntsmen inhabited the dappled lanes and alleyways, perusing the fleeting shapes of loping cats and leaping antelopes. As Rousseau wrote, in one of his posthumously published night poems, dated 1905: '...dark-skinned figures from an ancient warrior-race with blazing eyes, wait to surprise around every corner. Under cover of darkness too, the trees of the great boulevards are suddenly alive with chattering monkeys, big cats and sleeping serpents.'

If these, the imagined, nocturnal morphologies of the modern city were places of magical transformations for Rousseau, then the evidence of his oeuvre overall, shows that the bustling life of the modern city by day, was just as engaging. In stark contrast to the paintings of Picasso in which the figures seem always to disport themselves in a neutral landscape – as indicated, very often, by a simple division between earth and sky which is hardly identifiable as either countryside or city, landscape or interior – le Douanier's pictures are frequently of specific Parisian locations and bear witness to this in their titles: *Tour Eiffel et Trocadero* (1898), *Vue de Malakov* (1908), *Le Parc Montsouris* (c.1909) and so on. He also painted pictures of the great Paris celebrations and public entertainments in works like *Un centinaire de l'independance* (1892) and *La Republique* (1907). Where Picasso's figures seem to inhabit a dystopic

Arcadia somewhere, Rousseau's citizens live out their existence in a 'real' and predominantly urban world; a world already shaped by the instrumental diversions and benefits of modern life. Streetlamps, motor cars, bicycles, balloon flights, aeroplanes, the gaudy trappings of the street carnival or the fairground, riverboats and riverside picnics. In fact, in stark contrast to the night paintings, these emblems of modern city life became the very stuff of Rousseau's daytime paintings; in celebration of city-people, living out their existence in eternal sunshine under limpid blue skies.

I have already mentioned on two occasions that le Douanier Rousseau had two very different styles of painting, or, to be more precise, he worked with two very different types of 'image making'. And by now, it will probably have become clear that these relate to the picturing of Paris by day and the picturing of Paris by night. The daytime pictures are very open and outward looking. They depict the world very much as it is, but filtered through a simplifying and ordering pictorial intelligence which seems – at first sight, anyway – entirely bent on portraying the city as an amusing, socially comfortable and psychologically benign place in which to live. The night time pictures, on the other hand, internalise and transform the artist's experience of the city, turning it into a world that is inhabited by exotic creatures and on which is entirely redrawn by the imagination.

In reality, however, both views of the city – by day as well as by night – are equally fictitious; equally a product of the artist's need to remake the world in conformity with his own psychological projections. We need only look to the scale of things in the daytime paintings, to realise that things are not as true to life as they first appear. Real, true to life scale, has been replaced by one based upon the relative psychological importance of different things. In this painting of footballers, for example, by implication the players are almost as tall as the trees that line the pitch and frame the game. And in the context of le Douanier's imaginary, there seems to be nothing exceptional or extraordinary about this state of affairs. But there is another element in Rousseau's painting which detaches them absolutely from the world as seen.

Apollinaire was the first to make the observation that though Rousseau's Paris paintings were all bathed in a delightfully cosy sunlight; it is a sunlight that is without direction; a sunlight that plays no part in the rendering of form; a sunlight that yields up no shadows. It seems, then, that just like the half-light in Rousseau's night paintings, Rousseau's midday sun is more a 'light of the mind', more a metaphysical aura than a real condition of

vision. It's as if the world would be just as present without it, but altogether less durable and less stable. Indeed, by lighting up his city scenes in this way – by not insisting on a version of natural light as a condition of visibility – Rousseau achieves almost the purest of transformations of spirit into essential matter: succeeds in turning the complex inner-workings of reality – that restlessness of spirit which continuously stirs up and animates our day to day experience of things – into an apparently simple, more or less stable projection of reality.

Compared to this, the light in Picasso's paintings functions, absolutely, as the animator and the form-giver: as the agency that renders things visible. Unlike Rousseau, Picasso employs light, in the classical sense, to model form. Sometimes it is used to reveal fully-rounded figures. Of extreme subtlety in the case of the characters that inhabit the paintings of the 'Blue' and 'Rose' periods, for example. At other times he uses it to rake across rough-hewn surfaces turning them into rugged bas-relief. No matter which, Picasso's light is no light of the mind. Turn the light out in a Picasso painting and nothing but darkness will ensue. The 'divisionist' brushmarks that came with the 'analytical' paintings of 1910 and 1911 carried this process of vivification a significant stage further. Here, the small, repetitive strokes from a loaded brush, act like chiselled striations, catching the light and bringing the whole picture surface to life. In these pictures, particularly, it is impossible to avoid the impression of a complex form of relief carving.

It is perhaps very surprising, then, that in drawing his now-famous distinction between the traditional rhetoric of 'modelling' and 'carving' – a distinction which, he argues, holds for painting just as well as it does for sculpture – the English critic Adrian Stokes placed Picasso so firmly in the camp of the 'modellers'. While recognising that light is the absolute precondition for reading either, the meat of Stokes' distinction lies in the foregrounding and manipulation of substance – stone, wood, clay, charcoal, paint or whatever – to achieve a lively image. 'We recognise fine carving', Stokes writes, 'when we feel that not the figure, but the stone through the medium of the figure, has come to life... in modelling, the material has no rights of its own, it offers too little resistance to the process of conceptualisation.' And in a later essay on Matisse he writes, 'in the work of Matisse we look always to the cut of the form in order to discover authority in the image... in Picasso, form is arrived at through a process of accumulation, sometimes by superimposition.'

While it is easy to recognise the general distinction Stokes is making, there seems to be something missing from his diagnosis when he applies it to the paintings of Picasso. In a moment I will argue that what was missing was something that Rousseau had already understood – had intuited – when he accused Picasso of working in the Egyptian style. But before I do so, I want to take the comparison between the paintings of Rousseau and Picasso a stage further.

That the paintings of Rousseau and Picasso are in certain important respects, the opposites of each other, there is little doubt. In the case of Picasso, for example, Stokes is quite right when he says that his paintings nearly always face us with an accumulation of marks, and that together, these marks build a surface that is entirely different in character and optical effect from the plain surface from which the painting begins. In le Douanier Rousseau's work, the very opposite is the case. The picture is always made smooth. A single layer of paint, comprising carefully joined patches of colour, is applied with meticulous care. Where late alterations have to be made for the sake of the integrity of the image – as in the Prague self-portrait *Moi-meme, Portrait-paysage*, for example, where Rousseau undertook a major alteration to the size of his own figure, because (according to Leo Stein) he thought 'he had made himself too important' – every attempt is made to hide the correction. He reduced himself by approximately half a centimetre all round and to completely 'heal' the surface of the picture. In approbation of what I said earlier about Rousseau's deployment of psychological scale as opposed to real scale. This very extraordinary self-portrait is, perhaps, one of the most dramatic examples of this form of substitution.

Some years after Rousseau's death, Apollinaire wrote 'we can only admire the devotion with which Rousseau finished his paintings... we can enter so easily into his universe only because he saw his pictures through to the very end.' And Leo Stein, a regular visitor at Rousseau's studio, described his method as one in which everything was finished off to the painter's satisfaction as he went along. 'Starting with the plain canvas', Stein writes:

Rousseau would first of all spend some considerable time drawing in the image to be painted with sure and certain lines. When he had adjusted the drawing to his satisfaction he would then annotate it by writing a short description of the colours to be applied in each area. Only then would he start to paint, working from the top of the

picture downwards finishing each part as he went along, until he had reached the bottom edge of the canvas and the image was complete.

This, most unusual of working methods – the turn of the century equivalent of 'painting by numbers' – almost certainly gives the lie to Rousseau's claim to have had 'a proper academic training in painterly methods' in the studio of the French Academician, Felix Clement. A claim that he made in a pamphlet published in 1900, to herald the opening of his own 'creative' school, in which he taught courses in elocution, musicianship, drawing and painting. I can think of only one other canonical, modern painter to use a similar method, the English artist Stanley Spencer, who – reputedly – when working on the larger canvases like *Resurrection at Cookham Churchyard* – because of a serious eye defect, worked diagonally, left to right, across the surface, also completing the image as he went along.

At first sight, this very peculiar procedure would seem to put le Douanier Rousseau firmly in the camp of the amateurs; to place him amongst the legion of the aesthetically dispossessed; the unschooled 'Sunday painters'... the naive... the primitives... or the 'outsiders'... But does it...? Certainly Rousseau himself did not think so, and neither did such important contemporary figures as Apollinaire, Derain and Picasso. And even if it does, why has this had no apparent effect in subsequent years on history's judgement of Rousseau's importance to a modernist canon which, until the intervention of Jean Dubuffet and his invention of the category 'Art Brut' has sought to maintain clear water between the trained and the untrained; between the professionals and the amateurs. I want to spend the rest of the time exploring this question, but before I do so, I should like to make one more observation about Picasso and the Egyptian style.

There are two further possible explanations of Rousseau's statement, and as far as I know neither of them has been advanced before. Both depend upon a crucial shift of awareness in French metropolitan culture in the course of the nineteenth century.

Two years before Rousseau's party at the *Bateau Lavoir*, the great French Egyptologist, Gaston Maspero, had declared the nineteenth century in Europe, 'the century of Egypt'. He was referring, in the first instance, to certain key events. Napoleon's Egyptian campaign, just before the turn of the nineteenth century, had given the French an important foothold in Egyptian

archaeology, a foothold that, by the late 1820s when the great Luxor Obelisque of Ramesses II was raised in the *Place de la Concorde* – an event that Maspero described as 'bringing the light of ancient Egypt into the heart of Paris' – had provided them with privileged access to Egypt for the purpose of archaeological exploration.

By the 1860s, the flow of information and artefacts back to Paris had led to the opening of the Egyptian department at the Louvre. While the appointment of a Frenchman – Gaston Maspero himself – to the strategically important directorship of the newly created, Cairo Museum of Antiquities, followed just a few years later. The 1870s saw the excavation of the Valley of the Kings and in 1881 what became known as the Grand Procession occurred. More than 40 pharaonic mummies were brought down the Nile on a convoy of river barges for examination by Maspero in Cairo. Needless to say, such events received massive press coverage back in France, and led to a plethora of exhibitions in all types of institutions – from major museums to fairground booths – and an extensive popular literature incorporating some of the more sensational aspects of ancient Egyptian life and culture. By the close of the nineteenth century, the Egyptian influence had reached far beyond 'specialised cultural event' and had entered the general imaginary. Ancient Egypt was no longer an intellectual fad of the intelligentsia, but an important component part of the more evanescent world of French popular culture.

That both Rousseau and Picasso were engaged observers of this change in public awareness, there is little doubt. It is possible, then – even probable – that when Rousseau made his famous statement about Picasso and the Egyptian style, it was a simple observation about the faces in Picasso's paintings at that particular, transitional stage of the artist's progress towards analytical cubism. Certainly, the blanked out, staring eyes of the women in the studies for *Les Demoiselles D'Avignon* are reminiscent of those that are to be found in Egyptian statuary and relief carving up to and including the Eighteenth Dynasty. This might provide one, quite plausible explanation for Rousseau's statement.

But there is another more plausible one. Namely that ancient Egyptian art had already been a topic for lengthy discussion within their close circle. Alfred Jarry's 'Dr Faustrol', remember, visited Egypt accompanied by the ape, 'Bosse de Nage' in Jarry's last great fiction. Together they travel the length of the Nile and visit the great temples that they encounter on the way. And Apollinaire was quite clearly fascinated by pictographic and encrypted writing

of different kinds. Indeed, Apollinaire wrote several poems using his own pictographic sign system modelled on Egyptian hieroglyphics. It seems very possible, then, that Rousseau was suggesting nothing new when he accused Picasso of working in the Egyptian style. Nothing new at least to their close circle of friends. This then is perhaps the most likely explanation of Rousseau's notorious statement. That it was little more than an 'in joke' which Le Douanier, in his cups, had suddenly made public. If this is the case, if it no longer represents Rousseau's own view but belongs to ongoing discussions within the collective, which included such figures as Apollinaire, Derain, Jarry and the rest, then the statement becomes even more intriguing. It is just possible that it is referencing something deeper and more theoretically substantial. Clearly Rousseau was intent upon setting up a polarity of a certain kind. If it was one that had been discussed by such an influential circle of friends, then the question of 'precisely what kind of polarity' is well worth investigating. Rousseau is claiming that the two of them are facing in different directions... that Picasso is anchored in the present, but looking towards the past, while he, le Douanier, is anchored in the present and looking towards the future... that there is a quality in Picasso's work, which ties it to a history and a tradition of practice, and a quality in his own work which allows it to float free of both.

Rousseau, of course, is absolutely the image maker and as such a 'natural' iconoclast. By contrast, despite his radicalism, Picasso, is much more interested in rules and in 'rule making' and this crucial difference is somewhere embedded in what Rousseau was saying. While Rousseau's work is, unequivocally, pictorial, Picasso flirts all the time with the atomising processes of linguafaction: with symbolic signs and voided surfaces. Between the two of them – and perhaps this lies at the very heart of Rousseau's statement and the talk of the collective – they represent, in a fairly concise form, polar opposites in painting practice for the modern period.

Earlier on in this talk, you will remember, I pointed to the crucial distinction between 'perceptual' and the 'conceptual' images. Images that seek out a perceptual accommodation with states of affairs in the real world, as opposed to images, which are derived from, and validated by, the several functions of mind: memory, desire, etc. Now we have come across a further distinction within the category of the 'conceptual' image: between images which depend upon achieving pictorial unity, as in the case of a Rousseau painting, and images, which are atomistic, encrypted and language-like. Semiotic theory has usually explained this difference in terms of the domination of the

'iconic' over the 'symbolic' or vice versa. Accordingly, a painting by Rousseau, would be predominantly 'iconic', while an analytical cubist painting by Picasso would be predominantly 'symbolic' because the signs that go to make meaning are fragmentary and devoid of resemblance: syntactically arbitrary like letters and words before they are joined through the rules of grammar, to make meaningful words and sentences. That this – the semiotic distinction – when applied to painting, is in several important respects, unsatisfactory, has been pointed out by many distinguished theoreticians, including Ernst Gombrich, Richard Wollheim and one of the pioneers of the semiotic approach Umberto Eco and so I do not want to spend too much time discussing the problem here. It is sufficient simply to point out that signs in painting – of whatever kind, iconic, symbolic, indexical even – are always embedded. There is no fixed alphabet and no lexicon neither. They have no singular existence, unless extracted and given a speculative context by theoreticians for their own analytical purposes. Even so, I want to insist upon a division of the category... 'conceptual image'... along roughly similar lines, but approaching it from a rather different direction: from what might roughly be described as the phenomenological as opposed to the semiotic.

Taking this approach it is the issue of 'space' and 'place' which is foregrounded rather than the linguistic function of the sign. As I suggested earlier on, the carved hieroglyph is not an exposed relief, but an embedded one. It cuts no profile in the manner that Adrian Stokes would seem to require for it to enter into the highest domain, that of the 'carved'. The hieroglyph is not in this respect an applied ornament, but something, which is thoroughly contained. Its place of existence is not on, or even at the surface, but within the body of the stone. The semiotic sign, by comparison, has no place in which to exist, except the 'no-place' of language itself. And it has no space to occupy either, except it be the entirely arbitrary and abstract, one forged between chains of signifiers, like the space between letters or between words.

The conceptually charged pictorial sign, by contrast, like the hieroglyph, is always situated – placed – somewhere. It carries with it... it exists within... is an integral part of its very own 'subjunctive' space. It also exists – is subjoined, or added to – a world which is bounded; like a football pitch bounds the game of football – frames the action of the players and the conduct of the game – or like the walls of a monastery set the boundary of the religious life – frames its rituals, and embodies, in architectural form, its profession of faith. Such signs exist, then, within what is always, paradigmatically

speaking, a social and political space, and for this reason, image-making – the systematic deployment of visual signs to make for a unity – is inescapably an exercise of power. In the case of works of art in general, this 'exercise' is a rehearsal of the 'power of the maker', one who puts something new into the world, be it object or image. In the case of painting, it is very particularly an exercise in the power of the author, image-maker, who must not only set the actual and conceptual limits to the field of play, but must also write the 'rule book' that will determine the outcome of the game in any particular instance, and at any particular moment in time.

This, the rule making – world containing – exercising of the 'maker's' power, is made very clear in this painting by the Swiss, Art Brut artist, Adolf Wölfli. Like so many of Wölfli's images, it provides an elaborately encrypted and transfigured aerial view of a real place, replete with the images of himself located at strategic places on the ground. And the whole image, typically, is contained by a highly reiterative framing device. Boundaries, of course, are just as much about what is excluded as they are about what is included and it is abundantly clear that Wölfli wants there to be no confusion about where his appropriated world begins and ends. In political terms, it can be seen as a marking out of territory, a statement about where the artist Wölfli's jurisdiction begins and ends; a claim to sovereignty.

The French semiologist, Jean Marin, in his now-famous analysis of Thomas More's *Utopia*, discussing the depiction of utopias and 'ideal worlds' in general, made the very telling observation that the utopian gaze, like that of the cartographers, is a mono-focal gaze. And as seen is removed vertically above the proposed site. Like paintings, utopias tend to be built around opposing, vertical and horizontal – north/south, west/east axes. They are always rectilinear... mostly square... never circular. Like paintings too, they are about the ordering of things within the frame. That more than anything else, they are about visibility. Curved streets, for example – unavoidable in the case of a circular plan – would render most things visibly fugitive for most of the time. As Marin points out, even given a symmetrically arranged, square plan, the only location from which the 'utopic' relationships would be visible all at once, is from above. For this reason, the utopian gaze is manifestly a highly ambivalent one, involving, as it must, notions of surveillance and political control.

The depiction of spatial relationships, then inimitable to the act of painting, and to the representation of political power. In the virtual world of the painting, as in the social / political mapping of the real world, the power

of the maker is encoded spatially through deliberate and often forceful acts of dominion which history has layed one upon the other. The invention of perspective, for example, did not just change the way in which we were able to depict the world on the walls of our palaces and cathedral churches, but as Jean Baudrillard has pointed out, it also changed our experience of it. By turning the human gaze earthwards once more, it gave the human subject a place in which to be vertical once again. It placed our feet firmly back on the ground and gave us back our human point of view. There were real political consequences arising out of the invention of perspective too. As well as producing new approaches to public architecture and the planning of cities and public spaces, perspective also contributed to a more fluent acquisitiveness for territory and goods, and a new language of political patronage. As Baudrillard so cleverly puts it: 'If you change the way in which a society describes the world, then, for that society, if for no other, you have changed the world itself.'

The general drift of Baudrillard's argument is not a particularly original one. It was deployed first of all by the British writer, commentator and critic, John Berger in his controversial book, *The Success and Failure of Picasso* (1965). Writing about the aftermath of *Les Demoiselles* and Picasso's passage into the analytical phase of Cubism, Berger argues that what he calls 'real' Modernism begins with a change of attitude towards language. After about 1908, Berger argues, the use of language could no longer be treated as if it were 'natural', but something 'self-conscious' involving 'construction'. And he cites the very curious, historical coincidence occuring between the emergence of analytical Cubism, and the publication by Russell and Whitehead's *Principea Mathematica* (1910–13); the invention of symbolic logic; and the beginnings of 'Quantum Theory'. To summarise my argument so far and picking up on Berger's insight, I would suggest that Rousseau's famous remark at the party at the *Bateau Lavoir* might quite properly be viewed in this light. That either consciously or intuitively le Douanier was registering an historical shift of consciousness at a crucial moment in the emergence of the conceptual image. That the conceptual image first emerges in two quite distinct forms, one where the image itself is what is at stake, and another which is more atomistic and language-like. By referencing Marin's work on the representation of utopias, I pointed to a subdivision of the second of these two categories; between the cartographic inscription, such as we observe, say, in the pictures of Adolf Wölfli, or in the paintings of Jackson Pollock, and the more encrypted

and embedded hieroglyphic type of inscription that we find emerging in the paintings of Picasso after *Les Demoiselles*. I then gave a rather Nietzschian twist to the whole argument, by suggesting – rather controversially I hope – that the real psychological import of these three categories, lies in modern attitudes towards, and ways of formulating or representing power, where power is equated with 'the making of things' – by answering the desire to put new things into the world, and insisting upon their absolute visibility.

Right at the very beginning of this talk, I said that the 'conceptual' image, in all its forms, is not in any sense *aberrative* as many reactionary critics have tried to argue. That on the contrary, in its linguistic range, conceptual reach and its endless capacity to transform itself, it draws close to – even reflects, very directly – the dislocated and fragmented nature of modern states of consciousness. It is in this context, by way of arriving at a conclusion of some kind, that I now want to talk about what I will call 'visionary painting'.

Dubuffet, of course called it 'Art Brut', and in the English-speaking world, we call it 'Outsider Art'. I should, perhaps, say in passing, that I find neither of these terms very satisfactory. Each of them seems to reify a notion of 'otherness' which is more sentimental than it is reasonable. In the case of 'Art Brut', by seeming to suggest that there are values which are pure and unsullied and are absolutely 'other' to the values that we routinely rehearse within the professional discourse of high art. The uncultivated, the 'raw', the unschooled and the uncultured are *ipso facto* equated with the good. While to be cultivated, schooled, culturally sophisticated is of dubious value perhaps even a little corrupting or creatively dishonest. In the case of the term 'Outsider Art', the suggestion seems to be that there are people in the society who are also, at the same time 'outside' of it… recognised by the dominant culture but 'other' to it… capable of being brought inside the art domain and made subject to its processes of evaluation, but, at the same time, independent from it. Both of these terms, also seem to suggest that there is no causal link between the individuals involved and the society in which they live, unless it is construed as an utterly negative one.

But if – as is commonly argued – 'outsiders' are indeed the products of social alienation then I would at least like to insist upon the strict Marxist definition of alienation: namely that individuals are alienated 'within' the society in which they live, rather than 'from' it. Just like you and I, they exist in, and are made by society and its institutions.

Having cleared up this point; I want also to make it clear that I am interested in 'visionary artists' as a category because I believe them to be quintessentially a modern phenomenon. Their emergence coincides with, and is part of the symptomatics of modernity, and a product of the modernising process. Art history wise, then, they must be considered as an essential part of the evolution of Modernism and as subject to what Benjamin has called, the pattern of 'cultural shocks' arising out of the process of industrialisation. And one of the most important of those 'shocks' is the one suggested by Berger in *The Success and Failure of Picasso*. I have chosen to call it 'the denaturing of language'. Roland Barthes in the context of literature saw it as the opening up of a semantic – or interpretive space – in our apprehension of the text and suggested that it marked the end of that version of 'style' which was deemed to be inherent and to parallel the maturation of the individual sensibility. With the invention of the modern novel, Barthes argued, style becomes a matter of choice.

As I pointed out at the very beginning, there is no discernable stylistic development in the paintings of Rousseau over a period of 25 years, and this is perhaps another sense in which he might be considered modern. The world was shaped by his desire for it to be the way that he imagined it. And, as a consequence, it had always to take on the form in which he chose to project it as a type of relocation; the production of a familiar world conceptualised in the bounded form of the image. In one way or another this tends to be true for most visionary artists. In the work of Adolf Wölfli, for example, the framing and inscribing of his world and his determination to maintain hold over it; to hold it within view, as with all processes of mapping, also involves the notion of replication, making it much more than simple statement of ownership. It is also as statement of dominion, a show of territorial rights and charged with the type of ambivalence that Jean Marin suggests is integral to the Utopian gaze. While the paintings of the very remarkable, Croatian artist, Sava Sekulic seem to invoke a magic space endlessly replicated as ritual proposition, through the centred influence of the totemic form and the paintings by the Greek Cypriot artist, Alexis Perifimou, seem to invoke a similar doubling of the image as a greatly desired, projected world and familiar reality that we have already discussed in the case of Rousseau.

Visionary painting, then, reveals to us a very important truth about the hidden depths of the modern imagination. It shows us, in a very open and undisguised form, that somewhere at the very heart of the modernist dream there lies a highly paradoxical notion of 'newness'. A 'newness' that is familiar

and recognisable… which, in some extraordinary way, can be anticipated in advance of our experiencing it… that can be known in advance. What are we looking for when we look for new visions and new experiences from art? The pretence is that we don't know… and that we will know when we see it. It would seem then, as Wittgenstein said, that truth resides in tautology, in replication of a certain kind. And if we are speaking about the image this implies some form of prior process of 'imagining'. When Picasso came across the portrait by le Douanier Rousseau and described it as the 'perfection of a certain order of thought' he was suggesting that it existed along a trajectory of the imagination that he had already foreseen and recognised as a type… of which the portrait by Rousseau was the perfect prototype. An 'unstyled', originating image, the power of which, is the minds eye is inexhaustible. This paradox, it would seem to me, is crucial to our apprehension of visionary painting. That the artist can repeat, repeat and repeat again what in the conceptual domain ought in truth to be unrepeatable.

In *Roland Barthes by Roland Barthes* (1977), Barthes invokes the image of the Argos, the ship that sets sail on a long sea voyage… one that is so long that during the course of its passage, every part has been replaced because of storm damage. The ship that returns to port then, both is and is not the ship that set sail a year earlier. By now it has become an absolute replica, indistinguishable from the original and yet completely transformed into an image of itself. With this story it seems to me, Barthes captures the paradox which lies at the heart of the image and its relationship to the modern imaginary in a particularly vivid form.

Essay derived from Victor Musgrave memorial lecture delivered at the Irish Museum of Modern Art, Dublin, 2000.

ILLUMINANTS AND ILLUMINATIONS

Stephen McKenna plans his exhibitions with the same rigour – attention to detail – as he orders his large studio compositions. The careful disposition of works, the way in which the paintings sit with each other, is intended to be read. The structure is clear and waiting to be recognised and understood, not as narrative or as a thematic exercise of some kind, but as a measured argument about the adventure of figurative painting.

Typically, the painting which inaugurates our journey through this current exhibition – the image which confronts us as we enter – a painting called *The Crossing* (1990), suggests both a meeting place where different strands of McKenna's argument are brought together and made to coexist, and a point of departure that opens up very different prospects to the right and to the left.

Taken on its own *The Crossing* is in any case a portmanteau piece which references all of the main genres of painting, points up all of the painter's traditional concerns – the human figure, landscape and still life painting – presenting them in a strikingly hieratic form. A set of carefully crafted, fragmentary details pitched against a neutral ground – like exhibits in a museum – that seem almost to present painting as a set of tried and tested, eternally pertinent 'spiritual exercises' intended to connect the mind to the

senses; the human spirit to the eternal matter of art. In this respect, *The Crossing* is also par excellence the studio composition. Besides providing us with a typology of the painter's craft, it references separate geographies and journeys between different historical time frames, from the Etruscans to the High Renaissance, from the rich mythology of the ancient world to everyday realities; things that are commonly present to us, objects standing on a shelf or a view from a window. This is McKenna the artist at home, in his place of work, and thinking about the whole complex of material and immaterial relationships that determine his actions, his judgement and his vision. But *The Crossing* is also a picture, or to be more precise, a set of pictures and discreet objects depicted within a picture. The painter is here engaged in ordering fragments so as to invoke a notion of continuity without falling victim to it. It is a strategy that McKenna used previously in the Pompeian pictures, and it demonstrates his preference for pursuing the distinctive detail as a way of reaching the eventual goal of a workable composition rather than starting from an overarching notion of a unity by manner. It is a strategy which in the Pompeian pictures, as now, directs attentions towards the play of light, an interest which has come increasingly to dominate McKenna's work in recent years.

Even though McKenna works almost entirely in the studio, the sense of place seems to be of crucial importance to him. For this reason, he has always been something of a nomad. Recently he has kept two studios, travelling regularly between them for extended periods of work. One is in Ireland on the sea coast of county Donegal where the light can be defused by aerial dampness into a ghostly grey or witheringly sharp and cold, and the other in Italy, first in the softening, almost sepia-tinted light of the Tuscan hills, and afterwards further south. A two-year period in the illuminate, carved and grandly formal architectural spaces of Rome was followed by a move to the brighter, fresher light of southern Umbria. Significantly in the context of this particular exhibition, McKenna has placed one of the large Roman interiors, *Roman Studio* (1990), to the left of *The Crossing* and two small, still life paintings, *Cinerary Urn* and *Small Birdhouse* (1998), to its right. The choice would seem to be between the greatest possible degree of formal complexity – *Roman Studio* is a work in which a fairly straightforward interior architecture, a large room replete with studio furniture and a darkened space beyond, is transformed by repeating the spatial set-up in a painting standing on an easel in the foreground, an elaborate network of geometric connections as opposed to the imaging of a single object. But the comparison McKenna is

making goes much further than the playing of formal games. All three pictures are without any easily decipherable reference to a natural light source. The outside of the studio would seem to be in darkness. The evenness of the light – its flattening effect – which serves the structuring purpose of the geometry so well, suggest an artificial light source of the kind that we find in de Chirico's Ferrera pictures but it is neither so bright nor so heavily directional. Where de Chirico uses light to fragment the surface of things and to enhance graphic detail, McKenna uses it to unify and draw all the details together within a clearly defined pictorial language. The quality of light seems to envelop and to soften things. Almost it is calorific. We can imagine it is the afternoon and the shutters are closed against the downward-bearing, weighty glare of the Roman sun. By contrast, the cinerary urn is illuminated by a very gentle light source situated somewhere to the left of the subject. If it is sunlight at all, then it is early in the day, cool, indirect and highly defused. And the birdhouse, isolated on a ground which moves without any discernible break from the horizontal surface upon which it stands to the vertical plane behind – a favourite device of McKenna's – seems to be lit directly from above by a far away, warmly glowing light which suffuses the whole picture.

On the basis of the light alone none of these pictures are easy to locate in terms of a specific geography. However, in all four paintings light seems to refer to a kind of ambient temperature which in its turn gives a profoundly sensual even a tactile energy to the subject. Sense of place acquires a more comprehensive meaning. Indeed, it can be seen as a kind of *habitus*, a fusion between McKenna's intimate knowledge of location – a knowledge that extends far beyond the visual – and his capacity to make a sensible and lucid pictorial utterance. It is not simply the painter's grasp of geography that is at stake here, but his consciousness of time and place as it is recoverable in the act of painting; not simply a question of memory – of mastering the trick of capturing a memorial trace in the form of an image – but of achieving its materialisation as painted language.

As if to underline the absolute importance of this process of painterly translation, McKenna also includes in this first room an array of very different pictures; different subjects manifesting different moods. And each of them seeming to pose a different problem of painterly handling related to different historical antecedents. The great *Ovals Still Life* (1997), for example, a collection of domestic objects and utensils set against a mottled grey ground, because it raises the question of the rendering of material surfaces in a particularly acute

form, seems almost to hark back to Spanish painting of the sixteenth and seventeenth centuries: to Velásquez and to Zurbaran. While the two contrasting landscapes *Aventino* (1990)– one of a number of studio paintings McKenna made of the Aventine Hill in Rome seen from the opposite bank of the Tiber, and *Houses Castiglion* (1992), a view of the broad, familiar, grey-green sweep of the Tuscan hills studded with orange roofs, seem to be entirely located in modern Italian painting; in the landscape tradition that grew up in the wake of the *Scuola Metaphysica*. The theme of fragmentation is picked up again in two more still lifes, *Book and Map* which in its use of graphic detail has a strong de Chiricoesque feel to it, and *Landscape Sculpture* (1990) which in its centredness and its shifts of scale seems close to the paintings of René Magritte.

Significantly, the painting that carries us forward into the second gallery, *Interior with Frescoes* (1992), an example of McKenna's studied use of classical perspective is both a reiteration – a backward glance at *Roman Studio* with its symmetrically arranged spaces – and an almost tautological invitation to examine the idea of 'interior' as subject matter. It is here also, at a deeper level, that a vital subtext that seems to run through the whole exhibition is suddenly made apparent; the idea of 'inside'; seen as an alterity. Like *Roman Studio*, *Interior with Frescoes* shows a brightly lit room opening on to darkened spaces beyond. Painted doors thrown wide open, framed by matching doorways, these gaping spaces seem to suggest mysterious presences; presences which are not entirely graspable, which recede from consciousness. We are reminded of Levinas's description of the ultimate alterity of 'death', as a process of 'taking passage outside of the light', of undertaking a journey into a region where 'something absolutely unknowable can appear'. In the space of a single room, we have progressed from consideration of calorific light as '*habitue*', light as the signifier of a physical body and a living consciousness to which all material things are present, to consideration of its metaphysical other in the cessation of consciousness where presence itself is what is at stake. In this respect *Interior with Frescoes* is doubly the threshold painting. It functions not simply as an introduction to interior as genre but to interiority as an address to absence. Taking up McKenna's invitation and crossing the threshold, three pictures of domestic interiors follow immediately. *The Grand Piano* (1992), a shiny-black casket of muteness, with windows at either side framing strangely disjointed views of Tuscan villas; *Bedroom Crocknafeola* (1997), at once the most constructed and stylistically metaphysical picture in this current exhibition; and *Dalkey Window* (1997), a single window with looped

transparent drapes framing an unrelieved blue sky and an uninterrupted, gently lapping sea stretching to the far horizon. This last picture, in some respects so much the set piece 'Riviera' painting, a view of the sea seen from within a cool interior on a hot and sunny day, despite its cheerful appearance carries with it a number of more sinister references.

The rather metallic, implacable surface of McKenna's sea is the very opposite of the aquamarine wash flecked with liquid ultramarine of a Raoul Dufy, or even the inviting grey-blue swirl of light and heat that signifies sea in the Côte d'Azure paintings of Henrí Matisse. Viewed from a strictly pictorial standpoint, Magritte is the obvious point of reference for McKenna's *Dalkey Window*, while Carlo Carrà is perhaps the most theoretically pertinent. It was Carrà, remember, who took hold of the image of the sea and used it metaphorically as a model form of consciousness, replete with its own particular psychological dynamic of surface and depth. The continuously mobile surface of the sea stretching to the horizon was cast as the range and limit of everyday vision, while its aqueous depth was seen as the dwelling place of metaphysical phantasms and transformations, only apprehended in moments of clairvoyance. It was a model which quickly became synonymous with the idea of the inscrutability of everyday objects central to the very idea of a metaphysical painting. It was also the antithesis of the contemporary theory of the transparency of the image; the idea that images aim at the object and function like windows into the world that they represent. The metaphysical image, by contrast has its own density, its own opacity and casts its own impenetrable shadow.

Perhaps it is significant, then, that the four paintings completing this second room are all still life compositions. Two of the pictures, hanging side by side, point up material oppositions of different kinds: between a rather elegant glass vessel and a steel tool intended for gripping things – even for crushing them – in the case of *Carafe and Pincers* (1992); and between roughly cast iron and metal burnished and patinated by use in *Two Metal Trays with Dumbbells* (1992). Both paintings seem to function through a kind of pictorial muteness. As images they seem to absorb the quizzical gaze, refusing to confirm their own existence as bearers of significance beyond their presence as painted facts; as straightforward painterly translations. And yet there is something unsettling about them. An endlessly postponed future seems to hover around these painted objects, these shadowy reflections, these carefully contrived portraits of usable and used things. Here, it would seem, McKenna

is presenting the viewer with what is arguably the very essence of still life painting – in reality the essence of all painting – the unbridgeable fissure that can be revealed in the painting of common or garden things, between present and future. It reveals, in the stasis of resemblance, the allegory of being. Very tellingly, a third picture, *Vertical Olive Branch* (1993) – quite literally the 'Natura Morte' – seems to heavily underscore this reading. In all three of these paintings the objects are isolated in a shallow or indeterminate depth of field the very opposite strategy to that employed in the other major work in the room, the large and complex *Still Life with Cane Chair* (1998), in which everything exists in a thoroughly readable space. Clearly at this point McKenna has chosen to close the circle and return the viewer to the artist's studio.

It is *Vertical Olive Branch* that points the way to the upper galleries which are devoted to the genre of landscape. In fact it connects with the first painting that we see at the top of the stairs, a seascape called *Receding Water Surface* (1993), almost a memory trace of the sea as it is seen through the *Dalkey* window. The title suggests a study. It also has the appearance of a painting made before the motif. But as we have already observed all of McKenna's paintings, landscapes as well, are painted in the studio. In this respect it functions in the exhibition as an important occasion for recapitulation. Despite the change of subject matter, and the shift of focus from inside to outside the studio, *Receding Water Surface* makes it clear that McKenna's interest remains the same. For him, whatever the subject, painting remains a materially grounded, linguistic transaction. It is never the subject as such that is at stake, but its thorough translation into a painted language of representation.

As if to emphasise this point, *Receding Water Surface*, is one of three small pictures – the others being *Double Rock at High Tide* (1993) and *Surging Wave* (1993) – which are here hung alongside one of the most formalised of McKenna's landscapes, *Large Black and Yellow Lighthouse* (1994). While the three seascapes seem to refer to the painting of the great period of French Realism, in particular to the sense of elemental arrest that is so splendidly present in the landscapes of Courbet; *Large Black and Yellow Lighthouse* carries with it no such easily attributable historical reference. By contrast, the language of this picture and of its smaller companion piece, *Lighthouse with Figure* (1998), hanging in the same room, seems to have been forged afresh through the painter's address to the uncompromising geometry of the subject. Where landscape is concerned, they also seem to point to a marked change in McKenna's approach to light and colour. The seascapes retain some notion of the natural order of things, light

falls on particular surfaces transforming their local colour in a fairly predictable way, while the lighthouse paintings seem to play down light as effect and to heighten local colour. Here McKenna seems to be intent on doing for the genre of landscape what works like *Bedroom Crocknafeola* do for the domestic interior. Light is no longer merely a conditioning factor, rather it has become a means of discovering an added, we might call it a metaphysical dimension to things. Now the geometry of light and dark overrides detailed observation. References to the natural order of things are subdued or set aside altogether, to be replaced by an intimate incarnation which no longer purely and simply displays the exteriority of what is being depicted. This very important moment in the reading of the exhibition which amounts almost to a redefinition of the act of seeing, is given a subtly ironic twist by the inclusion of two paintings of light. The first of these, *Lighthouse in Fog* (1999) shows a defused, foggy light against the dying rays of the setting sun. The suggestions seems to be that there are two different kinds of light. One that might be seen as emanating from things in the world, and may or may not be a reflection of that other light, the sun, which in *Lighthouse in Fog* is still visible and despite its waning power, still seeks to hold sway over the natural world. In the second of these pictures, called very simply *Barrow Night Light* (1999), the defused light has spread from its source to obscure everything in the visual field.

And so, *Barrow Night Light* inserts what at first sight seems to be a highly paradoxical passage into the sunny inner sanctum of McKenna's exhibition. It is almost as if its seeming eradication of natural vision has suddenly been revoked. Two Irish landscapes, *Barrow Weir* (1999) and *Royal Oak Bridge* (1999), small, very freshly handled pictures signal a shift of pictorial language which might almost be passed over if it were not for the fact that they are followed by one of McKenna's most important Umbrian garden paintings, the very assured *Pergola* (1996). Like *Roman Studio*, this painting has a very pronounced foreground. A table is cropped by the bottom edge of the painting; a wine cooler, a clear, glass bottle and an empty dinner plate are pushed almost aggressively towards the viewer by this device. Beyond, McKenna has contrived a deeply receding, luminous space. Partly this is architectural, but it also depends upon the carefully structured treatment of an array of different kinds of foliage. Here, then, there is clear emphasis upon an extended painterly vocabulary which is neither geometric nor tonal as in the case of *Roman Studio*, or dependent upon discovering illusionistic equivalents for the natural effects of light of the kind that animates a work

like *Vertical Olive Branch*. For this reason, despite the forcing of the pictorial space, *Pergola* demonstrates a remarkable pictorial unity in which colour value has become the chief vehicle of representation. *Pergola* is the first of four Umbrian pictures which, in the context of McKenna's work overall, manifest what is in effect a new type of flattened space of the kind that we find in the paintings of Pierre Bonnard. The image in the second of this set of paintings, *Stable in Umbria* (1997), seems almost to be scaling the vertical picture plane with buildings, trees and fields piling up against a flat cobalt-blue sky, while in *Gate at Terni* (1998) and *Garden at Terni* (1998), strongly delineated areas of background colour are used to press the image forward, thereby unifying the picture plane. This strategy of flattening the pictorial space by contriving a forward moving colour dynamic that begins from the furthest point in the recessional field is repeated to great effect in the two Irish interiors that conclude our journey through McKenna's exhibition, *Dalkey Interior - Morning* (1997) and *Kitchen Crocknafeola* (1998).

Typically, McKenna has provided an adventure in painting which is at the same time diverse and yet highly structured. It requires the viewer to confront and come to terms with a whole range of different forms of symbolic transformation; a changing pattern of thoughts about the world, occurring at the level of pictorial language. Inevitably thought involves erasure. To think one thing is not to think another. And nowhere is this process of erasure more immediately apparent than when we are contemplating the complexities of representational painting. For example, to think about a crucial element like light in one way – in casting it in one role – is to prevent thinking about it or casting it in another. In this exhibition we can see McKenna exploring the notion of light in painting from very different standpoints and following through the consequences of this process in terms of all the other elements that go to make a coherent painted statement about the world.

Stephen McKenna, exhibition catalogue, Bahnhof Rolandseck, Remagen, 2000, pp.17–23.

I saw my first Panamarenko work, *Walvis (Whale)* in 1967, at the legendary Wide White Space Gallery run by Anny De Decker and the sculptor Bernd Lohaus in Antwerp between 1966 and 1977. I think of it now as a pivotal moment. Certainly it sent me in search of this very eccentric, but totally fascinating artist's work on every possible occasion thereafter. In 1999 Susan Brades asked me to negotiate a solo exhibition of his work at the Hayward Gallery, which I would go on to curate; it is no surprise that I saw it as both a privilege and a challenge. Belgium's most famous living artist had had very little exposure this side of the channel. A small number of works – mostly drawings – had been shown in the historical theme show, *Peer and Ocean*, at the Hayward Gallery in 1980, and I had included two early works in *Gravity and Grace* also at the Hayward in 1993. Despite his international celebrity, as far as the wider British public was concerned he was virtually unknown. The solo exhibition, then, had to be both comprehensive and lucid. The same was also true, even more

importantly perhaps, of the catalogue essay. As well as a philosopher of art and science – and I use the term 'philosopher' advisedly – Panamarenko is also a supreme ironist and a compulsive iconoclast. My fear was that the British public just wouldn't get it, that the pragmatic British mind would simply take flight when confronted by an artist like Panamarenko who, in all seriousness, or so it seems, questions the veracity of Einstein's theory of relativity and the resulting cosmological model. I felt duty bound, then, to try to preempt this kind of rejection by uncovering something of the complexity of his thinking and presenting it in a readable form. Given his undoubted critical intelligence, submitting my text for Panamarenko's approval was a daunting prospect. It must have been OK because he has used the text in several important publications since.

PANAMARENKO:
ARTIST AND TECHNOLOGIST

One of the most celebrated paintings in the history of Flemish art, Pieter Bruegel the Elder's *Landscape with the Fall of Icarus*, painted in 1558, hangs today in the Musées Royaux des Beaux-Arts in Brussels.[1] In the foreground a peasant farmer is seen ploughing his field, and in the middle distance behind him, almost incidentally, Icarus is faintly visible at the moment at which he splashes into the sea. Widely interpreted by art historians as a meditation on the importance and persistence of everyday life in the face of the most unusual or spectacular of events, the painting has acquired an almost sacred place in the social critique of art.

But it could be read in an entirely different way. It could just as easily be suggesting that real dreams persist somewhere in the back of the dreamer's mind, and that even their most dire consequences belong only to the dreamer; they have no need of witnesses. In one sense, the dream of flight is Icarus's property, but in another, it is the generative point of a rather ambivalent mythology which still touches upon the sculptural and the earth-bound in very interesting ways. It also, coincidentally, defines precisely the arena of activity of Belgium's most celebrated contemporary artist, the man who calls himself Panamarenko.

Usually referred to as a sculptor, Panamarenko himself prefers to be called an artist/technologist, and certainly the character and direction of his work over the past four decades supports such a distinction. Most of this time has been taken up making machines; from discrete power-units such as motors or engines, to transports for travel of various kinds: over dry land, airborne in flight and exploring space, and above and beneath the sea. In this respect, Panamarenko's works do not even look like sculpture, but neither do they look quite like anything produced in the normal run of engineering. They have the appearance of things that we already know, but in new and novel forms. Above all, they seem to exist as subtly humorous but thoroughly purposeful inventions which use technology – from old to new, primitive to highly sophisticated – as a means of revitalising aesthetic experience.

Panamarenko was born in 1940 in the northern Belgian city of Antwerp. His father was an electrical engineer who worked in the dry docks of the port area of the city. His mother, initially a factory worker, later kept a shoe shop in the busy *Offerandestraat* close by the railway station and Antwerp's famous Zoological Gardens. With the exception of a three-month period in the late 1960s when he stayed in New York, and a similar length of time in 1972 spent in Britain,[2] Panamarenko has continued to live and work in his native city.

Panamarenko attended the Royal Academy of Fine Arts in Antwerp in his late teens, and his intention was to become a designer of some kind. As he is still fond of recounting, he was labouring under the mistaken notion that a career in design would provide him and his family with a decent living, but it seems he spent very little time at the Academy. Most of his student days were taken up studying in the Science Library of Antwerp and visiting the cinema. When the time came for him to graduate, between new interests and new friends – such as the young Antwerp painters, Fred Bervoets and Hugo Heyrman – he had decided that he wanted to live and work as an artist. And so he passed from the Royal Academy to Antwerp's postgraduate study centre for fine art, the National Higher Institute of Antwerp, but – as Panamarenko puts it – as an unofficial student. He never enrolled, and by the time he had finished his 'clandestine' attendance at the Higher Institute in 1962, he had already achieved some local recognition as an artist. And one year later he showed his ten-part piece *Koperen plaatjes met Kogelgaten* (Copper Plates with Bullet Holes), a title which described precisely how it was made, with the CAW (*Comité voor Artistieke Werking*) an artist-led initiative, typical of the time, of which Panamarenko was a member.

Panamarenko's use of a pseudonym dates from this time and it is his only name as far as his public life is concerned. The explanation most frequently advanced by those who have written about him is that it is a reference to 'Pan Am' – Pan American Airways – a popular international airline of the 1960s and 1970s which went into receivership after the Lockerbie disaster of 1988. But this does not account for the Russian-sounding suffix 'enko'. Just as the term 'Pan American' embraces all the Americas – North, Central and South – so the addition of the suffix 'enko' – bearing in mind the background of the Cold War – seems to be a way of linking America and Russia; East and West. Considering also that in labelling his works Panamarenko sometimes shortens his name to 'Panama', writing it in the Cyrillic alphabet, it accrues another layer of geographical reference. Not only does it speak collectively of the Americas and the linking of East and West, but it also connects the world's two greatest oceans, the Atlantic and the Pacific. We might see Panamarenko's choice of a name as one man's gesture towards globalisation, long before 'global' had become a buzz word in cultural criticism.

ANTWERP: PLACE AND TIME

In Belgium there is an oft-quoted saying that 'a Belgian is born with a brick in his stomach', and it is true that most Belgians continue to live in the town in which they were born. Perhaps the reason for this is that Belgian cities have very distinctive characters and manifest strikingly different social and cultural atmospheres. The city of Antwerp – Panamarenko's city – has a strong feeling of border territory about it. Dutch tourists sweep into town each weekend, occupying the bars and restaurants in the historic centre of the city, driving the locals from their usual haunts and wandering up and down the main shopping street, the *Meir*, in droves. The feeling of resentment is sometimes palpable. In this respect, Antwerp is a place in which the seismic forces that shaped the old Europe can still shift and rub against each other in very uncomfortable ways. As a Flemish city, predominantly Catholic in feeling, Antwerp shares with south Holland and the divided provinces of Brabant and Limbourg the age-old suspicion of the Calvanistic north, and yet the border between the two countries remains the focus of powerful, negative projections. To the Dutch, the border signifies nothing less than the beginning of social irresponsibility and state-sponsored fiscal chaos, whereas to the Belgians, it is seen as the place where poetry ceases and the imagination dies.

But there is another more concrete way in which Antwerp signifies as border country. Once the largest seaport on the northern seaboard of Europe, it is still second only in importance to the Dutch port of Rotterdam, something you would never suspect when standing in the medieval centre by the cathedral. But take a flight from the airport at Deurne across the old city, going west towards London, and the size of the industrial and commercial maritime area reaching along the banks of the River Schelde is immediately apparent. This historic port area, where Panamarenko used to visit his father as a child, expanded greatly in the postwar period. It is the economic engine which has driven the city for centuries, but even during Panamarenko's lifetime its economic fortunes have tended to swing wildly to and fro between periods of depression and revival.

Like most people who live and work in maritime cities and depend, either directly or indirectly, upon the port for their livelihoods, the ordinary working people of Antwerp have a toughness about them. Natural *bricoleurs*, they are self-reliant and suspicious of authority. They cherish their privacy. This is a city in which people live out their lives behind closely woven, crisply laundered white net curtains. There are few places on earth that are more studiedly opaque, or where the distinction between public and domestic life is so jealously guarded. Panamarenko has chosen to live and work as an artist, here in his hometown, seemingly against the trend towards metropolitanism that has held sway for so many artists, internationally, through the period of late Modernism. His green-painted house overlooking the *Dambruggestraat*, with its wrap-round, first-floor balcony made of semi-opaque glass – entirely resistant to the prying gaze – seems almost to represent the distance that he has placed between himself and the wider art world. He only rarely attends art events, international exhibitions or private views, even when his own work is featured, preferring to stay close to home. In the Belgian context this is perhaps not so strange. The Belgian art world reflects the independent character of Belgian cities. It tends to be fragmented, factionalised, entirely identified with particular locales. Local people, indigenous artists, related professionals and businessmen collectors, hold sway over local art institutions.

In Belgium, just as in Italy, the regional centres have retained their cultural importance. Indeed, for most of the postwar period, certainly during the 1960s and the first half of the 1970s, the two Flemish-speaking cities of Antwerp and Ghent were more connected to the transatlantic, contemporary art scene than was the long-established art world of Brussels. Both seemed to

be vying with the capital city and with each other for supremacy, especially in the field of the visual arts. In Ghent the way was led by the Artists Association Gallery, the original *Vereniging voor het Museum Hedendaagse Kunst*, and later on by the *Vereniging voor Aktuele Kunst*. In Antwerp key exhibition spaces included the Wide White Space Gallery, where Panamarenko showed at regular intervals between 1966 and 1973, and the privately sponsored 'Art Institute' that Panamarenko ran himself called A379089 after the gallery's telephone number, located in the *Beeldhouwersstraat* (Sculptors' Street).[3] It was here that Panamarenko was later to build his great airship *The Aeromodeller* (1969–71).

The reasons for the push for cultural supremacy by these two regional centres are highly complex and particular to each. By the early 1960s, the predominantly student city of Ghent was less economically depressed than Antwerp, which had always been a harder, colder place to be. Now though, at the time when Panamarenko was beginning to show his work publicly, Antwerp was in the throes of serious industrial reconstruction. The south of Antwerp – the area around the magnificent old *Museum voor Schone Kunsten* between the *Amerikalei* and the *Cockerillkaai*, by now the main gallery area of the city – was just being opened up. Over the years Antwerp had developed settled immigrant populations from North and Central Africa and, more recently, from Turkey and the Eastern Mediterranean to provide manpower for a mining industry that was in decline. In the early 1960s, with the outbreak of the Vietnam War, there was a sudden influx of young Americans, some of them draft dodgers, on a smaller scale but similar to that which occurred in Amsterdam. And like Amsterdam, Antwerp became a centre for the peace movement in exile, a place in which to live out alternative lifestyles. A new kind of migrant population began to accumulate in the city; an internationally cultured, continuously changing, nomadic population of intelligent drop-outs and drifters; itinerant musicians, writers, poets and artists who tended to inhabit communes in the south of the city. For Panamarenko and his generation this influx afforded, for the first time, something of a genuine international context within which to think and work. Where the visual arts in Antwerp were concerned, this already rich cultural mix was further enhanced and given sharp focus with the opening in 1966 of the Wide White Space Gallery.

A key institution in the history of postwar art in Europe, Wide White Space Gallery was the product of a fortuitous marriage between Anny De Decker – an art historian and amateur journalist with a passionate enthusiasm for new art – and the young German artist, Bernd Lohaus – a student and friend of

Joseph Beuys, with a firsthand knowledge of art and the art world. Occupying part of the ground floor of one of the most extravagant Art Nouveau houses in Antwerp, the gallery was situated on the corner of *Schildersstraat* (Painters' Street) and *Plaatsnijdersstraat*, small roads that run to one side and cut across the back of the *Museum voor Schone Kunsten*. From the outset, its very existence had an undeniable air of provocation about it. Close by the most historically important exhibiting space in Antwerp, the new gallery was showing the most avant-garde art from Europe, America and the Far East. Recent exhibits in the older museum had included representative works by the early exponents of Belgian Modernism, artists like James Ensor and Constant Permeke, and the Belgian Surrealists René Magritte and Paul Delvaux. By contrast, the Wide White Space Gallery opened its doors with an evening of 'Happenings' by Hugo Heyrman, Bernd Lohaus and Panamarenko, and within the year it was to organise exhibitions by Marcel Broodthaers, Suhusaka Arakawa, Bernard Schultz, Blinky Palermo and Joseph Beuys as well as showing work by Karel Appel, Lucio Fontana and Piero Manzoni.

HAPPENINGS: THE FIRST PUBLIC WORKS

Stitched into the fabric of the politically reactive, liberating tendency that started with the American beat generation and came to its full fruition in the hippie movement was a close link with the young avant-garde artists and writers who were busy reshaping the mainstream of high culture on both sides of the Atlantic. This was particularly true of the emergent generation of artists in America – the post-Minimalists – and the more politically committed of the young Europeans, especially those from Italy and Germany who formed the tendency named by the critic Germano Celant, Arte Povera, and the group of young Düsseldorf-based artists who had gathered together around Joseph Beuys.

These different tendencies shared a determination to raise the question of 'form' as a pressing conceptual issue in reaction to the spareness and material asceticism of Minimalism. This commonality of focus was important because all three groups of artists were seeking to carry the question of 'form' beyond the limits placed upon it by the late modernist conflation of 'form' with 'style'; to lift it out of the aesthetic domain and to recast it, instead, almost as a political issue. We are speaking here, of course, of young American and European artists who belonged to the same generation as the revolutionary intellectuals who led the campus riots in the late 1960s at Ann

Arbor, University of California at Los Angeles and Kent State universities, and who organised the student occupations at the University of Paris, Cattolica in Milan and at the London School of Economics in London. It was this generation that raised the notion of individual freedom to the level of a preeminent political principle. And so the search for a new and more open definition of 'form' also became a search for languages that were capable of carrying the burden of representation in what was envisaged as a future, more open society: languages that would also be able to reflect the emerging, socially connected, construction of the self.

In the context of the visual arts, this led to a remarkable proliferation of ways of working and the invention of new categories of practice: new approaches to the generic disciplines of painting and sculpture; the use of film and new media; even a questioning of the necessity of the art object itself. In general though, out of a common tendency to foreground the act of making as a physical performance of some kind, this expansion of creative means carried with it a significant 'performative' aspect, and this was as true of the more process-based, experimental approaches to the generic practices of painting and sculpture, as it was of the new event-based forms themselves. However, in the 'Event Structures', 'Actions', 'Performances' and 'Happenings' of the time, the artist almost always appeared in person, either as performer or as a kind of *agent provocateur*. In the first instance, this was Panamarenko's chosen way of working. Towards the end of his time as an 'unofficial student' at the Higher Institute, it seems that Panamarenko had become caught up in this ferment of change. Within two years he was organising his own 'Happenings', working alongside Hugo Heyrman in the streets and open spaces of Antwerp. These were the earliest versions of what Panamarenko would later call the 'Milkyway Happenings' and they were usually curtailed abruptly by the police.[4]

It was at this time too that Panamarenko began to make regular contributions to *Happening News,* a journal published by him and his circle. His first published piece was an untitled collage made by cutting and pasting new fragments of text over a section of print taken from a newspaper that is sometimes referred to as the *Swiss Bicycle* (1965) collage. In many ways this work serves as an important pointer to future work. Both the superimposed texts and the image which gives it its name – a reconstructed, engraved advertisement of a Raleigh bicycle – seem almost to set the agenda for Panamarenko's work after 1967. The opening line of new text reads:

sculptors and // scholars, // stargazers, very simple // I need no
tubes nor // telescopes, for my gaze // itself is deep enough

and reading across the top of the collage:

> sculptors and // scholars, // Who knows anything // about the stars?
> Who can // commune with the universe // help me // Alladin //
> Genius-male American // wants to // the universe // learn to imitate
> the // flight of the birds /// and // glide with pleasure [5]

As Anny De Decker has always acknowledged, she opened the Wide White
Space Gallery as a direct response to the needs of the small group of artists
around Panamarenko and Heyrman who were regularly risking the wrath of
the Antwerp police by working in the city's streets. Speaking of the renting of
the space in *Plaatsnijdersstraat* she recalls: 'I suggested renting it so that they
could have their "Happenings" there. That way there wouldn't be any
interruptions, and they wouldn't have to run from the cops. They really did run
for it, in a big American car, with the cops hot on their tail. It was very funny.' [6]

 Panamarenko also had a hand in naming the gallery, with Anny De
Decker, Bernd Lohaus and Hugo Heyrman. Space happened to be the hot topic
of the moment and, by some strange quirk of history, their search for an
appropriate name coincided precisely with Yuri Gagarin's first manned space
flight. 'Suddenly', De Decker reminisces, 'space had become something
mysterious, an element which had only recently found its way into people's
consciousness.' The word 'space', then, was fairly easy to agree, but the use of
the word 'white' was the subject of more lengthy discussion. Panamarenko had
just started to use the prefix 'Milkyway' for his 'Happenings'. [7] But, according
to De Decker, this was only part of the story. They wanted, at all cost, to avoid
the middle-class imprint that characterised most galleries of that period. The
space was to be more like a workplace than a showroom and to paint the place
white was a sure way of achieving this. At that time, De Decker explains,
'white was something that only the poor used... We had "White Space", then
I thought of the alliteration "Wide White", even though it wasn't at all wide...
I saw the gallery rather as a mental space.' [8]

 The first show in the Wide White Space Gallery, described at
Panamarenko's instigation as *Milkyway Happenings*, opened on the evening
of 18 March 1966 and, alongside Panamarenko, included works and actions

by Heyrman and Lohaus. Panamarenko showed three pieces: the collage dated 1965, called *Embry Riddle* – also the name of the American University of Aeronautics – *Kreem-glace*, *(Ice cream)*, described in the catalogue as a 'readymade' and *Sneew, (Snow)*, both dated 1966. This last piece consisted of a pair of waterproof boots, a leather bag and a pile of tree branches cut to length, all covered with polyurethane foam to simulate snow, and it replaced the work announced in Panamarenko's section of the tripartite private view card *Panamarenko, Multimillionaire. Tree with Beautiful White Snow.* For the live work, Heyrman and Panamarenko dressed in beautifully cut, matching white double-breasted suits and Panamarenko blew large quantities of multi-coloured confetti into the air using a vacuum cleaner motor.

While it received little or no attention from the general public, the critical press or any but the most adventurous of the art world cognoscenti, this first public venture of the Wide White Space Gallery was nevertheless immensely important for the Antwerp art scene. The gallery was as much a meeting place as it was a space to make events or to show work, and it quickly attracted an international crowd. In the year that followed De Decker and Lohaus organised shows by Broodthaers, Arakawa and Schultz before opening a second show with Heyrman and Panamarenko in 1966, entitled *The First Mind Expansion in Colour.* The event was announced as a 'collaboration', but in reality comprised quite separate works. The two artists had decided in advance to make an exhibition of glamorous women and female film stars. Heyrman, as the painter, would provide flat images and Panamarenko, as the sculptor, would provide three-dimensional ones. In the event Panamarenko completed only two Styropor dolls, covered in felt and tailors' cotton and bearing the names *Feltra* and *Molly Peters.* Along with many young European artists of the period, both were fascinated by American Pop art, and these two 1966 works by Panamarenko seem to combine elements from the *Great American Nude* series by Tom Wesselmann and the Marilyn portraits of Andy Warhol – shown in Europe for the first time in 1966 – as well as the gravity-formed, soft sculptures of Claes Oldenburg. The influence of Oldenburg is apparent also in works from 1967, *Afwasbak (Sink with Dishes)* and *Cockpit* which was also included in an Accrochage at the Wide White Space Gallery in June 1967. In concert with the exhibition of paintings and sculptures, Panamarenko made a performance work which he referred to as a 'Stunt Happening'; which involved him firing a double-barrelled shotgun into a large steel cooking-pot full of hot chicken soup. This was advertised in

a self-consciously Pop art fashion, as 'een RIP! SLASH! WOOPS! Tentoonstelling (private view)' and was described as rather scary by those present.

As it turned out, this was the last of Panamarenko's 'Happenings', although he has continued from time to time to give event-based public lectures about his scientific theories and about space travel. Most of the works of the mid-1960s mark a transitional stage between work focused on the current concerns of the transatlantic art world and the emergence of a genuinely personal vision. Panamarenko says of his early works that he was reaching for success, a predisposition that he attributes to all young artists, and was, as he readily admits, overstriving into the bargain. He put the situation very clearly in an interview published in 1995. Asked about his earlier work, he stated:

> ...[it] was made from within a different mentality. Too much effort went into it. My urge to produce had me working frenetically – exhaustingly, but mainly academically. Composition and style were the main starting points. Now I concentrate on invention, on ideas. I have become more nonchalant, which has yielded room for adventure.[9]

The remarkable thing about Panamarenko's work in the late 1960s was that he was making startlingly original pieces alongside the more 'academic' Pop art influenced ones. The sculpture *Zwitserse Fiets, (Swiss Bicycle),* and the very distinctive *Das Flugzeug* (both 1967) – a vast, open, man-powered, twin-rotored flying machine with a bicycle seat and pedals at its centre – were quickly followed by the beached whale *Walvis* and the box-like and rather sinister *Prova-Car* of 1967, the forerunner of his rubber jet-powered car *Polistes* of 1974. This was the moment when Panamarenko began to move away from his contemporaries, initially in his changing attitude towards the use of material. Whereas in works like *Cockpit* and *Afwasbak*, the materials tended to be either descriptive or neutral in terms of the meanings of the works, in the new pieces they were required to contribute in both poetic and functional ways. If the *Swiss Bicycle* collage had effectively set out the issues Panamarenko would continue to address throughout his mature work, albeit in somewhat coded form, then several of the key works made between 1966 and 1970 show just as surely the beginnings of the complex language – somewhere between depiction and function, aesthetics and engineering – that was to characterise his later work.

By the start of 1967 Panamarenko had become acquainted with both Marcel Broodthaers and Joseph Beuys, mainly through their increased involvement in the activities of the Wide White Space Gallery. Anny De Decker had begun to be highly discriminating about the artists she was working with and it was this trio who were setting the pace. Although very different in character, the three artists found a common cause in a shared desire for works of art that would offer more than aesthetic elegance. They were suspicious of the smart reductivism of the new Conceptualism. They wanted an art that opened doors to new ideas, new forms and new types of experience, works of art that were more inclusive, that did and said something more.

Previously a poet and occasional critic, Marcel Broodthaers seemed to emerge into the art world of the mid-1960s almost fully formed as an artist. His first exhibition at the Wide White Space Gallery took place in May 1966, and it included some classic early works representing the main themes that preoccupied him throughout his working life. *Tour Marilyn* (1965), took a critical sideways glance at the vacuity, as he saw it, of American popular culture and *Grande Casserole de Moules (Large Pot with Mussels,* 1966) was one of the most ostentatious examples of his food-based critique of Belgian bourgeois life.

Although Broodthaers, born in 1924, was 15 years older than Panamarenko at the time of their meeting, he was hardly more experienced. Like Beuys he had lived through the Second World War and had come to art rather late. He had broken off his studies to work as a bank clerk before becoming a book dealer specialising in natural history and art. Panamarenko remembers him as a highly intelligent, sensitive and amusing man, extremely well-read and capable of setting any conversation alight with his wit and political passion.

By far the most important meeting from Panamarenko's point of view was with Joseph Beuys. In June 1967 Panamarenko travelled to Düsseldorf with Bernd Lohaus to visit Beuys, whose work had been shown in a mixed exhibition at the Wide White Space Gallery during the previous year. Even before they set off, there was an air of anticipation about this meeting. As it turned out it was very much a coming together of equals, and Beuys, who was then Professor of Monumental Sculpture at the Staatliche Kunstakademie in Düsseldorf, immediately invited the young Belgian artist to make an exhibition, an invitation that he was to take up the following year, in June 1968.

Although today, when he speaks of Joseph Beuys, Panamarenko is careful to make a clear distinction between the later, internationally successful, ever self-promoting Joseph Beuys and the Beuys of the late 1960s, he still speaks of him with real affection. When they met, the German artist, almost 20 years older than Panamarenko, was just beginning to make a mark for himself. According to Panamarenko, it was already clear that he had some idea about what a new approach to art might entail. This was the Joseph Beuys of the 'Actions' period. He was still fully engaged as a teacher, doing his performance/lectures and attracting great crowds of students to 'teach-ins' at the Academy. He had already performed *Das Schweigen von Marcel Duchamp wird überbewertet*, *(The Silence of Marcel Duchamp is Overrated)* in 1964 and *Eurasia* in 1963, the latter now widely recognised as a seminal 'Action Work' in which he held a conversation with a dead hare while at the same time manipulating its body using long pieces of wood. In Antwerp in 1968 he performed another classic 'Action Work', first made in the same year in Vienna, the sombre, shamanistic, *Eurasienstab*. This was also the time when Beuys was beginning to formulate what he was later to describe as 'a new, expanded definition of the work of art'. And here we can begin to discern some interesting parallels with Panamarenko.

Just as the young Belgian artist had spent time in the early 1960s reading widely in the natural sciences, so Beuys, prior to his enrollment as a student at the Düsseldorf Akademie had studied the history of science and natural philosophy from the alchemists to the present day. His approach though, was altogether more mystical than that of Panamarenko. Where the Belgian stayed very close to the tradition of the hard sciences, which for him afforded mysteries enough, Beuys allowed his interest to range widely over such arcane curiosities as theosophy, gnosticism and the anthroposophical writings of Rudolph Steiner. Nevertheless, there was clearly an important point of connection between the two men. Each had begun to see the limitation involved in art which had become separated from science. Both, it seems, felt a keen sense of dissatisfaction with what they saw as the reductive impasse arising out of the modernist pursuit of style. When Beuys organised Panamarenko's exhibition in Düsseldorf in 1968, it was a clear indication of his respect for the young artist whose work already demonstrated something of the quality that Beuys himself was seeking in his pursuit of a new, 'expanded definition of the work of art'.

Although the two men had something in common in terms of their attitude to 'making' which involved enquiry and invention – a quality, according to Panamarenko, that Beuys lost as he became more and more

successful – there were crucial differences when it came down to their specific interests. Where Beuys clung to the pre-romantic notion of the 'natura artifex', the idea that works of art obey or are caused out of the being of the artist, with all of the moral and ethical ambivalences that such a notion implies, and invoked something of the atmosphere of the Goetherian *Sturm und Drang*, Panamarenko, from the outset, seems to have been highly sceptical about art as 'affect' and 'expression'. Where Beuys was determined to recast the purpose of art as a reforming force of some kind, Panamarenko – although he was by no means indifferent to political questions – was also keenly aware of the limitations of art in general to influence social life and, in particular, of works of art to carry political messages. In this important respect, if in no other, the two men were facing in opposite directions. Where Beuys was continually seeking ways to extend the effective life of art into the social and political domain, Panamarenko seemed increasingly to want to confine the work of art to material and practical constraints, even to require some limited function from it by subjecting it to processes of empirical testing of various kinds.

It would, of course, be profoundly misleading to suggest that either Marcel Broodthaers or Joseph Beuys influenced the young Panamarenko in anything other than the most general sense – or, indeed, that Panamarenko had influenced them. They were all three very distinctive characters: Broodthaers at that time was still a very bookish man, the intellectual of De Decker's trio of gallery artists; Beuys was the charismatic teacher and political activist, while Panamarenko was gifted with remarkable intuition and a fund of practical intelligence. Nevertheless, something of great importance occurred between these three artists, something which can perhaps best be described as a tacitly-agreed, shared ambition for the redefinition of the work of art itself.

THE ARTIST AS INVENTOR

Significantly, it was Panamarenko's enormous, deconstructed, or to be more precise 'hybridised', pedal-powered helicopter-cum-aeroplane *Das Flugzeug* – occupying a space 16 by 7 metres – which formed the central focus of the 1968 Düsseldorf exhibition. This was the first public showing of what is now widely recognised as the most formative of Panamarenko's early works. Out of its sheer inventiveness, *Das Flugzeug* seems to open up many of the themes and strategies of making that would come to distinguish his work.

As we have seen, Panamarenko sets great store by the notion of 'invention' which, in the interview quoted earlier, he sets in critical opposition to what he calls 'the academic'. But even with a spectacular example like *Das Flugzeug* before us, Panamarenko's use of the term is still not easy to comprehend. In English usage, current understanding of the term tends very much towards the utilitarian. In the contemporary sense, an inventor originates solutions according to specific practical problems; the trajectory is towards an applied outcome of some kind. But if we reach back to a time before the mid-nineteenth century we find a fuller definition. Here, the meaning of the term is firmly attached to the workings of the imagination. This takes us much closer to Panamarenko's understanding of 'invention' but for him the word is linked to the idea of adventure, furthermore, adventure with a process of exploration and discovery. It points away from what is already known or understood, towards the 'hardly probable' or the 'merely possible'. Thus material engagement towards an aesthetic objective, alone, will never yield up 'invention'.

The intention might well be to 'invent' a machine that can fly, but this intention can only exist, in the first instance, as a vacancy remaining to be filled. As the French philosopher and phenomenologist Maurice Merleau-Ponty has argued, real 'invention' starts from a spatial intuition. It proceeds from an 'absence' to become the 'real stuff of knowledge'. It has no prior existence except as an imaginative impulse of a certain kind. In Merleau-Ponty's words: '...it is in the experience of the thing itself that the reflective ideal of positing thought has its basis.'[10]

This statement is an almost perfect description of Panamarenko's notion of 'invention' as creative method because for him 'inventive' thinking must be invested in something, it must be realised in some way. Thus when Panamarenko speaks of his machines as 'working', he is not simply talking about function – although this is of enormous importance to him – but about the way in which a whole trajectory of new thought, aimed at an empty location of a certain kind, the journey into the unknown, the 'adventure', becomes embedded in or embodied by a thing. Even if this trajectory is never completed and the flying machine, despite repeated attempts at improving the technology, fails to get off the ground, the concept together with the material engagement with the 'thing itself', will lend it an undeniable sense of purpose. It will make it intelligible, both as an object of technology and as an 'object of knowledge' in the Merleau-Pontian sense. Most important of all, it achieves an independent existence as what might best be described as a radically de-styled

work of art. After 1969, it becomes inappropriate to categorise Panamarenko's works according to their appearance within some overarching notion of his development as an artist. We must look at them instead as types and categories of things, whether aeroplanes or birds, insects or cars.

THE VISIONARY, THE ARTIST, THE SCIENTIST, THE TECHNOLOGIST

The impetus underlying Panamarenko's approach to work is a somewhat sceptical one, and his scepticism is directed at the institutions of both science and art. In this respect it is part of an important and still current strand of scepticism in the complex weave which forms the history of ideas in the postwar period.

By the late 1960s Panamarenko had embarked on what was arguably the most formative period of his work. By this time, the most basic assumptions of science – its institutionalised forms and routine methodologies – were being questioned by a generation intent upon pursuing their dreams rather than acquiescing in the face of a technology-driven, steadily intensifying Cold War. In the field of art, this same spirit was manifest as a root and branch attack upon the modernist conception of relationship, upon the idea that in some profound sense art should demonstrate belief in a world, even a universe, that was potentially analysable, describable and measurable in its entirety. And this sceptical outlook extended to the nature of human existence. Rapid advances in the social sciences were leading individuals to question the biologically singular and rationalist construction of the human subject. For a brief historical moment it looked as though there were no certainties any more; it seemed that everything was up for grabs.

Viewed in this light, the latter-day beatniks and hippies were not, as they are so often painted, simply a generation of young Americans fleeing from the 'draft', able to mobilise like-minded people of the same age-group at home in the States, Europe and Japan. They were a generation in revolt against a particular definition of the human subject so graphically described by W. H. Whyte in his cult book of 1963, *The Organization Man*. Their author-heroes were people like Aldous Huxley, Timothy Leary, R.D. Laing, Alan Watts and Carlos Casteneda, all of them advocates of changed states of consciousness. In place of the malleable, corporate minded, would-be young executives envisaged by Whyte, there would come into existence a new breed of human beings, equipped with a vastly expanded consciousness.

Significantly, Panamarenko used his 'Nailati Efil' symbol, the sign of the peyote cactus so beloved of Casteneda's shamanistic hero Don Juan,[11] for the first time in 1967 on a series of studies he made for the *Prova-Car*, some three years in advance of the publication of Castaneda's first book. It appears thereafter on several of the early drawings, including one of *The Aeromodeller*. The reversal of the phrase 'Italian Life', 'Nailati Efil' – apparently a reference to Federico Fellini's film *La Dolce Vita* – was linked to the image of the powerfully hallucinogenic peyote cactus. With its associated dreams of mood enhancement, fantastic transports and ephemeral delights, it has shades of the Lotus Eaters about it. But as usual with Panamarenko, it is glossed with a distinctly Northern European brand of irony. According to Panamarenko, the crew that will eventually experience interstellar flight in his spaceship, *Ferro Lusto X*, will consume crushed peyote cactus washed down by an alcoholic drink made of potato and peyote cactus peels. They will never suffer from hangovers because the pleasurable effects of the peyote juice will last much longer than the unpleasant effects of excess alcohol: 'All [the] harmful effects that are usually caused by the lack of serotonin are broken down by the longer working alkaloids in the peyote peels.'[12]

In many ways the ongoing project *Ferro Lusto X*, which first appears in drawings and small models made in the 1970s, represents a desire for completeness which is characteristic of all Panamarenko's work.[13] Even after the shell of the spaceship – the spherical hold that provides the astronauts' living quarters and the surrounding inverted saucer-shape designed to produce the necessary lift – was completed in 1997, there remained the task of perfecting the *Bing* motors, the power-units required to accelerate the spacecraft.[14] That Panamarenko should also have given consideration to the daily nourishment and, by implication, the physical and mental well-being of the crew is typical of the way in which, over time, he works to develop the vision implicit in each of his projects. But as usual, the search for solutions has consequences beyond the *Ferro Lusto X* itself. For example, the dialectic of chemical oppositions in Panamarenko's simultaneously hangover-inducing and hangover curing beverage – soul food of the astronauts – leads us to consideration of one of his most frequently adopted conceptual methods, the privileging of a logical deduction over a scientific fact, especially when the scientific fact might prove a bar to what he sees as real 'invention'.

Panamarenko invoked the same principle when working on another key early work, the model airship *General Spinaxis* (1968), the final, full-scale

version of which was installed outside Bremen airport, Germany, in 1978. He was quick to realise that if *General Spinaxis* – intended from the outset as a solar-powered craft – was ever to get off the ground, it would require a mechanically-assisted power-unit of some kind, and this led him to the important speculative principle he called 'The Closed Systems Theory', which he refers to as a theoretically 'schoolish' precursor of *Toymodel of Space.*

The term and the principle are borrowed from thermodynamics. 'Closed' systems can exchange energy with their surroundings without any material transaction taking place – a theory which allowed Panamarenko to play with the possibility of separating coexistent, mutually interactive forces in such a way as to enable them to act independently of each other. In the case of a child's spinning-top, for example, there is the energy which sustains its revolutionary motion around the vertical axis and the energy which can drive it horizontally across a surface. Half the kinetic energy is used in maintaining rotation, while the other half is used up by its forward motion. Panamarenko often explains this by referring to the slow flight of a helicopter, the rotor of which comprises a fast-moving, advancing blade and a lagging blade thus halving the kinetic energy available for forward flight. In 'The Closed Systems Theory', Panamarenko suggested, that it should be possible to separate out these two functions of kinetic energy and use one of them to power a spacecraft. At first sight the mechanical principle seemed to be very simple: to impart spin to an object by 'giving it a push outside of its centre of gravity'. At the time he believed that application of this principle could provide the basis for an object that was capable of continuous acceleration within a 'closed system'. Later on he was to conclude that theoretically it was a good deal more complex than that.

The vision conjured up by this early theoretical model is not far removed from the images of flying saucers familiar from science-fiction movies, mysteriously agile, fast-moving rotational crafts, capable of accelerating with ease beyond the speed of light. But Panamarenko's version is more like a dumbbell, with two or sometimes four equal volumes joined by a bar or crossbar passing through a fixed centre of rotation. In a drawing of 1975 he shows a finger and a thumb flicking it into motion: the artist's own hand exercising an imperious, casual, almost God-like gesture.[15]

'The Closed Systems Theory' continued to preoccupy Panamarenko and in the mid-1970s he linked it to Einstein's Special Theory of Relativity. This was an important step on the way to a videowork of 1992 called *Toymodel of Space,* in which Panamarenko is seen sitting in the pilot's seat of his *V1 Barada Jet,* a

small, balsa-wood, single seater, V2-style jet with sawn-off wings, discoursing on the nature of the universe. The declared intention behind *Toymodel of Space*, as stated on the midnight-blue cover of the box containing the tape, is to reveal the 'mechanical model behind Quantum', a proposition which at first seems quite breathtaking. Panamarenko was offering *Toymodel of Space* as a new approach to understanding the workings of the universe at both the micro and macro levels, proposing that it would side-step some of the most persistent theoretical contradictions of post-Einsteinian physics and, on the practical side, afford new principles for the construction of space vehicles capable of interstellar and intergalactic flight – 'real space travel' as he calls it. This was a hugely ambitious claim, by any standards. However, it is important to see *Toymodel of Space* and its underlying argument as part of a much bigger theoretical picture, which starts with Panamarenko's long-standing preference for pre-Einsteinian physics.[16]

As so much of his work clearly demonstrates, over the years Panamarenko has maintained a continuing interest in electromagnetism. In conversation, he will often refer to the nineteenth-century French mathematician and astronomer Jules Henri Poincaré, author of one of the most important treatises on the subject.[17] The earliest of Panamarenko's works in which he sought to harness electromagnetic energy directly for the purpose of levitating an object, making it hover or fly, were *Magnetische Velden*, *(Magnetic Fields)* of 1979 – the prototype magnetic-field generator and precursor of the *Plumbiet* motors designed to raise steel plates – and the far more elegant *Vliegende Schotel*, *(Flying Saucer)*, a model magnetic-field generator made in 1979 and designed to levitate a tiny flying saucer. Both of these works explicitly underline the fact that one of Panamarenko's main concerns, and one he has returned to over and over again during his working life, is to discover or devise an energy source powerful enough to lift a spaceship beyond the earth's atmosphere and gravitational pull. Alongside other works they indicate that he has continued to view electromagnetism as offering the best chance of success. Between 1980 and 1984 he produced a whole series of models and prototypes using electromagnetism, amongst them the two versions of the *Flying Cigar Called Flying Tiger,* an electromagnetic device capable of riding its own energy field. Other examples included *Relativistische Motor. Experiment voor Ruimteschip, (Relativistic Motor. Experiment for Spaceship),* the series of *Gyro-Efflux* model transporter-crafts, and the *Plumbiets,* magnetic, monopole motors, including the *Grote Plumbiet, (Big Plumbiet)* which had its field trial with terrifying results in 1984.

But Panamarenko's preference for electromagnetism over Relativity is not, perhaps, as contrary as it first appears. He has frequently argued that there is nothing in Einstein's theory which was not already present through the study of electromagnetism. Strangely, rather than carrying him further away, this view takes him closer to Einstein. It is no secret that Einstein looked upon Poincaré's treatise and his work in thermodynamics as predictive of his own theory. But there are links with other theoretical forerunners of Relativity Theory, too. Reading Panamarenko's cryptic introduction to *Toymodel of Space* and looking at his notes and drawings which appear in his *Blue Book* published in 1975, we can detect at least two more influential figures who were also of great interest to Einstein: the Scottish physicist James Clerk Maxwell[18] – favourite scientist of Alfred Jarry,[19] the originator of pataphysics – whose curiously confused but highly imaginative speculations concerned the nature of magnetic fields and the celebrated German physicist, Ernst Mach,[20] who gave his name to the ratio of speed to sound in the course of a body passing through air, and whose theorising of 'inertia' as part of his work on the 'science of projectiles' is undisputed even today.

It seems that while there is certainly an intended provocation in Panamarenko's questioning of Einstein, he considers there are also adequate scientific grounds for so doing. Einstein's model of the universe, as it emerges from his Special Theory of Relativity, places the three elements of space, time and gravity at its centre; with gravity functioning as a kind of universal glue holding the whole elaborate edifice together. According to Panamarenko there is a paradox in the fact that all of it is determined by gravity, but in a curiously indeterminate way. Everything is acted upon by everything else and yet everything is supposed to work in concert with everything else, producing a conflict between rules and events. The invisible, so called 'massive bodies', supposed to create the huge gravitational forces upon which the whole thing depends, are only the start of the problem, first in a long list of the unobserved and unobservable.

As with all 'grand' models, Relativity Theory also left in its wake some very prominent theoretical loose ends. Einstein was himself conscious of a problem arising out 'field theory' and spent the last years of his life searching, unsuccessfully, for a unifying formula that would draw together the three predominant energy systems: gravity, electromagnetism and thermodynamics. Add to this the so-called last great unsolved mystery, the problem of time: whether, in contradiction to many of the greatest thinkers of modern physics,

including Isaac Newton, Einstein himself, Werner Heisenberg and Erwin Schrödinger; time has direction as suggested by the Second Law of Thermodynamics. Then we can see that Einstein's view of universal order is built upon a far from perfect or complete theoretical terrain.[21]

For Panamarenko the problem lies in the complexity of the model, especially when it is linked with Quantum Theory.[22] He argues – and it is a view which also has adherents even within the rarefied world of particle physics – that the true picture of the natural world must be more simple and therefore more miraculous than this.[23] Beyond this founding intuition – the desire for greater simplicity – there must also be a practical outcome of some kind. In the case of Panamarenko's videowork *Toymodel of Space* of 1992, the introductory notes which appear on the cover make clear his intuitional impetus. Despite the abstractions heaped upon our idea of the physical universe by Quantum, there must be a 'mechanics' governing its physical attributes and the behaviour of its various substantial parts. Panamarenko's practical objective in *Toymodel in Space* can also be stated very simply to achieve 'real', manned space flight by harnessing the forces already operating in the universe. This leads Panamarenko to adopt an oddly original mechanical principle by reconceptualising the relationship between 'intertia' – resistance to motion – and 'mass' – potential stored energy.

According to Panamarenko's account given in *Toymodel*, all rotating objects that have weight and mass, from the smallest neutron to the largest of stars, 'roll'. 'Stars', Panamarenko argues, roll 'like a wheel on THE SPACE FIELD.' Just as the looping dumb-bell-like form he drew in the lithoprint *Atom and Manpower* of 1975, propelled by the flick of a finger, has a leading and a following 'mass', so stars have a fast and a slow edge. According to the 'Lorentz Transformation' the fast side will contract producing a clear differential between the two sides in terms of 'mass', 'time', and 'length'. This in turn produces a circling motion, an orbit which is entirely geometric in nature. The principle is very clearly stated at the bottom of the print:

> A rotating object with a forward speed has two different sides, parallel to the direction of its forward motion. A slow and a fast side. The fast side will contract. An electron is therefore not attracted by i[t]s nucleus but follows a circular path along its contracted side. An object travelling this way will not follow Newton's laws because it will not keep its direction of impulse.

The mechanical principle of 'rolling' allows an object to attain orbit without requiring the pull of gravity.

Panamarenko's desire to escape or oppose the force of gravity is an ambition which has never left him. According to Hans Theys, Panamarenko once said that he believed the 'highest purpose one can have is to devise a way to leave the earth'.[24] As always with Panamarenko the conversational irony is not practised for its own sake, but is intended to point towards a practice of a different kind, the making of things which of themselves are not particularly ironic. This translation of the ironic perspective is at work in very early pieces like the drawings and maquettes for the projected *Reuzeboom (Giant Tree)* of 1969, where it shows itself as a mechanistic imitation of natural forces. The tree of the title takes on the appearance of a fountain, the water turned to ice creating a static tracery in mid-air. But we can also see it in more recent works like *Catapult Max* of 1997 or the aquatic scooter, *Noord Zee Pedalo (North Sea Pedalo)* made in 1994, where it takes a rather different form. Here the irony is dressed up in a comedy of consequences which snaps immediately into place as soon as you begin to imagine yourself using one of these machines, zooming up and down, strapped to an elastic-driven gyro, for instance, or being propelled through the waves on a cold, wet, solitary journey across the North Sea.

Whatever form the ironic impulse takes in Panamarenko's work, the dream of flight – the desire to escape the forces that hold us earthbound – is almost always present, tempered by a shrewd assessment of the practicalities of the project. If it were not for this hard, experimental edge to Panamarenko's work it would be little more than a romantic, even childlike preoccupation with the idea of flight of the kind that surfaced in so many popular cultural icons of the 1970s.

Already by 1969, year of the Anglo-French Concorde's first supersonic flight and of the first moon landing, space had become media territory and the 'final frontier' had been rendered permeable. After the Russian Yuri Gagarin's first manned space flight in 1962 the Americans had quickly seized back the initiative in the space race and had begun to exploit its potential as a political metaphor for human freedom in the propaganda war. By the time Neil Armstrong stamped the first bootprint on the lunar dust – an event Panamarenko marked with a lecture on his project for *The Aeromodeller* given at his 'Art Institute' A379089 – space had become an integral part of the transatlantic media circus.

Within ten years, orbiting satellites, men, women and space vehicles of different kinds, as well as the launching of ambitious scientific probes intended to inform us about the furthest reaches of our galaxy, had become commonplace items of news.

While the breakthroughs in the exploration of space undoubtedly provided Panamarenko with a new reservoir of imagery which surfaces in works like *Raket* (1969)– the 'one-seat rocket' with its strange array of remote power units – and the more practical looking *Portable Air Transport 1* (1969) which has something of the skeletal appearance of a real lunar module, his interest is at once more serious and more genuinely experimental than a superficial engagement with the popular imagery of space travel could allow. Significantly, between 1969, when Panamarenko made the *Portable Air Transports*, and 1971 when he attempted to inflate the completed *Aeromodeller* in a field near the Belgian village of Balen-Nethe, he was almost entirely preoccupied with the invention of electronic devices – motors and power-units of different kinds – as well as the long series of experimental *Versnellers, (Accelerators)*, with which he aimed to achieve the high speeds necessary to leave the earth's atmosphere.

We can detect a certain pattern here which repeats itself in Panamarenko's working life, an oscillation between grand projects for flying machines and a concern with more down-to-earth technical problems. This very intensive period of work served to establish the experimental, technological pole of his project as a counterbalance to his more fanciful and imaginative concerns. Indeed, the coincidence between the making of the sixteenth and final version of the *Versnellers* and completion of the great inflatable, semi-transparent pupa – the airship *Aeromodeller* – with its gondola topped by four co-active Flymo engines, can be seen as mapping the conceptual boundaries of Panamarenko's project: the development of a visual poetics of flight, bridging the gap between technology and nature; between aeronautical engineering and the natural mechanics of flight; between art and science.

In the 12 months following the attempted launch of *The Aeromodeller* Panamarenko entered a period of intense activity. The first major work to emerge, the pedal-powered, ominously threatening *Donderwolk, (Thundercloud)*, which employed Panamarenko's cloth-covered version of a kite-shaped 'Regallo' wing, was followed in 1972 by the more elegant pedal-powered aeroplane, *U-Kontrol III* and, the three wing-flapping *Meganeudons* (1972–73), mechanical, four-winged creatures with which Panamarenko sought to imitate the flight mechanics of the insect species hypenoptera.

The argument concerning the relative values of nature and art is first articulated in the context of western European culture by the Greeks. Aristotle cites Plato's *Laws,* where Plato argues that all things are produced either by nature, by chance or by art.[25] The 'greatest and the fairest' are produced out of the first two – nature and chance – and the 'lesser and least fair' by art. Art, Plato suggests, cannot even manage to reproduce the web of a spider or the nest of the smallest bird with the 'beauty and appropriateness of its purpose'. Significantly, the argument is not simply about the beauty of appearances, but incorporates a notion of function, and this is where art is manifestly inferior both to nature and to chance. In so far as 'purposefulness' is bestowed by the gods, art is quite simply incapable of it, and therefore bound, unavoidably, to deception, pretence and artifice.

In the modern period the particularity of the argument has been submerged in the debate on representation. In so far as works of art partake of much larger signifying systems that bridge nature and manufacture, they might be seen as 'purposeful'. Beyond this, works of art in themselves, by definition, are without purpose. But rather than concerning himself with the values of art, Plato was trying to see where art stood in relationship to values derived from the natural order of things, and he found art lacking an evolutionary dimension. For today's inhabitants of a universe which is, according to contemporary science, in the deeper sense 'unfinished', there is something very sympathetic about this formulation. Indeed we might see it as pointing the way towards an idea of creativity which is less static and much broader in scope than is suggested by the modernist inheritance – one that functions at a point of reconciliation between the human subject and nature, on the one hand, and nature and technology on the other.

Panamarenko was, from the very beginning, involved in a search for a new, more open, definition of the work of art. With the making of the three insect-like *Meganeudons*, a theme surfaced in his work which is related to this objective. It is perhaps best described as an interest in 'mechanical and technical naturalism', or the attempt to make engineering and technology behave like nature.

Panamarenko's interest in natural history began in childhood and led into an interest in science and the systematic mapping of the natural world. It has become in the fullest sense a *habitus,* a place in which to dwell both physically and intellectually. The first floor of the house in Antwerp where he

lives and works has been transformed into a tropical plant house, filled with all kinds of exotic birds, fish and insects which have, over the years, become an integral part of Panamarenko's working life.

As a consequence, there is a closeness about his engagement with nature which transcends the scholarly, and which is entirely devoid of sentimentality. Panamarenko converses with nature in the old-fashioned sense and the observations mirrored in his work are informed by firsthand experience of its creatures. Works like the *Meganeudons* and the much later series of birds, the primeval *Archaeopteryx*, made in 1990 and 1991, clearly derive from an intimate knowledge of the natural world. However, in line with the Platonic distinction between appearances and purpose, Panamarenko is not primarily concerned with mimesis but with mechanical principles. He has no intention of producing a machine that simply looks like an insect of a bird, or even one that, in its totality, behaves like one. His real interest lies in inventing or discovering equivalent technologies.

With the *Meganeudons*, Panamarenko was trying to extrapolate from the natural mechanics of the insect species hypenoptera a principle that might be applied in the building of an effective, load-bearing flying machine, and it was a particular character of wing action, an extremely rapid flapping motion that Panamarenko was after. The first of the three versions used pedal power. The second, which in its trials achieved a wing-beat in excess of 50 beats per second, was powered by electricity. The third and most sophisticated model returned to the basic bicycle format, this time incorporating a more advanced drive mechanism enabling it to maintain maximum, regulated motion of its twin, reinforced glass-fibre wings. In the case of *Meganeudon III,* having recognised that the speed of the wing-beat was the crucial factor, Panamarenko opted for a rapidly rotating fly-wheel designed to convert the effort of the pedalling pilot into something approaching a high-speed vibration. The effectiveness of such a device depended upon the speed with which the mechanism, after each downbeat, returns the wings to their original position, achieved here by the use of springs that re-engage after each stroke.

Despite its technological sophistication, *Meganeudon III* could only approximate rather than replicate the wing-action of the hypenoptera. In this respect, Panamarenko knows full well that his search for a 'natural mechanics' is unavoidably ironic. The tiny wings of the hypenoptera are at once the most intricate and most fragile of things, and their capabilities are infinitely more varied and complex than anything the *Meganeudons* might achieve. By setting

his sights on achieving this degree of mechanical and technical efficiency, he is knowingly seeking to act outside of the scope of normal human capabilities. By deploying such grand irony, Panamarenko condemns himself to a measured form of comic brutality. Even when static, the grotesquely large wings of the *Meganeudons* stand as a cruel parody of natural flight. This returns us full-circle to the performative aspects of Panamarenko's work. In designing, making and testing his machines, he performs his irony rather than just uttering it. If his venture happens ultimately to be futile, as with the imitation of the wing-action of the hypenoptera, he is concerned to demonstrate its futility. And as witnesses we are expected to accept the attempt in good faith.

The mechanical principle explored by Panamarenko in *Meganeudon III* took on a new lease of life with the series of works called the *Umbillys* (1976–84). In the most mechanically refined version, *Umbilly I,* he used more powerful springs and the connection of these springs to the drive mechanism involved a repeating process of severance – hence the title *Umbilly* – from 'umbilicus'. At first sight, the *Umbillys* also have something of the appearance of grounded insects, of feeding mosquitoes. A compact body carries both the pilot's seat and the mechanical apparatus, with the wings hoisted high up to the rear. But further examination shows that this animistic dimension resides only in the details. The rest, it would seem, is nothing more than straightforward engineering.

As we have seen, Panamarenko expressed his desire to 'fly like a bird' as early as the *Swiss Bicycle* collage published in *Happening News* of 1967. Unlike his ongoing project, the spaceship *Ferro Lusto X,* which seems to speak of a rather jolly, half-intoxicated, type of communal activity, solo flight suggests an entirely different kind of ecstasy. Following on from the *Meganeudons* and the *Umbillys* were a whole range of works which aimed to achieve this, including the *Rugzaks, (Rucksacks)* and the *Pastillemotors*. These last two series, starting in 1984 with the *Groene-Rugzak, (Green Rucksack)* and ending in 1987 with the last of the *Pastillemotors,* represent Panamarenko's most serious attempt at building a lightweight power-pack that would allow him to experience a highly individualised form of flight approaching that of the birds.

According to Propertius, the Athenian playwright Aristophanes was fond of asking the rhetorical question, 'when will men be most unlike themselves?', and in response to the puzzled looks of those around him, providing his own answer, 'when they learn how to fly like birds'.[26] He was to a degree speaking metaphorically, of human bondage and of the human desire for freedom, suggesting that freedom is to be measured against a lack of self-

sufficiency. But if we are to learn to fly like birds there is a price to be paid: we must learn to accept life as a solitary performance, as an endless peregrination, as an aerial arabesque, as an inscription of some kind. This is where the necessities of nature draw very close to the condition of language.

The dream of freedom that came to characterise Panamarenko's generation during the political protests of the late 1960s led to a search for new languages that would reflect the needs and desires of a more liberated human subject. We might think that Panamarenko's dream of solitary flight, is an extension of precisely this kind of optimistic search. That his dream has become tinged with a certain knowingness, has gained a more distanced, ironic tone, is by no means surprising. For humankind, unaided flight can have no reality except as metaphor. But this is a metaphor which Panamarenko has chosen to inhabit.

In the last few years Panamarenko has made two self-portraits. In a typically Belgian turn of phrase he refers to them as 'puppets'. *Pepto Bismo*, completed in 1996, is a human helicopter with multiple rotors that is, quite literally, wearing Panamarenko's clothes. In the more recently completed *Aero Pedalo No. 9* he is strapped into a back-pack power system with a single, large propeller blade, about to be raised off the ground by a mattress-like, free-fall parachute. Here, metaphor is no longer simply a product of the poetic imagination, but by projection it has discovered a new location in space. Curiously, the fact that as 'puppets' they are inescapably attached to the earth renders them even more potent as images of solo flight. We find ourselves responding to an almost childlike need not to see. As with Antoine de Saint-Exupéry's *Little Prince* we find ourselves screwing up our eyes and chanting 'What is essential is invisible to the eye.'[27]

THE PARADOX: SCIENCE TRUTH OR SCIENCE FICTION?

Between 1986 and 1989, despite focusing much of his attention on the flying *Rucksacks* and the *Pastillemotors*, Panamarenko also completed a number of important works based upon the idea of a single-seater, rotor-driven aircraft or helicopter. The most unusual of these was a 'crash-proof' flying machine called *Paradox* which Panamarenko worked on over a six-year period, completing it in 1986. Although it had existed as a submerged element in his work as early as *Das Flugzeug* of 1967, paradox emerged as a fully fledged theme first time in two drawings from 1975, *OO. P. Z. Paradox* and *'Paradox II' Ship*, and again in two models for large-scale works made in 1980: *Paradox met Koepel (Paradox with*

Cupola) and *Experiment II, Paradox.* An oddly truncated, rather comical machine, *Paradox* is a cross between an insect and fish, helicopter and landing module, the very embodiment of the deeply contradictory nature suggested by its title. Panamarenko's aim in these projects was to make a machine that could raise itself off the ground and against the pull of gravity on an upward air current of its own making using nothing but an attached parachute. As with the airship, *General Spinaxis*, Panamarenko was privileging logic over science. There would seem to be no apparent reason why a machine should not be able to raise itself up in unassisted flight, and then descend safely using nothing but its own parachute. However, from a scientific point of view, the proposition is thought to be impossible in terms of any real technology of flight, hence Panamarenko's ironic addition of the term 'crash-proof' to their titles. As Hans Theys has pointed out,[28] in so far as they explore a similar kind of logical lacuna, the *Paradox* machines are very close in spirit to 'The Closed Systems Theory'. But they also take the argument further, carrying Panamarenko's scientific scepticism forward into the realm of a real and conspicuously practical form of poesis.

In conversation with those who are coming to Panamarenko's work for the first time, the question as to whether his machines are intended to work is almost invariably followed by a similarly sceptical questioning of his knowledge of mathematics and science. Panamarenko clearly knows a great deal about mathematics and science, but he does not feel bound by the truths that are routinely validated by the institutions of science. For Panamarenko, science is a domain to which he has the right of access, according to his own intelligent interests and needs. As with the art world, he does not have to join the club. As the term 'paradox' suggests, he wishes to retain the possibility of coexistent and opposing truths.

In so far as they embody a contradiction between what we might call 'scratch thought', seen as a basic human activity, and a view which is derived from science textbooks, the *Paradox* machines might be viewed as deliberately perverse. In so far as they employ the idea of paradox in order to unpick the uncertainties of the scientific paradigm itself, we might view them as delivering an important corrective to the perceived authority of science.

Closely related to the two 'paradox' drawings of 1975, *Bernouilli*, completed in 1995, carries the gentle absurdities of the earlier *Paradox* machine to a new level. An airy, elegant, almost insubstantial piece, it is at once the most grounded, most earthbound thing, and yet the most buoyant. Its platform and

power-unit straddle two diamond-shaped, wire mesh cages enclosing twin rotor-blades, used to raise aloft two large air-filled balloons made of translucent PVC, charged with the impossible task of lifting the whole apparatus, pilot and all, off the ground. When exhibited it stretches between floor and ceiling, as if to emphasise the opposing nature of the forces that hold it in place. This is a flying machine that is going nowhere, that has nowhere to go.

More than any other of Panamarenko's later works *Bernouilli* demonstrates his approach to air as a medium, as the stuff of sculpture. This leads us to the consideration of a very different kind of paradox which emerged first of all with stunning clarity but in a more literal form in *The Aeromodeller*. The title refers not only to the actual work, but also refers back to Panamarenko himself. He is 'The Aeromodeller'. Furthermore, as a thing, *The Aeromodeller* is very clearly shaped by the element it is intended to inhabit. It models air just as surely as it is modelled by air, and in this duality we discover a kind of elemental poesis. Now the element of paradox has become in truth a paradox of the kind originally set down by Zeno, the *reductio ad absurdum* of spaces within spaces, the moving arrow that is forever still.[29] In both *The Aeromodeller* and *Bernouilli* this very sophisticated game – the playing off of elemental transience and formal ambiguity – is given increased poetic impetus because it is tied to a rather primitive, slightly comedic, even self-defeating technology.

We can see the same principle at work in another of Panamarenko's later works, the submarine *Panama, Spitsbergen, Nova Zemblaya*. Far from being the sleek and deadly modern nuclear craft that is now familiar to us, it is rather a snub-nosed, pot-bellied thing, reminiscent of the lugubrious puffer fish he keeps at home in the aquarium he has so conspicuously labelled 'Mangrove Swamp I'. Even on dry land, *Panama, Spitsbergen, Nova Zemblaya* looks as though it would be entirely at home in water. Though static and at rest it nevertheless embodies a distinctive character of movement, the type of sluggish, almost lazy and rather meandering motion that in predatory fish is referred to as basking. The whole apparatus, with its horizon-scanning periscope, seems more suited to viewing the ocean floor from its downwardly-inclined observation window.

THE SOLITARY FLYER ONCE MORE

According to Callisthenes, Daedalus the father of Icarus who made the wings that enabled his son to realise his dream of flight, is also to be credited with the title, 'the first sculptor'.[30] The story is well known. The young Icarus, carried

aloft on wings of his father's making, against his father's explicit advice, flew too close to the sun. The wings disintegrated and he fell into the sea where he was drowned. On one level it was a success story: Icarus actually succeeded in flying, but sadly we must credit Daedalus the sculptor with the first technological failure. He alone was to blame for the first recorded aeronautical disaster.

Daedalus's failure was as much conceptual as it was technical. In designing the wings for his son, he had first of all determined upon a strategy of mimetic representation, presumably in the belief that anything that behaves like a bird should look like one. But he also selected his materials – the wax and the feathers – more for their appearances than the demands of sound, practical aeronautics. This conceptual failure led to technical failure and in the process, Daedalus the sculptor proved himself to be the poorest of aeronautical engineers.

However, there is something that remains hauntingly poignant about this mythological, at first sight highly contradictory, linking of sculpture to the dream of flight. On the one hand there is the tacit acceptance of gravity as a precondition of material practice – a notion which lies at the very heart of the sculptor's task – and then there is a desire of the kind that has been attributed to Baroque architects like Francesco Borromini and Gianlorenzo Bernini, (the latter claimed that he could make even the stones fly) which also seems to be powerfully at work in Panamarenko's efforts to transcend it. Perhaps it is this ambiguity, albeit in a highly ironic form, that is being celebrated in Panamarenko's series of *Archaeopteryx,* made between 1990 and 1991.

Members of the family of pre-Jurassic creatures called the archaeornithes, some of which could swim as well as fly, the archaeopteryx are generally thought of as the first birds. In Greek the name means 'ancient wings', but although they retained some of the features of reptiles – most notably a long, bony tail – they were not feathered or furry creatures. Their wings were membraneous, similar in certain respects to those of the bat, and skeletally speaking they were very much closer to birds than to mammals. We might imagine that as a transitional species the archaeornithes in general, and the archaeopteryx in particular, must have experienced the desire to fly in a most acute and bewildering fashion. Predisposed and therefore genetically programmed to seek to defy gravity without in any sense being able to understand why or indeed how, the archaeopteryx had to 'invent' flight from scratch. It is hard to escape the impression that Panamarenko identifies with this strange creature's representation of the desire of Icarus to fly and the confusion

of Daedalus in his technological failure. One of Panamarenko's *Archaeopteryx*, commissioned for the Open Air Sculpture Park in the Middelheim district of Antwerp, is perched precariously above head height on a tree stump where it is condemned endlessly to attempt flight. It rehearses this primeval struggle over and over again, a futile flapping of wings in comic imitation of its prehistoric predecessor's first desperate attempts to get off the ground.

Weighted down by a bewildering array of mechanical and technological gadgetry packing their bulging, wire-mesh bodies, the first versions of the *Archaeopteryx* seemed already to demonstrate an extreme form of mechanical absurdity. But this absurdity was even more evident in two later versions, *Archaeopteryx IV* and the *Blue Archaeopteryx* by the addition of solar-power in the form of light-sensitive cells that layer their wings in place of feathers. Theoretically speaking, a creature like the *Blue Archaeopteryx*, unlike the young Icarus, should grow more efficient the closer it gets to the sun. But in practice these mechanical creatures are no more able to survive than was Icarus himself. As Panamarenko is fond of recounting, his first *Archaeopteryx* worked reasonably well until the diodes that controlled the servomotors, burned themselves out and the 'chicken' simply turned up its toes and 'died', a victim, he claims, of built-in technological obsolescence.

Despite the ironic and humorous intent, there is a deeply serious side to Panamarenko's experiments with the *Archaeopteryx* which makes them exemplary in a certain way. We find it expressed in the Icarus myth in the form of a failure to resolve the conflict between mimesis and function. As we remarked in the case of *Bernouilli*, there is a profound 'elementalism' underlying Panamarenko's work. Form is determined in part by function, which in its turn – as with things in the natural world – is ordered in relation to the elements: earth, air and water, either singly or in combination. We might assume that this type of poesis has its origin in his early readings in the Science Library of Antwerp and has gathered strength in his work thereafter. By now it has become internalised as a process of empathic identification with the subject. In the *Blue Book*, for example, Panamarenko includes a chapter called 'Insect Flight Viewed from Within the Body of the Insect'.[31] Such a proposition carries the notion of mimesis way beyond physical appearances, suggesting a complete translation of the act of seeing. Not only must we be able to empathise with a form of movement appropriate to the particular element in which a thing – man-made or natural – is designed to move, but we must also be able to identify with its view of the world.

If we apply this rubric to Panamarenko's machines – whether they are intended to fly or to float, to hover over, skid across, or submerge themselves beneath the sea, they suddenly acquire a strangely compelling, subtly animated presence. Imagine being submerged inside Panamarenko's submarine, *Panama, Spitsbergen, Nova Zemblaya*. Consider the character of the movement you would experience and the act of looking that such a movement would demand. Imagine exploring a tropical rainforest in his *K3, Jungle Flyer*, 1993 – carried to and fro in agile flight, chasing exotic birds and dodging tree-trunks. Think of the slipping and sliding manoeuvrability of such a craft and the all-round visibility that the shape would allow. Think of skating across the surface of the sea perched high in the cabin of Panamarenko's most recently completed full-scale flying machine, the giant motor-foil, *Scotch Gambit*. All of these seem to suggest experiences which, in the first instance, have been observed in the natural world – in the attitudes, behaviour and habits of insects, birds and fish – and only afterwards given their equivalents as machines, through engineering and technology. They carry with them the indelible trace of the original point of their inception. If this were not the case they would be incapable of firing the imagination.

It is for this reason that Panamarenko's works repay close scrutiny so handsomely. They are formed so precisely in relationship to an intended function, as engineering and as a repository of a trajectory of thought. There is nothing that is superfluous in them, nothing that is there merely for the sake of appearances. Every detail is meaningful. Each rivet, piece of bent wire or soldered seam has something important to say about the whole assemblage and about its value as poetic metaphor. Set loose in the world of Panamarenko, we can imagine a unity of purpose which transcends the old divisions between art and science; poetry and mathematics; nature and technology; rules and events; material or immaterial elements and states of affairs. But we can also experience, firsthand, something of art as sublime necessity.

Sometimes, in his more talkative moments, Panamarenko is fond of declaring that 'art can save the world'. It is a statement of belief which he gives in one minute only to take away again the next. His final word on the subject is usually to add the qualifying phrase 'but not quite yet'.

Panamarenko, exhibition catalogue, Hayward Gallery Publishing, London and Museum Tinguely, Basel, 2000, pp.13 – 43.

1 There are three versions of Breugel's *Landscape with the Fall of Icarus*: one in Brussels, one in the Metropolitan Museum of Art, New York, and the third in a private collection.

2 Panamarenko spent his time in Britain at the Cranfield Institute of Technology testing his aeroplane *U-Kontrol III*.

3 Referred to by Panamarenko as 'Institute A', it was set up at the suggestion of the Europhile American artist, the late James Lee Byars, and was supported by such figures as Kasper Koenig and Isy Fiszman.

4 Significantly, these already incorporated aerial pyrotechnics of different kinds.

5 *Happening News*, first issue, 1965.

6 Anny De Decker interviewed by Yves Aupetitallot, *Wide White Space 1966–1976: Behind the Museum*, exhibition catalogue, Paleis voor Schone Kunsten, Brussels, 1994.

7 The adoption of the term 'Milkyway' shows very clearly that even at this early stage Panamarenko was already citing his practice in relation to his readings of science, astronomy and astrophysics.

8 Anny De Decker interviewed by Yves Aupetitallot, *Wide White Space 1966–1976: Behind the Museum*, exhibition catalogue, Paleis voor Schone Kunsten, Brussels, 1994.

9 Panamarenko interviewed by Hans Theys, *Panamarenko Multiples 1966–1994*, exhibition catalogue, Galerie Jos Jamar, Antwerp, 1995.

10 Maurice Merleau-Ponty, *Phenomenology of Perception*, trans., London, 1962.

11 Carlos Casteneda, *The Teaching of Don Juan*, London, 1970.

12 Hans Theys, *Panamarenko*, Brussels, 1993.

13 The model of the projected spaceship *Ferro Lusto X* has the secondary name of *Bing*, hence the use of the term *Bing* motors. The full-scale version, in the manner of Thunderbirds, will eventually carry the submarine *Panama, Spitsbergen, Nova Zemblaya*, also named *Bing*, in its hold.

14 The *Bing* motors, a prototype of which is shortly to be tested, comprised high-grade titanium rolls on magnetic bearings, driven by a jet of compressed air so that they rotate at 300,000 revolutions a minute. Pananarenko calculates that it will take 300 such motors to raise the small version of the *Ferro Lusto X*.

15 Panamarenko, *Blue Book*, 1975.

16 As a step towards *Toymodel of Space*, Panamarenko needed to define 'mass' from a relativistic standpoint. The pressure of light/energy falling on the surface of the earth acts upon every object equally. Thus the pressure is equal to the mass/weight of any object that is moved or accelerated.

17 Jules Henri Poincaré, *Les methodes nouvelles de la mécanique celeste*, 1892–99.

18 James Clerk Maxwell (1831–79) was a Scottish mathematician and physicist who produced a complete theory of 'electromagnetism' with the English chemist Michael Faraday (1791–1867). Towards the end of his life, he contributed important insights towards the emergence of a coherent kinetic theory. His theory of 'Clinamen' – deviation or swerve – produced one of the most frightening literary representations of modernity, 'The Great Beast Clinaman' who rages through the world destroying everything in its path.

19 Pataphysics – 'The Science of Impossible Solutions' – was described by the French author and playwright, Alfred Jarry (1873–1907) as going a step beyond metaphysics. It was made the subject of the international society, the 'Collège de Pataphysique', of which Panamarenko is an honorary member.

20 Ernst Mach (1836–1916) was a German physicist and philosopher who argues that the inertia of a material object – an object's resistance to the force of acceleration – is not an intrinsic property of matter, but a measure of its interaction with the rest of the universe (Mach's Priniciple).

21 One of the great debates which still exercises scientists today is the issue of whether the flow of time is irreversible. Most modern scientists, including Heisenberg and Schrödinger, have sought to argue that it is neutral. However, in the words of the Irish scientist Lord Kelvin,

the Second Law of Thermodynamics states that 'there is an inexorable trend towards degradation of mechanical work into heat, but not vice versa'. The implication of this is that all energy transformations are irreversible. Thus the theory of entropy was born. It would seem to follow that if energy transformations are irreversible, then so is the passage of time.

22 The discovery of Quantum Theory greatly complicated the business of theorising the natural world. Discovered by the German physicist Max Planck (1858–1947), Quantum Theory called into question the 'mechanistic' world view and the concept of the reality of matter. Einstein came to look upon Quantum Theory as a nuisance, but it has stood the test of time and now provides the terminological basis for much orthodox modern physics.

23 In contrast, contemporary science has begun to address the possibility that rather than simply running down, the universe is creating itself by generating increased degrees of complexity. Observations seem to show that new complexities appear abruptly rather than out of slow and continuous evolution. This seem to suggest that the natural world is making itself up as it goes along. This new topic of though has already acquired the name Complexity Theory.

24 Hans Theys, *Panamarenko*, Brussels, 1993.

25 Aristotle, *The Ethics*, Weldon (trans.), London, 1906.

26 Propertius S., *Histories and Tales*, James (trans.), London, 1943.

27 Antoine de Saint-Exupéry, *The Little Prince*, London, 1943.

28 Hans Theys, *Panamarenko*, Brussels, 1993.

29 The Third and Seventh Paradoxes of Zeno, of which there are eight in total, state: 'if all that is is in space, space itself must be in space, and so on ad infinitum', and 'so long as anything is in a space equal to itself, it is at rest... an arrow is in a space equal to itself at every moment of its flight and therefore also during the whole of its flight... thus the flying arrow is at rest.'

30 Calisthenes, an Athenian commentator on art, is generally considered the first 'art critic'. He was particularly interested in sculpture and over half of his fragmentary writing focus on the representational aspects of Greek sculpture.

31 Panamarenko, *Blue Book*, 1975.

This paper was first presented at a colloquium on 'Representation' at Tate Modern and then at a conference on 'The Image' at the Jan van Eyck Akademie in Maastricht; both taking place in 2001. At the time, I was concerned about the barely reflected-upon rise of photography as a form of fine art practice, which seemed to me in urgent need of deeper theoretical consideration beyond that offered by current art theory. For me, the unquestioned power of the image to 'represent' – its appeal to 'truth' in other words – gave rise to more questions then than it answered, and still does. The rise of 'representation' as a key theoretical topic is a part of what Terry Eagleton has called 'culturalism'; the idea that everything in our material nature is culturally constructed. It is a point of view which is to my way of thinking 'reductive' and just as 'essentialist' as its opposite; an uncritical appeal to the natural order. Blanchot's 'cadaverous' image finds a baldly aggressive equivalent in Eagleton's assertion that: 'dead bodies are indecent: they proclaim with embarrassing candour the secret of all matter, that it has no obvious relation to meaning'.

SIMONE WEIL:
DIALECTIC OF APPARENT OPPOSITES

I once succeeded in producing a hostile, collective silence at a conference of art theorists in Rotterdam by suggesting that there were only three books that any serious artist absolutely had to read... that none of them addressed art directly and none of them could be easily incorporated into the emerging canon of visual theory. The three books were, the *Tractatus Logico-Philosophicus* (1918) of Ludwig Wittgenstein, *Gravity and Grace* by Simone Weil (1947), and *The Writing of the Disaster* by Maurice Blanchot (1980).

Of course, I was being deliberately provocative. But not simply that. I was also trying to make a serious point. Namely that most so-called visual theory hardly touches upon art at all, and never at the point of its origin. That, strictly speaking, visual theory is all about how we talk about works of art and how we come to understand the context in which works of art find themselves; never, in any important sense, about how they come to be made. I know that many, sociologically inclined art theorists, argue that the two things cannot be separated. But speaking as an artist, I have to insist that they always are; leastwise at the point when, metaphorically speaking, the paintbrush is poised to make the first mark. When the artist is preparing to invade that mysterious ontological territory where all works of art must find themselves.

But why did I choose these particular books? All of them difficult, even in their own terms, and, as I have already indicated, all of them seemingly entirely oblique to art theory or practice.

On one level the answer is simple.

I take it as axiomatic that the first purpose of the work of art, whenever it occurs in art history – and therefore, at the deepest level, the chief subject of art's address – is to report on the condition of the human soul, and to do so in a manner which is intelligible to its own time. And I believe that these three books, taken together, can help us to understand something of what is entailed in such a notion.

But my argument and the task I have set myself is even more particular than this. I want to focus on 'abstraction'. What founds it as a poetic concept and the source of a particular order of aesthetic experience that Wittgenstein describes as 'unsayable'. (I will return to what Wittgenstein means by this in a moment.) And then I want to try to identify that quality of 'presence' in the context of visual works of art that, in the case of song or verse, we often refer to as 'the lyric'.

I will start with the distinction that Wittgenstein makes between 'representation' and 'reflection'; or what can and cannot be said in language. I will then look at the dialectic that Simone Weil sets up between 'gravity' and 'grace' and the implications that it has for the work of 'representation' and for what she calls 'de-creation'. And finally I will look at Maurice Blanchot's two versions of the 'image'; image as 'cadaver', and image as 'resemblance'.

o o o

In the *Tractatus*, Wittgenstein shows that no matter how earnestly we pursue symbolic clarity through language, we end up by laying bare the domain of the mystical; that the symbols we use are so bound by common usage that if we dress them in obscurity through over-specialisation, we put at risk their capacity to make ordinary 'meaning'. '"Symbolic languages" are always more or less vague', Wittgenstein states, 'and provide us with a limited view of the world', precisely because symbols arise out of darkness, and to darkness return.

Most particularly, Wittgenstein is concerned to point out the limitations of scientific language, or, indeed, any specialised form of language that pretends an authoritative account of things in the world. Towards the end of the *Tractatus* he writes, 'when all possible scientific questions have been

answered, the problems of life will remain completely untouched'. Life is not defined by the vast array of scientific or quasi-scientific problems that seem to us to be so inimitable to it, but by the thoroughly animated – lived – space which is their 'remainder' once they have all been answered. This, Wittgenstein suggests, is why we find it so very difficult to speak of what constitutes life's 'sense' and life's 'meaning'.

To venture a typical Wittgensteinian tautology: life's 'remainder' remains, absolutely unsignable and beyond our capacity to speak it. 'There are things that cannot be put into words, but still they make themselves manifest... they are what is mystical', Wittgenstein writes... and then... in the resounding, final sentence of the *Tractatus*, 'What we cannot speak about we must pass over in silence.'

Referring to the *Tractatus* in a letter to a friend in Vienna, shortly after its completion in 1918, Wittgenstein puts a very particular gloss on this final sentence, a gloss that forces us to look at the book in an entirely new light. 'My book', Wittgenstein writes:

> draws limits to the sphere of the ethical from the inside as it were, and I am convinced that this is the *only* rigorous way of drawing those limits. Thus, the *Tractatus* has two parts, the one, the written book, and the other, the essential (book), which is not and cannot be written, on ethics itself.

We are asked to consider the book's 'remainder', then – the book which cannot be written, either by Wittgenstein himself, or by anyone else – as more important than the *Tractatus* itself.

Used in this context, the term, 'from the inside' is a crucial one. It allows Wittgenstein to conclude that whatever is 'outside', whether in the domain of 'ethics' or of what he calls 'the mystical' – whether, in other words, it is concerned with human behaviour, character and morals, or addressing metaphysical questions concerning the nature of existence – even though it cannot be logically contained by the play of everyday language, nevertheless 'manifests' itself as a 'remainder' to that language, by occupying a region of the human soul that Wittgenstein calls the 'ineffable'.

In the final analysis, of course, Wittgenstein is pursuing the notion of an 'ideal' language, that is a language that means what it says... a language that is 'truthful' and unambiguous... a language that can provide a proper account of

the way in which it relates to the world as a totality of facts. It is a formidable ability to construct languages capable of expressing every sense, without having any idea how each word comes to have meaning or what its meaning is – just as people speak without knowing how the individual sounds are produced. Perhaps then language serves to disguise more than express our thoughts.

Significantly, the analogy Wittgenstein uses to expand on this point has two aspects. Firstly it analogises language in terms of the body as 'organism': and secondly, it analogises 'applied language' as 'clothing'. The same proposition continues: 'Everyday language is a part of the human organism and is no less complicated than it.' It is not humanly possible therefore to gather from it, what the logic of language is. 'Language disguises thought', Wittgenstein writes, 'so much so, that from the outward form of the clothing it is impossible to infer the true form of the thought beneath it', indeed 'it is not designed to reveal the form of the body, but for entirely different purposes.'

The purpose that Wittgenstein ascribes to language as clothing is that of 'representation', while the body – Wittgenstein calls it the 'body of meaning' – the 'human organism' that lies hidden beneath, is what makes 'representation' possible. Accordingly, if our objective is clarity of expression, we can only speak *about* objects, we cannot *put them into words*; we can only say *how* things are and not *what* they are. 'We can make to ourselves', as Wittgenstein puts it, 'pictures of facts', but the realm of form is something that we can neither make nor control.

It would be easy to mistake Wittgenstein's intention here by supposing that he is reducing language to a biological function, but the opposite is the case. By pointing to this division within language between its conscious purpose to 'represent', and the 'reflective formation' which allows conscious linguistic activity to occur, Wittgenstein is making language an 'immaterial' and 'abstract' attribute of mind. Far from being merely an 'instrumental' thing, then, language is – in an important sense – constitutive of our lives as human 'subjects'. As he writes much later on in the *Notebooks* (1914–16): 'The concept of life forces us to understand language as an activity through which an organism is related to its surroundings. Not through "usage" but from within language itself.'

The corollary of such a construction is clear. It cannot be the functional aspect of languages – their power to 'represent' reality that makes different language modes intelligible to each other, but an innate and shared 'reflective' capacity. As Wittgenstein puts it, 'a gramophone record, the musical idea, the written notes, and the sound waves, all stand in the same relation to

one another, in the same "internal" relation of depicting that holds between language and the world... they are all in a certain sense one.' Similarly, if we seek a translation of 'meaning' from oral or pictorial languages into writing or speech – as far as they can be made outwardly intelligible to each other at all – it can only be via this same 'internal' relation of depiction.

It can be seen from this that while there are some similarities between Wittgenstein's analysis of language and semiotic theory there is a clear difference in the way in which he constitutes the human subject. Where semiology – as originally envisaged by Saussure – as a scientific enquiry into the life of signs, sets in motion a centrifugal movement away from notions like 'the individual', 'the immediate', 'presence' and 'the imaginary', Wittgenstein's theory of 'reflection' places the immediate and absolute presence of the experiencing individual, human subject, at its very centre. 'Reflection' is self-evidently, the individual human organism, as Wittgenstein puts it, 'all the time in agreement with the world'. Where semiotics, as an aspiring science, looks outwards, shunning what is inside and striving to establish timeless, general laws capable of catching hold of something that we might call the 'external real', 'reflection' demonstrates the truth that lies at the heart of the human organism's solipsistic impulse. Wittgenstein sums it up beautifully when he says: 'The world is always *my* world', and again, 'The limits of *my* language mean the limits of *my* world.' Significantly, the possessive pronoun 'my' is italicised in both statements tying the concept of 'world' absolutely to a notional, individual human subject.

According to the dictionary, the term 'ineffable' means that which cannot be described or translated – the 'inexpressible'. And we can be certain that when Wittgenstein chose this word, he did so with the utmost care. He wanted us to think beyond the veil of representation. He wanted us to consider the thoroughly mysterious nature of the space that exists beyond the opaque screen that we use to endlessly play back as 'representations', the projections of our individual and collective psychology.

On this point, Wittgenstein is very clear. It is psychology that muddies the waters of 'ordinary' language, rendering 'meaning' more or less fugitive, and so it is psychology that is antithetical to the philosophical project in general. But this is the subject of a whole new paper.

Recognising the nature of this 'plane of separation' between the inside and the outside of language, for Wittgenstein is crucial for the idea of 'presencing', which, while Wittgenstein remains understandably sceptical about the way in which the human soul is usually defined, he nevertheless sees

it as a function of what he calls 'something higher'. And here it is entirely legitimate to speak about the idea of 'revelation'. The active principle that Wittgenstein calls 'showing'.

In a startling moment in the *Tractatus*, Wittgenstein fires off three, seemingly aphoristic and, at first sight, quite paradoxical statements concerning the workings of language, in quick succession. 'What finds its reflection in language, language cannot represent. What expresses itself in language, we cannot express by means of language. What can be shown, cannot be said.'

Wittgenstein seems to be setting up three points of opposition here.

The first is between 'reflection' and a 'representation. A 'reflection', Wittgenstein is arguing, cannot be a 'representation', because it occurs inside language, as if in the space of a mirror. A 'representation', on the other hand, derives its correspondence from outside language... from the subject that is being pictured. 'Reflection', then, depends upon a 'structural' coincidence occurring between language and the world, while 'representation' is a model which corresponds with 'states of affairs' which are real.

The distinction Wittgenstein is arguing here is one that is often misrepresented and misunderstood. It is certainly not the often proclaimed distinction between form and content. As far as Wittgenstein is concerned these are 'one and the same', and so such a distinction would be 'non-sensical'. Rather it is the important distinction that must be drawn between 'content' and 'subject matter': between what, from the inside, makes language what it is – language's own condition of perfect 'orderliness', as it were – and the multitude of things in the world which, at any one time, might become the subject of its address.

You will see, as we proceed, how this idea finds its equivalent in the writings of both Simone Weil and Maurice Blanchot.

Wittgenstein's second distinction carries the same argument a significant stage further, by suggesting that languages carry with them their own, internal, preexistent expressive force; a force which is self-revealing and entirely distinct from their 'applied' purpose of expressing our thoughts and intuitions about things in the outside world. This internal force, Wittgenstein calls the emerging 'conditions' signalling the timeless experience of 'presence'. 'Presentness', Wittgenstein writes, 'is a state of grace... eternal life belongs only to those who live in the present.'

Wittgenstein's third distinction provides a very succinct and compelling answer to the age-old philosophical conundrum asking how it is that a depiction of ugliness can also be beautiful. If, as he seems to be

suggesting, it is an internal 'condition' of language that it forms 'reflections', then it is not difficult to understand how an image can be a 'reflection' of the world through the beauty and orderliness of its inner linguistic structure at the same time as it 'depicts' ugly sentiments, distasteful, brutish or bloody events.

It is similar insight that we find in one of Wittgenstein's favourite philosophers, Heraclitus of Ephasus. 'They do not comprehend', Heraclitus writes, 'just how a thing can agree being at variance with itself: it is a fitting together, an atunement that turns back upon itself, like that of the bow and the lyre'. Significantly, the subject of this fragment is what the early Greek thinkers called the 'logos' – 'the active principle by means of which all things come to pass... and are made to agree and fit together in tension and in opposition', and described in the commentaries of Philolaus as 'that which no man can understand'.

Now I want, in a moment, to part company with Wittgenstein, and to change the focus of my discussion to encompass some aspects of Simone Weil's book *Gravity and Grace*. But before I do so I want to say something about his use of the term 'imagine'. For Wittgenstein 'imagination', surprisingly perhaps, is closely related to the instrumental purpose of language, that of 'representation'. To 'imagine', Wittgenstein argues, must take as its 'model' states of affairs as they are observed in the external world. Without a flow from world to mind, the imagination cannot function. It will, hopefully, become clear when we come to discuss Simone Weil's critique of the imagination, just how this aspect of Wittgenstein's view of 'representation' is replicated in her writing although it is glossed very differently.

In the opening lines of Simone Weil's book, *Gravity and Grace* we find her setting out the 'natural' dialectic that will cover the whole work. 'All the *natural* movements of the soul are controlled by laws analogous to those of gravity. Grace is the only exception,' Weil writes, and a little further on, 'all that comprises the *natural* universe is ruled by two forces; "light" and "gravity".'

Reading Weil of course is a difficult business. *Gravity and Grace*, as well, is perhaps her most obscure and difficult text. A mixture of troubled spiritual contemplation and social and political polemic, all heavily spiced with irony; its central argument to rediscover the fault line between what she calls the *natural* and the *supernatural*, is all the time turning back upon itself in a truly Heraclitian manner.

A clear example of this is the way in which Weil first defines and then continually redefines the dynamics implicit in her two main terms.

Defined physically, or *naturally* as Weil would put it, 'gravity' is, *ipso facto*, a downward acting force, and the main one holding things in place in the world. For this to be otherwise, she writes, would require *supernatural* intervention. But then when she comes to define the term 'gravity' sociologically, it takes on an entirely different dynamic. 'Gravity' becomes a horizontal force governing our movements away from and towards one another. It takes on the array of conflicting feelings and the emotional characteristics of the human subject: attraction, repulsion, love and hate, etc. When she uses the term 'gravity' in a spiritual or moral context, it becomes an upward acting energy which, in Simone Weil's own words, is what 'makes us fall towards the heights'.

We can observe a similar diversity of dynamics when we come to look at what Weil means by 'Grace'.

Viewed in the context of the physical or *natural* order, 'Grace' is an upward movement, discernible as a conspicuous quality in the 'gravity-bound' things that make up the physical universe. But when she speaks of 'Grace' as a moral concept, she says that it is the opposite, a descending movement, the force of which makes it possible for the human subject to rise up the scale of 'moral gravity'. In the spiritual sense too, 'Grace' has the power to enter into things... to fill empty spaces. Both cause and effect, it can only enter in where there is a void waiting to receive it. It is 'Grace' itself, Weil suggests, 'which must make this void'.

Here, then, is one important place where, according Weil, the line between the *natural* and the *supernatural* is most clearly drawn. 'To accept a void in ourselves requires the supernatural', Weil argues, because 'the (enormous) energy needed (for its creation) has to come from somewhere else...' (not from us). The energy must be 'sufficient to allow for something desperate to take place', she writes, 'the void must be created', (it cannot just occur). And she concludes with the equation, 'Void = the dark night.'

This short, last rather enigmatic statement betrays Weil' s fascination with the poetry of St John of the Cross and his highly individualised and aesthetically charged notion of the relationship between individual human beings and the power of God that is advanced by him. It is also part of the crypto-theological problematic contained within Weil's writing (she was an orthodox Jew, remember, who by choice converted, not just to Christianity but to Catholicism, with all of the troubling contradictions that such a conversion would involve). This is a road that I do not particularly want to go down just

now and so for the purposes of this paper, if it is possible, I would like us to consider her use of the term 'God' more as a metaphor representing certain forms of non-material transaction, rather than as some kind of theological absolute.

Now, a little later on in the book Weil returns to the question of the relationship between 'grace' and the 'void' in the course of a highly provocative discussion of the role of the imagination. 'The imagination', she writes, 'is continually at work filling up all the fissures through which "grace" might pass.' 'The imagination, filler up of the void is essentially a liar', she states vehemently and goes on to argue that 'the imagined' has no more dimension than a dream, concluding the passage with the scary, rhetorical question, 'what is more frightful than to die in a nightmare?'

You will notice that there is a polarity being set up here – between inside and outside – which is not dissimilar to the one we have already observed in Wittgenstein's *Tractatus*. When I say similar, I want to keep the door open for the discussion of one or two key differences.

On one level, Weil's idea of 'inside', like that of Wittgenstein, is of something that is unknowable – Wittgenstein you will remember used the word 'ineffable'. A strong similarity emerges when Weil describes the 'void', as a place which is 'empty of things' to be described, and therefore knowable only through 'God'. As in the *Tractatus* too, this inner void is also a space where 'reflection' occurs, and in a form which is similarly abstract, though the character of its engagement with what is outside is somewhat different. In Weil, 'reflection' is a function of the spirit (it is 'God focused') more than it is to do with the more general ontological mystery that we find in the workings of language. 'There is a clear distinction', Weil writes:

> between those who remain inside the cave, shutting their eyes and imagining the journey and those who really take it... surely nothing is more deceptive than what we call inner feelings... We must learn to distinguish the imaginary from the real in the spiritual realm... We must learn to prefer real hell to an imaginary paradise.

Weil's 'void' must, at all costs, be preserved as an 'emptiness' and the enemy of this emptiness is the 'imagination'. The void can all too easily 'be filled by the work of the imagination', she writes, and so we must strive to 'continually suspend the work of the imagination... to prevent it from filling the void within ourselves'.

As is so often the case in Simone Weil's writing, the metaphor that seems to govern things has a physical, mechanical feel to it, and the economy it suggests is almost a hydraulic one. Just as the force of 'Grace', when it acts in the spiritual domain, acts downwards in order that the human soul can rise up; the 'void' is sustained as an emptiness by the divine guarantee of fullness in the physical universe. 'If we simply accept the void, no matter what, then what stroke of fate can prevent us from loving the universe. For we have the assurance that, come what may, the universe is full.'

As in the *Tractatus*, the imagination for Weil too, is attached very much to the external world and at odds with everything that is internal. For Wittgenstein it generates 'representations' which obscure the inner power of language to yield up 'reflections'. For Weil, it obstructs the space made to receive 'grace', by filling it with the plethora of misleading 'interpretations' spawned by the 'imagination'. And she goes further: 'imagination' is the enemy of the body as 'incarnation' – and this is perhaps where Weil comes closest to Wittgenstein's two-tier model of language – 'imagination', she says, is 'the enemy of the word made flesh'.

Once again Weil is mining the line between the *natural* and the *supernatural*.

Just as it takes 'supernatural' energy to render the 'void' ready to receive 'Grace', so it requires 'supernatural' energy, in the form of an all-pervading, supernal beauty, to incarnate the word as flesh. This beauty, she writes, is able to 'captivate the flesh and obtain permission for it to pass right through to the soul.' Incarnation is thus a two-way process, mediated by the abstract ordinance – Weil describes it as 'impersonal' and 'distanced' – that is absolute beauty. 'It is for this reason, she argues' that 'incarnation' is central to the really profound work of art, wherein, as Weil puts it, 'beauty' is always visible, even beyond the 'network of chance and evil' – the perversities wrought by the working of the imagination. 'A double movement of descent', she writes, 'to do again and again out of love what "Gravity" does. Is not this the key to great art.' And she returns again to this reflexive double movement again, in the closing pages of the book: 'Most art concerns itself with the "possible" which is the realm of the imagination and thus of degradation', Weil writes, and she goes on, 'we must therefore wish either for that which already exists or for that which cannot in any way exist – still better for both... since both are outside the realm of "becoming"', beyond, in other words the reach of 'possibility'.

There is an obvious similarity between Weil's negative view of 'imagination' and Wittgenstein's equally negative view of 'representation'. Indeed it is easy to map the one onto the other.

Both, for instance, are concerned with a version of illusion which is based upon 'resemblance'. Wittgenstein sees the illusion involved in 'representation' as product of projected, highly subjective, psychological material that disguises or hides the subject of address. 'Truth', if it is viewed from the standpoint of the theorising of 'appearances', then, is inescapably fugitive. By contrast Weil is more extreme, although the general drift is the same. For her, 'appearance' is the hook that attaches the 'ego' to the natural order of things, and so to the work of the imagination.

Our attachment to appearances gives rise to the highly dubious process that she calls 'hypothesising'... In other words she is suggesting that we only know things through what she calls our natural faculties – eyes, ears, nose and all the rest of the 'sensing' apparatus of the body – 'hypothetically'. That our senses are all the time making imaginary propositions about the nature of reality without offering us any certainty about what is being represented. Weil puts the dilemma posed by 'appearances' in a neatly allegorical form. 'A woman looking at herself in a mirror... adorning herself... does not feel the shame of reducing herself to a small space,' she writes. 'A very beautiful woman who looks at her reflection in the mirror can very easily believe that she is (what she sees). An ugly woman knows that she is not (what she sees).'

For both Wittgenstein and Simone Weil, then, certainty about the truthfulness or otherwise of a 'resemblance' is thrown into a state of absolute crisis at the point at which 'reflection' takes over from 'representation'.

This brings me to the final point that I will discuss today from the writings of Simone Weil: the idea of 'de-creation' which she sets in opposition to 'destruction'. 'De-creation', Weil writes, 'is to make something created pass (back) into the uncreated', while 'destruction' is 'to make something created pass into nothingness'. There is of a strongly theological construct at work here but there is a more general creative principle too. 'The creator gives our existence to us – creates us – in order to beg it back from us', Weil writes, and a little later on, 'We have to die... in order to possess an energy which is free and capable of understanding the true relationship of things.' Dressed in the guise of a reciprocal economy of 'gift giving', Weil is here equating de-creation with death. We create, she is suggesting, in order to de-create: bring something to life in order to experience its death. (It is important to stress that we are not talking

here about procreation, which is a transaction between people; it is, for Weil, a social construct – but about an immaterial transaction occurring inside the individual). Weil, of course is not the first philosopher to link the creative impulse to the idea of death. There have been many, amongst them such important thinkers as Schopenhauer, Nietzsche, Heidegger, Husserl and more recently Levinas. But Weil was the first to raise it specifically in relationship to 'appearances'. At the end of the chapter dealing with 'de-creation' she writes:

> Appearance clings to being... For whosoever is in possession of being, there can be no appearance, Appearance chains being down... For what is outside is a substitute for decreation... it results in unreality... it is necessary, then, to uproot oneself.

By way of a conclusion I want to relate this first of all to Maurice Blanchot's definition of 'appearance' and its 'remainder', or as he calls it, 'its apparition', in *The Space of Literature*. It brings us full circle back to Wittgenstein's notion of the remainder as the 'unsayable'. 'True appearance', Blanchot writes, 'appears only when everything has disappeared', this is exactly what we call an 'apparition'. It is 'the everything has disappeared', appearing to us in its turn... and the 'apparition' tells us that when everything has disappeared, there is still something remaining.

Blanchot's demolition of the idea of the image as resemblance is precise, his conclusion inescapable.

Writing the Disaster (1980) 'concludes' Blanchot's meditations on what he calls '*le Dire*', first raised in the much earlier in *The Space of Literature* (1955). By 'le Dire', Blanchot is advancing the idea of an entirely reiterative language, one that is uttered only in order to confirm itself as 'means' (through the sheer telling of itself, in other words) the consequence of which is to say nothing. The highest purpose of language is not that of providing a vehicle for images. In great literature or great poetry, Blanchot argues, language does not contain images... 'it does not come after its 'objects'... it does not 'represent'. Neither is it built up from distinct linguistic figures – not signs, not metaphors, not figures of speech etc. – but it emerges from the absence of things and is, in its entirety... 'altogether image'. For Blanchot (as for Wittgenstein) the 'apparition' of resemblance – we might choose to use the word 'representation' or 'image' – is a damaged, even a corpsed, 'cadaverous' thing. He invokes the idea beloved of André Breton of the broken tool, a tool

which can no longer fulfil its purpose; one that is robbed of its use value. 'In this case', Blanchot writes, 'the tool, disappearing into its use (as an absence), *appears*.' (Blanchot's italics.) It 'resembles', 'reflects' and 'doubles' itself:

> The cadaverous resemblance haunts us. But its haunting presence is not the unreal visitation of the ideal. What haunts us is something inaccessible from which we cannot extricate ourselves. It is that which cannot be found and therefore cannot be avoided. What no one can grasp is the inescapable. The fixed image knows no repose, and this is above all because it poses nothing, establishes nothing. Its fixity, like that of the corpse, is the position of what stays with us because it has no place.

The opposition that Blanchot is setting up here is between two quite distinct locations and qualities of presence, which can be usefully compared with Simone Weil's dialectic of inside and outside: the unknowable emptiness within as opposed to the 'hypothesised' world that we think that we know through our senses. But there is a crucial difference. For Weil the inside is empty of things; an essential condition which for her is endlessly threatened by the imagination's tendency to fill up every available space; for Blanchot it is the outside that is empty. And scarily the image speaks to us, Blanchot writes, 'of that less than nothing that subsists when there is no-thing'. This doubling, the doubling of the world by remaking it as 'image', also consecrates the notion of 'form without matter' which he suggests is the true domain of art. Blanchot puts this assertion in the form of a rhetorical question:

> And isn't the task of artists, who are exiled in the illusory realm of images, to idealise beings – to elevate them to their disembodied resemblance?

In Simone Weil's case, as we have already observed, for her it is the 'small' space of the mirror which represents the translation of matter into image; effecting an 'appearance' of form without substance as it does so. Reflection involves a kind of necessary death, the function of which is to release... 'a *tied up* energy' capable of understanding the true relationship of things. 'Appearance chains being down', Weil writes and goes on to say that the two must be separated by violence. Blanchot in '*The Writing of the*

Disaster' uses a similar argument. For him the *otherness* of the reflected image constitutes a double death... 'for the other is death already and weighs upon me like an obsession'. And he goes on to extend his concern with the cadaverous, emptied out nature of the image, first essayed in *'The Space of Literature'* in a lengthy meditation on the bafflement of Narcissus before his own reflection:

> An image is not a likeness to anyone or anything; the image characteristically resembles nothing. Narcissus 'falls in love' with the image because the image as such – every image – is attractive: the image exerts the attraction of the void, and of death in its falsity. The teaching of the myth, which like all myths resembles a fable to some extent and is instructive, would be that one must not entrust oneself to the fascination of images which not only deceive but render all love mad.

All three writers, then –Wittgenstein, Weil and Blanchot – have important and mostly highly skeptical things to say about the idea of the representational force of images. Wittgenstein's concept of the 'reflective formation' – that which makes 'imaging' possible – also points us towards the abstract nature of language and its solipsistic undertow. 'The world is always "my" world'. Wittgenstein's assertion leads inevitably to the question of whether it is entirely illusory to claim that a truthful picture of the world might be arrived at collectively? In *Zettel*, having posited that we all give signals when we imagine things and use different signals for different images, he asks the question himself: 'How have we managed to agree together what each signal is to mean.' Significantly, Wittgenstein leaves the question hanging in the air. Unanswered or unanswerable? Later on, speaking of the passage between inside and outside that 'imaging' entails, he describes it as 'a "gappy" space'. A space, presumably, which itself has holes in it. In other words a space in which things might lose themselves twice over.

For Simone Weil, our imaging of the world locates the problem firmly with the process of human apprehension and the psychological muddle – including our solipsistic inclinations – that apprehension entails. She longs, she writes under the heading 'Illusions', to see a landscape as it is when she is not present:

> May I disappear in order that those things that I see may become perfect in their beauty from the very fact that they are no longer

things that I see. I do not in the least wish that the created world should fade from my view, but that it should no longer be to me personally that it shows itself.

Weil goes on to argue that the problem with representation is that it seems to necessitate interpretation. We cannot, in any case, simply look at the world and on the basis of our looking apprehend the difference between the real and the illusory. But images compound this problem by making it seem that the process of apprehension is without inwardness. The act of interpreting images tends to submerge perception in imagination. We imagine that we know what we see and in the process, we are no longer able to perceive it. According to Weil, only intense looking can yield up that state of perfect detachment, which enables us to see beyond the fog of deceptive values that interpretation involves.

There is a distinctly puritanical drift in Weil's critique of the imagination and its capacity for generating images, which finds a more open-ended treatment in Blanchot, when, towards the end of '*The Writing of the Disaster*', after describing language as necessarily 'cryptic', he advances a picture of the space of language not far removed from Wittgenstein's 'gappy space'. Language, in its totality, he writes, 'contains pockets, cavernous spaces' in which words become 'things'. These regions of 'inside' are no longer accessible via cryptographic analysis. 'The code no longer suffices' because the possibilities of translation are infinite. At this point, in contrast to Weil's desire to loose the self – the 'I' – when faced with the world, Blanchot assumes precisely the opposite position.

When the other of 'I' – the 'me' – appropriates 'word-things' in order to bury a secret in them and to enjoy it without joy, in the fear and the hope that it be communicated (shared in common with someone else in the lack of any common measure between them) then it is a petrified language through which nothing can be transmitted. It is perhaps in this direction that 'the idiom of desire' tends, with its mimetic motivations whose sum is unmotivated and which offer themselves in decipherment as the indecipherable absolute.

Blanchot's situating of 'otherness' between the 'I' and the 'me' also places the human imaginary within the terrain and scope of a solipsistic reverie. In this respect all three writers find common ground.

Essay derived from a lecture written mostly in 2000 and delivered at Tate Modern, London in 2001.

This was perhaps my craziest ever invitation to write. I had to make the trip to Los Angeles to discuss the project with Paul Schimmel, the organiser of the exhibition *Public Offerings* and Howard Singerman, the commissioning editor of the catalogue, and to meet up with my fellow authors. I say crazy in part because of the title of the exhibition, and Schimmel's idea that big international exhibitions of contemporary art were suitably metaphorised (ironically or otherwise) in terms of corporate share issues. This notion didn't really appeal to me and I said so at the meeting, arguing that in the British context at least, socio-political matters were more directly formative than commercial ones and this would be reflected in anything that I wrote. In the event, Singerman, who seemed quite *au fait* with the British situation, sided with me and so I agreed to write. I was very shocked when I received my first copy of the catalogue published by Thames & Hudson. In the context of the catalogue, the design layout and typography were so gratuitously glossy that they eclipsed the artists and their works almost completely.

THE ECONOMICS OF CULTURE:
THE REVIVAL OF BRITISH ART IN THE 1980s

The link between the art market and prevailing economic conditions requires little explanation. It can be put very simply: When an economy is booming and producing a surplus for spending at the luxury goods end of the market, cultural purchasing power is also greatly increased.

We need look to only one set of statistics to support this view. Almost always in times of economic depression, private galleries close-down; conversely, when the economy is on an upward path, new galleries open-up. However, the well-being of the art market is not simply an economic matter. There is also a political, even ideological, dimension governing its performance, particularly in countries like Britain where the institutions of cultural patronage and the great majority of public museums are funded either directly or indirectly by the government. When the main purchasing power lies firmly in the hands of state-funded institutions, and when there is virtually no longstanding tradition of private patronage – no collecting class, in other words – then the ideology of the government of the day tends to impact very directly on the effective role of private galleries and the workings of the art market in general.

In Britain too, the power of the government to influence the shape and behaviour of the art scene has been greatly influenced by the historic strength of the art school system. A de facto system of patronage as well as a form of education, the art schools were still the most important means of direct support to artists by the beginning of the 1980s. In the absence of an indigenous collecting culture, they were virtually the only means by which artists could live and support their practice. The state of affairs was to change dramatically as Thatcherite monetary conservatism, inaugurated by the squeeze on public finances in the budget of 1979, gathered pace during the 1980s. In the ten years that followed, the art schools lost their power of patronage and with it their independence.

By the end of the decade, along with the rest of Britain's cultural institutions, the art schools had been made subject to the new cult of public accountability. Margaret Thatcher's first term as prime minister began in May 1979. There followed three consecutive periods of office, ending in the autumn of 1990. The young British artists who came to prominence during the late 1980s and early 1990s, including Damien Hirst, Gary Hume, Chris Ofili, Sarah Lucas and Rachel Whiteread (all of whom are represented in *Public Offerings*), were schooled, trained and achieved early recognition as artists under Thatcherism. For this reason, as well as attracting such titles as the Brit-Pack and the YBAs (Young British Artists) from the tabloid press, more serious newspapers have sometimes cast them as part of a wider generational grouping: Thatcher's Children. As Thatcherism's products they acquire a more negative social gloss: Thatcher's Children, by definition, are self-seeking and lack any sense of collective social purpose.

But Thatcherism is not so easy to define in strictly social terms. Arising out of an almost theological dispute over economic method, it mixed moral imperatives with practical economics. It may be most easily defined as a hard-line, Milton Friedman-like monetary experiment designed to energise the British economy by deregulating and liberalising the market; its main concern is for 'honest' money. There were shades of moral rearmament about it, too. As a *realpolitik* it required a dramatic change in the economic culture: in the public and the private sectors of industry; in the banking and finance houses; and in the minds of trade unionists and of the public at large. Margaret Thatcher referred to this process of reform in almost messianic terms, as 'a crusade for national regeneration' intended to halt 'the drift into state socialism'. In this respect the Thatcherite 'counter revolution' was designed from the outset to reach far beyond the boundaries of routine economic policy.

Analysis of Margeret Thatcher's speeches from her first period as prime minister also reveals a highly ambivalent social dimension, expressed very often in carefully crafted sound bites concerning 'ending the dependency culture' and 'rolling back the nanny state'. Thatcherism was intent upon teaching the British people how to be tough and self-reliant. It was a high-risk strategy, and it was clear that Thatcher and her colleagues fully accepted there would be casualties along the way. By the summer of 1980, there had already been a record number of bankruptcies, and by 1982 the national unemployment figure had risen to 3.25 million. Informed opinion had always held that if unemployment in Britain reached beyond the 2 million mark there would be serious civil unrest, and indeed the period between 1981 and 1985 saw a marked escalation in incidents of urban disorder. Some of them – occurring in such major cities as Bristol, Manchester, London, Birmingham and Liverpool – involved full-scale rioting with a disturbing racial dimension. For the first time since the 1930s, Britain was witnessing the formation (and, some have argued, the deliberate construction) of an urban underclass.

Given the crusading objectives of this first Thatcher government – its intention to re-energise and renew not just the economy, but the British way of life – it seems highly paradoxical that it reserved some of its most destructive and socially divisive policies for the state education system. As unemployment was allowed to grow, the education budget was allowed to wither under inflationary pressure until its share of the gross national product had fallen by seven percent. Universities and polytechnics, as well as schools and departments of art and design – the higher education sector – were hardest hit. Class sizes were forced up and research budgets were cut. Top academics began to quit their posts. Brilliant young scholars began looking to make their futures elsewhere. By the mid-1980s, the 'brain drain', as the press had christened it, had reached frightening proportions. This period of imposed financial stringency had a tremendous impact on the art education system. Apart from the immediate, very obvious consequences – the loss of human and material resources – it raised vital long-term questions of a deeper, philosophical kind, in particular the issue of whether the art school's primary function was to produce artists or whether it was just another limb of the general education provision. In the past, wiser minds quite rightly had thought is was a question that was best not asked. Now, in the colder economic climate, it emerged centre stage.

Predictably, in the asking, it changed altogether the liberal, vocational ethos of these historic institutions, as well as the career intentions of their

graduates. The British art school system had grown out of the utopian ethos of nineteenth-century political thinkers such as Arthur Bradshaw, William Morris, Robert Owen and John Ruskin. They shared the same ideological roots as the WEA (Workers' Education Association) and had always shown an open door to anyone who could demonstrate even the smallest amounts of creative ability, regardless of their social class or academic qualifications. During the inter- and postwar periods, art schools had come to function as an escape route for the educationally disaffected, providing an important opportunity for thousands of young people who for one reason or another had been unable to prosper in, or benefit from, the experience of mainstream schooling. Now this open door was gradually being forced shut by a series of government inspired measures linking recruitment to academic qualifications by means of fiscal inducements; the art schools became more and more the domain of the educated middle class. Having been stripped of their principled alternative educational function, and with the teaching profession contracting at every level, the schools were forced to professionalise their educational objectives. There was nowhere else for graduating art students to go except into the outside world as practitioners.

For the most self-aware of the schools – those in metropolitan centres in particular – this change towards a more professional attitude had, in any case, already started to gather pace from the beginning of the 1970s. Force of circumstance now meant that this process was greatly accelerated. Exceptionally, at Goldsmiths College, tucked away in one the poorest districts of southeast London, the change had already been achieved by the middle of the 1970s. Whenever the revival of the British art scene is talked about it is invariably linked with the rise of the Department of Fine Art at Goldsmiths College. And if you list the names of young artists who came to prominence in the 1980s and early 1990s, you would observe that a substantial number were taught there. The reasons why this particular school was able to be so prominent by the end of the 1980s, during a time of steadily increasing political and economic control, are very complex. The presence of a very high-quality staff comprising young, professionally committed artists, all working on part-time contracts, was one very important factor. Perhaps it was even the most important. But there were other reasons, too. The recent history of the place – the Marxist/Leninist- and Maoist-inspired occupations of the late 1960s – had made it ripe for reform. And the anomalous position of Goldsmiths College within the higher education sector meant that reform was possible.

The worldwide campus uprisings and occupations of 1968–69 occurring in the States in places like Ann Arbor, Berkeley and Madison, and on mainland Europe at the Universities of Paris, Milan or Rome and Turin – found their sharpest point of focus, not surprisingly, in Britain at the LSE (London School of Economics). More curiously, the most intense secondary points of confrontation occurred at art schools, with prolonged student disturbances and occupations occurring at Hornsey College of Art on the northern fringe of Greater London and at the opposite end of the city at Goldsmiths. Despite the distance between these two institutions, subsequent analysis has shown that the two groups of student leaders were in close communication with each other and presented their respective colleges with a common agenda for reform: a set of quite reasonable demands for improvements in both the substance and delivery of their courses, and fairly standard requests for greater participation in the decision-making processes governing student life. Mixed in with these was an array of highly contentious proposals – including the purging of named members of staff with largely imaginary 'fascistic' tendencies, and a call for collegiate declarations of solidarity with a number of global revolutionary movements headed by such fashionable figures as Ho Chi Minh, Fidel Castro and Mao Tse-tung.

Thus far, whenever Goldsmiths story has been told it is hardly ever mentioned that, but for astute handling by the academic leadership of the college, what local history now calls the 'Hornsey Affair' might easily have ended up as the 'Hornsey/Goldsmiths Affair'. The reactions of the two institutions were strikingly different. Prompted by their public-sector paymasters, Hornsey opted for a policy of confrontation and resistance. By contrast, Goldsmiths, which enjoyed greater scope for independent action, straightaway entered into negotiations with its students, applying at the same time a strategy of 'controlled inertia'. The intention was to be as constructive as possible, but also to slow down events so as not to be forced into conceding too much too quickly. Predictably, the Hornsey troubles were brought to an end more decisively, but with a great deal of damage to the social and academic fabric of the institution, while the gradualist approach adopted at Goldsmiths allowed the argument to rumble on into the early 1970s, but with certain very positive outcomes for the future of the college.

The 1970s saw increased regulation of the British art education system. Edicts from the government were delivered on an almost weekly basis which, taken together, spelled a potentially very damaging restructuring of

the whole provision. Although Goldsmiths' real estate was owned by the University of London, it was not funded by the Court of the University or by the University Grants Commission. It cherished a longstanding ambition to become a school of the university, and it taught University of London degrees across a wide spectrum of subjects, but its application for school status had been blocked for political reasons on successive occasions.

Goldsmiths, alone amongst British art schools, existed in a funding limbo between local authority financing and direct grants from the government with neither institution prepared to take full responsibility. Having no single, all-powerful funding authority tugging at its purse strings meant that, while it was in no position to ignore this process of regulation, it was at least able to invent its own solutions to the problems that it caused. This state of uncertainty continued into the late 1980s and it generated a spirit of independence which, in concert with the reforms set in motion by the occupation of 1969, contributed to the transformation of Goldsmiths into the most significant centre of fine art education in Britain.

This freedom to determine its own course of action was of considerable importance to the subsequent development of the fine art department. Seen in the context of the rest of British higher education, from the late 1960s through the 1980s Goldsmiths was an entirely unique institution. The form of teaching that is now referred to as the Goldsmiths-model was intended to achieve one very simple objective: in line with student demands, it was to make the educational experience for young artists correspond more closely to the conditions prevailing in the professional world outside. However, to call it simple is not to disguise the more problematic, even contradictory political dimension of the project; the fact that, although it sprang from an entirely different ideological perspective – that of the principled, libertarian Left – the underlying objective found an extraordinary (and, some have argued, more fortuitous) echo in the individualistic brand of conservatism espoused by Thatcherism. Such arguments, though, are deeply misleading.

Expecting to obtain the cabinet portfolio for education in Margaret Thatcher's first government, Sir Keith Joseph, Margeret Thatcher's ideological mentor, coined the phrase 'education for working life' prior to the election victory of 1979. It subsequently became almost a political *cri de coeur* for New Conservatism. Under Thatcher education was to be made responsible and purposeful; all New Conservative citizens were to be equipped to live a useful life. The difference between the education philosophies of Goldsmiths and the

ruling conservative government, then, is crystal clear. Goldsmiths' objective was to release and radicalise the creative potential of young artists. Joseph's philosophy was aimed at achieving conformity. Young people were to be taught how to occupy prefigured, idealised roles as full participants in the commercial and social construction of a new middle class. They were individuals only insofar as they were able to contribute a necessary component within an essentially asocial, conservative utopia. As a disciple of the American theologian and social scientist Michael Novak, Margaret Thatcher hated the very idea of society except as a 'concrete' entity, a 'structure of responsible individuals'. Beyond this, as she states in her memoirs, society is a useless 'abstraction'. On the surface, there is nothing particularly reprehensible about such a notion, if it were not for the fact that Thatcherism worked with a version of the individual that was obsolete except in the conservative clubs of small-town, rural Britain. Exemplary of what she describes as 'Victorian virtues', they were to be hard-working family-builders, self-disciplined and self-reliant, with a strong sense of civic pride and responsibility. Even if they happened to be poor, they had to be on the right side of the moral divide between the 'deserving' poor and the 'underserving'.

This Thatcherite 'individual' was also relatively uncultured. During her 11 years as prime minister, there was no cabinet portfolio for the arts or for culture. And in almost 900 pages of political memoirs, she devotes only four to arts policy, a retrospective apologia for her stand against increasing state subsidies to the arts. In passing she defines the arts as 'unplanned, unpredictable, eccentrically individual' and, in their effect, 'serving only the vested interests of the arts lobby'. Artists, in short, were beyond the proper scope and reach of the responsible state. 'No artist has a right to live off his work,' she writes, 'independent of market forces.' Again it was the very opposite construction of the role of the artist to that envisaged by the Goldsmiths model, which started from a belief in the absolute necessity for a mixed economy in the arts. As true individuals – inventive, free-acting, non-conforming, critically responsible members of a lived, continuously evolving culture – artists would come in every shape and size, and would involve themselves in many different forms of practice, some of which would find no comfortable or appropriate niche in the commercial art market.

Though the objective behind the Goldsmiths model was simple, by starting with the very basic question of what should be taught to an ambitious art student in the last quarter of the twentieth century, it came to threaten many

of the most cherished and longstanding beliefs of British art education. The traditional, craft-based divisions between painting, sculpture and print were dismantled and replaced by an integrated, idea-led model that embraced all of the new forms of practice on equal terms. Compulsory drawing was abandoned. Classes and short-course teaching were stopped and a tutorial system installed, which for the first time embraced art theory as an integral part of practice. It amounted to a radical review of the idea of 'studentship' itself. In a comparatively short space of time the residual pedagogy of the old academies and the institutionalised authority of the teacher had been replaced by something approaching a community of artists talking and working together.

In the event, Goldsmiths programme produced strongly committed young artists of radical disposition who were also self-confident and articulate, well able to hold their own in any arena of critical debate. Even so, they were shunned by the main postgraduate centres because they were said to be 'too formed', 'too clever' or, most damning of all, 'too professional'. As late as the mid-1980s, the barely ghosted figure of the nineteenth-century grand amateur still stalked the corridors of British art schools. The annual exhibition of Goldsmiths student work had become a notable event on the London arts calendar, attended by dealers, critics and collectors, and yet there was still nowhere else in the so-called higher levels of art education for Goldsmiths graduates to go. By now it is a matter of history that at a certain moment – sometime during the first half of the 1980s – they stopped trying to go anywhere and opted instead for the direct leap into the world of professional practice.

By the early 1980s forces were already at work that would change the London art scene dramatically within a decade. While it is undoubtedly true that the commercial gallery system tends to shrink as a recession takes hold, it is also true that the art market is often one of the earliest strands of the economy to respond positively to signs of an economic upturn. Optimism and pessimism can also sometimes appear to coexist, and this was very much the case in the London art world of the early 1980s. Sales of high profile, blue-chip contemporary artists were becalmed while another space in the market was beginning to open up.

Periods of economic depression can hold within them the seeds of change and offer the opportunity to build something new. In the case of fine art sales (as with all commodity markets), a subtle shift in the economic climate can precipitate a change in the prevailing mood of consumers. Margaret Thatcher's monetarist experiment suffered its darkest hour in the

winter of 1980–81. By January, 'good-weather' adherents of the monetarist cause, including some cabinet ministers, had begun to abandon ship; and in February, the conservative *Times* newspaper, in an attempt to change the direction of the government's economic policy, carried the headline 'Wrong, Wrong, Wrong'. But Margaret Thatcher stuck to her guns and the budget of 1981 was again solidly monetarist in its drift, though at the behest of her closest economic advisor, Sir Alan Walters – and against the advice of the Treasury – it included measures designed to allow the monetary base of the domestic economy to grow more quickly. The seeds of economic recovery had been sown. By the close of the year the first green shoots of an economic upturn were beginning to show through, all but buried beneath the debris of a disastrously inadequate social policy. Just two short years later, in 1983, Margaret Thatcher was able to announce to the House of Commons that public finances had improved to the point that she was able to fund the 1982 Falklands campaign out of the government's contingency reserve, with no extra taxation and no adverse effects on the financial markets.

Most serious dealers and gallerists, especially those who work at the cutting edge of the international art market, seem gifted – like gamblers everywhere – with an unreasonable degree of raw optimism. Buying and selling contemporary works of art inevitably involves taking risks; even when the cold wind of recession is blowing at its most chill, rather than simply batten down the hatches, their first instinctive response tends to be a commercially aggressive one. Instead of retreating, they redouble their efforts to make sales, search for new markets, and, perhaps most of all, look for new artists with distinctive new products to promote. This was very much the prevailing atmosphere in the London of the early 1980s. The dealing fraternity was out and about visiting studios, making mixed exhibitions, giving opportunities to young up-and-coming artists to make their mark. The first, tentative signs of economic recovery seemed to set into motion a process of transformation that, over time, was to bring about the complete restructuring of the London art world. Driven by a consensus on the need for change, which at the time seemed almost to have arisen subliminally, people began to behave differently towards artists, towards each other, and towards the larger art world outside.

Enthusiastic observers of the London art scene have tended to attribute its revival to the activities of particular institutions, key individuals or the advent of certain important regular events: the founding of the Tate Gallery's Friends of New Art in 1976, Patrons of New Art in 1982, the start of

the Turner Prize in 1984, the collecting activities of Charles and Doris Saatchi in the 1980s and the opening of the Saatchi Gallery in 1985, or Damien Hirst's *Freeze* exhibition in 1988. All of these and many more besides were clearly of great moment and served to influence the subsequent pattern of events in important ways. But, as is so often the case, the truth is more complex than that. It is clear, for instance, that by the mid-1980s there were a lot of people in the London art world who were seeking to make a more contemporary response to the changes that were occurring in the practice of artists and in the global art market. New money had replaced old as the engine of cultural capital. The exclusivity of the collecting habit had begun to break down, and this in turn was transforming even the geography of the London gallery scene.

From the interwar period on, private galleries had clustered together on and around Bond Street, the most expensive and exclusive commercially rated shopping area in London's West End. With the notable exceptions of Nicholas Logsdail's Lisson Gallery on Bell Street; Nigel Greenwood Inc near Sloane Square; and Matt's Gallery, a pioneering, studio-style showing space in the East End run by the artist and teacher Robin Klassnik, this was still the case at the beginning of the 1980s. But as the decade got underway, chiefly because of economic pressure, the gallery scene began to disperse. New galleries were opened by a new generation of gallerists and dealers. Situated in less predictable, sometimes quite obscure parts of the capital, most of these were focused around what was already being referred to as new art: 'new' having by this time superseded 'contemporary' in the lexicon of the fashion-conscious cultural set. New British art also needed an informed audience and a committed group of collectors. Both were there for the building as the recovery gathered pace. New British art also needed to find its place in the international art scene – and not simply along the old transatlantic axis that had served previous generations of postwar British artists so well.

Like the global economic landscape, the landscape of the global art market was undergoing rapid change. New York was losing its dominance. The European revival was underway in Germany and Italy. Many of the new breed of London gallerists – Karsten Schubert, Victoria Miro, Mario Flecha, Nicola Jacobs, Maureen Paley at Interim Art and Robin Klassnick at Matt's – had considerable international experience and were ideally placed to assist in this process of contextualisation. Others, like Anthony Reynolds, Laure Genillard, Nigel Greenwood and Richard Salmon, concentrated more on the task of securing a place in the market for the emerging generation of British artists.

Younger collectors of new art had started to emerge in growing numbers where few had existed before. A new moneyed class had begun to show itself – one that was mostly involved in the increasingly successful service sector of the British economy. Margaret Thatcher's policy of deregulation had spawned a new type of nouveau riche – lifestyle junkies determined to be at the cutting edge. And cutting-edge art was an important part of their social currency both at home and at work. Advertising and public relations agencies, television and graphic design studios, fashion houses and new designer stores led the way, establishing a different approach to the working environment in which up-to-the-minute works of art were an important part of the 'image building' array.

Fashionable tendencies depend on leaders of fashion, and Charles and Doris Saatchi were tailor-made for the task. He was rich, successful, socially active and culturally engaged. As one half of the advertising partnership Saatchi and Saatchi whose slogan 'Britain Isn't Working' brought Margaret Thatcher to power, Charles was also politically tuned in. Doris Saatchi, by contrast, was an art world insider, an art historian with a passion for collecting contemporary art. During the late 1970s and the first half of the 1980s, working together and out of the public eye they built a truly extraordinary collection, staggering in its scale and quality. It was made visible only in 1985 when they opened a gallery on Boundary Road. The British art public had seen nothing like it. America, it seemed, had come to Britain. And while there were detractors – dark murmurings of American imperialism – the enthusiasm of the young was unconfined. As founding members of the Friends of New Art, influential international collectors, and owners of an important, semi-public gallery space in the capital, the Saatchis were uniquely placed to influence public institutions and public taste. They set about doing both. Indeed, their activities were instrumental in feeding the desire for change. But it would be misleading to suggest that there was some grand purpose behind their activities, beyond personal ambition and the public display of a shared enthusiasm for new art. Nevertheless, their early curatorial activities at the Boundary Road gallery conspired with other factors in the development of what became known as the 'Goldsmiths style'.

Most critical commentators on the Goldsmiths artists describe the work as a collision between Duchamp and Minimalism. Naive though this description is, it is not entirely erroneous. Two of the earliest show at the Saatchi Gallery – a group exhibition of American art including a major showing of Minimalism that inaugurated the gallery in the autumn of 1985

and one year later, *New York Art Now*, were of great importance to successive years of Goldsmiths students graduating between 1986 and 1990. Indeed, they exemplify two of the main concerns shaping attitudes at Goldsmiths at that time: the desire to be formally lucid and materially direct, and the intention to deal with the emerging complexities of contemporary life in an openhanded way. Firsthand experience of major works by Donald Judd, Brice Marden and Richard Serra, previously accessible only through magazines and catalogues, taught them something about a way of 'thinking' and 'making', while the Neo-Geo artists Ashley Bickerton, Robert Gober and Jeff Koons – as well as fuelling their desire to be sharp and stylish – demonstrated a way of referencing the world without representing it. The bar room chat of the time held 'expressiveness' to be absolutely out and the 'dumbshow' – work that refused to disclose – absolutely in. If there is a distinctive flavour to the Goldsmiths brand of irony, then, it would seem to subsist in the pretence that as long as works of art look thoroughly at home in the current 'commodity-scape', they can simply lie doggo and that is enough. Gary Hume's door paintings and Damien Hirst's spots, some of which were made at Goldsmiths College as early as 1987, seem to exemplify this approach. It is of course a pose, a rather disingenuous form of self-stereotyping – a facade of ironic chic. Beneath the smart outward show and the assumed rhetorical ease, this so-called Goldsmiths style, which by now has come to represent a much broader strand of British contemporary art, is focused in reality on the question of 'values'. This is its Duchampian aspect. Skeptical towards both the market and the institutions of cultural attribution, at its toughest – and here it is appropriate to cite the work of artists like Tracey Emin, Sarah Lucas, Bob and Roberta Smith, Mark Wallinger and Gillian Wearing – it is steeped in the spiritual ennui that attends all radical forms of doubt. Furthermore, to choose to live the conflict – art world as comfortable '*habitus*' versus art world as a 'grand folly' – rather than simply coming down on the side of the status quo in the British context ties the debate inevitably to the question of social class.

Since the Second World War, British art has tended to draw its energy from popular culture, while its values have continued to be shaped by an older order: the patrician connoisseurship of the educated middle class whose members have traditionally filled the ranks of the civil service and occupied key positions in the mainstream cultural institutions and quangos (Quasi-Autonomous Non-Governmental Organisations) put in place to control them. In this respect, the formation of cultural values has mostly

been a case of like minds agreeing with like according to a shared agenda of interests. This natural consensus remained unchallenged until 1979 when Margaret Thatcher came to power. Part of the objective of the Thatcherite counter-revolution – she puts it very concisely in her political memoirs – was to remove the 'deadening hand' of the liberal, middle-class consensus from affairs of the state. In Thatcher-speak this meant professionalising its administrative functions by importing sound business methods and expertise into every level of public life. Accordingly, the arts saw the advent of a new breed of administrator. The 'arms-length' principle, in place since the 1930s, was comprehensively breached by a whole series of politically motivated appointments, and the existing, privileged executive class was replaced by one in which business interests were at least as important as cultural ones.

By the late 1980s monetary economics, coupled with the natural course of industrial change, had produced a severe contraction of Britain's traditional manufacturing base. Large tracts of land where industry had once ruled supreme were in urgent need of regeneration, and all sorts of new quango-style organisations were put in place to help facilitate this process. In London a vast area to the east of the city, north and south of the river Thames, known as Docklands had been laid waste, as had tracts further east and on the margins of north and south London, too. Many of these sites were in the hands of development agencies or tied to local planning initiatives through public/private partnerships of different kinds. Not surprisingly the agents were looking for short-term 'lets', anything that would help them bridge the income gap before full-scale development could begin.

Artists and artist organisations moved in to create studio complexes, followed by temporary exhibition spaces aimed at escaping the usual processes of institutional scrutiny. In the event, the new breed of property entrepeneur proved more prepared for risk-taking cultural ventures than the old-style arts establishment. Docklands became a place for artists to live, work and show their wares. The first major initiative of this kind to capture the public imagination was Damien Hirst's *Freeze*, held in a disused tally-warehouse in Surrey Docks over the summer of 1988. Featuring work by three generations of Goldsmiths students including Angela Bulloch, Mat Collishaw, Ian Davenport, Angus Fairhurst, Damien Hirst, Gary Hume, Sarah Lucas, Simon Patterson and Fiona Rae, it attracted widespread critical attention both in Britain and abroad. Hirst, who was only in his second year at Goldsmiths, had achieved a breakthrough in the exhibiting options available to young artists, one that

would be imitated many times over in the course of the next five or six years. Notable examples from 1990 include *Modern Medicine*, a joint curatorial venture between Hirst, Billee Sellman and Carl Freedman at Building One, which introduced the work of Abigail Lane to the art-going public; Sellman and Freedman's *Gambler*, which included Hirst's first large-scale vitrine piece, *A Thousand Years*; Michael Landy's vast, thematic, solo show, *Market*; and Sarah Lucas and Henry Bond's *East Country Yard Show*.

As the property market roller coaster rumbled on into the 1990s, so the round of exhibition-making continued. Warehouse shows that sought to imitate those at Saatchi Gallery or Kunsthalle-style showing conditions became almost routine. A symbiotic relationship was established with the property market as the alternative art scene and its exhibitions became part of the selling and letting strategies of estate agents. Although commerce had effectively closed down many of the spaces that the young artists of the 1980s had worked so hard to open up, suddenly, a more conventional type of gallery space began to look like an attractive proposition again. Many of them were run by artists – mostly on a short-term basis – without the trappings of art-dealing attached: the Woodstock Street space run by Tamara Chodzko and Thomas Dane, where Hirst made the important early installation piece *In & Out of Love* using live butterflies, or the Milch Gallery where Lawren Maben organised the remarkable first and last London showing of work by the late Hamad Butt, a seminal early attempt to make an effective link between the languages of art and science. 'The Shop' on Bethnal Green Road, run by Tracey Emin and Sarah Lucas, marketed 'bad-girl' artefacts – the first systematic attempt to reflect upon the increasing commodification of the London scene – and the betting-shop-turned-art-gallery City Racing mounted occasional exhibitions with many of the new generation of artists, including Mark Wallinger, Sarah Lucas and Sam Taylor-Wood.

During the 11 years of Thatcherism a seismic shift had occurred in the character and operation of the London art scene. In a way though, it had come full circle. Once a slightly sleepy, even rather comfortable place for artists to live and work, now it was much more commercially active and professionally competitive. However, what had started off as a radical, artist-centred initiative set to bypass both the gallery system and the orthodoxies of the middle-class cultural establishment, by the mid-1990s had drifted into a new kind of commercially focused, commodity-oriented conservatism. For the most part, the new generation of British artists had succumbed entirely

to the heady blandishments of the galleries and surrendered themselves to the institutions of the state, to be used jingoistically in the promotion of the economically revitalised new Britain.

In this respect, it is interesting to compare developments in British art during the second half of the 1990s with the direction art was taking on mainland Europe. While continental European artists were exploring ways of dissolving the art object by adopting informal installation strategies and the use of new media (I am thinking of artists like Suchan Kinoshita, Keiko Sato, Eran Schaerf and Joëlle Tuerlinckx), British art remained wedded to the object and to its treatment as the furniture of spectacle with a few notable exceptions – Steve McQueen, for example, or the Wilson twins. This was perhaps the most noteworthy characteristic of the *Sensation* exhibition held at the Royal Academy in London in 1997. While European artists were becoming more and more preoccupied with developing 'positional' critical thought in clear opposition to the idea of the work of art as saleable object or commodity, British artists seemed to have given themselves over almost entirely to the gallery system and embraced the mythology of freedom that goes hand-in-hand with the ideology of the open market. This is not to say that the British art scene of today is without critical dimension, just that it has been temporarily drowned out by the clamour of art world successes. Indeed, the critical issue remains the same: a continuous undercurrent in British art since the time of John Ruskin and William Morris that is about cultural ownership, art's humanising mission and its ultimate intelligibility.

Public Offerings, exhibition catalogue, Museum of Contemporary Art, Los Angeles and Thames & Hudson, London, 2001.

A SMALL MATTER OF THE PERFECT LIFE
IN THE PERFECT DEATH

James Lee Byars came from Detroit, Michigan, and studied philosophy at the Merrill Palmer School for Human Development. He preferred Europe to his native America, and chose to live most of his life in exile; as a nomadic artist, travelling widely from his base in a small pensione in the San Tomar district of Venice, close by the Grand Canal. Thomas McEvilley has described Byars as 'a golden man parading around the world leaving a trail of what seemed like ideal atmospheres.'

Certainly the splendidly baroque and gilded surface of Byars's life-long odyssey, seems to have been bound up in the search for absolutes: absolute beginnings; absolute perfections; absolute silences; absolute absences; absolute brilliance, the list is endless. At a deeper level though, it was about the microscopic exploration of a singular *absolute*: that of human measure; of living and dying amidst the doubts, desires and secret intimacies of the self. Byars was a man who acted out his contradictions. And for this reason his work as an artist seems to hover, endlessly, somewhere between the grand metaphysical gesture and the private joke; between ostentatious, public performance and private inscription. For Byars too, the performance never stopped. Once having turned his entire life into a conspicuous act of theatre,

like his favourite poet, W.B. Yeats, he came – in the end – to seek after the mystery of human identity in the manner and ritual of his own death.

Byars travelled light; a few belongings tied up in a black silk square.

And always amongst them the works of Yeats who, in *Discoveries*, had already linked the idea of 'the travelling subject' to the cycle of being, and the mysterious life of objects – their 'circular perfection' – to the process of magical renewal. For years, then, the form of the circle – black, white, red or gold – represented divine perfection, represented *Perfect*, as he called it. And he inscribed circles of stone, of glass, of paper, of silk – endlessly marked them with this solitary and absolute word. *Perfect* became a signature and a provocation, a transcendent value and an object to be sold. Sometimes it was printed, sometimes handwritten, in a plain, rather awkward, looping script and sometimes it was adorned and spangled with stars. Always it was at the centre. 'The Godhead', Yeats wrote, 'is a circle whose centre is everywhere, the saint goes directly to the centre and the poet and the artist to the ring where everything comes round again.'

Byars was certainly no saint, he was too much of the trickster for that, but he was the visual poet *par excellence*, and he knew very well the infinite distance that must be travelled between centre and the periphery. He cut and tore most of his circles from coloured papers, folded them and dispatched them to the four corners of the world. By contrast the rings – empty centres – were carved or sometimes cast. Significantly, the ring and the circle appear together in their most vivid and virginal forms – most weighty and at the same time most ethereal – in *The White Mass*, created by Byars in 1995 (some three years before his death) for the Jesuit Church of St Peter in Köln. The celebrant, dressed from head to foot in white, was required to step into a ring of pristine marble, carved according to Byars's most exacting instructions in the ancient quarries of Thessaloniki (a stone's throw from Mount Athos) before raising the pure white disc of unleavened bread – the host – to the heavens.

The story goes that Byars instituted a search to find the whitest possible communion wafers, and that he finally ran them to earth in a convent in northern France where they were made by the nuns. The discovery must have amused him greatly. It was the opposite of the quest for an absolutely black pizza, he pursued night after night, year in year out, at Fausto's restaurant on the Zatterre in Venice. The restaurateur, Fausto himself, playing Mephistopheles to Byars's Faust. Responding with infinite patience to Byars's

imperious demands for a more perfect circularity, or a greater intensity of blackness, as one severely charred pizza after another was brought to his table for inspection.

As well as reminding Byars of his favourite Zen game of opposites, picked up in the monasteries of Kyoto during his first trip to Japan in the 1960s, finding such a wonderfully pure and virginal disc, must also have returned him to the metaphysical conundrum that most fed his philosophical doubt; the problem of *isness* as it is consecrated in the contradictory theology of the *One*. *Is Is*, he famously declared... 'all that is is all there is'. *Isness*, it seems, functioned for Byars as a kind of metaphysical glue, it enabled him to act against the infinite variety and divisibility of things: allowed him to double, treble, multiply everything; to break apart and scatter things. Sometimes, as in the Goethe performances, with great violence, as if he was trying to test the very idea of *Oneness* to destruction; to shatter, disperse or dissolve the singular into the innumerable. Read Byars's letters and it is amazing how many times he speaks of a 'million': 'a million angels'; 'a million perfects'; 'a million pounds'. For Byars a 'million' was an unthinkable quantity wrapped up in a simple singularity; the same relationship that exists between the absolute mutability of currencies and the immutability of gold.

Plotinus, author of what was to become a curiously apt Venetian heresy and one that greatly charmed Byars, held 'the One to be in all things and in none of those things', and he required his followers to live this contradiction by becoming double and divided personalities. Only this way, according to his teachings, could they hope to reconcile the world of opposites. In a startlingly modern aphorism, that might well have been written by Byars himself, Plotinus describes the self-reflective and airless nature of this splitting as 'Two holes and me in the middle, slightly choked.' The Renaissance poet, Dante Alighieri, himself a closet neo-Platonist, greatly influenced by the writings of Boethius, describes this state of partial suffocation as occurring between entrance and exit – the way in and the way out – between birth and death, in other words. Like Dante, Byars too, pictures this condition in the form of a spherical body – a drilled-through *perfection* – containing the breathlessness abjection, fear and self-loathing of the fallen man, to be written around and eventually raised to transcendence, in the form of *a spherical text*.

Over the years, reconciliation of the *imperfect* inside and the *perfect* outside was foreshadowed as a lived state through Byars's studied assumption of sartorial elegance. After his return from Japan he cloaked his body only in

the silken threads and colours of the oriental seasons; white, red, black and gold. And towards the end of his life, bright, metallic gold – signifier of the spirit and of death – came to dominate all of his live performances. In Brussels, at the Galerie des Beaux Arts, in 1994, a golden suit, dripped with golden light, in a golden room. Refracted light dissolving geometry and telescoping space, saw Byars, eyes blindfolded and wearing his black silk Top Hat, functioning like the dead centre of an ancient undiscovered sun, pointing relentlessly to the subject of his own *perfect* death. A golden unity at last, spelling out the eventual end of all doubt.

By contrast, one of Byars's most celebrated and perhaps most fleeting performances, *The Perfect Smile*, enacted in Köln in the same year, was set against a large black wall, almost an infinity of blackness. A kind of optical void. Byars, again dressed in his gold suit and accompanied by a friend walked to the centre of the wall and turned to face the assembled company. The friend adjusted the blindfold, pulling it down to leave only the artist's mouth visible, before withdrawing. After a suitable pause, Byars smiled a brief and barely perceptible smile before turning on his heels and walking away.

Thomas McEvilley has suggested that it is of the very essence of Byars's art that there is no mixing of codes, no inflation of language, no histrionic extension of the event, but that a 'slender datum is experienced in its purity' or 'self-sameness'. Viewed in this light, this very small and secret, almost interior smile, Byars's *Perfect Smile*, might easily be construed as a reductive gesture. However, though it was certainly Byars at his most enigmatic, it was also Byars at his most dense and compressed. A few years before, in a conversation at his 50th birthday party he had questioned friends about a particular smile occurring in one of Shakespeare's history plays. The young King Richard II has been deposed and knows that one way or another he will be put to death. In his imagination he sees the figure of death – the 'antic' as Shakespeare calls him – seated within the golden circle of his crown; sees the 'antic' smile a 'little smile' before boring through the King's skull.

That a man should be able to foresee his own end is essential to the Yeatsian notion of the 'wheel'. It stands as proof of the individual's encapsulation within the serial and successive nature of the human condition. Byars courted his own death in his performances, long before he knew that death was just around the corner. It was a preoccupation proper to his quest; one that had been with him from the beginning. Throughout his life, he had searched after wisdom, divorced from moral and ethical imperatives, and wisdom, according

to Yeats, is hardly compatible with the simple living of a life. Wisdom is the antithesis of the quotidian and leads inexorably towards the eradication of the subject by dissolving the boundary between self and other. By the same token *perfection* cannot be achieved in a single lifetime. Indeed it might easily require a succession of historical periods and a succession of lives.

Perfection, in this respect can only ever be guessed at. As Plotinus writes in Book IV of the Enneads, 'if whiteness were existence itself, it would possess an eternal and absolute existence, but in reality it is nothing more than whiteness.'

James Lee Byars, exhibition catalogue, Biennale for Contemporary Art of Leuven, Leuven, 2001.

I was really excited when Orla Barry – one of the brightest and linguistically clued-up of artists – asked me to write about her film, *Foundlings* commissioned by Argos, which was to be premiered in their specialised exhibition space in Brussels. As a long-standing admirer of her installation works, her performance works and her writings – with her encouragement too – it gave me the opportunity to write about a single rather complex work of art in a new and different way; to take on board the poetic nature of Barry's work and to try to produce something like a parallel text. Somewhere lurking in the back of my mind were Frank Kermode's essays (once a favourite book but long mislaid) on James Joyce's *Ulysses*, and this memory set me reading Joyce's masterpiece all over again. Reading the piece now, much as I still like it, I think that Joyce took over rather too much at the *Foundlings'* expense, although Orla Barry has never chided me about it.

THE WANDERING ROCKS

A pedestrian in a brown macintosh, eating dry bread, passed swiftly and unscathed across the viceroy's path.
– *Ulysses,* James Joyce

One of the most mysterious and talked over figure in Joycian exegesis is the 'Man in the Macintosh'. He returns and returns. He seems to have no proper role in the overall narrative; is neither identified nor his presence explained. From within the story, Leopold Bloom, Joyce's unlikely hero, is the first to notice and name him, calling him by the diminutive 'M'Intosh'. From outside, commentators have cast this literary 'foundling' variously as Leopold M'Intosh, a second version of Bloom; as a reworking of the character Theoclymenos, friend of Telemachus in Homer's *Odyssey* (the schematic model for Joyce's novel); as James Joyce himself; and as Stanislaus, Joyce's maniacally religious and puritanical brother. Indeed, these several cases have all been well argued by Joycian experts and scholars. But it is just possible that such attributions are missing the real point. Namely, that 'M'Intosh is there simply to be himself, a hermeneutically free spirit, if you like; free, that is, from the mechanistic necessities and forward motion of Joyce's pseudo-Homeric narrative. If this is the case then we might think of it as a most curious paradox, that the 'Man in the Macintosh' has generated so much interpretive energy over the years.

But is it? Surely Joyce, the self-proclaimed lover of 'mysteries and puzzles', more than anyone else knew that texts, of whatever kind – visual or

verbal – demand interpretation. That the more seemingly oblique or
disconnected a narrative is – as long as it has a distinctive literary shape
and is 'well-baited' – the more the compulsion to understand is conjured
up in the mind of the diligent reader.

It seems more than likely, then, that M'Intosh is intended to stand
out alone, as a gritty outcrop, in the ebb and flow of Joyce's narrative. That as
well as resisting all attempts at routine interpretation, the function of M'Intosh
is that of an enigma, a decoy and a lure.

> Lure, l(y)oor, n, any enticement:
> bait: decoy (like a bunch of feathers used to recall a hawk), – v.t. to
> entice:
> decoy. [O. Fr. loerre (Fr. leurre) – M.H.G. luoder (Ger. uder), bait.][1]

Viewed in a more general, theoretical light. If M'Intosh is intended to serve as
an enticement in relation to the readers' compulsive search for meaning, he is
also there to make it clear that all subjects, whether they are inside or outside
of the narrative, are afloat in the same limitless ocean that is language; a space
which has no exterior and from which there is no exit. Significantly, Joyce's
adopted Homeric voyage takes place upon a sea which, like language itself,
coincided with the limits of the known world.

> Sea. Bottomless. Symbol of infinity. Induces deep
> thoughts. At the shore one should always have a
> good glass. While contemplating the sea, always
> exclaim: 'Water, water everywhere.'[2]

But leaden skies, the sheer greenness of the land and – in particular – the
sullen grey, ebbing and flowing, hissing and rattling of the lunar tides –
horizon dividing the water from the sky, viewed resolutely by the foot-
journeying 'man', walking upon terra firma – seem to comprise the elemental
backdrop against which we must read so much of Ireland's literature and art.
An allegorical energy animating the wanderings of Leopold Bloom in Joyce's
Ulysses, by the time that Samuel Beckett wrote *Imagination Dead Imagine*
(1965), this same backdrop had transformed itself into a metaphorical site
charged with metaphysical significance for the act of inscription itself. In the
opening lines of Beckett's story, a vision of verdurous islands and azure sea

and sky – glimpsed and vanished – is abruptly collapsed into the intense whiteness of what Beckett calls the rotunda. The blank page waiting to rediscover for itself the creative act. Jacques Derrida's *White Mythology* (1982). Distant echos of Belacqua's *Dream*. What goes around comes around.

Writing with stones upon the sand. Rock fragments, worn smooth by the action of the waves, remark upon the pulverised remnants of themselves – their ghosted bodies – discovering their own deeper meanings in the process. Thus the body of the text is closed in upon itself, and the act of inscription, eternally feminised. Just like Joyce's 'Man in the Macintosh', the wandering 'Woman in the Red Bathing Costume' in Orla Barry's *Foundlings* passes through the quotidian world without seeming to be engaged by it. Almost she is inviolate. Wedded to the cold grey sea, she touches events without being touched by them. Like M'Intosh she has the knack of escaping the action; of surviving unscathed. Having emerged from out of the sea – her bathing costume proclaims it – her solitariness and singularity of purpose, simply to proceed barefoot, alone and unchallenged through the landscape, is enough to effect a reconciliation between the land, the sea and the sky, charging the whole with a certain grandeur. Like M'Intosh is to Bloom's Dublin-day too, she entices us into Barry's narrative space, already littered with self-scattering fragments, making no offer of syzygy and without at all betraying the significance of her own presence there. In the end she returns herself to the sea: as the picture fades and darkness rushes in she seems to have been swallowed up by it.

> Sea, scarcely audible.
> Henry's boots on shingle. He halts.
> Sea a little louder...
> (Slither of shingle as he sits. Sea, still faint, audible
> throughout what follows whenever pause is indicated.)[3]

See now how 'Sea', delivered as an instruction, is both the first and the last word of Beckett's sound play, *Embers* (1957). In between the two, the voice of Henry alternates with the distant sound of its ebbing and flowing. The sea must be heard in every break occurring in the spoken text. Beckett insists upon it. Hating the sound of the sea's endless roaring, Henry sometimes walks the beach with his gramophone; at other times he crashes rocks together to drown out its sound. At a certain point in the play, he remarks to Ada, a second liquid,

saxophonic, conspicuously female voice – Beckett describes it as a low-pitched, remote voice throughout – that the sound of the sea is only its surface and that underneath all is quiet as the grave... not a sound... all day, all night, not a sound. Suddenly, we realise that Henry, more than anything else, fears words and the space between words; that he craves real silence; that he longs to escape into the absolute, utterly abstract and thoroughly deafening silence that exists on the other side of language. Suddenly we know for sure that Henry's heart's desire is to reach outside the stream of his own consciousness, to cease his linguistic wanderings, to step off the white, black, white, black roller coaster of endlessly unpunctuated half-sentences and finally come to rest in a place where words no longer swarm and jostle like ants. Henry, in Beckett's *Embers*, despite the woman Ada's attempts to deflect him, is seeking oblivion, no less. Even so, perhaps the real key to Beckett's woebegone tale lies in the melodious timbre of Ada's voice; in the honeyed tone of her siren song, which – to paraphrase Derrida – coils itself like a serpent in the labyrinth of the listening ear: both beguiling and treacherous. Friedrich Nietzsche, in *Joyful Wisdom* (1882) remarks upon the sexual energy that seems to characterise certain types of female vocalisation. The powerful contralto voice particularly seems to fascinate the young philosopher and he imagines it as a ship with its white sails, like an immense butterfly passing over the dark sea; passing – as he says – over existence itself. The opposite of the soprano or treble voice, the contralto voice, Nietzsche believes, is an empowered voice and seems to transcend the difference between the sexes. It is man in woman and woman in man and as such represents the ideal lover, for example, a Romeo or a Sappho. But it also retains something of the mother, most of all when words of love are on her tongue.

Black, white, black, white: the supple and dark, utterly feminine voice-print... lover and mother... the written word spoken... sound laid over vision... the discontinuous voices in Barry's *Foundlings* seem to be extended endlessly by the sound of the sea. And it acquires, in the process, the sinuous linearity and liquid cadences of the Orphic lament which, according to Ovid, for the very first time, made pale phantoms and even the Furies weep.

> But an amazing thing will happen to you, Orpheus:
> you now charm wild beasts and trees, but to the
> women of Trace you will seem to be sadly out of tune
> and they will tear your body in pieces, though even
> wild beasts had gladly listened to your voice.[4]

Orpheus, in Arcadia, Philostratus tells us, was without beard, never man, more boy/woman, his skin blushing white, unblemished and unburnished by the heat of the sun. His inescapable destiny, like that which befell Pentheus son of Enchion, was to be stoned and then dismembered by a demented and enraged sisterhood of Ciconian women, who alone, out of all nature, found Orpheus' singing tuneless and irritating. Thus within the narrative play afforded by a single sentence, Philostratus calls attention to a slippage occurring between three, quite different narrative realms: the timeless, mythical site of conflict that the Greeks called Arcadia, a place in which actions, no matter how wilful or destructive, accrue no blame; the attenuated, pluralising, proleptic space of storytelling in which all possible outcomes are known and sanctioned in advance; and the space of 'difference' in which values are routinely reversed or turned upside down. In the course of this slippage previously fixed typologies begin to bend, shift and disperse themselves. The old sensual and semantic dualities start to break down, opening the way for new readings of the world and the self. Philostratus tells Orpheus in advance what is to become of him. He is to be torn apart, his masculine identity dismantled and the remnants of his body scattered to the four winds by the crazed women of Trace. But what he does not tell him is that his remains, including his still vocalising head, will be swept down river to the sea, afterwards fetching up on the shore of Sappho's island of Lesbos, where, through the intervention of Apollo, the shade of Orpheus passes beneath the earth to be reunited with that of Eurydice.

According to Philostratus, the Orphic lament is in tune mostly with the voice of the ocean as it breaks against the sands that ring the luxurious island of Lesbos. The place where its plaintive strains were finally extinguished in the conspicuously de-gendered gaze of his beloved Eurydice. And Ovid, in the Metamorphosis, describes a new kind of integrated and thoroughly democratic love relationship occurring between the two:

> There they stroll together, side by side: or sometimes Orpheus
> follows, while Eurydice goes before, sometimes he leads the way
> and looks back as he can safely do now at his Eurydice. [5]

In Orla Barry's *Foundlings* the metaphor of the island – in this case her native Ireland – seems to carry with it some of the 'lyric' complexity that classical exegesis has given to the island of Lesbos.

In Barry's Ireland, for example, a clear distinction is drawn between the 'public' world of men and the 'private' world of women. Men, like the dogs that bark in country lanes and hunt in packs, vocalise, drink and play together. There is a certain uniformity about them. They rehearse ritual conflicts and trials of strength with each other. Women, on the other hand, move with caution and some precision through this largely masculine domain. They seem to travel alone too. Treading the earth gingerly like cats. And, when eventually they congregate together, they do so – it seems – for no other reason than to be convivial and to share with each other their secret thoughts. While men seem content to exist quite simply between the cradle and the grave – waking and sleeping, working and playing – women are more quixotically engaged; amongst themselves as well as with their surroundings. Mostly they seem to be engaged flirtatiously with each other, and only turn their gaze in the direction of men in order to tantalise and to tease them.

Like Lesbos too, Orla Barry's 'lyric' Ireland shows itself most strongly in the folk memory of its women: in the games they play together as children; in the songs they sing; in the remembered joys and sorrows they bear through into old age; and perhaps most poignantly, in a shared and often profoundly frustrated erotic consciousness. Barry's island of Ireland, then, like the Ireland that through the mediating voice of Molly Bloom, James Joyce discovers in the closing pages of *Ulysses* is one in which the peculiar secularised ecstasies of women are finally recognised and given their rightful sexual force.

Sappho describes 'women's consciousness' – as distinct from the 'Homeric' consciousness (supposedly attributable solely to men) – using the Greek word *poikilophron* which, roughly translated, means to have a mind which is many-faceted... thought processes which are fluid... a spirit which is restless... moods and emotions which are less predictable because they are more complex. In her most famous poem in praise of Aphrodite, the goddess of beauty – and of sexual arousal – *Poikilophron athanat' Aphrodita*, Sappho uses the descriptive word dappled and likens it to the richly embroidered cloak gifted by Helen of Ithaca to Odysseus in preparation for his return to his father's house after the sea voyage described by Homer in *The Odyssey*. The same garment, the tattered remnants of which, in the event, served to hide Odysseus from his father gaze. Odysseus remembers, draws back the tattered remnants of Helen's cloak to reveal the place where he was pierced through as a young boy by the tusk of a charging he-boar.

The scar then, first of all. Look, here the wild
he-boar's flashing tusk wounded me on Parnassos;
do you see it? You and my mother made me go,
that time, to visit Lord Artolykos, her father, for gift
she promised years before on Ithaca. [6]

Thus in Homer's *Odyssey* the metaphor of 'women's consciousness' is used first
to hide – to cloak and to cover over – the invaginated figure of the seafaring
adventurer... to disguise the pierced body of the male hero, allowing it afterwards
– through a momentary homoerotic chiasm in the final scene – to become an
object of revelation. The drifter has returned. He (turned she) has been yielded
up by the sea. The wounded one is all of a sudden only identified by the wound.
Just as in Orla Barry's imagination it is the driftwood dagger that pierces;
bloodies and is bloodied in return. As the American anarchistic philosopher
and poet, Edward Dalberg, argued in a celebrated essay on Herman Melville's
epic novel, *Moby Dick* (1851); if you once set the human imagination loose in
the wild rough-and-tumble of the ocean, then sooner or later it will arrive at
the ultimate metaphor for politico-sexual transgression. What starts as an
image of enclosure – of wrapping around – ends up as one of erotic unfolding:
of a triumphant, even an excessive, exposure of the self as body. Thus it is that
seaborn fantasies, which in most circumstances carry with them uniquely
analeptic images of physical and psychological well-being, once they are
powered by the desire for sensual, and sexual liberation, are also capable
of putting the whole panoply of accepted social manners to flight. This is
precisely the road taken by Orla Barry's *Foundlings*. 'The Woman in the Red
Bathing Costume' whose attention throughout seems to be fixed upon the sea,
signals right from the outset a reverie that dwells upon the desiring female
body; its location and groundedness in a particular landscape and a particular
set of memories. We observe her progress as she transgresses the divisions
between the sea, earth and sky, between ocean and dry land. At a certain
moment she rolls her body lasciviously in the foaming surf. An Aphrodisiac
simulation of rebirth. Finally we watch as she descends, barefooted over a
rocky outcrop to plunge into the sea. The lugubrious water's molten waves
surge over the rocks. The camera first picks up and then – for the briefest
of moments – holds on to the head of a circling seal before turning back
towards the girl. Now it follows her as well, a creature of the sea – as she swims
purposefully away from the land, closing all at once the several intertwining

loops of Barry's filmic narrative. Echos of the fiddler playing her lilting, sometimes fluid, sometimes halting threnody in the Brandane Inn.

A FOOTNOTE...

Odysseus, Homer tells us, on the advice of Circe, chose to avoid the 'Wandering Rocks' where not even birds can pass by unharmed, preferring, instead, to take passage between Scylla and Charybdis. Joyce offers Leopold Bloom (or the reader) no such option. Together they must undertake the ultimate trial. They must enter the maelstrom that Circe describes as the place of the drifters. They must pass between the same violently moving outcrops of rock that, according to Greek mythology, once stood guard at the entrance to the Black Sea and like the vagina dentata, could suddenly snap shut to the ruination of all unsuspecting seafaring men. In this respect, 'M'Intosh'; the brown-clad hermeneutic man-island... dry-bread-eating, literary Foundling... an anonymous, humble, penitent... serves as a still point in the bustling human street-life central to Joyce's picture of Dublin. Just as Jason's ship, Argo, is able to pass quickly and unscathed through the boiling surf and fiery winds of the 'Wandering Rocks', so the Man in the Macintosh rides the aqueous streets and alleyways of Joyce's native city, swept along on the rush and surge of the Joycian narrative, without being at all affected by it.

Foundlings, Argos, Brussels, 2002.

1 *Chambers's Twentieth Century Dictionary*
2 *The Dictionary of Accepted Ideas*, Gustave Flaubert
3 *Embers*, Samuel Beckett
4 *Orpheus*, Philostratus the Younger
5 *Metamorphosis*, Ovid
6 *The Odyssey*, Homer

Although well established in Belgium, the work of Guy Van Bossche is hardly known in Britain. First of the new breed of Belgian figurative painters, his very distinctive contribution has tended to be eclipsed by the more flamboyant international career of his contemporary, Luc Tuymans. When a large-scale exhibition of his work for the Museum van Hedendaagse Kunst (MuHKA) in Antwerp was proposed, and the director, Flor Bex, asked me to write the catalogue foreword, it seemed like a good opportunity to try to set the record straight. Where the history of art is concerned Van Bossche is one of the most erudite artists working today; his knowledge of painting is encyclopaedic. He is also a keen student of drawing, which provides a solid foundation for his work as a painter and as a teacher. Characteristic of the so-called new Belgian painting, of which Van Bossche and Tuymans are usually cited as exemplars, is the pursuit of highly enigmatic subject matter based on images gleaned from photojournalism, picture magazines and illustrated books. By reshaping the pictorial context so as to change the way in which they are read, found images – figures usually – are given a new, often sinister meaning. I thought that Courbet was a good starting point for a discussion of Van Bossche's work mostly because of his declared interest in historical realism. But I also wanted to use the essay as an entrée to what for those closely engaged with the new painting seems to be a highly problematic point of reference: Belgian Surrealism and more particularly, the paintings of René Margritte.

THE ENIGMA OF THE PAINTED IMAGE: TALKING ABOUT PAINTING WITH GUY VAN BOSSCHE

To start with: a historical diversion.

It is no accident that Modernism was born out of the art-historical moment that was French Realism, or indeed that French Realism's most complete demonstration is to be found in Gustave Courbet's very large, schematic painting of the artist's studio called, very simply, *L'Atelier* (1854–55). Prior to this the painter's place of work was usually depicted as an intimate place where 'he' went to practise the craft of ecclesiastical or courtly representation, aside from the hurly-burly of the workshop. By redirecting our critical gaze away from the subjects of art towards its objects, *L'Atelier* recasts it as a site of discourse. Significantly, there is little or no sense of enclosed intimacy in Courbet's picture. The walls of the studio are airy, transparent, highly permeable things. They have already allowed an invasion of people from the outside world. Gathered in the shadowy half-light on the left-hand side of the painting are arranged a dozen or so rough-hewn characters representing the everyday world of work in countryside and town; while on the right behind the seated figure of Courbet himself – out of sight but very definitely not out of mind – there is an array of full-figure portraits of some of the leading intellectuals of the day. A cross-section of the high

Parisian cultural set, at the mid-point of the nineteenth century. Prominent critical commentators have argued that this last group, because of its specificity, functions as a mind-scape which is intended to be read counterpoint to Courbet's typological depiction of the quotidian classes. But this is to mistake the painter's main critical and political purpose, which is to draw attention to the mediating role of the artist. Courbet is providing us with a detailed conceptual model of the artist's studio; showing it to be a site where all the different threads of a contemporary culture – high and low, popular as well as erudite, rural as well as urban – converge to be reconstituted as symbolic, visual language. He is inviting us into the interior world of the aesthetic system itself. After *L'Atelier* a painting would no longer signal a mysterious, sealed off arena of experience. The expressive domain of art would be made an open and democratic one.

But there is also something disingenuous about Courbet's invitation to enter into his creative space. As Roland Barthes has pointed out, the appearance of transparency that 'realism' works with depends almost entirely on what he calls *the last order of connotation*, the function of which is to reinforce the 'realist' text – its apparent directness and simplicity – re-presenting it as a state of 'truth' in an almost sociological sense. We believe in Courbet's *L'Atelier* because all of the details are in place that conspire to place Monsieur Courbet, the artist – mind and body – at the centre of a 'real' world. Beyond this, however, buried beneath the minutiae of its surface connotation, there lurks a very different pattern of signification and one that might be said to mark the beginning of the modern state of mind. While the figures that inhabit Courbet's world seem solid enough, the studio itself is anything but concrete. The dissolving transparent walls of this crepuscular vaulted space – the furthest reaches of which are inhabited by unexplained shadows and vaguely recognisable sculptural fragments that seem to point to the final abandonment of the classical order – seem to be the very image of that fluid state of change and chronic uncertainty that characterises modern life. In Courbet's depiction of the artist's studio, there is already a premonition, then, of what Karl Marx, in the *First Communist Party Manifesto* described as the quintessentially 'modern' condition; one in which *all that is solid melts into air.*

By closing off the circle of representation and re-casting the painter's studio as a site about which the shifting topology of the contemporary human subject circulates as discourse; not only did Courbet shift the critical focus away from the subjects of art to its objects – after *L'Atelier* art's subjects would

be determined by the manner in which they had become embedded in the work of art itself – but, metaphorically speaking (and much later this would become a precondition of painting's facticity), he also opened up... flattened out... and made more shallow... painting's conceptual space, bringing it closer to the utopic space of language. It is a most strange, even a wonderful paradox, that it was a short-circuit in the illusionistic motor of 'realism' that revealed the artist for the very first time as his own proper subject; irretrievably embroiled in modern social and political discourse and at the same time displaced by a labour of language from all the old certainties of painting as a representational craft.

o o o

One of the most celebrated British art critics of the postwar period, Laurence Alloway, once remarked that when visiting a painter's studio he always looked at their palette before he looked at their paintings. When asked why by an indignant young painter, Alloway argued that he could get more 'hard' information – of the kind that gets buried deep within the painted structure – that way. 'If you can only read the clues', he concluded, 'it's like taking a trip through the painter's mind.'

A visit to the studio of Guy van Bossche is exemplary in this respect. Like his paintings it is a well ordered space, but not neurotically so. Everything has its place, but in a relaxed, almost casual way. It is also immediately apparent that Van Bossche is an erudite painter, as concerned with the historic visual culture as he is with the contemporary. Books about painters as diverse as Piero della Francesca and Thierry de Cordier lie all about. Some lie open on tables as if in constant use. Postcards and cuttings taken from art magazines of favourite works by favourite painters are scattered on his working tables or pinned to the walls. And two things strike home straightaway. Firstly that Van Bossche's mind – when he is in his place of work at least – is focused almost exclusively on the traditional practice of painting rather than on art in general. And secondly that he sees painting as an essential cultural force; its continuation, the artist's most pressing cultural responsibility. Closer scrutiny reveals other, perhaps more idiosyncratic characteristics. Van Bossche, for example, practises a most curious brand of connoisseurship. It is almost 'saporous' or even 'olfactory' in character, and once you know it is there you can trace its outcome very clearly in the finished paintings. He is a lover of... salivates over... sniffs

out... rare and subtle colours. The tubes laid out on his work table are what give the game away; the dough-coloured Unbleached Titanium White (the most receptive and malleable of all pigments that go under the name of white); an array of different Naples Yellows, stretching from the palest cream to a rich custard yellow; aquatic greens and blues, like the very unusual Phthalocyanine Turquoise; and a whole range of floral pinky-reds, greyed-off ochres and purple earth-colours. Indeed, there is hardly a generic colour in sight, and yet this is a painter who, as so many of his paintings show, loves to use local colour.

There have always been painters, of course, for whom a particular colour mood has come to pervade more or less all of their paintings... André Derain, after the Fauve period for example, Edouard Vuillard and one of Van Bossche's favourites, the Italian 'metaphysical' painter, Giorgio Morandi. But unusually, Van Bossche's search for a unifying atmosphere seems to begin before the studio. A flaneur of the Artist's Colour Men, it is as if he goes in search of rare sensations and carries them back to the studio where they tantalise and torment him. For Van Bossche, recognising and choosing colours – it would seem – is the beginning, not just of a way of seeing into the future of the work, but of recognising himself in the process. It is his way of rehearsing in advance, his role as a 'thinking', 'sensing' subject who attends to the world through the procedures of painting.

We can discover a very similar mechanism at work in the way that he selects, brings together and orders, the visual raw material that will eventually emerge as the subject matter of his paintings. And evidence of this process of construction is also visible amongst the impedimenta of his studio.

Look around at the paintings hung up and leaning against the walls and it is plain to see that one rather striking characteristic of Van Bossche's paintings is a certain awkwardness about the way he depicts people. His figures have all the attributes of the human, but they stand stiffly like mannequins, lie down like ragdolls or like corpses. And when they are shown in action, they seem to move like automata. Besides which, both animate and inanimate objects are either cropped so that they are barely recognisable, or they are brought up close to the eye so as to heighten the strangeness of their silhouette and increase their visual hulk. These carefully contrived ambiguities are quite clearly deliberate and intended to amplify the semantic 'density' of the painted image, adding complexity to the reading. Because we are never quite certain as to the true 'nature' of what is being depicted, we are driven to read and re-read

the signs, generating a kind of anagogic slippage between the image as representation and the painting as an abstraction in the process. For this reason the prolonged examination of Van Bossche's paintings seems to point us more and more towards the abstract space of the drawn image: towards the point at which perception turns back upon itself to return as diagram. Van Bossche's deep and abiding interest in suchlike points of transformation – or interface – where observation becomes conception, is everywhere evident in the images he wrests from old photographic manuals, newspapers and magazines. In the medical books with their curiously static photogravure plates of obscure physical procedures of different kinds; in the instruction manuals in which figures are diagramatised doing things with and to each other: dancing... wrestling... administering first aid... practising rescue and resuscitation techniques, and so on.

o o o

In the studio, after an initial awkwardness. Drinking coffee. Van Bossche is only too happy to talk. He holds strong opinions about almost everything and usually they are deeply grounded in his own experience. Despite the fact that he attended two different Academies he considers himself to be a self-taught artist. The academy, he states with some vehemence, taught me almost nothing... and *absolutely nothing* useful for someone who, from the outset, it seems, wanted only to be a 'painter' in the grand old-fashioned sense of the term. He is still scathing about the failure of his teachers to teach. He wrings his hands over the fact that even though he spent his allotted time in the life-class, lacking proper guidance he emerged after years of study still unable to draw. Even at this early stage, painting for Van Bossche was founded very much on the old verities of hand and eye and this lack of drawing skill troubled him greatly. So much so, that he decided that he had no option but to postpone his larger ambition to paint until he had taught himself to draw.

There was, of course, a theoretical dimension to this decision which needs some unpicking. For a start there is the question of what precisely Van Bossche meant by drawing. And then, once we have winkled that one out, there is the question of how this more specific definition might have borne down upon and given particular focus to his practice as a painter thereafter. Consideration of the first of these questions must start from an examination of his self-imposed pedagogic regime.

We might think it of the utmost significance, that rather than going directly to nature as the great teacher, to quote John Ruskin, Van Bossche decided to excavate the tradition of European draughtsmanship by copying from the old masters. From the outset, then, he chose to bypass all of the inventions in method arising out of the history of Modernism, as well as the ideologically proscriptive rubrics of the eighteenth-century academies. It was as if he was trying to side-step the historic, institutionalised, pedagogical machinery, and return himself – a humble neophyte in the service of the studio master – to the apprentices' bench. There to carry out the same kind of concentrated exercises as Giorgione might have practised in the studio of Giovani Bellini, or the young Raphael Santi in the studio of Perugino. As Van Bossche readily admits, the decision to take this particular route depended as much upon blind-faith and instinct as upon reasoned thought. But it arose, also, from something much more substantial than a romantic itch to start over again. It seemed to Van Bossche that late Modernism had reduced drawing at best to a rather tired set of technical methods, and at worst to a barely coherent expressionism. And that both routes had arrived at their own particular kind of impasse. The first in a clutter of dried out and dehumanised exercises for plotting and mapping – a dematerialisation of the subject, in other words – and the second in a decaying melange of worn out expressionistic tropes and hand-me-down manual clichés. Van Bossche had observed both of these at work in the academy. Now he was going to try to recover drawing as a fully rounded and carefully nuanced language of expression – founded in what the aesthetician Andrew Harrison has described as practical thought with materials – and use it in the service of a new kind of figuration. Copying, as a method of learning, for Van Bossche was not simply about paying attention to what had been done but also – crucially – about matching observation in the muscular sensations of the body, in particular, the pressure and motion of the hand as it was set to re-enact the pattern of attention present in the original. There was also an important 'mind' dimension to the process. A copyist must seek to understand and then to replicate through the process of mark-making, the thinking of the original maker, or else the copy will never convince.

Van Bossche talks about the benefits that can be derived from copying with great enthusiasm. And he illustrates his argument from portfolios of old drawings and notebooks lovingly preserved in his studio. It amounts to a carefully stored and tabulated history of his own hard-won victory over a self-confessed, manual incompetence. There are copies of drawings by the likes of

Leonardo da Vinci, Piero di Cosimo, Jean Dominique Ingres and Peter Paul Rubens. Some he has repeated over and over again, in his determination to get as close as possible to the thought, formation and touch of the original.

There is, of course, a certain quaint obstinacy about Van Bossche's adherence to copying as a way of learning to draw. Indeed, it would be very easy to dismiss it as little more than an arcane eccentricity if it were not for the fact that he still advocates it as a pedagogic method. It looks even more curious, when we also realise that it attaches itself almost exclusively to artists who worked before the beginning of the nineteenth century and the intervention of the great Romantic masters – painters like Theodore Gericault and Eugene Delacroix – who effectively prepared the way for the modern movement. Once again, it would appear that Van Bossche is advancing a taste judgement; that he is intent upon stating his preference for a world of expression which is predominantly classical in feeling. But once the accusation is made Van Bossche is quick to refute it.

To understand this more fully, we have to separate – just for a moment – consideration of Van Bossche the teacher from Van Bossche the artist, bearing in mind that he can wax equally passionate about both roles. As a drawing teacher he proceeds by establishing clear, stage-by-stage learning objectives, attached only to those things that can be taught without prejudice to individual development. In the case of drawing this means treating it in the first instance at least, quite straightforwardly as a language of abstract marks which taken together give clear and readable testimony to an exercise of thought on the part of the maker. This level of purposeful readability, Van Bossche argues, is more immediately apparent, and generally more accessible in the studio drawings of the middle to late Renaissance and in Mannerism. Less so in the case of Romantic, post-Romantic and Modernist drawings, where clarity of purpose is in part hidden by the play of psychological affect; the state of mind or immediate emotional disposition of the artist. Teaching himself was in this respect, no different than teaching someone else to draw. He needed to look for – in order to work from – examples of drawing which demonstrated an appropriate quality of visual articulation and clarity of intent.

But even at this early stage in his quest to educate and remodel himself as an artist, Van Bossche was fully aware of key figures from the modern movement which he would have to take account of eventually, if he was to reach his main objective of a fully rounded, thoroughly contemporary, figurative style. Talking about it now he speaks very openly about the way in which he deliberately postponed close engagement with the drawings of artists

like Paul Cézanne, Henri Matisse and Pierre Bonnard until he felt that certain elements in his understanding of the drawing process had fallen into place. Afterwards, Cézanne especially was to become a key influence on his drawing style, but in the early stages of his self-imposed learning regime Van Bossche would allow himself only a sideways glance in his direction.

Working through portfolios of Van Bossche's drawings today, we see all the evidence of a preeminently intelligent period of personal struggle. Most remarkable is the amount of intellectual will power that shows itself so clearly in his rendering of the human form; the final certainty of its linear construction. But the best of his drawings are much more than well wrought. They achieve something approaching a high baroque refinement of rhythmic expression. The portions of the drawn naked body are passed from side-to-side of torso and limbs in a way which can only be described as intensely sensual. Henri Matisse once remarked that drawing, before all else, was a tactile form of expression. And this dictum is amply demonstrated by the products of Van Bossche's highly personal odyssey. Although his interest in drawing began as a pursuit of method, it ended up as a way of touching reality. The later drawings are strongly constructed, taut of line and solid in their formal articulation, but they are never over-schematised or clumsily diagrammatic. In addressing them, always in the end – excitingly – we are left alone to caress the subject in our mind's eye.

By now Van Bossche has stopped making separate drawings on paper, preferring to allow his hard-won dexterity as a draughtsman to take its proper place as a fully integrated element within his painting language.

However, between the painstaking copies made in the mid-1970s, and the drawings completed immediately before he took the decision to stop in 1986, there is ample evidence of a quite remarkable process of development... in the activity, certainly, but also in his thinking. It is now clear that what started out as an instrumental objective, ended with a largely philosophical outcome. At one level, nothing much had changed. He still believed... still does believe fervently, that sound drawing is the root of all forms of painterly expression. The truth, for Van Bossche, can be stated very simply: *if you can't draw then you can't paint*. But by now the question of what comprises 'good drawing' has become an infinitely more complex one.

In the first instance, Van Bossche began to realise this complexity through his own practice as a painter, but it was strongly underlined, when in the early 1970s, he came across the work of the artists of the School of London; including the American painter and draughtsman R.B. Kitaj; the British 'Pop'

painters, Richard Hamilton and David Hockney; the Irish-born painter Francis
Bacon; and the London-born 'realist' painter of Austrian extraction, Lucian
Freud. Initially it was Kitaj's use of drawing that captured Van Bossche's
attention, followed soon after by the drawings and paintings of David Hockney.
Here were two young painters who were busy promoting the activity of drawing
and at a time when it was in general decline in the art schools and academies of
mainland Europe. They seemed also to have found effective ways of integrating it
into their paintings. In the changing course of his own painterly practice moving
from drawing into painting, Van Bossche had felt the disturbing pull of opposing
logics: the abstract logic of a drawn language and the more wayward, sensual
altogether less reasonable – thought processes demanded by painting. Working
alone in his studio in Antwerp he had begun to understand that while these
different logics are thoroughly complementary, even interdependent, they also
need to be reconciled in some way. He could see clearly that the life-force of
painting as a language depended upon it. The paintings of R.B. Kitaj and David
Hockney showed him one way to effect such a reconciliation. Showed him that
by allowing the planar, graphic space of the painting to take over... by treating
the picture-surface as a neutral space almost like a draughtsman treats a sheet
of drawing paper, and by animating this flat planar space by shifts of scale and
spatial exaggerations in the rendering of the subject, it was possible to gain
freedom from the painterly demand for sensual totality, on the one hand, and
the more abstract rigours of a drawn language of depiction on the other. While
this was to have a lasting effect on the way in which Van Bossche would continue
to order his paintings – even today his figures tend to isolate themselves against
an empty background – it was by no means a complete solution. Ultimately he
was to discover this, from within the activity of painting itself.

o o o

When painting is the topic, it is impossible to have even the briefest of
conversations with Guy Van Bossche without him bringing up the School of
London. This is somewhat problematic for an artist or critic from Britain, since
the term 'school' invests a quite disparate collection of artists, from different
generations, with a common identity. Even a cursory investigation serves only
to highlight their differences. 'School' suggests that they know and meet with
each other; that they share certain beliefs and values; that they have common
attitudes to the history of art and their place within it; that they have a shared

approach to practice. In fact, nothing could be further from the truth. As a group of artists, they have almost nothing in common beyond the fact that they all work in London and all of them are committed to figurative painting. Look beyond these rather meagre links and this so-called 'school' falls immediately into a number of quite small sub-groups, each with its own very local history. Lucian Freud and Francis Bacon, for example, came out of the postwar British surrealist movement, along with artists like Graham Sutherland and John Piper. Richard Hamilton – in some ways the most radical artist of his generation – emerged, paradoxically, from the ranks of the ultra-conservative Euston Road School. While the younger generation divides between Royal College of Art 'Pop' painting – R.B. Kitaj and David Hockney – and the student followers of the expressionist painter David Bomberg – Leon Kossoff and Frank Auerbach.

Go back a generation and we find that only two of these are British – Hamilton and Hockney – neither of them born in London. With the exception of Bacon, the rest are first generation sons of Jewish immigrant parents from Austria and Germany. The School of London, then, is no 'school' at all... more a site... a meeting point around which circulate different, sometimes conflicting, cultures and traditions of practice. On the one side there is the rich tradition of British and American political and satirical illustration and narrative painting – from William Hogarth to Norman Rockwell – and on the other, the weighty presence of German Expressionism – the likes of Karl Schmidt Rottluff and Ernst Ludwig Kirchner – and the painters of the Neue Sachlichkeit – Christian Chard, Max Beckmann and George Grosz. Also, sandwiched between the two, there is a whole ragbag of residual influences also in play: including, from French painting via the Euston Road and Camden Town Schools – most notably in the work of William Coldstream and Walter Richard Sickert respectively – and from Italian 'neo-realist' and Metaphysical painting via the work of such locally important 'imagist' painters as Edward Wadsworth and the brothers John and Paul Nash.

Talking to him, it is clear that Van Bossche knows a great deal – but not everything – about this curiously eclectic group of artists referred to as the School of London. It is also clear that his attachment to them as a group, is as much a romantic attachment to the idea of a 'school of figurative painting' as it is to the School of London itself. Beyond that, his involvement is with particular individuals and even then, these have waxed and waned over the years. As his taste in painting changed – as it became more sophisticated – in line with the evolution of his own mature painting style, so some of the old

adherences have faded, while others have fallen away altogether to be replaced by new ones. Nowadays, for example, when talking about the work of R.B. Kitaj, Van Bossche manifests a carefully judged degree of scepticism. Kitaj, like Van Bossche himself, called a halt to his early career as a fringe Pop artist at a certain point and also set about the task of teaching himself to draw all over again – as he said – like Degas. While he applauds Kitaj's attempt, Van Bossche is not at all impressed by the outcome, describing Kitaj's new drawing style as clumsy and insensitive. He is similarly disaffected by the progress of David Hockney over the years. An immensely gifted draughtsman and painter, and another 'aesthetic revisionist' – at one stage Hockney declared his solemn intention to teach himself to paint like Jan van Eyck – according to Van Bossche, he also lost his way. His work having declined, in recent years, into an oddly unsatisfying form of painterly decoration. For the rest, he still admires the paintings of Lucian Freud without liking them very much. And he retains some interest in the post-Bomberg artists, Leon Kossoff and Frank Auerbach without at all sharing their expressionistic tendencies.

Two artists remain for whom Van Bossche's admiration has never wavered, Richard Hamilton and Francis Bacon. At first sight there is very little in common between the two, and even less in common between their work and that of Van Bossche. And yet he still claims them as important influences. Of the two, the influence of Hamilton is by far the most difficult to understand. A mandarin-like figure in the context of the British art scene, Hamilton is loved and hated in almost equal measure. There are those who think of him as the most important – not necessarily the greatest – British artist of the postwar period. Others who see him as a pretentious intellectual... a cold and calculating strategist who has cleverly ridden the coat-tails of Marcel Duchamp. Bacon, by comparison, has few detractors. He is very generally considered to have been a great artist. But what precisely is it, that attaches Van Bossche to either or both of them. Is there a common thread of some kind that might make sense of them as influences.

Before Francis Bacon's death, of course, Bacon, Hamilton and Freud were friends. And in conversation, according to the critic David Sylvester who knew all three of them well, they would happily admit to there being some kind of link between their work, although it was never really explained. However, there are certain fairly obvious common threads, some of which are quite technical (although not completely so) – a shared interest in the relationship between drawing, painting and photography, for example – and others that are

much more intimately connected to subject matter. Although it is contexted differently there is a distinct undertow of violence in all three of them; violence depicted as an integral part of contemporary urban life. In Bacon, this shows itself as existential and the dislocation of sensual experience; in Hamilton's work – heavily distanced by irony – as a loss of social intimacy brought on by consumerism; and in the paintings of Lucian Freud, it emerges in the form of a 'hyper-realist' rendering of ravaged flesh... as a crisis of the body, in other words. Cleverly, it was Richard Hamilton – the intellectual socialist, ex-Situationist who summed up this violent undercurrent in one, almost talismanic, cuttingly sarcastic sentence, when he titled his most seminal early work, the collage which inaugurated the British Pop art movement, *Just what is it that makes today's homes so different, so appealing?* (1956). He might have been speaking for them all. Each, in his different way, points very directly to a radically disassociated form of social life characterised by the breakdown of domestic life.

However, it would be a mistake to suggest that Van Bossche is making common political cause with either Hamilton or Bacon. It is far more that he seems to share an aberrative mood with them. Van Bossche's world is not the technological phantasmagoria of Hamilton; it is also much more subtly 'out of joint' than the skewed nightmarish world of Francis Bacon. Even so, it is filled with human presences whose very humanity seems to be continuously put at risk. Silently, deliberately, people are doing things with and to each other, we do not know precisely what... or if we know what, we do not know why. We are cast more as watchers... involuntary witnesses rather than viewers: more 'reluctant' voyeurs, secretly enjoying what we see than innocent bystanders. Trapped in Plato's cave, inhabited by a dumb-show of chimerical players, we are presented with projected mental images that slice through what seem to be violent events – molestation, rape, murder – movie stills that have been robbed of their narrative links: inexplicable moments, frozen – for some reason – in time. If, as Samual Beckett once suggested, Limbo is 'anti-theatre', *the absolute cessation of events* a place, where nothing has ever happened and where there is no expectation that anything ever will, then it would seem reasonable to think of Hell as an 'arrested theatre' in which the human subject is caught up in the same split-second of violent – or even pleasurable – anticipation, in perpetuity. In the paintings of Francis Bacon such moments are usually internalised as episodes in his own – perhaps every individual's – pathology of mind. In Van Bossche's pictures, it is more the condition of an ever-present, external reality. The opposite of Beckett's 'anti-theatre', he paints pictures of a world in which

the passage of time, once experienced as a natural phenomenon, has given way to an endless sequence of pathetically eroticised fragments. There is no progression and no hierarchy of importance either. One fragmentary experience is shown to be very much like any other. Painful or pleasurable, it matters little.

The French philosopher and critic, Emmanuel Levinas, has suggested that what characterises the art of our time – image as well as allegory – is that it is made under the sway of the *shadow* and carries with it the inertia of an impending end, endlessly postponed. 'The painting', Levinas writes, 'does not lead us beyond the given reality, but somehow to the "hither side" of it... it is symbol in reverse.' We might think that this notion of a 'reversed symbol' has profound significance for the project of figurative painting in our time. Most importantly, it banishes representation's dependence on resemblance and yields up – returns – the painted image to itself, freed from the incidental values given to it through mimesis. We can no longer think of the painted image as a neutralised vision of the object of depiction, which then differs from sign or symbol because of its resemblance to that particular object. According to Levinas, the painted image must now be seen, first and foremost as a sensible thing that resembles nothing more strongly – or more absolutely – than its own sensible form. A new kind of subject is instantiated which constitutes a dimension of 'evasion' in relationship to the 'real'. As Levinas writes:

> The poet and painter who have discovered the 'mystery' and downright 'strangeness' of the world they inherit every day are free to think they have gone beyond the real. However, the mystery of being is not its myth. The artist moves in a universe that precedes the world of creation, a universe that the artist has already gone beyond by his thought and everyday actions.[1]

The 'hither side' of the image in the paintings of Guy Van Bossche, is signalled by the fact that the ground against which the action takes place is usually empty of objects and devoid of topographical reference. Rather it is filled with painterly detail, caused by the brush touching, stroking and stabbing at the canvas. The figures that comprise the action are real enough, but they are made to perform in a void of non-seeing; in the shadowy space of a conspicuously painted but otherwise nonexistent world. In this sense Van Bossche's paintings are the very opposite of Bacon's which occur almost always in the theatrical rotunda – the reversed panoptican – of the Celtic gyre.

As we have already remarked and as the evidence of his studio testifies, Van Bossche uses all sorts of secondary source material to make his paintings, including, most importantly, secondhand photographic images. When questioned about this, like most contemporary figurative painters, he is entirely comfortable with this idea, but he qualifies it by saying that photographs – whether they are by him or by someone else – cannot simply be replicated in paint, but require both interpretation and translation. And this, for Van Bossche, is where drawing and photography must join forces. Photography and painting 'hold the subject in mind in entirely different ways', he argues. The photograph is inescapably mimetic and is experienced indexically, by contrast, the painting must attend to and ultimately reveal the subject, only as it can be seen in paint. Without him even realising it perhaps, Van Bossche's formulation draws very close to that of Levinas.

'Interpretation' and 'translation' suggest a highly compressed, staged process, taking place in time. And one that seeks to establish and maintain a particular quality of relationship between the final translation and its source, rather than trying to forget or hide the source altogether. In this case, 'interpretation' means the search tor intelligibility within the language of the photograph and it comes before 'translation', the act of making meaning thoroughly intelligible in another language form, that of the painting. Essential to this process, to Van Bossche's way of thinking, is the mediating intervention of a third language... drawing. An image chosen from an instruction manual... a book of photographs... a journal or a newspaper, must first be re-thought – if not re-worked – in a drawn form if it is to be properly introduced into the very special, highly 'sensible' world of 'the painted'. Drawing alone (or the regimen of thought that is drawing) has the capacity – Janus-like – to look both ways... back to the flattened, laminated trace which is the photograph and forwards to the animated, permeable yet powerfully regulated, illusionary space of the painted image. Drawing alone has the power to make meanings stolen from one, take on a new and entirely convincing existence in the other. Even so, something is always carried over into the painting from the photographic trace; a residue which still attaches the image to its source and which, in its turn, is greatly valued by most figurative painters of Van Bossche's generation. In order to understand the nature and function of this residue, we must engage, briefly, with the theoretical debate

that has come to surround the topic of 'representation', in recent years, especially where this touches upon the death of painting.

The French semiotician and cultural theorist, Roland Barthes, in his celebrated late book on photography, *Camera Lucida* (1980), sets out to make clear the distinction between 'representation' and 'figuration'. 'Representation', Barthes argues, is exemplified by the pictorial tableau; 'figuration' by theatre. The one works with a constellation of signifiers around the theme of the mask, 'the motionless, made up face beneath which we see only death', the other allows us to see what remains of the 'active human subject as if from within the Utopian topoi of live theatre, human desire and fluent signification'. Significantly, Barthes associates photography with 'representation' and painting with 'figuration' a judgement, it would seem, upon both. In an extremely illuminating passage in an earlier book, *The Pleasure of the Text* (1973), Barthes had raised the same issue. On that occasion giving it a distinctly ethical, almost a moral, dimension. His questioning concerned the truthfulness of 'representation' and he concludes:

> figuration is the way in which the erotic body appears... in the profile of the text (a diagrammatic not an imitative structure) to reveal itself in the form of a body, split into fetish objects, into erotic sites. While 'representation' is embarrassed figuration, encumbered with other meanings than those of desire: a space of alibis (reality, likelihood, readability, truth, etc).[2]

Accordingly, 'figuration' because it is linked absolutely to the desiring body, has an authenticity which gets lost within the complex layers of meaning that constitute representation's appeal to truth. In the case of painting's relation to photography, then, we might think that this seeming paradox works itself out in a most peculiar and unexpected way and that painters like Guy Van Bossche import rhetorical devices from the representational language of photography precisely because they seem to carry with them – in an almost forensic way – evidence of the 'real' world; because they seem to bare the burden of 'true' experience. While in reality such devices can only serve to undermine painting's 'truthful' unity in the body's desiring.

But the issue is altogether more complicated than this. Indeed, it is at this juncture that we find ourselves hard up against the linguistic 'hiatus' that critical theorists like Douglas Crimp have characterised – prematurely

we might think – as the symptomatic of painting's imminent demise. Paintings seeming inability, of and for itself, to fulfil the contemporary longing for certainty and truth. Unlike the photograph, the argument goes, painting can no longer authenticate itself, but is by its very nature 'fictional'. While photography, the past, present and future of whose objects it is impossible to doubt, carries with it all the force of documentary evidence. As Susan Sontag has argued – while the photograph seems to 'exist as an indelible referent somewhere on the other side of language' – painting remains ensnared in the mythic and the unknowable... is wedded to the emptied-out sublime. In short, painting can no longer travel under its own steam, but has come to depend on the whole contemporary world of circulating images for its very survival.

Van Bossche is happy to talk at length about the problems facing contemporary painting – as he sees them – especially where they touch upon the role of photography and the appropriation and incorporation of the photographic trace into the language of painting. He acknowledges, for instance, its role as a putative bearer of truth. But he also argues that, to a very large extent, this role is illusory. Van Bossche's real interest in the language of photography is not, in any case, in the photograph's appeal to truth but in its potential – the offer it makes – of a mixed economy of languages. In conversation, he expresses a liking for the Barthian idea of the photographic representation as 'death mask' and the narrative opportunities this holds. Painting can play the truth game at the same time as showing the game to be nothing more than a game. Photography, Van Bossche argues, does not have that option. With painting too, you can do quite naturally many of the formal things that a photograph does. You can crop and frame the painted image as if it were a photograph; you can play with focal distance and depth of field, without – as photorealism so clearly demonstrated – at any point compromising the existence of the painting as a thing in itself; a unique exemplar of a distinctive order of things.

Van Bossche's views on appropriation and incorporation are very straightforward, almost completely pragmatic. As far as he is concerned, no matter which devices are imported from other visual sources, painting as figuration will benefit, as long as the business of painterly exchange is properly managed: as long as we can still perceive the objects of vision depicted in the brushmarks and follow the brushmarks as they work to assemble the objects of vision. This 'active' duality in reading the figurative, painted image allows it to

incorporate all kinds of different fragments borrowed from photography's representational array without compromising its own integrity as figuration. The imported elements will appear almost as ornamentation (in the Albertian sense) enriching the body of the 'painterly' text... act as decoy... create a diversion... provide a pretext – as Roland Barthes puts it – an alibi that hides 'the essential purity of painting's emptiness by seeming to fill out its absences'. We might think that it is ornamentation of this kind, that holds today's painting fast within the space of a thoroughly contemporary, general art discourse, preventing it from slipping away into the realm of the sentimentalised 'surreal' or the 'metaphysical'.

In fact, Van Bossche makes two very different kinds of painting, both of which employ rhetorical tropes borrowed from photography. In the first picture type, the whole action is contained within the frame and viewed as if from a frontally placed, very static camera. We are required to view the subject full on – and centred – as if for information purposes, or else we are made to look down from above, from the position of surveillance, in other words... at mysterious and unreadable events occurring in the park or on the street. In the other picture type, the action is seen in close-up. The subject seems almost to be pressing itself against the surface of the eye. And it is brutally cropped – sometimes to the point of illegibility. In both types the colouration is subdued – veering towards the monochromatic – as if to refer us back to the black and white photograph. Occasionally there are sudden outcrops of vivid local colour. Nearly always the depth of field is kept shallow; a shallowness which belongs neither to the indexical pictoriality of photography nor to abstract painting, but to the wrap-around immediacy of the journalistic image and the tableau vivant. Somewhere beyond all of this – for Van Bossche as for so many postwar figurative painters (including Francis Bacon) – there hovers the ghostly figure of Eadweard Muybridge, the nineteenth-century British photographer and inventor of the zoophraxiscope, who was the first to succeed in passing beyond the capacity of normal vision to determine precisely how strangely animals and humans move. Muybridge's strung out, tightly gridded multiple photographs of the horse in motion, published in 1878, upset forever the simplistic belief that the act of perceiving stood somewhere beyond the reach and outside the scope of language; that perception, on its own, could make possible the mind's conceiving. His subjects, trapped in shallow space, between the conceptualised, conspicuously smooth surface of the photographic print and the pictorialised, carefully staged apparatus of an objectifying science, still cause us to stare wide-eyed into the gap that yawns between the subject and its retrieval as an object of

vision. We now know, beyond peradventure, that for figuration to succeed it must overcome what Ernst Gombrich – after the sixteenth-century Italian theologian Gabrielle Paleotti – has called 'the defect of distance'. Paleotti's formulation suggested that sacred images (of the saints and christian martyrs) were invented 'so that in their absence, we might return them to vision, make up for the defect of distance, by making what might be lost to thought, forever present'[3]. Gombrich re-deploys Paleotti's term to point to the fact that all figurative images – prints, paintings, photographs and the rest – bring things into our ken by 'substitution' and if they are to have power they must carry with them their own particular type of contingent or subjunctive space. They must fix the limits of their own reality. In the images of Muybridge this is characterised as a repeatedly interrupted, linear 'passage' occurring in space/time; in the work of Francis Bacon – as we have already remarked – it is the notion of eternal return, the centrifuge or the gyre; in Van Bossche's work it is the framed and permanently frozen moment... ripped, as it were, from the unknowable and yet finite trajectory of a lost narrative. It is tempting to analogise it as a cinema still. However, unlike certain of his contemporaries Van Bossche is uncomfortable with the idea of the cinematic. His paintings, he argues, inhabit the frame 'formally' and show none of that potential for movement, either of the frame in relationship to the action or of the action within the frame, that a notion like 'the cinematic' would seem to demand. Similarly, while many of his paintings raise the spectre of narrative by depicting an action which is clearly part of an event that has duration, they have none of the incidental detail that characterises the film still. Lost narrative, in this respect, configures itself very differently to hidden, unseen or unwatched cinematic narrative. The feeling of dislocation is at once more abrupt and more absolute; the moment of seeing altogether more immediate and more vivid.

o o o

Painters, more than any other kind of artist, live their lives between conflicting realities. They must enjoy or endure – at the point of practice at least – something approaching a radical division of the self. The self caught up in the routine practical tasks that attend the activity of painting so clearly reflected in the disposition of things in the studio, and another self – transfixed – sometimes beyond endurance by the allure of an all too illusive imaginary. Marc Chagall, in an early poem, described this as a 'crucifixion', and a condition

in extremis. There is another way of reading the semiotics of the studio then. It can be seen as a theatre of illusions, the limits of which are illuminated by the often troubled landscape of the artist's mind. Viewed in this light the walls of Courbet's *L'Atelier* begin to signify in an entirely different way. No longer are they a semi-permeable transparency made alive by images leaking in from the outside world, but an imprisoning architecture of the mind, a blank opacity whose only life lies in the projected images it receives from the artist's desiring gaze. Perhaps they also point inexorably to what happens when the sustaining imaginal thread breaks... when the magic lantern stops turning and the lamp goes out... when it seems that a premature finality has been reached. Look again at *L'Atelier* and suddenly it seems as if the eminent painter, Gustave Courbet, has invited all manner of persons from the world at large into his inner sanctum, there to participate with him in the making of a new, distinctively 'modern' art discourse while in reality he would like nothing better than to escape back into a sylvan idyll; his voluptuous model, her child and their small dog at his side. Is it then the picture on the easel that tells all? And is Courbet anticipating that strange ambivalence – between eagerness and fearful anticipation – that modern painters sometimes express towards their place of work?

If the artist's studio does, indeed, function as a hall of mirrors, all the time playing back the painter's most intimate thoughts, it must return the negative at the same amplitude as the positive. More disturbing still, it must also reflect the artist's immediate state of mind: presenting at lucid, clear and optimistic picture at one moment and an opaque, confused and pessimistic one the next.

Francis Bacon, whose own studio was notoriously chaotic, once described the activity of painting as 'a continuous struggle between the desire for order and the onset of chaos'.[4] For certain he was referring to something other than the accumulated chaos of his own making which was so much a feature of his studio-flat in West London: the scraps of drawing paper, used once and then discarded... the hastily torn out newspaper cuttings... the bits of paint-soaked sponge and old paint-rags... all trodden under foot – compressed into a second, very uneven floor – the drips and splashes of paint on the walls and furniture. And yet the paintings he made there were utterly clear and lucid images. If we are to reach a real understanding of what Bacon might have meant when he spoke of the struggle against the 'onset of chaos', then we must look elsewhere for the evidence. We must look to the paintings themselves and their relation to the world outside, rather than to the studio.

To the sceptical postmodern critic, of course, Bacon's formulation seems tainted with an unreconstructed sublimity; it appears melodramatic even a little self-indulgent. But strip away the hyperbole and there remains an essential germ of truth in it. The images conjured up by the figurative painters of Van Bossche's generation must be wrested from a vast, highly volatile and endlessly expanding array of images, signs and visual stimuli. And although the semioticians may argue that this seeming chaos and visual flux is, in reality deeply structured; at the point of reception it has all the appearance of the overwhelming and the incomprehensible. Faced with this, the figurative painter must not only function as a visionary, one who is capable of seeing into and reaching beyond the surface phenomena of the visual world, but he must also act the part of the voyeur. He must lie in wait, observe and bear witness to the discontinuity that lies beneath. Perhaps the most quoted of all the Russian filmmaker Serge Eisenstein's many telling images, is the close-up, crazing of the nurse's spectacles in the cinematic epic, *The Battleship Potempkin* (1925). This image, more than any other seems to metaphorise the modern world as a scopically shattered, endlessly refractive and fragmenting one, beyond imaginal ordering or semantic control. Significantly, it was this image that Bacon appropriated. Not just visually in the notable series of paintings made in the 1960s, but also – more importantly – philosophically. Bacon used Eisenstein's image as an epistemological metaphor for the waywardness of the modern world and it helped him to explain the savagery of his own imaginary to himself.

By now the condition – we should perhaps call it the postmodern condition – in which today's figurative painters find themselves, is at once more extreme and more 'abject' than that enjoyed by Eisenstein or even by Francis Bacon. There are no more heroic episodes waiting to be acted out in the privacy of the studio. Instead, the contemporary painter stands – head bowed – a naked supplicant before the image in its absolute ubiquity; while the image, in its indifference, stubbornly refuses to confirm the old modernist offer of originality... is resistant to the very idea of newness. Everything in our time has become appropriation. All images are made transitional. They spell out nothing more – for certain – than the absence of the object of representation. In this respect, the 'memorable' image has become the fragile embodiment of our present day experience of lack. They remind us that there are no over-arching systems of meaning any more and no reliable value systems either... confirming Levinas's diagnosis of a reversal in the processes of symbolisation.

It is for this reason that so many of today's figurative paintings have the feeling of having been born out of a disconnected instant of some kind. It is for this reason too that they seem saturated with sadness and wedded to their own dark shadow of unknowing.

Talking about the instantiation of the image with Guy Van Bossche he refers to the notion of 'an emergence'. For him, not only do images, ripe for appropriation, pre-exist the moment in which he recognises them, but they also pre-exist – in their painted form – the moment that he rediscovers them through the act of painting. Almost, he seems to suggest, they lie in wait for him before revealing themselves. Such a notion describes perfectly the sense that his images achieve on the canvas. There is a certain breathlessness about them... an air of expectancy, if you like, similar to the experience of watching a photographic image emerge in the darkroom. Van Bossche's painted images, like the photograph, also have the feeling of a critical moment of curtailment, as if the process of their emergence has been arrested at a crucial moment in their realisation. It seems, then, that we are being invited to take part in the event which is the images emergence itself, to relive the mythic force of the image as an event.

This 'quickening' of the image in the experience of the viewer is Van Bossche's solution to the residual 'deadliness' of the appropriated image, its sense of having been alive once but is now 'suspended' in its very being, through a futile act of replication. Appropriation can only work, Van Bossche suggests, if it can be done in such a way as to return the image to its primal state of the enigmatic. Only then can it upset, perhaps even reverse the flow – the implication of a *reductio ad absurdum* – of replication.

Exhibition catalogue, MuHKA Museum of Contemporary Art, Antwerp, 2002, pp.25–38.

1 Emmanuel Levinas, *Reading, writing, revolution*, 1948.
2 *The Pleasures of the Text*, 1973
3 *Discourso intorno alle imagini sacre e profane*, 1582
4 BBC interview, 1981

Andrew Brighton, then a member of the editorial board of *Critical Quarterly*, invited me to take a critical look at the effects of the government's policy on the reshaping of university education in post-Thatcher Britain. My brief was to focus on the changes that had taken place specifically in art education. I wanted to provide a history of art schools that was more critical than the picture that was usually painted by the universities' main apologists. In reality it is a very sad tale, the betrayal of an important educational tradition that goes back to John Ruskin and William Morris. At its best, this offered an emancipatory alternative to the bookishness of the university mainstream. Together, the art schools were the one place where the visual was seen as at least as important as the verbal in terms of human understanding and experience.

ART EDUCATION:
FROM COLDSTREAM TO QAA

In August 2004, after more than 45 years, I retired from teaching fine art. My career spanned a period of quite momentous change in art and higher education. It started at the turn of the 1960s with the Coldstream reforms. My first teaching job was at Lancaster College of Art, where I was plunged immediately into the preparation for a validation visit from the Summerson Council. It ended at Middlesex University, in the financially starved and academically alienated environment of the fine art department.

When I arrived the whole department was engaged in the preparations for a Quality Assurance Agency for Higher Education (QAA) inspection. History seemed to be repeating itself. In between Lancaster and Middlesex was Goldsmiths College, where I spent more than 21 years including a period as head of the department of fine art, and the Jan van Eyck Akademie, the postgraduate *Workplatz* in Maastricht where I was in charge of postgraduate fine art teaching for six years.

For me, returning to British higher education in 1998, the changes that had been wrought over the period of my time in the Netherlands were particularly vivid. The 'binary line' had been dissolved, an educational disaster in my view. The polytechnics had disappeared, swallowed up by

a greatly expanded university sector. Further, the commercial, market-led model of higher education, as dreamed up by the second Thatcher government, had become even more entrenched under New Labour. Students were now quite openly referred to by the new administrative class as 'clients' and 'consumers' and teachers were 'service providers' working in 'educational services'. In the six short years I had spent in Maastricht that wonderfully subtle, broadly assumed yet largely unstated bond between the teacher and the taught, which had come to characterise the British university system in the period after the Second World War, had been usurped by an approach that belonged to the management of corporate business.

Shortly after my return, I attended a conference in Oxford, organised by the Ruskin School, 'Research and the Artists: Considering the Role of the Art School'. We were told by a vice-chancellor from one of our more privileged centres of higher learning that we all had to get used to the idea that a university was a business like any other business. His role as chief executive was the efficient management of resources. He advocated an approach like portion control in the catering industry. His job, he said, was to set 'economically realistic' limits on the teaching input, so as to curb per capita educational costs and maximise what he referred to as 'the throughput of students'. The holy grail was to achieve the government's target figure of 50 percent of eligible students in Britain's universities by the end of the decade and, as far as he was concerned, the means, of whatever kind, were very definitely justified by the ends.

But this was not what surprised me most about the Oxford conference. What surprised and horrified me more than anything else was the way in which the assembled array of university teachers and administrators seemed quite content to discuss quality and the questions of educational standards in general as if they were purely technical matters. As an artist, used to thinking of quality as something manifest, as relating to a kind of apophthegmatic absolute, the idea of measuring quality simply by graphing 'input' against 'output', teaching against learning, seemed to me naive.

When viewed from the standpoint of a practice-based, creative activity like fine art, even absurd.

In fine art, learning occurs very largely through personally directed conceptual and material experimentation. The teaching 'input' can only ever be highly speculative, its relevance and effectiveness is uncertain. The learning 'outcome' is correspondingly unpredictable and, since it depends on developmental factors outside the teaching situation, it is often indeterminately

delayed. However, when I raised this for discussion in one of the study groups, I was told rather abruptly by a lady administrator that I was missing the point. They were talking about 'quality' in relation to undergraduate, not postgraduate, courses. When I protested that I was also talking about undergraduate courses, another member of the group suggested that I was talking about 'excellence' rather than 'quality' – so much for collegiate understanding across disciplines. The same man went on to explain that 'quality', in what he called the 'professional educational context', was measured according to 'mean levels of performance' and not – and these were his words – 'what a really good student might achieve on a good day with a following wind'.

During the subsequent QAA inspection, I discovered that 'quality control' was the managerial term on everyone's lips. The main issue was how to guarantee standards that would meet the demands of the newly established array of government agencies of surveillance and control from within a reducing, per capita, resource base. Most of those present seemed to have swallowed the Keith Joseph, Thatcherite and early Blairite line that there was no necessary connection between resource levels and the quality of the education provided, no direct or necessary connection between the quality of student performance and the availability of resources. They were also keen to reject any suggestion that less to spend in real terms on the education of the individual student would lead to any overall lowering of academic standards across the generality of university subjects.

In listening to my fellow academics talking and noting their apparent complicity in this grand illusion and the ease with which they covered over the self-evident contradictions in such a view with a plethora of new terms and acronyms, all spawned in the few short years I had spent away, I was reminded of the dictum of my favourite political philosopher, Randolph Bourne: 'if you want to change minds you must first change the words that people use.'

The shift into 'management speak' clothed and partly obscured a fundamental change in the institutional politics of British education. The drive for greater efficiency, the application of financial pressures, was a means of achieving greater immediate political control over educational objectives. It also had a longer-term ideological purpose of greater political conformity. Forcing upon higher education a more instrumental notion of what a graduate education should be has the effect of limiting that academic independence traditionally enjoyed by Britain's universities. The new vocabulary, with its talk of 'basic skills', 'learning outcomes' and 'employment destinations',

spelled the end of university education as I had previously understood it. University education in the old sense, a subject-based study undertaken in depth, for its own sake, with no other motive in mind than personal satisfaction, was no longer on the educational agenda. It was also clear to me t hat the notion of choice – the word was tossed into every conversation at the Oxford conference as if it possessed magical powers – or the illusion of choice was a crucial plank in this process of politically inspired change. It was discussed as if it was realisable, even though instrumental measures designed to ensure value for money, combined with increasing levels of self-financing, had already begun to erode the student's real freedom to choose. And the lemming-like, collective rush into modularisation, supposedly a way of generating 'diversity' and 'flexibility', far from delivering on its promise to provide a wide range of genuine, high quality academic opportunities to students, had already set in train a marked decline in academic standards.

 The reasons for this are quite simple, modular structures are more about accountancy functions than the realisation of academic objectives. They are of more use to managers than to academics. The wholesale 'modularisation' of degree courses, backed up by what are referred to as 'hard' management strategies, has been the main engine of driving down 'real' unit costs in Britain's universities over the last decade or so. The educational price paid for this politically inspired manoeuvre has been a serious loss of academic coherence: within the institutions, the dissolution of subject-based, academic authority and the historic scholarly values this represents; for students, at the receiving end, the fragmentation of their learning experience; for the collective body of university teachers, a dispersal of their academic responsibilities and the steady erosion of scholarly authority within their universities.

ooo

But how has fine art education fared in all of this? In my view, as a returning exile, not very well. When I left England, the majority of fine art departments were situated either in polytechnics or in the rump of independent art and design colleges. When I returned, most of them had been bundled unceremoniously into an extended and unified university system where they found themselves subject to the same kind of generalising academic and professional pressures that have always been applied in the governance of university subjects. Fine art has been reduced, in short, to being a study area amongst other study areas – in the

old terminology, an academic subject amongst other academic subjects. This is despite the fact that fine art is not a subject of study. It does not define itself by negotiating boundaries with other subjects. Nor is it a discipline. It has no 'root' or normative rules of procedure. Rather, it is a loose assemblage of first-order materially based activities taking place in a speculative existential territory that has no boundaries and is designed, as Guattari so aptly describes it, to 'extract complex forms from chaotic material'.

By now, this barely acknowledged change of status – the turning of fine art into a university subject, has been enforced and reinforced from both inside and outside these new-style university institutions. From within, through the drive to 'programmatise', thoroughly 'academicise' and 'professionalise' all undergraduate work. From without, through the systematic restructuring of higher education funding, including the incentive funding of research through the Arts and Humanities Research Board (AHRB), changes in labour law and the imposition of the several processes and instruments of academic testing, quality-monitoring, surveillance and control: the array of indiscriminate, marginally corrupt and largely unaccountable bodies like QAA and Research Assessment Exercise (RAE).

The art and design community, by partaking in this process of academicisation, either wittingly or unwittingly, has finally sacrificed its birthright for a mess of university pottage. It has betrayed its own extraordinary history, including the principles established by the first Coldstream Report, published in 1960, which, even though compromised, produced the space that allowed for the regeneration of British art and design education that came to its full flowering in the 1980s and 1990s.

In 1959 William Coldstream was asked to make recommendations to government about the future shape of art and design education. As a libertarian socialist with a pronounced anarchistic streak, he was profoundly sceptical of professional educators of all types and shades of opinion and he was especially sceptical of what he referred to as the 'art education lobby'. He wanted professional artists and designers to decide on the future shape of British art and design education rather than the professional educators, and chose the membership of his committee with this objective in mind.

He was also a man who liked to consider all the options before making his views known. For instance, he declared himself unconvinced by his friend Herbert Read's notion of 'education through art' and rejected Read's distinction between 'visual' and 'verbal' learning types; he rejected any binary

opposition between 'thinking' and 'doing'. As a consequence – although he thought that all children should do art at school – he could see no grounds for giving art a privileged, central, educative role in the school curriculum as advocated by Read. Likewise, he remained similarly unconvinced by the arguments of those who wanted to systematise fine art and design teaching at all levels along vaguely Bauhaus lines.

Later on, talking to him just after the mass resignation of his committee in 1970 over polytechnicisation of art schools, I asked him why he had rejected the pro-polytechnic arguments of such prominent figures as Victor Pasmore and Harry Thubron. He responded, rather typically, with a rhetorical question: 'What would have been the point in replacing one tyranny with another?' He went on: 'You see the world has changed since I was a young man. Uncertainty is the condition that young artists today have to learn to live with, and that is what we were trying to accommodate.' This, then, was the visionary aspect of Coldstream's endeavour. He wanted to empower a small number of independent specialist schools, by providing a reasonably stable institutional framework but without a general curriculum. Beyond a general rubric to teach some art history and provide for some intellectual enrichment of their programme, to be determined by the schools themselves, under the heading 'complimentary studies' what these art schools did was to be filled in by them. The bulk of the courses would comprise studio-based practice, the pattern to be determined by the teachers on the ground. Working conditions for the student would as far as possible imitate those of artists and designers working in the world outside. Fine art students would have earmarked studio spaces and design students their own work stations.

In support of this approach, Coldstream advocated the continuation and expansion of the provision of part-time teaching. He described the part-time staff as 'the life-blood of the new schools' because it allowed for a steady ebb and flow of new people with new ideas. The underlying ideal was that of communities of artists and designers – some, who happened to have had more experience than others – meeting and exchanging their ideas and know-how gleaned directly from their experiences as artists/practitioners.

Most important of all, perhaps, was Coldstream's intention that there should be as few institutional trappings as degree-equivalent status would allow. Students were to be formally assessed only twice. First at the point of entry, to decide whether they were the right material for the specialist course for which they were applying, and again at the point of exit, to determine how well they

had done to date. In between times, student progress was to be monitored on a day by day basis through an individual tutorial system and whatever additional, informal method of assessment the schools thought to be appropriate.

In the event, very few schools were ever allowed to realise this ideal in any fulsome way. Indeed, the history of the Coldstream reforms is one of betrayal at almost every point. From the outset, because of pressure from the local education authorities, the Summerson Council, set up to implement the Coldstream recommendations, approved far too many colleges, thereby threatening the whole 'specialist' enterprise – a blatant piece of sabotage that even the usually reticent Coldstream felt driven to publicly disassociate himself from, declaring that there were not enough high-level artist-teachers available to staff the number of schools approved. The teachers' associations and unions were against a system that encouraged part-time teaching and commenced heavy political lobbying to have it curtailed. And then came the Weaver plan to incorporate art schools into a new generation of large-scale institutions called polytechnics.

Looking back, it is easy to see that the incorporation of the art and design schools in the new polytechnics spelled the beginning of the end of the Coldstream reforms. I was a part-time visiting teacher at Leicester College of Art at the time – living in London and commuting on the early train two days of the week – and I vividly remember the fiercely contested arguments that accompanied the consultation period. It was clear that the art schools were being courted by the polys for one reason and one reason only, because they were already approved to do degree-level work.

Coldstream and his committee made no secret of the fact that they were against incorporation, on the grounds that it would spell the end of that uniquely independent tradition of visual education inaugurated by Reynolds and embracing such figures as John Ruskin, J.M.W. Turner, William Morris and the Arts and Crafts movement. At a conference called to discuss the issue by the Young Contemporaries, Andrew Forge, the public voice of the Coldstream Committee, declared very forcefully that the polytechnicisation threatened the art and design schools' historic spirit of intelligent independence. It would destroy the community of art and design interests, and once this was lost, it would be lost for ever. Prophetically, he saw no benefits at all for fine art education and predicted short-term gains and long-term losses for the design subjects. Members of the Coldstream Committee were not alone in these views. Many influential voices were raised against incorporation, but to no

avail. The majority of local education authorities were in favour of it for political and economic reasons and in the end these were bound to prevail. I raise this now because I believe we are still living through the consequences and divisive aftermath of incorporation, now intensified by the polytechnics' recently acquired status as universities. With this in mind, it is worth pausing for a moment to take stock.

It is certainly the case, as Andrew Forge predicted, that the community of art and design interests was largely dismantled by the polytechnics and is being further eroded in the new generation of universities. The principle of divide and rule has come to prevail almost everywhere, turning the house against itself. Where once an atmosphere of mutual support held sway, we now have a dog-eat-dog situation, with the old Art and Design subjects scrapping endlessly amongst themselves over diminishing territories and steadily reduced resources. Over the years, the polys expanded recruitment as and when it suited them, so that the Coldstream idea of a highly selective, specialised study has long since gone by the board. Following the virtual demise of part-time teaching, the idea that teachers should – before all else – be professionally active in their chosen fields, has been thoroughly compromised. The mobile army of part-time professional artists and designers has been replaced by a new race of spuriously professionalised, institutionally tied, art and design pedagogues – teachers first and practitioners afterwards. Even their own work, nowadays referred to as research – and I will return to this curious phenomenon and its consequences in a moment – is subject to the approval of their institution and funded by incentive research money administered by their university.

The open-ended, developmentally flexible degree courses envisaged by Coldstream have more or less disappeared, replaced by the over-regulated, over-supervised and over-examined, pedagogically staged, benchmarked and modularised undergraduate courses so beloved of university administrators, quality-control specialists and finance officers. Some of the contortions that fine art courses especially have had to put themselves through in order to try to ameliorate the worst effects of these so-called 'common academic plans' have by now entered into folklore where they have spawned a new vocabulary of resistance. Despite the best efforts of some of those concerned, modularisation has been damaging to fine art's values and the cause that all artists espouse, that very special and highly unpredictable and irregular state of coming into knowledge through practice. The new generation of university

administrators seem to be incapable of understanding how a heavily developmental subject like fine art works, unable to comprehend in what sense the process might, too, be rigorous.

In the meantime art history teaching has almost ceased to exist, replaced by a new orthodoxy, often referred to as art theory teaching – an agenda that mostly comprises sociological and psychoanalytical topics drawn from the extended field of cultural studies, with the result that generations of fine art students know hardly anything about the history of their chosen form of practice, even those fairly recent histories that have helped to shape their own work.

To my way of thinking, this checklist serves more than anything else to point up the bogus and highly misleading nature of what is referred to as the 'research-led teaching ethos'. Like most other measures that have contributed to the decline of British education in recent years, it originated in the USA. The idea was outlined in a document published by the Boyer Commission, *Reinventing Undergraduate Education, a Blueprint for the USA's Research Universities*, published in 1998 by the Carnegie Foundation for the Advancement of Teaching. Drafted into the British situation, it is dangerously naive stuff, especially where it deals with fine art and the performing arts. I quote it here, because it has already been used in the national context as an argument in support of the reduction of fine art practice to a category of scholarly research, and I use the term 'reduction' very deliberately. This is what the Boyer Report says:

> Most if not all universities have recognised a special role in visual and performing arts. After students learn to use the material of the discipline, students in the arts are engaged in independent research throughout their programmes, for every exercise in painting, photography, musical composition or dance performance is a problem to be solved as surely as a problem in physics or math.

Those of you who are involved with teaching fine art will recognise the absolute erroneousness of the Boyer argument. No longer do we separate the learning of techniques and skills from the purposeful act of making works of art. There are no logical grounds any more for so doing. We do not operate a regime of practical exercises. Neither do we describe the act of making art, in itself, as research. Making works of art is not a quasi-scientific process of problem solving. As Duchamp remarked, 'in art there is no solution because there is no problem.'

Ironically, if you read the rest of the Boyer Report with care, it fields the most cogent argument I have come across against the incentive funding of research in universities. It describes a situation in American universities where, because of the revenue it can raise, research has become far more important than teaching. The most distinguished of their scholars, listed on their websites for recruitment purposes, hardly ever enter the university buildings and rarely meet, let alone teach, an undergraduate student. And now, in this country, the race to achieve high RAE ratings is beginning to generate a similar state of affairs. Individual scholars are being courted, employed and afterwards kept for their capacity to write books and raise research points, their teaching carried out my junior academics and research assistants. Whole departments are being funded through incentive research money with no commitment at all to undergraduate teaching.

By way of a conclusion, I want now to return to the question of fine art practice and its spurious recasting as fine art research. Controversially, at the Ruskin School conference on fine art research, I stated very forcefully that artists do not go to their studios to do research but to make art. And today I want to reiterate that point: works of art collectively or individually cannot properly be describable as 'measurable research outcomes', with or without attendant explanatory text or illustrated catalogue. To claim otherwise is to belittle the practices of art themselves and reduce them to mere scholarship.

The title page of the first edition of James Joyce's *Ulysses* bears the words 'a modern novel by James Joyce' – not 'a research outcome' by James Joyce. This makes it perfectly clear that the values that it celebrates belong to literature and not to history, criticism or scholarship. Similarly, the poster that advertised the Guston exhibition at the RA referred to 'the paintings' and not 'the research outcomes' of Philip Guston. Again, the values celebrated belong to the domain of art and not to some wacky version of scholarly activity.

I want to be very clear about this one point. Ultimately, art is more important than the whole contemporary gamut of interpretive research. I believe that writing works of literature, making works of art are fundamentally superior activities to endlessly researching, writing about and theoretically recontextualising other people's work. George Bernard Shaw's intentionally provocative riposte to Haldane, that 'a single Beethoven quartet or one Shakespeare sonnet has done more to deepen our understanding of the human condition than all the university theses that have ever been written', has an inescapable germ of truth in it.

I suggested earlier on that as a community of interests, we have already sold our birthright for a mess of university pottage. I was referring, of course, to the ongoing process of academicisation that is forcing entirely the wrong kind of change on the teaching of fine art practice. But our meek acceptance of the new research-led regimes is perhaps the most dangerous development of all. The recent paper from AHRB called Research in the Creative and Performing Arts, gives the sharpest possible definition to the problem. It marks the end of what has been a very short honeymoon period. Now the academic screws are really being tightened.

Just two short quotations.

Creative works, no matter how highly esteemed, cannot in themselves be regarded as outputs of research. They can only become so in association with explanatory or contextualising text.

And later on:

Work that results purely from the creative or professional development of the artist however distinguished is unlikely to fulfil the requirements of research. We do not believe that creative performance or practice-led output should be allowed to stand on its own as a record of research activity... any research output submitted to the RAE should have associated with it a record... of its research process.

These demonstrate very clearly scholarship's attachment to what Guattari has labelled 'linguistic imperialism'. Without a written commentary and analysis, the work that we do as artists cannot be accessed, given academic weight or properly evaluated. The most depressing aspect of this approach is the monumental ignorance that it shows about art in general and about the relationship that pertains between artists and the things that they make.

Creative work in the visual arts starts with material and is consecrated in a pre-linguistic moment. Its processes begin before the word and before the image. All sorts of things can be said about works of art, except how they come into being; why and how the process of their making is worked through up to the moment of completion. Guattari has set this process into the space of what he calls 'a-semiosis', as being, in itself, unsignable. Varela has described it as a form of 'autopoesis', where it is the 'machinic' order that is in

play. Making works of art is, then, axiomatically both 'productive' and 'reproductive'. As process, it requires no explanation or justification outside of the topology of the network of thoughts and actions that are embodied through the act of making.

Critical Quarterly, Vol.47, no.1–2, Wiley-Blackwell, Oxford, July 2005, pp.215 – 25.
This talk was given in September 2004 at Tate Britain at a conference on art education occasioned by Jon Thompson's retirement from the Research Professorship of Fine Art at Middlesex University.

THE MAD, THE BRUT, THE PRIMITIVE
AND THE MODERN:
A DISCURSIVE HISTORY

This exhibition, *Inner Worlds Outside*, shows the work of established artists from the history of art alongside the work of *Art Brut* or Outsider artists. This is not the first time, but it is the first comprehensive attempt to do so in an unqualified way. The focus is on the works themselves rather than an overarching theme. There are two main reasons, both easily stated but difficult to argue. The first starts with the premise that all human minds are fundamentally the same and that this 'sameness' is manifest in the works of Outsider and mainstream artists alike. The second arises from the conviction that, historically speaking, both 'insiders' and Outsiders are products of the condition we call 'modernity'. As Karl Marx argued, in modern societies alienation extends to every type of relationship – between 'man and man, man and object, man and society, man and myth, man and language'.[1] It colours all human psychological and physiological behaviour, from that of extended social groups to the most private preoccupations of the individual. In modern industrial and postindustrial societies, 'the very fact that we live, work, produce and form relationships, means that we exist in alienation'.[2] While the work of Outsider artists may, in certain instances, constitute an extreme response to this condition, it is nevertheless thoroughly embedded in modernity's history and its cultural legacy.

It is not surprising that the growing interest in what we now call *Art Brut* or Outsider Art closely paralleled the evolution of psychiatry and the struggle to understand the manifold mysteries of the human mind during the nineteenth century. The earliest collections were made by doctors working in psychiatric clinics and concentrated on the works of patients for two reasons. Viewed as diagnostic instruments, the drawings of psychiatric patients were seen by some doctors to provide a more direct route into the workings of the human soul than they might give out verbally. Such drawings also demonstrated certain common characteristics that were useful for the 'mapping' procedures essential to the creation of an effective, generally applicable symptomatology of mental illness. The underlying belief was that while behaviour patterns might differ markedly, minds were fundamentally the same.

In western European thought this idea of a common instrument for human thought occurs as early as the pre-Socratic philosophers. In 500 BC, Herclitus of Ephesus, for example, speaks of the *holos*, a model universal mind which is dynamic, plural and complete unto itself and which enables 'all men to know themselves and to think well'.[3] Significantly, in modern thought, the most vivid description of this 'sameness' of minds – is to be found in Sigmund Freud's writings, when he seizes on the metaphor of the 'crystal' in the *Lectures on Psychoanalysis* (1915). Similarly formed and faceted, worn and damaged by life experience, 'If it is thrown to the floor,' Freud writes, 'it can break into haphazard pieces... it comes apart along its lines of cleavage into fragments whose boundaries, though they were invisible, were predetermined by the crystal's structure... mental patients are split and broken structures of this kind.' 'Even we', he continues, 'cannot withhold from them something of the reverential awe which peoples of the past felt for the insane... they have turned their gaze away from external reality, but for that very reason know more about internal, psychical reality and can reveal things to us that would otherwise be inaccessible to us'.[4]

Freud's model of the mind as 'crystal' is striking because it argues a preexistent structural unity; an essential wholeness which persists beyond the experience of trauma. It also suggests that this notional unitary mind takes precedent, in certain important respects, over the diagnostic processes arising in psychiatry.

In another lecture on symptom formation, Freud also points to a connective tissue linking madness and something approaching creative insight.[5] Accordingly, Freud suggests, mentally ill people, like artists, see and come to

know things about themselves and the world that other people do not. Artists and 'the insane' share a psychic pathway leading from fantasy and reality and although 'neurosis is always close at hand', their mechanisms of repression are less insistent. Artists differ in their ability to give external and independent form to their fantasy. They 'understand how to work over their day-dreams', Freud wrote in *The Paths to the Formation of Symptoms*, so that 'they lose what is too personal, making it possible for others to share in the enjoyment of them'. Most important of all, the artist 'possesses the mysterious power of shaping some particular material until it has become a faithful image of his fantasy', so that for the time being at least, 'repression is outweighed and lifted by it'.

The lecture on symptom formation was first published in 1916, some three years before Dr Hans Prinzhorn, the self-proclaimed 'revolutionary on behalf of things eternal', was appointed to the Institute of Psychiatry at the University of Heidelberg, where the most important collection of art by psychiatric patients still bares his name. Although Prinzhorn was not the first collector of such work, he was almost certainly the most aesthetically receptive. Having trained as an art historian before studying medicine, he was uniquely qualified to take charge of the large body of visual material – already described as a museum – bequeathed to him by his predecessor at Heidelberg, Dr Emil Kraepelin, and to undertake the task of giving it some order and academic force.[6] Prinzhorn stayed at the Heidelberg clinic for only two years, but even in that short space of time he was able to greatly expand and systematise the representative collection of visual material held by the university. More importantly, he was able to complete the ground work for the book which is still considered seminal for the study of art by people with mental illness, *Artistry of the Mentally Ill*, first made available as an academic publication in 1922.[7]

Prinzhorn's personal interest was in art and its place within society and as the writer and curator Bettina Brand-Claussen has pointed out, his declared aim of 'acting to clarify (something) within the chaos of today's art' carried with it an implicit cultural critique.[8] Prinzhorn's underlying purpose was much broader than his professional clinical interest, or his more specialised involvement with the art of psychiatric patients. Even so, his book established a powerful link between art and psychiatry which has had negative as well as positive effects on the subsequent status and theoretical treatment of Outsider art. It is increasingly problematic, for example, that most serious discussions of the subject have tended to be dominated by psychological and psychoanalytical considerations. Furthermore, the work of Outsider artists in general, even those

who have no clinical history of mental illness and seem to have lived fairly ordinary lives, is frequently allied with the symptomatology of mental illness and the psychology of social isolation. While the link with psychiatry has yielded a great deal of important interpretive material to the field of academic psychology and the practice of psychoanalysis, it has almost certainly impeded the acceptance of Outsider art as an integral part of modernist art history. Indeed, the habit of psychologising it continues to be a key instrument in its ghettoisation.

As we have already discussed, Freud's model is careful to separate the mind itself from its symptomatics. In other words it proposes a *wholeness*, with a specific topography and structure which precedes the process of diagnostic fragmentation. Freud calls this *wholeness* 'an inherited disposition' which is 'qualitatively alike' in all human subjects. He also proposes it as the deep site and origin of the human imagination. This has some fascinating implications for the consideration of Outsider art as it does for the aesthetic domain in general.

By now it is broadly accepted that the rudimentary components of spoken language are inherent. They are already present at birth and manifest themselves in the first sounds that a child utters. It would not be at all surprising then, if the same were true of our capacity to make images. Indeed, much recent research into children's drawing as part of the broader field of child development points strongly in this direction. The first marks the child makes and the subsequent evolution in mark-making has been shown to have a common and entirely purposeful progress. There is also a distinctive and common development in terms of image formation. Research has demonstrated that this process is intimately connected, though not synonymous with, the evolution of the child's language skills. It is impelled socially and thus arises out of the same space of enunciation as the need to speak to others – the drive to make communicative sense. Very young children see their scribbles as depictions of people and things although they remain unrecognisable to others. They expect adults to recognise who or what is depicted, long before being introduced to notions like *correspondence* or *verisimilitude*. The progress of their mark-making habits proceeds quite logically too: from concentrated circling movements with most of the resulting marks confined to the space of the paper to more vertical scribbling actions in clumps; from stabbing and pointing gestures resulting in dots, dashes and small, heavily impressed, tightly arching lines to more deliberate attempts at shape-making. This surprisingly uniform pattern of development points to the existence of something approaching an innate and possibly universal visual grammar.

The linguistic philosopher, Noam Chomsky in his celebrated essay, *Language and Unconscious Knowledge* (1976), advances the idea of a visual system that 'begins in some genetically determined initial state common to the species'.⁹ It has some small variations within it but Chomsky states that these are sufficiently minor to be ignored. This predisposition, he argues, evolves through several stages in early childhood until it achieves a final 'steady state' which undergoes only marginal further change. Its outward show can be greatly refined and even augmented through life experience and the learning process but the underlying system remains fairly constant. This suggests that there is genuine common ground to all image-making pursuits, some kind of tendency towards structural coherence arising between the eye and visual cortex and the rest of the cognitive system that renders the world and its sign systems visually legible.

The key instrument in our capacity to develop visual images is that of perception and artists of whatever type or persuasion must work with and through it. As Richard Wollheim observed, artists are the first and most astute observers of their own work and their observations are crucial to its evolution.¹⁰ Neither is perception, as Descartes was the first to point out, a simple matter of receiving sensory information. On the contrary, perception is by definition a thinking process. Indeed, thinking in pictures (as distinct from the routine mechanics of 'apperception') may well have primacy over thinking in words – although we still have no way of knowing what a picture might be to the unconscious mind. Freud certainly thought that what he called 'mnemic impressions' precede our thinking in words and he states quite unequivocally in his introduction to *The Interpretation of Dreams* (1899) that dreaming is 'nothing other than a particular form of thinking'.¹¹ Dream thoughts – whether waking or sleeping – result from the principles that Freud calls '*dream-work*'; a process, essentially of transcription, through which dreams occur to us.¹² Here, symbols and signs play a significant role in what is an upward, psychic movement from one mode of expression into another – from a latent into a manifest form of visual language. The movement is upward, because it enjoys the natural dynamic occurring between the subconscious and preconscious aspects of the mind. However, Freud weaves a complex, cautionary web around this process of translation. Having outlined some of the mechanisms that characterise *dream-work*, he warns his audience in the 'Lecture on Dream-work' against making easy assumptions. It is, he argues, a very unusual form of transcription –

not a word for word or sign for sign translation; nor a selection made according to fixed rules... nor is it what might be described as a representative selection – one element being invariably chosen to take the place of several; it is something very different and far more complicated... it consists in transforming unconscious thoughts into palpable visual images.

Freud's cautionary note assumes its full significance only if we bear in mind that the unconscious is not directly accessible and is unknowable in and of itself.

As the psychoanalyst Marshall Edelson has stated in his fascinating essay *Language and Dreams* (1972), 'By making explicit the means by which a dream – a symptom, a joke, a myth, a work of art – is constructed, Freud placed psychoanalysis at the very centre of the emerging science of Semiology.[13] He changed the way in which we read images, carrying it beyond the reach of the older, interpretive work of iconography, wherein meanings were consecrated pictorially as tableaux or story-telling. Because of Freud we know now, for sure, that the attribution of meaning is always, to a marked degree, propositional. We are also intuitively alive to the types of mechanisms Freud describes in his analysis of *dream-work*: the collapsing of temporal frameworks; the condensation of wide ranging symbolic material into simple and singular images; image displacement; exaggeration and distortion; metonymic substitution; and the regressive (substitutive of other forms of satisfaction) transformation of thoughts into pictures. Such devices have become the very stuff of modernity's endless fascination for the visual sign in the media as well as in art. There is certainly a remarkable degree of coincidence between the psycho-linguistic model of mind, as outlined by Chomsky and that of the semiologist, Umberto Eco, for example, in *A Theory of Semiotics* (1976), suggests that all kinds of art are characterised by the same 'super-system of homologous structural relationships' which he calls 'the aesthetic ideolect'.[14] As with Freud's *dream-work*, this is elaborated through the violation of simple codes. A commonality of deep structure is thus overlaid by what he calls 'the deviation matrix' peculiar to each individual work of art. After an attempt at the scientific approach to semiotics advocated by Ferdinand de Saussure, Roland Barthes' later writings step back from claiming this degree of universality.[15] Even so, he still sees language as something which is 'gifted' and 'received'; 'gifted' through the activity of writing or making images in sound or vision; 'received' because it can only arise out of the material experience of the body's interaction with the world.

Semiotics of course is nothing less than an attempt to rewrite the human subject as one born in and out of the material of language itself. In its first 'scientific' phase as outlined in Barthes's *Elements of Semiology* (1964), semiotics sets its face against notions like the individual and intangibles like presence and immediacy preferring to see the creative act in terms of universal principles. However, in his later writings Barthes embraces the notion of the unexpected, the unforeseeable, the spontaneous and the new as desirable outcomes of the individual imagination. He argues that an erotic impulse provides the motor that drives the writer, the composer or painter to undertake a journey through language and to fulfil desire. Just as Eco concludes that the individual work of art is manifestly 'deviant' in certain ways, Barthes arrives at the conclusion of 'a body split into fetish objects and erotic sites'.[16] In their different ways, both reflect Freud's distinctly modern insight that the creative act closely parallels the shape and psychic substance of neurosis. It is modern, because, like psychoanalysis itself, it springs from an awareness that could only emerge in the wake of the collapse of 'Grand Narrative' in the latter part of the nineteenth century. And here we reach a crucial point of intersection.

The emergence of interest in *Art Brut*, as Dubuffet called it or Outsider art as it is called in the transatlantic, English-speaking world, is also a product of this same quintessentially modern state of consciousness. In particular it arose as part of the spirit of *fin de siècle*, with the demise of a central, generally accepted language of painting and the last remnants of a Renaissance inheritance. High Modernism was born out of this radical breaking point manifesting Janus-like, nigh on schizophrenic characteristics. It embraced the primitive alongside the scientific; secularism alongside a burgeoning interest in obscure cults and spiritual practices; a love of realism cheek-by-jowl with the new Expressionism; 'art for art's sake' with art as responsible social politics. Roger Shattuck in his trenchant critical essay, *The Social Institution of Modern Art*, puts it very neatly when he writes 'Western art between 1880 and 1930 attempted to jump out of its own skin.'[17] Art began to divide between the desire to found a new society and a longing for an ahistorical oblivion in which art was to be lived as a form of intellectual dandyism rather than practised for its power to move the human heart. It was also during these 50 years or so that the interest in art by people with psychiatric illnesses gathered pace and began to develop a broader view that reached beyond the walls of the psychiatric institution.

The antinomy in modern society between 'Primitivism' and science and technology is of most interest as it was precisely this bracketing that constrained Prinzhorn's thinking about the art of mentally ill people during his time at the Heidelberg clinic. The polarity was clear enough: art was either a product of the primordial urge, a common emotive force that links all humans or a mere phenomena that one day would be easily explained (away) by the rapidly evolving science of the mind. There is no doubt about where Prinzhorn stood. His aim was curative, to rediscover creative authenticity and to search for what he called the 'genuine artist'. He recognised this in its most powerful form in the work of the 'autonomous, autistic, mad artist' and in particular the person with schizophrenia whose creative impulse 'wells up' to create an *unio mystica* with the whole world'.[18] His views were in no sense typical of his profession but were more the product of his study of art history and his passion for the new German art: Expressionism. His writings of the time are littered with terms and concepts first coined by the expressionistic painters like 'essential insight', 'primordiality', 'cosmic feeling', 'spiritualisation' and 'internalised or natural empathy'. From Prinzhorn's standpoint, in as far as the art of mentally ill people had abandoned 'direct apperception of the world', it demonstrated a profound inward affinity with the latest avant-garde art.

Expressionism, of course, had a hard 'cerebral' edge to it too. Wilhelm Worringer, in his seminal work, *Abstraction and Empathy* (1907), characterised it as driven by a 'primitive urge towards abstraction'. This seeming contradiction finds a fascinating historical precedent in the writings of Paul Gauguin, the painter most admired by Wassily Kandinsky and Franz Marc, artists of *Der Blaue Reiter* who stated, quite unequivocally, that 'primitive art proceeds from the mind'. It 'uses nature without (falling into) the abominable error of naturalism'. And he continues: 'Truth is to be found in a purely cerebral art, in a primitive art – the most erudite of all in Egypt. There lies the principle, and in our present plight the only possible salvation lies in a reasoned and frank return to principle.'[19] This evocation of Egyptian art as the gold-standard of the primitive finds a powerful echo in Freud's writings and goes some way to explaining Henri 'le Douanier' Rousseau's famous remark to Picasso – 'We are the two greatest painters of our time. You in the Egyptian style and I in the Modern.'[20] Nevertheless, it is important to understand precisely what is envisaged by Worringer and Gauguin, They sought a quality of transparency, a purity of expression that echoes Freud's model of mind and that Franz Marc referred to as 'crystalline', stemming from an uninterrupted transference from

the 'preconscious' mind or the imagination – via the hand of the artist – directly to paper or to canvas.

However, by conflating directness with simplicity, this use of Egyptian art as a model, gives rise to a certain amount of confusion. The clarity observed in Egyptian art is hardly spontaneous, but results from the diligent application of representational conventions and a prolonged process of stylistic refinement. By contrast, the revealed work of the imagination that we observe in the work of Outsider artists, as with Freud's 'dream-work', is altogether more complex, psychologically messy, riddled with obtuse and uncertain meanings. If it can properly be described as 'crystalline', it is because of the way in which it fragments and shatters all of our routine representational certainties. Viewed in this context Outsider artists are not at all concerned with style or the generalising work of representation, but with configuring themselves to themselves as replete, sensing subjects, Roland Barthes makes a most telling distinction in *The Pleasure of the Text* (1973). 'Figuration', he writes, 'is the way in which the erotic body appears... in the body of the text. Representation, on the other hand, is embarrassed figuration, encumbered with other meanings than that of desire: a space of alibis (reality, likelihood, readability, truth, etc.).'[21]

With only a few notable exceptions – the Chicago-based artist Henry Darger, Joseph Schneller and Adolf Schudel from the Prinzhorn Collection and Guillaume Pujolle from the Sainte-Anne's Hospital Collection, for example – Outsider artists work through a process which is best described as 'inscription', a largely drawn language of personalised signs and emblematic images which sits somewhere between writing, diagram and 'design' (in the original meaning of that term). They accept the abstract unity of the paper as the given, rather than trying to construct a pictorially coherent, alternative or conspicuously 'believable' representational space. In some respects, this answers Worringer's modernist formulation – 'the primitive urge towards abstraction' – but it has a wider significance too. As Roger Shattuck argues, one of the key polarities governing the history of modern art is that of 'realism' and 'abstraction', where abstraction is defined by reference to the twin process of 'condensation' and 'simplification' exemplified by ancient and tribal artefacts or 'primitive' art. While both processes are clearly present in the work of many Outsider artists, they are rarely if ever deployed strategically or for stylistic reasons, but are driven by the desire to register an emotional state in its most intense visual form. It is for this reason that most works

by Outsiders are without titles. Completion or 'closure' is an absolute state. No aid to reading is necessary and no further verbal definition or qualification is required.

The qualities that attracted Modernist artists to Outsider Art were an entirely different order to those that drove them to look at Cycladic and African sculpture, Japanese prints or Balinese puppets. Where 'primitive' artefacts from Africa and the Far East could be seen quite simply as the exotic 'other' with the potential to enrich and renew a flagging pictorial tradition, Outsider art challenged the post-Romantic definition of art at its very root by asking questions about its much vaunted claim to creative freedom. For the Expressionists, it seemed to offer the possibility of undertaking a journey into 'the deepest strata of the mind' there to raise up 'brain-born images, superior to nature and uncorrupted by history or the Academy'.[22] For the Surrealists, it seemed to offer the possibility of direct access to eidetic clarity; the possibility of grasping involuntary and dream images and, as André Breton wrote, 'fixing them on the page without imposing any kind of qualitative judgement'.[23] For Expressionists, Outsider art offered release from the institutionalised burden of tradition, while the Surrealists found freedom from the value-forming apparatus and an escape by way of a 'free-fall' dive into what Breton describes as 'the unmeasurable region between the conscious and the unconscious mind'.[24]

André Breton's *Manifeste du surréalisme* was issued in Paris in 1924, two years after the publication of Prinzhorn's *Artistry of the Mentally Ill*.[25] On one hand, Breton calls for childlike 'innocence', 'perhaps childhood is the nearest state to true life', he writes, and on the other, he points to the sexualised, darker side of the human psyche revealed in the writings of Freud, which he describes as the shameful 'fauna and flora of Surrealism' that 'cannot be confessed'. These two dimensions of the Surreal are to be reconciled by means of a 'pure psychic automatism' directed towards achieving the 'fearful' and 'ecstatic' states that we experience in dreams. Central to this process is an obsession with the image – Breton calls it a 'vice'. The image is common property, a democratising force, 'a means towards the total liberation of the mind and *of everything that resembles it*'. As Breton and his fellow Surrealists believed that images can exist beyond the reach of preemptive judgement, they could rehearse this ideal by playing their favourite game, '*Le Cadavre Exquis*' (The Exquisite Corpse), of which the poet Paul Eluard writes, 'No more anxiety, no more memory, no more tedium, no more stale habit. We gambled with images and there were no losers'.[26]

The magical, erotic impulse behind all of this is clear. 'Le Cadavre Exquis' divides the body into 'zones' more than into parts: the head where the brain is situated; the uppertorso, chest and breasts; the lower torso including the genitals; the great divide between the legs and feet. In this, the veiling of the image invites projections which are precisely in line with Barthes's 'body split into fetishes and erotic sites', but it also pushes the making of the image in the direction of what Breton calls 'the interior model of reality'. In the second manifesto, *Le surréalisme et la peinture*, published in 1928, Breton lists the artists who he thought capable of making this journey, including Pablo Picasso, Max Ernst, André Masson, Joan Miró and Man Ray.[27] The longstanding concern with the representation of the external world, Breton declares, is 'an unforgivable abdication' and if the 'plastic arts are to meet the need for a complete revision of real values... they must either seek a *purely interior model* or cease to exist.'

As already remarked, Roland Barthes too, in *The Pleasure of the Text*, seems to suggest that representation with its 'alibis' and strategic deceptive feints is the real ghost in the human creative machine. He seems to argue that the demands of representation – the rules and principles that determine what is believable, socially legible and pictorially truthful – constrict, confine and ultimately defeat the creative process. The alternative in its pure form is always somehow recoverable out of the figural blossoming of the erotic body in the inscribed or written text. At the same time he knew that it was not easy to escape the clutches of representation. In *The War of Languages*, written in the same year as *The Pleasure of the Text*, he declares, somewhat ruefully, that 'every strong system of discourse (Medicine, Law, Literature, the Fine Arts) is *representation*... a rhetorical staging of arguments... nothing less than a hysterical mimodrama.'[28] With works of art, then, as with works of literature, the institutional context shaping the particular discourse is everything. It fixes the parameters of interpretation and has the power to recast even the most intuitive and inward-looking work as a representation in its own image.

With the intervention of the French painter Jean Dubuffet, the overarching regime of interpretation governing *Art Brut* or Outsider Art shifted quite dramatically from psychiatry into the more open domain of the visual arts. He worked in secret to expand the definition of *Art Brut* and to widen the search for exemplary figures. However, there was always a certain ambivalence about Dubuffet's formulation and an element of denial foreshadowed by the very label with which he chose to describe it, *Art Brut* (raw art). His initial impulse was to make a collection that was accessible to only a select group of people but not to

the public and to 'ear-mark' but not to define the *Art Brut* artist; Dubuffet's founding ambivalence continues to the present day. Paradoxically, despite his passionate interest in the work of artists who lived and worked independently of the mainstream and his pioneering work in bringing such work together as a collection, he remained a convinced 'separatist'. He wanted the achievements of these artists to be recognised but kept apart from the art of the Modernist, or as he called it 'academic', mainstream. Even after his collection had been given its own museum in Lausanne, he insisted on a singular highly restrictive condition for its future use: no work from the main collection was ever to be removed and used in curatorial projects in other museums.

But the most problematic aspect of Dubuffet's 'separatism' adheres to the term *Art Brut* itself, with its implications of a 'founding' or 'originating' creative impulse as an antidote to an overly cultured art. Accordingly, image-wise *Art Brut* figures as a pure, stylistically autonomous, ahistorical, unschooled art, arising out of the burning inner necessity of individuals who are detached from cultural processes and institutions and exist beyond the margins of 'normal' society. The impossibility, perhaps even the absurdity, of such an existence is clear. Examine each point of definition in turn and there quickly emerges something of Barthes's hysterical mimodrama in such a self-reflecting and overly simplified 'representation' of creative life. Look closely at the work of artists like Henry Darger, Joseph Joakum, Scottie Wilson or even that of Adolf Wölfli who was hospitalised with psychosis and this highly restrictive, ultimately negative picture is rendered fugitive. Clearly these artists – and many others like them – enjoyed rich imaginative lives. How these lives were fed varied with individual circumstances. Darger, for instance, had a working life and obsessional interests outside of his more secretive existence as an artist. His paintings and drawings also engaged him in an ongoing search for visual material from popular printed sources including books, magazines and newspapers. As a young man, the Navaho Indian Joseph Yoakum travelled extensively, often as a stowaway and also worked as an itinerant circus-hand. He started drawing landscapes in his mid-seventies making images based on postcards of places that he had never actually seen. Scottie Wilson saw military service in India, South Africa and during the First World War, in France. After demobilisation he ran a junk shop in Toronto where he began to make symbolic drawings of the timeless conflict between the forces of good and evil. The one time agricultural worker, Adolf Wölfli was accused of child-molesting and committed to the asylum in Bern in his early thirties where he

remained until his death at the age of 66. Despite his continuous incarceration and a life punctuated by violent psychotic episodes, Wölfli left behind a staggeringly rich and varied legacy of visual and written material, a projected mythological universe in which he cast himself in the role of saint and divinity.

All four, then, were very much connected with the wider world, even with imagined sites far removed from their immediate day to day circumstances. But it is the seemingly detached, isolated Adolf Wölfli, who is perhaps the most telling example of the Outsider artists' utter worldliness. Despite its jewel-like splendour and its baroque elaboration, Wölfli's wonderfully fabricated 'other' place, far from being independent of the world beyond the walls of the Bern asylum, is thoroughly penetrated – mythologically as well as structurally – by institutional models coincident with those in the social world outside. It mixes the hieratic with the cartographic, the numinous with the everyday, order with disorder, the sacred with the profane, the forces of nature with those of urbanisation. Metaphorically, it is as luminous and illuminating as the *Très Riches Heures* of the Duc de Berry and *The Book of Kells*. Its mysterious, dream-like distances are energised by music in the form of musical notation and the winged presence of song birds. And all of this is contained within formal structures as rigorous as those of a Mondrian or as studied and orderly as the paintings by Juan Gris.

It is a popular misconception that mythology exists in an entirely different order to other descriptions of reality that are apparently endowed by a higher degree of objectivity. There is a similar misconception that the world of myth is 'unreal' in some way, a place of escape and refuge wherein the creative mind is perfectly free to indulge itself in utterly spontaneous and independent acts of the imagination, or an alternative space where the mind no longer has to contend with the material world, with its objects and modes of organisation. Nothing could be further from the truth. The 'sameness' of minds – their very 'objectness' – even bearing in mind Freud's model of the flawed and fissured crystal, means that Wölfli's world is nothing other than our world, though it is depicted in a thoroughly transfigured form. As Claude Lévi-Strauss was so keen to emphasise in his seminal book, *The Elementary Structures of Kinship*, 'If law is anywhere then it is everywhere... if the human mind appears determined even in the realm of mythology, *a fortiori* it must also be determined in every other sphere of human activity.'[29] In this respect, the mythological structures deployed by an Adolf Wölfli, a Henry Darger, or a Bispo do Rosario, like the transformation of *dream-work* into dream, is

nothing other than another way of objectifying thought. That this other way is conspicuously aesthetic in its method – that it is part and parcel of the human activity that we call art-making – is undeniable. And, as Marcel Duchamp argued, there is only one 'Art'.[30] After that there is only the question of quality.

Inner Worlds Outside, exhibition catalogue, Whitechapel Gallery, London, Irish Museum of Modern Art, Dublin and Fundación 'La Caixa', Madrid, 2006, pp.50–89.

1 Cited by Umberto Eco in his essay *Form as Social Commitment*, Bompiani, Milan, 1971.
2 Ibid.
3 Charles H. Kahn (ed.), *The Art and Thought of Heraclitus*, (The Cosmic Fragments) Cambridge University Press, 1979.
4 Sigmund Freud, Lecture VI, in *The Complete Introductory Lectures on Psychoanalysis*, James Strachey (trans., ed.), George Allen and Unwin, London, 1971.
5 Ibid., Lecture XXII: 'The Paths to the Formation of Symptoms'.
6 What was originally set up as a 'teaching collection', by 1909 was already being referred to as a 'museum'. As Brand-Claussen has suggested in her foreword to the Hayward Gallery exhibition of 1996, this says a lot about the ambition that the University of Heidelberg cherished for its collection.
7 Hans Prinzhorn, 'Bildnerei der Geisteskranken, Ein Beitrag zur Psychologie und Psychopathologie der Gestaltung', Springer, Berlin, 1922. English trans., *Artistry of the Mentally Ill*, E. von Brockdorff (trans.), Springer-Verlag, New York, 1972.
8 Bettina Brand-Claussen, 'The Collection of Works of Art in the Psychiatric Clinic, Heidelberg – from the Beginnings until 1945', in *Beyond Reason. Art and Psychosis: Works from the Prinzhorn Collection*, exhibition catalogue, London, The South Bank Centre, 1996.
9 Noam Chomsky, *Rules and Representation*, Columbia University Press, New York, 1980.
10 Richard Wollheim, *Painting as an Art*, Princeton University Press, 1990.
11 Cited by Noam Chomsky in his essay 'Language and Unconscious Knowledge', in *Rules and Representations*, Columbia University Press, New York, 1980.
12 Sigmund Freud, *The Complete Introductory Lectures on Psychoanalysis*, Lecture XI: 'Dream-work'.
13 Marshall Edelson, 'Language and Dreams: The Interpretation of Dreams Revisited', in *Psychoanalytic Study of the Child*, 27 (1972), pp.203–82.
14 Umberto Eco, *A Theory of Semiotics*, (English trans.), Macmillan, London, 1976.
15 Saussure called for a generally applicable 'linguistic science of signs'. Barthes concluded that such a project was anti-creative and proposed the transgressive theory of the shifter instead. Signs that shift their meaning and collapse meanings into each other.
16 Roland Barthes, *The Pleasure of the Text*, Richard Miller (trans.), Cape, London, 1976.
17 Roger Shattuck, 'The Social Institution of Modern Art', in *Candor and Perversion*. W.W. Norton and Co, New York, 1999.
18 Hans Prinzhorn, *Artistry of the Mentally Ill*, Springer-Verlag, New York, 1972.
19 Paul Gauguin, *Letters to my Friends*, H. Stennings (English trans.), Malingue, Paris, 1948.
20 This remark is commonly placed at the banquet arranged by Picasso in Rousseau's honour at the Bateau Lavoir in 1908, but this is unlikely since le Douanier is reported to have been too drunk to speak on that occasion. It is more likely to have happened at one of Rousseau's own weekly soirées. It is important to be clear about Rousseau's meaning. It was certainly not intended as a put-down but as a compliment. Egyptian art was absolutely in vogue in Paris during the first two decades of the twentieth century.

21 Roland Barthes, *The Pleasure of the Text*, Richard Miller (trans), London: Cape, 1976.

22 The Blaue Reiter *'Almanac'*, 1912. Cited by Dietmar Elger in Expressionism, Taschen, Köln, 2002.

23 *Manifeste du surréalisme*, 1924. Cited by Sarane Alexandrian in *Surrealist Art*, Thames and Hudson, London, 1970.

24 Ibid.

25 *Manifeste du surréalisme*, 1924. See Patrick Walberg's *Surrealism: A Documentary Anthology*, Thames and Hudson, London, 1966.

26 Paul Eluard (with André Breton), *Dictionnaire abrégé du Surréalisme*, Galerie Beaux-Arts, Paris, 1938.

27 André Breton, *'Le surréalisme et la peinture'*, Gallimard, New Edition, Paris, 1965.

28 Roland Barthes, included in *The Rustle of Language*, Blackwell, Oxford, 1986.

29 Claude Lévi-Strauss. Cited by the author himself in the Introduction to *The Raw and the Cooked*, Jonathan Cape, London, 1970.

30 Marcel Duchamp, *On the Creative* – address to the Art Students of the Chicago Institute, 1957.

UNCANNY TUESDAY

For years I have railed against the idea of the uncanny. After today I must give testimony to the fact that the uncanny happens. For no apparent reason, I woke up this morning thinking of Guy Debord and when I Googled him discovered that it was exactly 16 years after this polemicist co-founder of Situationism shot himself at his home at Champot. Gripped by this 'uncanny' coincidence, I reached for my well-thumbed copy of *The Society of the Spectacle* (1967), with its old underlinings and almost indecipherable marginalia, and for an hour or so found myself revisiting thoughts that I had had years ago. In particular I discovered a heavily underscored passage, which reads: 'Art in its period of dissolution... is at once an art of change and the purest example of the impossibility of change. The more grandiose its pretensions, the further from its grasp is its true fulfilment. This art is necessarily avant-garde, and at the same time it does not really exist. Its vanguard is its own disappearance.' For some reason – and again I am going to blame the uncanny for want of any more cogent explanation – it was a parade of images of Tate Modern's Turbine Hall that instantly sprang to mind when I reread this highly provocative passage. In my mind's eye, the ersatz sunrise leads the way in a procession of overblown, grandiose (in the

Debordian sense) spectacular projects, which with one or two notable exceptions, owe more to the children's playground than to the art museum.

Even though Debord's commentary is barely remembered amidst the promotional mishmash of today's art scene, reading it again it remains to my way of thinking the most pertinent to art's survival in the age of the image. If, as Guy Debord suggests, 'commodified (digital) time' – 'an infinite accumulation of equivalent intervals' – has indeed supplanted historical time, which has effectively put history to flight and we are left with the chronic problem of how to give lasting value to things in a world dominated by the technologies of mediation. In a reality mediated by images, in the instant in which we apprehend the work of art, the arch-pessimist Debord concludes, effectiveness replaces historically grounded judgements of quality and the meaning of history and taste are lost. Bereft of the past of art, under the sway of the spectacle, the prestigious commission and the museum's purchasing power come to authenticate everything.

It is arguable that things are even worse today than they were when Debord penned his great polemical work. Now that corporate interests are so clearly aligned with those of the institutions of art in the guise of cultural vanguardism and the pursuit of novelty, the good intentions of the artists themselves are in danger of becoming entirely compromised. Artists are lured into hubris, compelled to overreach themselves, to surf the promotional wave and the mediating power of the great institution to their own destruction. It was Thucydides, five centuries before Christ, who stated that history is the only true measure of novelty. Surely an eternal truth. Which is why it serves the purpose of those fake vanguardists of our own time, who prize the appearance of novelty above everything else, to eradicate history as a means of measuring it. Without history we are stuck with contingency as it is reflected in the processes of mediation. In his own commentary on *The Society of the Spectacle* published by Debord some ten years later, he writes: 'When significance is attributed only to what is immediate and to what will be immediate immediately afterwards... it can be seen that the uses of the media can only guarantee an eternity of noisy insignificance.'

PICPUS, Issue 5, London, Spring 2011.

THE RISE OF THE OBJECT:
DISPATCHES FROM THE WAR ON FORM

The American critic Rosalind Krauss was the first to attempt a comprehensive, theorised overview of modern sculpture in her book *Passages in Modern Sculpture* (1977). This was Krauss in her 'formalist' phase, and her general drift is one that leads away from the sculpture as a conveyor of iconic significance or narrative towards the sculpture as autonomous presence. In this regard, the transition she describes is not a particularly radical one. Sculpture remains bodily – gestural at the very least – and still comprises extensions in space, except that now, having abandoned figural frontality, it has become conspicuously a spatial encounter that occurs over time.

Though narrow in its theoretical scope, Krauss's space /time hypothesis proved for a time a surprisingly useful glass through which to view the sculpture of the postwar period. Although Duchamp's readymade poses a problem, her general thesis copes reasonably well with the more formal side of the modern movement and allows for the inclusion of performance art, film and video work and aspects of staging (tableau and installation) within sculptural practice. Her treatment of Minimalism, however, is less than satisfactory. In particular, she fails to address adequately the issue that accrued from a major shift in the behaviour of the viewing subject, defined by Michael

Fried as 'a new genre of theatre' – a theatre of 'presence'. Fried's conclusion, that this change in the relationship between work and viewer brings sculpture within touching distance of the world of entertainment, spawned one of the fiercest critical disputes of the postwar period.

The argument came to rest on the question of the status of the work of art as 'object' and was conducted in the main between the critics Clement Greenberg and Michael Fried and the Minimalist artists Donald Judd and Robert Morris. Its chief focus was on what Donald Judd termed 'specific objects', which he defined in opposition to the relational components in what he called 'part-by-part' sculpture. These, by contrast, he thought of as residually naturalistic or anthropomorphic, and therefore distinctively European. Most importantly, 'specific objects' carried with them no aesthetic surplus and – ideally – approached as near as possible to a condition of 'singularity'. They eschewed the notion of aesthetic 'wholeness' – by which he meant a quasi-metaphysical unity – so that multiplicity could only exist in terms of the orderly repetition of like forms.

Typically, Greenberg's main concern is with the grounding of aesthetic judgement, as he argues that the distinction between 'high and less than high art' obtains between those artists who show their connectedness to the tradition and those whose novelty sidesteps or even negates what has gone before. Where sculpture is concerned, Judd's rejection of the European tradition in pursuit of the new, for Greenberg meant not just the abandonment of historic sculptural materials, processes and forms identified with 'high art' in favour of materials and processes associated with commodity manufacture, the machine aesthetic and the world of the media, but the abandonment also of a richly varied and profoundly humanistic conceptual terrain as well. For him, the problem was epitomised by Duchamp's invention of the 'readymade', which was both 'dematerialising' – denying art's very nature as a material practice – and anti-aesthetic. When Duchamp signed the first bought object, *Bilboquet* (1910), designating it a work of art, he was substituting a 'thing' for a 'form' and by doing so he emptied the work of art of almost everything that had previously given it definition. As well as taking away the intention to give form to inchoate material, he was also severely curtailing the artist's purchase on aesthetic judgement, replacing it with what he was later to describe as an attitude of 'indifference'. Most pointedly, perhaps, the readymade inaugurated the idea of the work of art as ironic 'distraction': the one-liner, the clever aside, the closed language game or conceptual conundrum.

Even though Greenberg's view of Duchamp's readymade is not entirely sustainable, it came to be reflected in a vivid form in the evolution of British sculpture from the late 1960s. Prior to the Thatcher government's higher education funding reforms of the 1980s, the art school system had long been the main organ of patronage for young British artists. Working as part-time teachers gave them the income and the time to continue with their practice. It is no surprise, then, that certain schools became focal points in the evolution of British art in the postwar period. Among them were St Martins School of Art, where under the influence of Anthony Caro, what was known as the 'B' course in the sculpture department became the centre of the Greenbergian approach to sculpture,[1] and Goldsmiths College – the Fine Art department – the most prominent focus of opposition.

After David Smith, Caro was Greenberg's ideal sculptor. His background as a figurative sculptor meant that where figuration was concerned he was less dogmatic than many of his protégés. Even in his high 'formalist' phase Caro retained a firm belief in drawing from the human figure. Perhaps this is why, as well as reinventing sculpture linguistically – giving it a new type of existence as 'spatial syntax', as Michael Fried put it – even Caro's early 'abstract' work retained something of the anthropomorphic, gestural life of living bodies that was so disapproved of by Donald Judd. While seeking formal transparency, it seems that Caro also understood the need to achieve a certain liminal density, analogous to kinetic muscular memory. It seems, also, that he wanted to keep a hold on the linguistic, humanistic minimum of what figurative sculpture had once been, while at the same time shedding all traces of mimesis. In this respect his attitude to teaching sculpture sought to hold to a very demanding philosophical line.

That Caro's teaching legacy[2] – broadly speaking – failed is now a fact of history. By the beginning of the 1970s, a number of his colleagues and students – Phillip King, Tim Scott, William Tucker among others – had, with the critical support of Greenberg and Fried, succeeded in establishing themselves on both sides of the Atlantic. Within ten years they had faded from the public eye, unable to sustain the critical momentum behind Caro's philosophy of making. In large part this was due to the rapid advance of 'post-critical' (postmodernist) art theory. Given that the trajectory of Fredric Jameson's devastating 'postmodern' critique of Modernism has its starting point in the 1950s, it is arguable that the Caro-led revival of modernist sculpture, which took place at St Martins School of Art in the 1960s and 1970s, was already over before it had begun.

Using hindsight, it is revealing to cast sculpture teaching at St Martins in the 1970s as the terminus of a phenomenologically inclined, 'structuralist' enterprise, and the teaching of fine art at Goldsmiths College as a 'post-structuralist' one. And the fact that the former proved to be inflexible in the face of postmodern criticism and that the latter was entirely at ease with it is worthy of further consideration.

In the context of high modernism, 'structuralist' thinking resulted in what can only be described as a 'set' mentality. Artists tended to make work, not serially but synchronically; in familial groups. Objectness was seen as dependent on a set of shared components – linear elements, planes and/or shapes – tied to shared principles of transformation. The resulting object fed upon a particular type of illusion. It had to appear more than the sum of its parts. The pursuit of this 'sensible' surplus was what lay at the very heart of Caro's teaching and spawned a straitjacket of perceptually grounded methods and rules of evaluation.

Beyond this, as has been said before, there was something Messianic about Caro's teaching during his time at St Martins and this was carried through to his influence afterwards. It required and played upon the idea of the master and of mastery. Mastery implies control over a conceptually bounded terrain of some kind and in Caro's case this involved nothing less than the annexation of the historical terrain of sculpture in the name of a belated modernist cause. By contrast, the teaching of fine art at Goldsmiths College from the 1970s was based upon the premise that there were no masters any more, and no useful subject boundaries either. By 1972 the institutional divisions between painting, sculpture, print and media had been dissolved, and an integrated programme that included elements of the 'new art history' and 'art theory' was established a year later. The initial objective behind these changes was in no sense ideological but quite simply intended to match the way art was taught more closely to the way it was now practised. However, when viewed in retrospect, it is apparent that what started out as a non-doctrinaire, 'modernist' school was transformed in just a few years into the first struggling attempt at a self-consciously 'postmodern' one.

Although there were no 'masters' at Goldsmiths, the teaching tended to focus attention on certain 'models'. Painting-wise there was sustained interest in the painters of the second-generation New York School (Jasper Johns, Robert Rauschenberg and Andy Warhol), in American 'imagist' painting – the later works of Philip Guston, David Salle and the 'pre-expressionist' works of Julian Schnabel – and the German Pop artists Gerhardt

Richter and Sigmar Polke. Looming large over this mix were two key historical figures, testimony to a highly significant and rarely discussed link to Surrealism: Giorgio de Chirico and Francis Picabia.

Where three-dimensional work was concerned, the teaching tended towards hybrid 'object making' and 'installation' work, whose historical antecedents also lay with Surrealism, filtered through a wide spread of postwar tendencies and movements.[3] The point of origin for the pedagogical focus on the 'art object' started in the conceptual space opened up by Duchamp's 'readymade' but sought to go beyond it by establishing more open and flexible ways of framing the object philosophically. Key to this were such major historical figures as Piero Manzoni, Yves Klein and Marcel Broodthaers.[4]

This rather curious amalgam was held in place by an ongoing theoretical debate, which, as well as tackling the broader issues raised by postmodern criticism, included more focused discussion of feminism and race and gender differences. Taken together, this mix made for a lively and challenging arena in which to practise, but it also had its problems. Without close and continuous attention to questions of interpretation and the politics of representation, the 'postmodern' project lacks the critical fibre necessary to make diversity work in terms of anything other than those determined by fashion and the market. As Edward Said has stated, postmodern work, to be effective, requires a dialectical approach. It is easy to allow all instances of interpretation and forms of representation to be deemed equally valid and it is difficult to preserve past values – to paraphrase Luciano Fabro's famous dictum – while critiquing them. If the Goldsmiths programme failed in anything, it failed in this.

Perhaps one of the most noteworthy strands in the critical debate at Goldsmiths, from the 1970s through to the 1990s, took the form of a steady progress away from 'expressiveness' towards what was sometimes referred to as 'dumbness'. The 'expressive' object was one that had a lot to say for itself and, as Robert Morris put it, was full of 'self-importance', while the 'dumb' art object was self-effacing and content, very simply, to be itself – to enjoy its 'thingness'. The influence of Duchamp is obvious. 'Dumbness' borrowed much from the Duchampian idea of 'indifference', and derived its effectiveness through an irony of 'distraction', either by promising readability without delivering it, or by advancing a semblance of 'form' divorced from relationship. Both of these aesthetically negative strategies are exampled in the early work of Damien Hirst. His *Medicine Cabinets*, for example, present the viewer with a frontal array of labels whose collective meaning remains entirely opaque,

while the *Spot* paintings – their polite regularity – seem to be offering a model, formal relationship, although in reality they deny the viewer any experience of contiguity. Another, more general critical point can be made here. The increased concentration on the 'thingness' of the art object led to a diminution in the attention paid to a politics of interpretation and allowed instead description to be elevated to the status of a critical method. Within a very short period of time, formal concerns were mainly confined to questions of presentation.

An increased interest in installation work was the natural outcome of this change of emphasis, and here too, the Goldsmiths version was inflected in a very particular way, showing itself in the very deliberate use of semi-museological modes of presentation. Discrete objects were encased within vitrines, mounted on display stands, or shown as sets of related or like examples, arranged neutrally within a given space. The intentional irony behind this mimicking of the museum is perhaps best exampled by Michael Landy's large-scale installation work *Market*, made for an exhibition at Building One in 1990. Exceptionally, *Market* also fulfilled Said's demand for the 'dialectical' by pointing up the predictive correlation existing between the museums that buy and display works of art and the institutions that promote and sell them. Taken overall, however, this self-conscious museologising of the work of art can only be seen as a regression from the 'readymade'.

But in considering the work of the Goldsmiths generation we must also look at the wider question of 'decrafting' in the postwar period. Much of the work of these artists, though handmade, sought to achieve the clean-cut look and finish of factory-produced or machine-made things. Part of a historic trajectory, 'decrafting' is an integral component in the evolution of modernism. After the Second World War process in painting was greatly accelerated by the Abstract Expressionists who looked to achieve an appearance of effortlessness, of a 'spontaneous flowering', as Morris Louis described it. The deliberate crafting of a painting was displaced by a belief in the rightness of some kind of inner force. By contrast, sculpture remained embroiled in its craft traditions well into the 1970s. Even so, looking back, we can see that both traditions of practice were in crisis.

Much of the painting going on in Britain in the 1980s demonstrated very clearly that so-called Abstract Expressionism had, for the most part, already decayed into the worst kind of gestural mannerism. But the break with traditional forms of sculpture was by no means the same story. Indeed, it is

arguable that craft-wise, sculpture was put into crisis much earlier and that the break that came with Surrealism was already terminal. While Surrealism confronted painting with the problem of 'retinality', as Duchamp was quick to see, it faced sculpture with the much more intractable problem of its stubborn materiality. Painting could escape the dictates of the perceiving eye by depicting 'fantastic things'. It could quite happily 'dematerialise' our vision of the world – indeed it had been doing so in one way or another since the time of J.M.W. Turner – but sculpture was stuck with the 'imprint of the hand', with 'sculptural stuff' and the arcane stamp of its 'material processes'. It is something of an irony, then, that as things turned out, the issue was confronted and solved by Duchamp – if unintentionally – in the guise of the 'readymade'. In reality, Duchamp had little or no interest in sculpture. In all of his writings, letters and lectures he mentions it only occasionally in respect of his brother, Duchamp Villon, and his close friend Constantin Brancusi.[5]

Arguably the rise of the object or the search for object quality among British sculptors, even for middle-generation artists like Tony Cragg and Richard Deacon, has its origin – wholly or partly – with Marcel Duchamp. They all proceed with the notion of the work of art as a 'finished' (unified by process) more or less autonomous 'thing'. Where there is evidence of 'crafting', it is more in the manner of industrial 'pattern-making' or 'prototype engineering' than the hand-melding of an artefact. In the case of the Goldsmiths generation of artists this distanced quality is taken a stage further by the use of specially commissioned or found, made-to-measure or off-the-peg elements, each with its own quality of 'thingness', but used as part of a collective. Mimicry – the simulacrum – is used to rethink the way in which works of art reference the world, as with Landy's *Costermongers Barrow* (1991), or Hirst's *Pharmacy*, shown at the Tate Gallery in 1992.

Now, some 30 years on from the 1980s, and still living in the shadow of Conceptualism, we might think that Greenberg's fear that 'art will become something deduced rather than felt or discovered' was exaggerated. But his position was very simple and still worthy of our consideration. Great works of art make themselves accessible through their inner power. In this sense, they are, by their very nature, democratic. The near-impossible task of criticism is to try to show why and how they work upon the human subject in the way that they do. Critical and theoretical extension, whether before or after the fact, reduces the work of art to the 'instrumental' and robs it of its 'essential' power to move its audience.

In the British context, the argument between what we might call a Modernist 'idealism', with its promise of humanist unity and continuity and a postmodern acceptance of discontinuity, rupture and fragmentation, was played out by successive generations of artists educated and coming to prominence during the 1970s and 1980s respectively. On the surface, this looks to be the eclipse of one generation by another, but the picture is by no means so clear-cut. Certainly, the conflict showed up in its starkest form in the field of sculpture, with the demise of traditional sculptural methods and ways of conceptualising sculptural form and the colonisation of the field by performative forms of practice. In this sense sculpture might be said to bear testimony to the 'dematerialising' effect of today's technologies – the routine translation of the real into 'images'. This leaves us with the problem of how to attach lasting value to the ubiquitous 'de-aestheticised' composite object/thing so lauded by today's global art market.

As Fredric Jameson has pointed out, at least modernism carried with it a certain contestatory intent. Its purpose was to act as a social and cultural irritant. Jameson asks the question: 'can anything of the sort be said of postmodernism and its social moment. We have seen that it replicates the logic of consumer capitalism... is there also a way in which it resists that logic?' Given the market-led antics of so many young British artists since the 1990s, it seems that the jury is still out.

Modern British Sculpture, exhibition catalogue, Royal Academy of Arts, 2011, pp.234–41.

1 There were two sculpture programmes within the Sculpture Department at St Martins School of Art in the 1960s and 1970s. The *B* course was the inheritor of the Caro/Greenberg line and the A course, headed up by Ken Adams and afterwards by Peter Kardia, was seen as more open and diverse in its approach to sculptural practice. The latter produced the more interesting artists, among them Richard Long, Richard Deacon and Bill Woodrow.

2 In fact Caro taught at St Martins for a comparatively short time, although as a highly charismatic teacher, his influence outlasted him by more than a decade.

3 For example Spatialism and Arte Nucleare; Nouveau Réalisme and Arte Informel; Pop art and Objectivism; Minimalism and Conceptual art; Arte Povera and post-Minimalism.

4 Studio discussion also ranged over a wide variety of artists currently gaining critical attention, figures such as Donald Judd and Robert Morris, Michelangelo Pistoletto and Giuseppe Penone, Joseph Beuys, Blinky Palermo and Martin Kippenberger, Andrea Fraser and Janine Antony, Chris Burden, Jeff Koons and David Hammons.

5 Duchamp's attitude to sculpture is perhaps best expressed – apocryphally – by a remark he is said to have made to Brancusi when looking at an aeroplane propeller at the Paris air show: 'It's all over for painting. Who could better that propeller? Tell me, can you do that?'

INDEX

CREDITS

Published in 2011 by Ridinghouse
5–8 Lower John Street
Golden Square
London W1F 9DR
United Kingdom
www.ridinghouse.co.uk

In association with
Akerman Daly
6 Victoria Chambers
Luke Street
London EC2A 4EE
www.akermandaly.com

Distributed in the UK and Europe by
Cornerhouse
70 Oxford Street
Manchester M1 5NH
United Kingdom
www.cornerhouse.org

Distributed in the US by
RAM Publications
2525 Michigan Avenue Building A2
Santa Monica, CA, 90404
United States
www.rampub.com

British Library Cataloguing-in-Publication Data
A full catalogue record of this book is available
from the British Library

ISBN 978 1 905464 37 1

Ridinghouse Publisher: Doro Globus
Edited by Jeremy Akerman and Eileen Daly
Editorial Assistant: Louisa Green
Copy-editor: Eileen Daly and Susannah Worth
Designed by Marit Münzberg
Printed by Samhwa Printing Company, South Korea

Ridinghouse

 The Henry Moore
Foundation

Middlesex
University LOTTERY FUNDED

Foreword and interview © Jon Thompson, Jeremy
Akerman and Eileen Daly
Texts © Jon Thompson unless noted on p.535
Image © Jon Thompson; courtesy Anthony
Reynolds Gallery
For the book in this form © Ridinghouse

Image p.9:
The Toronto Cycle #9, Absent Roots, Two Fold
2009
Oil and acrylic on canvas
177.8 x 152.4 cm
Courtesy Kirkland Collection